THE PAINTINGS
OF REMBRANDT

REMBRANDT

THE COMPLETE EDITION
OF THE PAINTINGS

BY A·BREDIUS

REVISED BY H·GERSON

PHAIDON

Paintings in the Royal Collection are reproduced by gracious permission of Her Majesty the Queen. The Phaidon Press would like to thank all museums and private owners who have provided photographs for reproduction.

ALL RIGHTS RESERVED BY PHAIDON PRESS LTD · 5 CROMWELL PLACE · LONDON SW7
FIRST EDITION 1935 · THIRD EDITION 1969

PHAIDON PUBLISHERS INC · NEW YORK
DISTRIBUTORS IN THE UNITED STATES: FREDERICK A. PRAEGER · INC
111 FOURTH AVENUE · NEW YORK · N.Y. 10003
LIBRARY OF CONGRESS CATALOG CARD NUMBER: 68-27416

SBN 7148 1341 9
MADE IN GREAT BRITAIN
PRINTED BY HENRY STONE AND SON LTD · BANBURY

CONTENTS

OUTLINE BIOGRAPHY

1606 Rembrandt Harmensz. van Rijn born on the 15th of July, at Leyden, the son of Harmen Gerritsz. van Rijn, miller, and Neeltgen Willems-dochter van Zuidbroeck, daughter of a baker.

1620 20th May: Rembrandt's name appears on the roll of Leyden University.

1620-24 Period of apprenticeship: three years with Jacob Isaaksz. van Swanenburgh in Leyden; six months with Pieter Lastman in Amsterdam; perhaps also a short phase with Jacob Pynas.

1625 Earliest surviving dated picture: *The Martyrdom of St. Stephen* (Br. 531A).

1628 Gerard Dou becomes a pupil.

1630 Death of Rembrandt's father.

1632 Rembrandt settles in Amsterdam.

1633 Begins work on a series of paintings of the Passion for the Stadholder, Prince Frederick Henry of Orange.

1634 Marriage to Saskia, on 10th July.

1639 Rembrandt buys a house—for which he is unable to pay—in the St. Anthonie-Breestraat.

1640 Death of Rembrandt's mother.

1641 22nd September: baptism of Rembrandt's son Titus.

1642 14th June: death of Saskia.
"*The Night Watch*" (Br. 410).

1649 1st October: Hendrickje Stoffels documented in Rembrandt's household; probably engaged as a nurse for the young Titus, she remained with Rembrandt as his mistress.

1654 30th October: baptism of Hendrickje's daughter, Cornelia.

1656 25th July: inventory of Rembrandt's possessions made on the occasion of his bankruptcy.

1658 Sale of Rembrandt's house and household property.

1660 The house made over to Rembrandt's creditors. To protect himself from them, Rembrandt becomes an employee of Titus and Hendrickje, who had been carrying on an independent art-dealing business since 1658.

1661 *The Conspiracy of Julius Civilis: the Oath* (Br. 482).

1662 *De Staalmeesters* (Br. 415).

1663 Death of Hendrickje.

1668 Death of Titus, who had married Magdalena van Loo in 1667.

1669 Rembrandt's last self-portraits (Br. 55 and 62).
4th October: death of Rembrandt.
8th October: buried in the Westerkerk, Amsterdam.

FOREWORD

The Paintings of Rembrandt by A. Bredius was first published by Phaidon Verlag in Vienna in 1935, and has become a 'classic'. This is not on account of its text—the book has only a brief introduction and some "short explanatory notes on some of the pictures"—but because it contains a complete set of reproductions of Rembrandt's pictures. The illustrations, Bredius wrote in the introduction, should speak for themselves. Equally remarkable for an art book published at that period was its low price.

The Bredius Rembrandt has become a standard work of reference; and there has not appeared since a single book on the artist of any significance which does not refer to the Bredius numbering. Bredius superseded the older publications of Bode, Hofstede de Groot and Valentiner; it also corrected them. In a way, it is astonishing that the work of an old man like Abraham Bredius—he was then eighty years old—should have gained such an ascendancy over the clever, well written monographs of the younger generation. Part of the reason, we may suppose, lay in the very character of the book, in which the pictures, and nothing but the pictures, were the main feature, an emphasis which coincided with a growing preference for looking at, rather than reading about, works of art.

It may be of interest to learn from the only surviving member of the original editorial team a little about the genesis of the book, and also about its remarkable author. When Abraham Bredius died in 1946, shortly before his 91st birthday, the obituaries hailed him as a gifted connoisseur and man of refined taste; as a discriminating collector (he owned eight Rembrandts); as an administrator—he had been a Director of the Mauritshuis; and as a generous benefactor, who had left his collection to the Dutch people.[1] Curiously enough, he had never studied art-history formally. His first great enthusiasm had been for music, and it was only when he travelled in Italy that he became deeply interested in art. At first, it was Italian art which appealed to him; but Wilhelm von Bode, renowned connoisseur and director of the Berlin Museum, encouraged Bredius to study the art and artists of his native country. And that is what Bredius did. His parents were rich, and he had been a somewhat spoilt child, but his sense of vocation was so strong that it was easy for him to exchange, for long periods of time, the allurements of a luxurious home and leisured society for the drier, though often more exciting, world of the archives.

Bredius published his findings in a succession of articles in the magazine *Oud-Holland*, and in his seven volumes of *Künstler-Inventare* (1915-22). From 1883, he was co-editor of *Oud-Holland*, to which he contributed regularly right up to his death, and for whose maintainance he provided large sums of money. Many more unpublished Bredius notes are preserved in the Rijksbureau voor Kunsthistorische Documentatie in The Hague.

[1] W. Martin in *Maandblad v. beeldende Kunsten* 22, 1946, p. 71; in *Jaarboek Maatschappij der Nederlandse Letterkunde te Leiden* 1946-1947, 1948, p. 29; A. W. Byvank in *Jaarboek der Koninklijke Nederlandse Akademie voor wetenschappen* 1947-1948, 1948, p. 193; H. E. van Gelder in *De Gids* 109, 1946, II, p. 46; in *Oud-Holland* 61, 1946, p. 1; in *Bulletin van de Nederlandse Oudheidkundige Bond* 5/1, 1947, p. 5; in *Maatstaf* 4, 1956, p. 190.

To my mind, his archival work alone has secured for Bredius a permanent place among the most distinguished Dutch art-historians. The big books were few in number—*Jan Steen* in 1925, the first edition of the *Rijksmuseum Catalogue* (1885) and the *Mauritshuis Catalogue* (1891)—but his articles were numerous, the result not only of his work among the archives but also of the constant and intensive study of paintings that he made on his many travels in Europe and America. With von Bode and Hofstede de Groot, he was one of the leading connoisseurs of Dutch art before the first World War—a group which had a decisive influence both on research and on the 'image' of Dutch painting that was presented to the general public. Their reputation became clear, for all to see, after the big Rembrandt exhibitions of 1898 in Amsterdam and London.

In the meantime, Bredius did not neglect his duties as Director of the Mauritshuis (1889-1909). This was not a post that brought out the best in Bredius, who was certainly an obstinate and in some respects a pathetic man, and behind many of the controversies in which he was involved one can discern the weaker sides of his personality. He was engaged in a more or less constant struggle with the administration, and in particular with a then very powerful official, Victor de Stuers. Bredius frequently threatened to resign, and he wrote letters of complaint to the States General, the Minister and even to members of the royal family. Never ending controversies with colleagues, especially his former collaborator, Hofstede de Groot, filled not only the art journals but also the columns of so distinguished a newspaper as the *Nieuwe Rotterdamsche Courant*. Bredius was also at odds with the Minister of Finance, whose tax-policy, he felt, would ruin him. Finally, in 1922, he retired to his home in the South of France, the Villa Evelyne at Monaco. 'Retired', though, is not perhaps quite the right word: whether in Monaco, or on his annual visit to Holland, he was accustomed to receiving a constant stream of visitors, with or without cherished treasures they wished to have 'expertised'.

It was in the late 1920s that I first met Abraham Bredius. The situation was delicate. I was then a devoted assistant to Hofstede de Groot and I knew enough about the breach between them, on both a personal and a scholarly level, to feel that the new association might be unworkable. Fortunately, it was not, though at first I found it disconcerting. Bredius was then in his seventies and he retained the manners, at once polished and polite, of a *grand seigneur*. Gossip about the art world always gave him pleasure. Less appealing was the degree—sometimes it was really quite astonishing—to which he was susceptible to flattery. I was upset to see how dealers, great and small, played on this weakness, so as to gain prestigious recommendations for poor pictures. Leaving aside this weakness (and weakness it was: Bredius was never paid, directly or indirectly, for certificates), however, one could still feel the full force of Bredius' remarkable personality, the enthusiasm and integrity of a man who had secured for Holland more works of art than any rich industrialist in modern times; who had worked, day after day, in the archives; and who, in his relentless pursuit and study of paintings, had travelled all over Europe, from Russia to Spain, from Sicily to Poland, to the smallest museums in the French provinces and to the Renaissance castles of rich noblemen in Galicia.

So far as I recall, the idea of a new and comprehensive volume on Rembrandt's paintings was conceived by Dr. Bela Horovitz, the enterprising head of the Phaidon Press

in Vienna. It was first discussed with Dr. Hans Schneider, who, after Hofstede de Groot's death in 1930, had been appointed director of a new art-historical institute, which housed the photographs and notes that Hofstede de Groot had bequeathed to the Dutch nation. Innately modest, Hans Schneider was to leave Bredius to take all the praise as author of the new book, but it was really due to his tact and foresight that many controversial paintings, certified and even published in magazines by Bredius, were eliminated.

Looking over the preparatory lists with Bredius' notes on the Valentiner catalogues (the material survives), and the many short notes that passed between the "Monaco Bredius" and the "Hague office", it becomes clear that Bredius' agreement was applied for in the case of every item reproduced; but I am afraid that it was an overstatement on Bredius' part to emphasise that he had "as far as possible examined afresh all pictures" reproduced in older publications. Quite understandably, there were a number of paintings about which Bredius could not make up his mind, and it again depended on Schneider's discretion and knowledge whether these border-line cases were admitted or rejected. An equally important factor at the time was Bredius' hostility towards Valentiner and his conception of Rembrandt's oeuvre. Valentiner's catalogues included about 700 works, and Bredius had strongly criticized the last volume of *Rembrandt, Wiedergefundene Gemälde*[2]—and no wonder, when one remembers the 'fighting spirit' of the time, and the way attacks and counter-attacks followed one upon the other, to be joined in some cases by salvoes from a third party.[3]

Bredius favoured a smaller oeuvre, though even his catalogue included over six hundred items. When the final list had been determined, my main task was to write an introduction about the life of Rembrandt, and to provide a brief explanatory note to accompany each picture. I was quite aware that it was my duty to act as a ghost writer, and I was proud of the fact that Bredius never changed a word of my text, except for one picture in his own Bredius Museum. Shortly afterwards, a second (English) edition was published; the edition was small, and copies are extremely rare. Nine newly discovered items were added, but communications between The Hague and Monaco must have been less smooth because Bredius complained bitterly that one painting had been added that he himself would never have admitted. Bredius was so upset that he refused to see his former colleague, Schneider, again. The second World War interrupted the collaboration in any case. It was also probably on account of the war that Bredius' book never aroused the degree of discussion that one might have expected. One might have supposed that the Valentiner-Rosenberg party, which favoured a large Rembrandt oeuvre, or the Martin-Bauch group, which reduced the number of autograph works still further, would have raised their voices.

Though the criticism of the Bredius Rembrandt was limited, research into the artist's life and work did not diminish after 1935. What has changed, however, is the direction

[2] A. Bredius in *Zeitschrift für bildende Kunst*, N.F. 32, 1921, p. 146.
[3] W. R. Valentiner in *Zeitschrift für bildende Kunst* N.F. 32, 1921, p. 172; *Kunstchronik* 23, 1921/2, p. 58; A. Bredius in *Kunstchronik* 23, 1921/2, p. 391; C. Hofstede de Groot, *Die holländische Kritik der jetzigen Rembrandt-Forschung*, 1922; W. Martin in *Kunstwanderer* 1921/2, pp. 6 and 30; 1922/3, p. 407; C. Hofstede de Groot in *Kunstwanderer* 1923/4, p. 31.

of interest, in accord with the general reorientation of art historical studies since the second World War. The Dutch-German leadership has been replaced in Rembrandt studies by an Anglo-American one; iconography has seemed of more interest than connoisseurship; and much thought has been devoted to the history of Rembrandt criticism itself. The tendency towards iconographic research is, of course, much older, and one can only wonder why it affected Dutch art history so late. The first great show-piece in this line, so far as Dutch art is considered, was Erwin Panofsky's article Der gefesselte Eros in *Oud-Holland* in 1933.[4]

The great comprehensive monographs of former times have gone out of fashion. Neumann's two volumes, which went through four editions between 1902 and 1924, are plainly out of date now.[5] Also in German are the books by Weisbach (1926) and Hamann (1948), but I wonder whether they were ever much read or understood outside Germany.[6] The counterparts in English are the monographs of Hind (1932) and Rosenberg (1948); the latter rightly appeared in a second edition not long ago.[7] I am afraid, however, that the modern monographs in French, Dutch, Russian, Rumanian and Czech, are of only parochial interest.[8] More influential have been the surveys, often of great length, in textbooks and encyclopaedias.[9] In many respects more important, and just as popular, are the catalogues proper, of museums and exhibitions, and of the drawings (Benesch's six-volume work published between 1954 and 1957) and the etchings (Münz and Björklund).[10] Reactions here have been manifold; and the many reviews of exhibitions, catalogues and books, have really stimulated our knowledge of Rembrandt's art. However, it has been on the subject of the drawings and etchings, rather than the paintings, that recent research has been most profitable.

The reluctance to produce a full-scale monograph on Rembrandt is partly due to the "debunking" tendency of modern art interpretation. The desire to write—and to read—such a book must spring from an idealistic optimism in historical thinking which is no longer prevalent. But this does not mean that historical research or historically based interpretations of Rembrandt's art have ceased. Many modern Dutch historians and art

4 *Oud-Holland* 50, 1933, p. 193 (referring to Bredius 474).
5 Carl Neumann, *Rembrandt*, 1st ed. Berlin, 1902; 3rd ed. Munich, 1922; 4th ed. Munich, 1924.
6 Werner Weisbach, *Rembrandt*, Berlin, 1926; Richard Hamann, *Rembrandt*, Berlin 1948.
7 A. M. Hind, *Rembrandt*, Oxford 1932; J. Rosenberg, *Rembrandt*, Cambridge (Mass). 1948; 2nd ed. London, 1964.
8 M. Alpatov, *Studies in the History of Western European Art*, Moscow-Leningrad, 1939, p. 76-90 (Russian); E. Fechner, *Rembrandt*, Leningrad-Moscow, 1964 (Russian); H. E. van Gelder, *Rembrandt*, Amsterdam 1946; G. Knuttel, *Rembrandt*, Amsterdam, 1956; E. Schilern, *Rembrandt*, Bucharest, 1966; M. Brion, *Rembrandt*, Paris, 1965; V. V. Stech, *Rembrandt*, Prague, 1966. The most widely known book of this type was probably A. B. de Vries, *Rembrandt*, Baarn, 1956 (also: German edition, Cologne-Berlin, 1957).
9 J. Rosenberg-S. Slive, *Dutch Art and Architecture*, Harmondsworth, 1966; O. Benesch in Thieme-Becker, *Allgemeines Lexikon der bildenden Künste*, Leipzig, 29, 1935, p. 259; E. Haverkamp Begemann in *Encyclopedia of World Art*, 11, New York, 1959, p. 91 .
10 O. Benesch, *The Drawings of Rembrandt*, London, 6 volumes, 1954-7; L. Münz, *Rembrandt's Etchings*, London, 1952; G. Björklund, *Rembrandt's Etchings*, Stockholm-Paris, 1955; K. G. Boon, *The Complete Etchings of Rembrandt*, London-New York, 1963.

historians have added to our insight and knowledge about the artist, and they have often corrected the too lightheartedly applied conclusions of foreign writers. One might point, for example, to the controversies surrounding Schmidt-Degener's interpretations of the *"Eendraagt van 't land"* (Br. 476) and *"The Night Watch"* (Br. 410), as well as his essay on Vondel and Rembrandt. It is a fact, however, that much of this controversial research has been confined to the Dutch language; and has in consequence only slightly stirred the world's interest in Dutch art-historical problems in general or Rembrandt in particular.[11]

The new research can be divided into two main categories. The first covers Rembrandt's life; his religious outlook; his position in the society of 17th century Amsterdam; his friends; the people who commissioned work from him, and so on. The second category is purely iconographic, and covers the history of subject matter and its representation. Seventeenth-century attitudes to life and thought, the period's literary traditions and contemporary art theory are naturally touched upon. To Rembrandt's most famous works—*The Anatomy Lesson* (Br. 403), for example, *The Conspiracy of Julius Civilis* (Br. 482) or *De Staalmeesters* (Br. 415)—long articles, even books, have been devoted. The tradition of various religious themes, the blessing of Jacob, the Supper at Emmaus, the stories of Hagar, Tobias, Haman, and others, has been investigated at great length. On the biographical side, the old tradition of archival research has been taken up by younger specialists in both history and genealogy. The rather romantic view of Rembrandt evolved in the 19th century has been replaced by a franker, less reverent interpretation, partly based on new documents, such as those referring to the unhappy Geertge Dircx. A new type of Rembrandt biography came into existence with the book by Christopher White, the Dutch edition of which (with Wijnman's notes) is even more revealing.[12]

By and large, this more diversified, specialist research has provided valuable new insights into Rembrandt's life and art. Three further lines of research remain to be discussed, albeit briefly. Particularly praiseworthy are the excellent modern bibliographies of Rembrandt and Dutch art in general.[13] Also worthy of note are the many critical surveys of the interpretation of Rembrandt's art; among them are some very remarkable books and essays, which, among other things, have put into their proper perspective the often arrogant assertions of writers and connoisseurs, past and present.[14] Finally there are the

[11] These special articles are referred to in the notes to the pictures. F. Schmidt-Degener's German version of *"Rembrandt en Vondel"* ("Rembrandt und der holländische Barock", in *Studien der Bibliothek Warburg* 9, 1928), has become widely known, but the strong criticism from Dutch historians on it probably not.

[12] Chr. White, *Rembrandt and his World*, London, 1964; *Rembrandt, biografie in woord en beeld met . . . aantekeningen door Mr. H.F. Wijnman*, The Hague, 1964.

[13] O. Benesch, *Rembrandt, Werk und Forschung*, Vienna, 1935; H. van Hall, *Repertorium voor de geschiedenis der Nederlandsche schilder- en graveerkunst*, The Hague, 2 volumes, 1936 and 1949; *Bibliography of the Netherlands Institute for Art History*, The Hague, 1943-; J. Białostocki, "Ikonographische Forschungen zu Rembrandt's Werk" in *Münchner Jahrbuch der bildenden Kunst*, 3/7, 1957, p. 195; H. van de Waal, "Rembrandt 1956," in *Museum* (Leiden), 61, 1956, p. 193.

[14] S. Slive, *Rembrandt and his Critics*, The Hague, 1953; R. W. Scheller, "Rembrandt's reputatie van Houbraken tot Scheltema" in: *Nederlands Kunsthistorisch Jaarboek* 12, 1961, p. 81; J. A. Emmens, *Rembrandt en de regels van de Kunst*, Dissertation, Utrecht, 1964.

contributions about newly discovered works, and the technical studies of brushwork made with the help of X-rays and other scientific aids.

A well-known example here is the much discussed Stuttgart *Self-portrait*, which has not been included in the revised edition of Bredius.[15] Generally speaking, there seems to be more agreement about what has been eliminated from the accepted oeuvre of Rembrandt than about the additions proposed by Bauch and others. Rather well established now is the view on Rembrandt's earliest works. Differences of opinion as to whether a certain painting is by the young Rembrandt or the young Jan Lievens do not make a tremendous difference, as both these young artists are worthy of our admiration.

In other respects, opinion on attributions, on what is to be regarded as genuine and what as a school-piece, is still much divided. Compared with the progress in iconographic and historical research, our advance towards establishing a good catalogue raisonné is still rather modest. In another study I have tried to show how fragile and unreliable the extra-pictorial sources are, and how small is the group of well documented pictures.[16] The signatures have often been retouched or added later—to school pictures and genuine works alike. The series of 'signed' pictures, therefore, is not a basis on which to build, especially since we know that Rembrandt signed and sold pictures executed by his pupils, as well as collaborating with Lievens on the same work.

Today, the tendency is to reduce still further the number of paintings attributable to Rembrandt. Bredius' own catalogue, as I have said before, was an answer to the inflated catalogues of Valentiner.[17] In his catalogue of 1966, Bauch rejected approximately seventy items accepted by Bredius—and in most cases, I think, rightly so.[18] Jakob Rosenberg, however, is not as severe as either Bredius or Bauch.

It can be easily understood that the republication of a standard work like Bredius' *The Paintings of Rembrandt* has been a lengthy undertaking. In full agreement with Phaidon Press, I have adopted some basic rules, in order to make the book as useful as possible to the modern reader. To do justice to Bredius—and to avoid full-scale re-numbering—I have retained all the original Bredius numbers for pictures, though a few paintings will be found out of their original sequence. This became necessary when a newly read, or re-read, date affected the chronological sequence (for example, Br. 491 and 544), or because a new interpretation of a picture altered its status in a category. Br. 179, for example, was originally included among the male portraits as a *Portrait of an Oriental*; but as it almost certainly represents *Uzziah stricken with leprosy*, it has seemed more sensible to transfer it to the section devoted to single figures with Biblical connotations.

15 P. Coremans and J. Thyssen in *Bulletin Institut Royal du patrimoine artistique* 7, 1964, p. 187; C. Müller Hofstede in *Pantheon* 21, 1963, p. 63; B. Bushart, ib. p. 90; P. Coremans in *Jahrbuch der Staatlichen Kunstsammlungen in Baden-Württemberg* 2, 1965, p. 175; H. Kühn, ib. p. 189.

16 H. Gerson, *Rembrandt paintings*, New York, 1968, p. 160.

17 A. Burroughs (*Art Criticism from a Laboratory*, 1938, p. 153) calls Bredius' catalogue "as inclusive" as Valentiner's, Bode's and Hofstede de Groot's!

18 K. Bauch, *Rembrandt Gemälde*, Berlin, 1966, p. 47.

Fifty-six paintings have been relegated to an Appendix at the back. This Appendix represents a problem that I cannot claim to have solved in a wholly satisfactory way—namely, what to do with the paintings that I (and often my colleagues as well) cannot accept as unquestionable Rembrandts. To have removed them all to the Appendix would have been to alter the character of the book entirely, and to have substituted a Gerson view of the oeuvre for Bredius' own. On the other hand, there are a number of paintings which have been generally rejected from the corpus in recent years; and I cannot help but feel that a man of Bredius' perceptions would have come to see the merit of the current view. It seemed unfair, therefore, to saddle his memory with these items; that is why they have been put in an Appendix, along with several paintings about which he himself expressed doubts in the first edition (and with which I agree), as well as a number of markedly inferior and unimportant pictures that I have had the opportunity of examining in recent years. Important works about which I have doubts, and unimportant paintings that are questionable, but which I have either never seen, or not seen recently, have been left in the body of the book. The body of the book therefore contains the pictures regarded by Bredius and many living art-hitsorians as genuine Rembrandts. My own opinions, which rather often vary from that of Bredius, can be found in the notes. The few new additions are distinguished by an A-number (e.g. the Wharton *Flight into Egypt* of 1634 becomes Br. 552 A, following Br. 552, which is the *The risen Christ showing His wound to the Apostle Thomas* of the same year), which is also used to indicate that where a picture exists in several versions, the variant reproduced now is different from the one chosen by Bredius.

The notes to the pictures have been completely rewritten, in an expanded form, in order to give the reader a summary of modern research on each painting. Besides expressing my own view, I have tried to bring together as many other opinions as possible, whether they corroborate or contradict what I feel myself. Sometimes these notes have grown into rather long discussions in their own right. Wherever possible, I have tried to check signatures and dates; though it is worth pointing out, in this connection, that thick, often discoloured, varnish sometimes makes it very hard to read the more tentative strokes and digits. Varnish can also make judgements of a more general kind very difficult. It is partly for this reason that, where possible, I have referred to X-rays.

I cannot claim, with Bredius, to have included "only those pictures whose authenticity seems to me beyond all doubt". As far as possible, I have made clear my opinion on the status of every item by putting my own views, in addition to those expressed in the literature on Rembrandt. With Bredius, though, I must admit that it "does not necessarily mean that all pictures which have been attributed to Rembrandt by others, and which do not appear here, are not genuine." There are border-line cases on both sides of the border! To be honest: there are, in fact, many, many border-line cases, with which I have struggled, as many others have already done. There are a good number of cases where I have expressed an opinion contrary to Bredius and other art-historians whom I respect. The reader will realise that the two groups of pictures—those definitely attributable to other hands, and those not beyond doubt—have become still larger in the last thirty years. This caution reflects, I am afraid, the real state of our knowledge of Rembrandt.

But even if my "pessimism" seems opposed to Bredius' "optimism", the intention of this new edition is not to ventilate my personal criticism but to make Bredius' book a useful work of reference and an aid to further research. If this aim has been partly achieved, it is thanks to the help and collaboration of the many colleagues and friends all over the world who spared no trouble in assisting me to study the works in their care. The discussions we had together belong to the happiest hours of art-historical research that I can recall.

A special word of thanks and praise to my collaborators of the last hour, Keith Roberts and Gary Schwartz, who helped me to get the book into final shape.

Groningen, April, 1968 *Horst Gerson*

SELF-PORTRAITS

ERRATA

Br. 63 on p. 61: for "panel" read "copper".

Br. 244 on p. 194: for "Mrs. Standish Baccheus" read "Mrs. Standish Backus".

Br. 359 on p. 280: for "formerly Vaduz, Liechtenstein Collection"
read "formerly Vienna, Lanckoronski Collection".

Br. 470 on p. 380: for "panel" read "canvas".

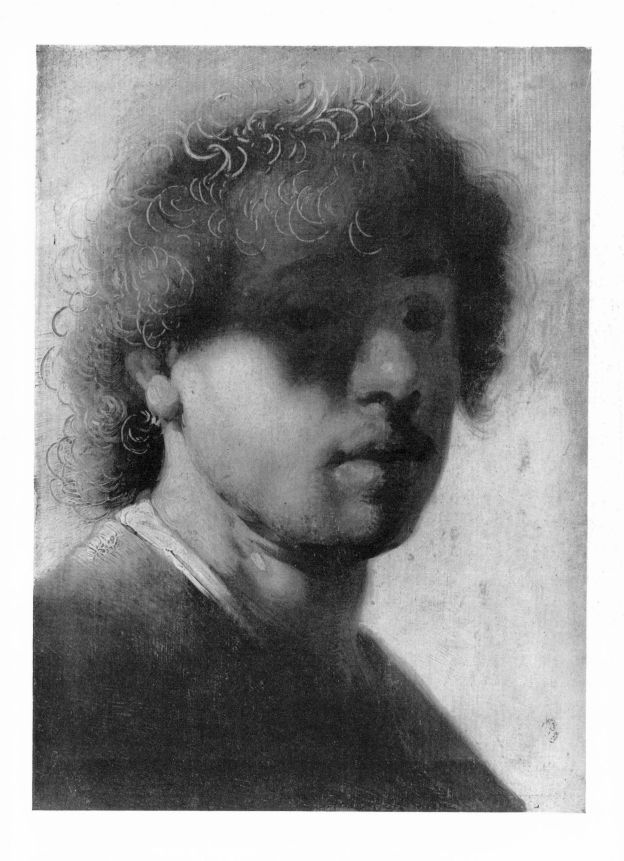

SELF-PORTRAIT. Panel, 23.5 × 17 cm. Cassel, Gemäldegalerie. (Br. 1)

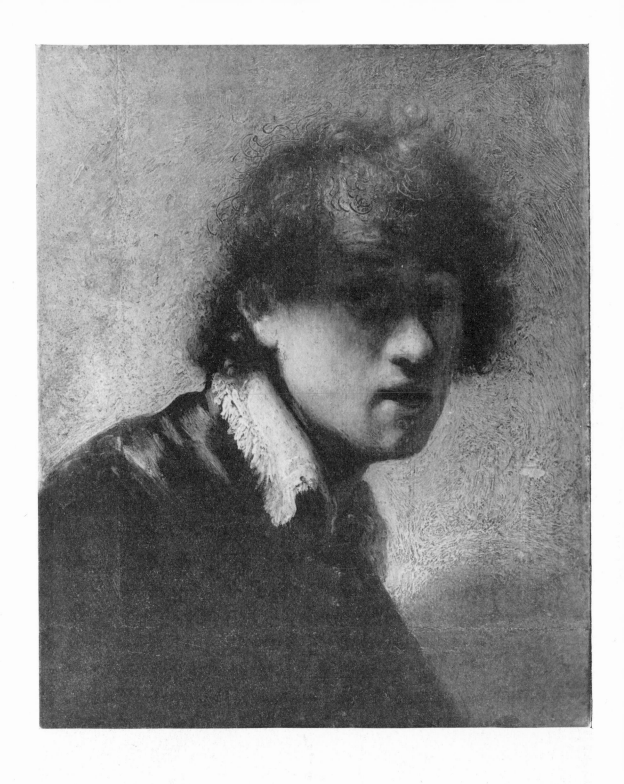

SELF-PORTRAIT. 1629. Panel, 15.5×12.5 cm. Munich, Alte Pinakothek. (Br. 2)

SELF-PORTRAIT. Panel, 43×33 cm. Formerly Lemberg, Lubomirska Collection. (Br. 3)

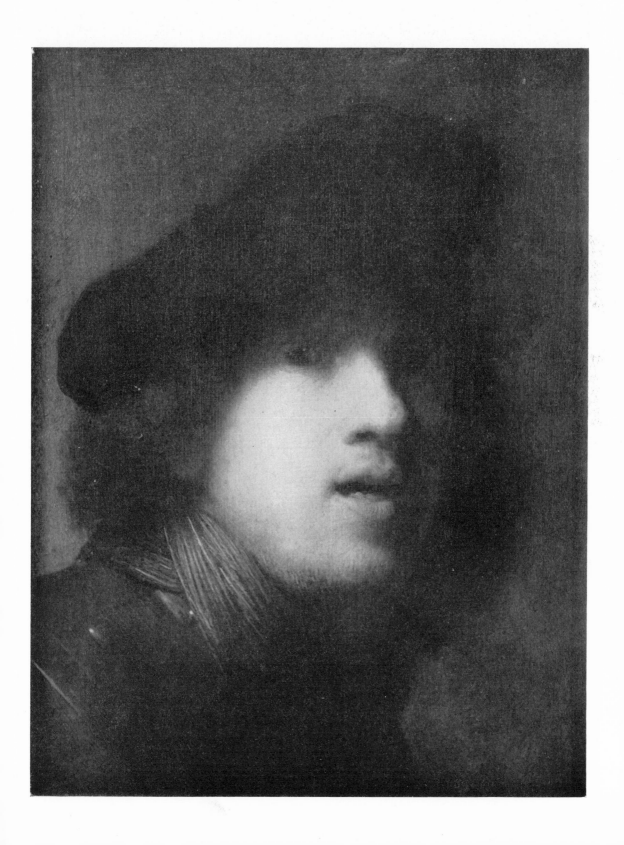

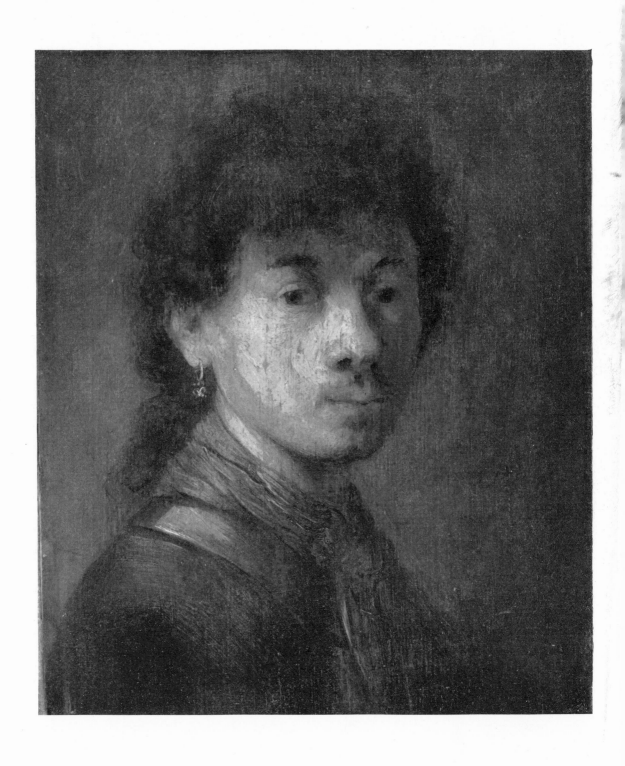

SELF-PORTRAIT. 1629. Panel, 21×17 cm. Cambridge, Mass., Fogg Art Museum (on loan from James P. Warburg). (Br. 4)

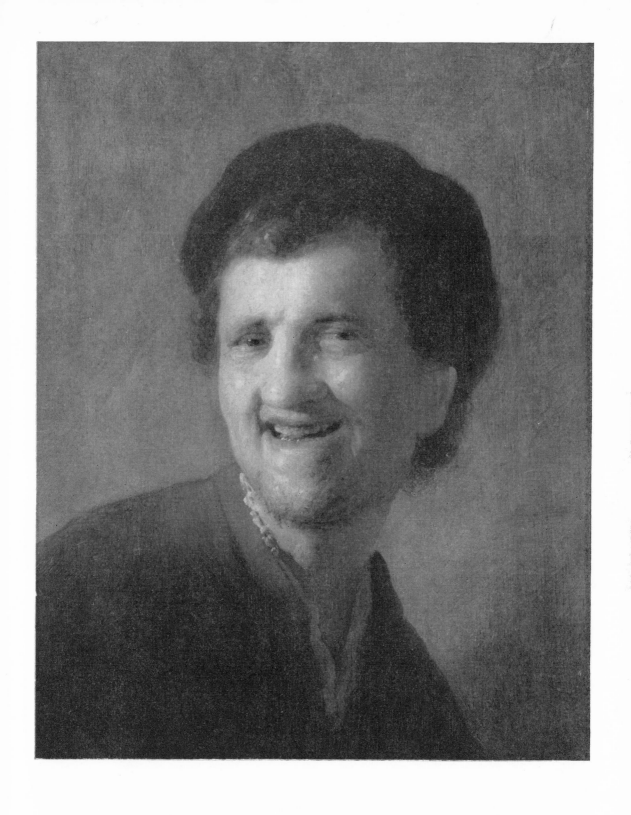

Self-portrait (?). Panel, 41×34 cm. Amsterdam, Rijksmuseum. (Br. 5)

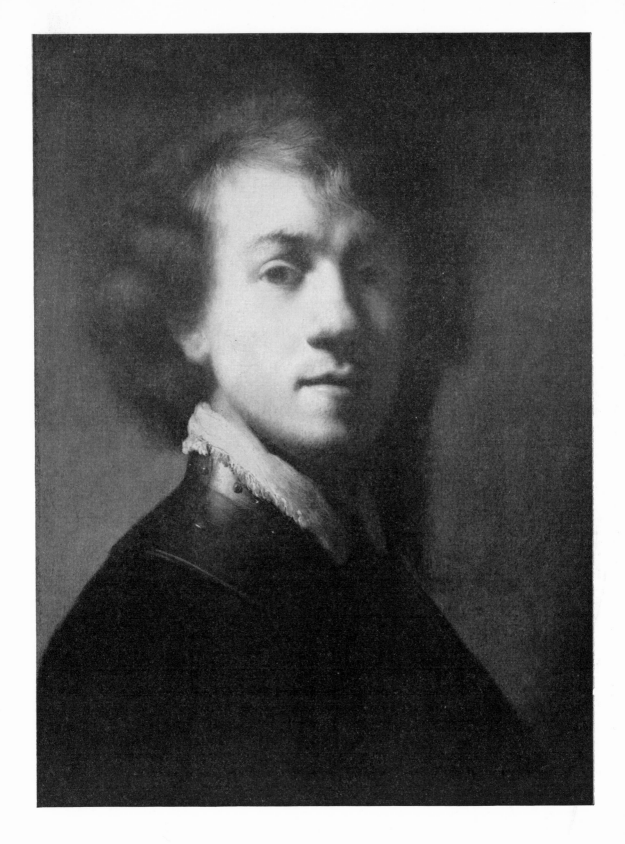

SELF-PORTRAIT. Panel, 37.5×29 cm. The Hague, Mauritshuis. (Br. 6)

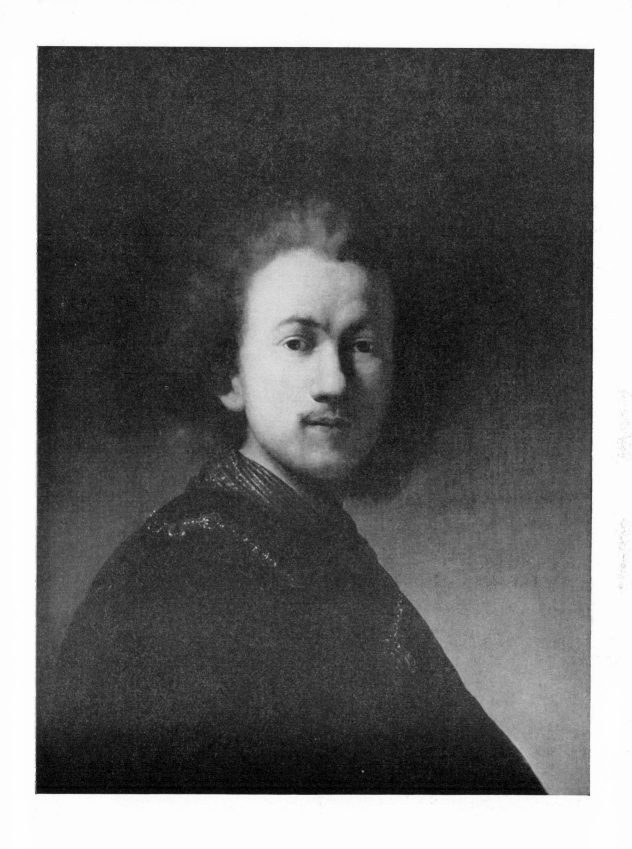

SELF-PORTRAIT. Panel, 61×47 cm. Paris, Sale N.K. (Katz), December 12, 1950 (lot 53). (Br. 7)

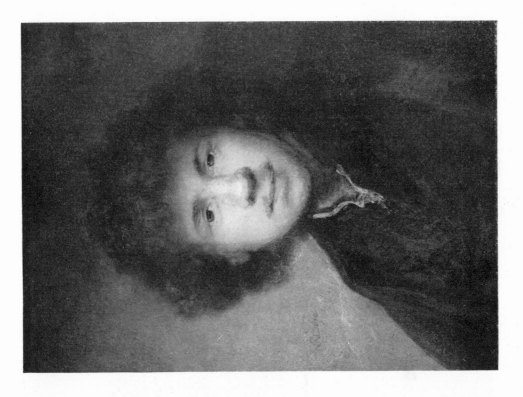

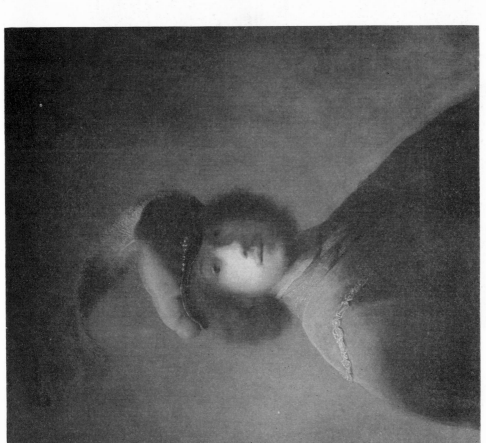

Self-portrait. 1629. Panel, 89×74 cm. Boston, Isabella Stewart Gardner Museum. (Br. 8)

Self-portrait. 1630. Panel, 49×39 cm. Aerdenhout, near Haarlem, Jhr. J. H. Loudon. (Br. 9)

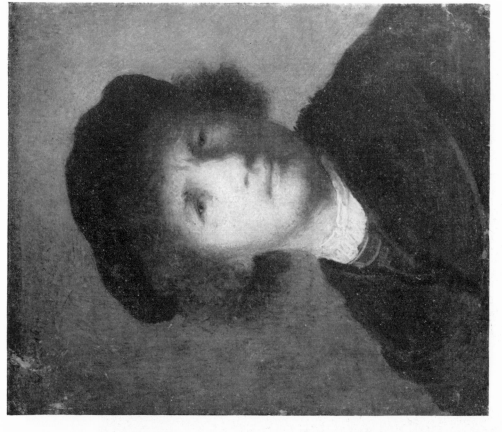

SELF-PORTRAIT. 1630(?). Copper, 15 × 12 cm. Stockholm, National-museum. (Br. 11)

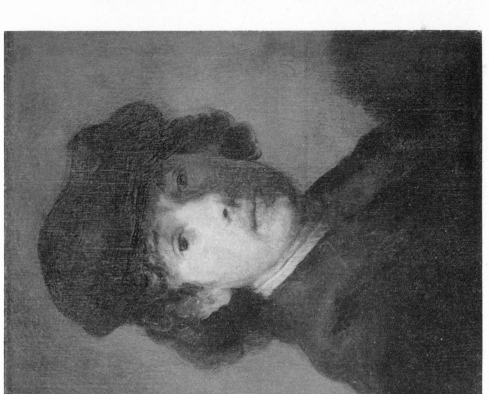

SELF-PORTRAIT. Panel, 21 × 16 cm. New York, Metropolitan Museum of Art. (Br. 10)

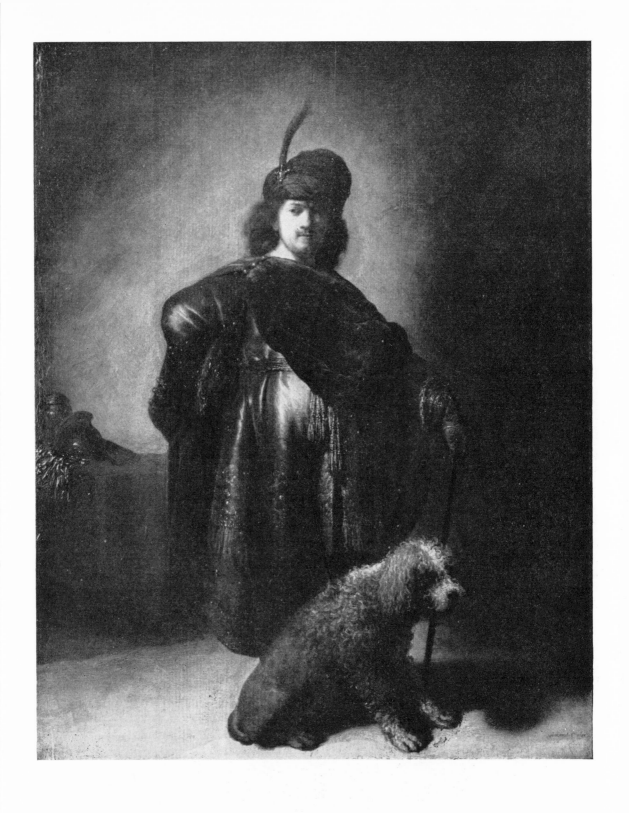

SELF-PORTRAIT. 1631. Panel, 81×54 cm. Paris, Petit Palais. (Br. 16)

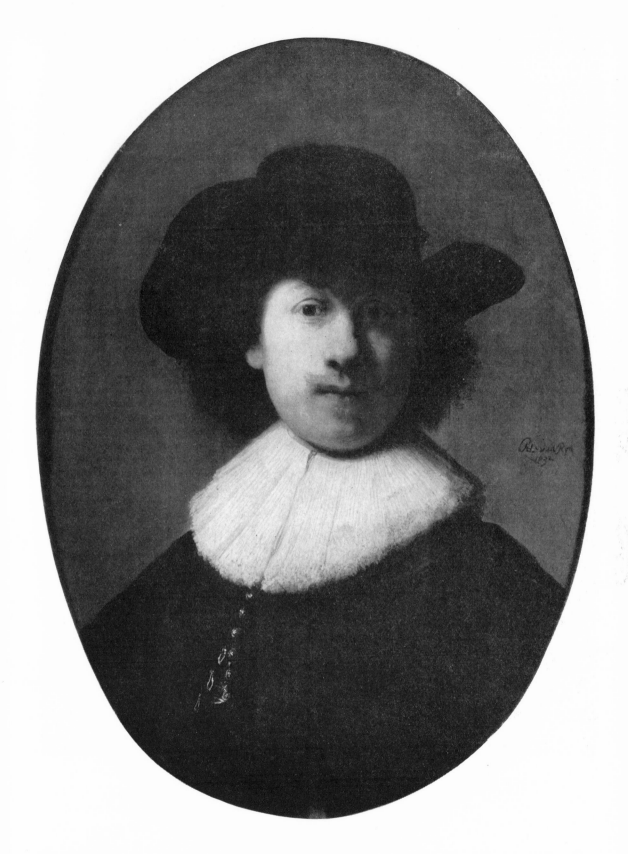

SELF-PORTRAIT. 1632. Panel, 63×48 cm. Glasgow, Art Gallery and Museum (Burrell Collection).
(Br. 17)

13

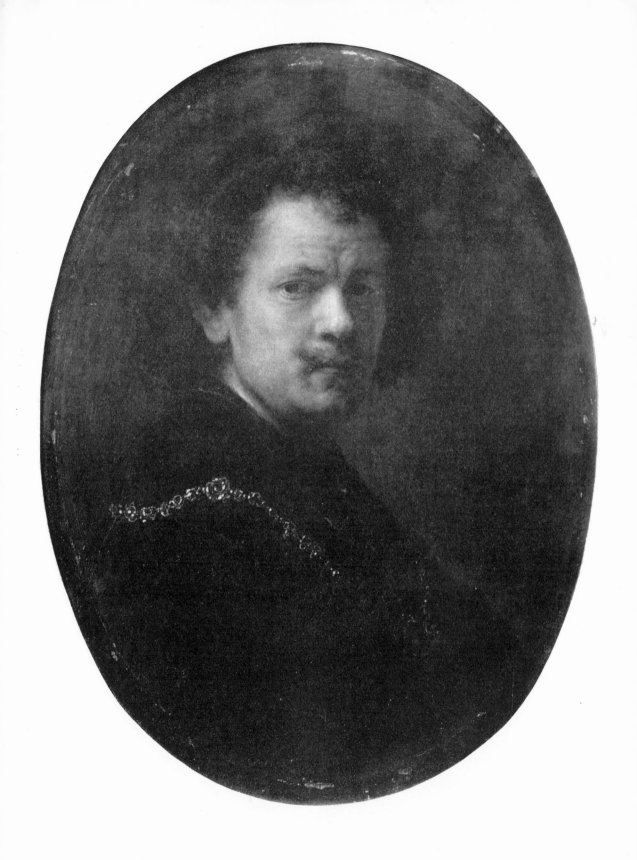

SELF-PORTRAIT. 1633. Panel, 58×45 cm. Paris, Louvre. (Br. 18)

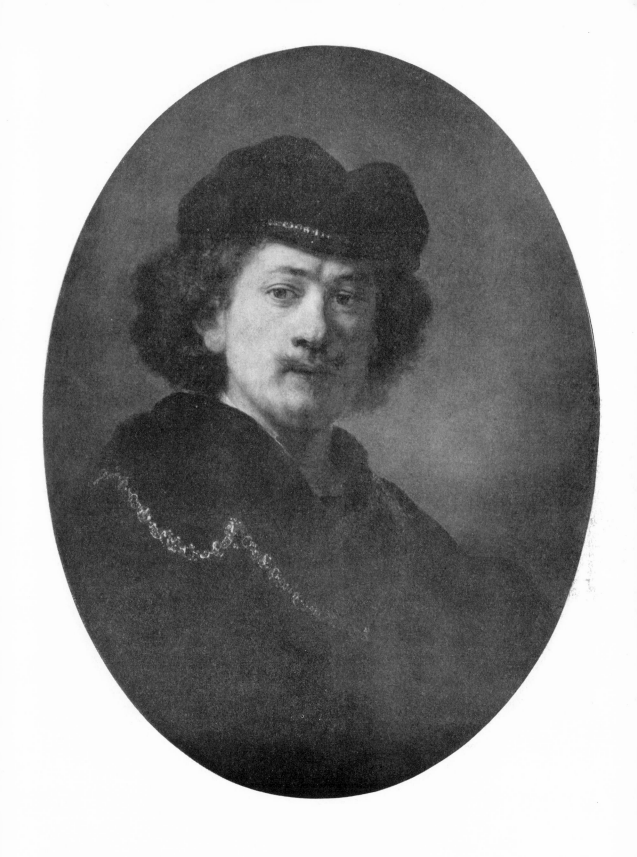

SELF–PORTRAIT. 163(4?). Panel, 68×53 cm. Paris, Louvre. (Br. 19)

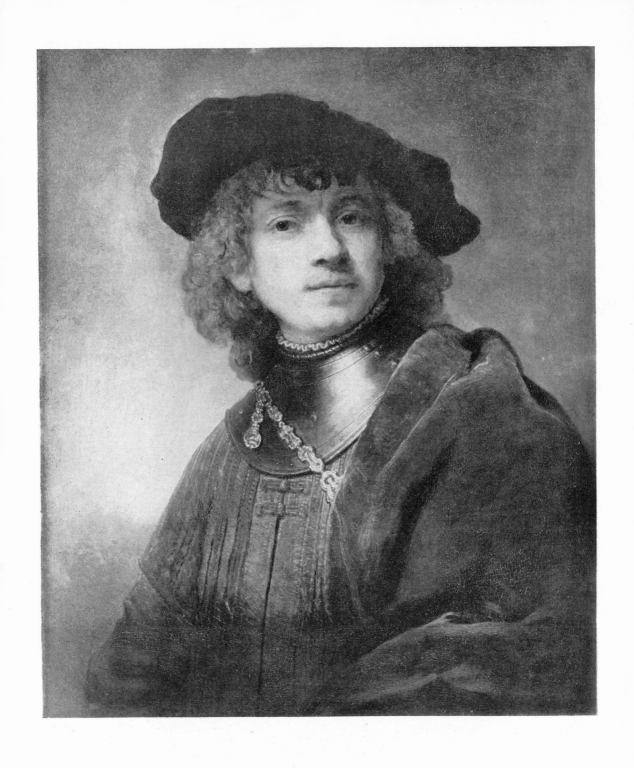

SELF-PORTRAIT. Panel, 67×54 cm. Florence, Uffizi. (Br. 20)

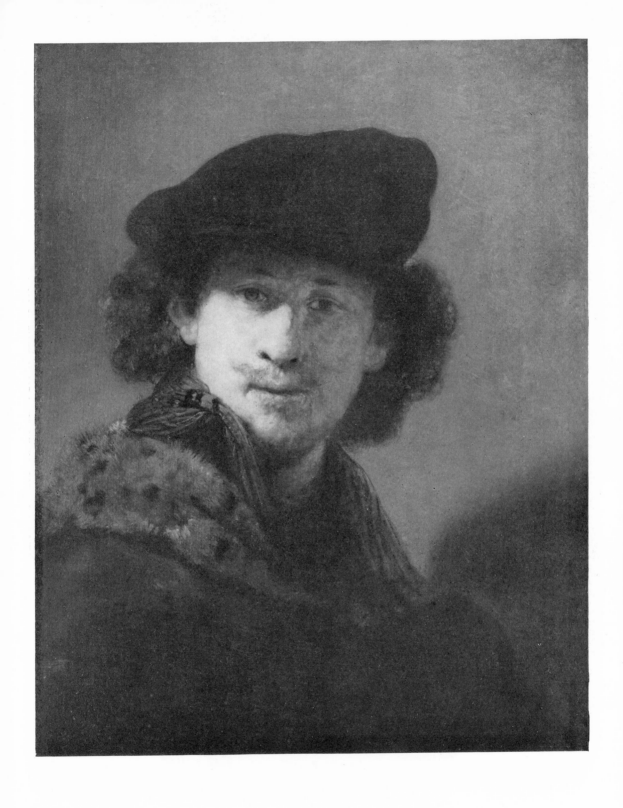

SELF-PORTRAIT. 1634. Panel, 57×46 cm. Berlin-Dahlem, Gemäldegalerie. (Br. 21)

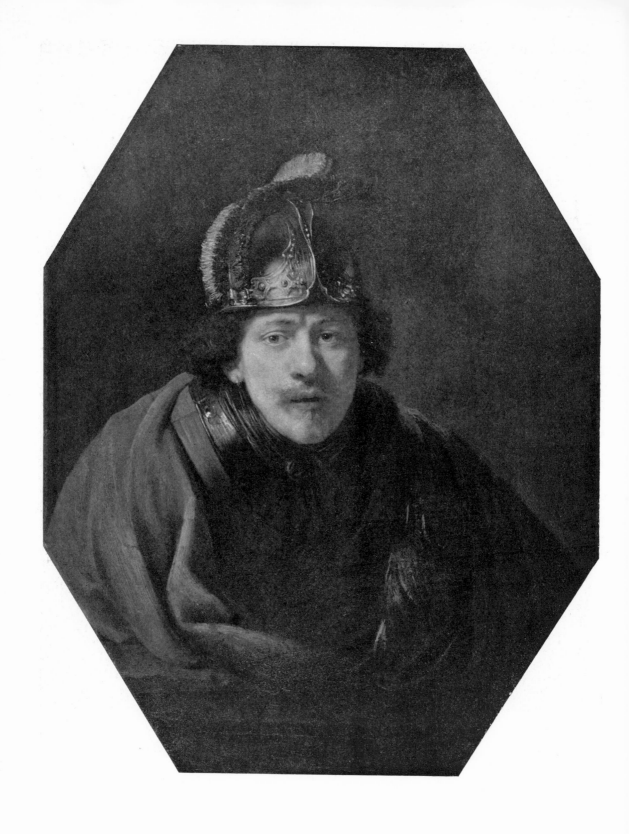

SELF-PORTRAIT. 1634. Panel, 80·5×64 cm. Cassel, Gemäldegalerie. (Br. 22)

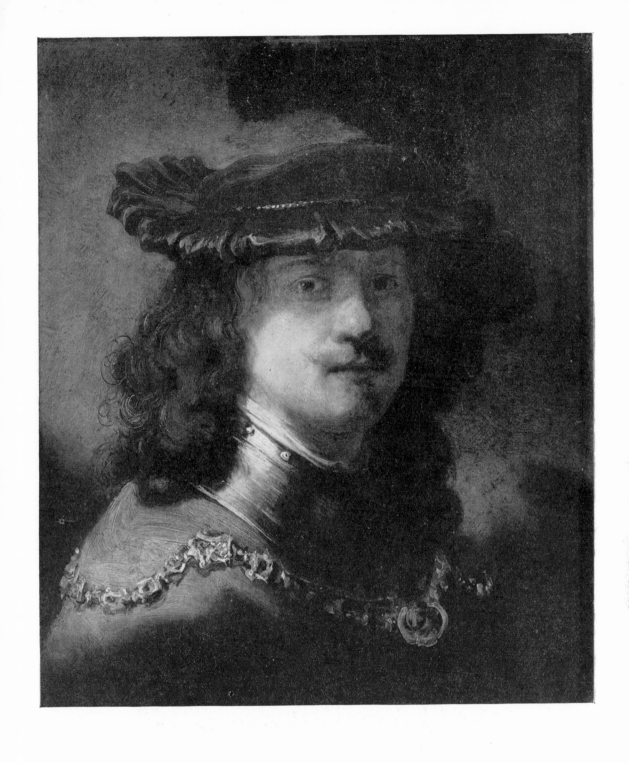

SELF-PORTRAIT. Panel, 55×46 cm. Berlin-Dahlem, Gemäldegalerie. (Br. 23)

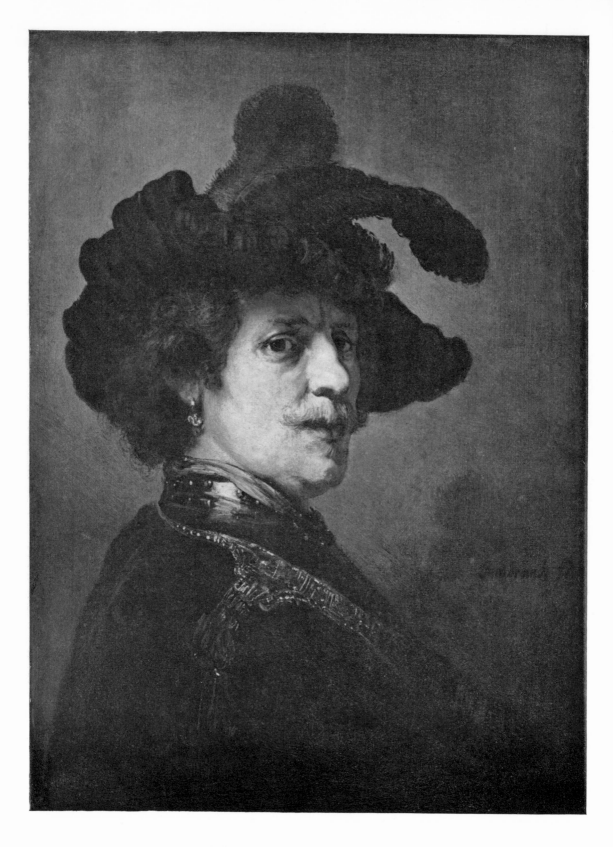

SELF-PORTRAIT (?). Panel, 62.5×47 cm. The Hague, Mauritshuis. (Br. 24)

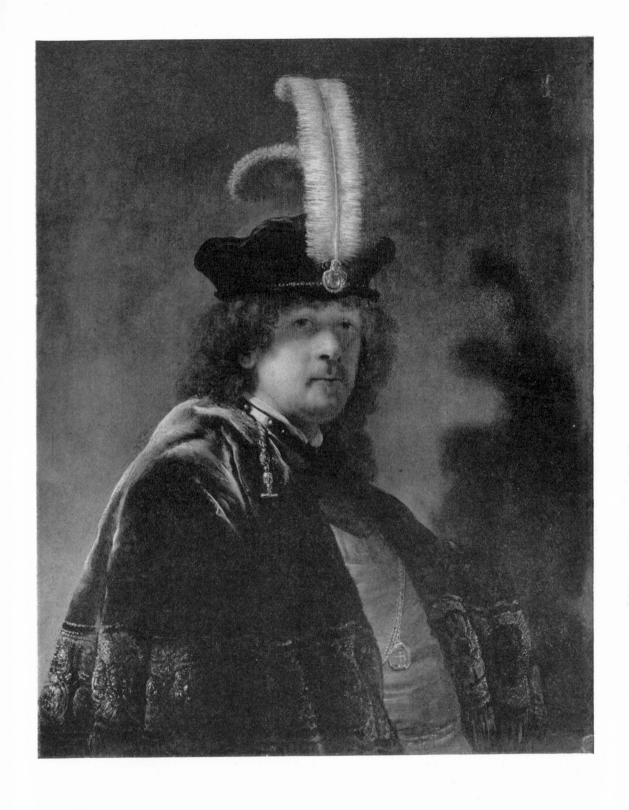

SELF-PORTRAIT. 1635. Panel, 92×72 cm. Formerly Vaduz, Liechtenstein Collection. (Br. 25)

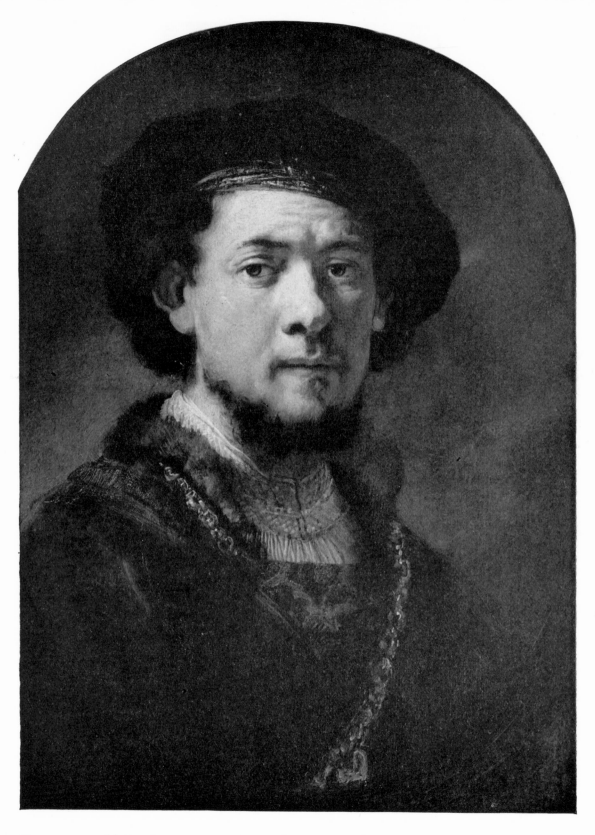

SELF-PORTRAIT (?). Panel, 57.5 × 44 cm. São Paulo, Museum of Art. (Br. 26)

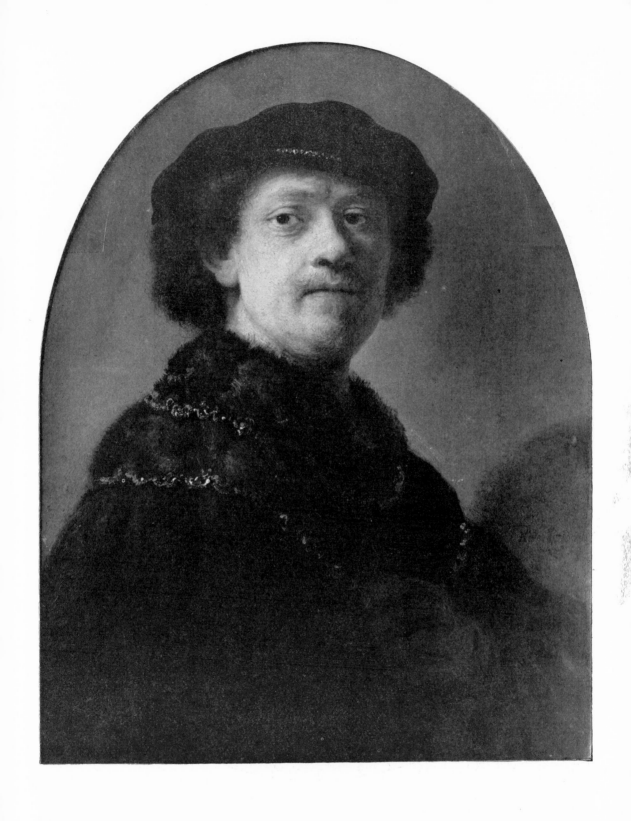

SELF-PORTRAIT. Panel, 63.5×49 cm. London, The Wallace Collection. (Br. 27)

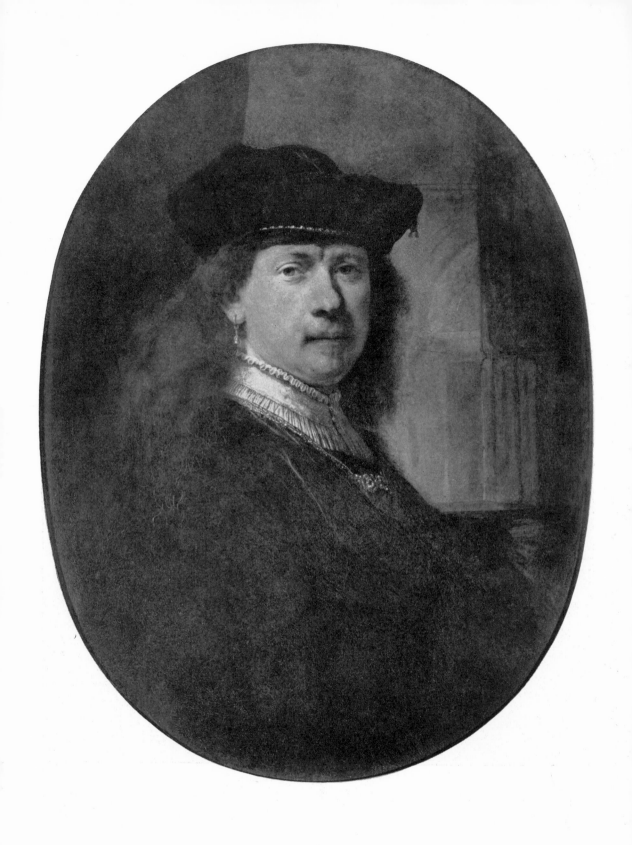

SELF-PORTRAIT. 1637. Panel, 80×62 cm. Paris, Louvre, (Br. 29)

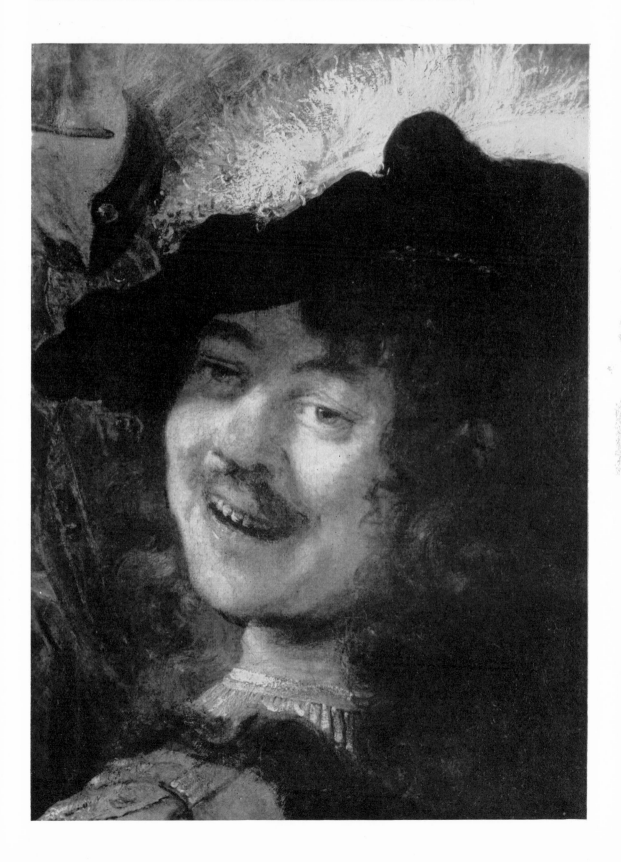

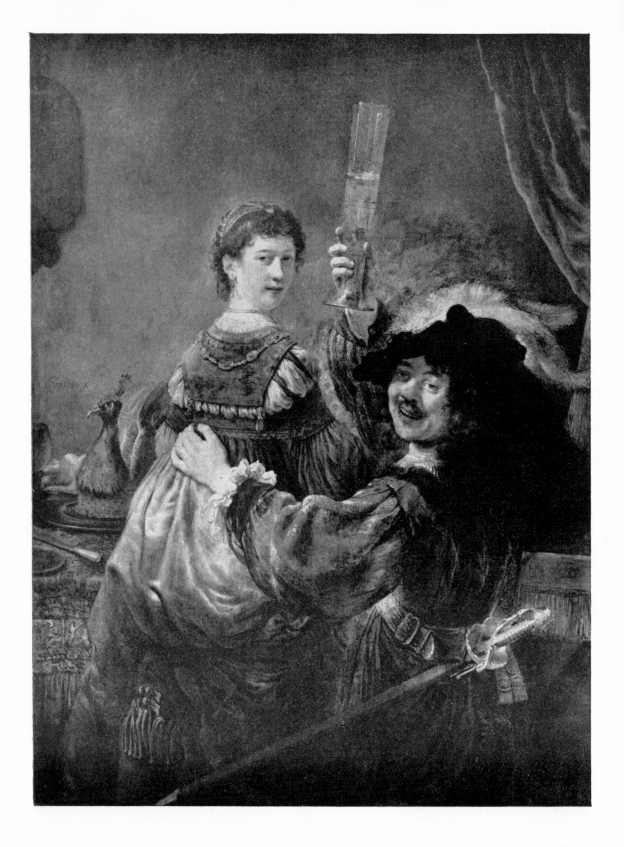

Rembrandt and Saskia (The Prodigal Son in the Tavern?). Canvas, 161×131 cm. Dresden, Gemäldegalerie. (Br. 30)

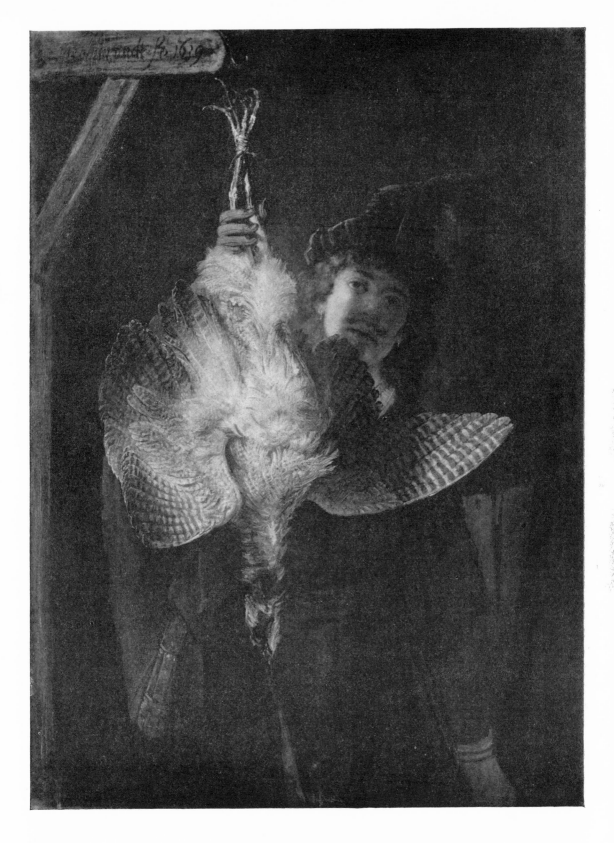

SELF-PORTRAIT, WITH A DEAD BITTERN. 1639. Panel, 121×89 cm. Dresden, Gemäldegalerie. (Br. 31)

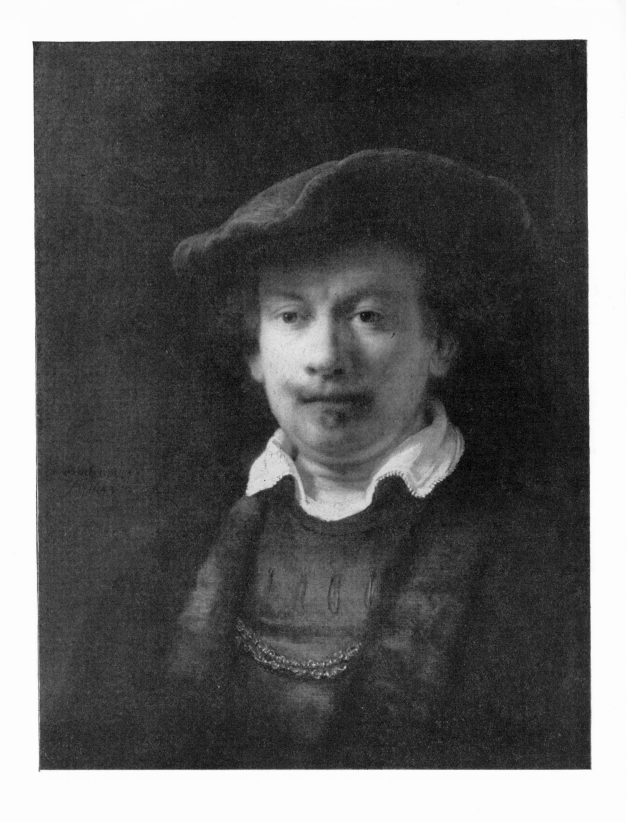

SELF-PORTRAIT. 1643. Canvas, 61×48 cm. Weimar Museum (not on display). (Br. 35)

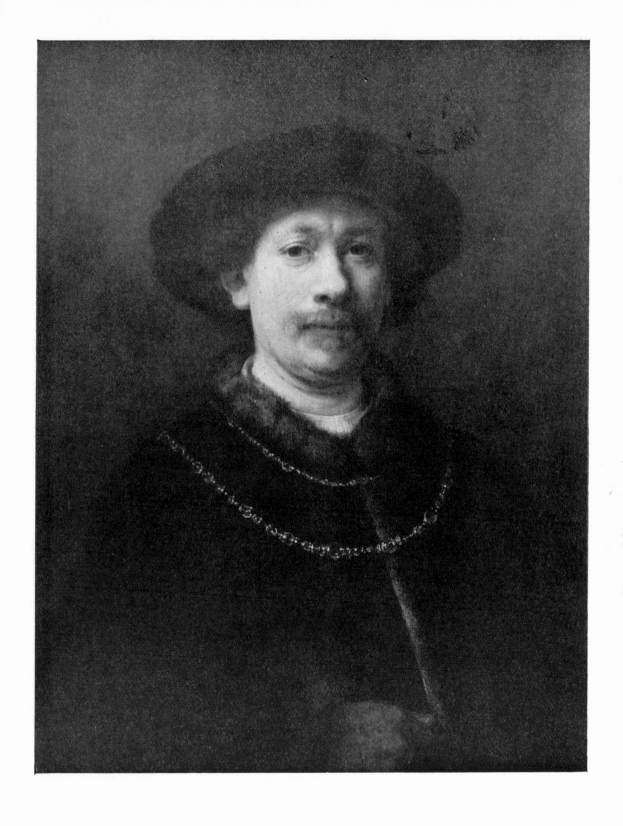

SELF-PORTRAIT. Panel, 71×57 cm. Boston, Museum of Fine Arts (on loan from R. W. Hoos). (Br. 36)

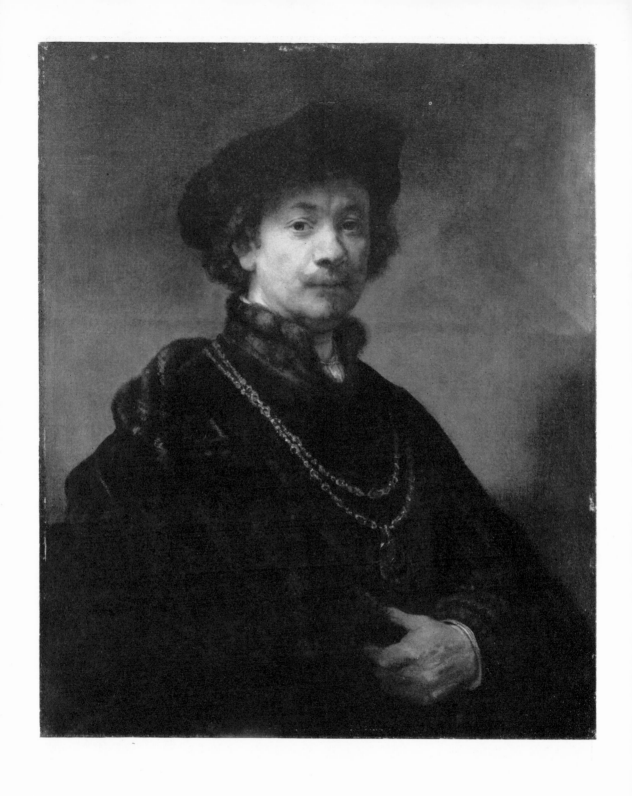

Self-portrait. Canvas, 90·5×75 cm. Woburn Abbey, Duke of Bedford. (Br. 33)

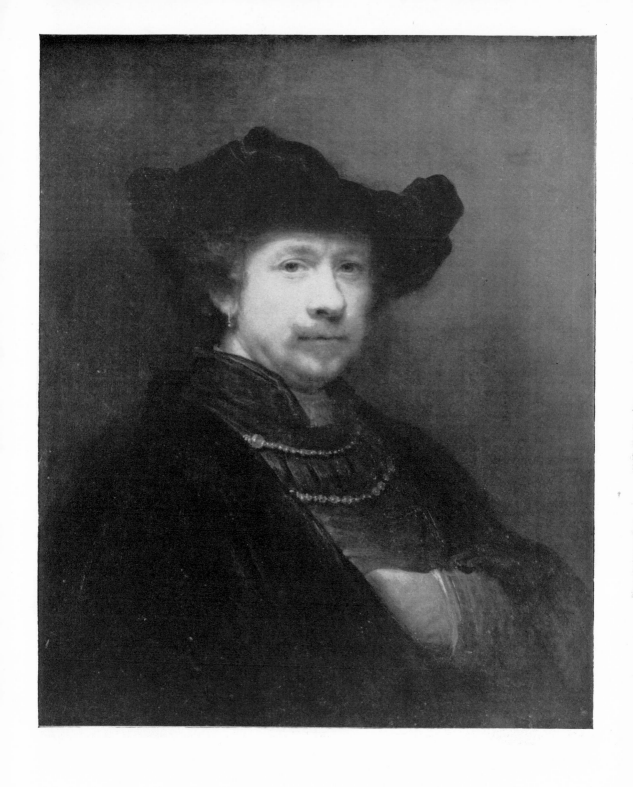

SELF-PORTRAIT. Panel, 67·5 × 57·5 cm. Windsor Castle. (Br. 37)

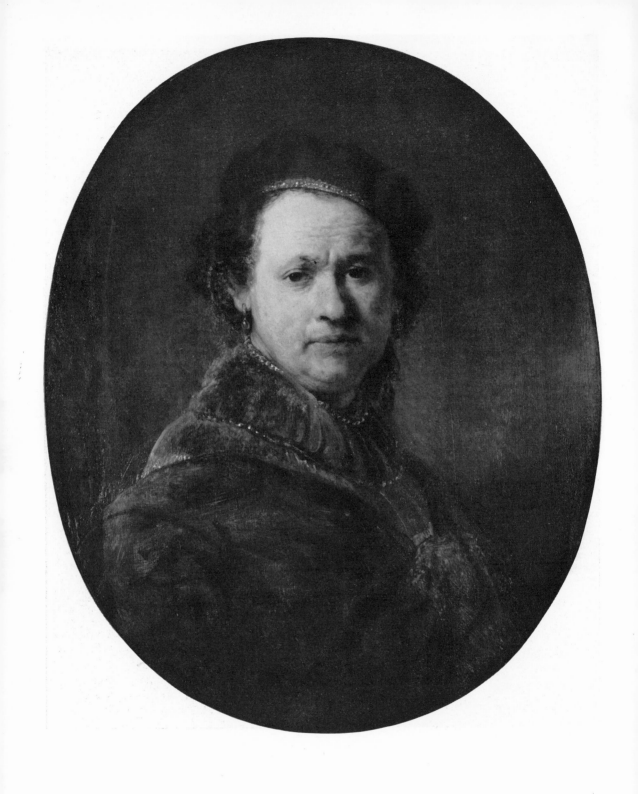

Self-portrait. Panel, 69×56 cm. Karlsruhe, Staatliche Kunsthalle. (Br. 38)

34

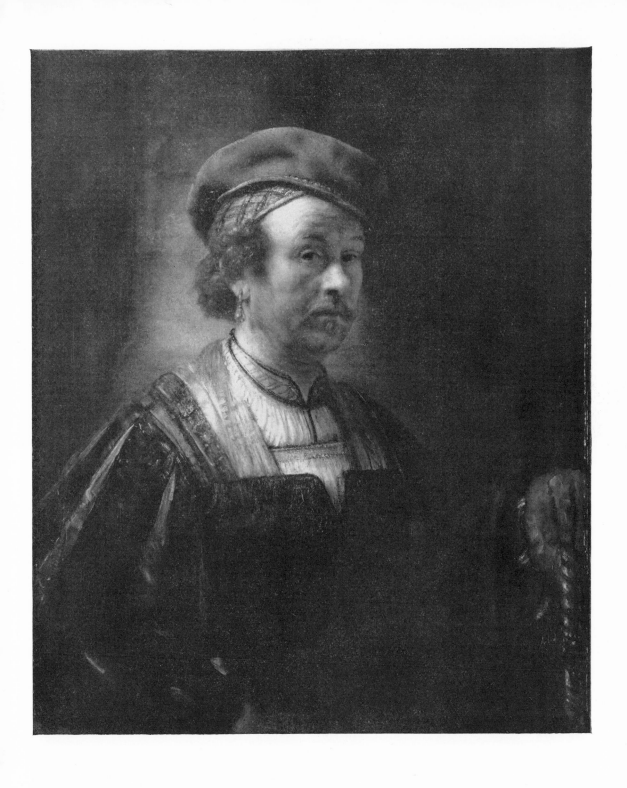

SELF-PORTRAIT. 1650. Canvas. 88·5×71 cm. Washington, National Gallery of Art (Widener Collection). (Br. 39)

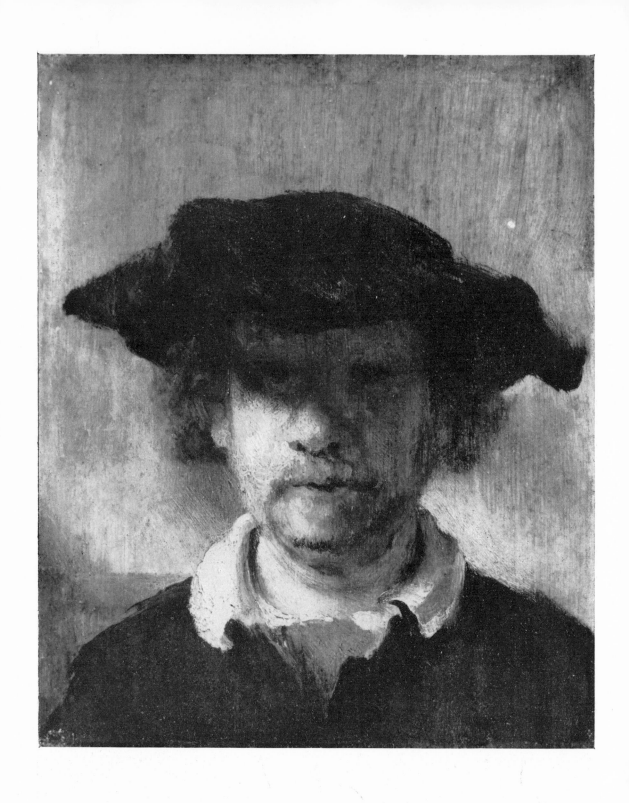

SELF-PORTRAIT. Panel, 26×21·5 cm. Leipzig, Museum. (Br. 40)

SELF-PORTRAIT(?). 1650. Canvas, 82×68·5 cm. Cincinnati, Taft Museum. (Br. 41)

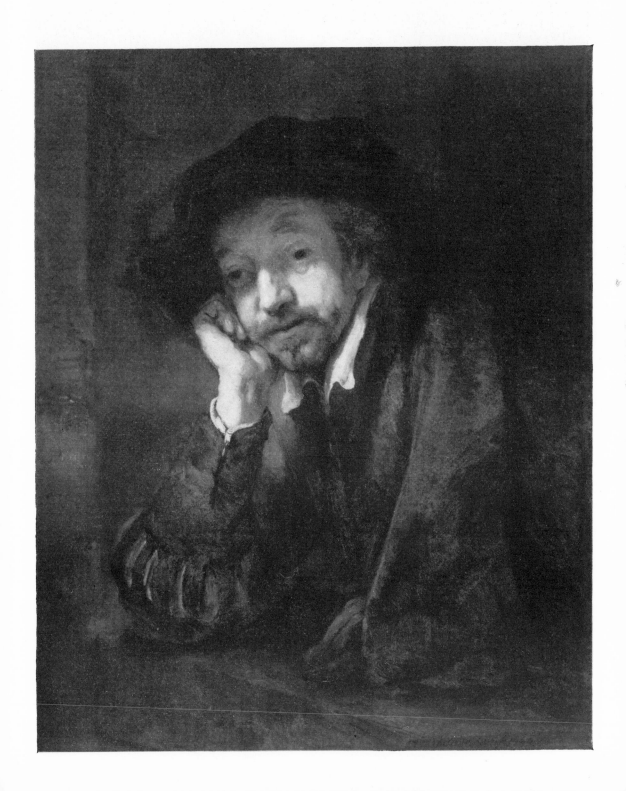

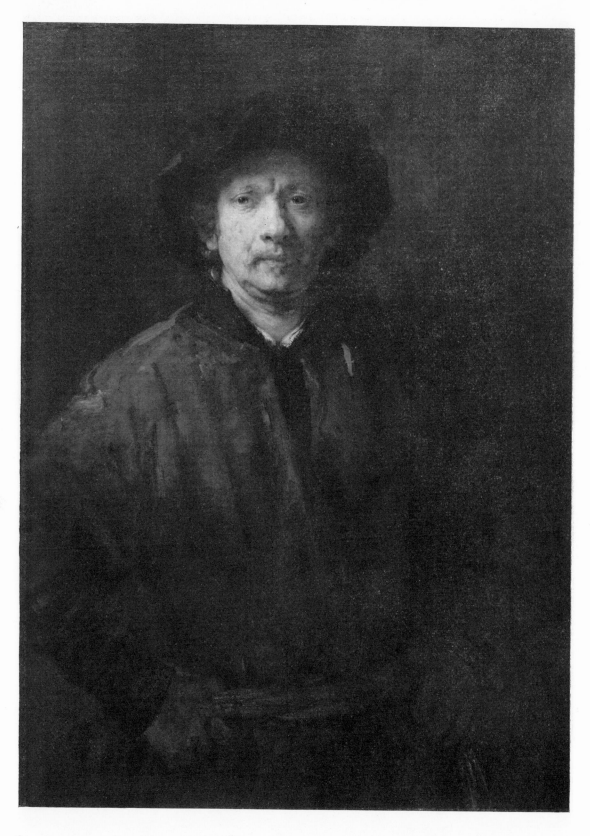

SELF-PORTRAIT. 1652. Canvas, 112×81·5 cm. Vienna, Kunsthistorisches Museum. (Br. 42)

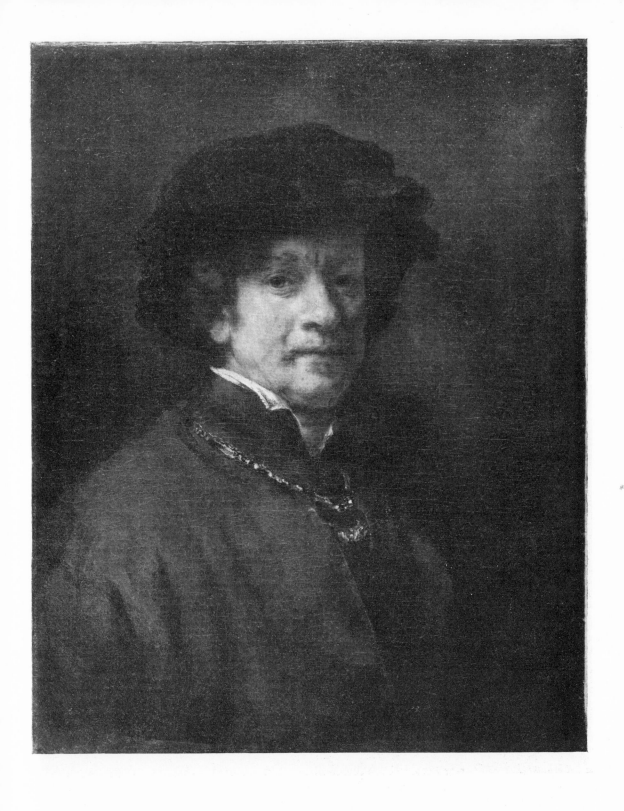

SELF-PORTRAIT. 165(4). Canvas, 73×60 cm. Cassel, Gemäldegalerie. (Br. 43)

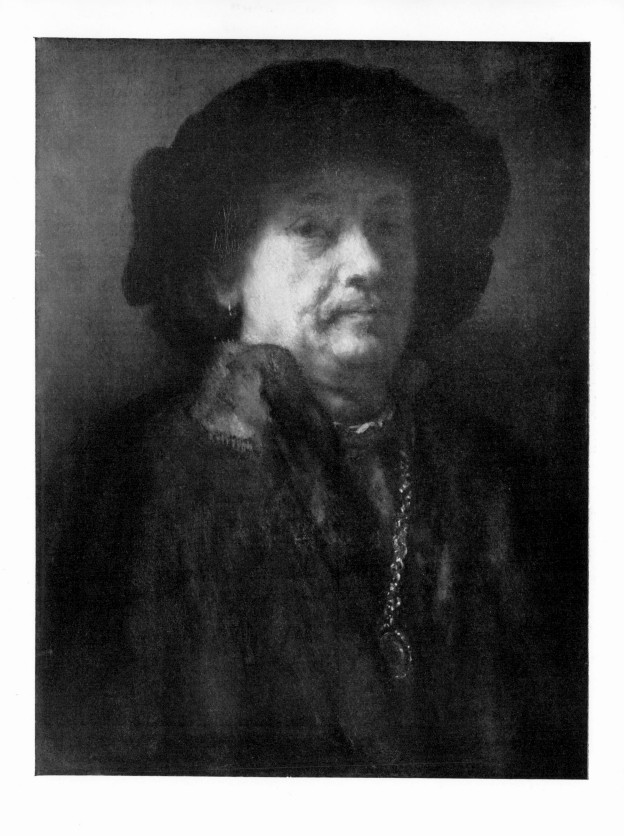

SELF-PORTRAIT. 1655. Panel, 66×53 cm. Vienna, Kunsthistorisches Museum. (Br. 44)

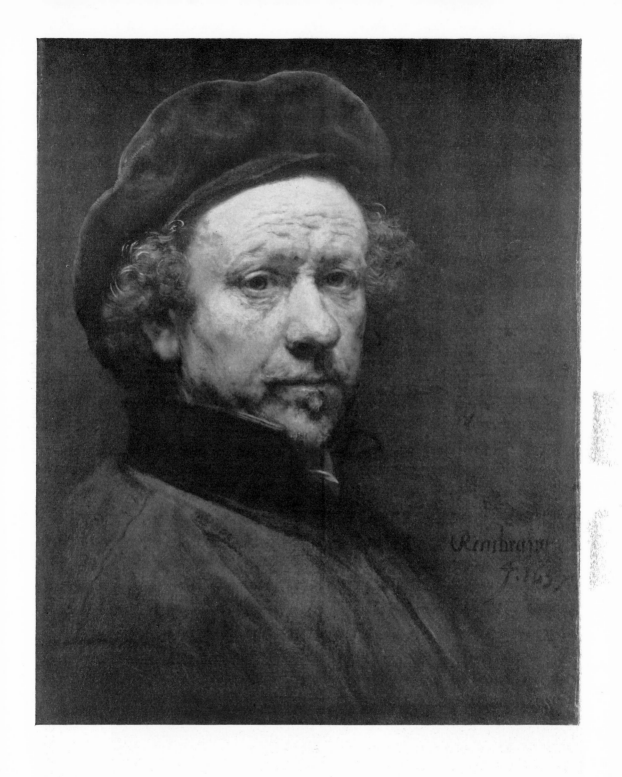

SELF-PORTRAIT. 1657. Canvas, 50 × 42.5 cm. Edinburgh, National Gallery of Scotland (on loan from the Duke of Sutherland). (Br. 48).

Self-portrait. 1657. Canvas, 85·5×65 cm. Dresden, Gemäldegalerie. (Br. 46)

Self-portrait. Canvas, 71·5×57·5 cm. Florence, Uffizi. (Br. 45)

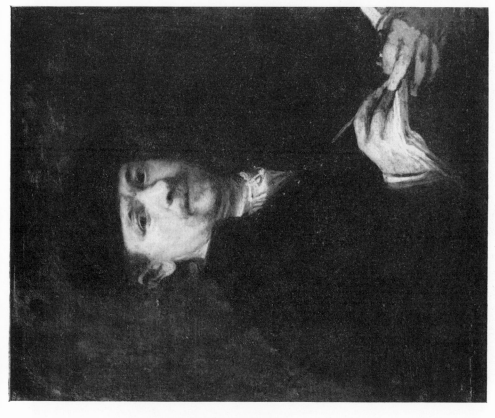

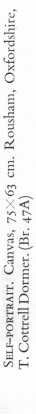

SELF-PORTRAIT. Canvas, 75×63 cm. Rousham, Oxfordshire,
T. Cottrell Dormer. (Br. 47A)

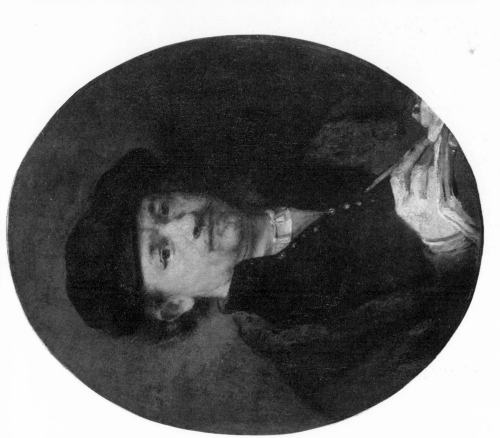

SELF-PORTRAIT. 1653(?). Canvas, 74.5×61 cm. San Francisco,
M. H. de Young Memorial Museum. (Br. 47)

SELF–PORTRAIT. Panel, 49×41 cm. Vienna, Kunsthistorisches Museum. (Br. 49)

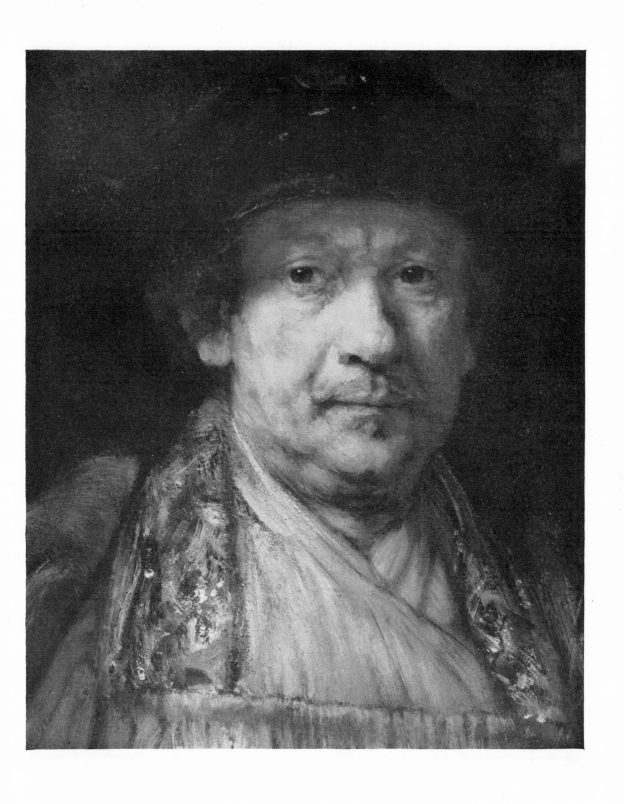

DETAIL OF SELF-PORTRAIT REPRODUCED ON PAGE 46

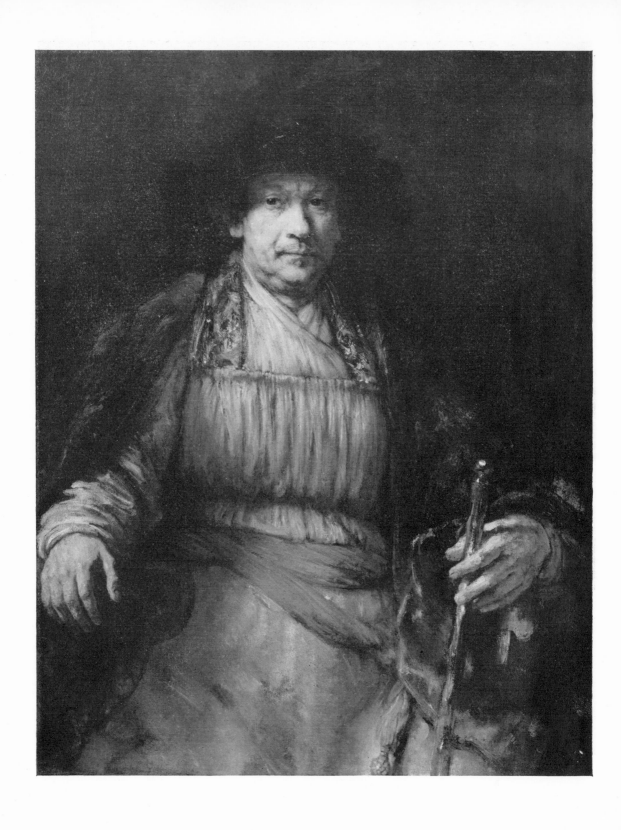

SELF-PORTRAIT. 1658. Canvas, 131×102 cm. New York, The Frick Collection. (Br. 50)

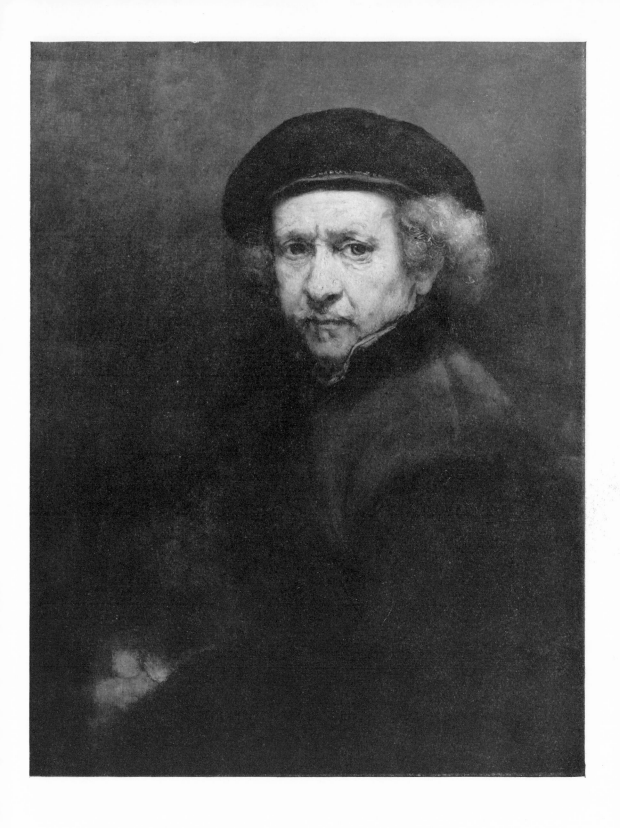

SELF-PORTRAIT. 1659. Canvas, 84.5×66 cm. Washington, National Gallery of Art (Mellon Collection). (Br. 51)

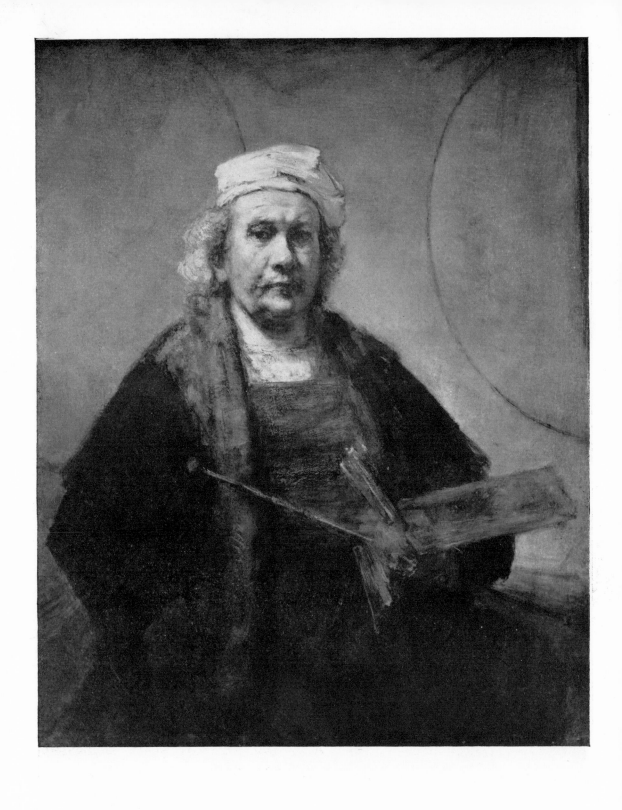

SELF-PORTRAIT. Canvas, 114×94 cm. London, Kenwood House, The Iveagh Bequest. (Br. 52)

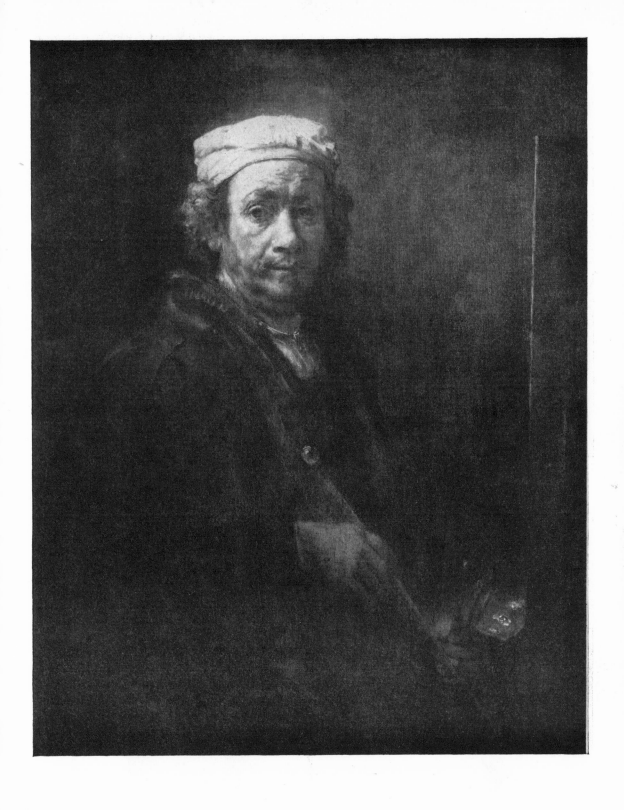

SELF-PORTRAIT. 1660. Canvas, 111×85 cm. Paris, Louvre. (Br. 53)

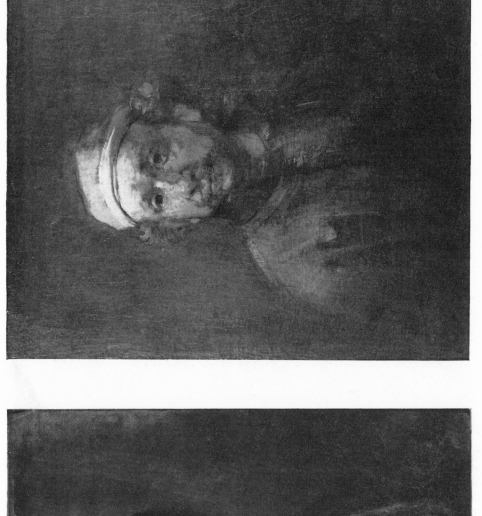

SELF-PORTRAIT. 1660. Canvas, 76.5×61 cm. Melbourne, National Gallery of Victoria. (Br. 56)

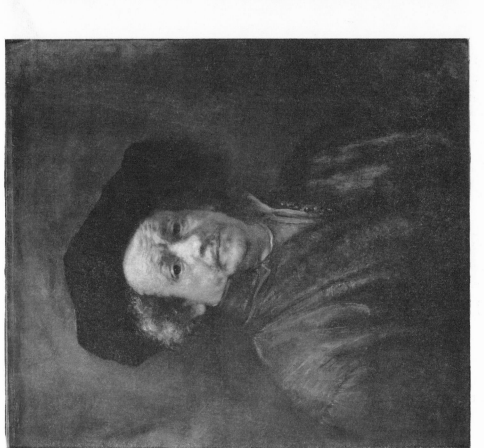

SELF-PORTRAIT. 1660. Canvas, 77.5×66 cm. New York, Metro-politan Museum of Art. (Br. 54)

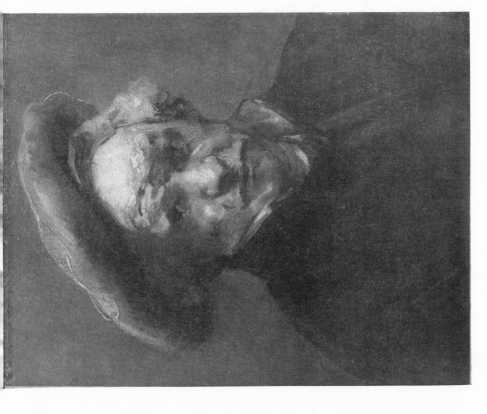

SELF-PORTRAIT. Canvas, 73×58 cm. Montreal, S. Bronfman.
(Br. 57)

SELF-PORTRAIT. Panel, 30×24 cm. Aix-en-Provence, Museum.
(Br. 58)

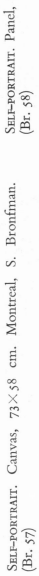

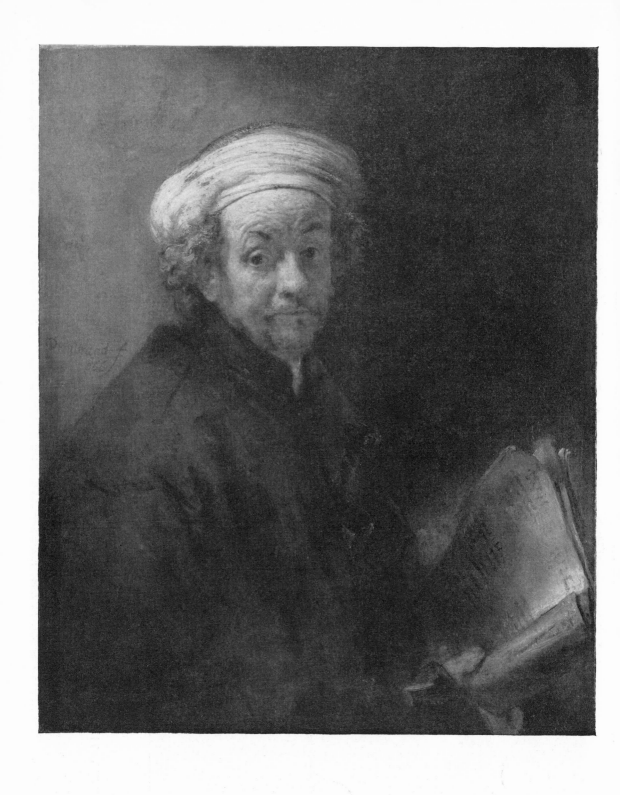

SELF-PORTRAIT AS THE APOSTLE PAUL. 1661. Canvas, 91×77 cm. Amsterdam, Rijksmuseum.
(Br. 59)

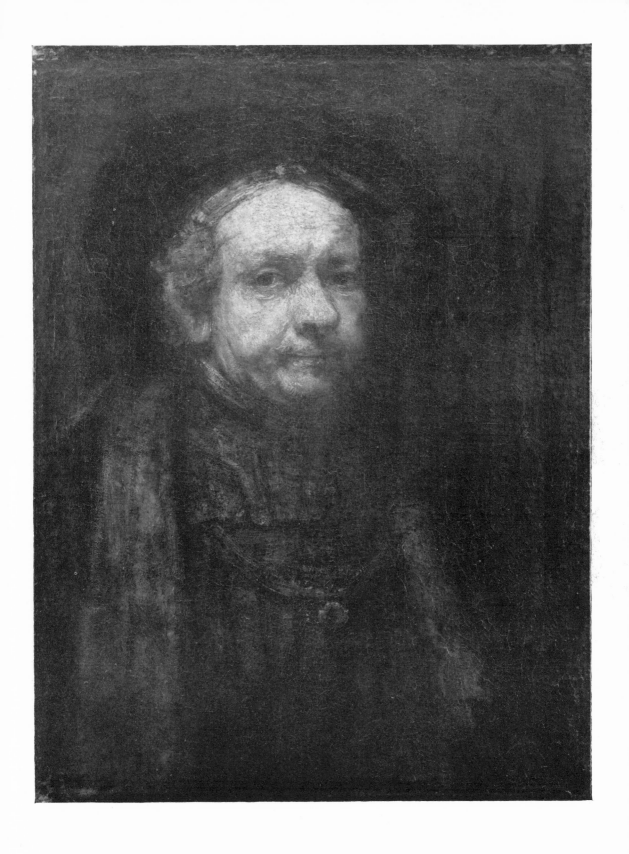

SELF-PORTRAIT. Canvas, 85×61 cm. Florence, Uffizi. (Br. 60)

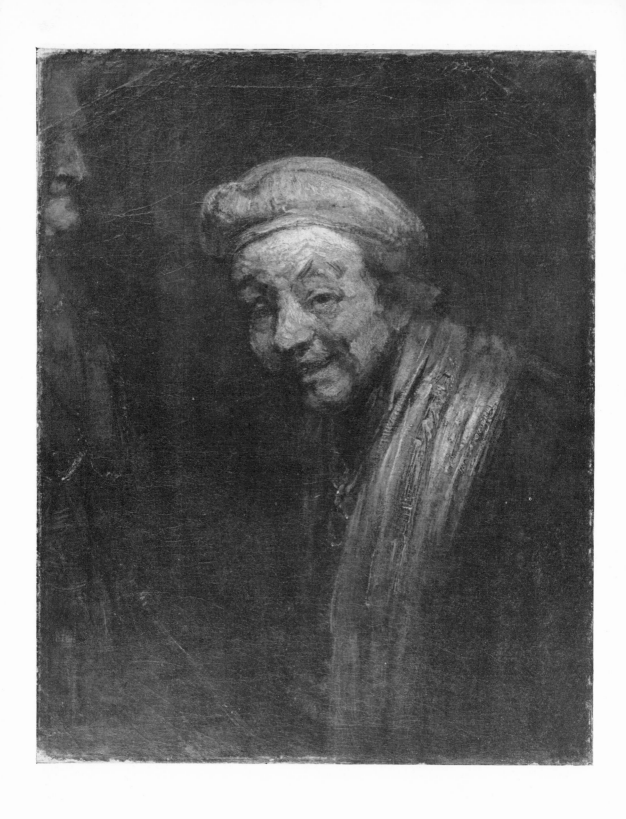

SELF-PORTRAIT. Canvas, 82×63 cm. Cologne, Wallraf-Richartz Museum (von Carstanjen Bequest). (Br. 61)

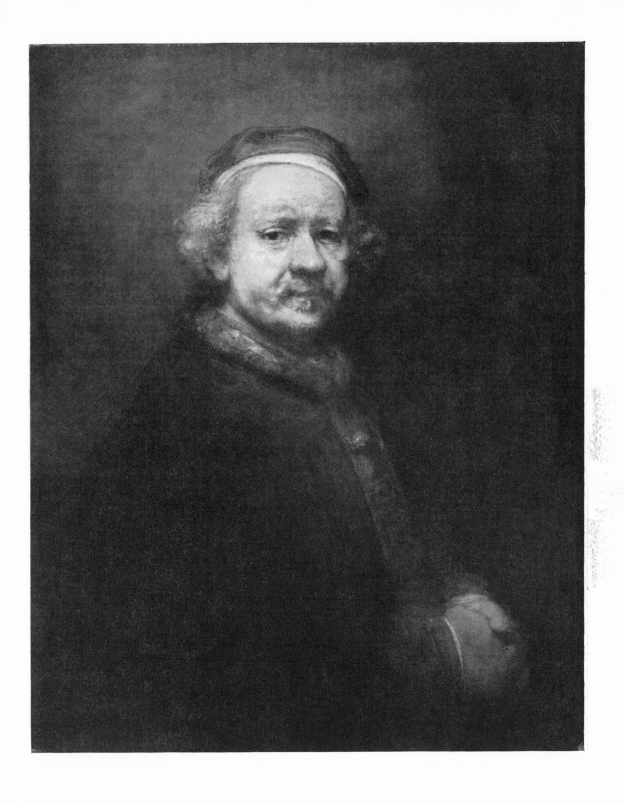

SELF-PORTRAIT. 1669. Canvas, 86×70·5 cm. London, National Gallery. (Br. 55)

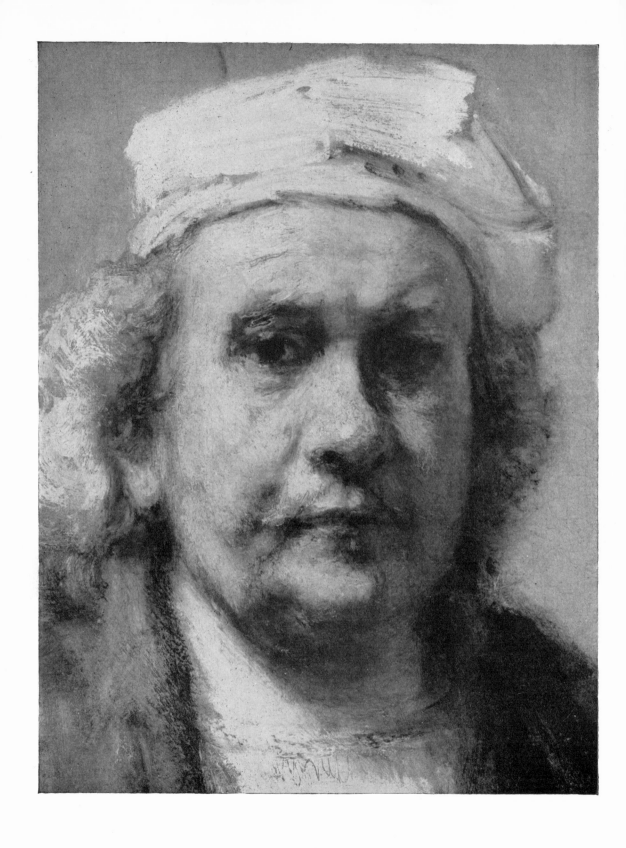

DETAIL OF SELF-PORTRAIT REPRODUCED ON PAGE 48

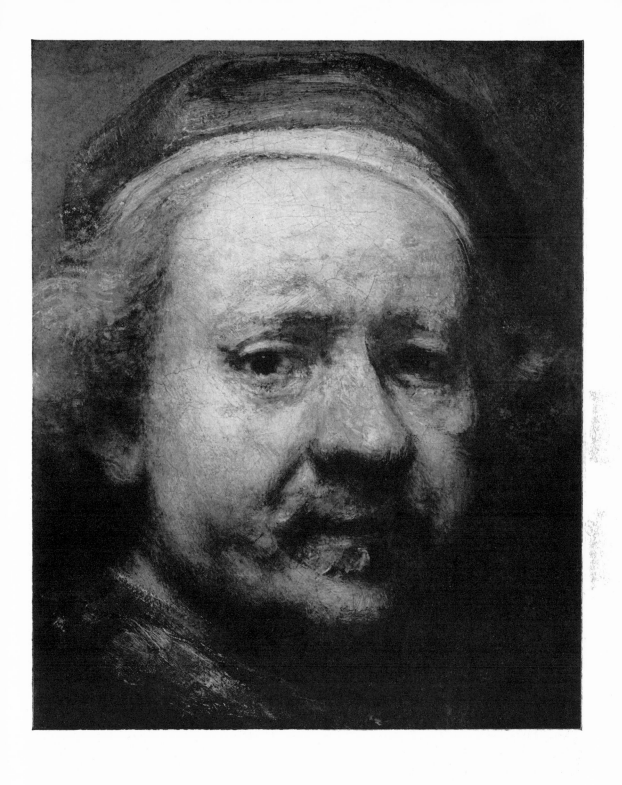

Detail of Self-portrait Reproduced on Page 55

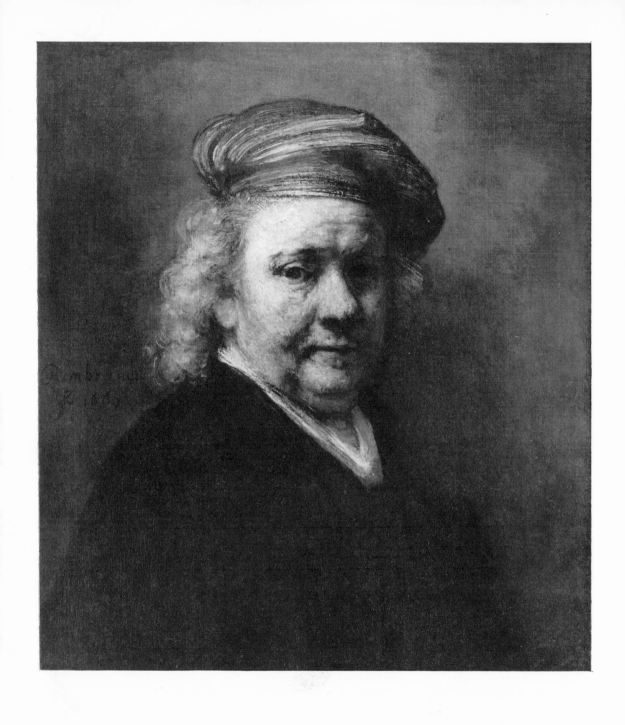

SELF-PORTRAIT. 1669. Canvas, 59×51 cm. The Hague, Mauritshuis. (Br. 62)

PORTRAITS OF
REMBRANDT'S FAMILY

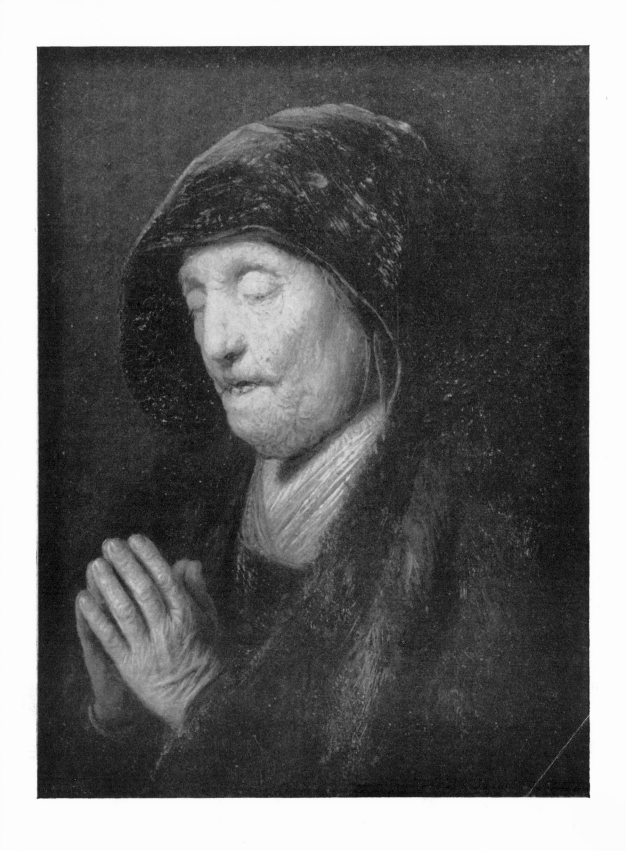

"Rembrandt's Mother." Panel, 15.5×13 cm. Salzburg, Residenzmuseum (on loan from the Czernin Collection) (Br. 63)

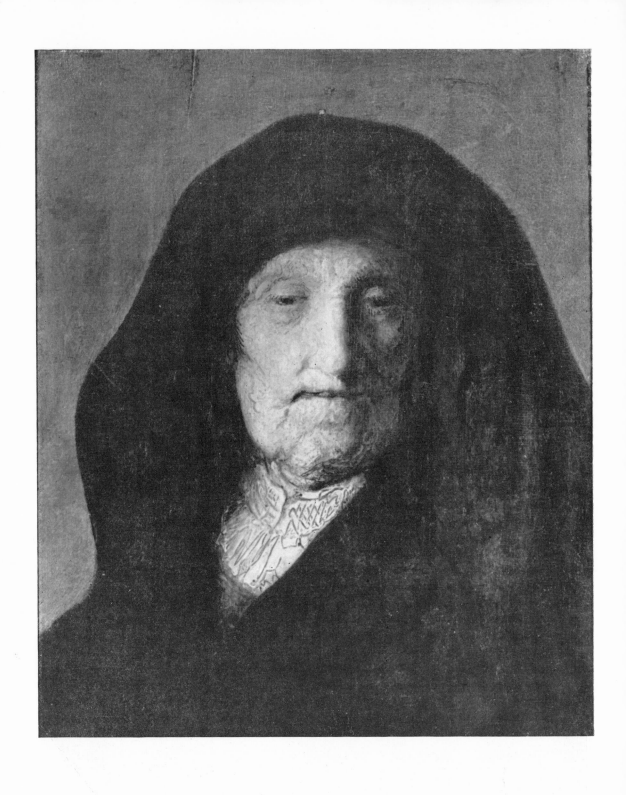

"Rembrandt's Mother." Panel, 35×29 cm. Essen, H. von Bohlen und Halbach. (Br. 64)

"REMBRANDT'S MOTHER." Panel, 17×13 cm. The Hague, Mauritshuis. (Br. 67)

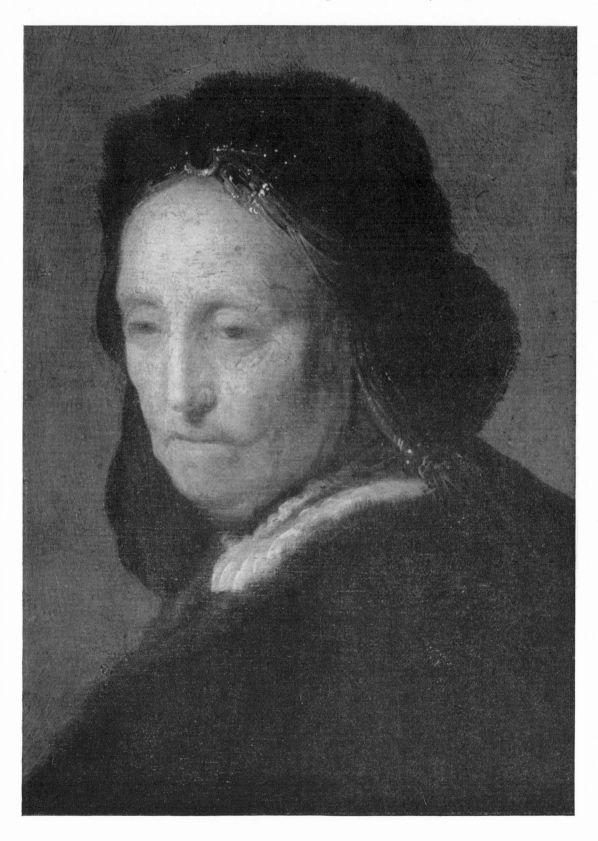

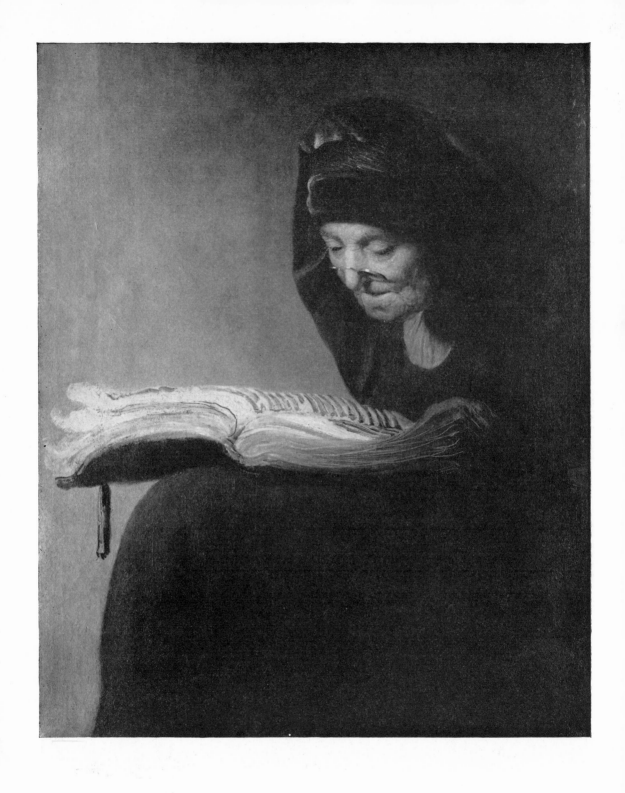

"Rembrandt's Mother" reading. Canvas, 74×62 cm. Salisbury, Wilton House, Earl of Pembroke and Montgomery. (Br. 68)

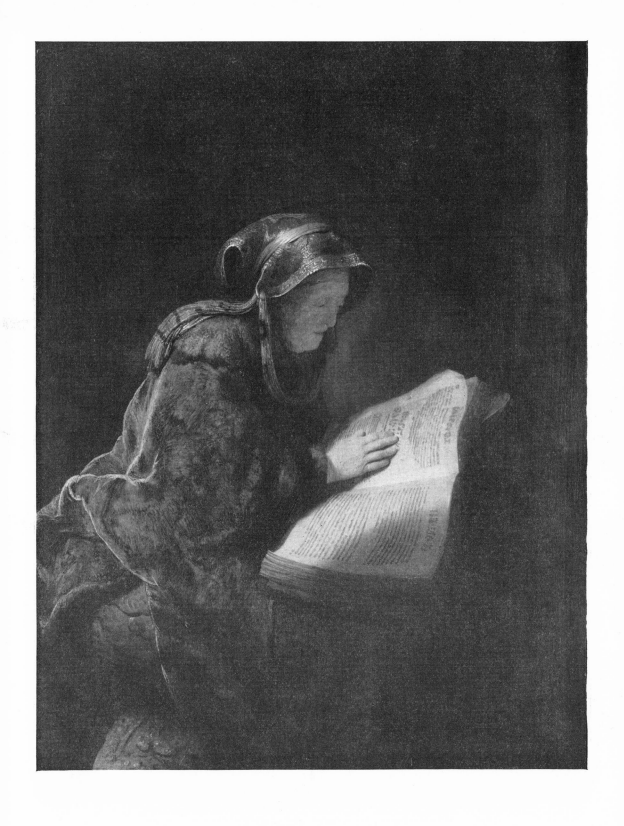

"Rembrandt's Mother" as a Biblical Prophetess (Hannah?). 1631. Panel, 60×48 cm. Amsterdam, Rijksmuseum. (Br. 69)

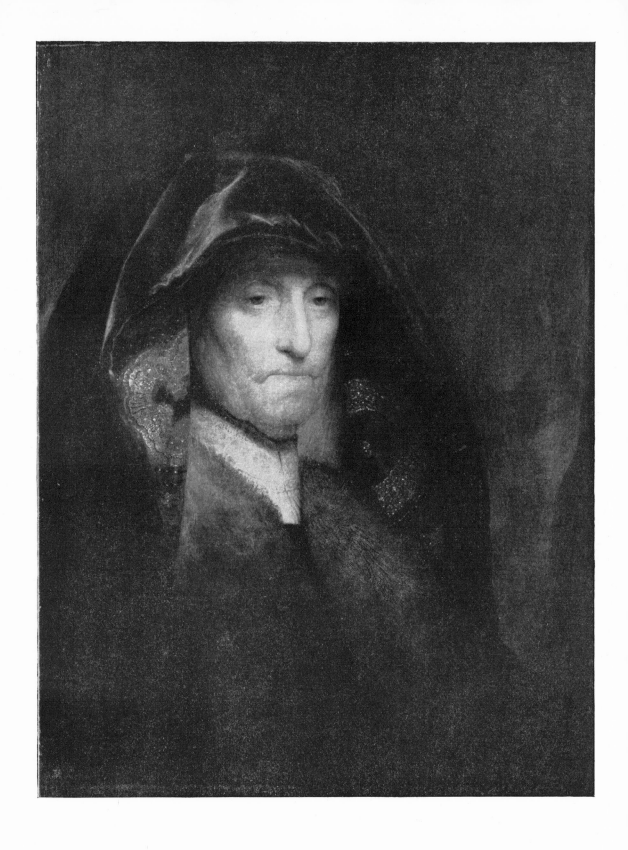

"Rembrandt's Mother." Panel, 58.5×45 cm. Windsor Castle. (Br. 70)

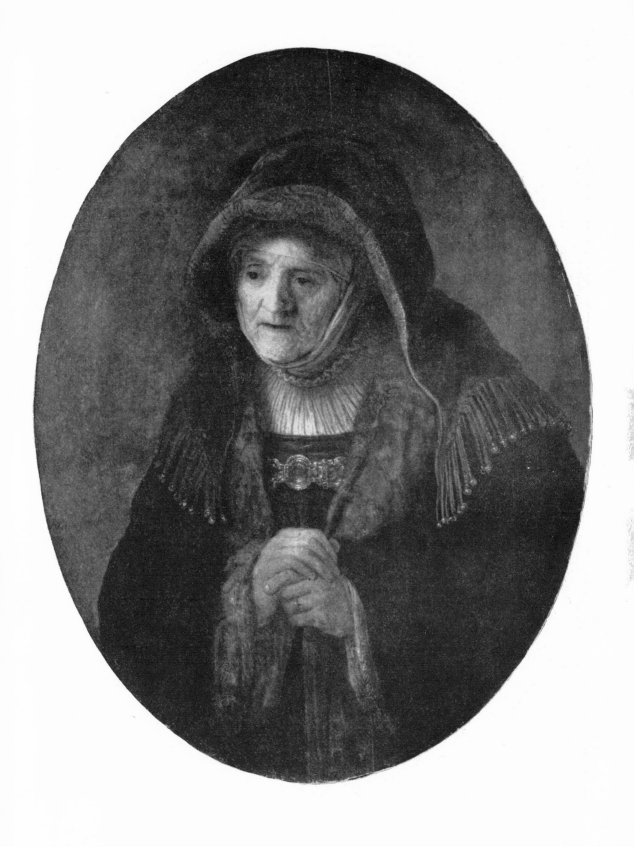

"Remrandt's Mother." 1639. Panel, 79·5×61·5 cm. Vienna, Kunsthistorisches Museum. (Br. 71)

"REMBRANDT'S FATHER." 1629. Panel, 20×17 cm. Cambridge, Mass., Fogg Art Museum (on loan from James P. Warburg). (Br. 74)

"REMBRANDT'S FATHER" (as the repentant St. Peter?). Panel, 74.5×60 cm. Boston, Museum of Fine Arts. (Br. 73)

"REMBRANDT'S FATHER." Panel, 47×39 cm. The Hague, Mauritshuis. (Br. 77)

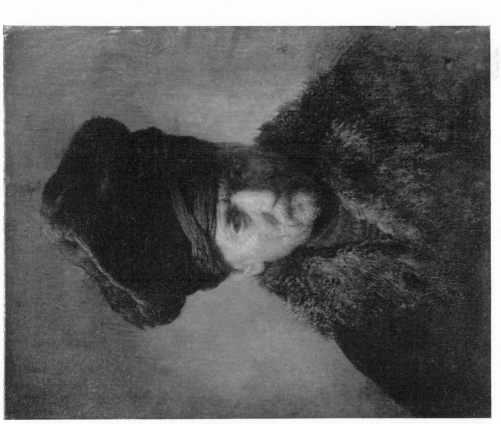

"REMBRANDT'S FATHER." 1630. Panel, 21·5×17 cm. Innsbruck, Museum Ferdinandeum. (Br. 76)

"Rembrandt's Father." Panel, 48×37 cm. Cassel, Gemäldegalerie. (Br. 78)

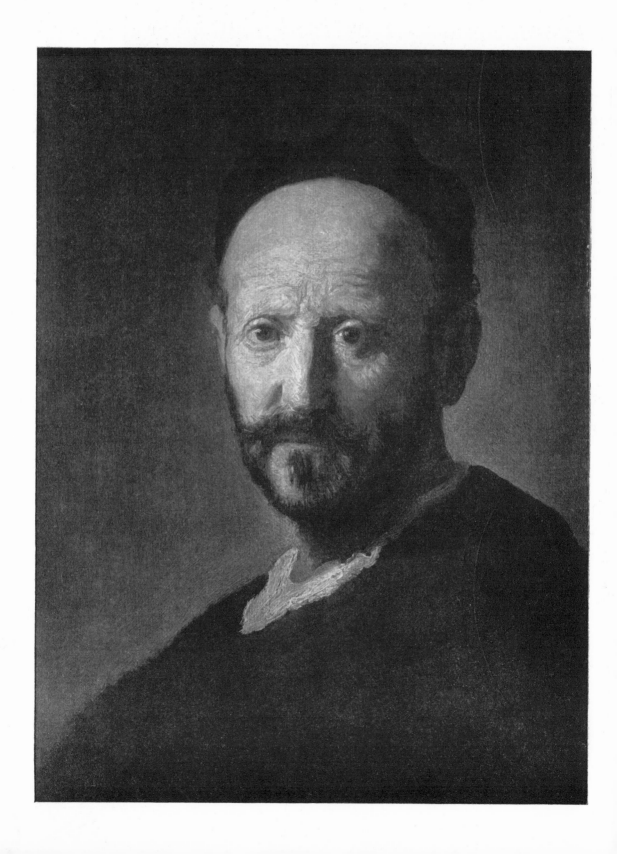

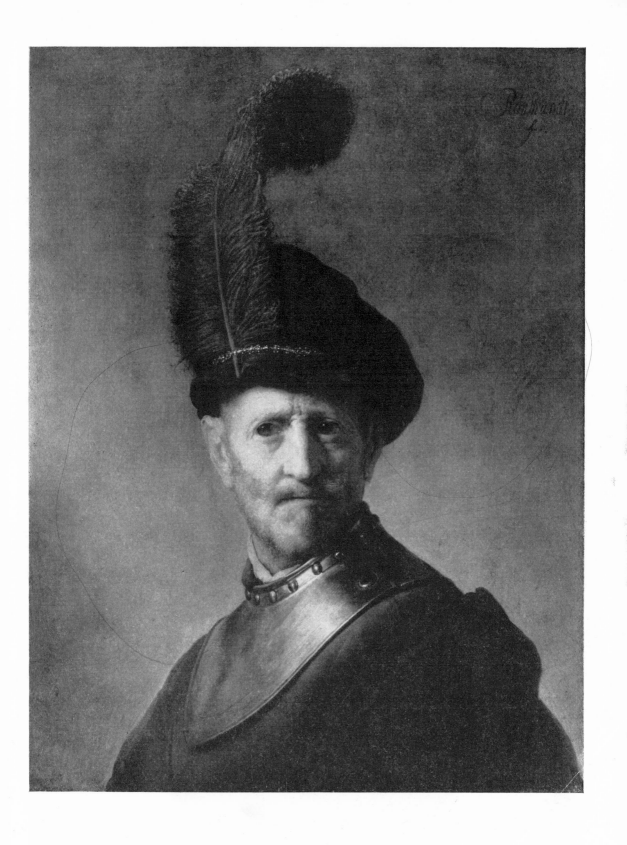

"Rembrandt's Father." Panel, 65 × 51 cm. London, Sir Brian Mountain, Bt. (Br. 79)

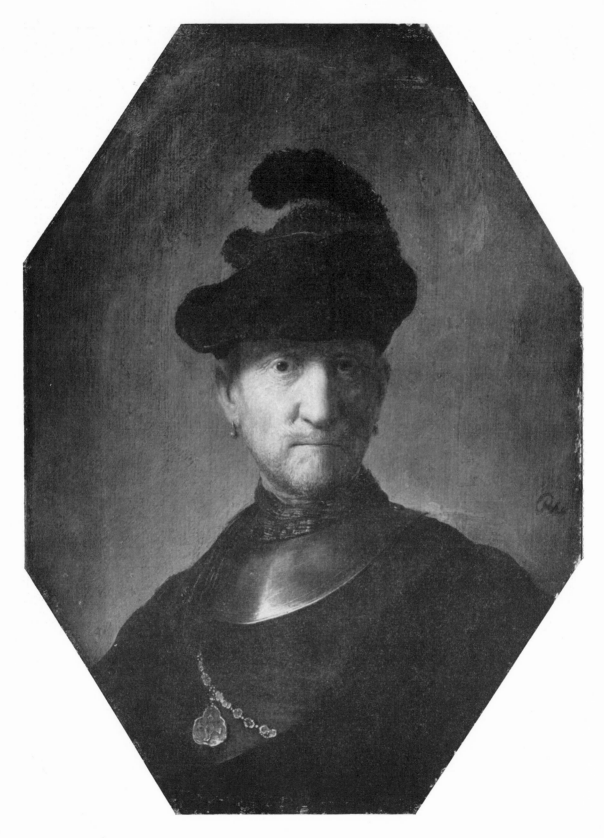

"Rembrandt's Father." Panel, 35×26 cm. Leningrad, Hermitage. (Br. 80)

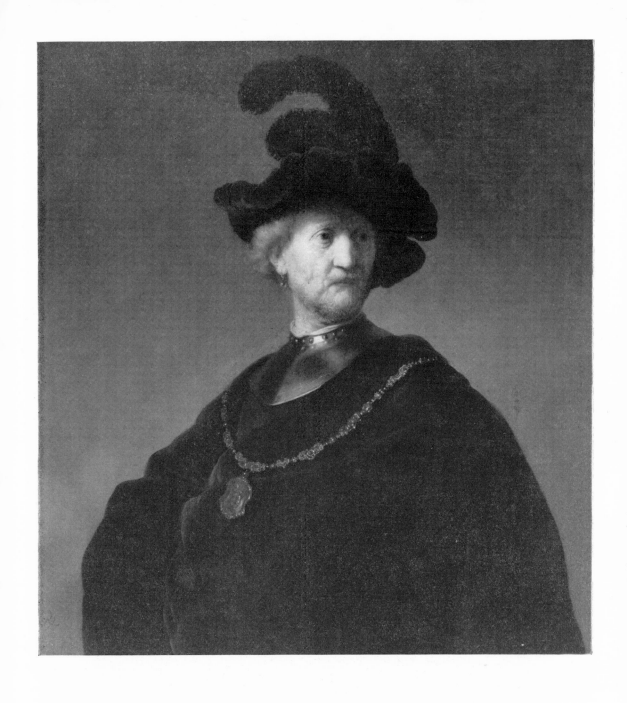

"Rembrandt's Father." Canvas, 81×75 cm. Chicago, Art Institute. (Br. 81)

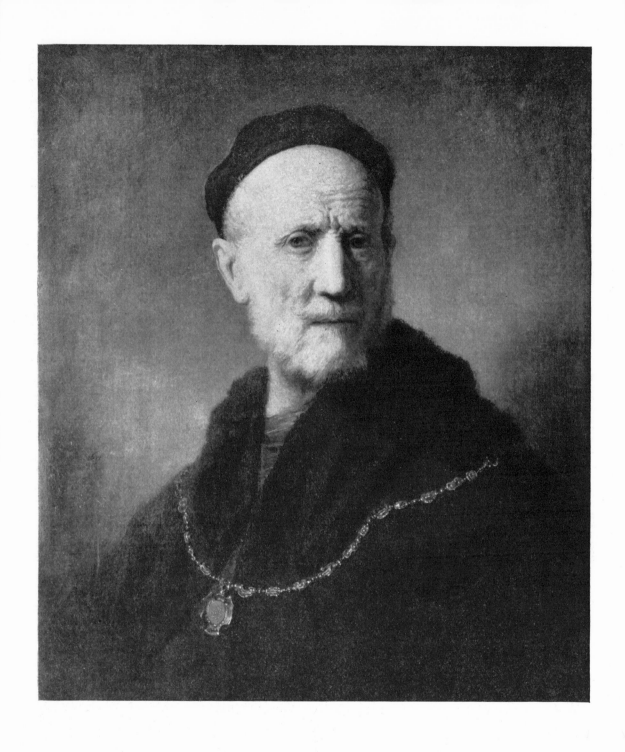

"Rembrandt's Father." 1631. Panel, 61×52 cm. Birmingham, City Museum and Art Gallery (on loan from Mrs. Oscar Ashcroft). (Br. 82)

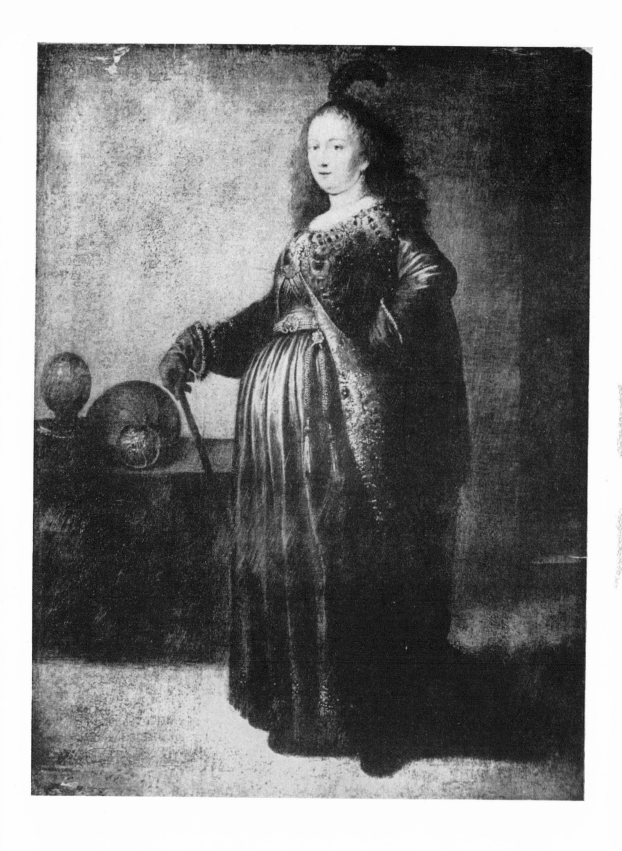

"Rembrandt's Sister." Canvas laid down on panel, 68·5×48 cm. Formerly Paris, Baron A. de Schickler. (Br. 83)

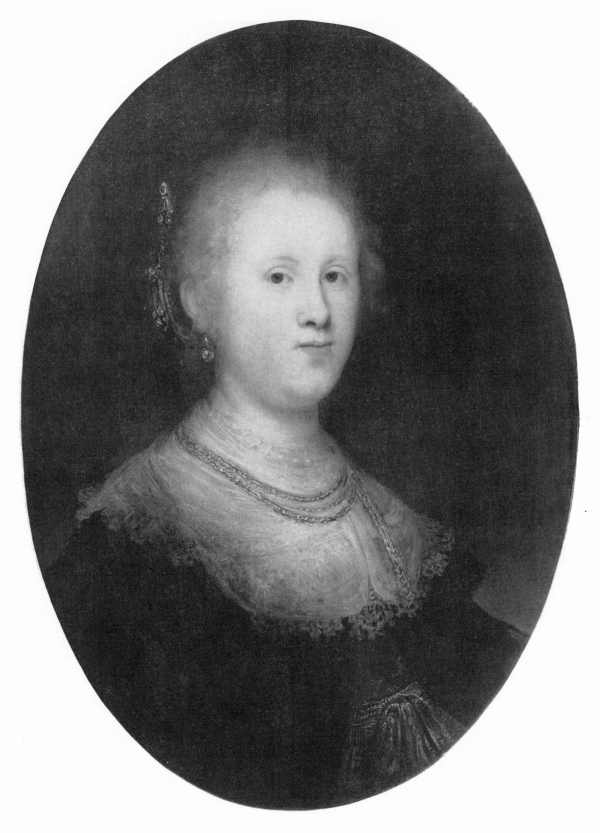

"Rembrandt's Sister." 1632. Panel, 63×48 cm. Allentown, Pa., Art Museum (Kress Collection). (Br. 86)

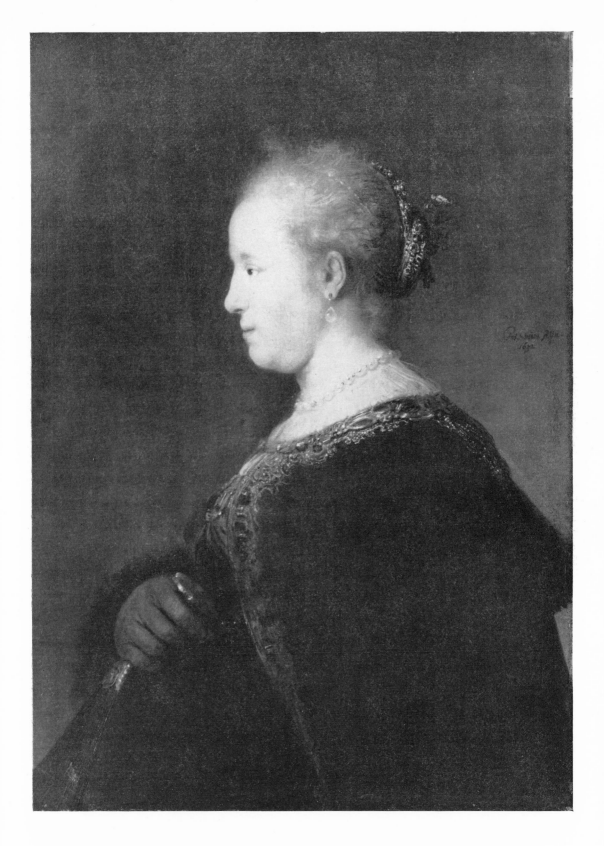

"Rembrandt's Sister." 1632. Canvas, 72×54 cm. Stockholm, Nationalmuseum. (Br. 85)

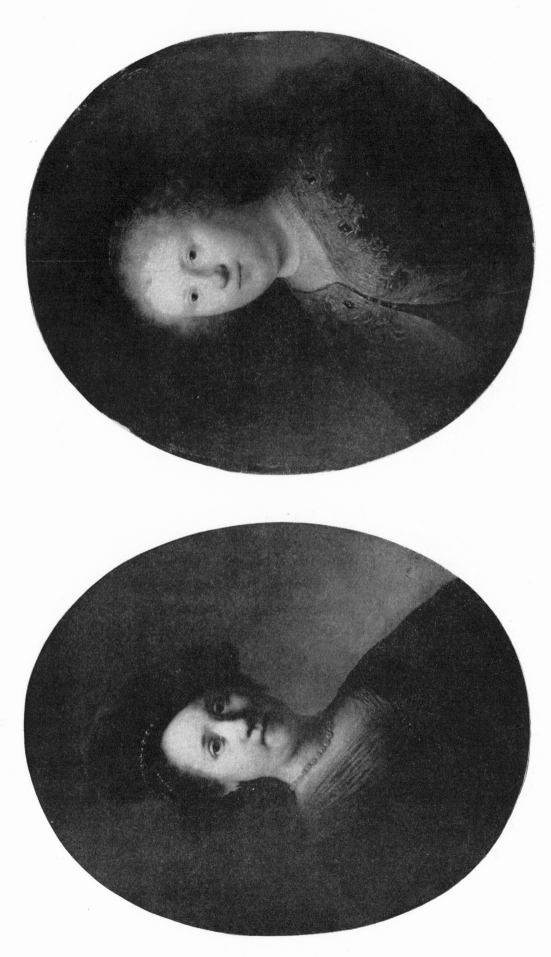

"Rembrandt's Sister." 1632. Canvas, 68·5×53·5 cm. Zurich, Dr. A. Wiederkehr. (Br. 84)

"Rembrandt's Sister." 1632. Panel, 55×48 cm. Milan, Brera Gallery. (Br. 87)

"Rembrandt's Sister." Panel, 52×39 cm. Chapel Hill, N.C., University of North Carolina. (Br. 88)

"Rembrandt's Sister." 1632. Panel, 59×44 cm. Boston, Museum of Fine Arts (on loan from Richard C. Paine). (Br. 89)

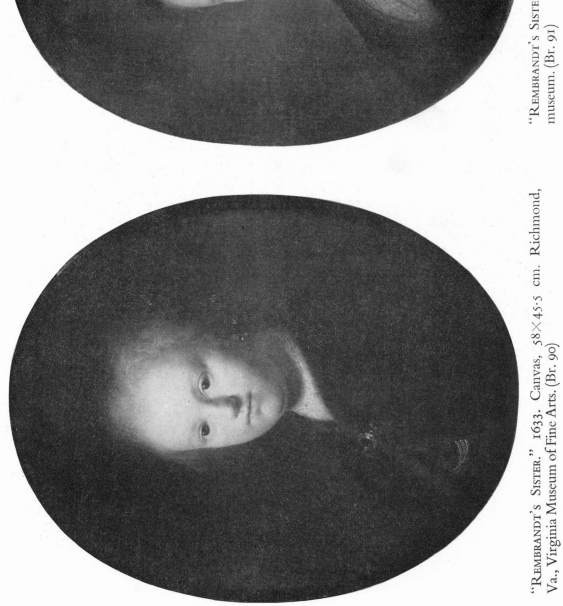

"REMBRANDT'S SISTER." 1633. Canvas, 58×45.5 cm. Richmond,
Va., Virginia Museum of Fine Arts. (Br. 90)

"REMBRANDT'S SISTER." Panel, 59×44 cm. Stockholm, National-
museum. (Br. 91)

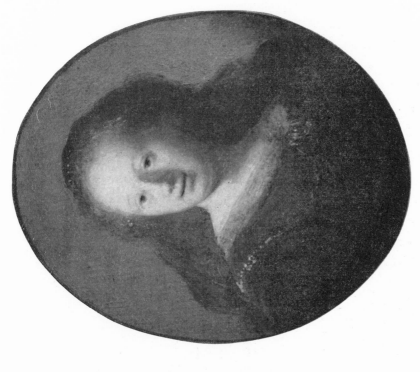

SASKIA. Panel, 9.7×7.7 cm. Private Collection, U.S.A. (Br. 93)

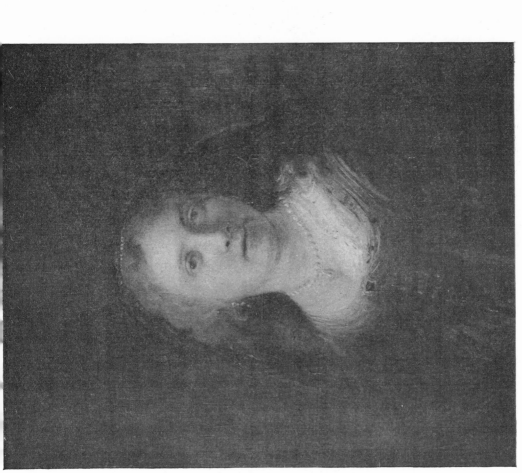

SASKIA. Panel, 21×17 cm. Richmond, Va., Virginia Museum of Fine Arts. (Br. 92)

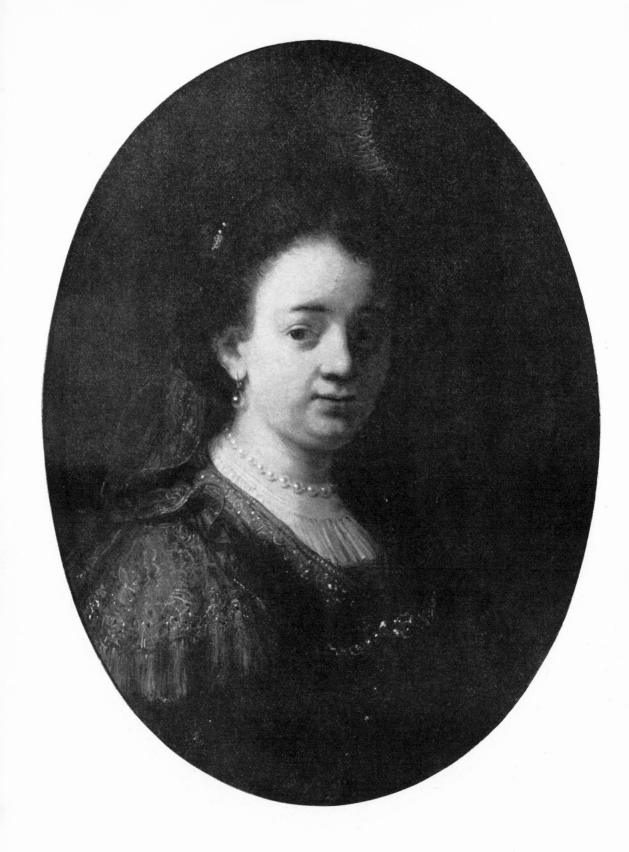

SASKIA. 1633. Panel, 72×48 cm. Leeuwarden, Fries Museum. (Br. 634)

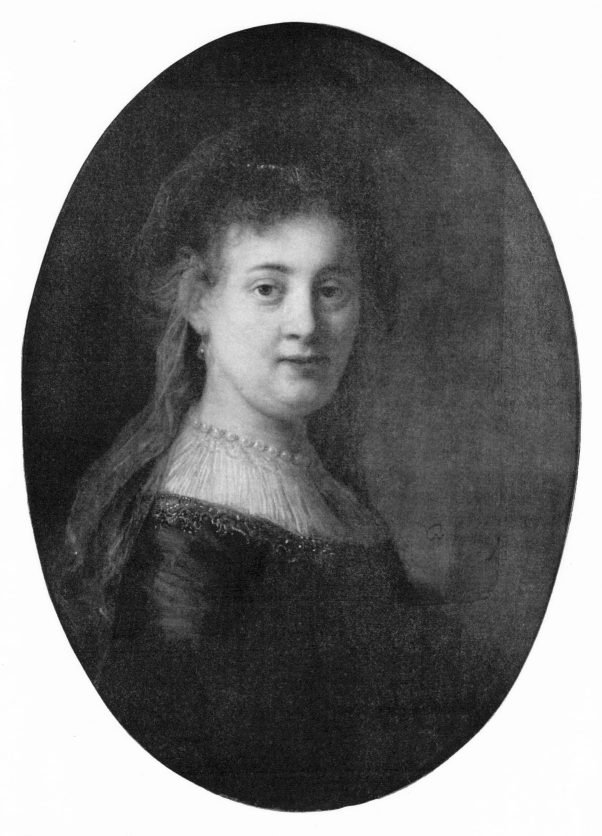

SASKIA. 1633. Panel, 66·5×49·5 cm. Amsterdam, Rijksmuseum. (Br. 94)

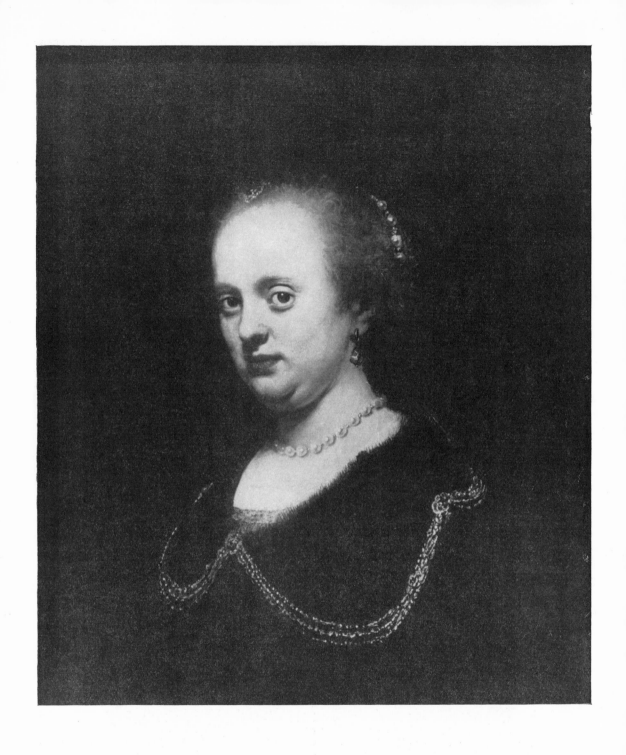

"Rembrandt's Sister." 1633. Canvas, 62×55.5 cm. Private Collection, South America. (Br. 95)

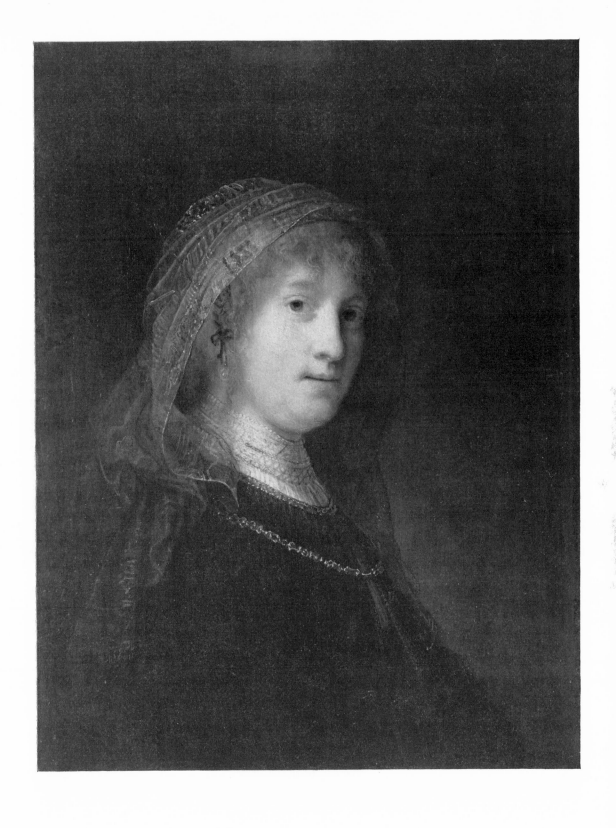

SASKIA. Panel, 60·5×49 cm. Washington, National Gallery of Art (Widener Collection). (Br. 96)

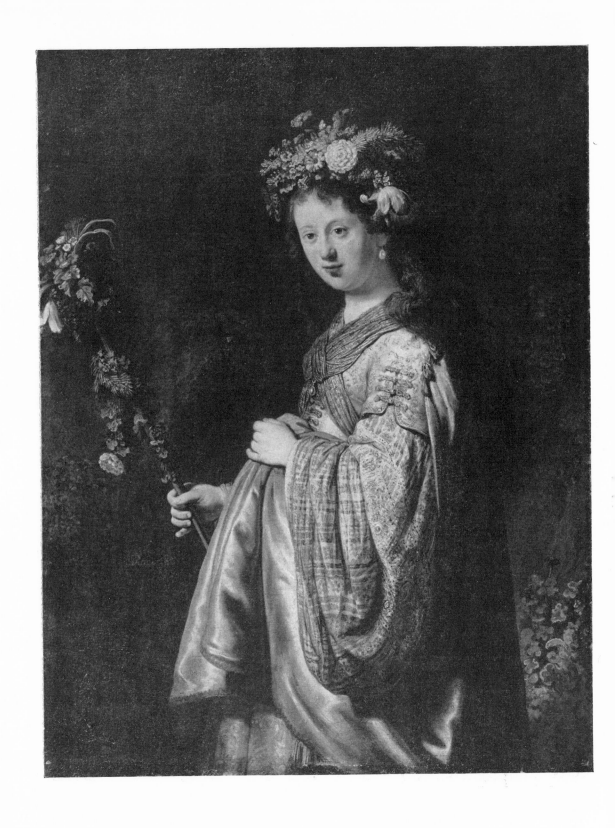

SASKIA AS FLORA. 1634. Canvas, 125×101 cm. Leningrad, Hermitage. (Br. 102)

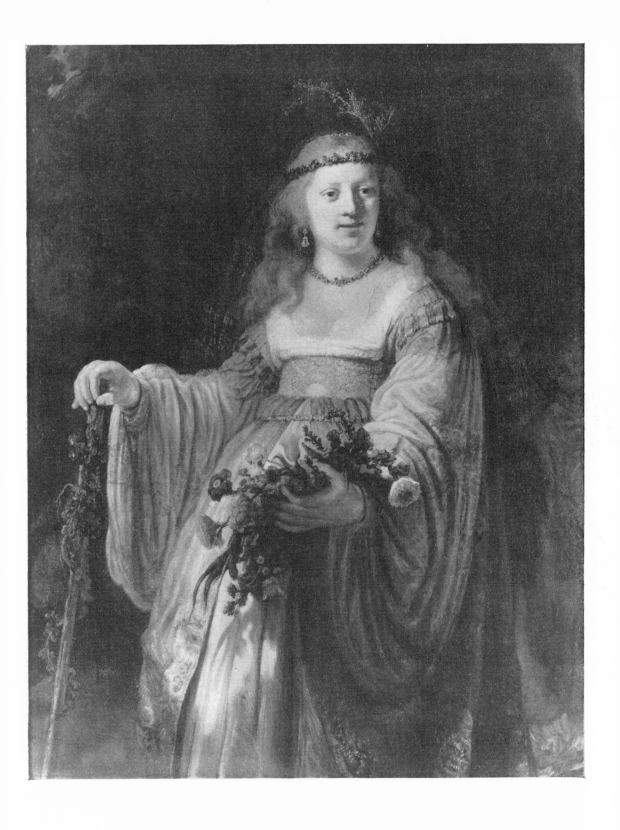

Saskia as Flora. 1635. Canvas, 123·5×97·5 cm. London, National Gallery. (Br. 103)

SASKIA. 163(5? 8?). Panel, 98×70 cm. Château de Pregny (Geneva), Baron Edmond de Rothschild. (Br. 104)

SASKIA. 1636. Canvas, 67·5×52·5 cm. Hartford, Conn., Wads-worth Atheneum. (Br. 105)

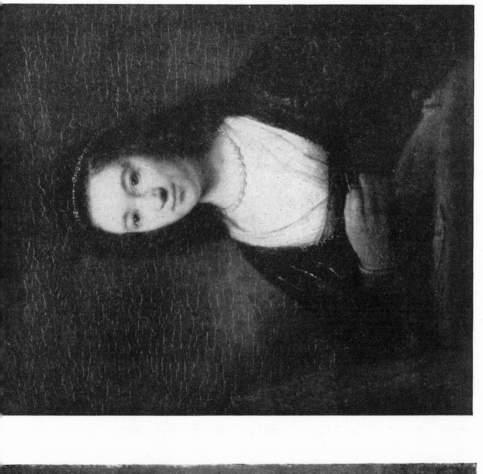

SASKIA AT HER MIRROR. Panel, 73·5×63·5 cm. Formerly London, Sir Edmond Davis. (Br. 107)

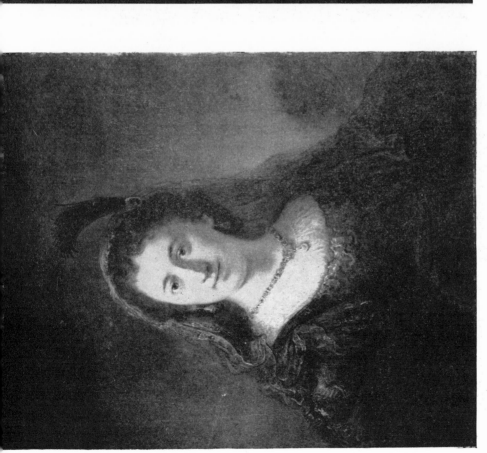

SASKIA. 1636. Canvas, 78·5×66 cm. Zurich, Mrs. Emil Bührle. (Br. 106)

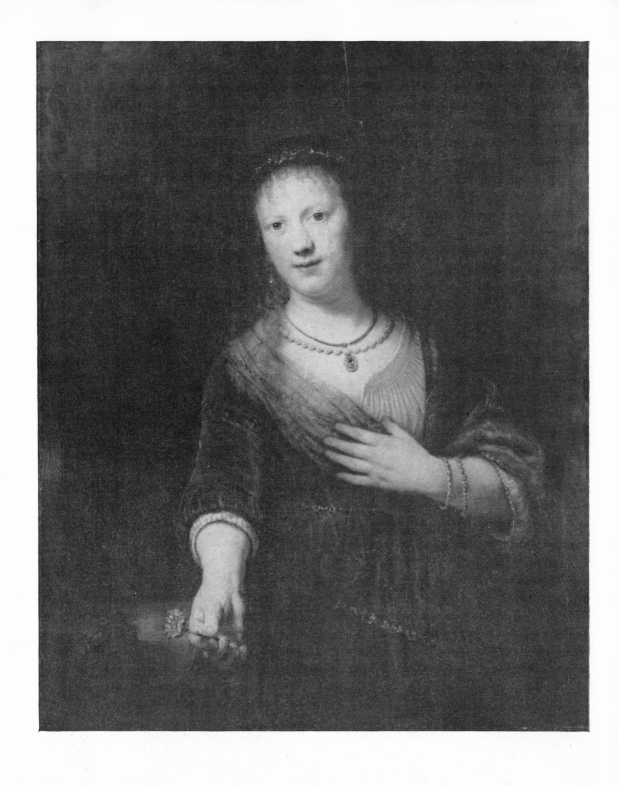

SASKIA WITH A FLOWER. 1641. Panel, 98.5×82.5 cm. Dresden, Gemäldegalerie. (Br. 108)

SASKIA (posthumous portrait). 1643. Panel, 72×59 cm. Berlin-Dahlem, Gemäldegalerie. (Br. 109)

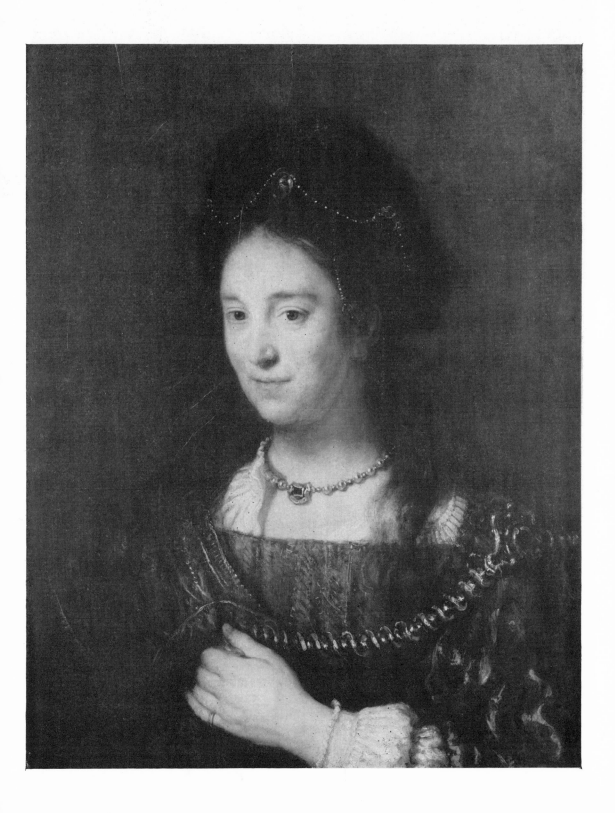

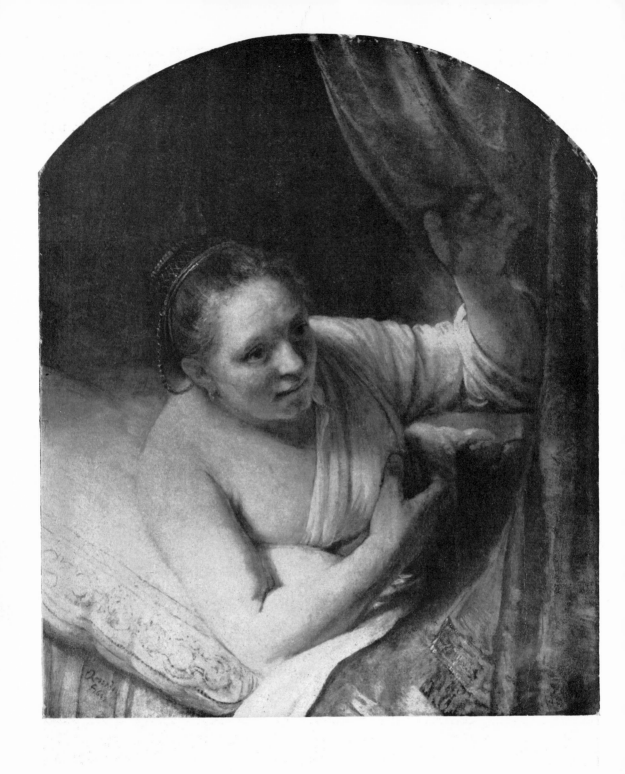

HENDRICKJE STOFFELS IN BED. Canvas, 80×66.5 cm. Edinburgh, National Gallery of Scotland. (Br. 110)

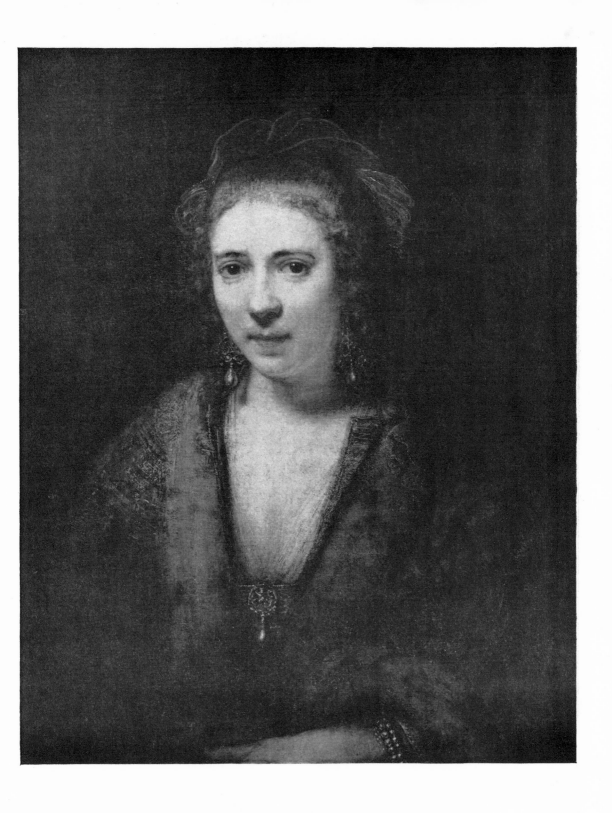

Hendrickje Stoffels. Canvas, 72×60 cm. Paris, Louvre. (Br. 111)

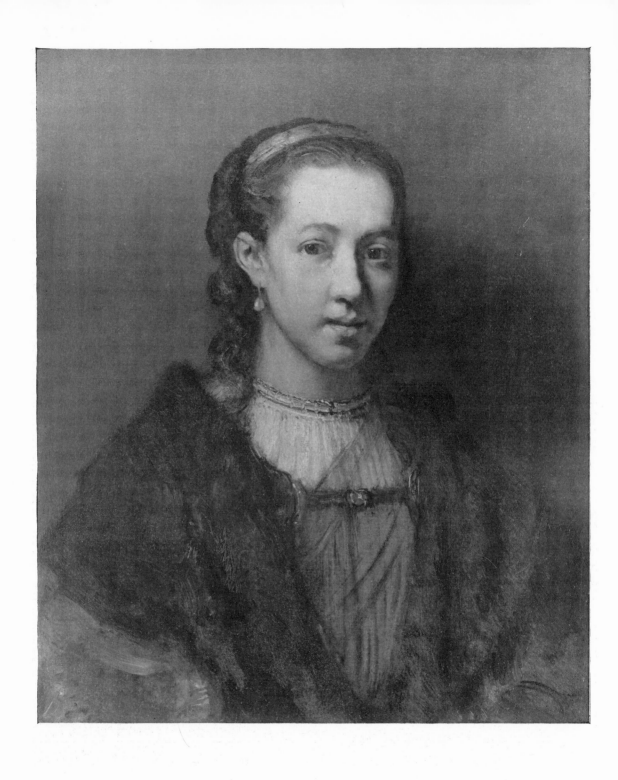

HENDRICKJE STOFFELS. Canvas, 65.5 × 54 cm. Fullerton, Calif., Norton Simon Foundation. (Br. 112)

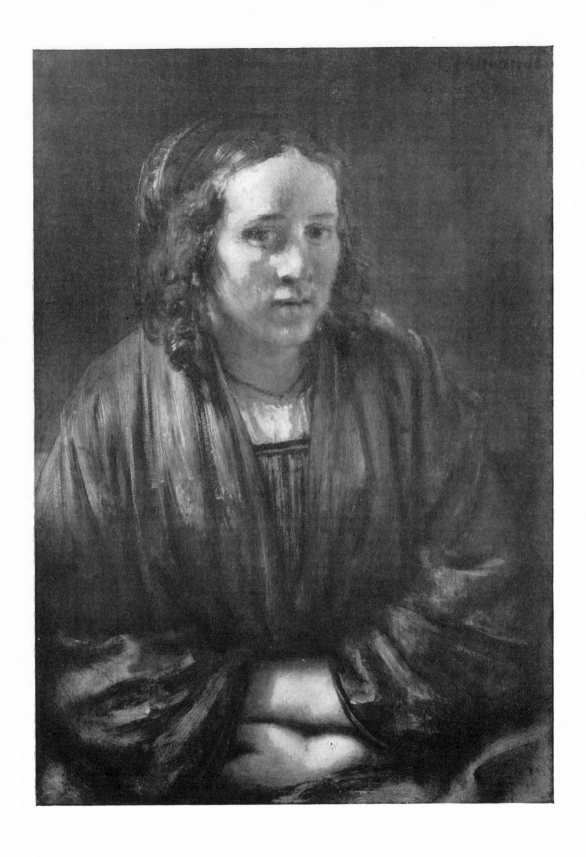

HENDRICKJE STOFFELS. Panel, 72.5 × 51.5 cm. Frankfurt, Städelsches Kunstinstitut (on loan). (Br. 115)

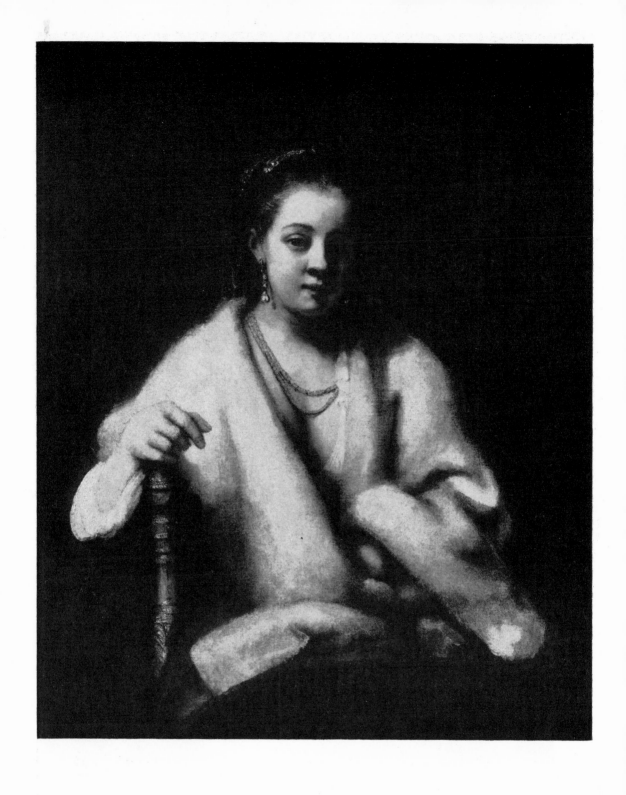

HENDRICKJE STOFFELS. Canvas, 100×83.5 cm. Sudeley Castle, Gloucestershire, Simon Morrison. (Br. 113)

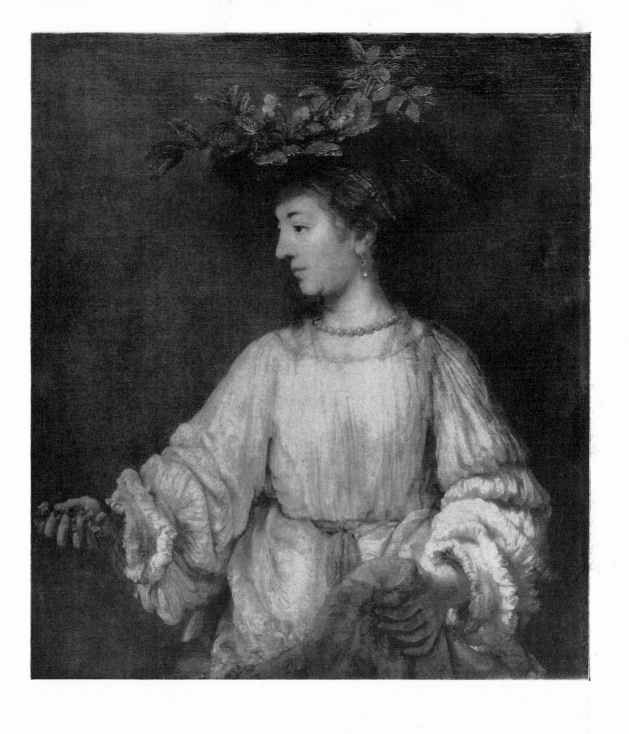

HENDRICKJE STOFFELS AS FLORA. Canvas, 100×92 cm. New York, Metropolitan Museum of Art. (Br. 114)

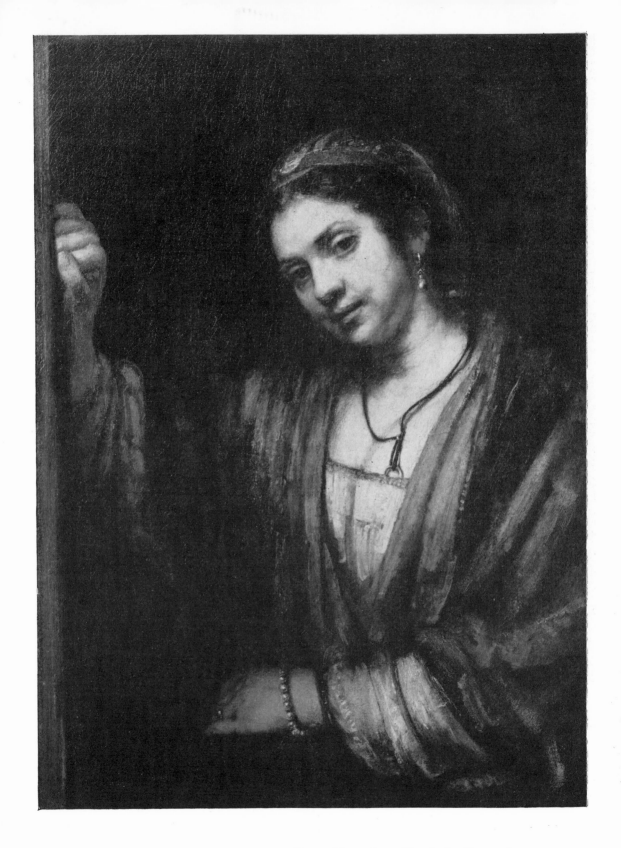

Henrdrickje Stoffels. Canvas, 86×65 cm. Berlin-Dahlem, Gemäldegalerie. (Br. 116)

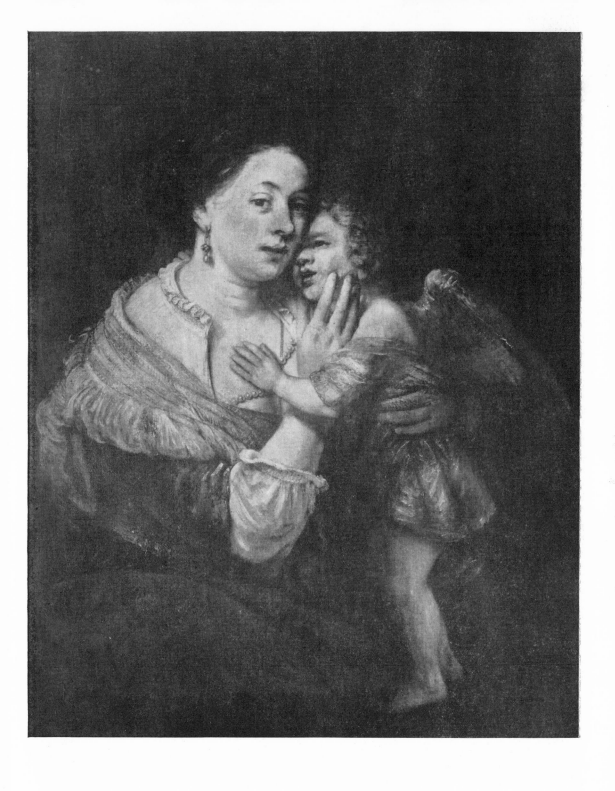

HENDRICKJE STOFFELS AS VENUS. Canvas, 110×88 cm. Paris, Louvre. (Br. 117)

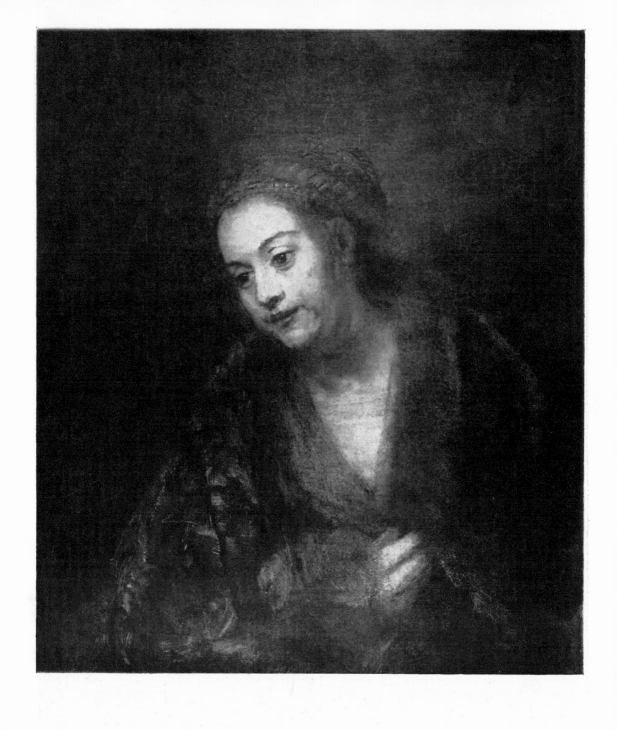

HENDRICKJE STOFFELS. 1660. Canvas, 76×67 cm. New York, Metropolitan Museum of Art. (Br. 118)

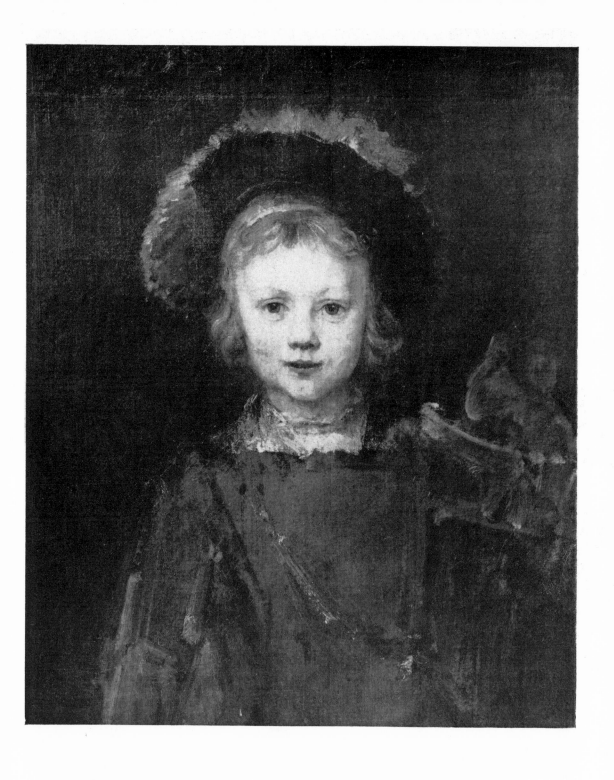

Titus(?). Canvas, 65×56 cm. Fullerton, Calif., Norton Simon Foundation. (Br. 119)

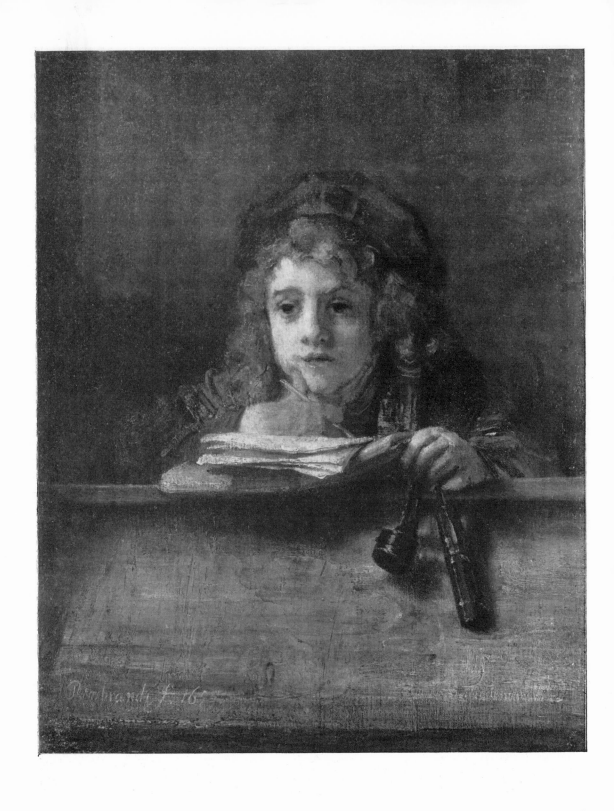

TITUS. 1655. Canvas, 77×63 cm. Rotterdam, Boymans-van Beuningen Museum. (Br. 120)

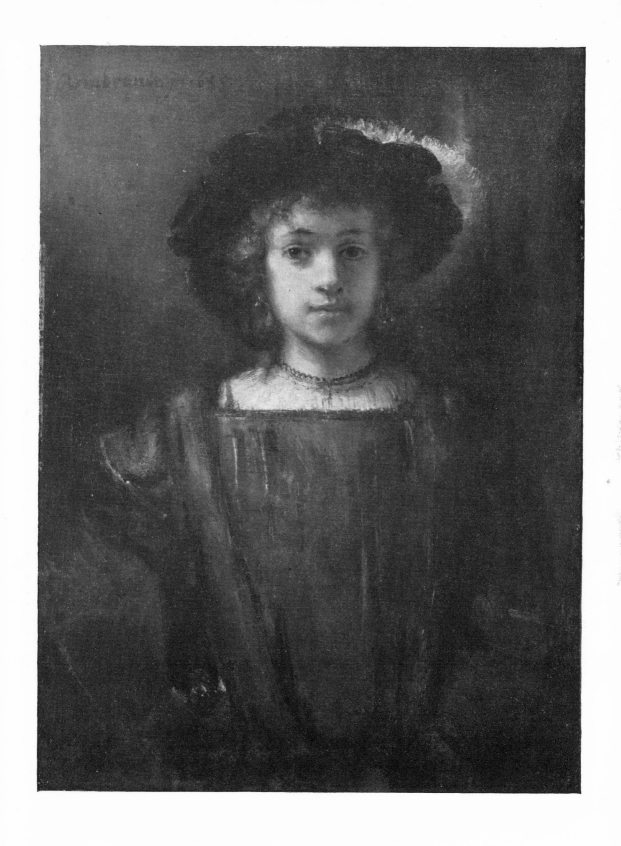

TITUS. 1655. Canvas, 79×59 cm. New York, Metropolitan Museum of Art. (Br. 121)

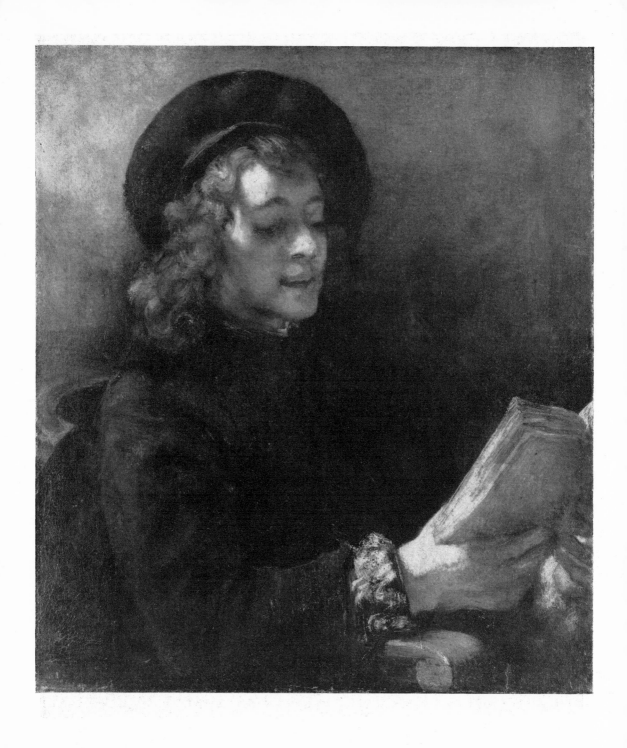

TITUS READING. Canvas, 70.5×64 cm. Vienna, Kunsthistorisches Museum. (Br. 122)

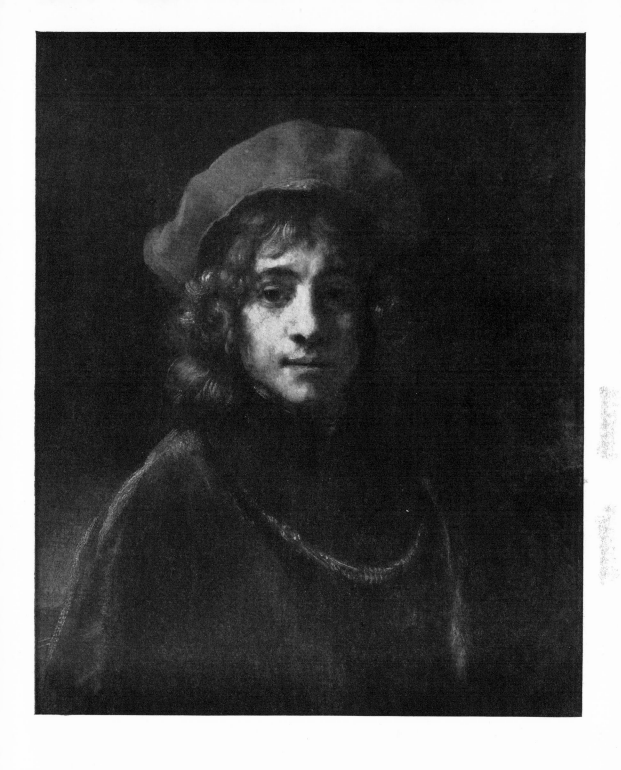

Titus. Canvas, 67·5 × 55 cm. London, The Wallace Collection. (Br. 123)

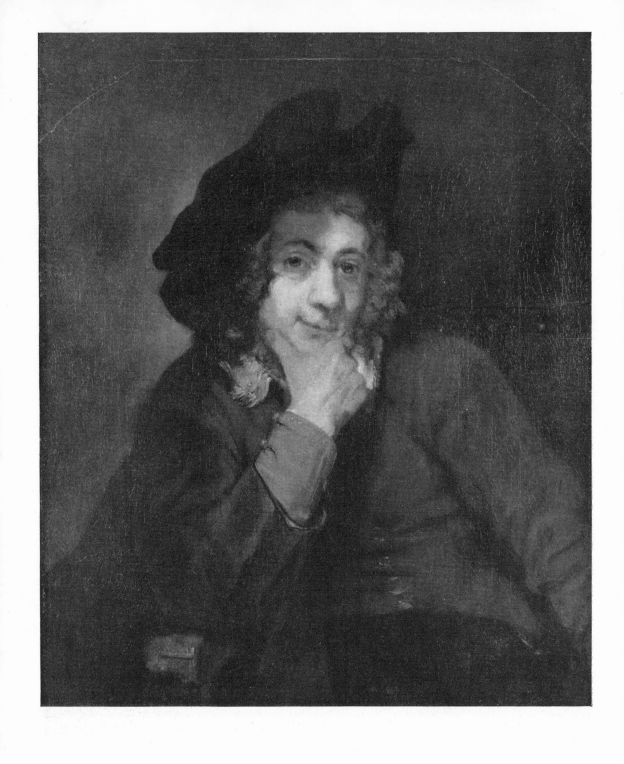

Titus. 1660(?). Canvas, 71·5×67 cm. Baltimore, Museum of Art. (Br. 124)

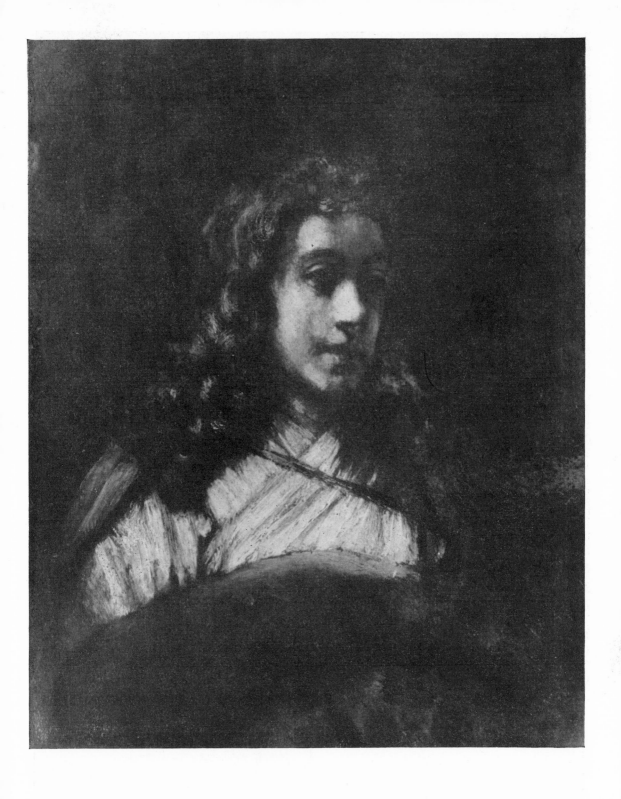

TITUS. Panel, 40×34.5 cm. Detroit, Fisher Collection. (Br. 125)

TITUS. Canvas, 72×56 cm. Paris, Louvre. (Br. 126)

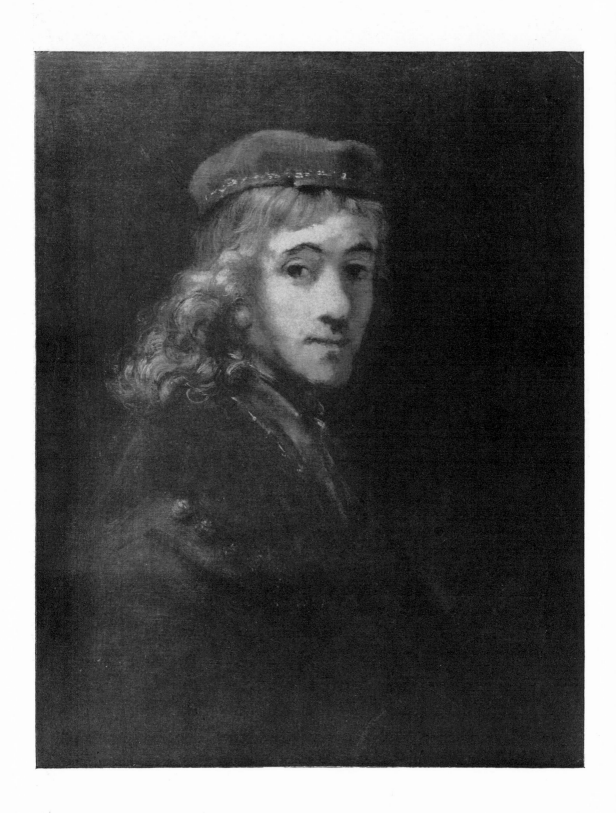

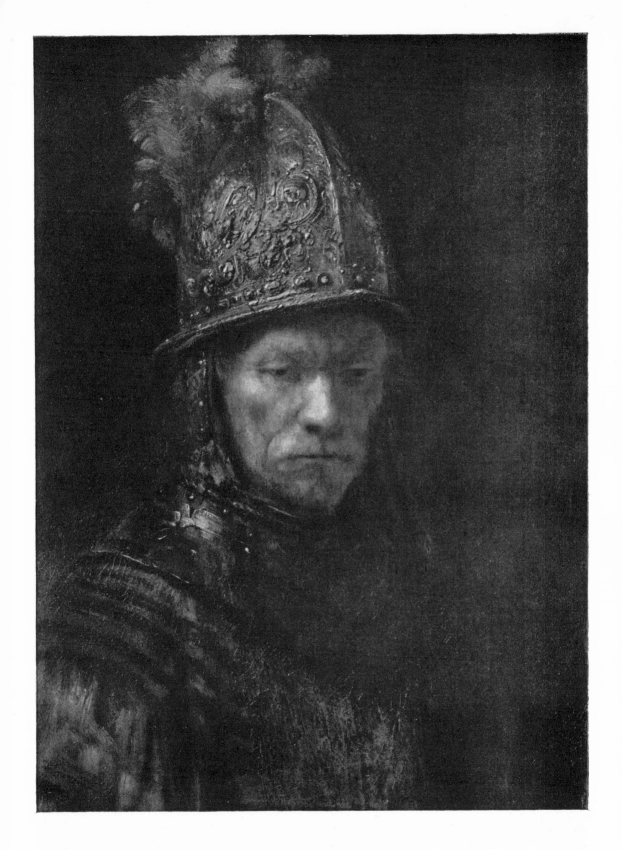

"The Man with the Golden Helmet" (Rembrandt's brother?). Canvas, 67×50 cm. Berlin-Dahlem, Gemäldegalerie. (Br. 128)

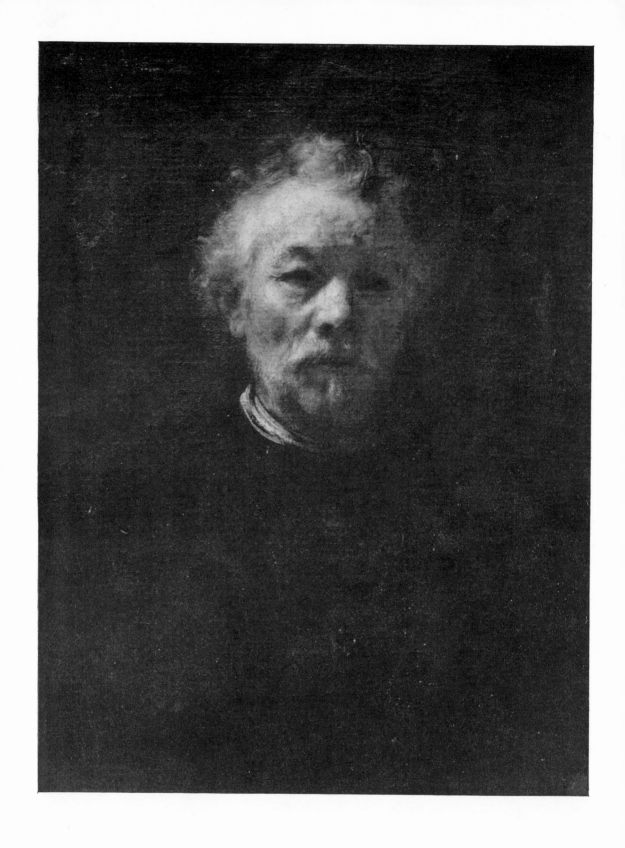

"REMBRANDT'S BROTHER." Canvas, 71×55 cm. Paris, Louvre. (Br. 129)

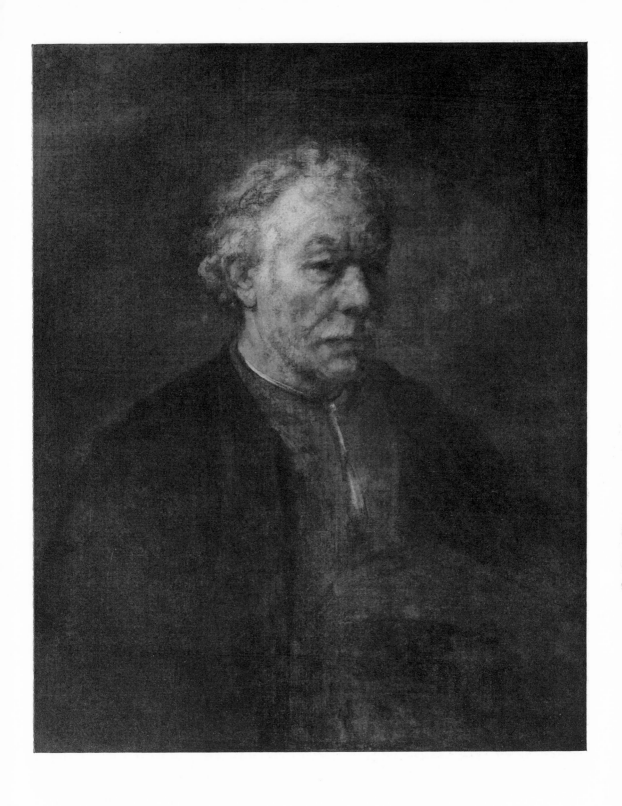

"Rembrandt's Brother." 1650. Canvas, 80×67 cm. The Hague, Mauritshuis. (Br. 130)

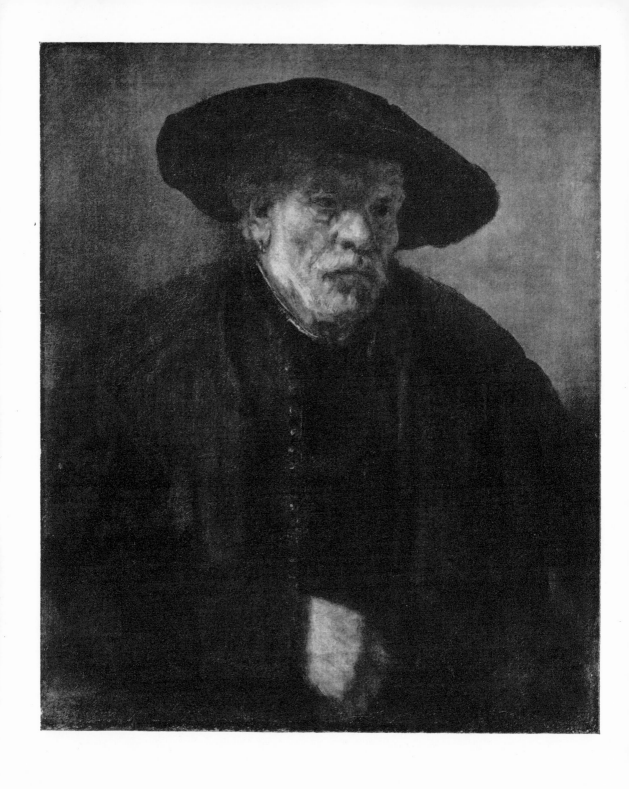

"Rembrandt's Brother." Canvas, 74×63 cm. Moscow, Pushkin Museum. (Br. 131)

MALE PORTRAITS

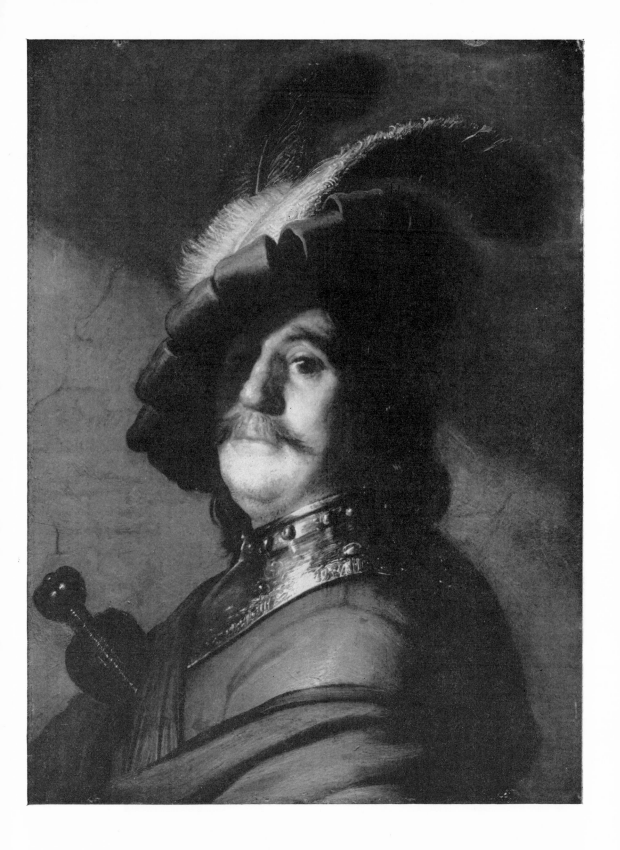

A WARRIOR. Panel, 39.5×29.5 cm. Lugano, Baron H. Thyssen-Bornemisza. (Br. 132)

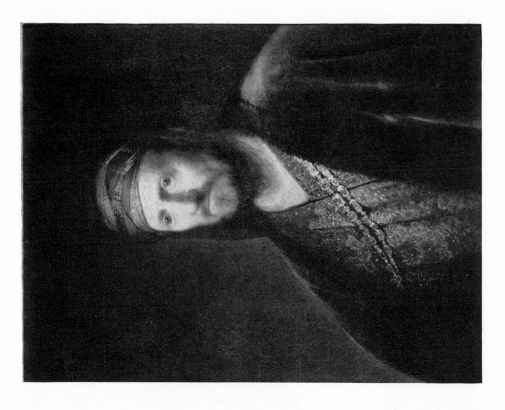

A MAN IN A TURBAN. Canvas, 83×64 cm. Philadelphia, Museum of Art. (Br. 133)

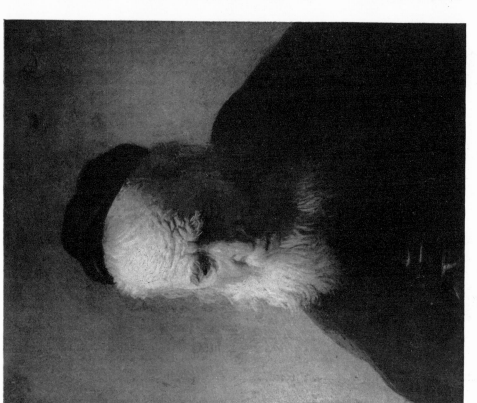

HEAD OF AN OLD MAN (Rembrandt's father?). Panel, 24×20·5 cm. Wassenaar (The Hague), S. J. van den Bergh. (Br. 633)

HEAD OF A MAN. Panel, 19·5 × 16 cm. Leyden, Municipal Museum. (Br. 135)

A MAN LAUGHING. Copper, 15·5 × 12·5 cm. The Hague, Mauritshuis. (Br. 134)

HEAD OF A MAN. Panel, 16×13 cm. Oxford, Ashmolean Museum. (Br. 138A)

HEAD OF AN OLD MAN. Panel, 19·5×16·5 cm. Copenhagen, Statens Museum. (Br. 136)

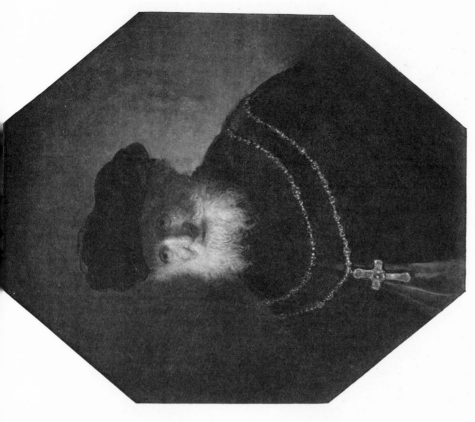

AN OLD MAN WITH A JEWELLED CROSS. 1630. Panel, 67·5 × 56 cm.
Cassel, Gemäldegalerie. (Br. 141)

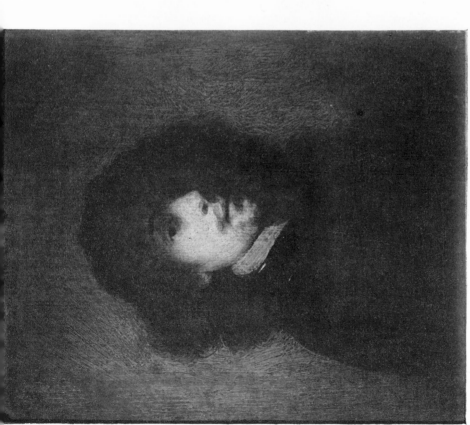

PORTRAIT OF CONSTANTIJN HUYGENS(?). Panel, 25·5 × 21·5 cm.
Formerly Glasgow, William Beattie. (Br. 139)

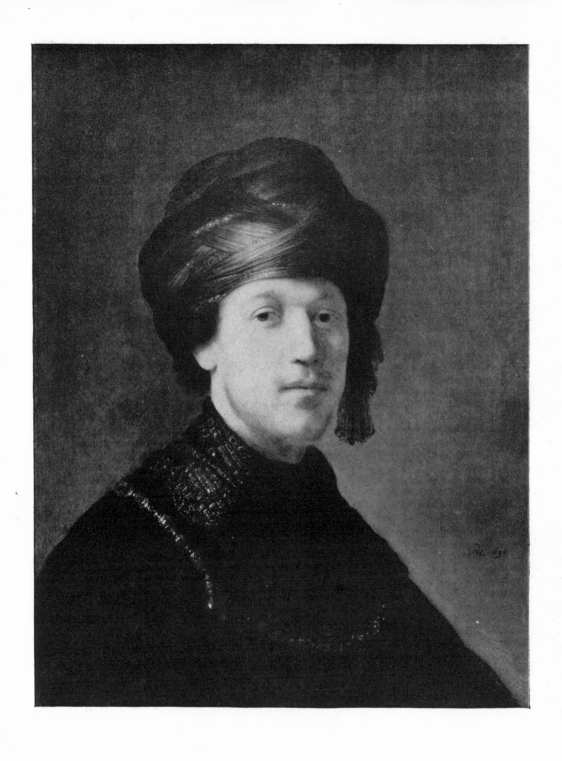

A Young Man in a Turban. 1631. Panel, 63.5×50 cm. Windsor Castle. (Br. 142)

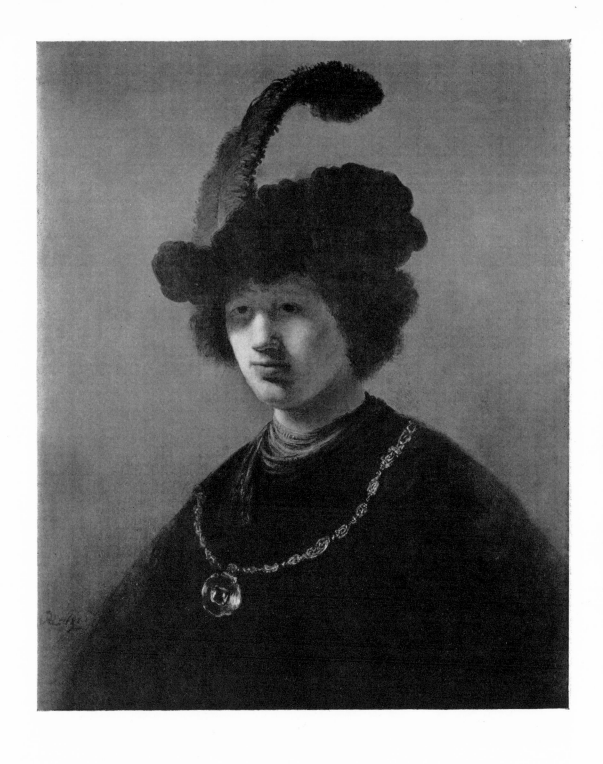

A YOUNG MAN IN A PLUMED HAT. 1631. Panel, 81×67 cm. Toledo, Ohio, Museum of Art.
(Br. 143)

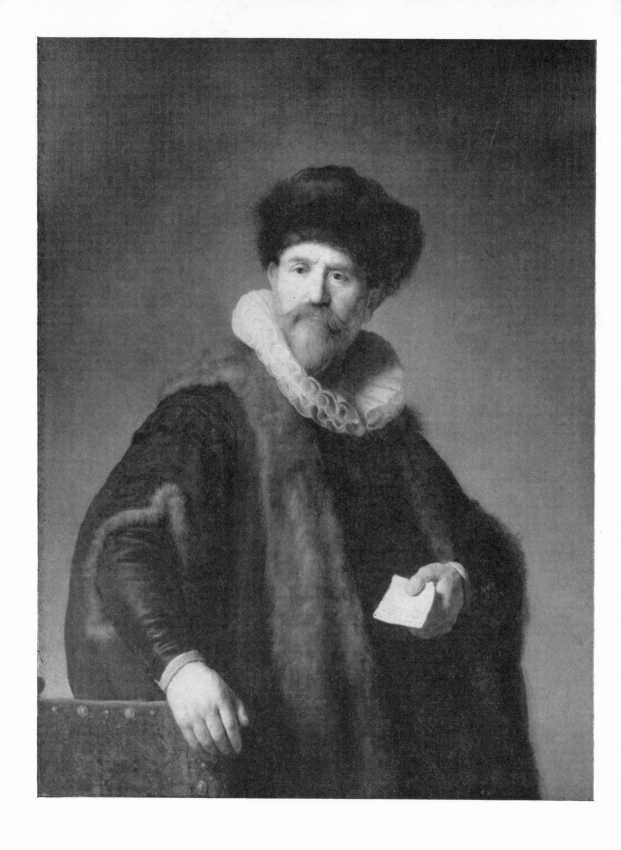

THE AMSTERDAM MERCHANT NICOLAES RUTS. 1631. Panel, 115×85.5. New York, The Frick
Collection. (Br. 145)

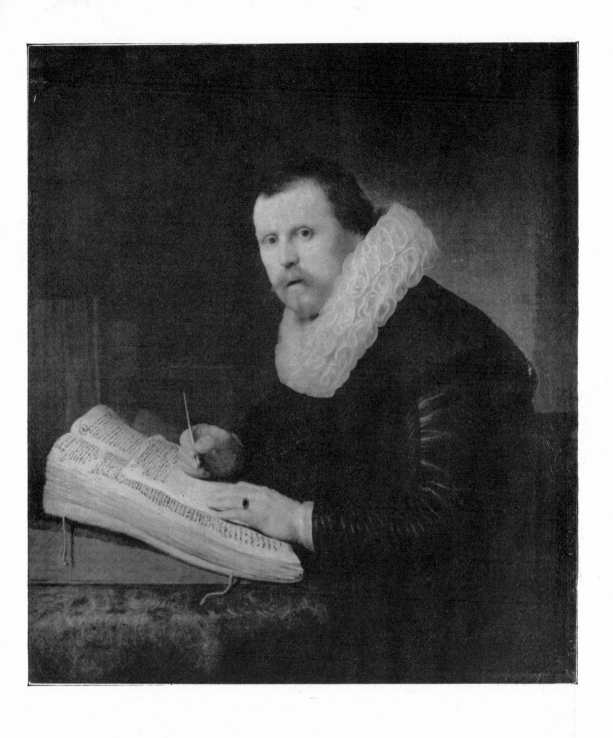

A YOUNG MAN AT A DESK. 1631. Canvas, 104×92 cm. Leningrad, Hermitage. (Br. 146)

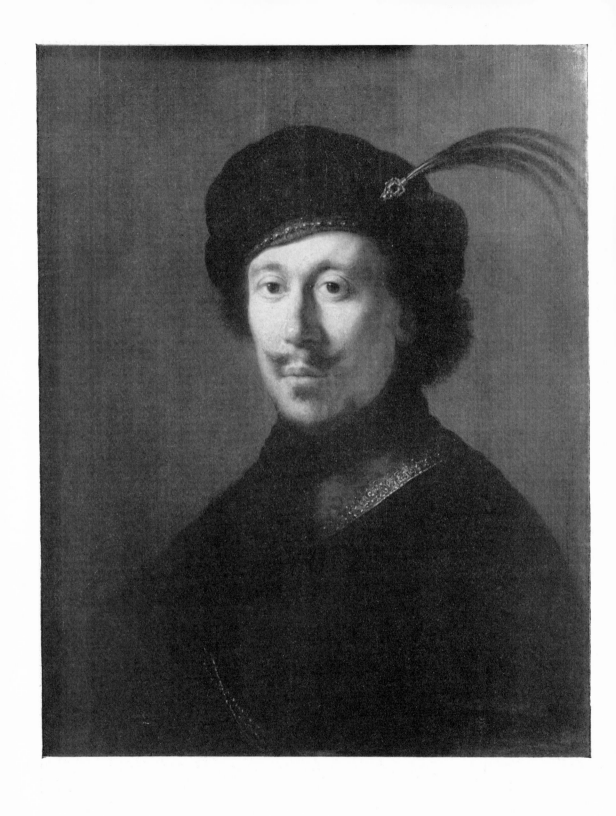

A Young Officer. 1631. Panel, 55×45 cm. San Diego, Calif., The Fine Arts Gallery. (Br. 144)

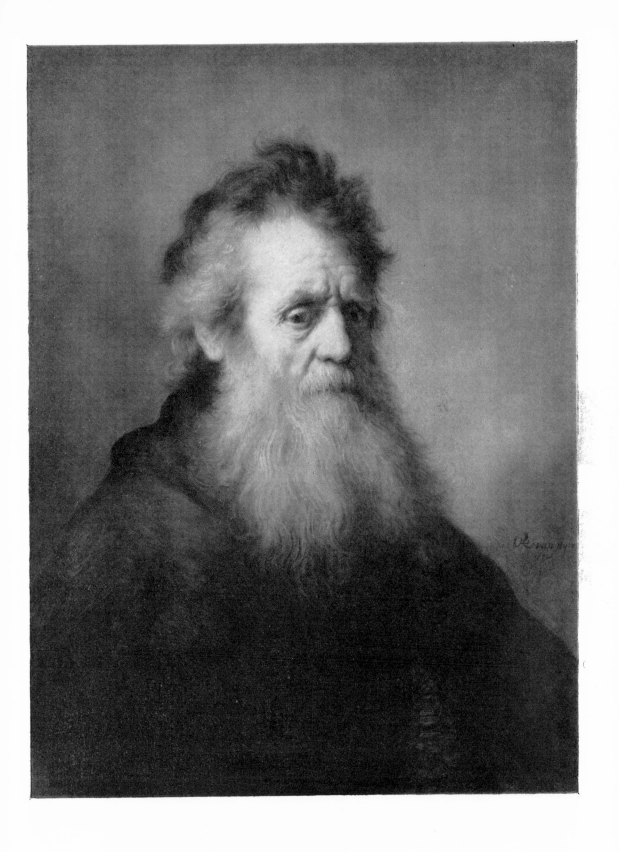

PORTRAIT OF AN OLD MAN. 1632. Panel, 66.5×51 cm. Cambridge, Mass., Fogg Art Museum. (Br. 147)

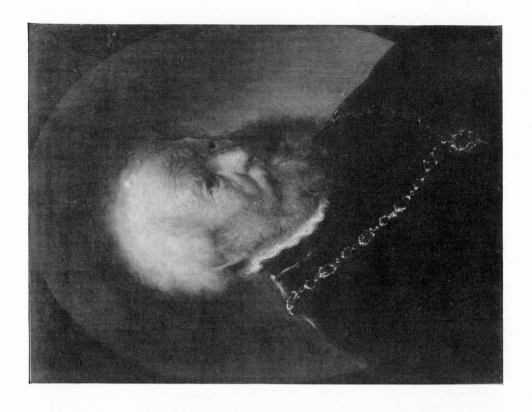

An Old Man with a Gold Chain. Panel, 64×45 cm. Los Angeles, Hans Cohn. (Br. 149)

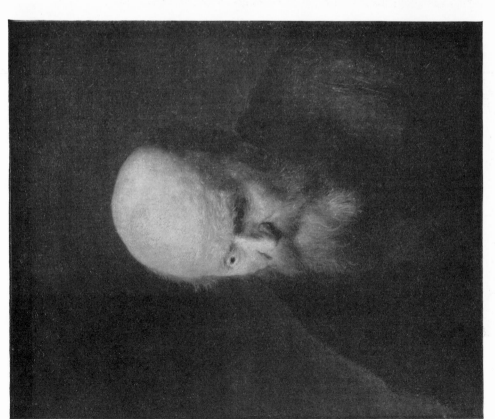

A Bald-Headed Old Man. 1632. Panel, 50×40·5 cm. Cassel, Gemäldegalerie. (Br. 148)

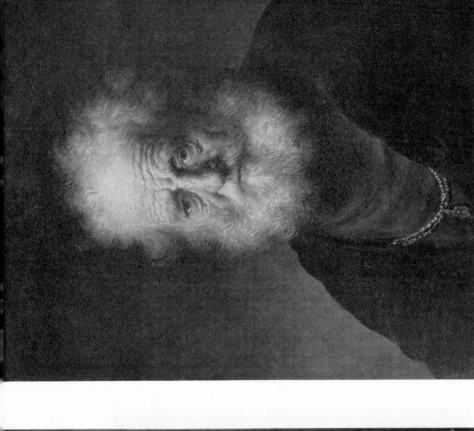

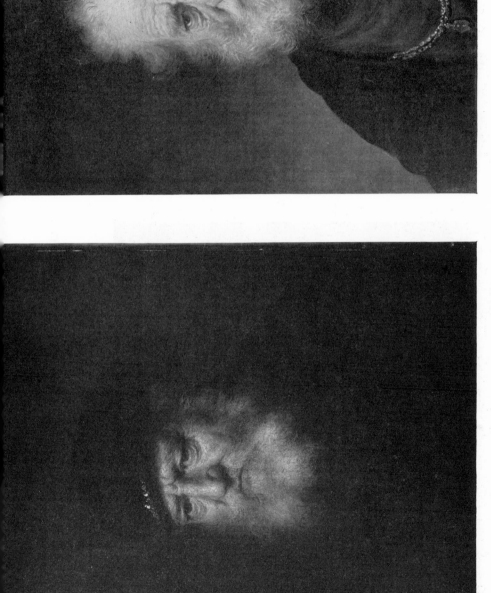

An Old Man with a Gold Chain. 1632. Panel, 59×49 cm. Cassel, Gemäldegalerie. (Br. 152)

Portrait of an Old Man. Panel, 57×47 cm. London, George Schicht. (Br. 150)

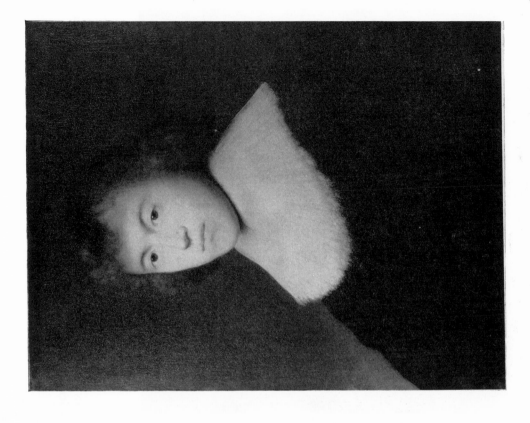

A Young Man with a Broad Collar. Canvas, 63·5 × 49·5 cm.
New York, Fleitman Collection. (Br. 154)

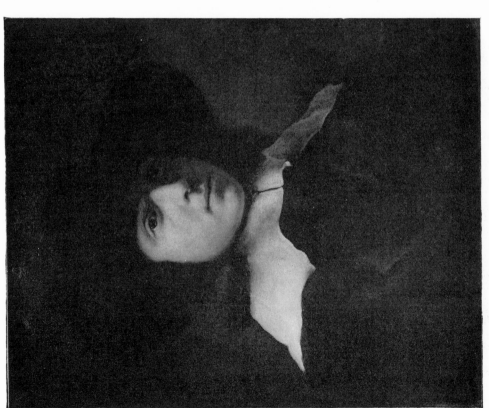

A Young Man in a Broad-Brimmed Hat. Panel, 60 × 48 cm.
New York, Jones Sale, December 4, 1941 (lot 23). (Br. 153)

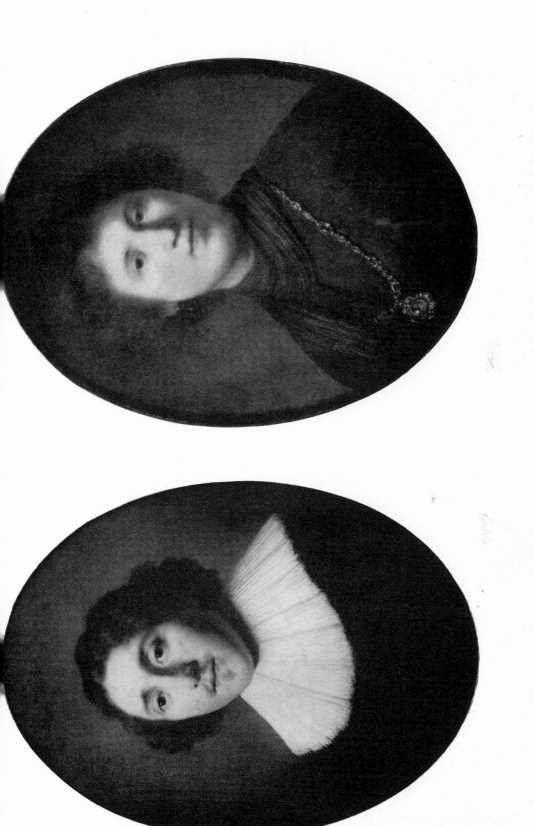

PORTRAIT OF A YOUNG MAN. 1632. Panel, 63×46 cm. Wanås (Sweden), Count Wachtmeister. (Br. 155)

A YOUNG MAN WITH A GOLD CHAIN. 1632. Panel, 56.5×42 cm. Cleveland, Museum of Art. (Br. 156)

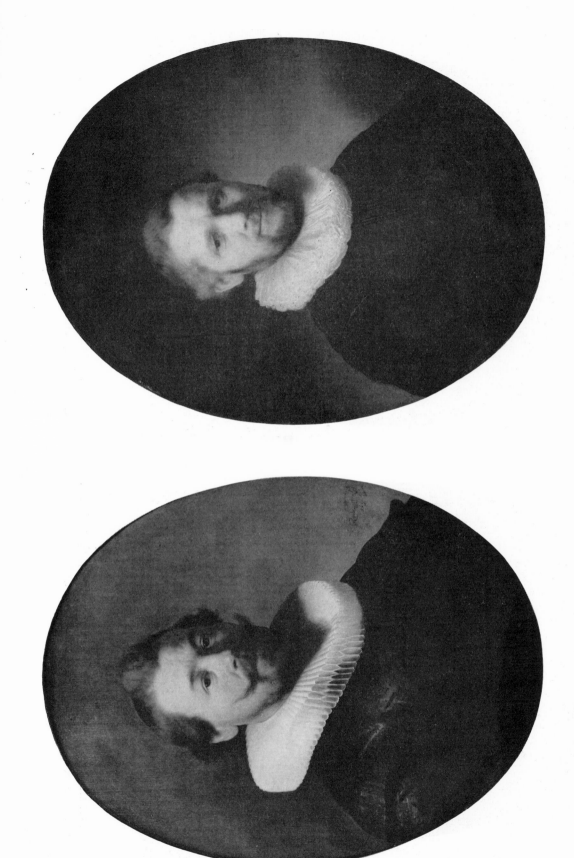

PORTRAIT OF A MAN. 1632. Panel, 72×52 cm. New York, Metropolitan Museum of Art. (Br. 160) Probably companion to Br. 335 reproduced on page 265

PORTRAIT OF A MAN. 1632. Panel, 63.5×48 cm. Brunswick, Herzog Anton Ulrich Museum. (Br. 159) Companion to Br. 338 reproduced on page 266

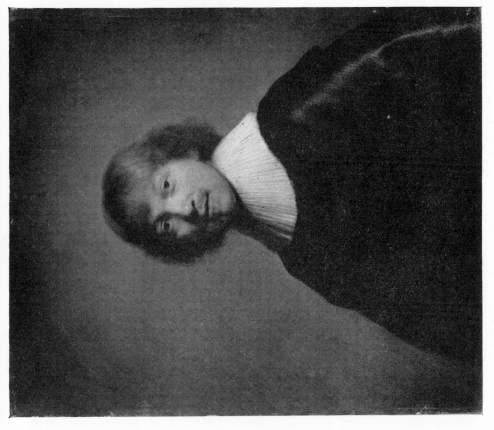

The Painter Jacob De Gheyn III. 1632. Panel, 29·5 × 24·5 cm. London, Dulwich College Gallery. (Br. 162) Companion to Br. 161

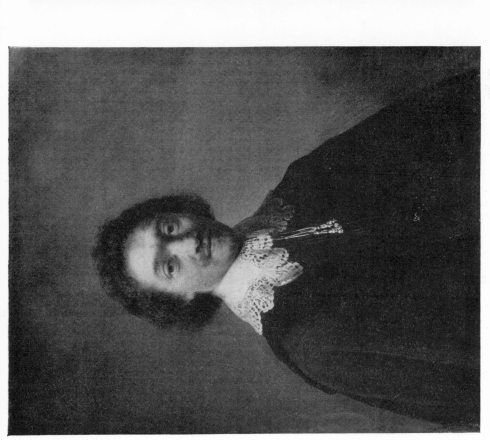

Maurits Huygens. 1632. Panel, 31 × 24·5 cm. Hamburg, Kunsthalle. (Br. 161) Companion to Br. 162

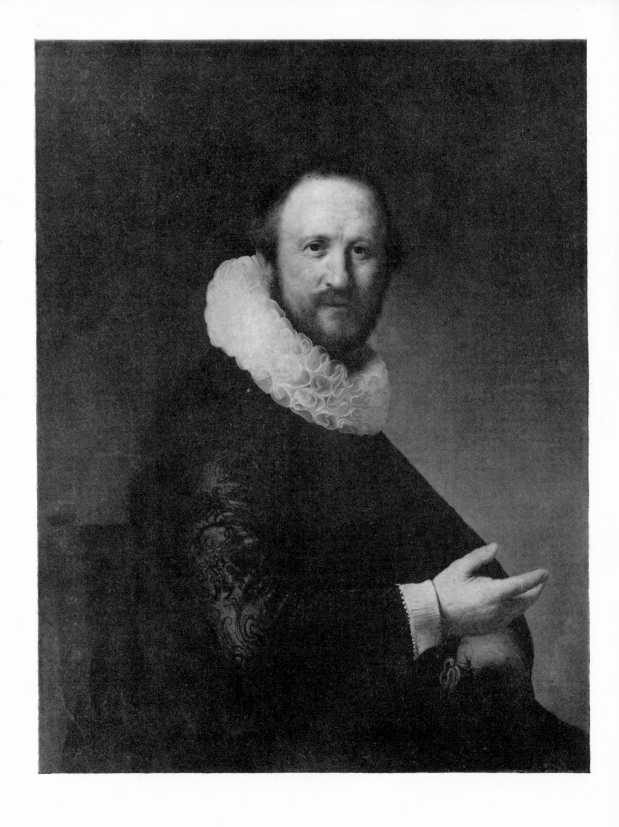

PORTRAIT OF A SEATED MAN. Panel, 90×68·5 cm. Vienna, Kunsthistorisches Museum. (Br. 163)
Companion to Br. 332 reproduced on page 263

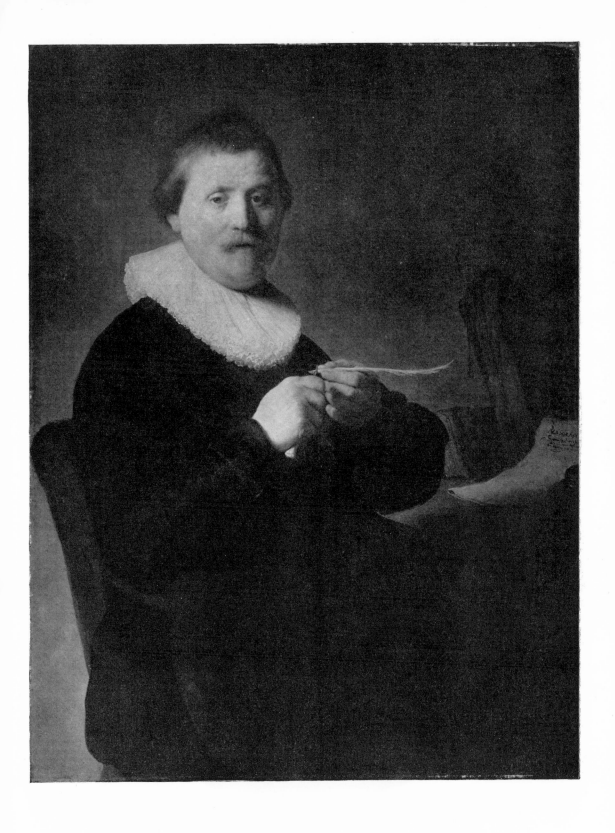

A Man Sharpening a Quill. Canvas, 101·5×81·5 cm. Cassel, Gemäldegalerie. (Br. 164)

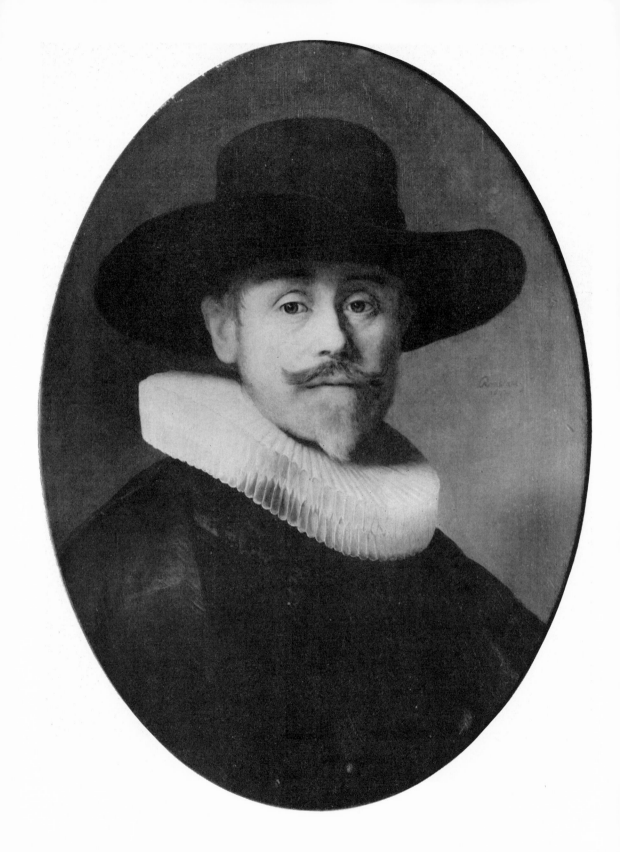

AELBERT CUYPER. 1632. Panel, 60×47 cm. Paris, Louvre. (Br. 165) Companion to **Br. 336** reproduced on page 265

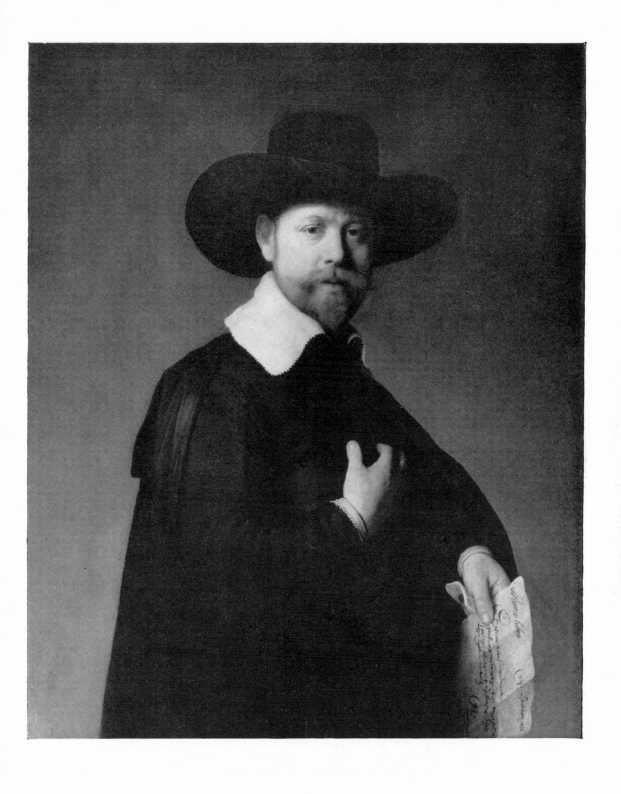

MAERTEN LOOTEN. 1632. Panel, 93×76 cm. Los Angeles, County Museum of Art. (Br. 166)

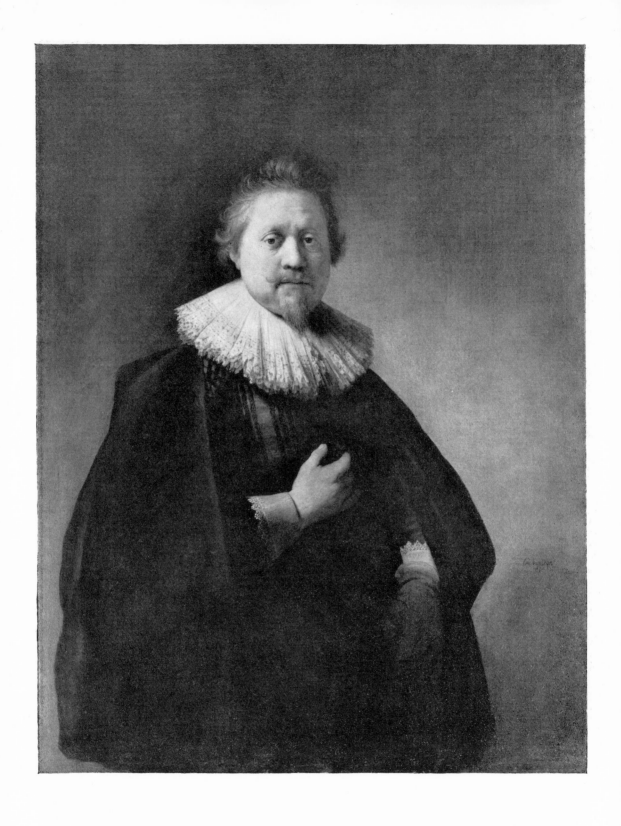

PORTRAIT OF A MAN. 1632. Canvas, 110×87.5 cm. New York, Metropolitan Museum of Art. (Br. 167) Companion to Br. 331 reproduced on page 262

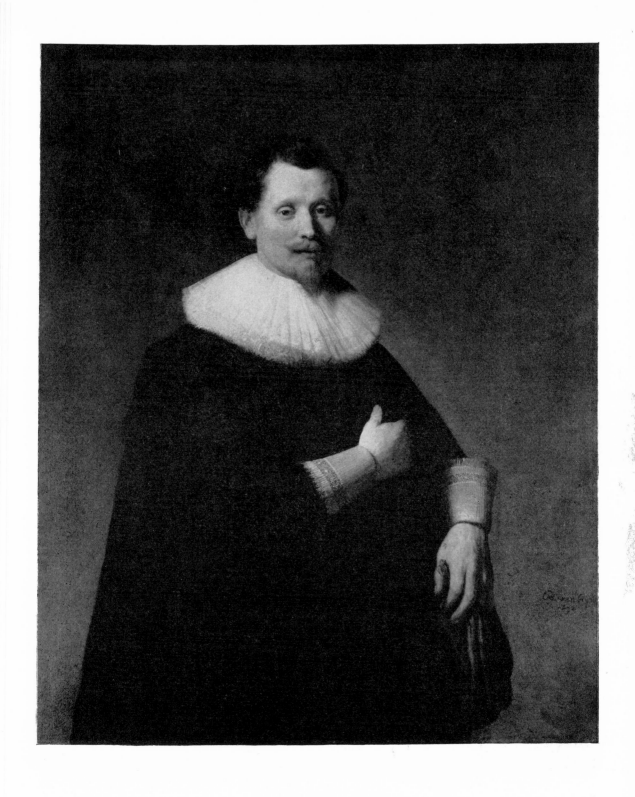

PORTRAIT OF A MAN WITH GLOVES. 1632. Canvas, 112×91 cm. Shelburne, Vermont, Shelburne Museum (Electra Havemeyer Webb Collection). (Br. 168)

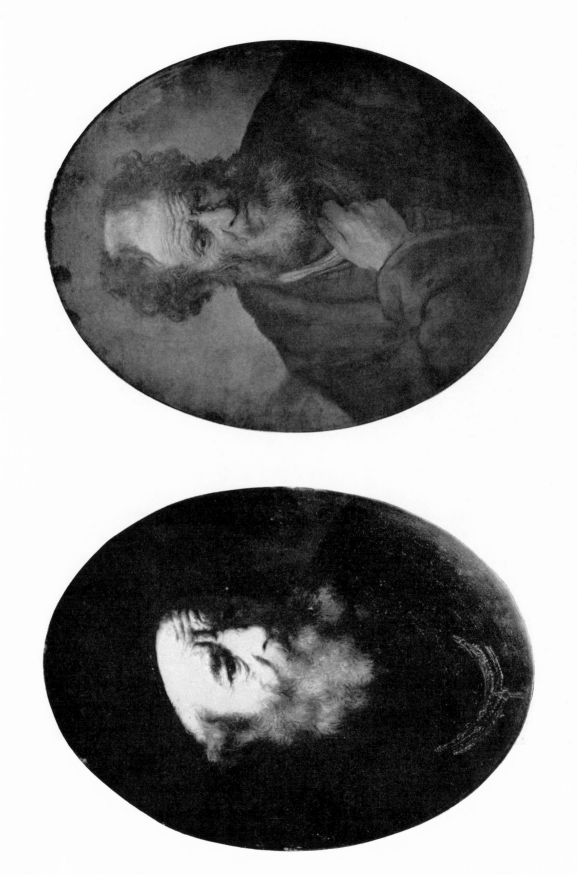

An Old Man with a Beard. 1633. Panel, 65×42 cm. Metz, Museum. (Br. 181)

An Old Man with a Beard. 163(4). Panel, 70×56 cm. Paris, Louvre. (Br. 182)

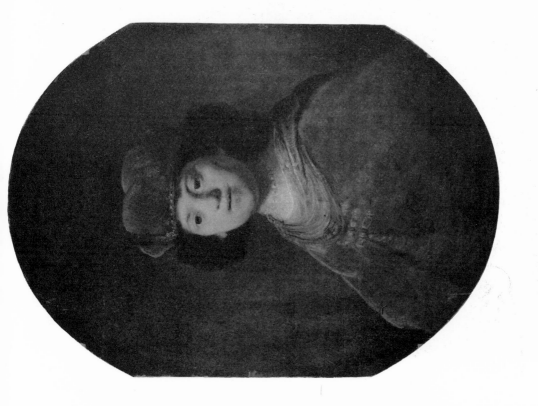

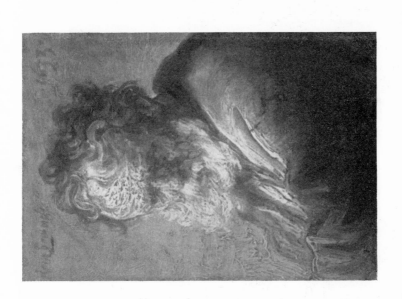

Study of an Old Man. 1633. Panel, 9·5×6·5 cm. New York, Arthur Armory Houghton, Jr. (Br. 183)

A Child in Fanciful Costume. Panel, 67×47·5 cm. Leningrad, Hermitage. (Br. 186)

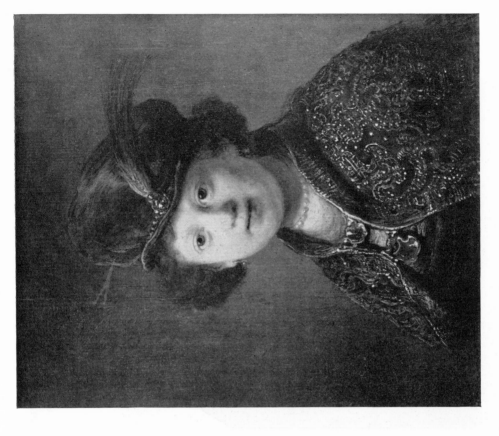

A Child in Fanciful Costume. 1633. Panel, 20×17 cm. London, The Wallace Collection. (Br. 188)

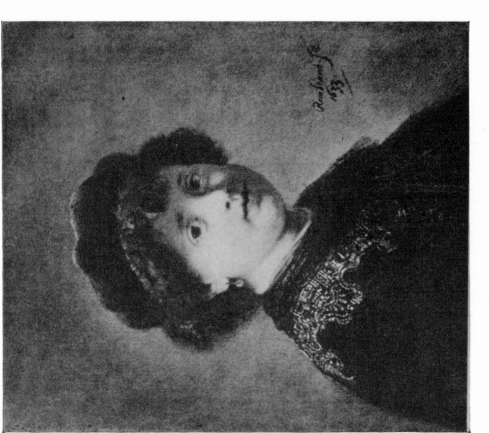

A Child in Fanciful Costume. Panel, 19.5×16.5 cm. Formerly Leningrad, Prince Youssoupoff. (Br. 187)

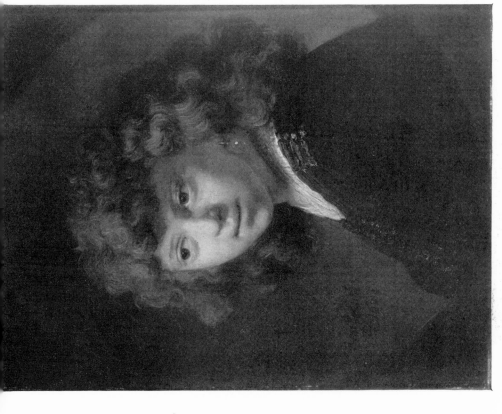

A Boy with Long Hair. 1634. Panel, 47×36·5 cm. Welbeck Abbey, Duke of Portland. (Br. 191)

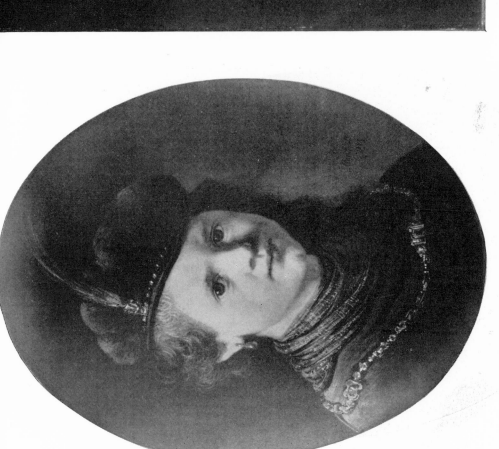

A Child in Fanciful Costume. 1633. Panel, 44×35 cm. Ferrières, Baron Edouard de Rothschild. (Br. 190)

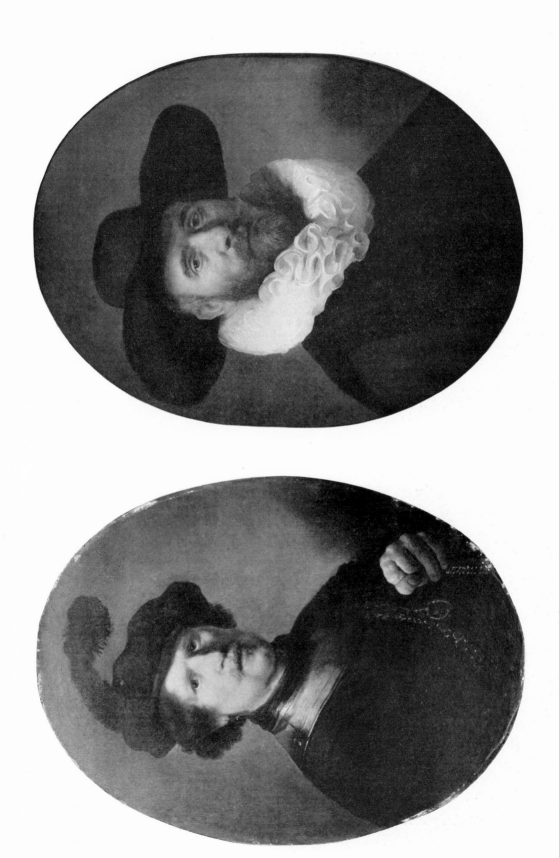

PORTRAIT OF AN OFFICER. Panel, 62×46 cm. Detroit, Wilson
Collection. (Br. 192)

A MEMBER OF THE RAMAN FAMILY. 1634. Panel, 67×52 cm.
Wassenaar (The Hague), H. Cohn. (Br. 194) Companion to
Br. 354 reproduced on page 276

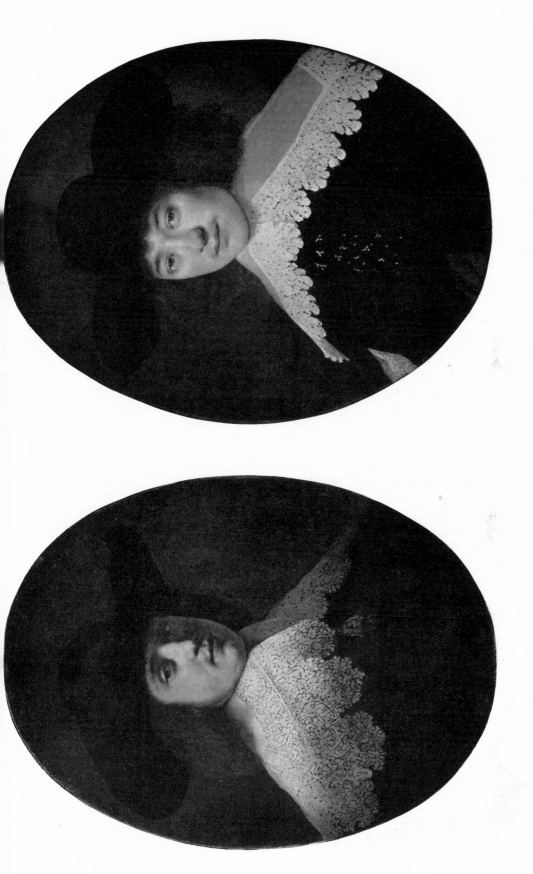

PORTRAIT OF A YOUNG MAN. 1634. Panel, 71 × 53 cm. Warsaw, National Museum. (Br. 195)

PORTRAIT OF A YOUNG MAN. Panel, 66·5 × 52 cm. Dublin, National Gallery of Ireland. (Br. 198)

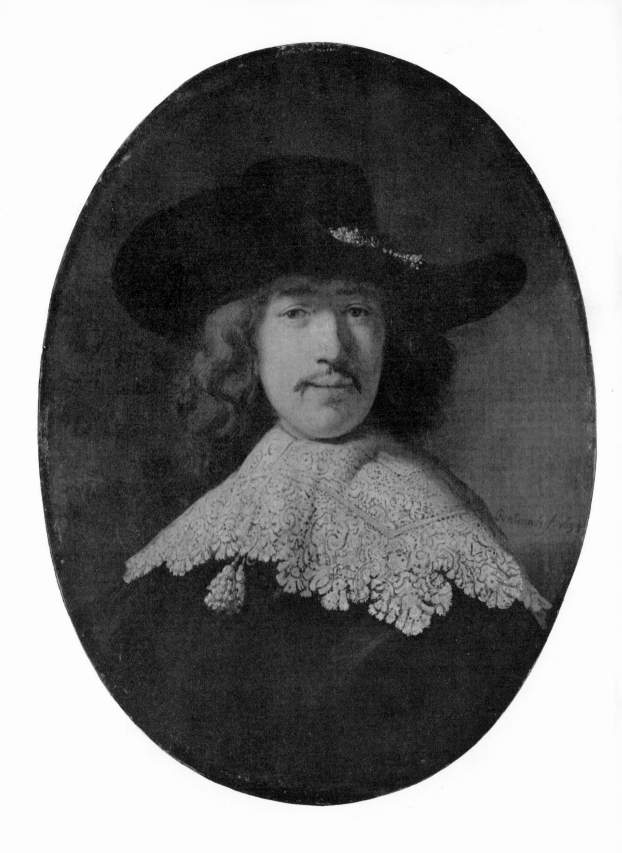

A YOUNG MAN WITH A MOUSTACHE. 1634. Panel, 70×52 cm. Leningrad, Hermitage. (Br. 196)
Companion to Br. 345 reproduced on page 271

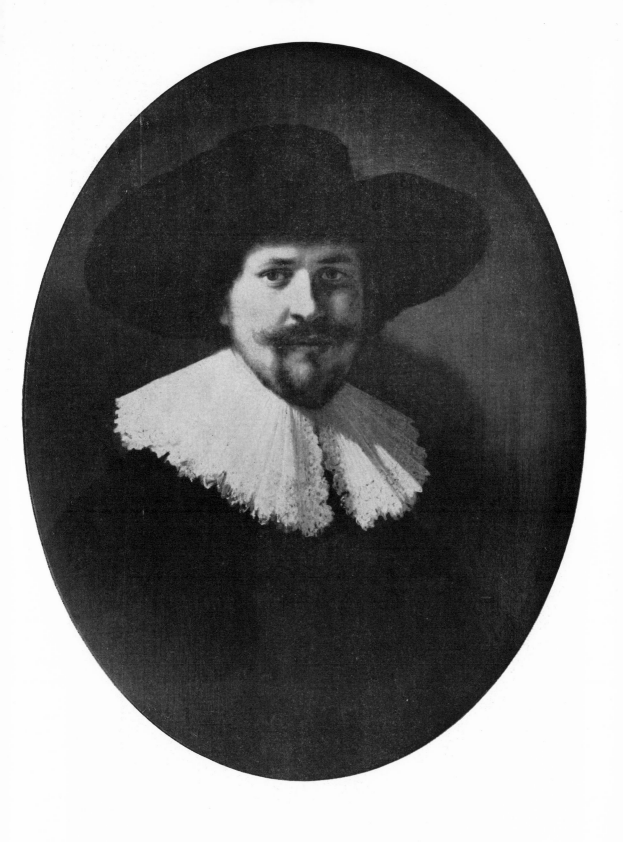

PORTRAIT OF A YOUNG MAN. 1634. Panel, 66.5×52 cm. Boston, Museum of Fine Arts. (Br. 197)
Companion to Br. 346 reproduced on page 271

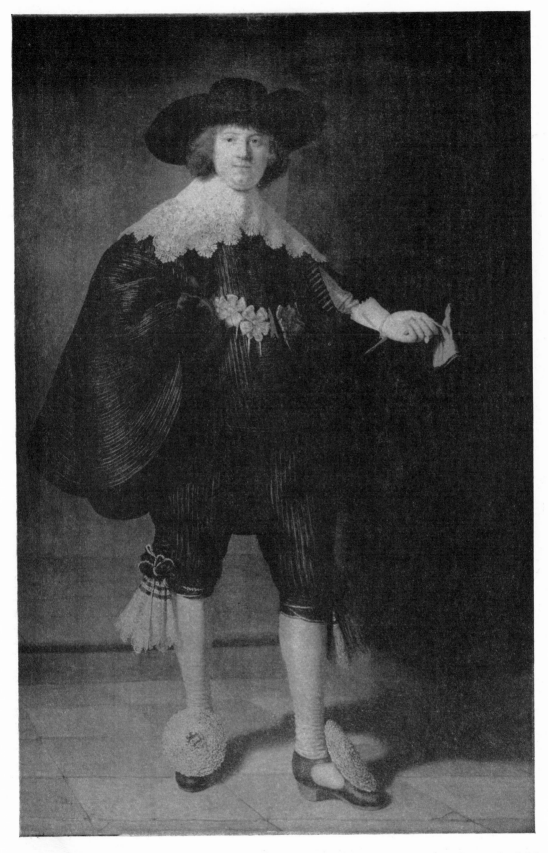

MAERTEN SOOLMANS. 1634. Canvas, 210×134.5 cm. Paris, Baron Robert de Rothschild.
(Br. 199) Companion to Br. 342 reproduced on page 269

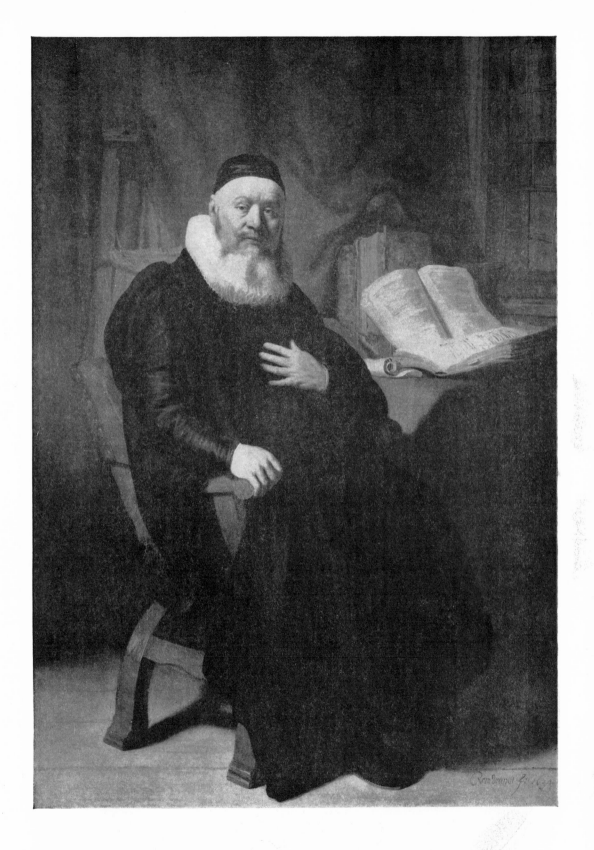

The Preacher Johannes Elison. 1634. Canvas, 171 × 122·5 cm. Boston, Museum of Fine Arts.
(Br. 200) Companion to Br. 347 reproduced on page 272

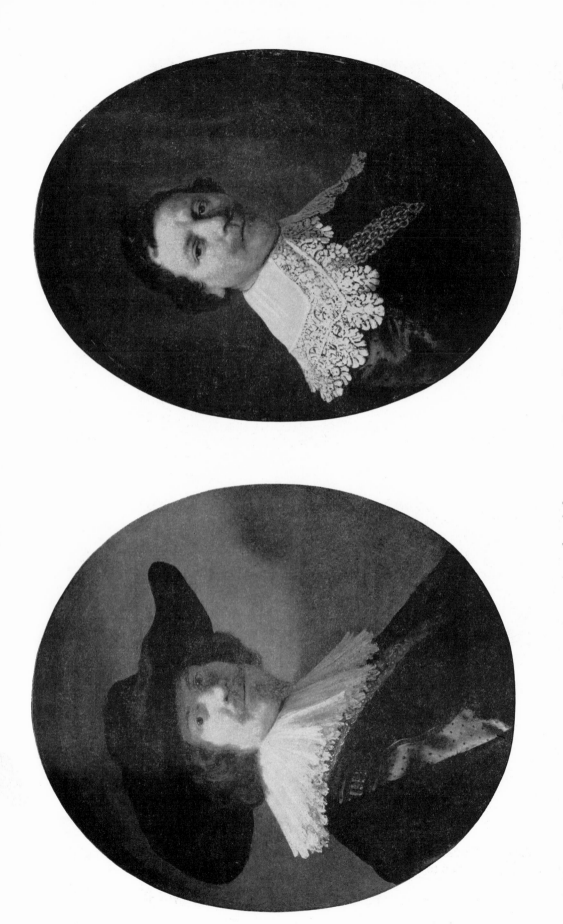

A Man in a Broad-Brimmed Hat. 1635. Canvas (transferred from panel), 76×63·5 cm. Indianapolis, Earl C. Townsend Jr. (Br. 201) Companion (?) to Br. 350 reproduced on page 274

Philips Lucasz., Councillor Extraordinary of the Dutch East Indies. 1635. Panel, 79·5×59 cm. London, National Gallery. (Br. 202) Companion to Br. 349 reproduced on page 274

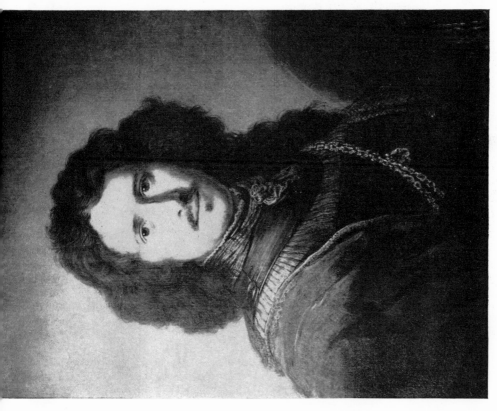

The Diplomat Anthonis Coopal. 1635. Panel, 83×67 cm. Green-
wich, Conn., Neuman de Vegvar Collection. (Br. 203)

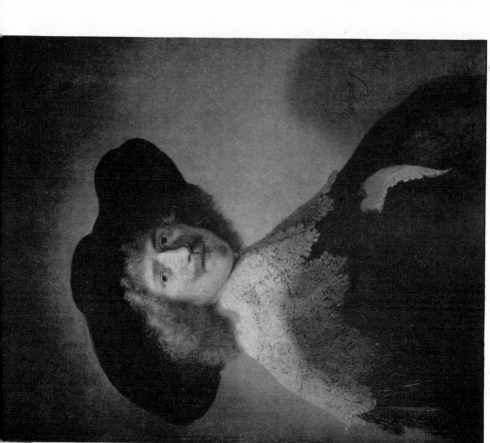

Portrait of an Officer. 1636. Panel, 66×52 cm. Zurich, Mrs.
H. Anda-Bührle. (Br. 204) Companion to Br. 352 reproduced on
page 275

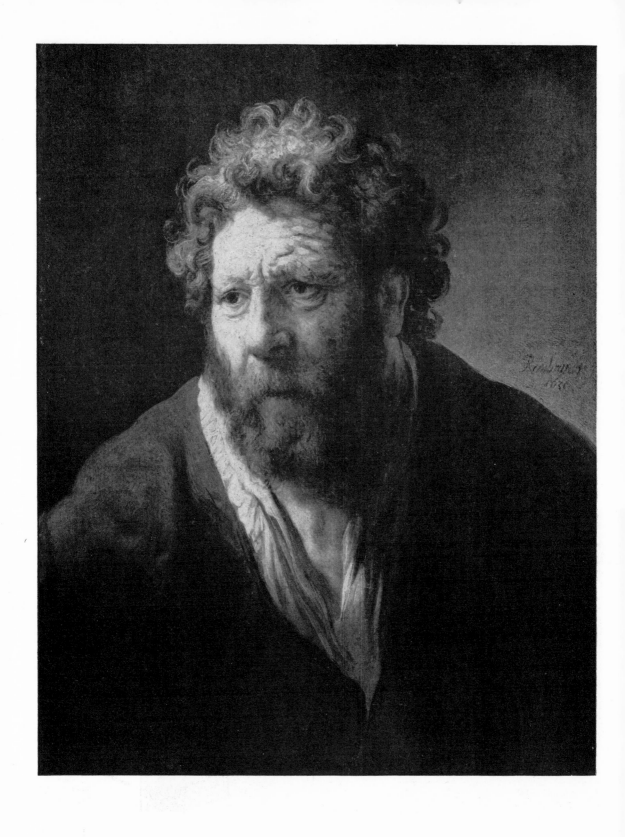

A MAN WITH DISHEVELLED HAIR. 1635. Panel, 66.5×53 cm. New York, Acquavella Galleries.
(Br. 205)

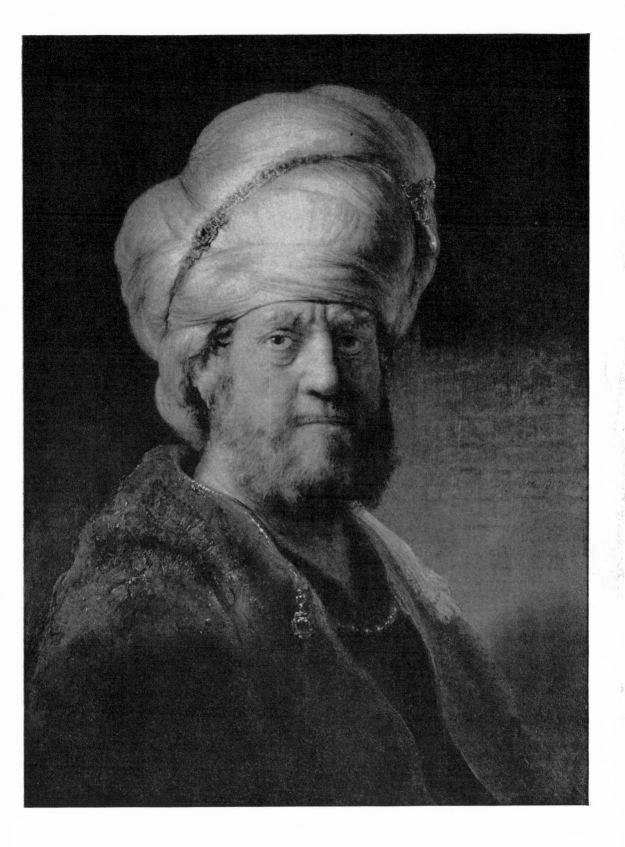

A Man in Oriental Costume. 1635. Panel, 72×54.5 cm. Amsterdam, Rijksmuseum. (Br. 206)

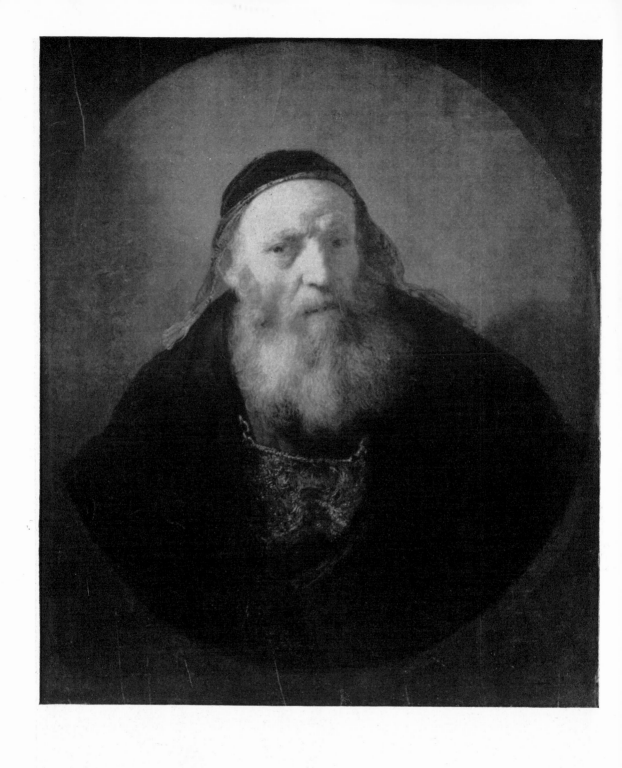

A Man in Fanciful Costume. 1635. Panel, 70×61 cm. Hampton Court Palace. (Br. 207)

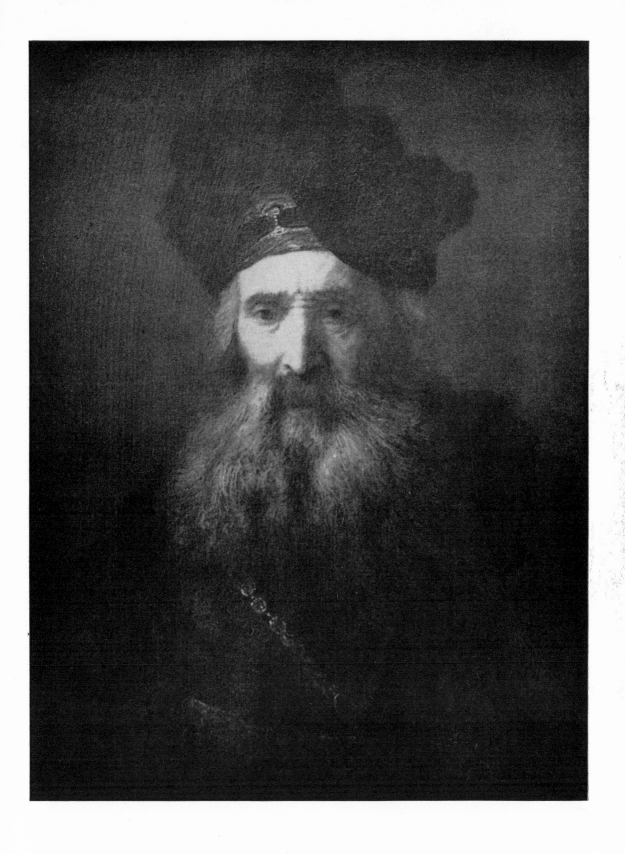

A Man in Fanciful Costume. Panel, 71·5×55 cm. Knowsley Hall (near Liverpool), Earl of Derby. (Br. 208)

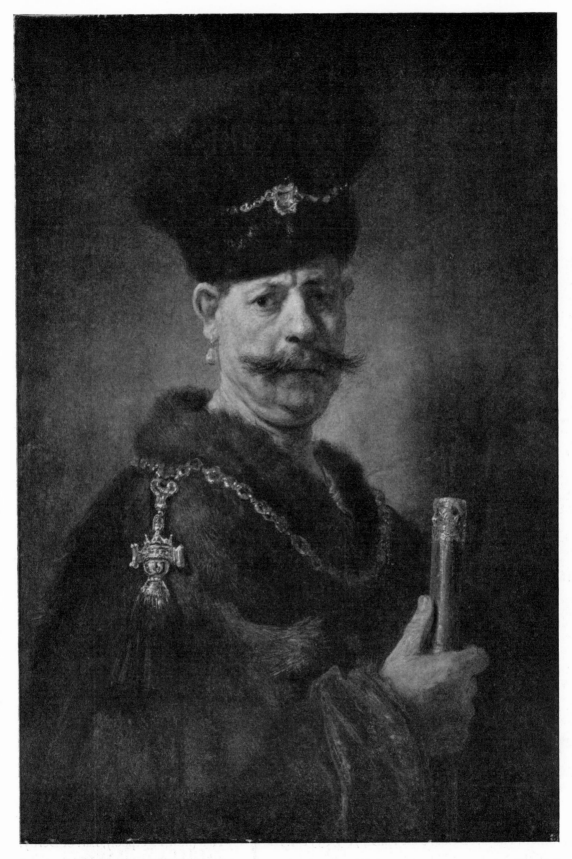

A MAN IN A POLISH COSTUME. 1637. Panel, 96×65 cm. Washington, D.C., National Gallery of Art (Mellon Collection). (Br. 211)

A MAN SEATED IN AN ARMCHAIR. Canvas, 124×95 cm. Washington, D.C., Corcoran Gallery of Art. (Br. 212)

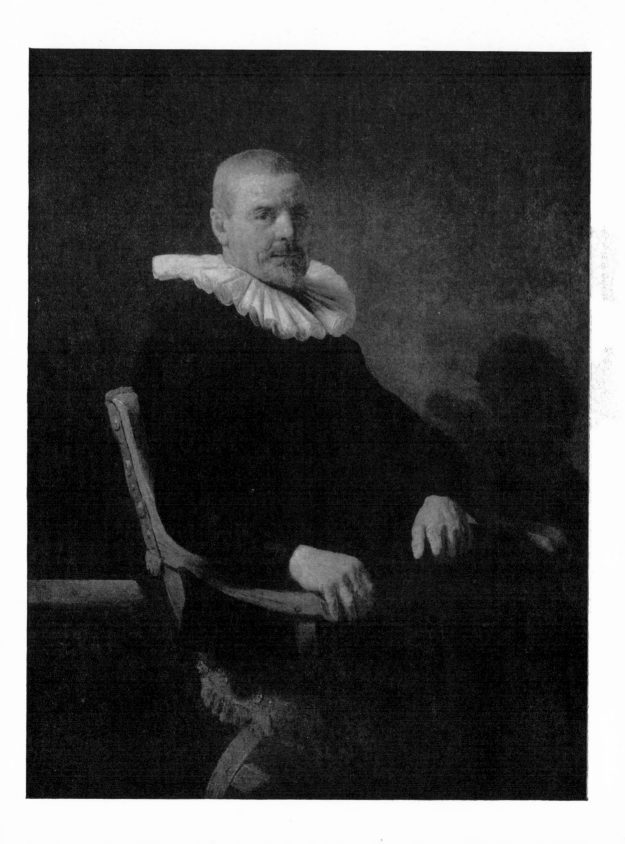

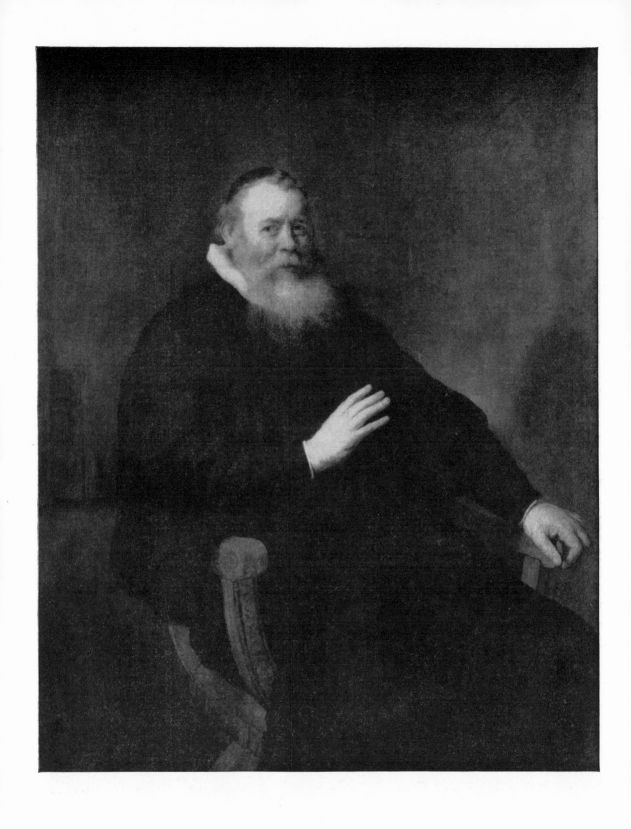

THE MINISTER ELEAZAR SWALMIUS. 1637. Canvas, 139 × 103 cm. Antwerp, Museum. (Br. 213)

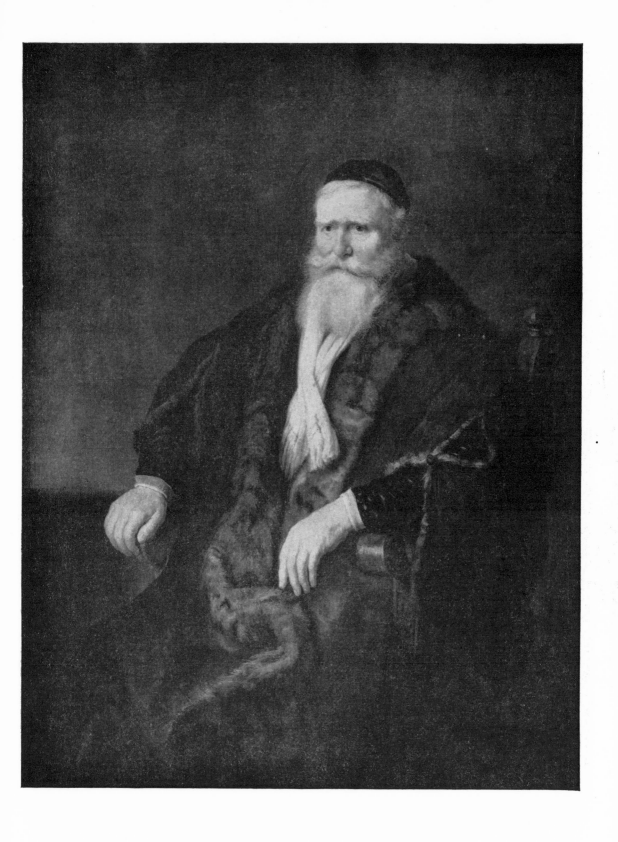

A Man Seated in an Armchair. 1637. Canvas, 133×104 cm. Mertoun, Berwickshire, Duke of Sutherland. (Br. 214)

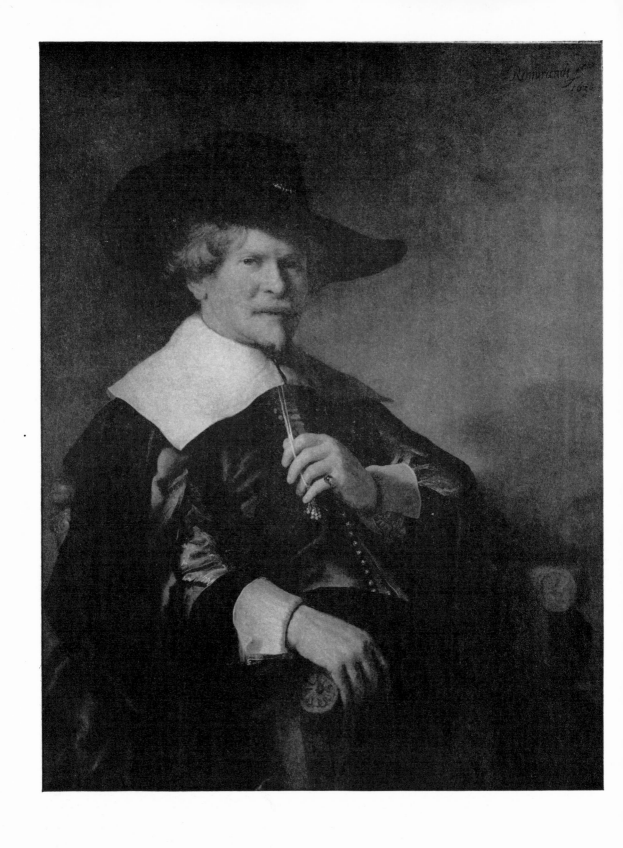

A Man Seated in an Armchair. 1638. Canvas, 105×81.5 cm. New York, Robert Lehman. (Br. 215)

A Man Standing in Front of a Doorway. 1639. Canvas, 200×125 cm. Cassel, Gemäldegalerie. (Br. 216)

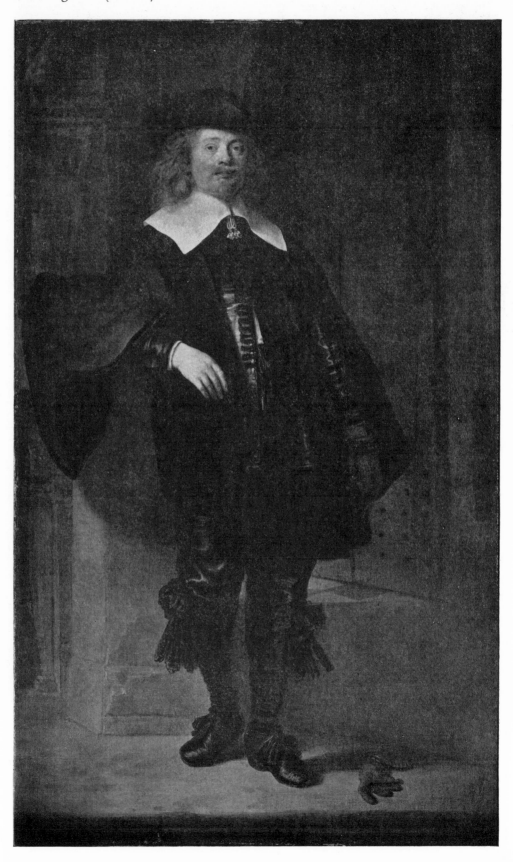

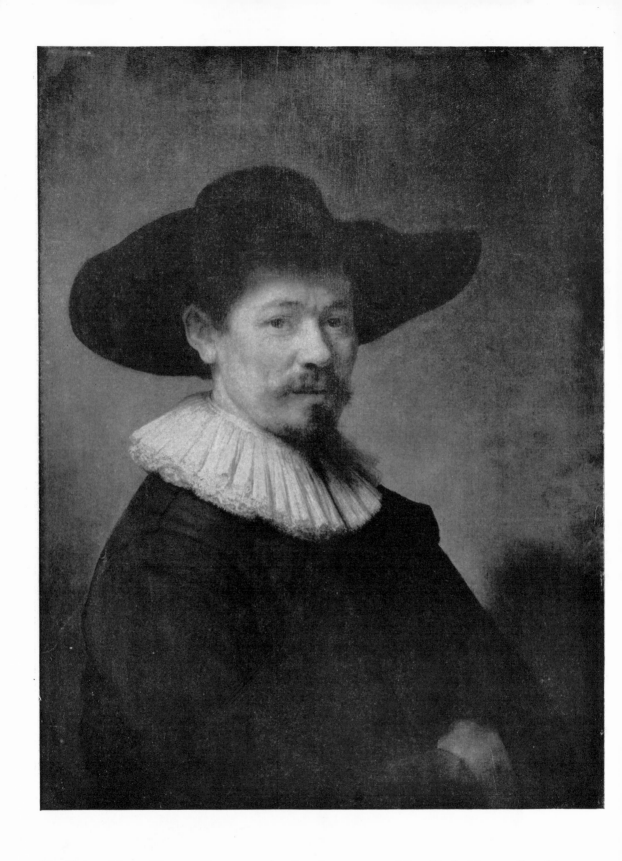

THE FRAME-MAKER HERMAN DOOMER. 1640. Panel, 74×53 cm. New York, Metropolitan Museum of Art. (Br. 217) Companion to Br. 357 reproduced on page 279

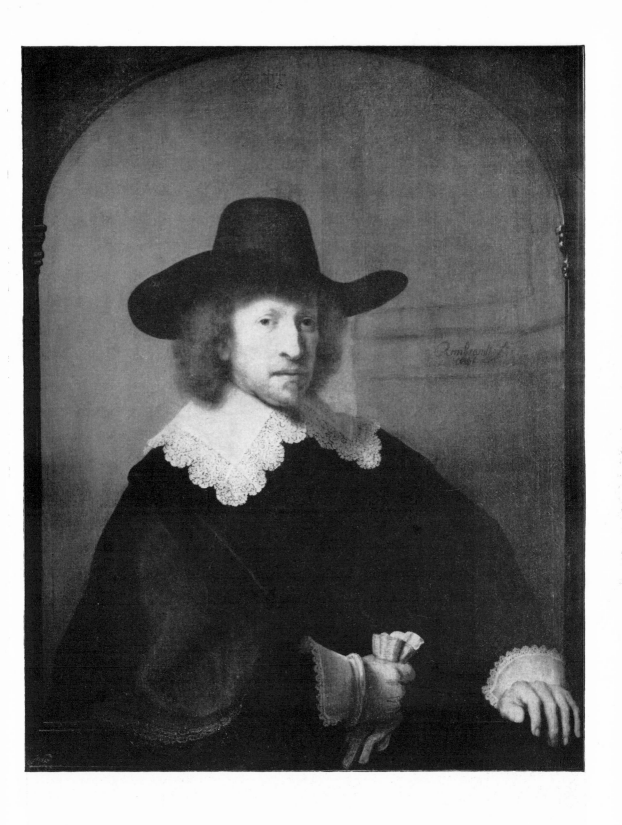

NICOLAAS VAN BAMBEECK. 1641. Canvas, 105.5×84 cm. Brussels, Musée Royal des Beaux-Arts.
(Br. 218) Companion to Br. 360 reproduced on page 281

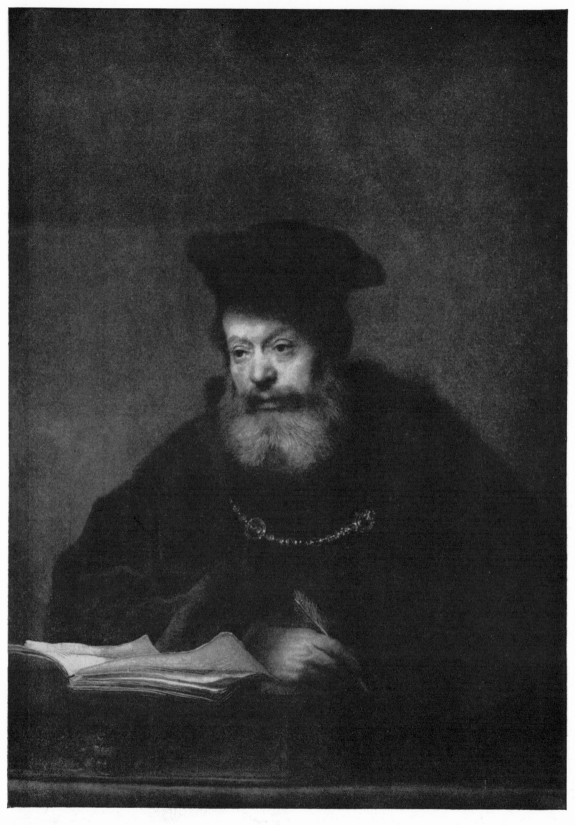

A Scholar at His Desk. 1641. Panel, 104×76 cm. Formerly Vienna, Lanckoronski Collection. (Br. 219) Companion to Br. 359 reproduced on page 280

A Man Holding a Glove. Panel, 81×67 cm. New York, Metropolitan Museum of Art. (Br. 221)

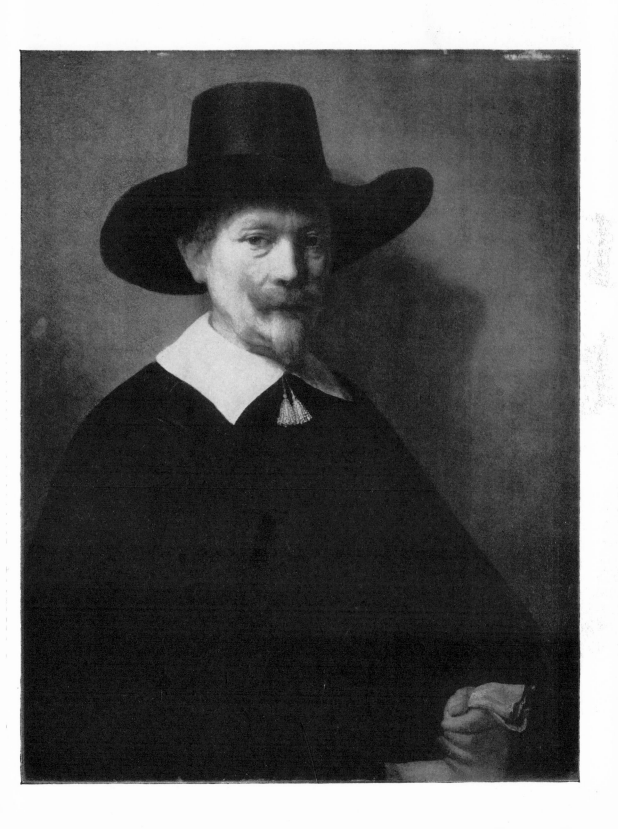

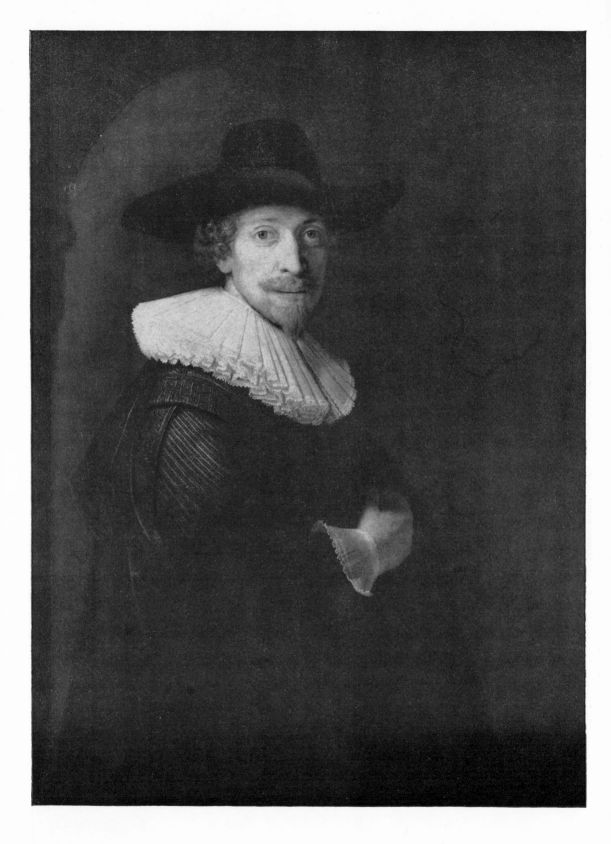

PORTRAIT OF A MAN. Canvas, 104×76 cm. Tisbury, Wiltshire, Lord Margadale. (Br. 222)

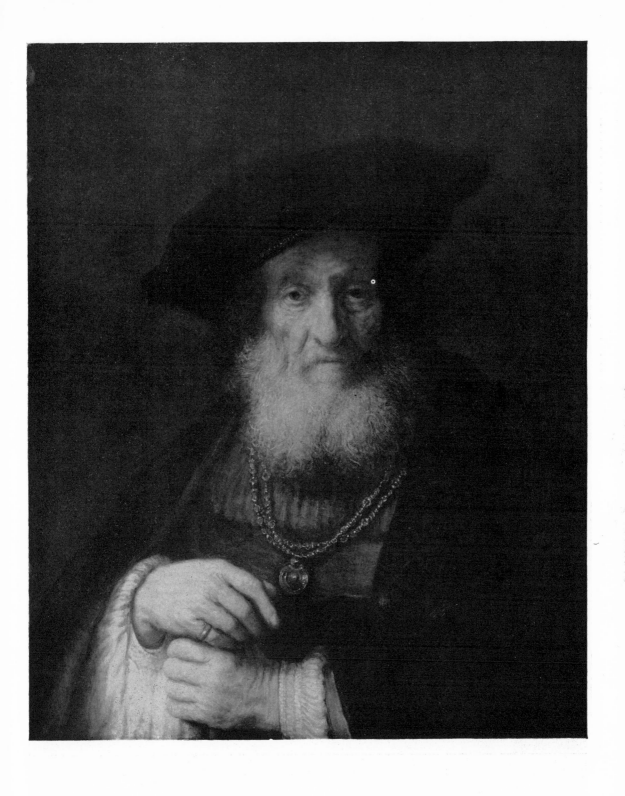

AN OLD MAN IN RICH COSTUME. 1643. Panel, 72·5 × 58·5 cm. Woburn Abbey, Duke of Bedford. (Br. 185)

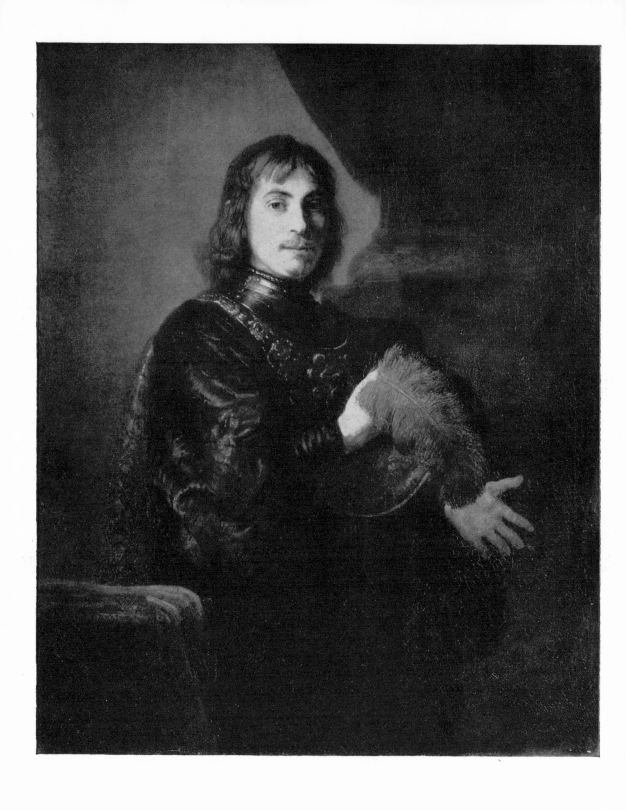

PORTRAIT OF A MAN. Canvas, 121.5×98.5 cm. New York, Metropolitan Museum of Art. (Br. 223)
Companion to Br. 364 reproduced on page 285

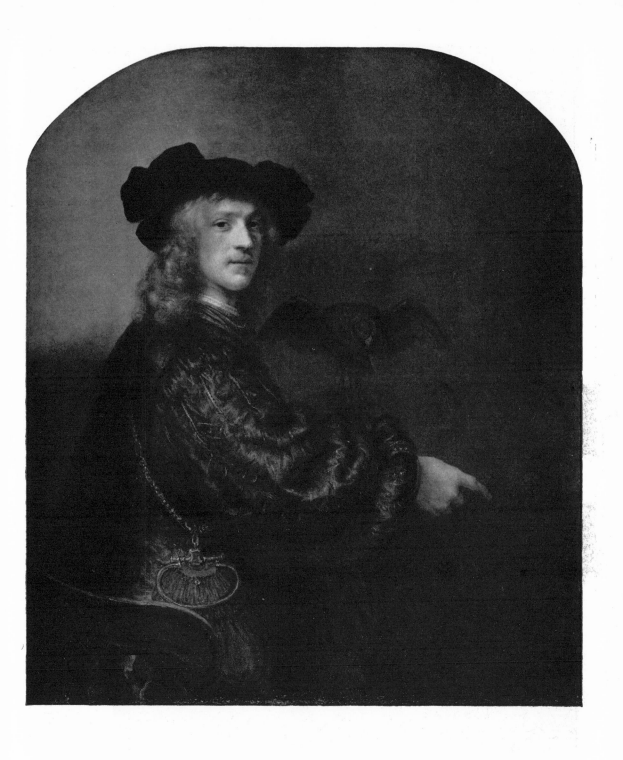

PORTRAIT OF A MAN WITH A FALCON. 1643. Canvas, 114·5×98 cm. London, The Trustees of the 2nd Duke of Westminster and Anne, Duchess of Westminster. (Br. 224) Companion to Br. 363 reproduced on page 284

A BEARDED MAN. Panel, 20×16 cm. Cassel, Gemäldegalerie. (Br. 230)

AN OLD MAN WEARING A BERET. 1643. Panel, 20×15.5 cm. Richmond, Va., Virginia Museum of Fine Arts. (Br. 232)

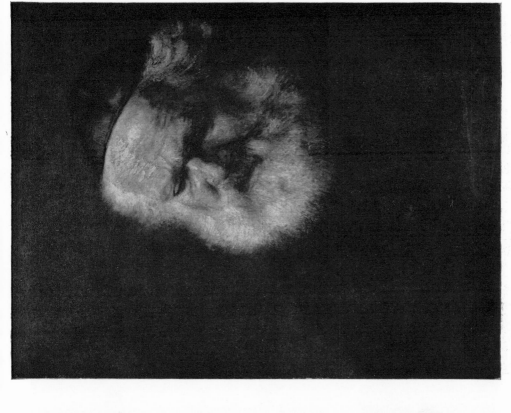

An Old Man Wearing a Beret. Panel, 51×42 cm. (originally 47×37 cm.). Leningrad. Hermitage. (Br. 229)

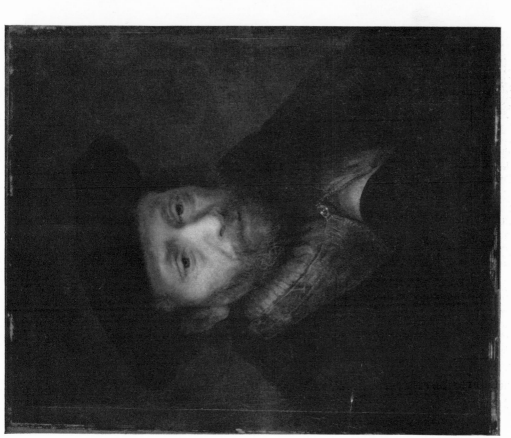

Portrait of an Old Jew. Panel, 62×45·5 cm. Dublin, National Gallery of Ireland. (Br. 231)

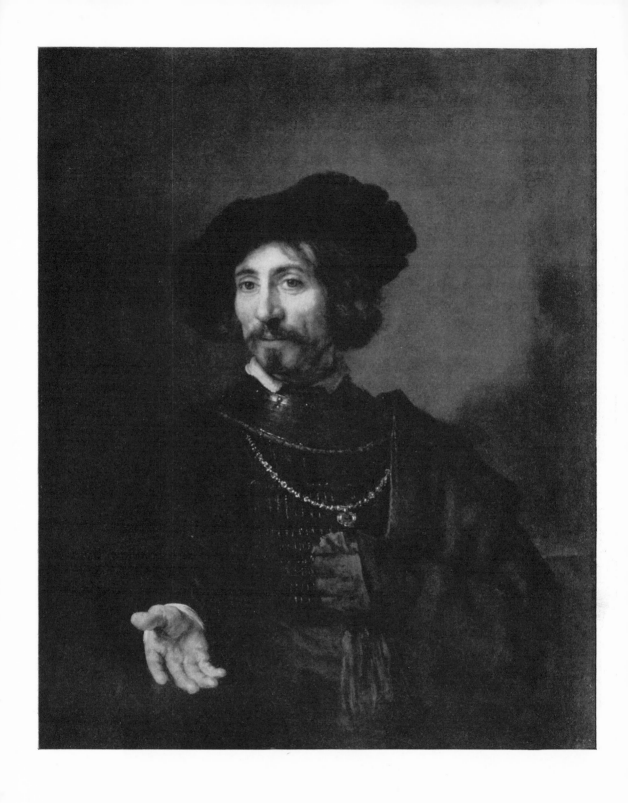

A Man Wearing a Gorget-Plate. 1644. Canvas, 94.5×78 cm. New York, Metropolitan Museum of Art. (Br. 234)

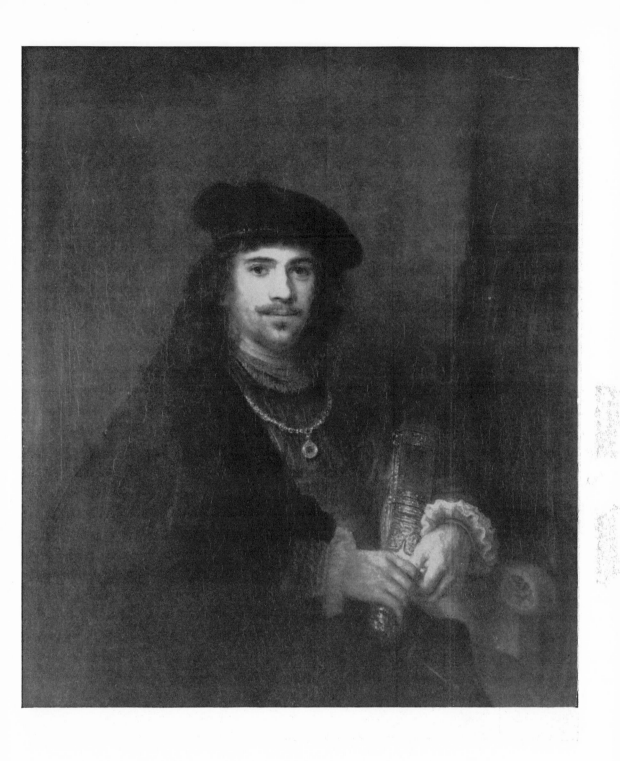

A Young Man Holding a Sword. 1644. Canvas, 102×85.5 cm. Brunswick, Maine, Bowdoin College Museum of Art (on loan from Eunice, Lady Oakes). (Br. 235)

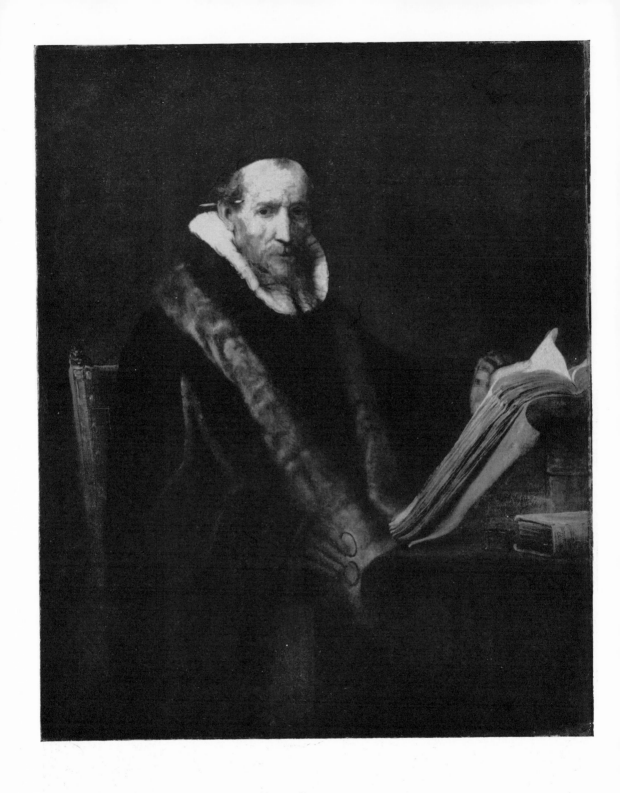

A Scholar at His Desk. 1645. Canvas, 129.5×100.5 cm. Cologne, Wallraf-Richartz Museum (von Carstanjen Bequest). (Br. 237)

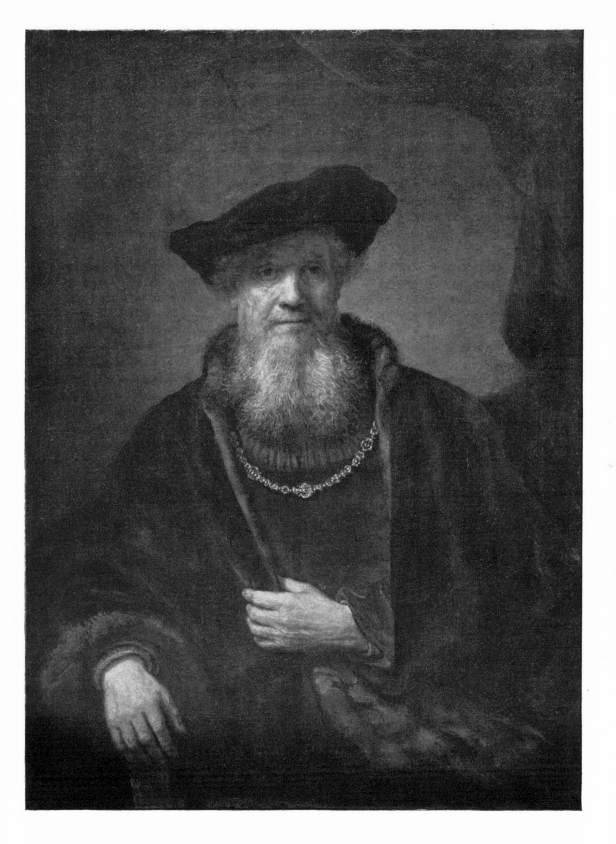

AN OLD MAN IN A FUR-LINED COAT. 1645. Canvas, 110×82 cm. Berlin-Dahlem, Gemäldegalerie. (Br. 236)

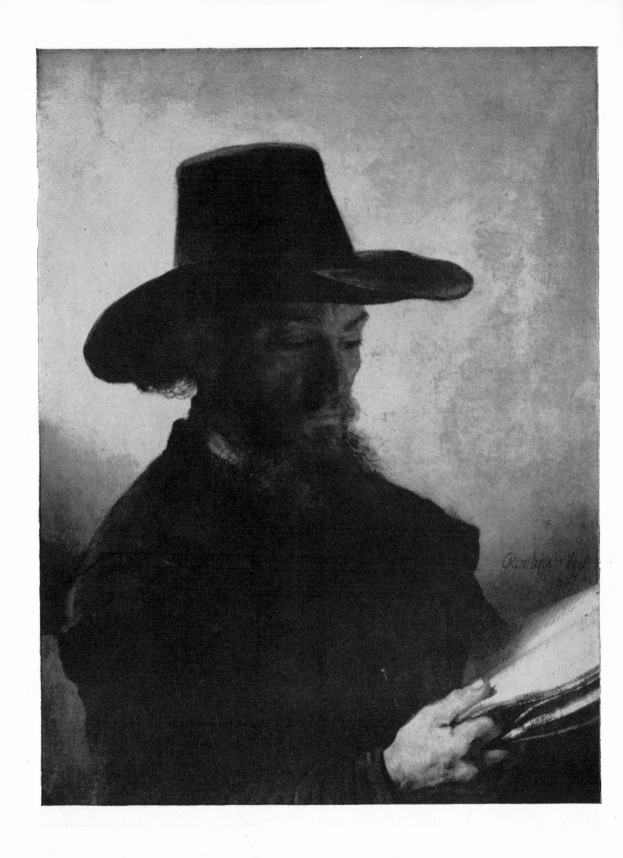

PORTRAIT OF A MAN READING. 1645. Canvas, 66.5 × 58 cm. Williamstown, Mass., The Sterling and Francine Clark Art Institute. (Br. 238)

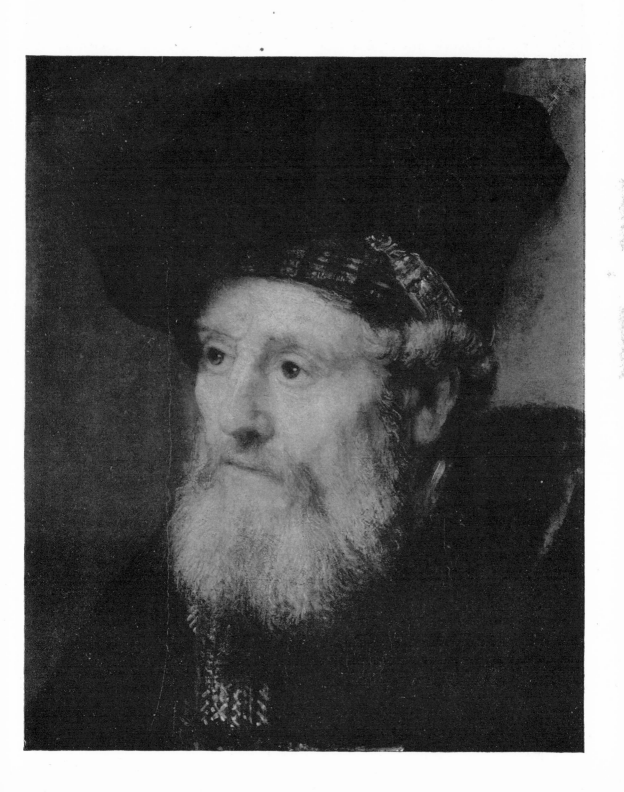

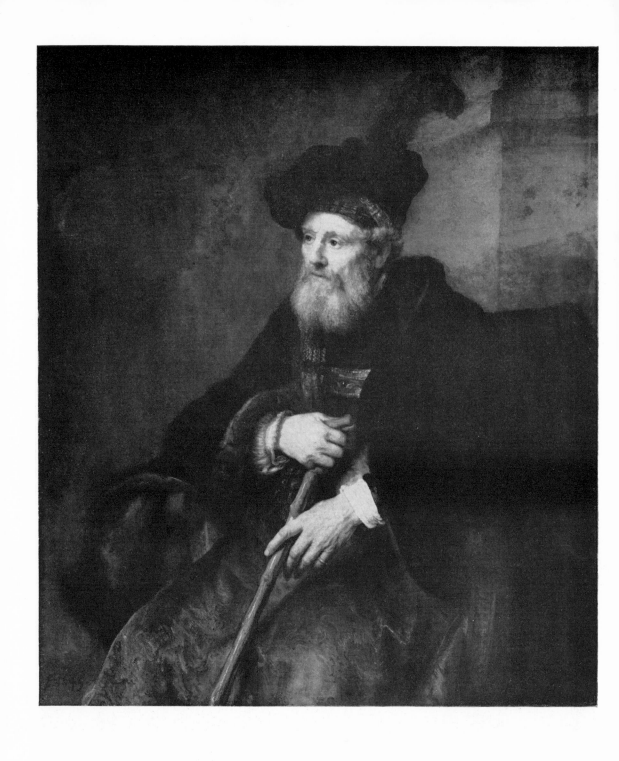

AN OLD MAN IN FANCIFUL COSTUME HOLDING A STICK. 1645. Canvas, 128×112 cm. Oeiras, Portugal, Calouste Gulbenkian Foundation. (Br. 239)

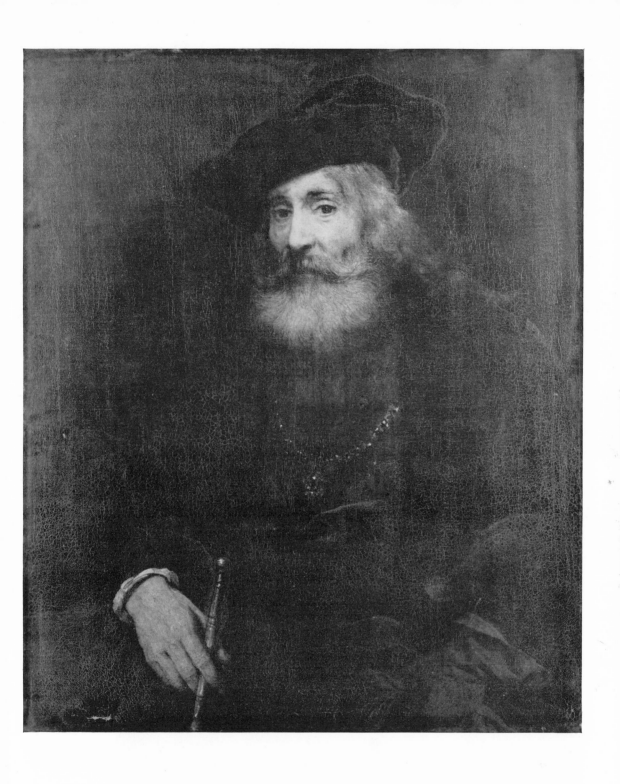

AN OLD MAN WITH A BEARD. Canvas, 95·5 × 80·5 cm. Dresden, Gemäldegalerie. (Br. 240)

Study of an Old Man. Panel, 20·5 × 17 cm. Detroit, Mrs. Standish Backus. (Br. 244)

An Old Man Wearing a Beret. Panel, 23·5 × 18·5 cm. New York, Valdemar Zedwitz. (Br. 242)

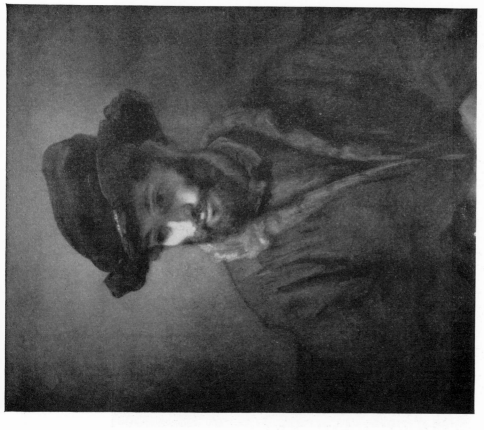

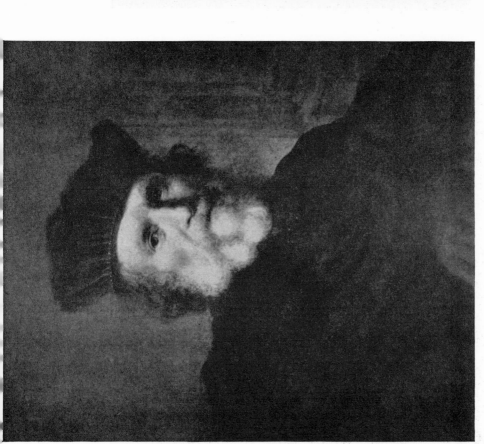

An Old Man with a Beard. Panel, 75×61 cm. San Antonio, Texas, Charles F. Urschel. (Br. 245)

A Young Man with a Beard. Canvas, 83×68 cm. Cleveland, Museum of Art. (Br. 246)

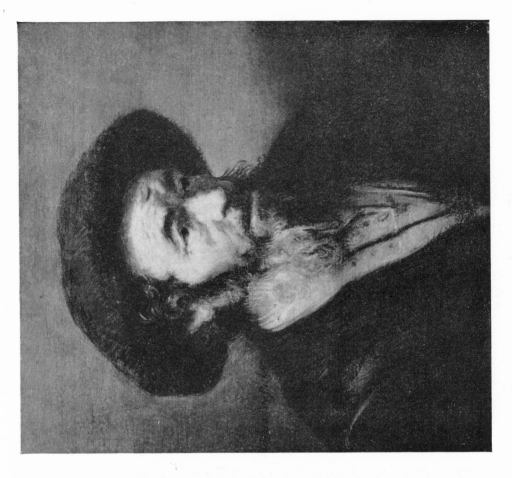

An Old Man Wearing a Fur Cap. 1647. Panel, 25×22.5 cm. Rotterdam, Boymans–van Beuningen Museum. (Br. 249)

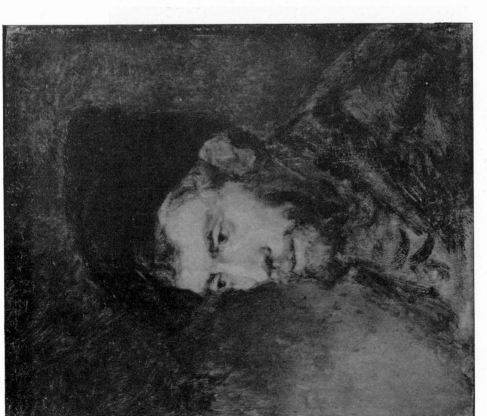

Head of a Bearded Man. Panel, 20×15 cm. Edinburgh, National Gallery of Scotland (on loan from the Duke of Sutherland). (Br. 247)

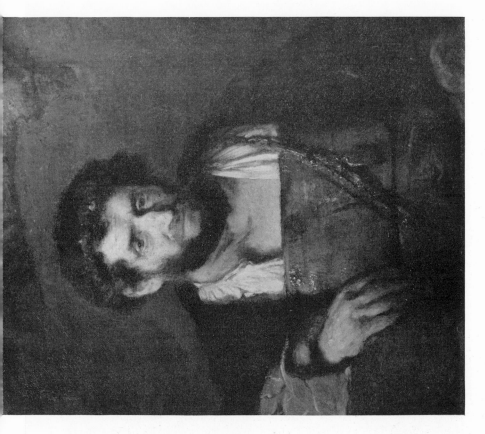

A Man with a Gold Chain. 1648. Canvas, 89×66 cm. London, Julius Weitzner. (Br. 253)

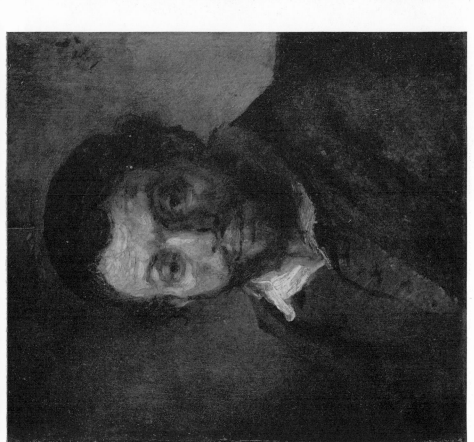

Portrait of a Young Jew. Panel, 24·5×20·5 cm. Berlin-Dahlem, Gemäldegalerie. (Br. 250)

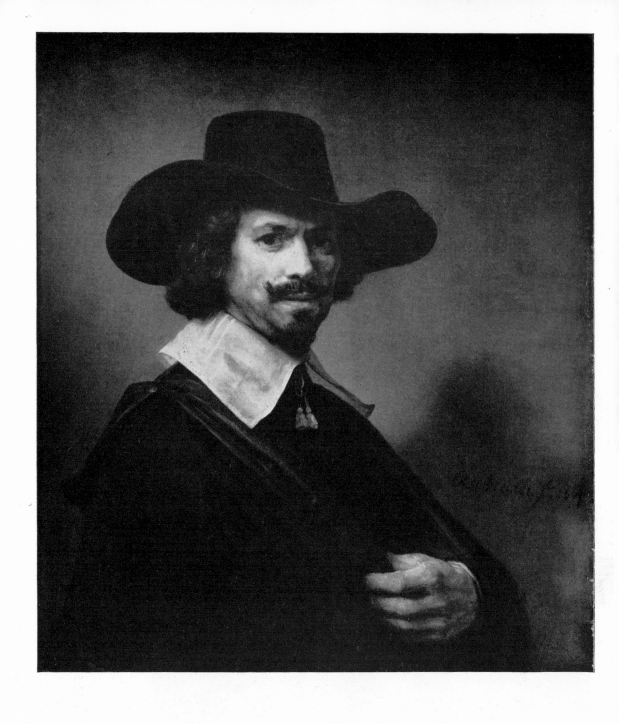

THE PAINTER HENDRICK MARTENSZ. SORGH. 164(7?). Panel, 74×67 cm. London, The Trustees of the 2nd Duke of Westminster and Anne, Duchess of Westminster. (Br. 251) Companion to Br. 370 reproduced on page 291

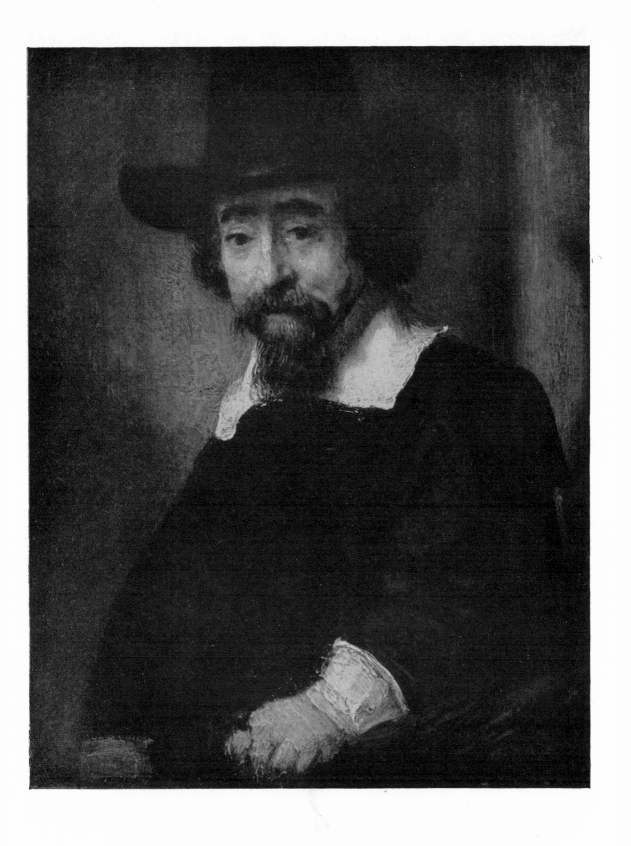

The Jewish Physician Ephraim Buëno. Panel, 19×15 cm. Amsterdam, Rijksmuseum. (Br. 252)

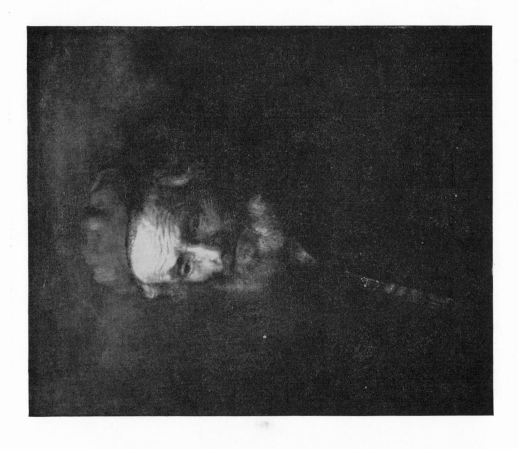

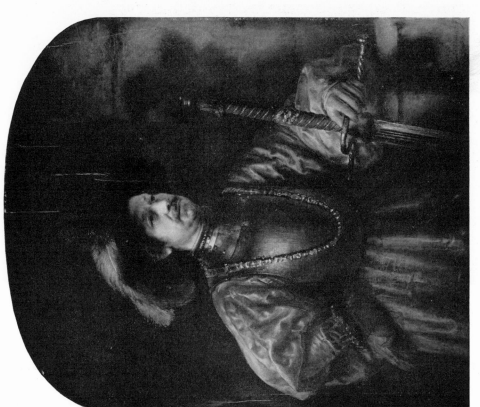

A MAN IN FANCIFUL COSTUME HOLDING A LARGE SWORD. 1650.
Panel, 126×103 cm. Cambridge, Fitzwilliam Museum. (Br. 256)
Companion to Br. 380 reproduced on page 296

A MAN WEARING A BERET. 1650. Canvas, 68×56 cm. Baltimore,
Museum of Fine Arts. (Br. 258)

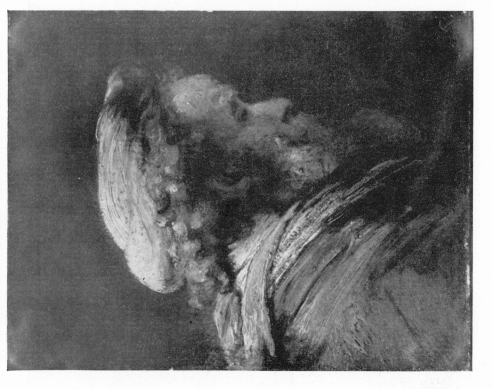

STUDY OF THE HEAD OF AN OLD MAN. Panel, 24×19 cm. New York, John Hay Whitney. (Br. 261)

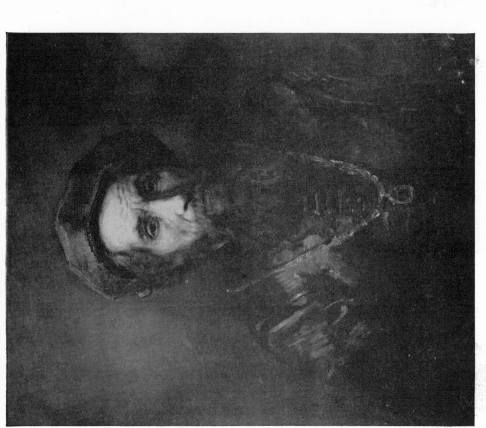

AN OLD MAN WITH A GOLD CHAIN. 1657. Canvas, 78.5×65.5 cm. San Francisco, California Palace of the Legion of Honor. (Br. 259A)

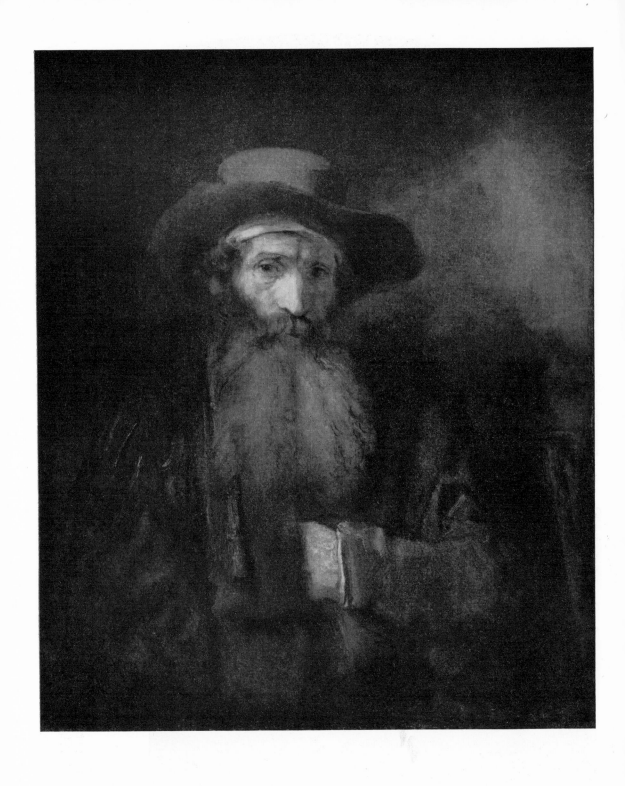

AN OLD MAN WEARING A LINEN HEAD-BAND. 1651. Canvas, 77×66 cm. Wanås (Sweden), Count Wachtmeister. (Br. 263)

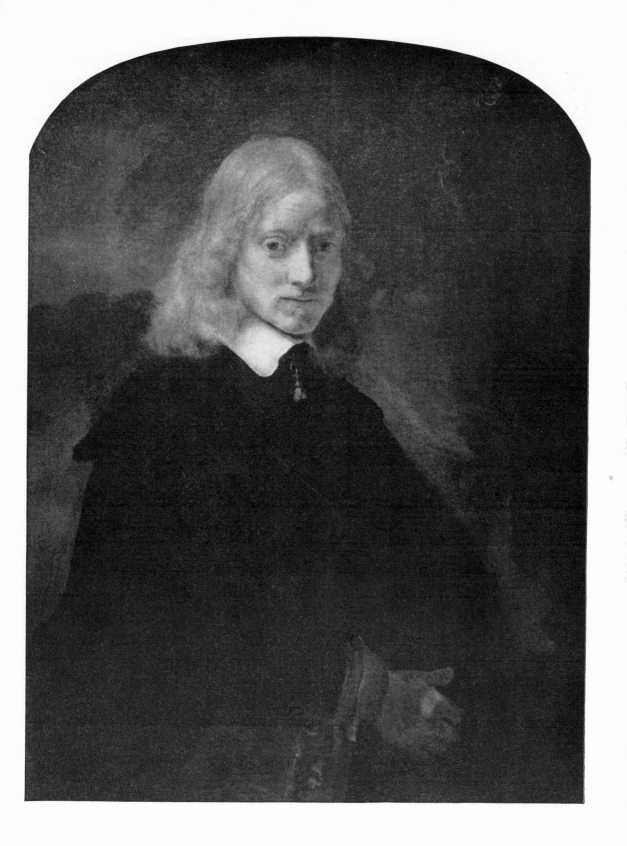

THE ART-DEALER CLEMENT DE JONGHE (?). Canvas, 92·5×73·5 cm. Buscot Park, Berks., The Trustees of the Faringdon Collection. (Br. 265)

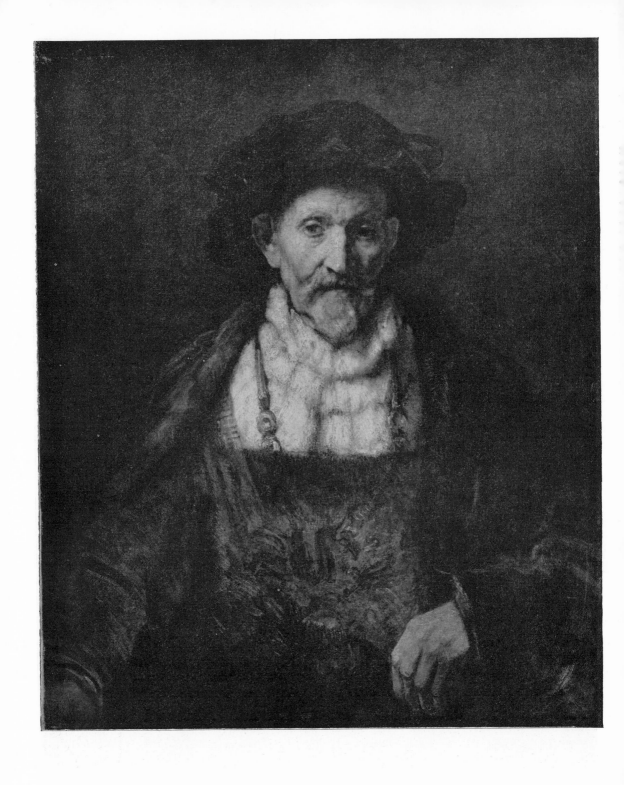

AN OLD MAN IN FANCIFUL COSTUME. 1651. Canvas, 78.5×67.5 cm. Chatsworth, Derbyshire, The Trustees of the Chatsworth Settlement (Devonshire Collection). (Br. 266)

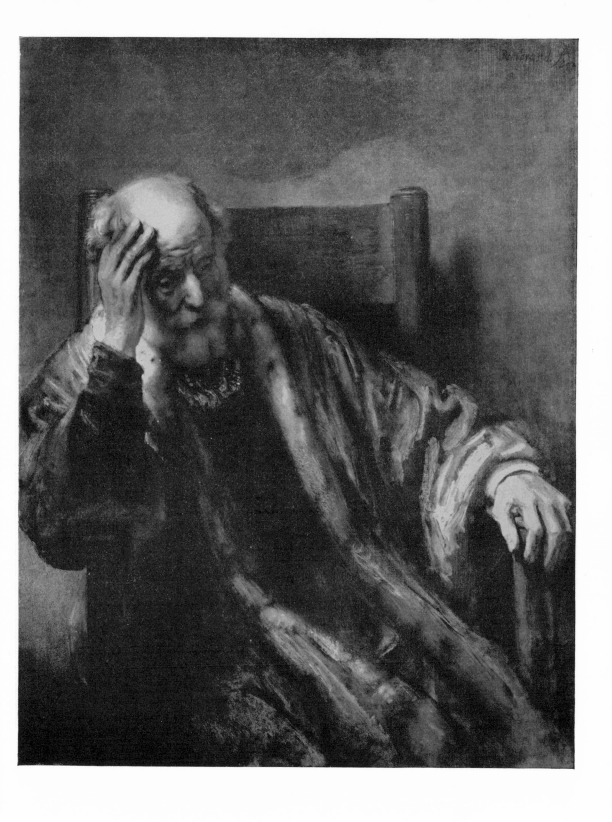

An Old Man in an Armchair. 1652. Canvas, 111×88 cm. London, National Gallery. (Br. 267)

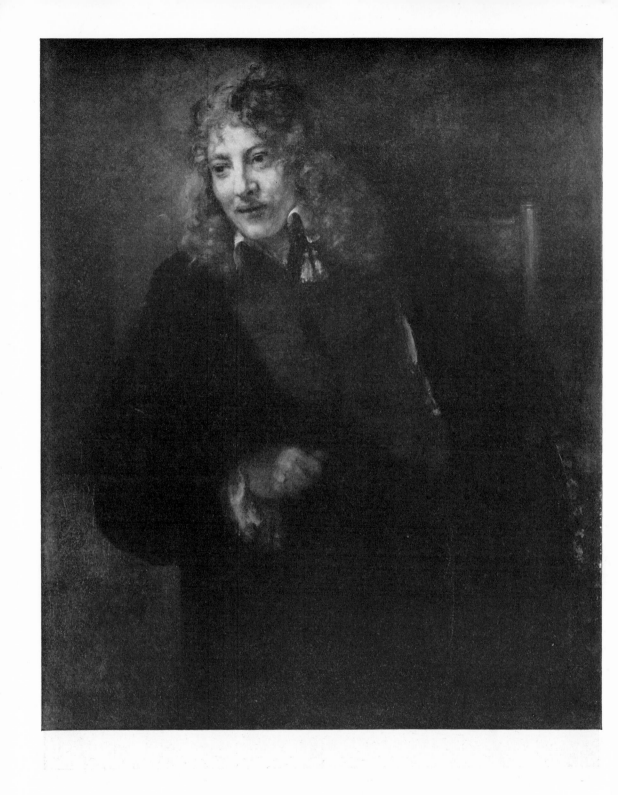

Nicolaes Bruyningh. 1652. Canvas, 107·5×91·5 cm. Cassel, Gemäldegalerie. (Br. 268)

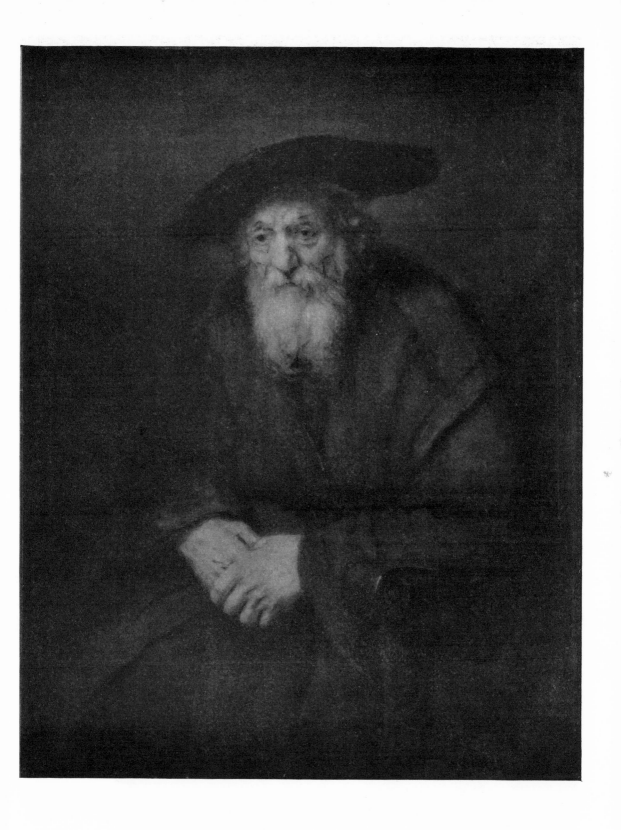

An Old Man in an Armchair. 1654. Canvas, 109×84 cm. Leningrad, Hermitage. (Br. 270) Companion to Br. 381 reproduced on page 297

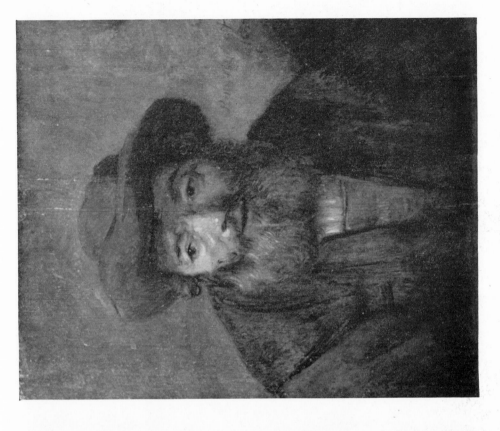

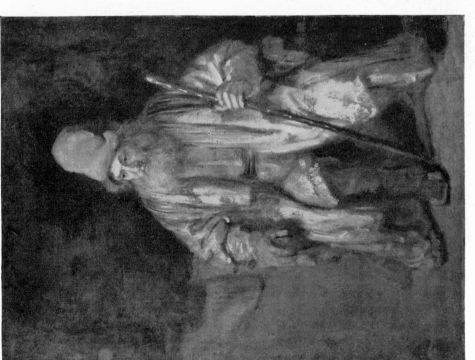

A Bearded Man. 1654. Panel, 25·5 × 21 cm. Groningen, Museum. (Br. 271)

An Old Man in an Armchair (a Biblical character?). Canvas, 51 × 37 cm. Berlin-Dahlem, Gemäldegalerie. (Br. 269)

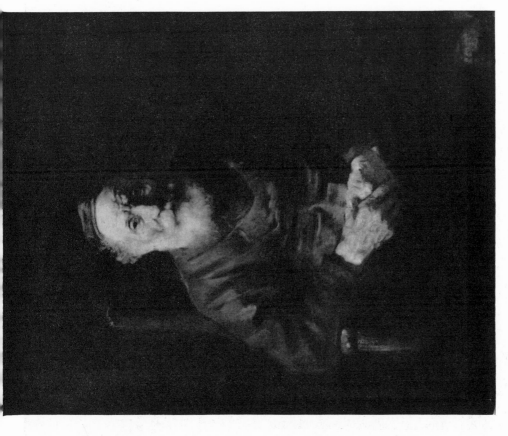

An Old Man in an Armchair. Canvas, 108×86 cm. Leningrad, Hermitage. (Br. 274)

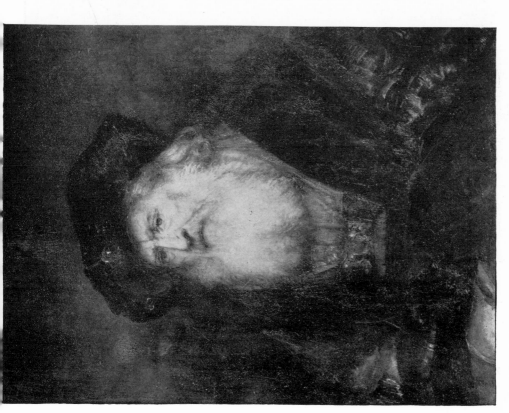

An Old Man in Fanciful Costume. 1654. Panel, 102×78 cm. Dresden, Gemäldegalerie. (Br. 272)

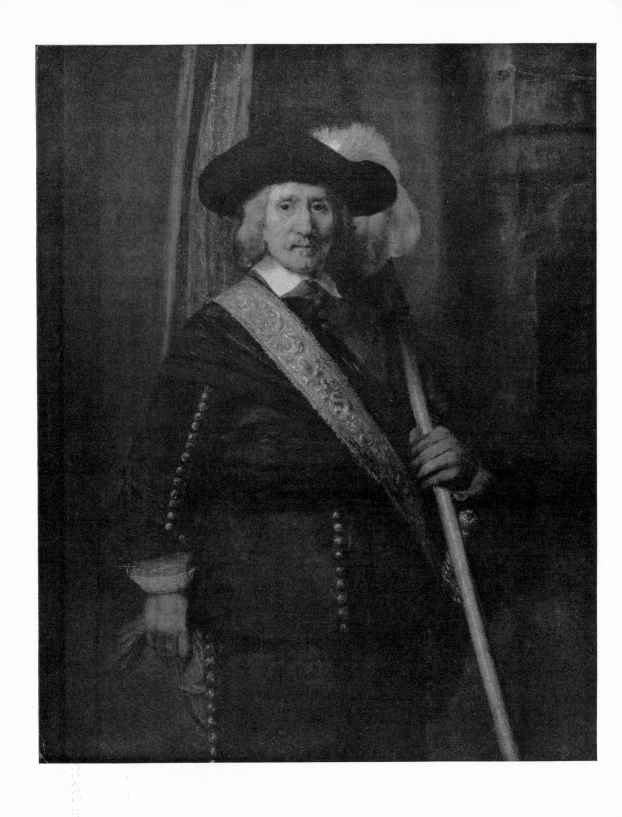

THE STANDARD-BEARER. 1654. Canvas, 138×113 cm. New York, Metropolitan Museum of Art. (Br. 275)

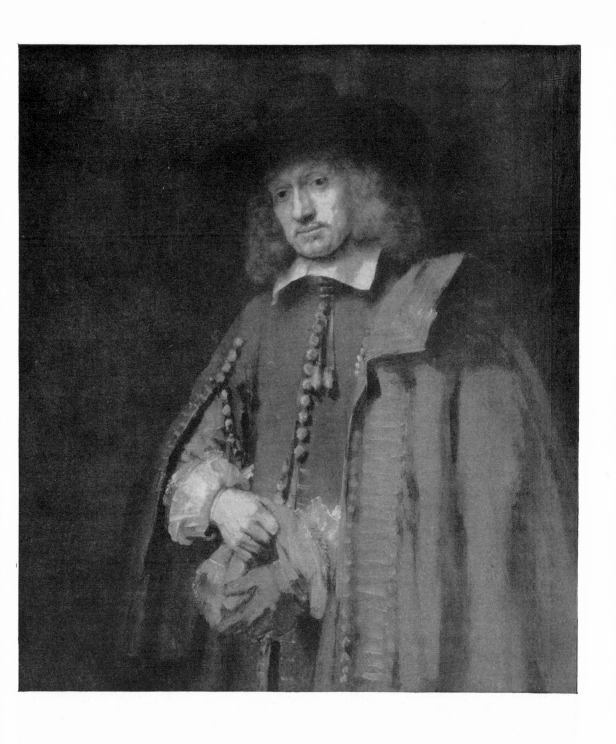

JAN SIX. 1654. Canvas, 112×102 cm. Amsterdam, The Six Foundation. (Br. 276)

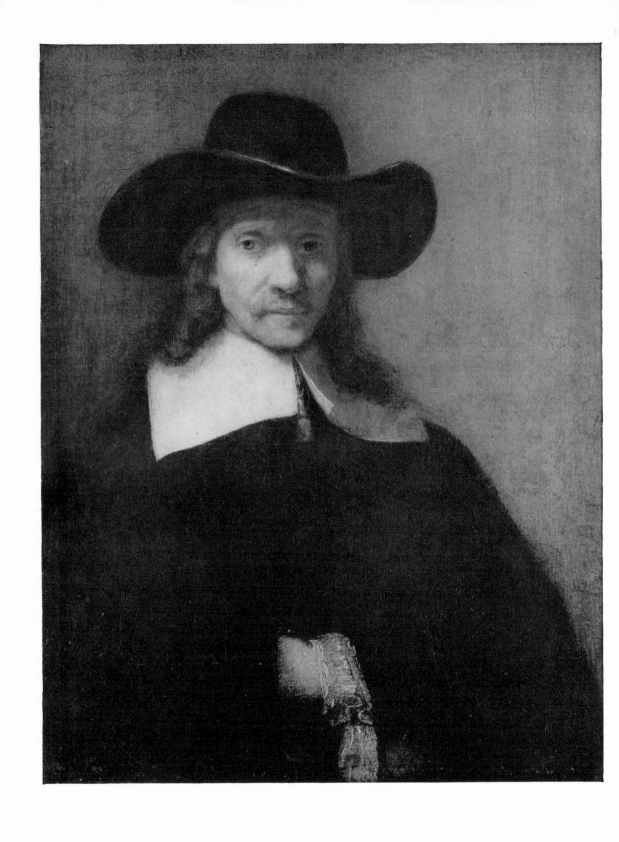

PORTRAIT OF A MAN. Canvas, 83·5×64·5 cm. New York, Metropolitan Museum of Art. (Br. 277)

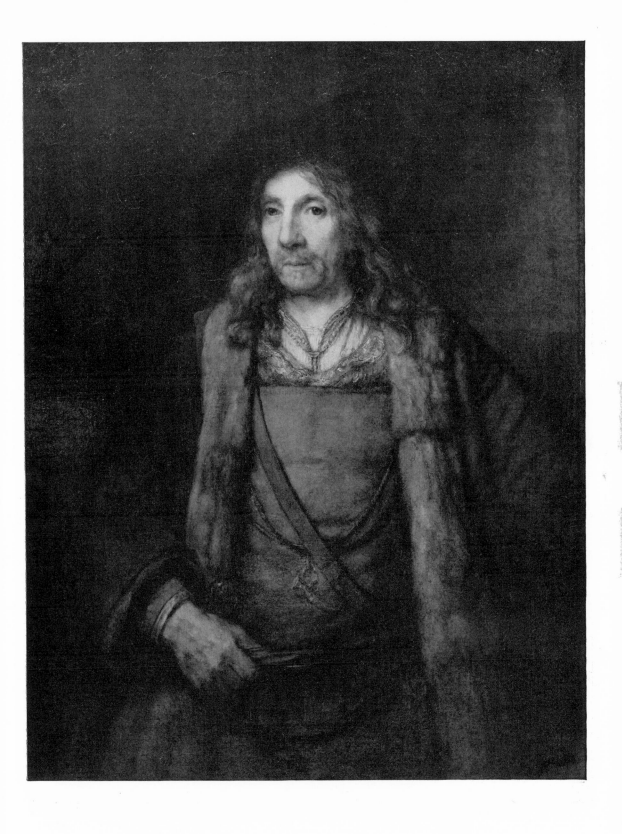

A MAN IN A FUR-LINED COAT. Canvas, 114×87 cm. Boston, Museum of Fine Arts (on loan from The Fuller Foundation). (Br. 278)

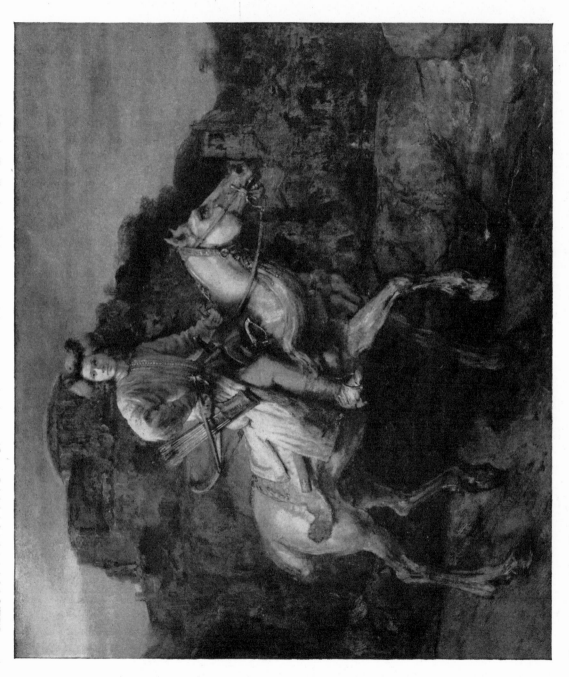

"THE POLISH RIDER". Canvas, 117×135 cm. New York, The Frick Collection. (Br. 279)

THE AMSTERDAM PHYSICIAN ARNOUT THOLINX. 1656(?). Canvas, 76×63 cm. Paris, Musée Jacquemart-André. (Br. 281)

AN OLD MAN WITH A STICK. 1655. Canvas, 89×73 cm. Stockholm, Nationalmuseum. (Br. 280) Companion to Br. 388 reproduced on page 300

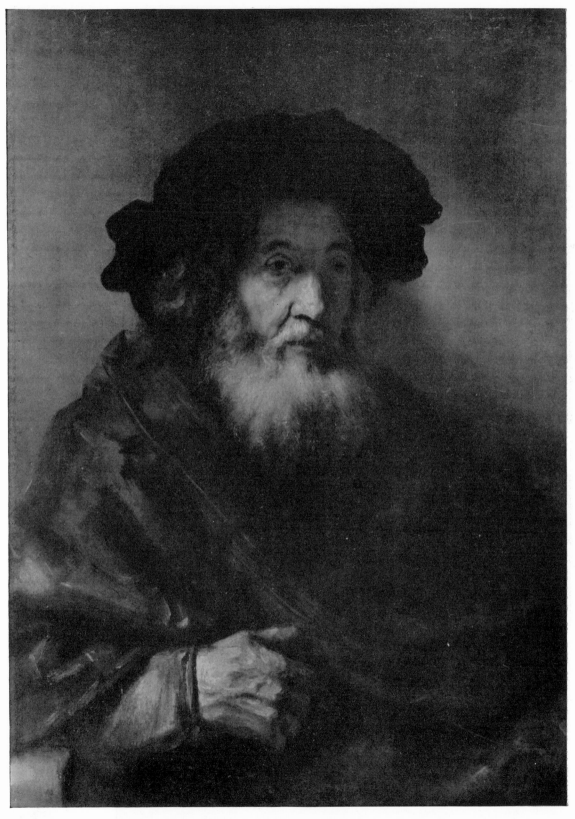

An Old Man in a Cape. Canvas, 82×65 cm. Kenosha, Wisconsin, R. Whitacker. (Br. 282)

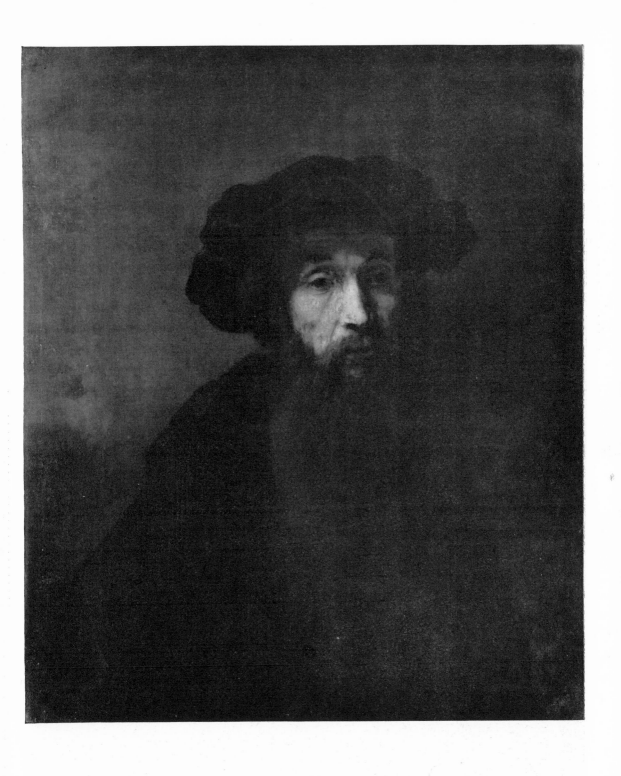

A Bearded Man in a Cap. Canvas, 78×66.5 cm. London, National Gallery. (Br. 283)

A Bearded Man. Canvas, 70·5 × 58·5 cm. Berlin-Dahlem, Gemäldegalerie. (Br. 284)

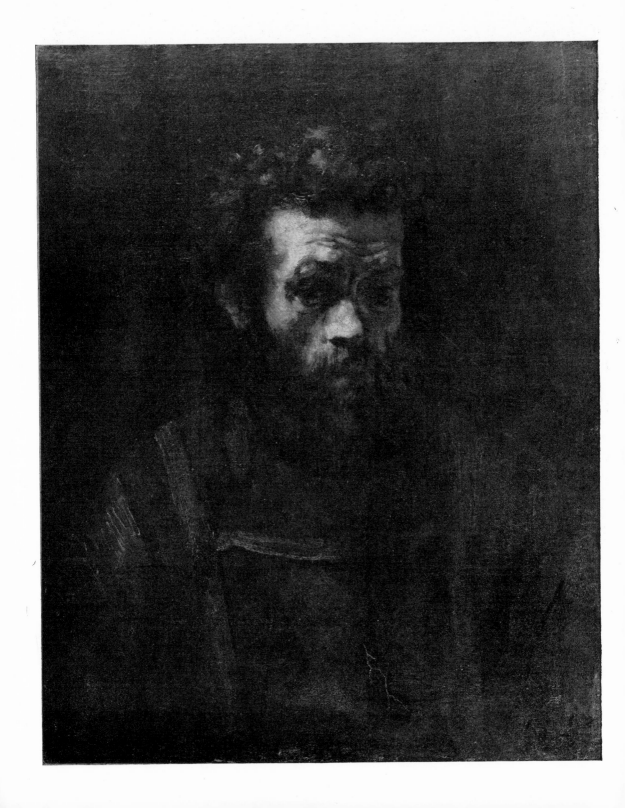

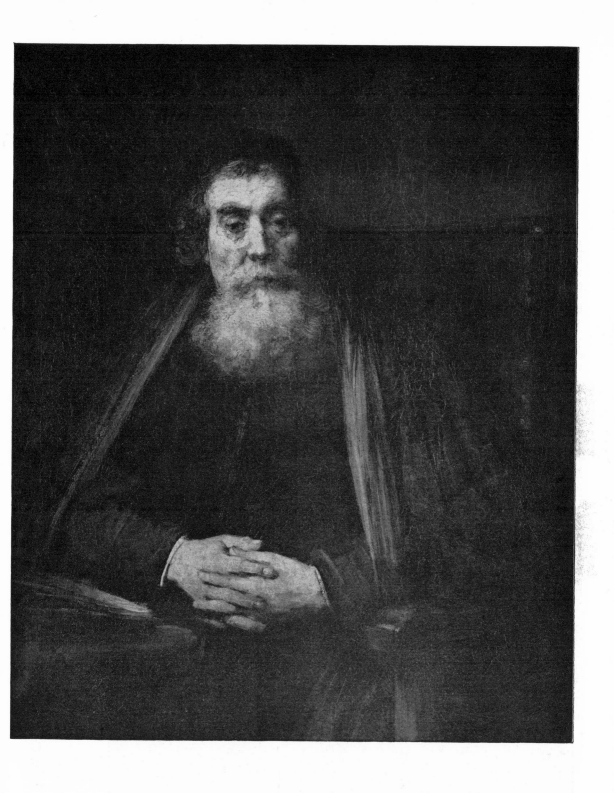

AN OLD MAN IN AN ARMCHAIR. Canvas, 104.5×86 cm. Florence, Uffizi. (Br. 285)

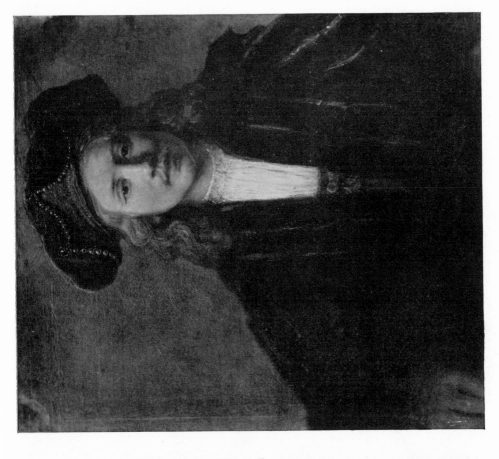

A MAN IN A PEARL-TRIMMED CAP. Canvas, 77·5 × 66·5 cm. Copenhagen, Statens Museum. (Br. 287)

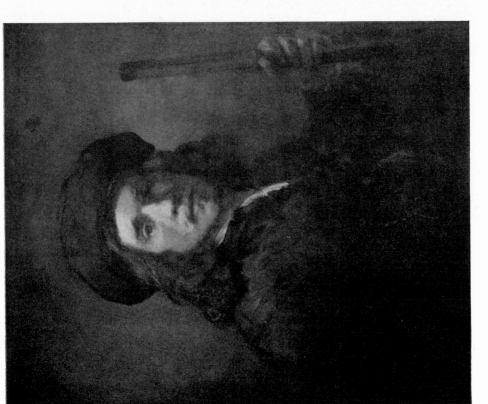

A MAN WITH A STICK. 1657. Canvas, 83 × 66 cm. Paris, Louvre. (Br. 286)

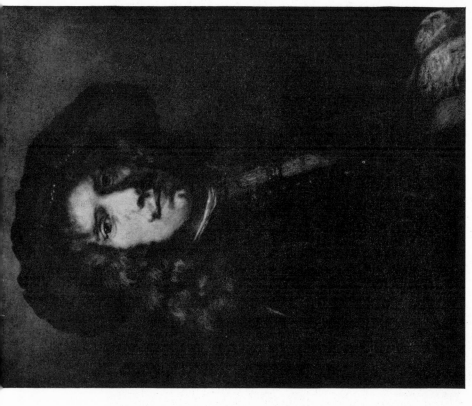

PORTRAIT OF A YOUNG MAN. 1658. Canvas, 73×61 cm. Paris, Louvre. (Br. 292)

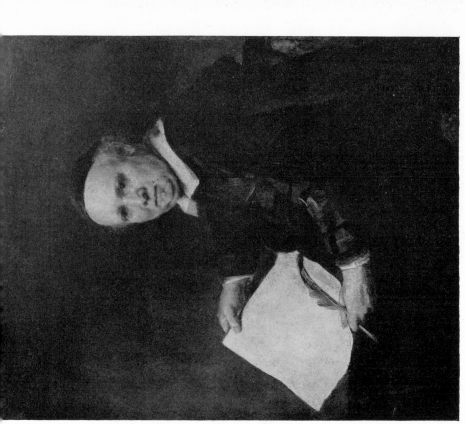

THE WRITING-MASTER LIEVEN WILLEMSZ. VAN COPPENOL. Panel, 36×28 cm. New York, Metropolitan Museum of Art. (Br. 291)

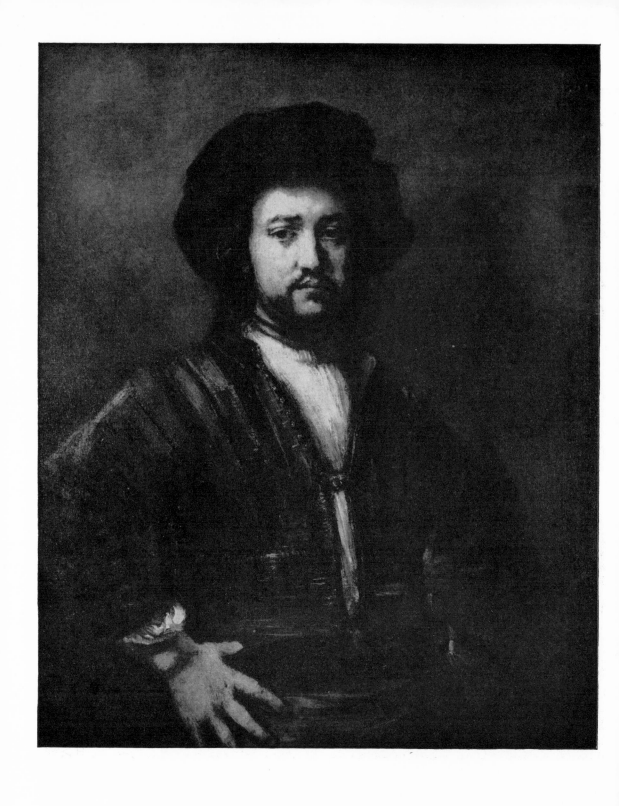

A MAN WITH ARMS AKIMBO. 1658. Canvas, 106·5×87·5 cm. New York, Columbia University. (Br. 290)

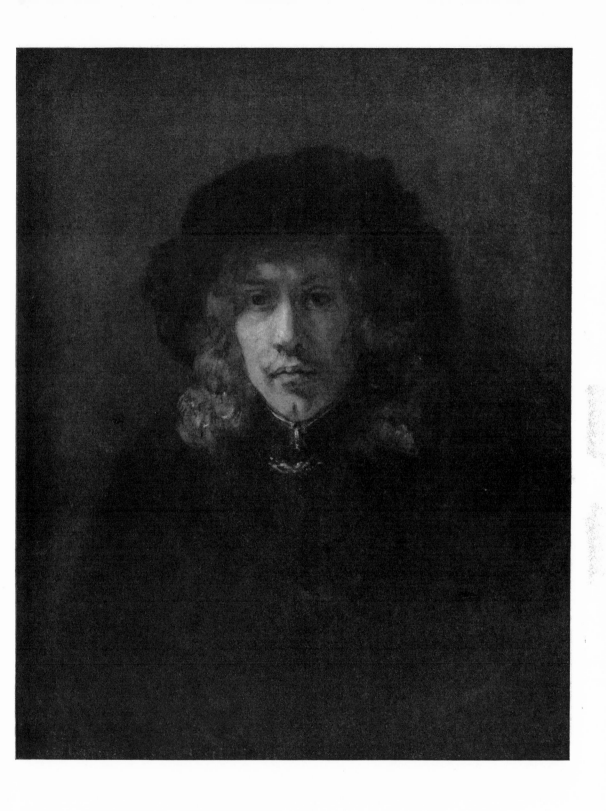

A Young Man with a Beret. Canvas, 76×61 cm. New York, Mr. and Mrs. Charles S. Payson. (Br. 293)

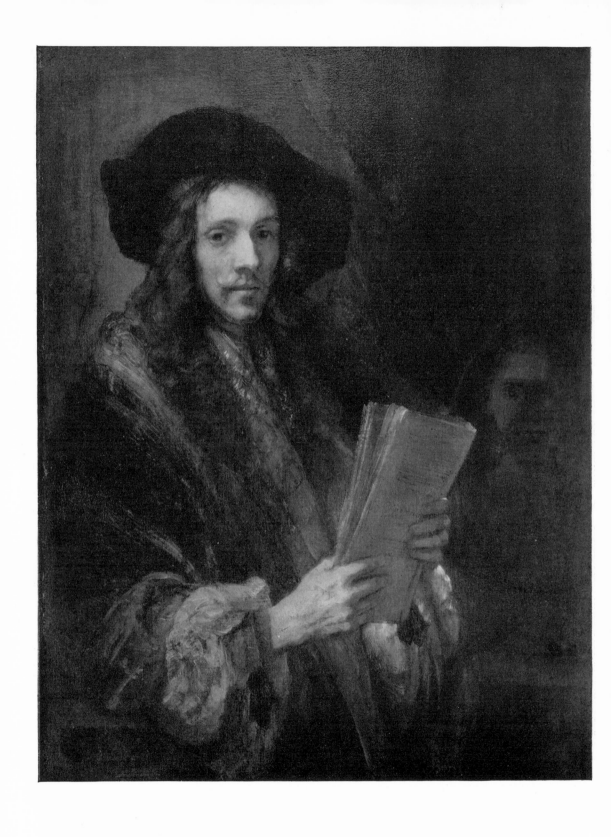

A Man Holding a Manuscript. 1658. Canvas, 109×86 cm. New York, Metropolitan Museum of Art. (Br. 294)

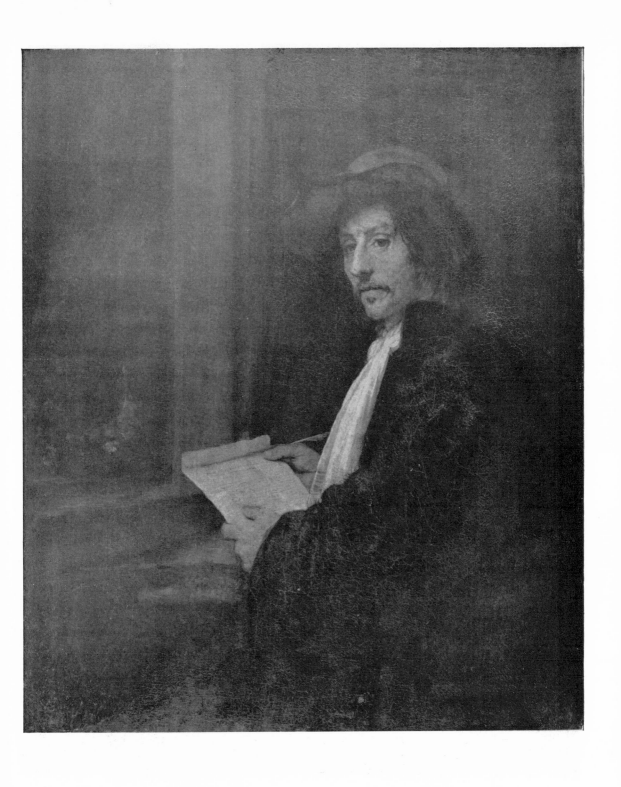

A Man Holding a Letter. 1658. Canvas, 113×95.5 cm. Château de Pregny (Geneva), Baron Edmond de Rothschild. (Br. 295)

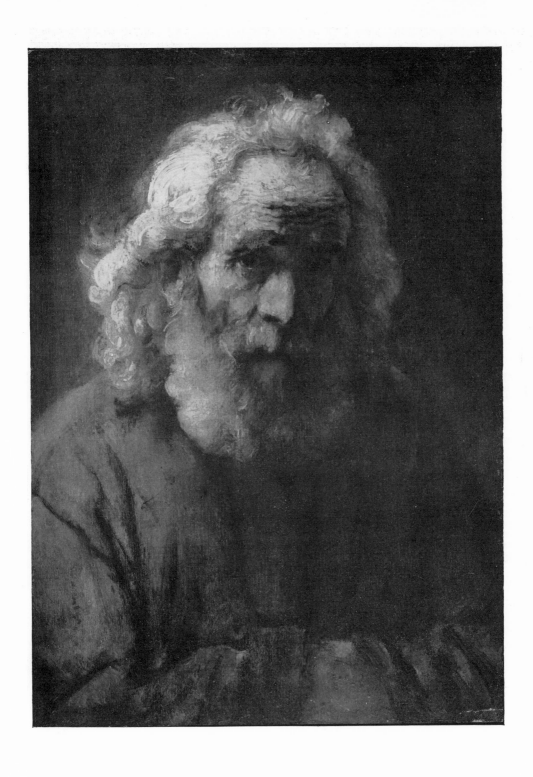

An Old Man. 1659. Panel, 37·5×26·5 cm. Birmingham, Derek Cotton. (Br. 295A)

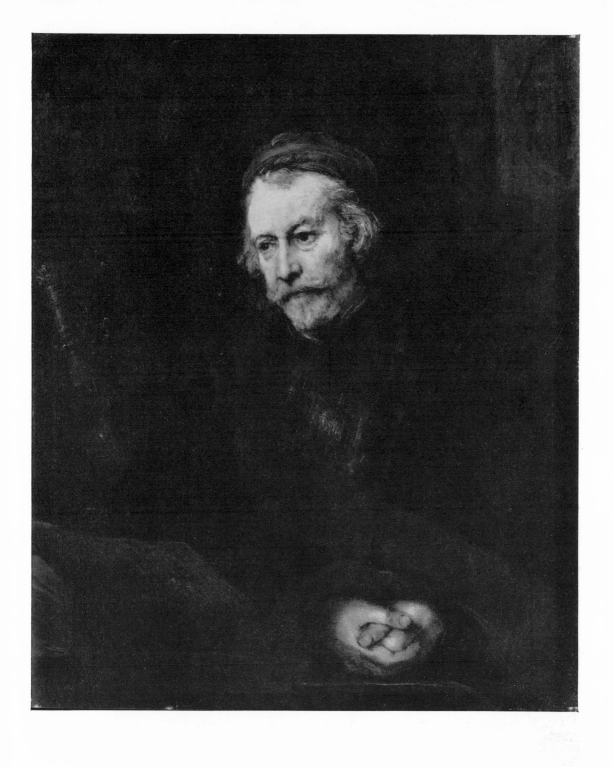

An Old Man as the apostle Paul. 165(9?). Canvas, 102×85.5 cm. London, National Gallery. (Br. 297)

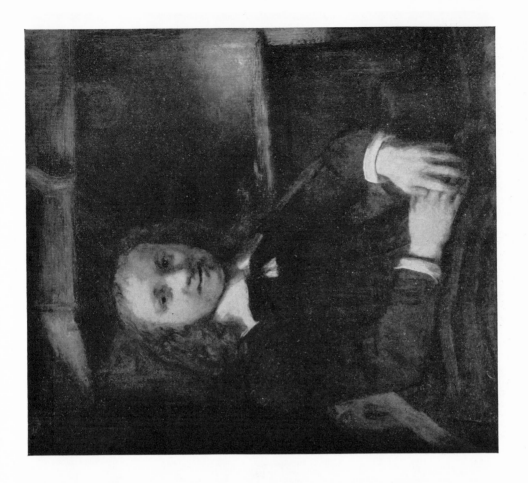

A Man Seated before a Stove. Panel, 48×41 cm. Winterthur, Stiftung Dr. Oskar Reinhart. (Br. 298)

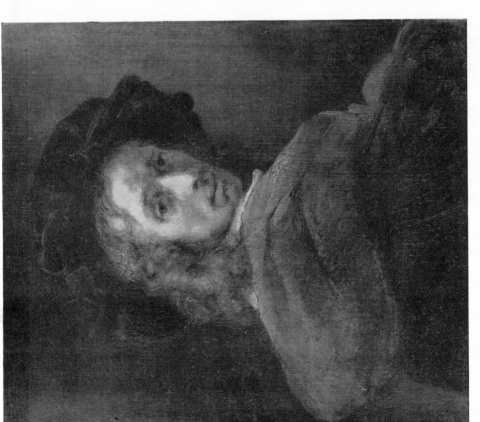

Young Man in a Red Cloak. 1659. Panel, 38×31 cm. New York, Metropolitan Museum of Art. (Br. 296)

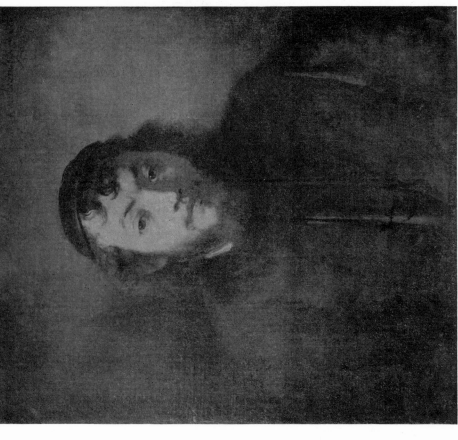

PORTRAIT OF A YOUNG JEW. 1661. Canvas, 64×57 cm. Montreal, Van Horne Collection. (Br. 300)

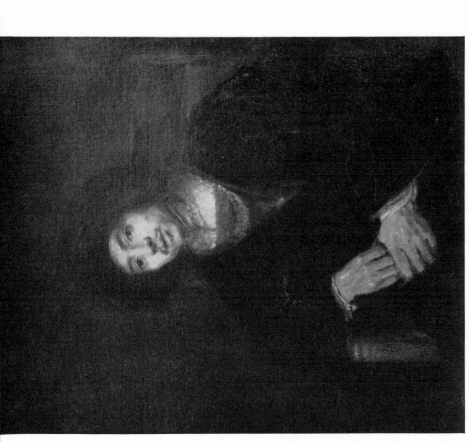

PORTRAIT OF A YOUNG MAN. 1660. Canvas, 91.5×81.5 cm. Rochester University (New York), George Eastman Collection. (Br. 299)

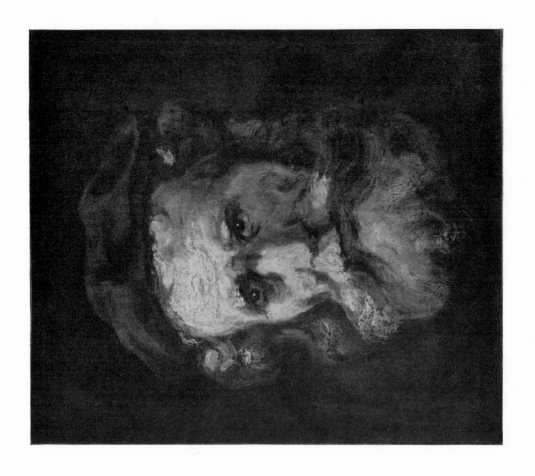

HEAD OF AN OLD MAN. Panel, 25×22 cm. Bayonne, Musée Bonnat. (Br. 303)

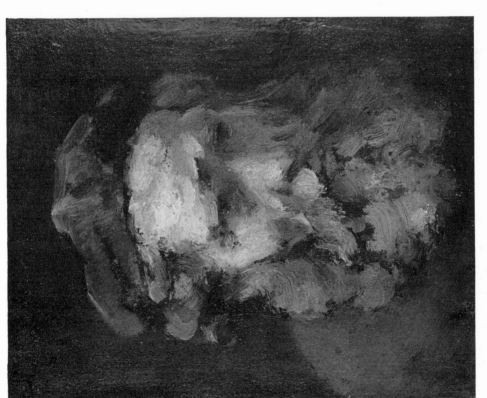

HEAD OF AN OLD MAN. Panel, 25×19.5 cm. Washington, D.C., National Gallery of Art. (Widener Collection). (Br. 302)

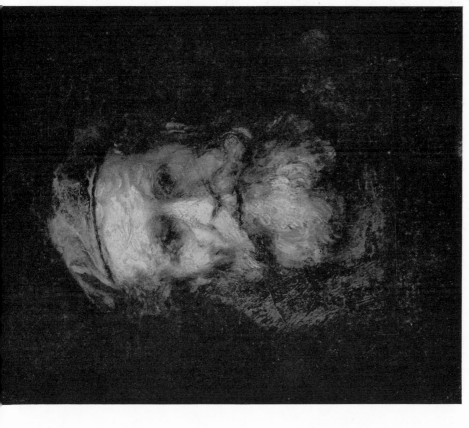

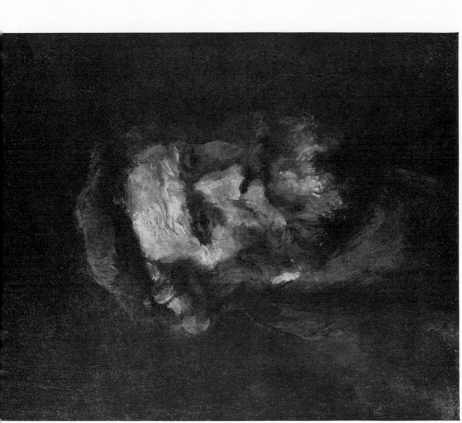

Head of an Old Man. Panel, 24·5×20 cm. England, Private Collection. (Br. 304)

Head of an Old Man. Panel, 27×22 cm. Detroit, William J. McAneeny. (Br. 305)

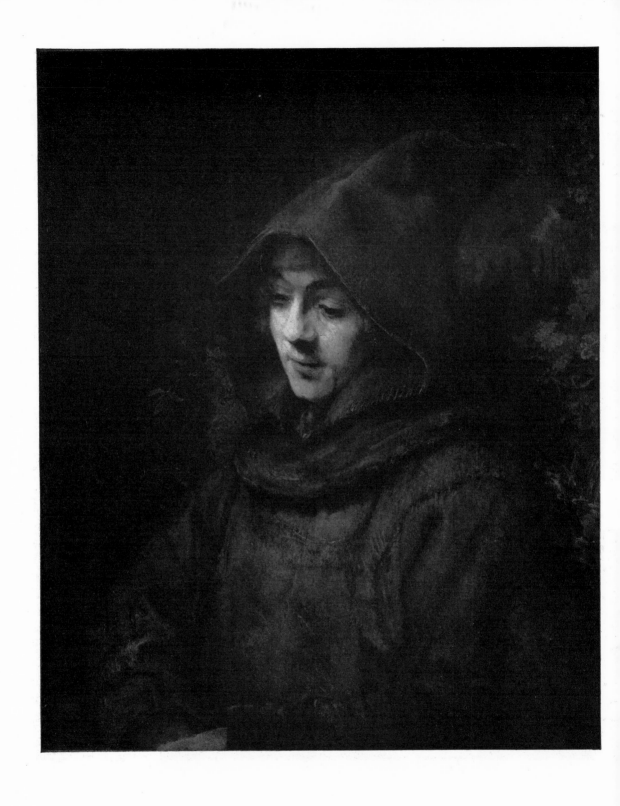

A Young Capuchin Monk (Titus). 1660. Canvas, 79.5×67.5 cm. Amsterdam, Rijksmuseum. (Br. 306)

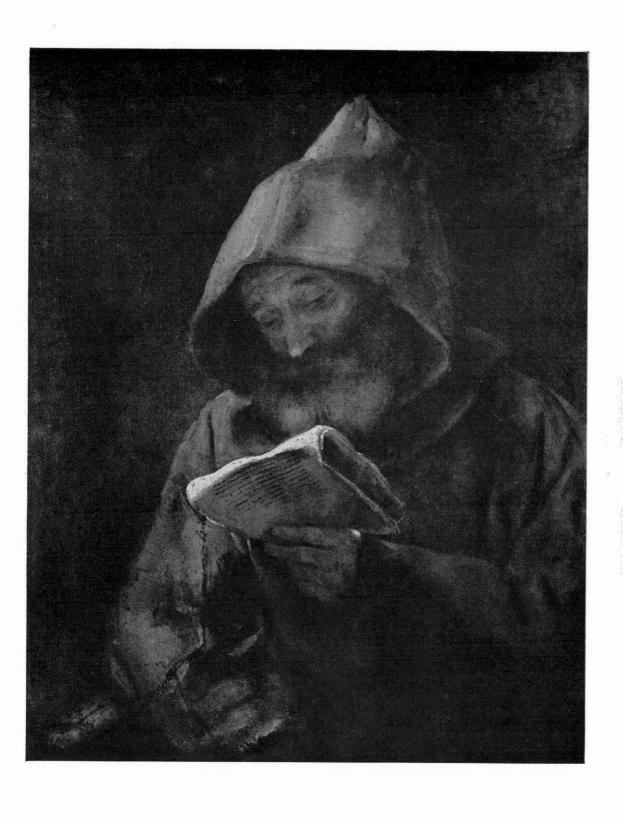

A Capuchin Monk Reading. 1661. Canvas, 82×66 cm. Helsinki, Ateneum. (Br. 307)

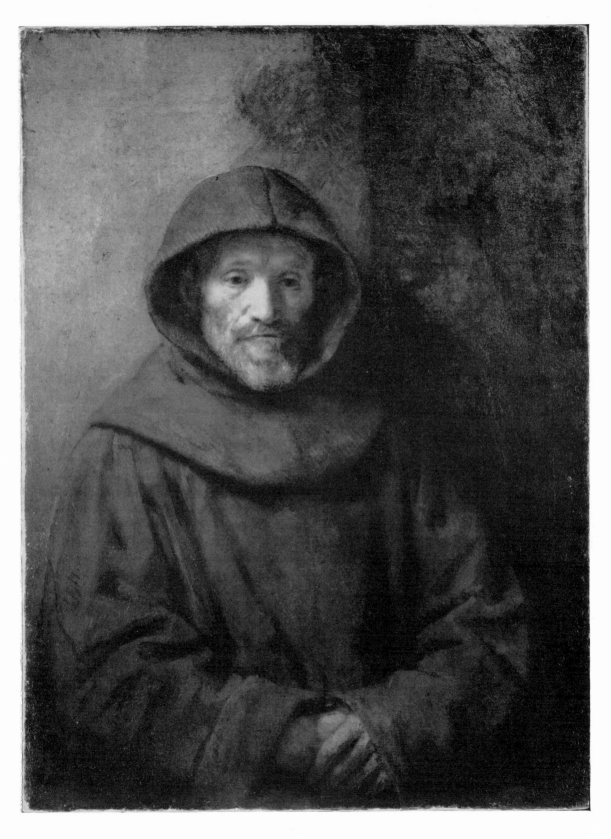

A Franciscan Monk. Canvas, 89×66·5 cm. London, National Gallery. (Br. 308)

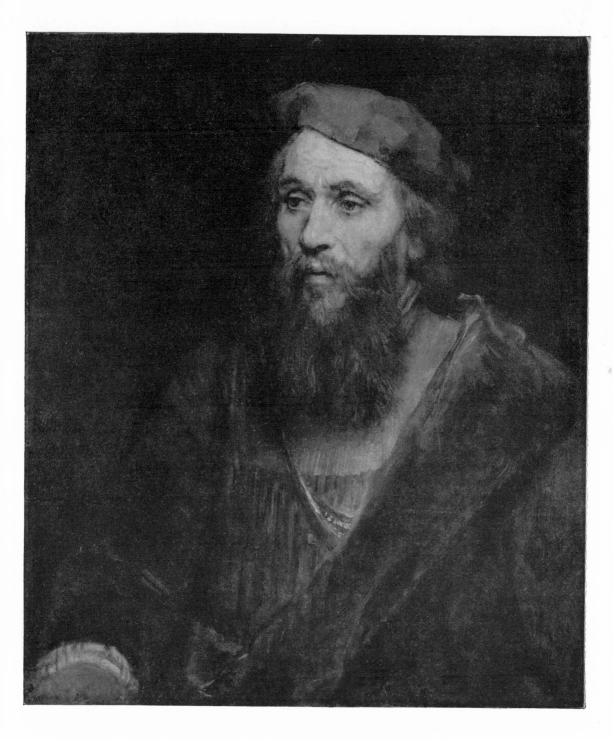

A Bearded Man. 1661. Canvas, 71×61 cm. Leningrad, Hermitage. (Br. 309)

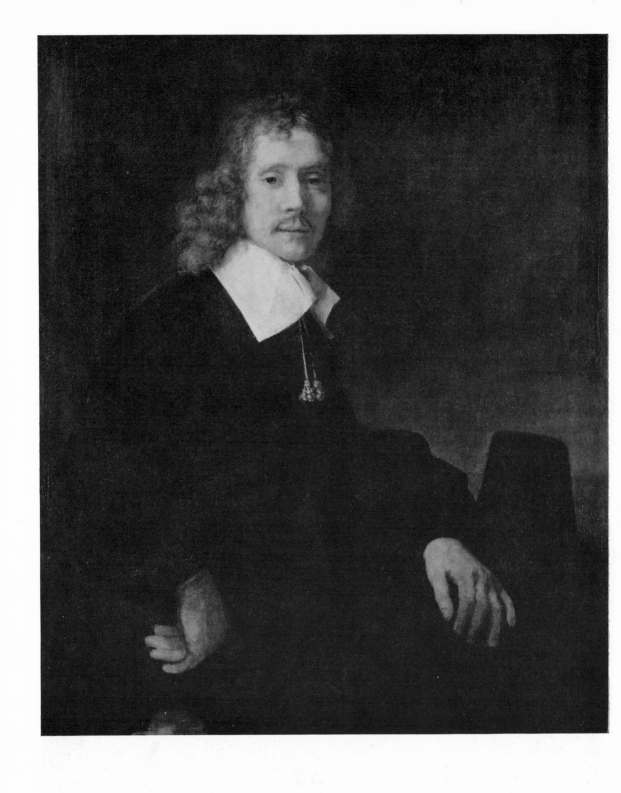

PORTRAIT OF A YOUNG MAN. 1663. Canvas, 110×90 cm. Washington, D.C., National Gallery of Art (Mellon Collection). (Br. 312)

PORTRAIT OF A MAN ON HORSEBACK (Frederik Rihel?). 1663(?) Canvas, 294.5×241 cm. London, National Gallery. (Br. 255)

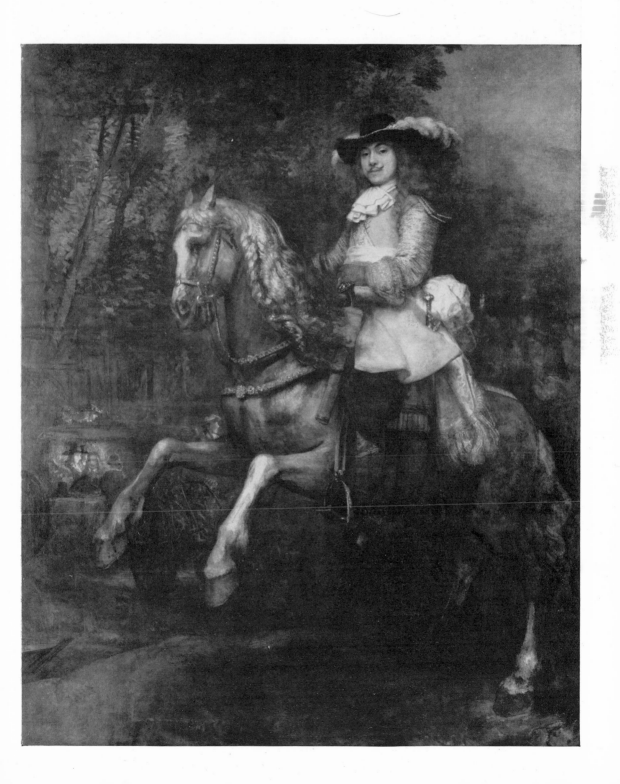

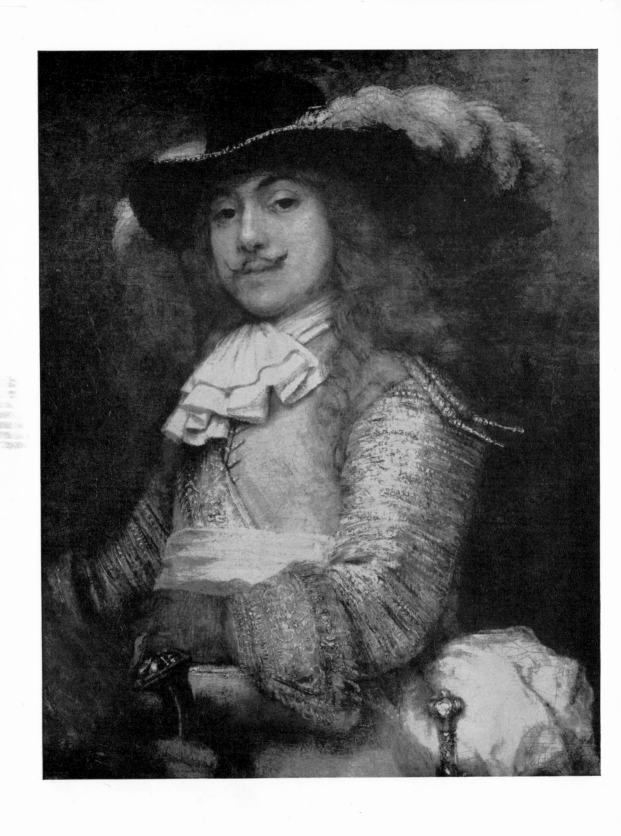

DETAIL OF EQUESTRAIN PORTRAIT REPRODUCED ON PAGE 239

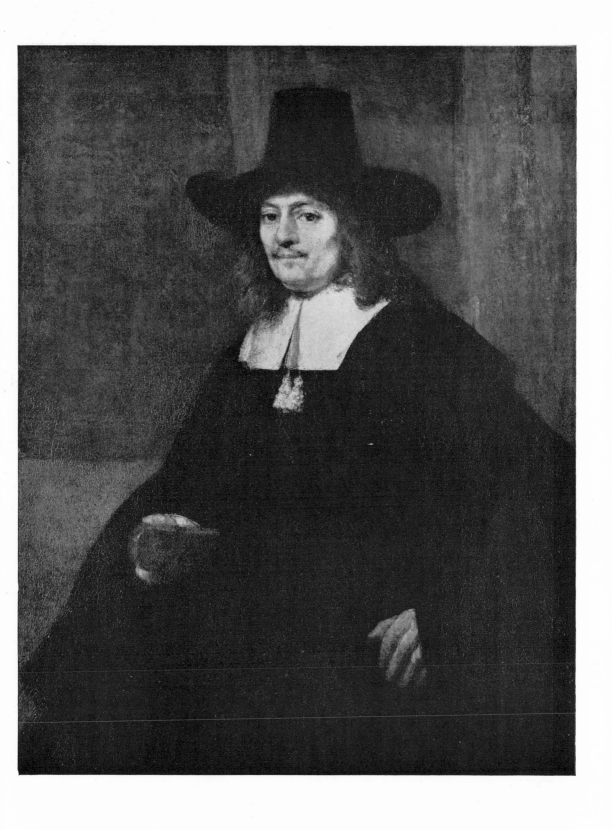

A MAN IN A TALL HAT. Canvas, 121×94 cm. Washington, D.C., National Gallery of Art (Widener Collection). (Br. 313)

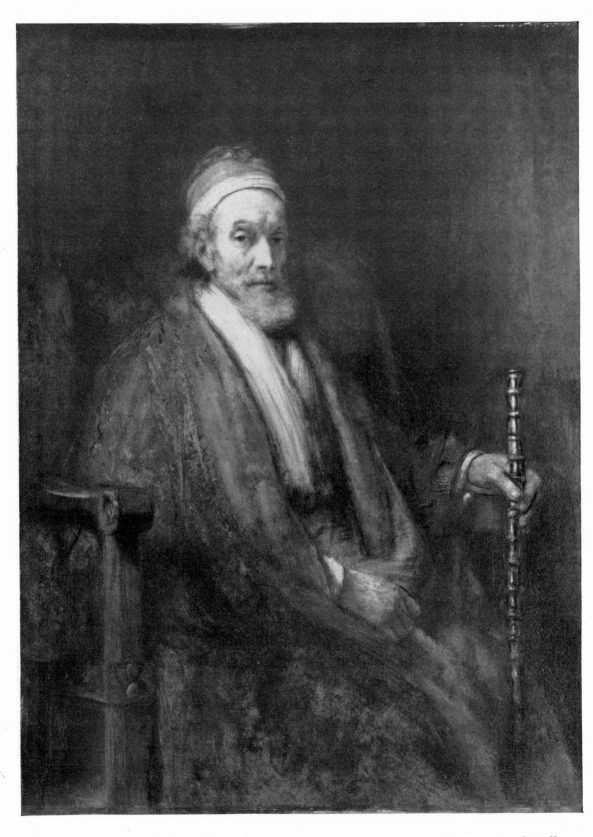

THE DORDRECHT MERCHANT JACOB TRIP. Canvas, 130.5×97 cm. London, National Gallery.
(Br. 314) Companion to Br. 394 reproduced on page 306

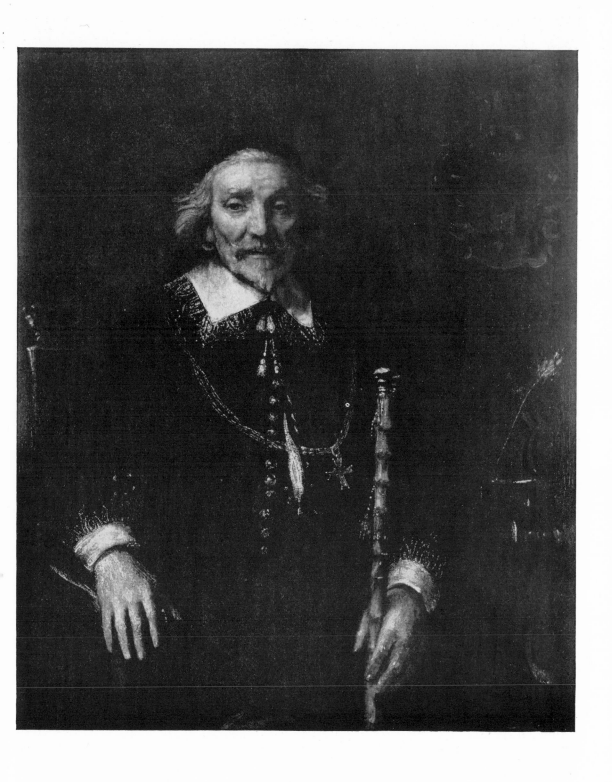

DIRK VAN OS. Canvas, 101 × 85 cm. Omaha, Nebr., Joslyn Art Museum. (Br. 315)

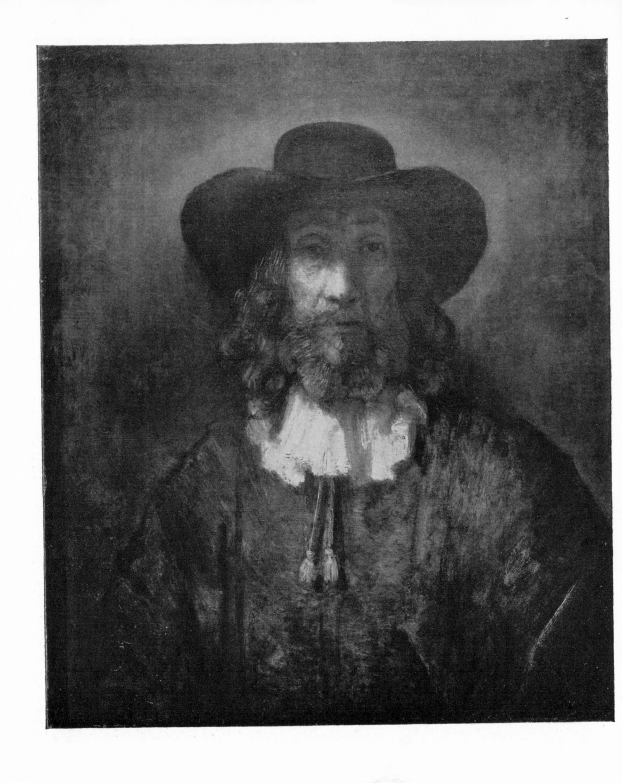

PORTRAIT OF A MAN. 1665. Canvas, 71×63.5 cm. New York, Metropolitan Museum of Art. (Br. 317)

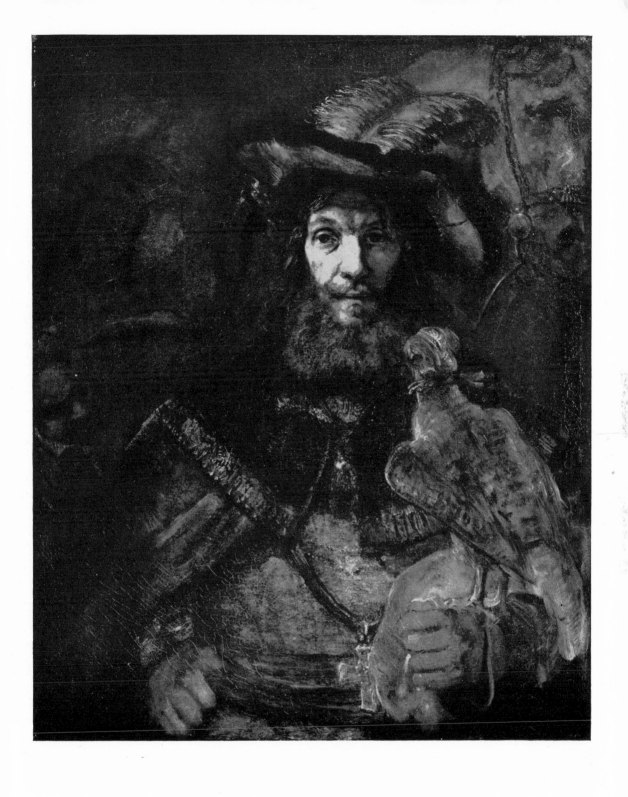

"THE FALCONER". Canvas, 98×79 cm. Gothenburg, Museum. (Br. 319)

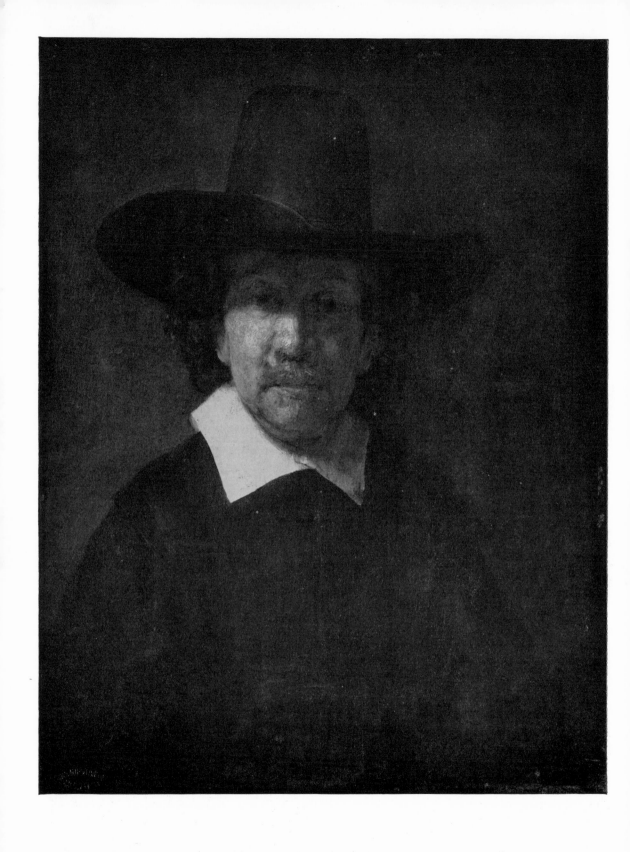

THE POET JEREMIAS DE DECKER. 1666. Panel, 71 × 56 cm. Leningrad, Hermitage. (Br. 320)

THE PAINTER GERARD DE LAIRESSE. 1665. Canvas, 112×87 cm. New York, Robert Lehman. (Br. 321)

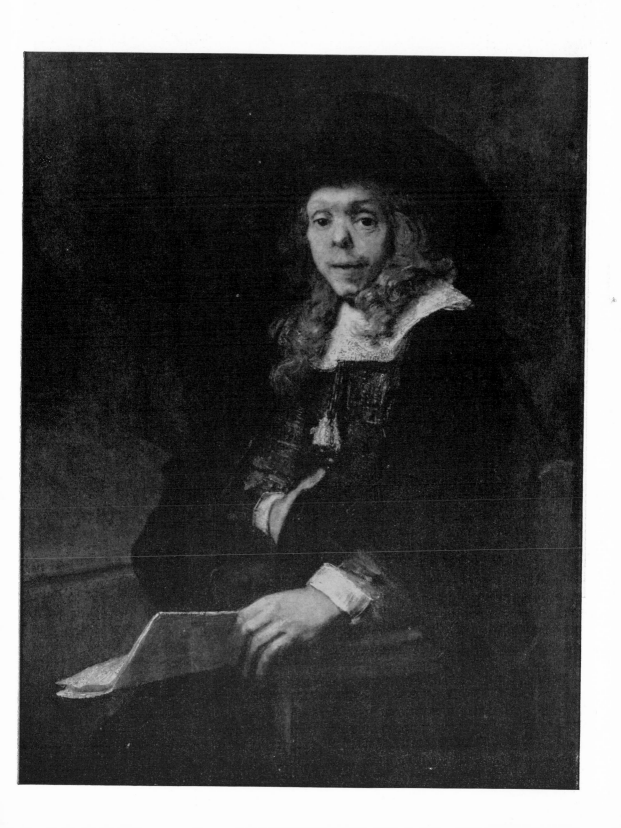

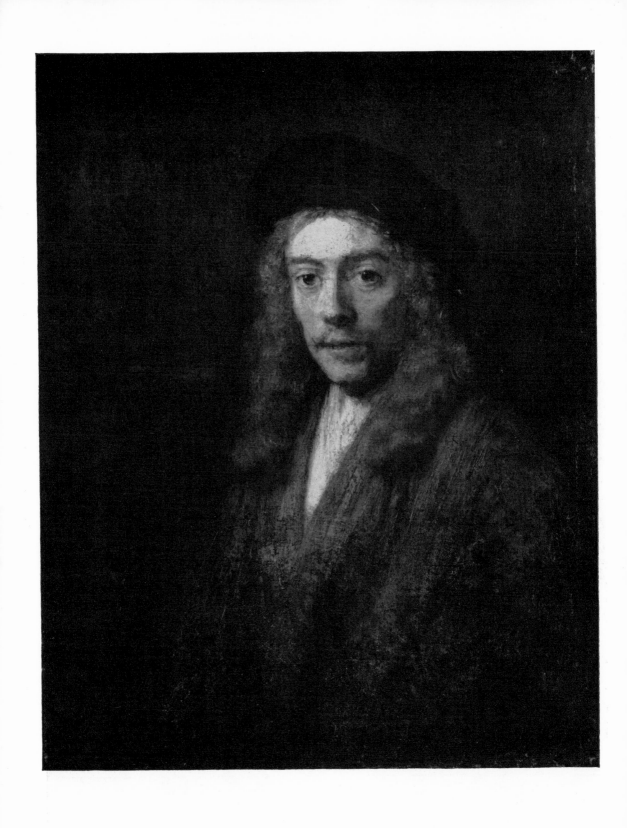

PORTRAIT OF A YOUNG MAN (Titus?). Canvas, 81×65 cm. London, Dulwich College Gallery.
(Br. 289)

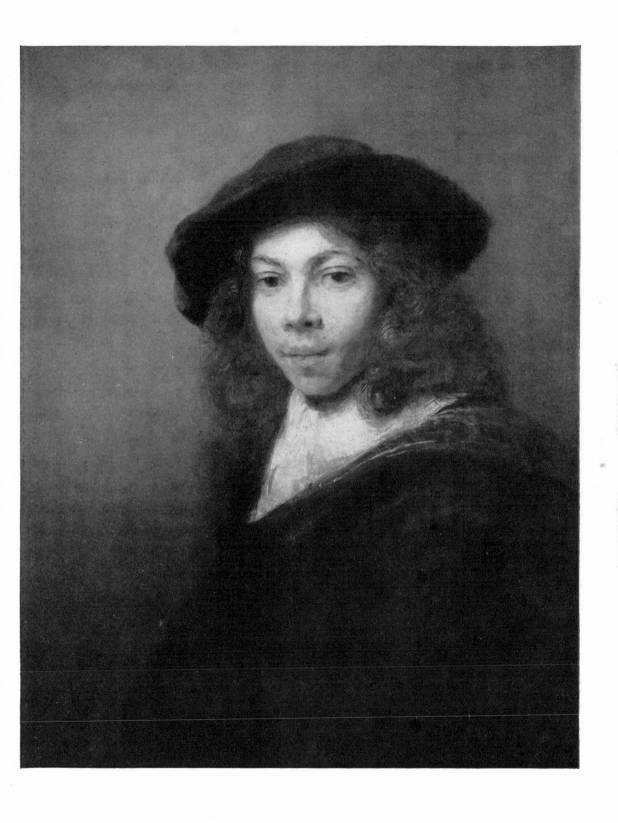

PORTRAIT OF A YOUTH. 1666. Canvas, 78×63 cm. Kansas City, William Rockhill Nelson Gallery of Art. (Br. 322)

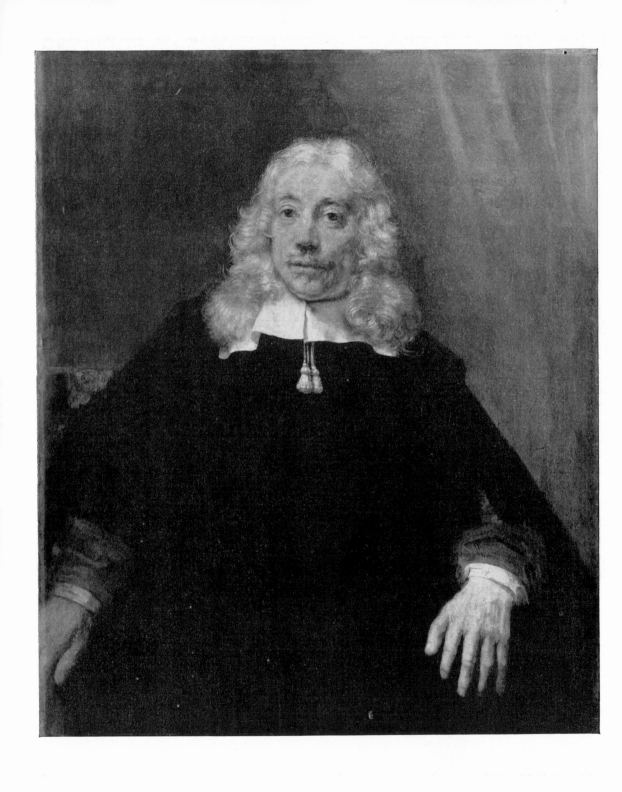

PORTRAIT OF A FAIR-HAIRED MAN. 1667. Canvas, 107·5×91·5 cm. Melbourne, National Gallery of Victoria. (Br. 323)

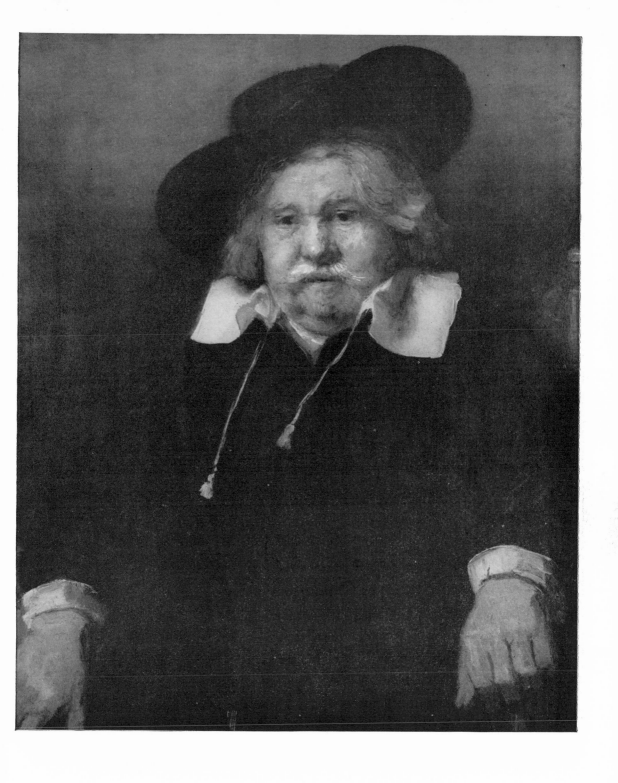

PORTRAIT OF AN ELDERLY MAN. 1667. Canvas, 81×67 cm. Cowdray Park, Sussex, Lord Cowdray. (Br. 323A)

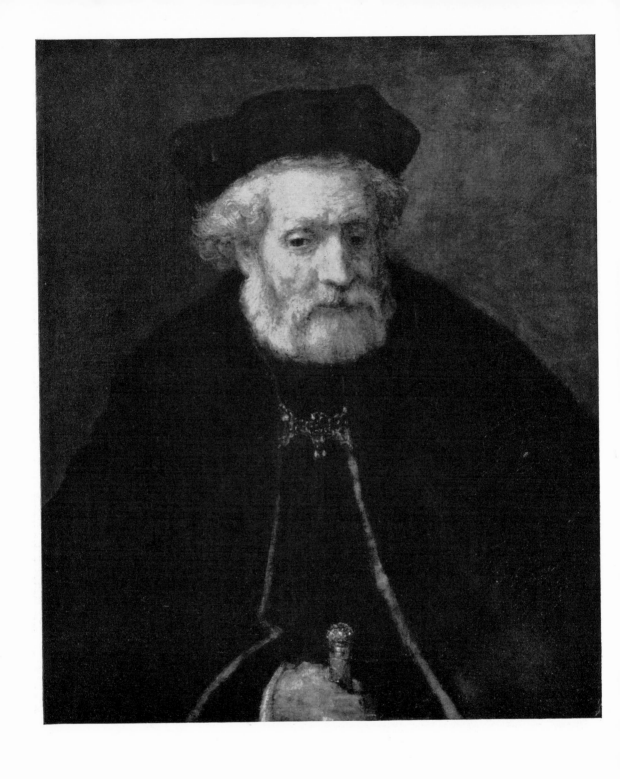

Portrait of an Old Man. 1667. Canvas, 70×58 cm. Formerly Lugano, Baron H. Thyssen-Bornemisza. (Br. 325)

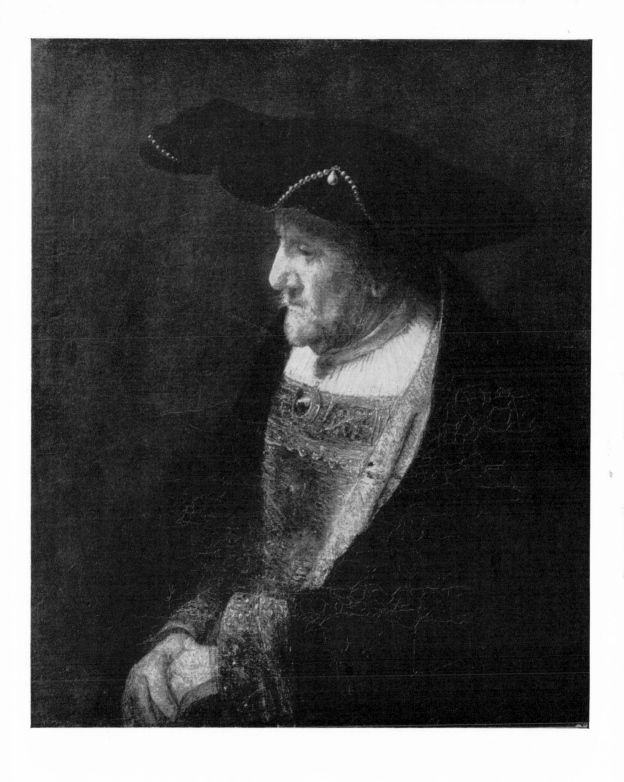

Portrait of an Old Man in a Pearl-Trimmed Hat. Canvas, 82×71 cm. Dresden, Gemälde-galerie. (Br. 324)

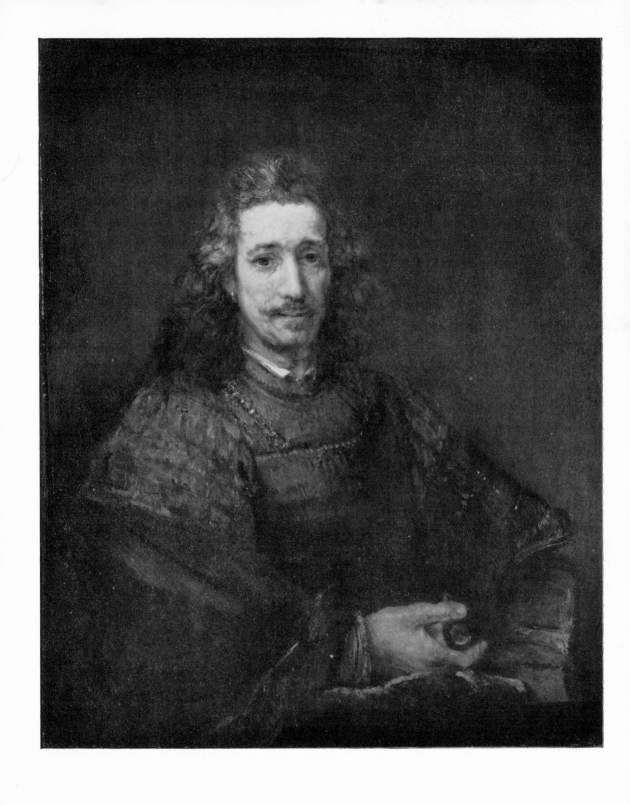

A MAN WITH A MAGNIFYING GLASS. Canvas, 90×73·5 cm. New York, Metropolitan Museum of Art. (Br. 326) Companion to Br. 401 reproduced on page 312

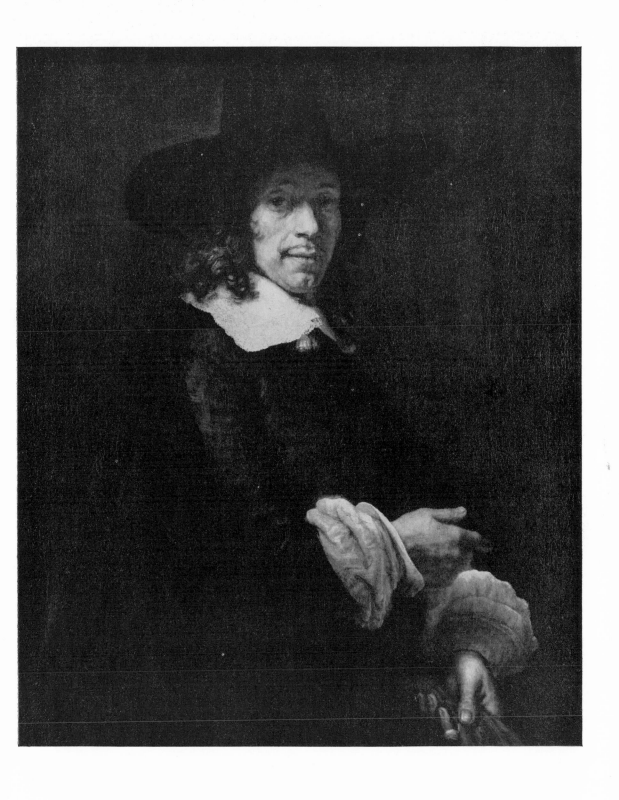

A MAN HOLDING GLOVES. Canvas, 99·5×82·5 cm. Washington, D.C., National Gallery of Art (Widener Collection). (Br. 327) Companion to Br. 402 reproduced on page 313

DETAIL OF THE EQUESTRIAN PORTRAIT REPRODUCED ON PAGE 239

FEMALE PORTRAITS

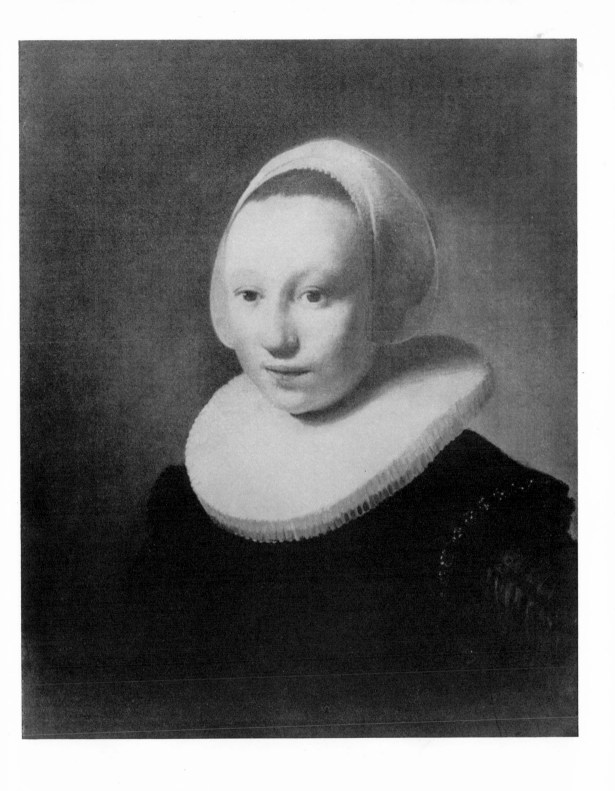

PORTRAIT OF A YOUNG GIRL. Panel, 56·5 × 44·5 cm. Philadelphia, Mrs. Zimbalist. (Br. 329)

PORTRAIT OF A YOUNG WOMAN. 1632. Canvas, 92×71 cm. Vienna, Academy of Fine Arts. (Br. 330)

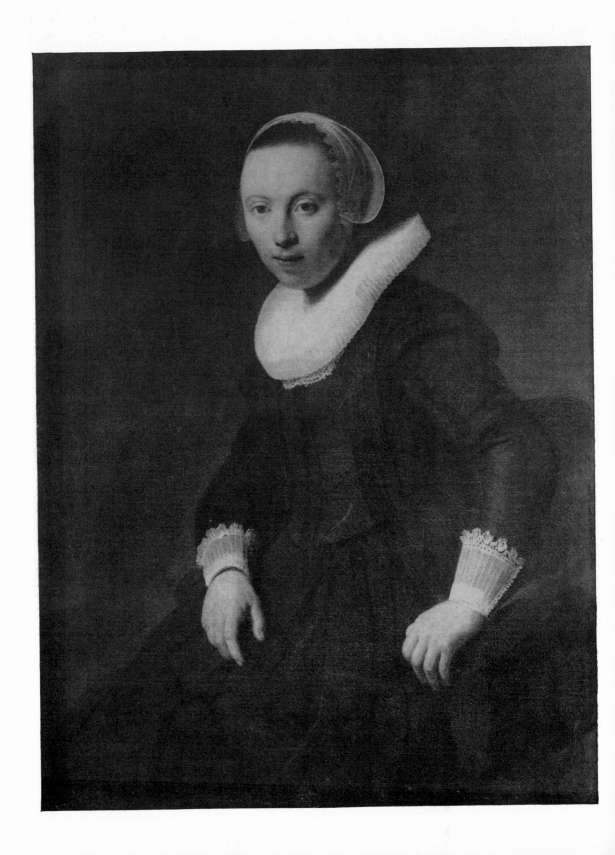

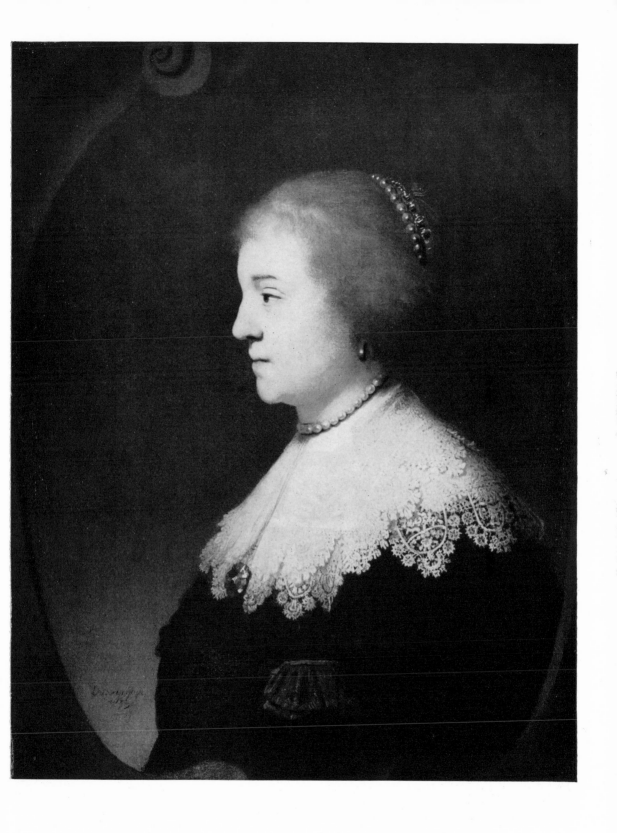

AMALIA VAN SOLMS. 1632. Canvas, 68·5×55·5 cm. Paris, Musée Jacquemart-André. (Br. 99)

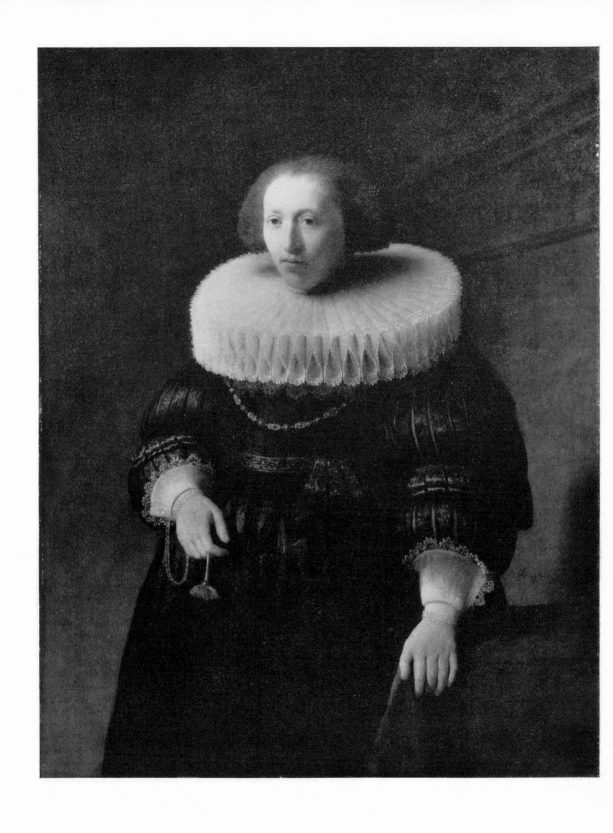

PORTRAIT OF A YOUNG WOMAN. 1632. Canvas, 110×87·5 cm. New York, Metropolitan Museum of Art. (Br. 331) Companion to Br. 167 reproduced on page 142

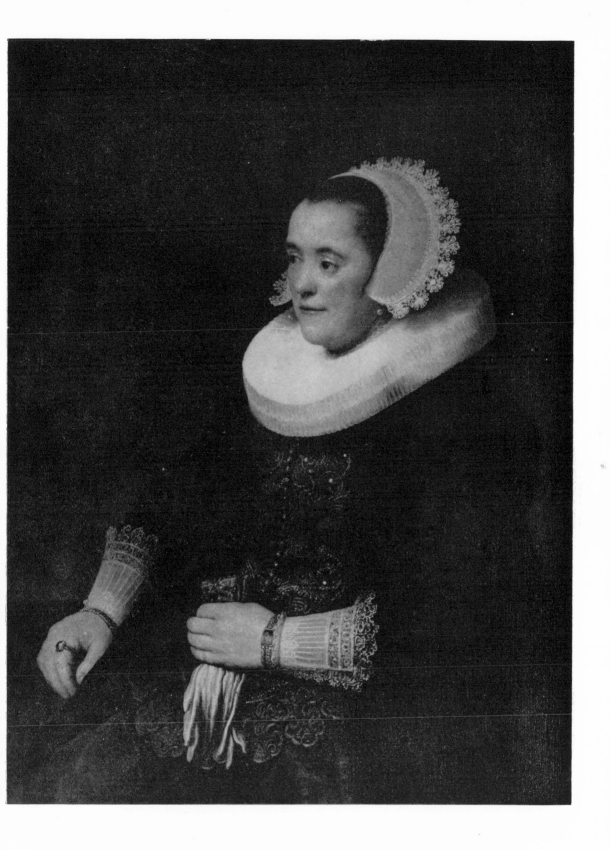

PORTRAIT OF A WOMAN. Panel, 90×67·5 cm. Vienna, Kunsthistorisches Museum. (Br. 332)
Companion to Br. 163 reproduced on page 138

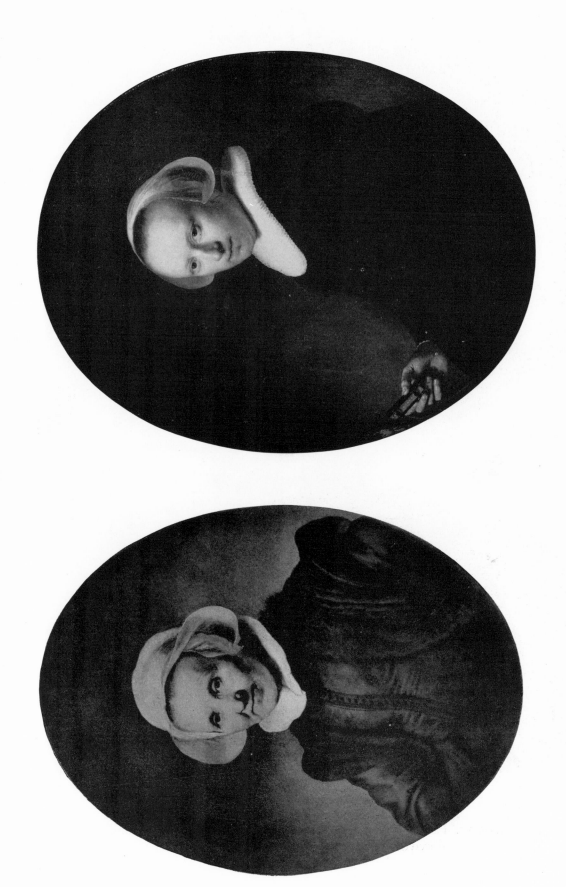

A Young Woman with a Hymn-Book. 1632. Panel, 76·5 × 59 cm.
Nivaa (Denmark), Museum. (Br. 334)

An Old Woman in a White Cap. 1632. Panel, 75 × 55·5 cm.
Paris, Baron Edouard de Rothschild. (Br. 333)

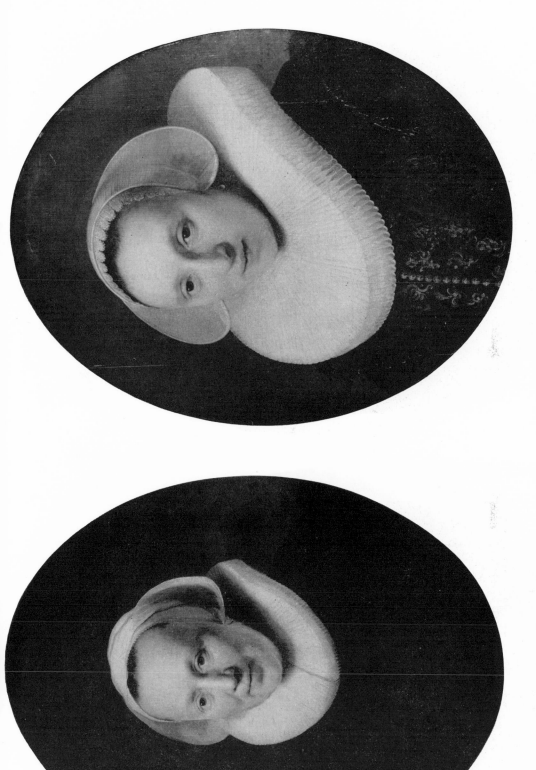

PORTRAIT OF A WOMAN. 1633. Panel, 66.5×49.5 cm. New York, Metropolitan Museum of Art. (Br. 335)

CORNELIA PRONCK, WIFE OF AELBERT CUYPER. 1633. Panel, 60×47 cm. Paris, Louvre. (Br. 336) Companion to Br. 165 reproduced on page 140

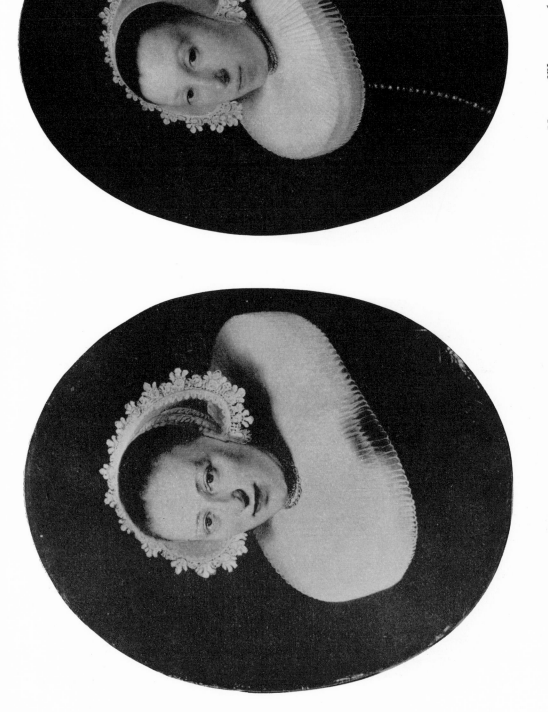

PORTRAIT OF A YOUNG WOMAN. 1633. Panel, 61×50 cm. Formerly
Piqua, Ohio, L. M. Flesh. (Br. 337)

PORTRAIT OF A YOUNG WOMAN. 1633. Panel, 63·5×48 cm.
Brunswick, Herzog Anton Ulrich Museum. (Br. 338) Com-
panion to Br. 159 reproduced on page 136

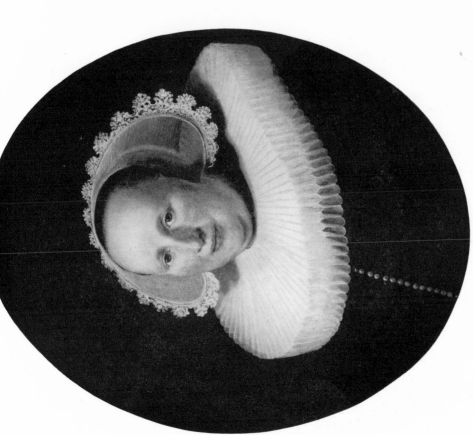

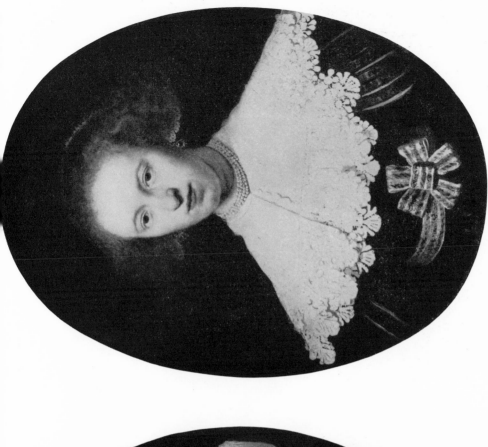

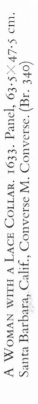

A Woman with a Lace Collar. 1633. Panel, 63·5×47·5 cm.
Santa Barbara, Calif., Converse M. Converse. (Br. 340)

Margaretha van Bilderbeecq. 1633. Panel, 67·5×55 cm.
Frankfurt, Städelsches Kunstinstitut. (Br. 339) Companion to
Br. 175 reproduced on page 150

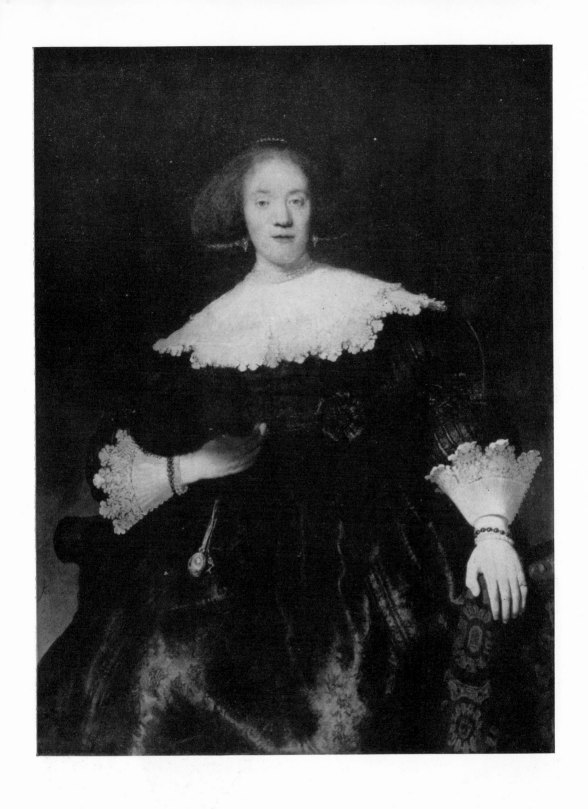

A YOUNG WOMAN WITH A FAN. 1633. Canvas, 127×101 cm. New York, Metropolitan Museum of Art. (Br. 341) Companion to Br. 172 reproduced on page 147

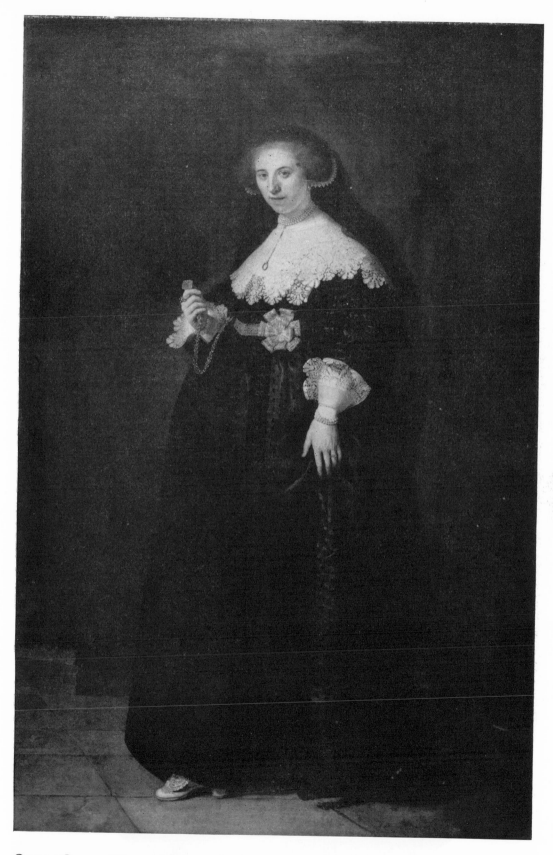

OOPJEN COPPIT, WIFE OF MAERTEN SOOLMANS. 1634. Canvas, 209.5×134 cm. Paris, Baron Robert de Rothschild. (Br. 342) Companion to Br. 199 reproduced on page 162

PORTRAIT OF AN 83-YEAR-OLD WOMAN. 1634. Panel, 68·5 × 53·5 cm. (enlarged to 71 × 56 cm. by false additions). London, National Gallery. (Br. 343)

PORTRAIT OF A YOUNG WOMAN. 1634. Panel, 66 × 52·5 cm. London, Sale W. H. Moore, March 23, 1960 (lot 68). (Br. 344) Companion to Br. 177 reproduced on page 151

A Young Woman with Flowers in her Hair. 1634. Panel,
71 × 53·5 cm. Edinburgh, National Gallery of Scotland (on loan
from the Duke of Sutherland). (Br. 345) Companion to Br. 196
reproduced on page 160

A Young Woman with a Gold Chain. Panel, 68 × 51 cm.
Boston, Museum of Fine Arts. (Br. 346) Companion to Br. 197 re-
produced on page 161

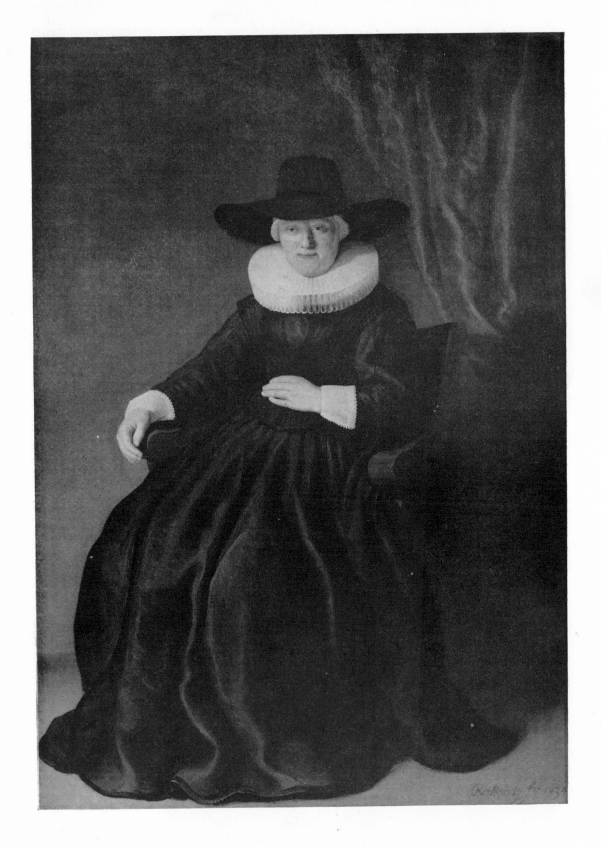

MARIA BOCKENOLLE, WIFE OF JOHANNES ELISON. 1634. Canvas, 173×125 cm. Boston, Museum of Fine Arts. (Br. 347) Companion to Br. 200 reproduced on page 163

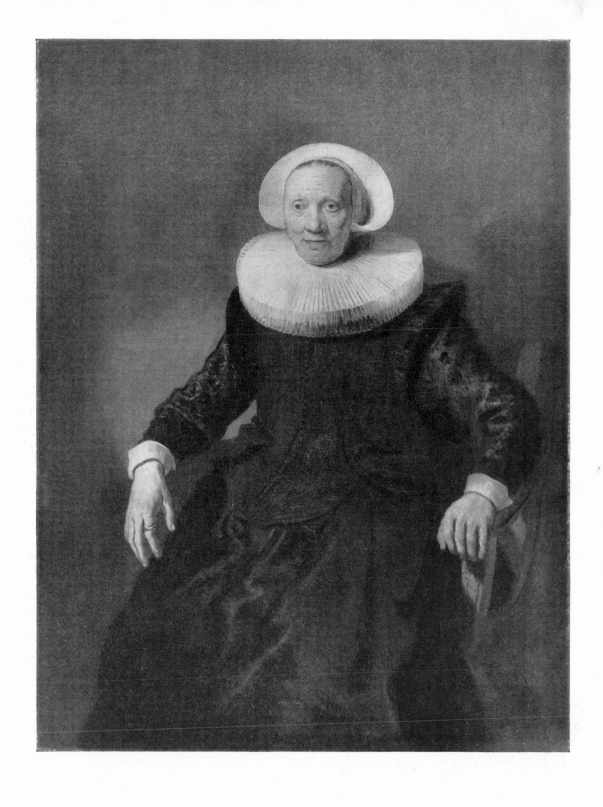

A 70-Year-Old Woman Seated in an Armchair. 1635. Canvas, 126×99 cm. New York, Metropolitan Museum of Art. (Br. 348)

PETRONELLA BUYS, WIFE OF PHILIPS LUCASZ. 1635. Panel, 76×58 cm. New York, André Meyer. (Br. 349) Companion to Br. 202 reproduced on page 164

PORTRAIT OF A YOUNG WOMAN. 1635. Panel, 77×64 cm. Cleveland, Museum of Art. (Br. 350) Companion (?) to Br. 201 reproduced on page 164

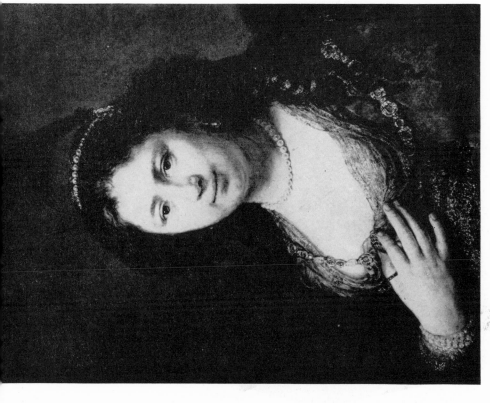

A Young Woman with a Heron's Plume in her Hair. 1636. Panel, 65×52 cm. Formerly Vaduz, Liechtenstein Collection. (Br. 352) Companion to Br. 204 reproduced on page 165

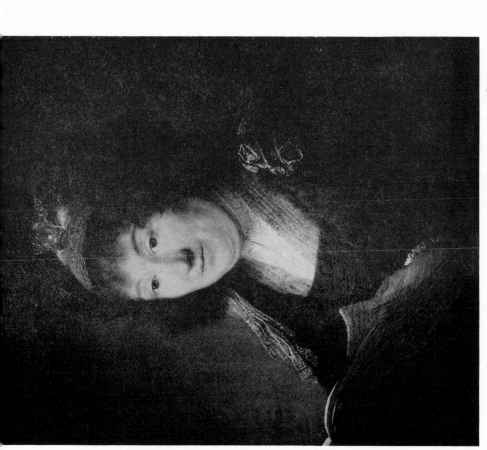

A Young Woman with a Book. 1635. Panel, 65×52 cm. Los Angeles, University of Southern California. (Br. 351)

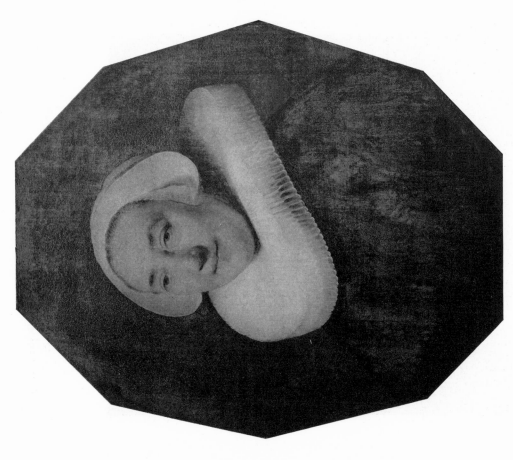

A LADY OF THE RAMAN FAMILY. 1636. Panel, 68×53 cm. Rossie Priory, Perthshire, Lord Kinnaird. (Br. 354) Companion to Br. 194 reproduced on page 168

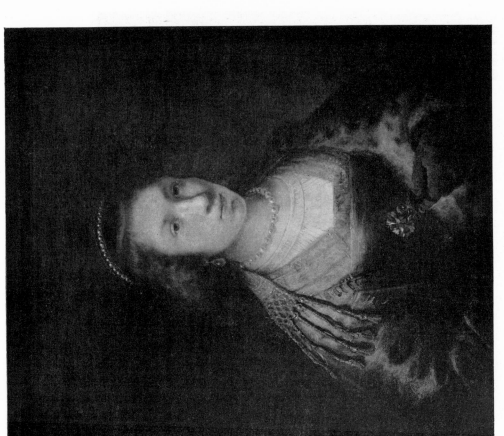

A YOUNG WOMAN HOLDING A CARNATION. Canvas, 72×59 cm. Cassel, Gemäldegalerie. (Br. 353)

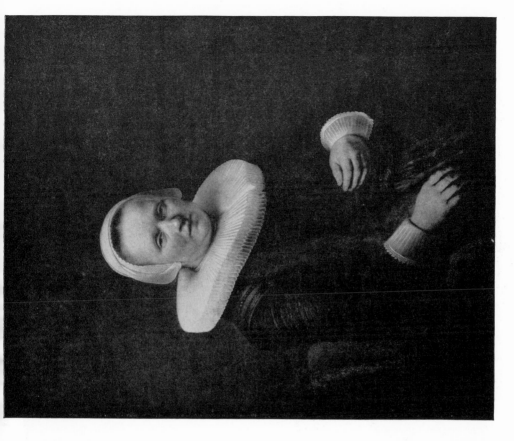

ANNA WIJMER (?). 1641. Panel, 96×80 cm. Amsterdam, The Six
Foundation. (Br. 358)

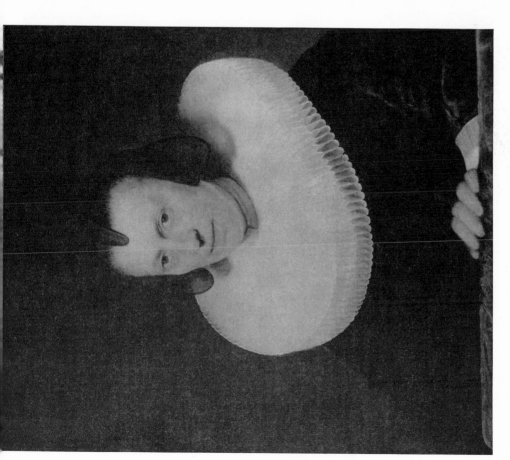

ALOTTA ADRIAENSDR. 1639. Panel, 65×56 cm. Rotterdam, Willem
van der Vorm Foundation. (Br. 355)

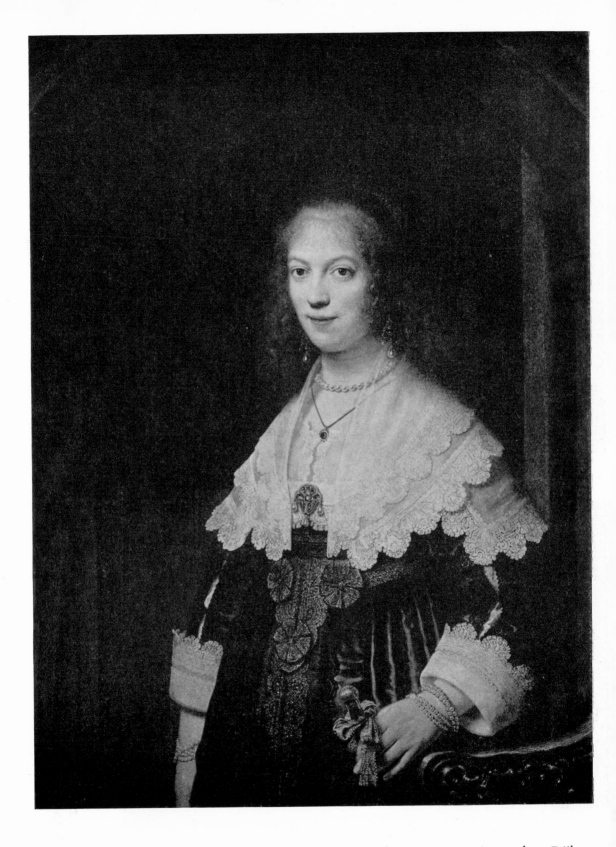

MARIA TRIP, DAUGHTER OF ALOTTA ADRIAENSDR. 1639. Panel, 107×82 cm. Amsterdam, Rijksmuseum (on loan from the van Weede Family Foundation). (Br. 356)

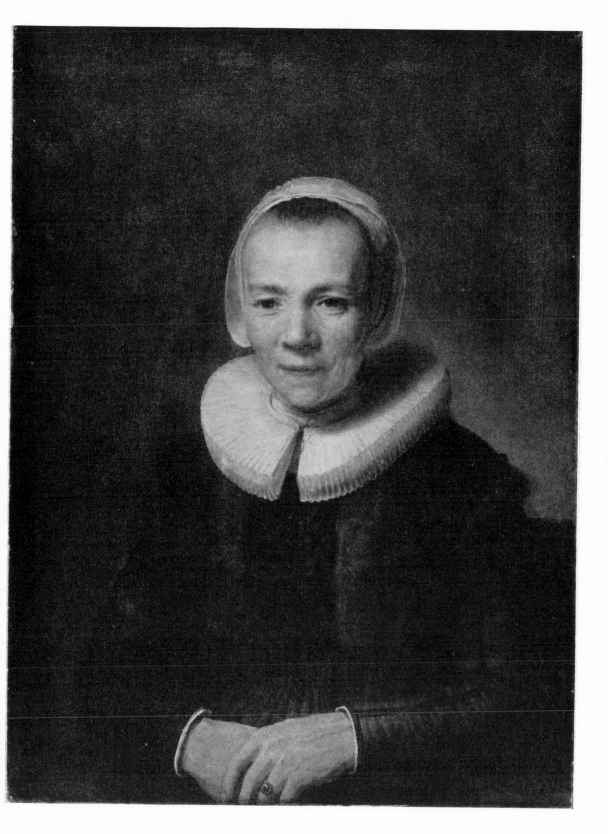

BAARTJEN MARTENS, WIFE OF HERMAN DOOMER. Panel, 76×56 cm. Leningrad, Hermitage. (Br. 357)
Companion to Br. 217 reproduced on page 176

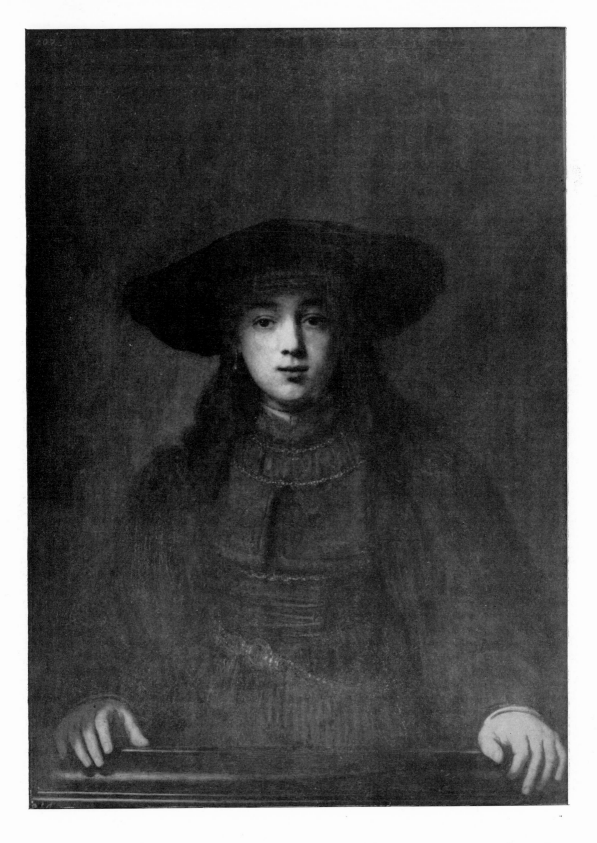

A Young Girl resting her hands on a Sill. 1641. Panel, 104×76 cm. Formerly Vaduz, Liechtenstein Collection. (Br. 359) Companion to Br. 219 reproduced on page 178

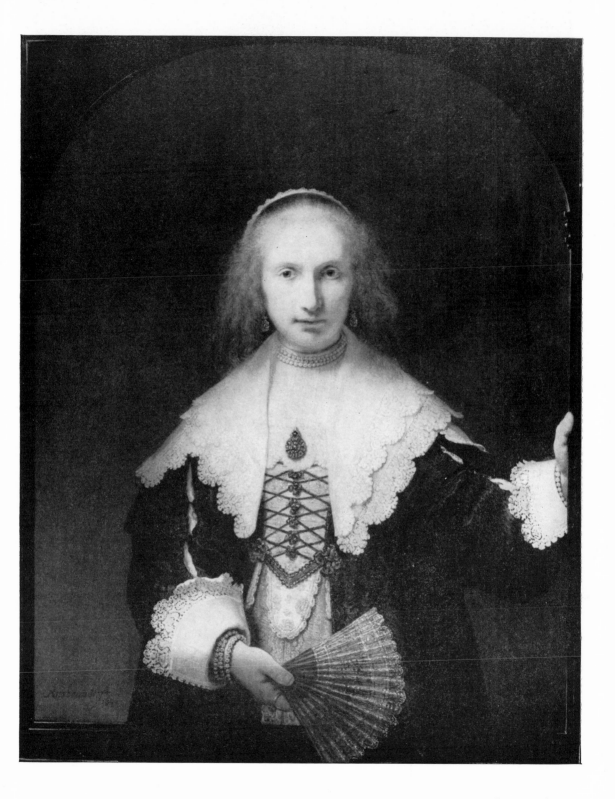

AGATHA BAS, WIFE OF NICOLAAS VAN BAMBEECK. 1641. Canvas, 104.5×85 cm. London, Bucking-
ham Palace. (Br. 360) Companion to Br. 218 reproduced on page 177

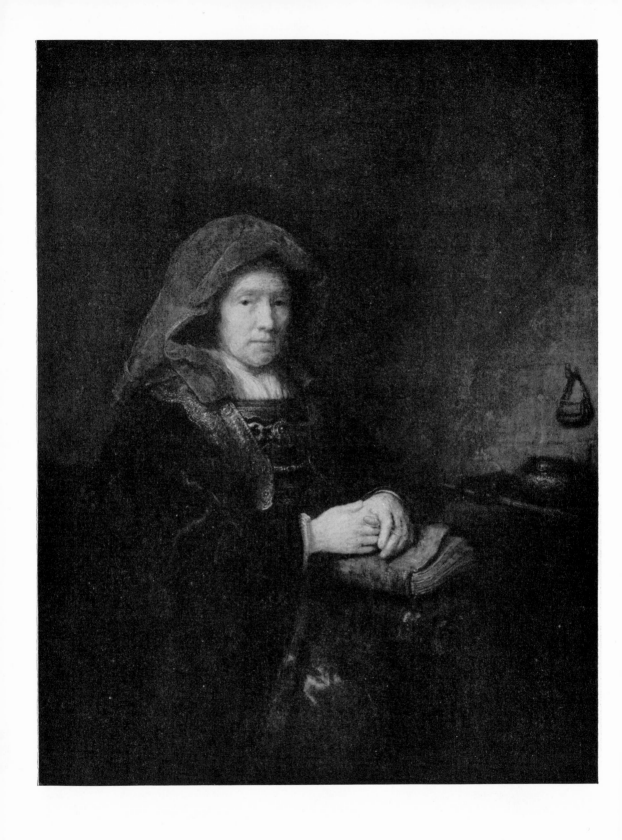

AN OLD WOMAN IN FANCIFUL COSTUME. 1643. Panel, 61×49 cm. Leningrad, Hermitage. (Br. 361)

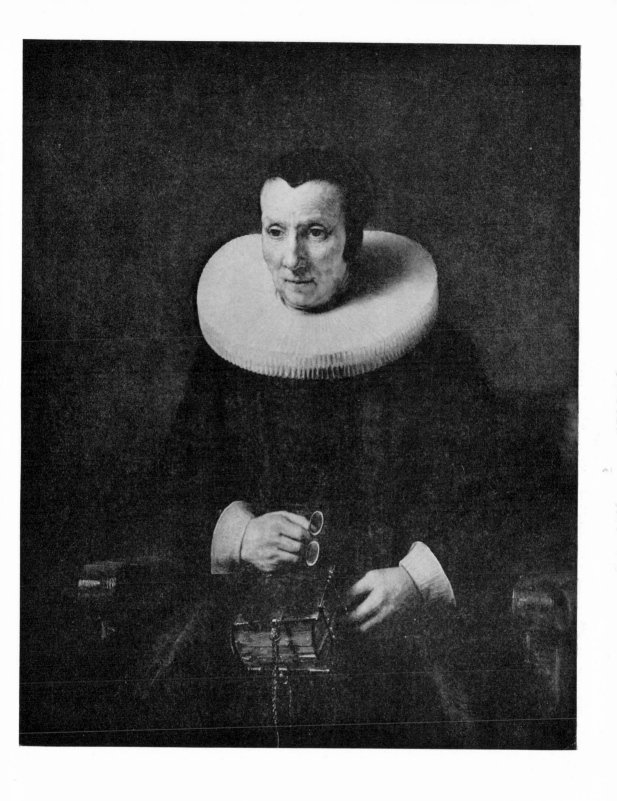

AN OLD WOMAN WITH A BOOK. 164(7). Canvas, 109×91·5 cm. Washington, D.C., National Gallery of Art (Mellon Collection). (Br. 362)

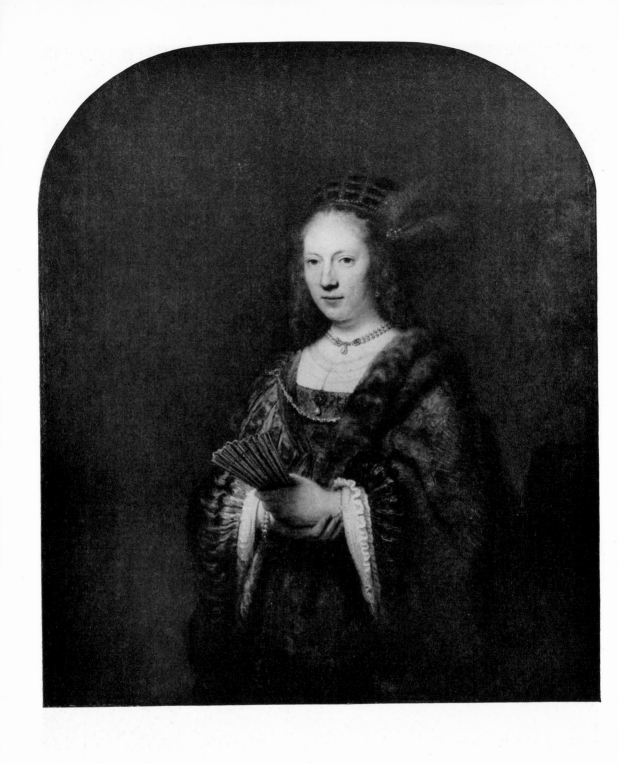

PORTRAIT OF A WOMAN WITH A FAN. 1643. Canvas, 114·5×98 cm. London, The Trustees of the 2nd Duke of Westminster and Anne, Duchess of Westminster. (Br. 363) Companion to Br. 224 reproduced on page 183

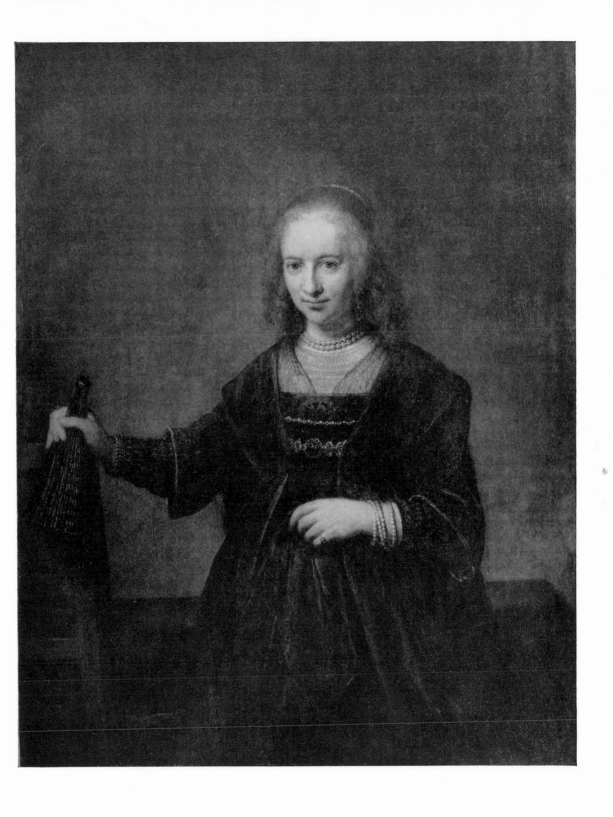

PORTRAIT OF A WOMAN IN A VELVET DRESS. 1643. Canvas, 119×96·5 cm. New York, Metropolitan Museum of Art. (Br. 364) Companion to Br. 223 reproduced on page 182

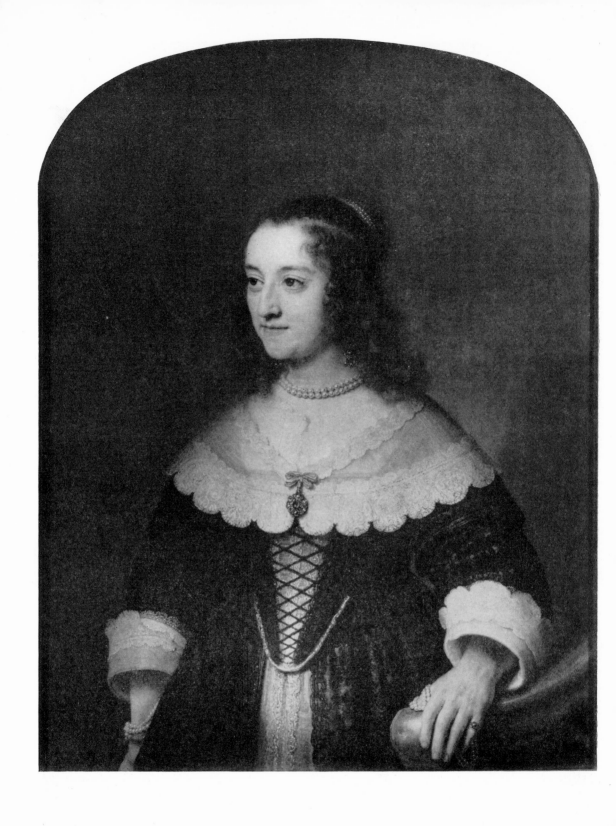

PORTRAIT OF A WOMAN. 1644. Panel, 93 × 73·5 cm. Buscot Park, The Trustees of the Faringdon Collection. (Br. 365)

STUDY OF A WOMAN WEEPING. Panel, 21.5 × 17 cm. Detroit, Institute of Arts. (Br. 366)

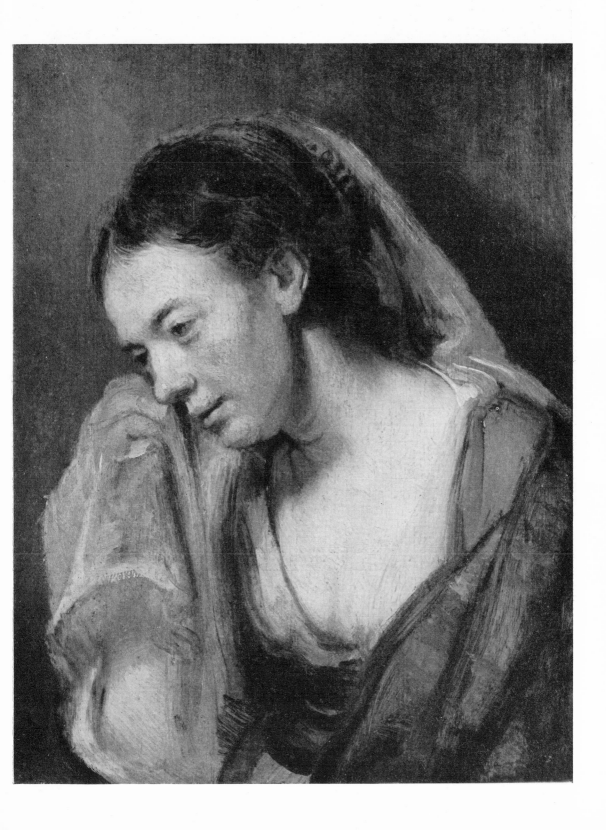

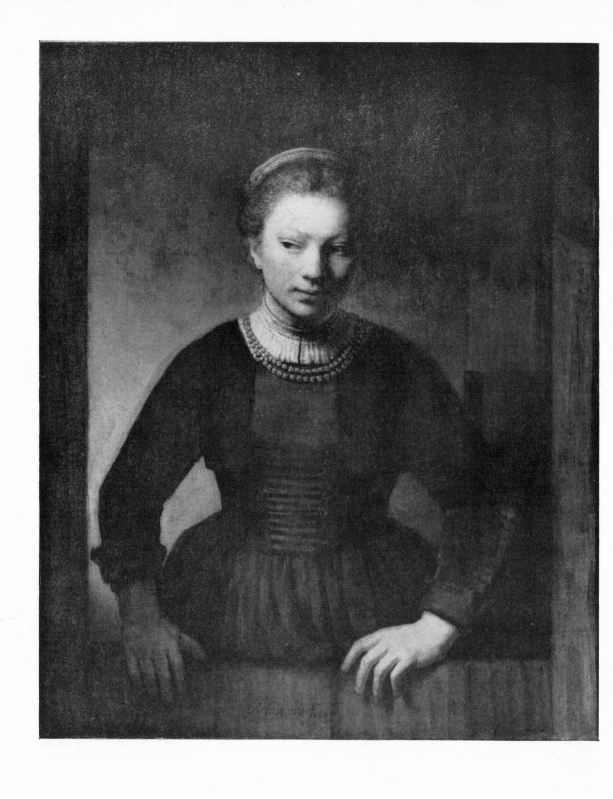

A Young Woman at a Door. 1645. Canvas, 102×84 cm. Chicago, Art Institute. (Br. 367)

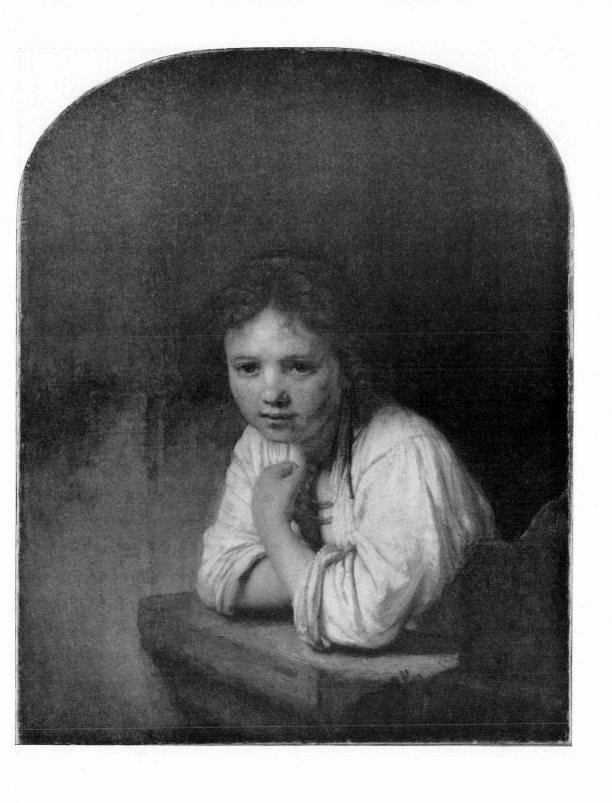

A Young Girl Leaning on a Window-sill. 1645. Canvas, 81.5×66 cm. London, Dulwich College Gallery. (Br. 368)

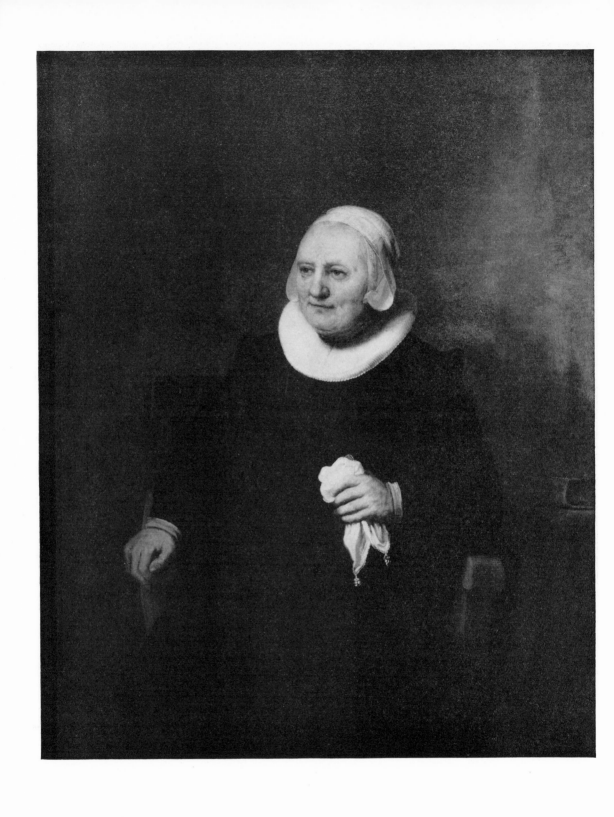

A Woman Seated in an Armchair. 1644. Canvas, 124.5×100 cm. Toronto, Art Gallery of Ontario. (Br. 369)

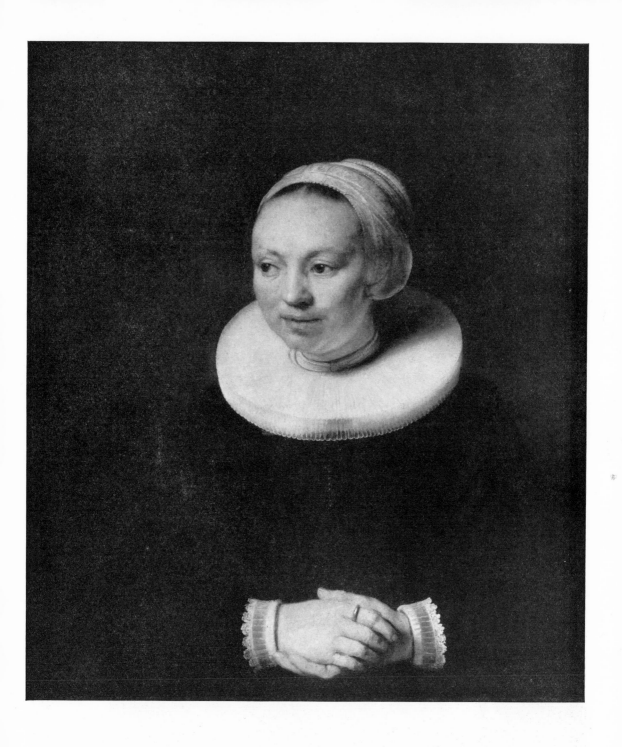

ADRIAENTJE HOLLAER, WIFE OF THE PAINTER HENDRICK MARTENSZ. SORGH. 1647. Panel, 74×67 cm.
London, The Trustees of the 2nd Duke of Westminster and Anne, Duchess of Westminster.
(Br. 370) Companion to Br. 251 reproduced on page 198

Head of a Girl. Panel, 21×17·5 cm. Wassenaar (The Hague), S. J. van den Bergh. (Br. 373)

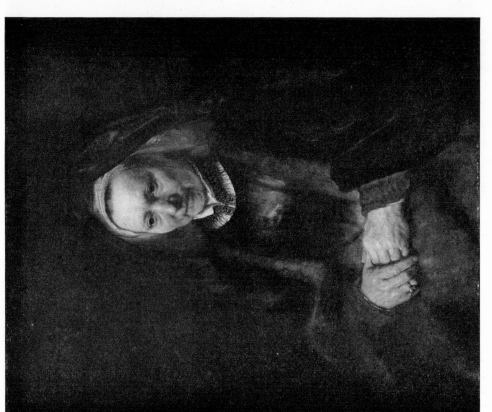

An Old Woman Seated. Canvas, 82×72 cm. Moscow, Pushkin Museum. (Br. 371)

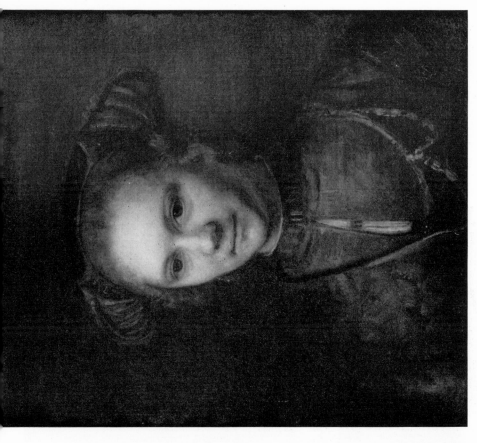

A YOUNG GIRL. 1651. Canvas, 58×48 cm. New York, J. Linsky.
(Br. 379)

A YOUNG GIRL. Panel, 22×19 cm. England, Private Collection.
(Br. 374)

A Young Girl at a Window. 1651. Canvas, 78×63 cm. Stockholm, Nationalmuseum. (Br. 377)

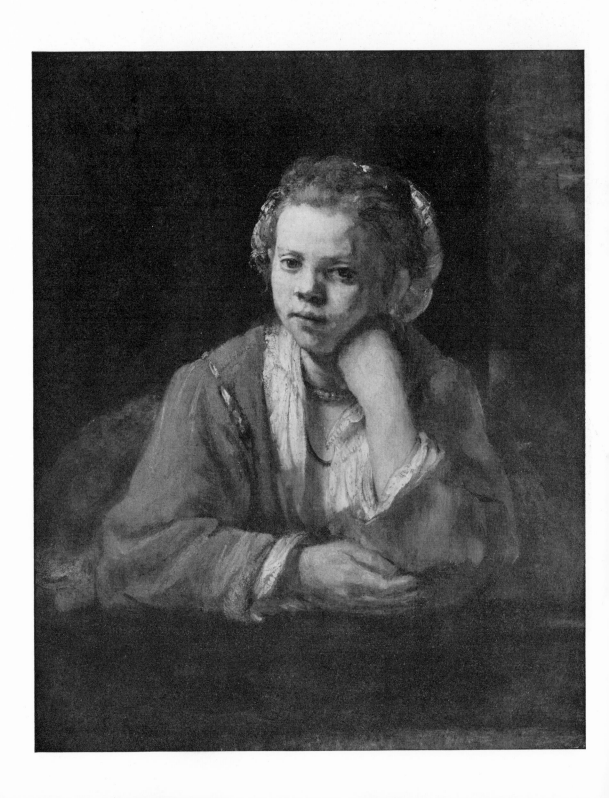

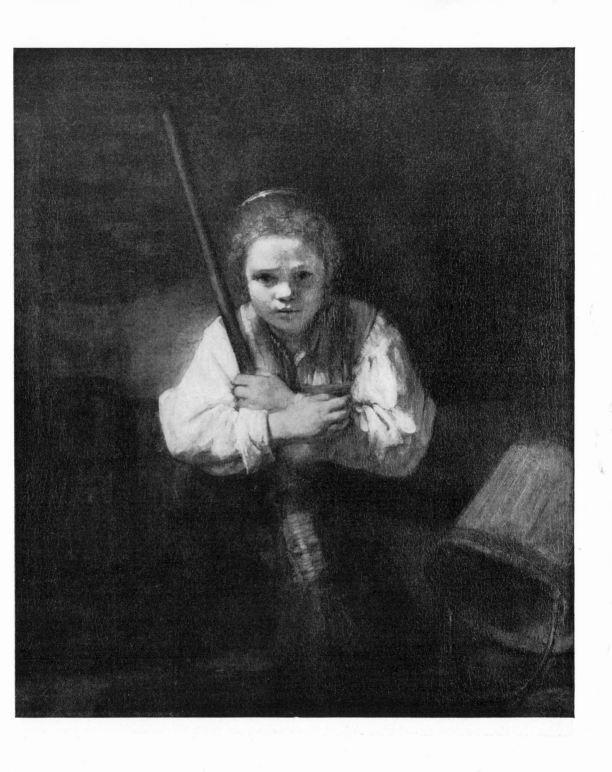

A Young Girl Holding a Broom. 1651(?). Canvas, 107·5×91·5 cm. Washington, D.C., National Gallery of Art (Mellon Collection). (Br. 378)

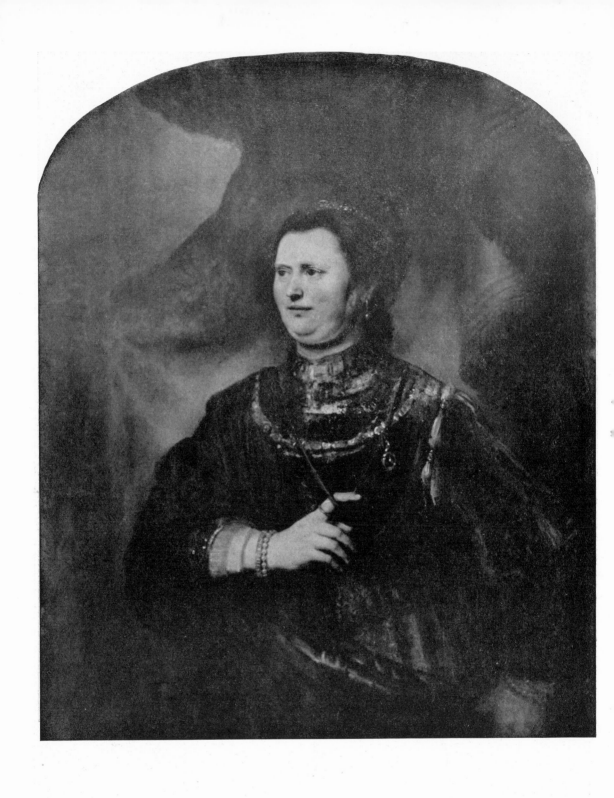

A Woman in Fanciful Costume. Panel, 137×101·5 cm. Sarasota, Florida, John and Mable Ringling Museum. (Br. 380) Companion to Br. 256 reproduced on page 200

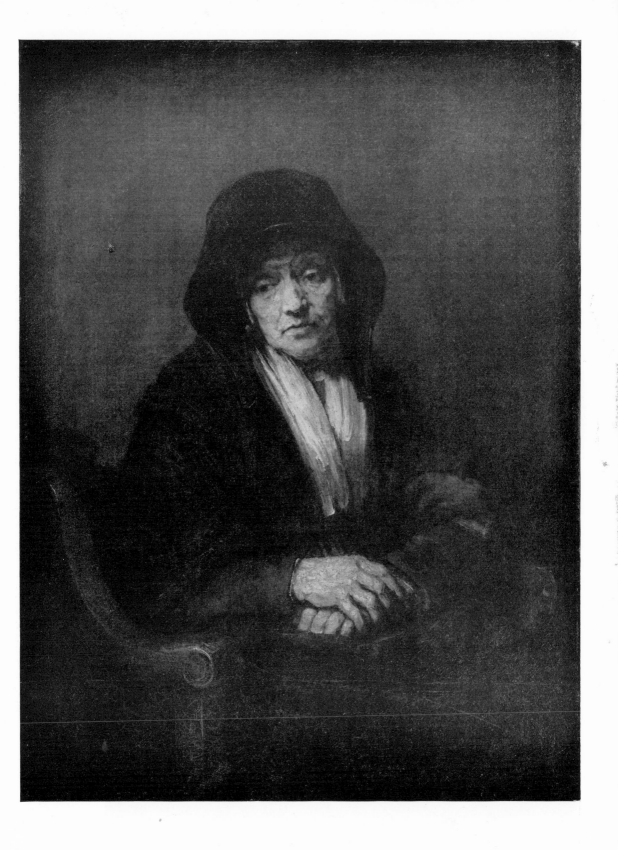

AN OLD WOMAN IN AN ARMCHAIR. 1654. Canvas, 109×84 cm. Leningrad, Hermitage.
(Br.381) Companion to Br.270 reproduced on page 207

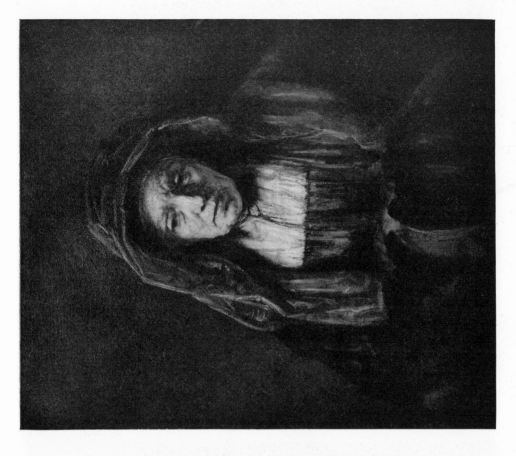

An Old Woman in a Hood. 1654. Canvas, 74×63 cm. Moscow, Pushkin Museum. (Br. 383)

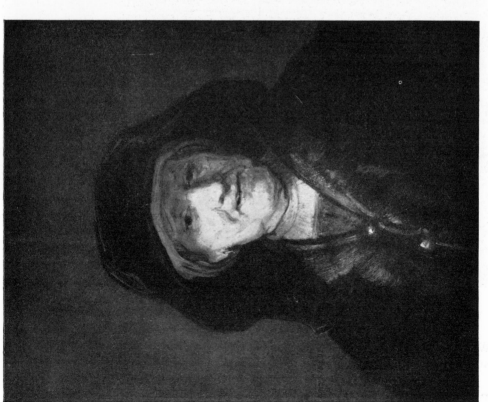

Portrait of an Old Woman. 165(?)2. Panel, 66×52 cm. Cincinnati, The Taft Museum. (Br.382)

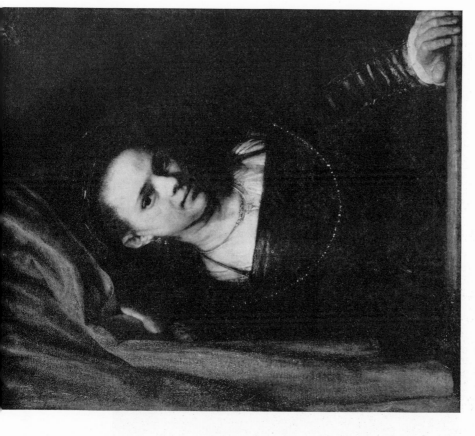

A Woman in Fanciful Costume. Canvas, 85×71 cm. Baltimore, The Walters Art Gallery. (Br. 386)

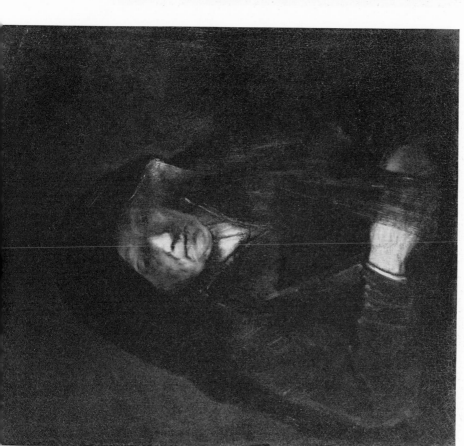

Portrait of an Old Woman. Canvas, 72×61 cm. Copenhagen, Statens Museum. (Br. 384)

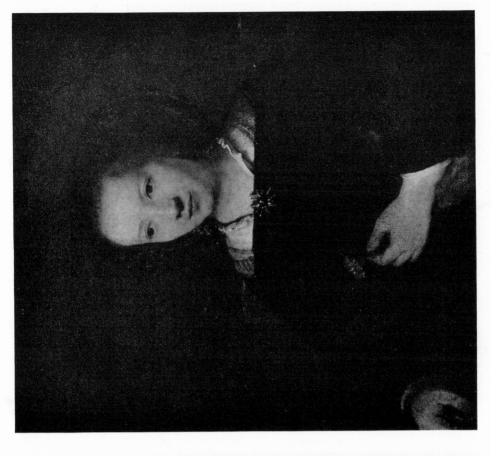

A Young Woman with a Carnation. 1656. Canvas, 78·5 × 68·5 cm. Copenhagen, Statens Museum. (Br. 389)

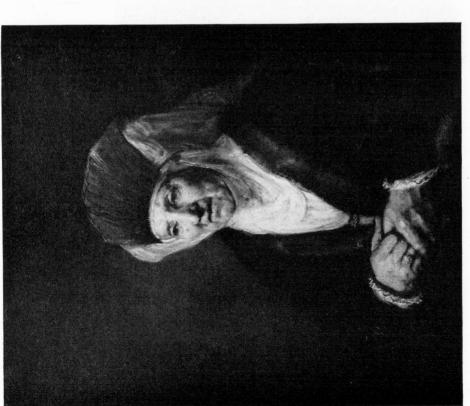

Portrait of an Old Woman. 1655. Canvas, 87 × 73 cm. Stockholm, Nationalmuseum. (Br. 388) Companion to Br. 280 reproduced on page 215

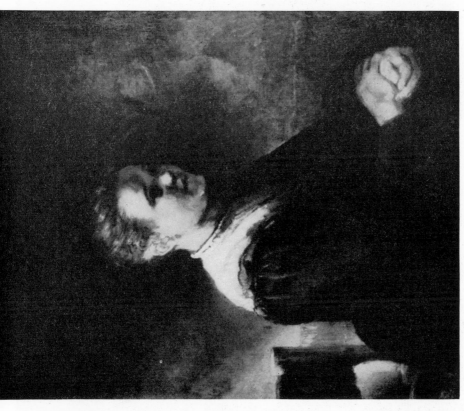

A YOUNG GIRL SEATED. 1660. Canvas, 77.5×65 cm. London, E.S. Borthwick Norton Sale, May 15, 1953 (lot 83). (Br. 393)

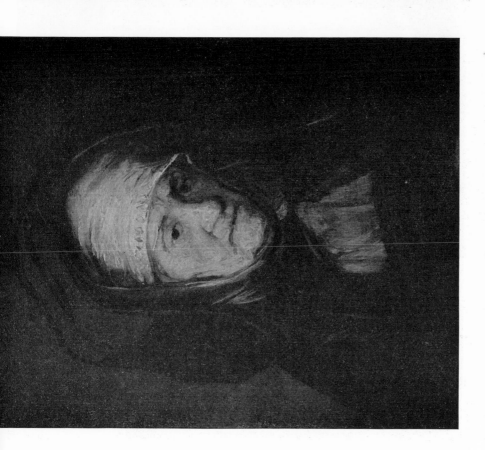

HEAD OF AN OLD WOMAN. 1657. Panel, 21×17 cm. Washington, D.C., National Gallery of Art (Widener Collection). (Br. 392)

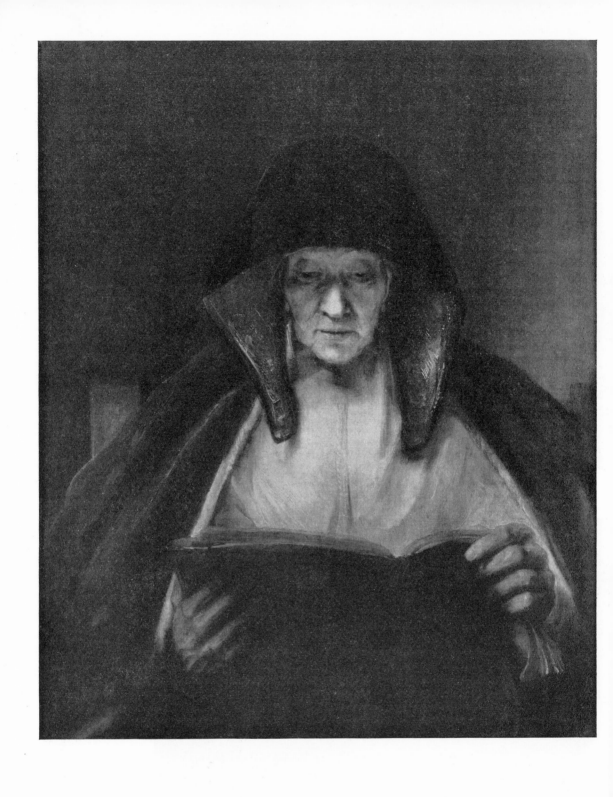

AN OLD WOMAN READING. 1655. Canvas, 79×65 cm. Drumlanrig Castle, Scotland, Duke of Buccleuch. (Br.385)

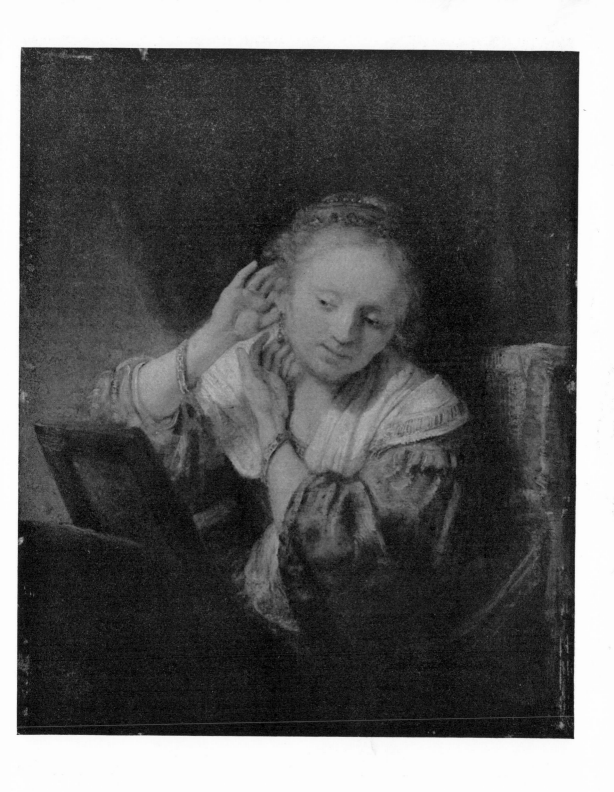

A Young Woman at her Mirror. 165(4?). Panel, 40×33 cm. Leningrad, Hermitage. (Br. 387)

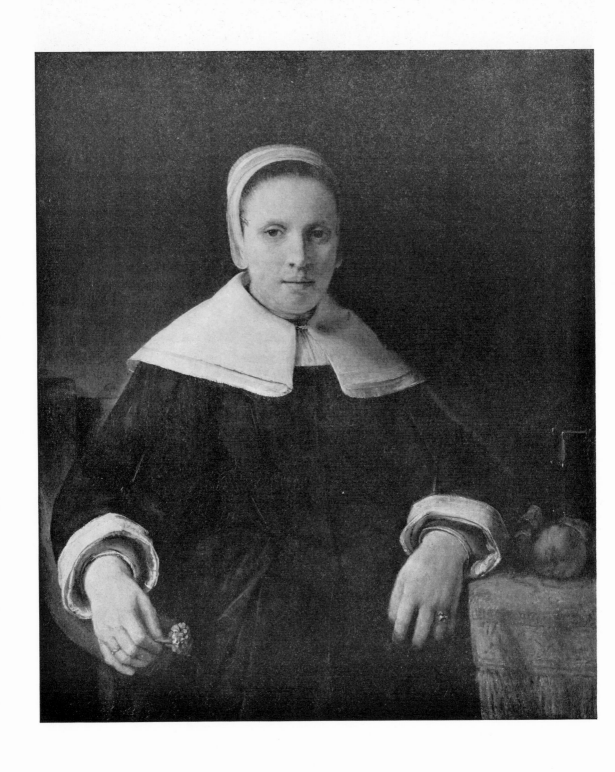

A YOUNG WOMAN WITH A CARNATION. 1656. Canvas, 103 × 86 cm. Washington, D.C., National
Gallery of Art (Mellon Collection). (Br. 390)

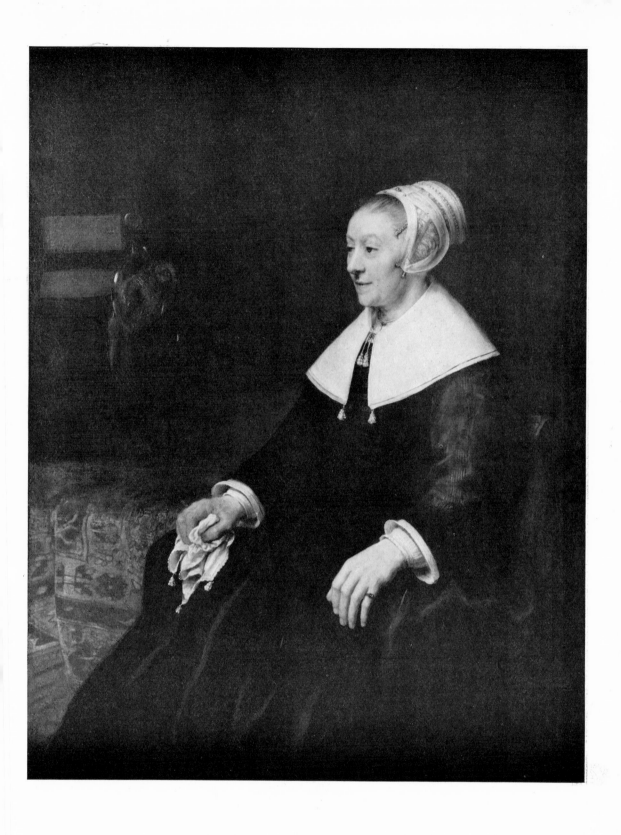

CATHARINA HOOGHSAET. 1657. Canvas, 123.5×95 cm. Penrhyn Castle, Caernarvonshire, Lady Janet Douglas Pennant. (Br.391)

DETAIL OF THE PORTRAIT OF MARGARETHA DE GEER REPRODUCED ON PAGE 306

GROUP PORTRAITS

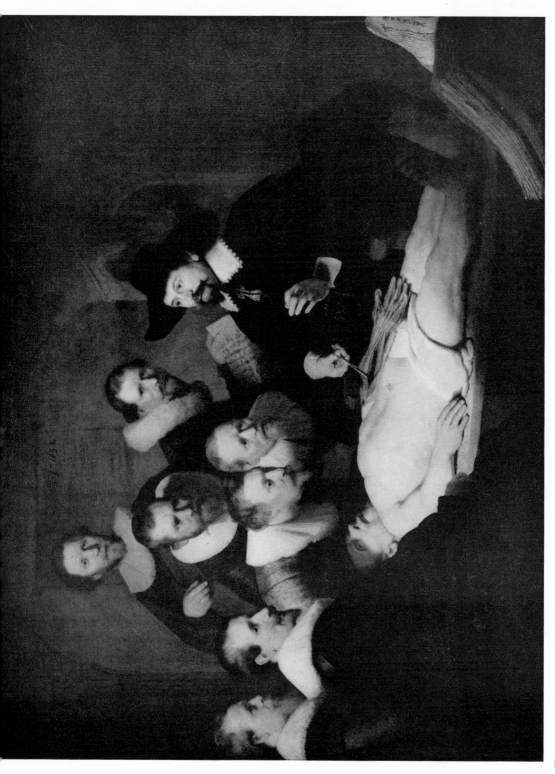

DOCTOR NICOLAES TULP DEMONSTRATING THE ANATOMY OF THE ARM. 1632. Canvas, 169.5 × 216.5 cm. The Hague, Mauritshuis. (Br. 403)

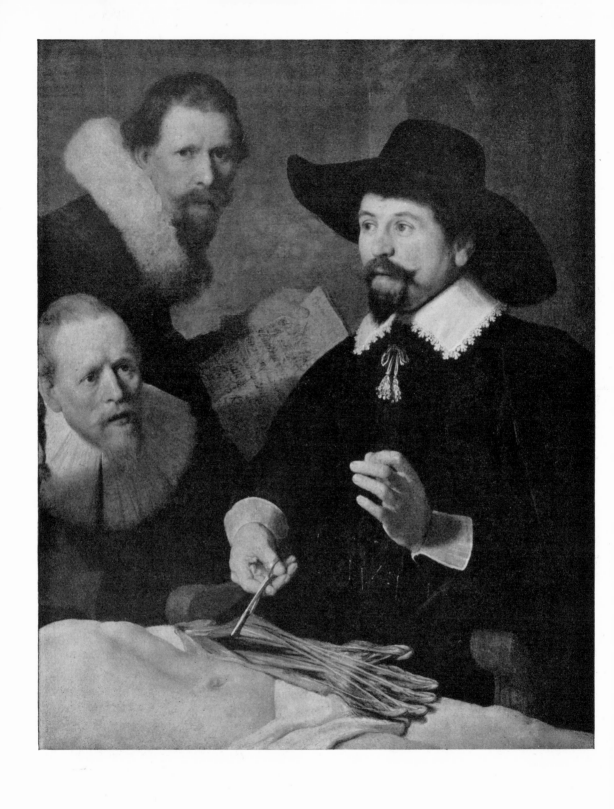

Detail of "the Anatomy Lesson" reproduced on page 317

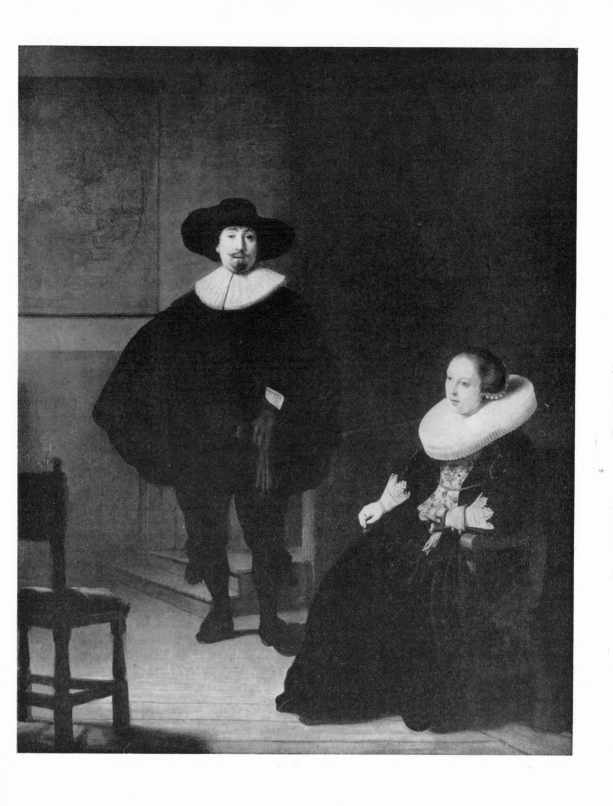

PORTRAIT OF A FASHIONABLY-DRESSED COUPLE. 1633. Canvas, 131×107 cm. Boston, Isabella Stewart Gardner Museum. (Br. 405)

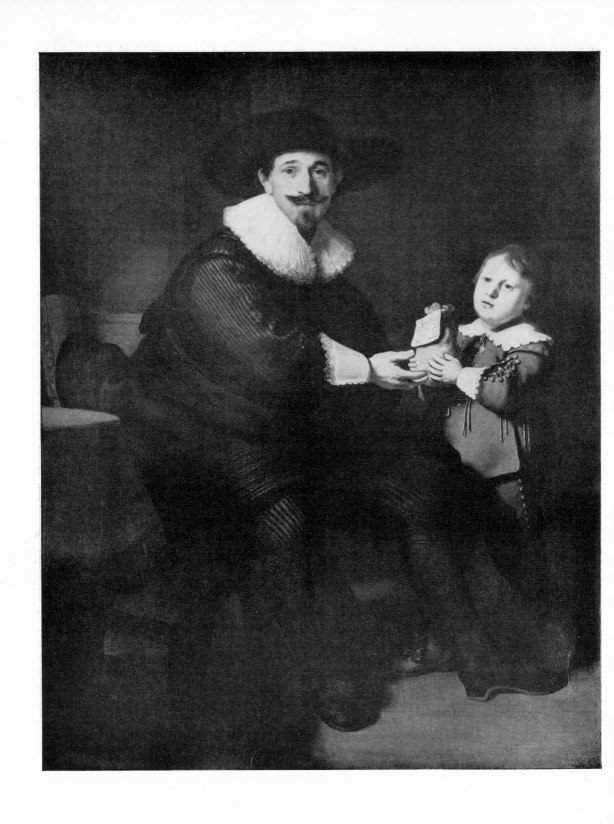

JAN PELLICORNE, WITH HIS SON CASPAR. Canvas, 155×123 cm. London, The Wallace Collection. (Br. 406)

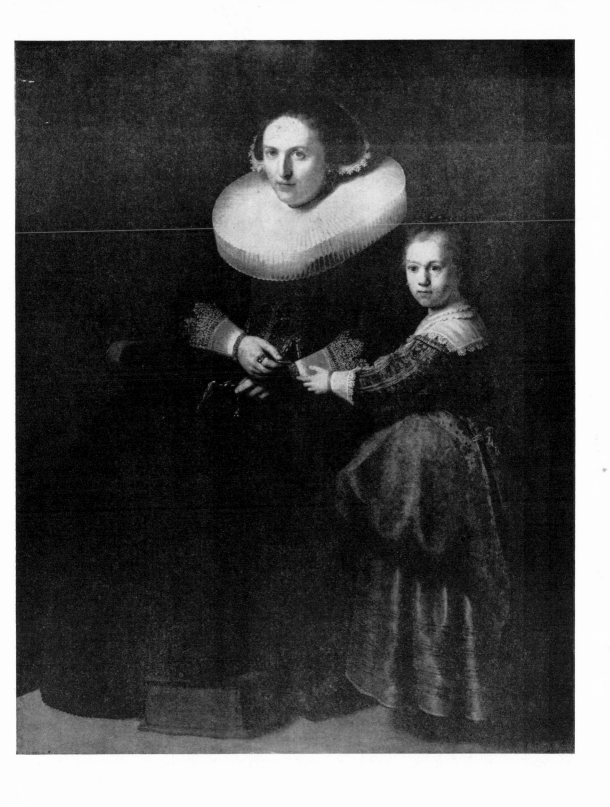

Susanna van Collen, Wife of Jan Pellicorne, with her daughter Eva Susanna. Canvas, 155 × 123 cm. London, The Wallace Collection. (Br. 407)

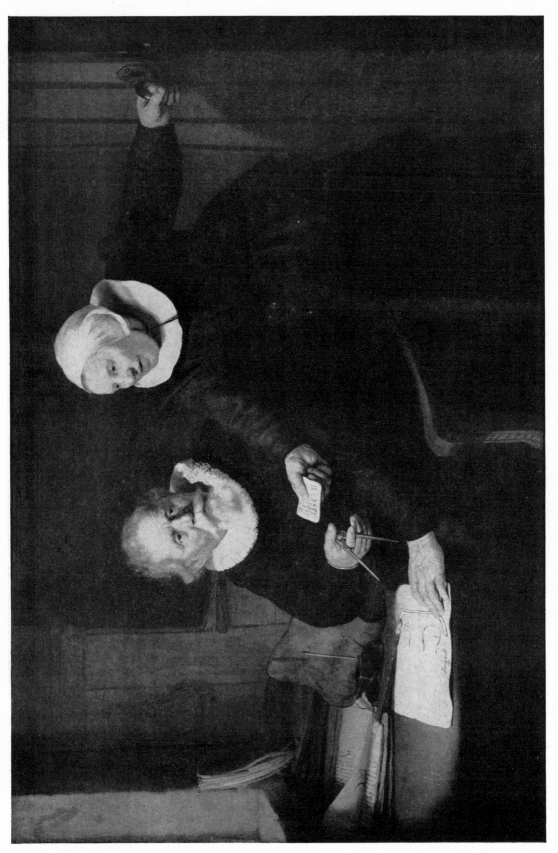

"The Shipbuilder and His Wife", 1633. Canvas, 115×168 cm. London, Buckingham Palace. (Br. 408)

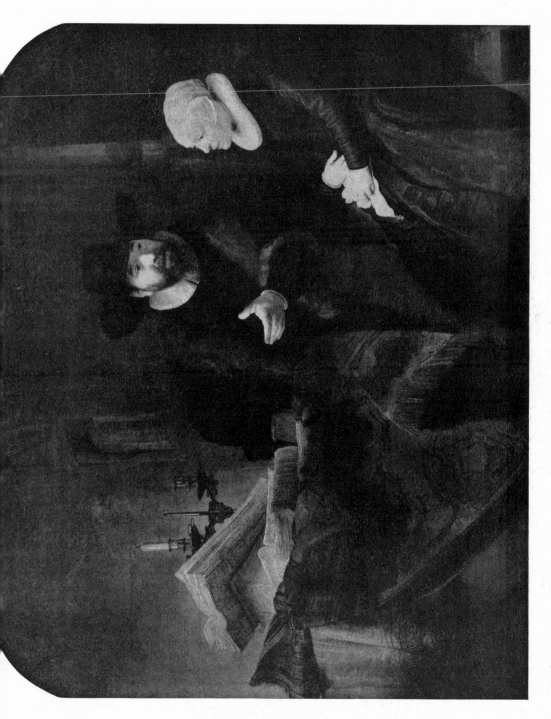

THE MENNONITE MINISTER CORNELIS CLAESZ. ANSLO IN CONVERSATION WITH A WOMAN. 1641. Canvas, 172×209 cm. Berlin-Dahlem, Gemäldegalerie. (Br. 409)

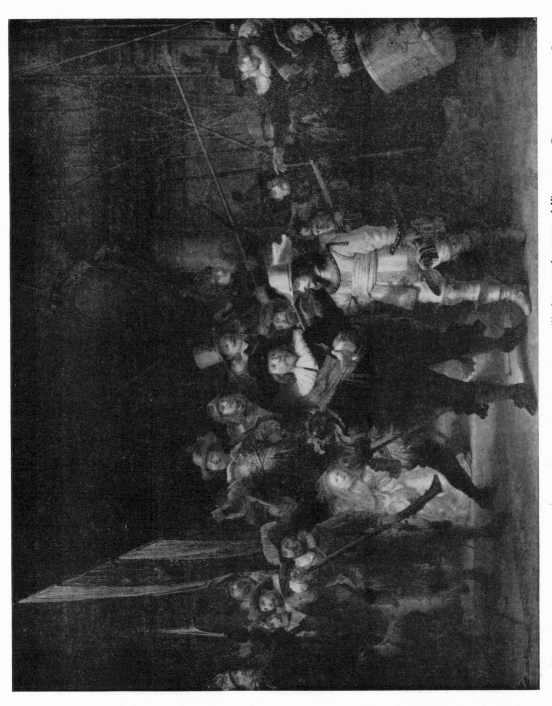

The Militia Company of Captain Frans Banning Cocq ("The Night Watch"). 1642. Canvas 359×438 cm. Amsterdam, Rijksmuseum. (Br. 410)

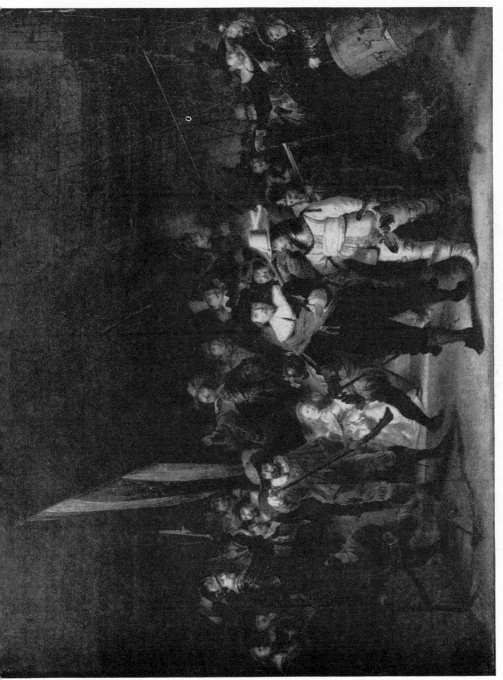

AFTER REMBRANDT (GERRIT LUNDENS?). Early copy of "THE NIGHT WATCH" in its original state, prior to mutilation. Panel, 67×85.5 cm. Amsterdam, Rijksmuseum (on loan from the National Gallery, London.)

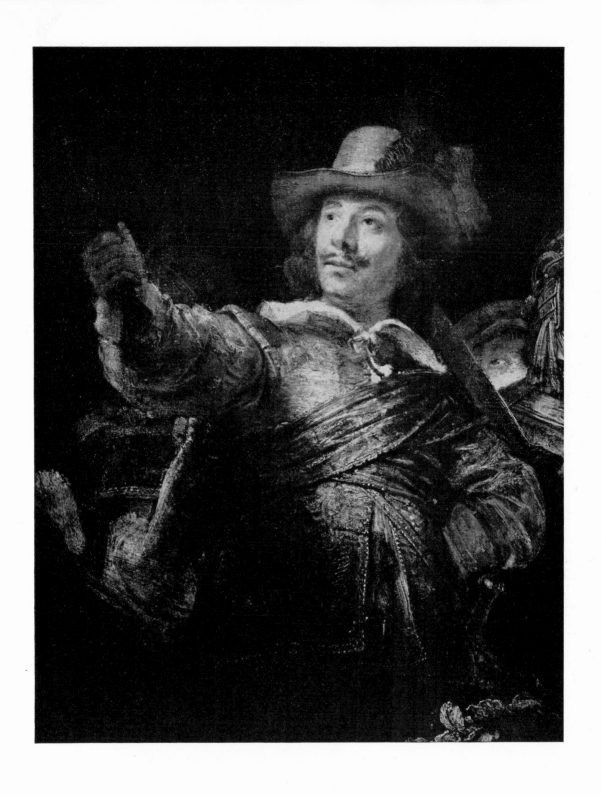

DETAIL FROM "THE NIGHT WATCH" REPRODUCED ON PAGE 324

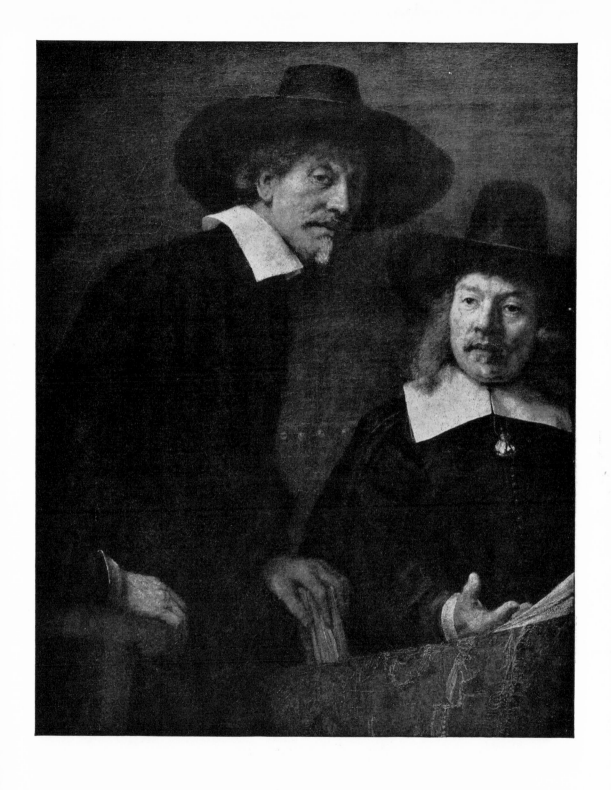

DETAIL FROM "DE STAALMEESTERS" REPRODUCED ON PAGE 329

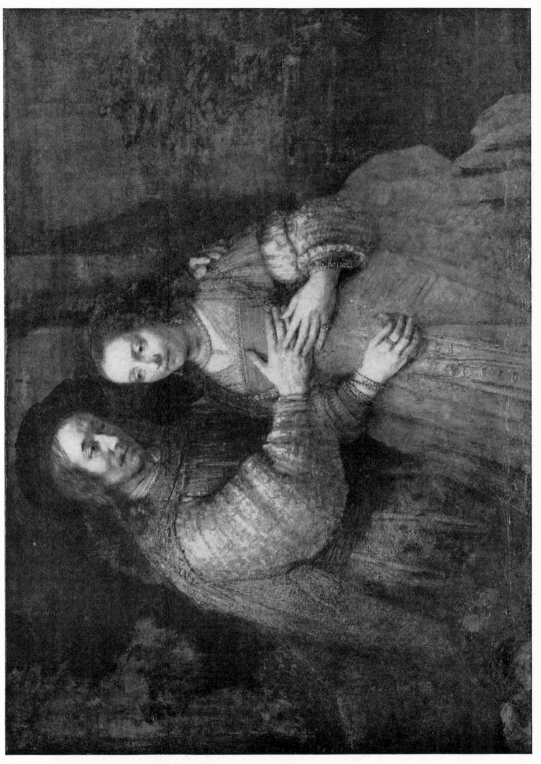

"The Jewish Bride" (Isaac and Rebecca?). Canvas, 121.5 × 166.5 cm. Amsterdam, Rijksmuseum. (Br. 416)

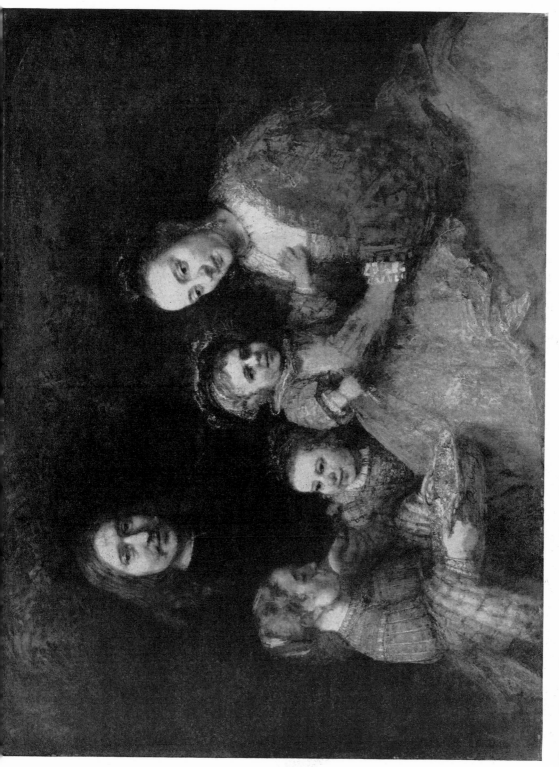

FAMILY GROUP. Canvas, 126 × 167 cm. Brunswick, Herzog Anton Ulrich Museum. (Br. 417)

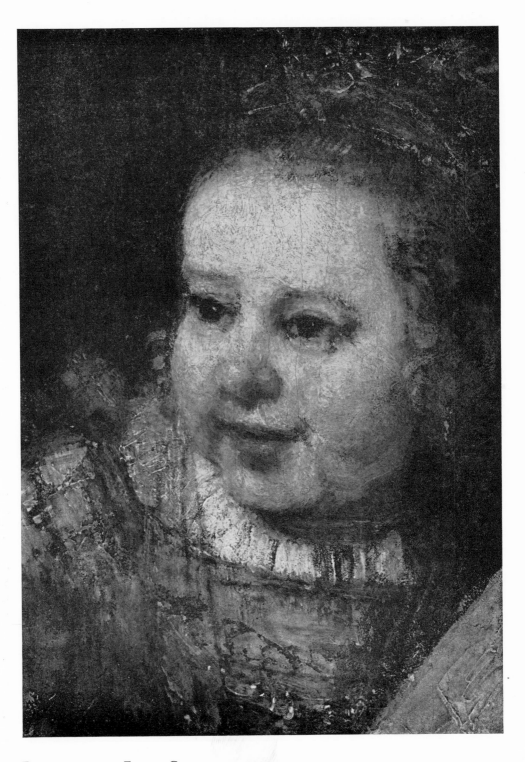

DETAIL FROM THE FAMILY GROUP REPRODUCED ON PAGE 331

GENRE

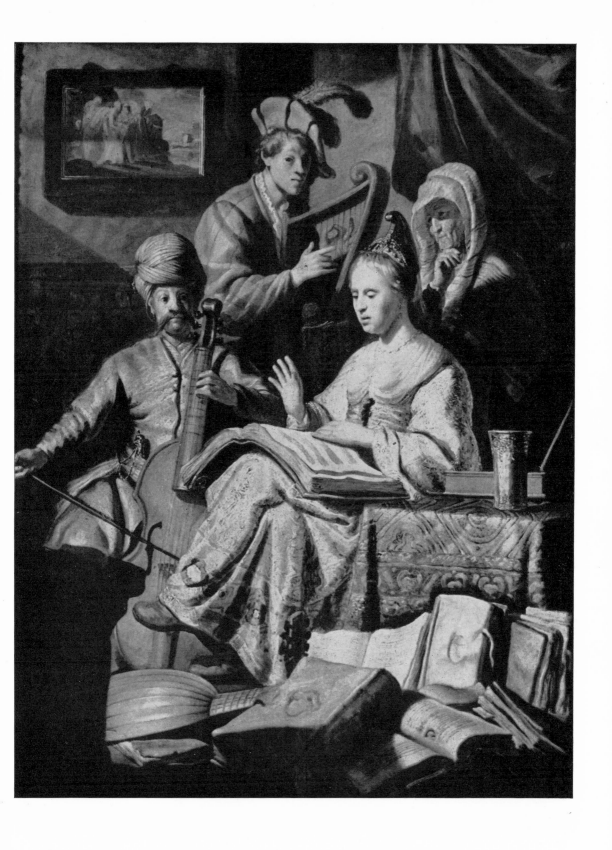

THE MUSIC-MAKERS. 1626. Panel, 63×48 cm. Paris, Sale N.K. (Katz), April 25. 1951. (Br. 632)

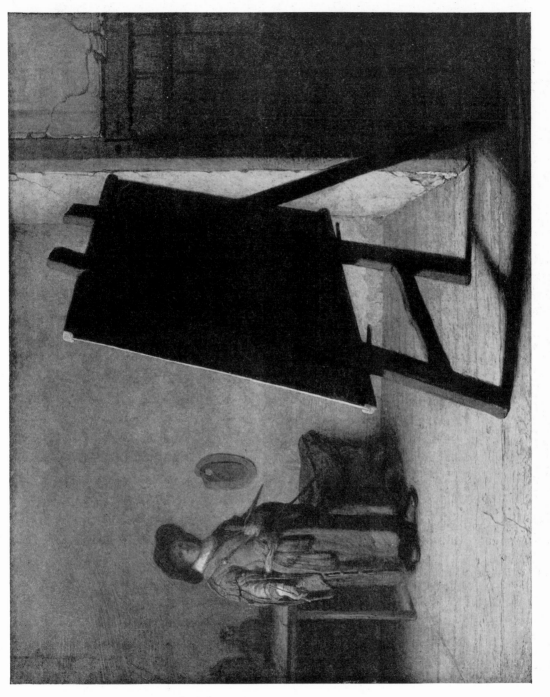

An Artist in his Studio ("The Easel"). Panel, 25×32 cm. Boston, Museum of Fine Arts. (Br. 419)

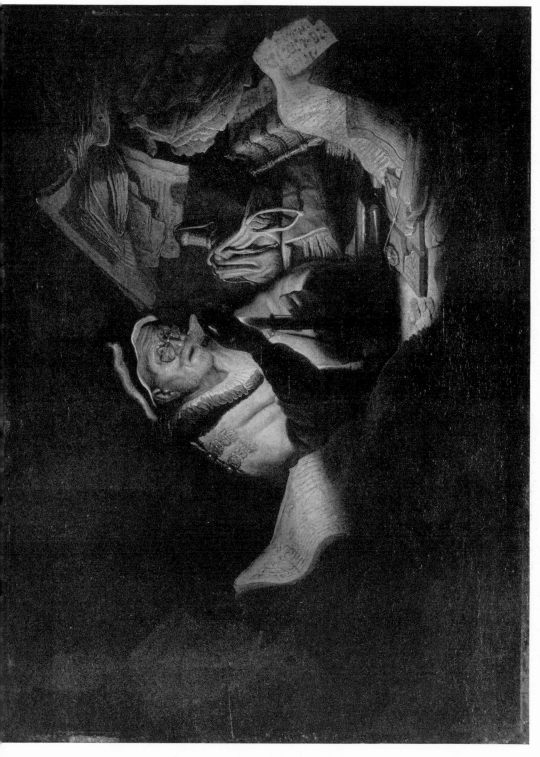

"The Money-changer". 1627. Panel, 32×42 cm. Berlin-Dahlem, Gemäldegalerie. (Br. 420)

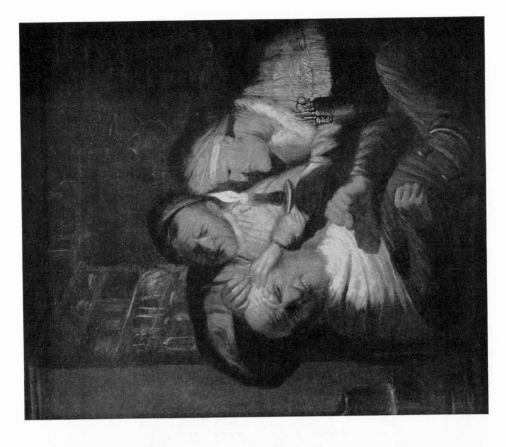

A Head Operation. Panel, 32×25 cm. Hoevelaken, N.J. van Aalst. (Br. 421A)

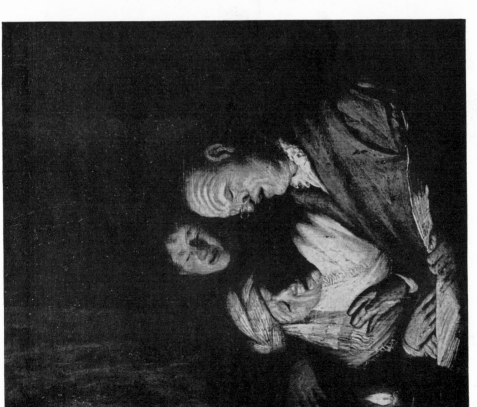

A Reading by Candle-light. Panel, 32×25 cm. Hoevelaken, N.J. van Aalst. (Br. 421)

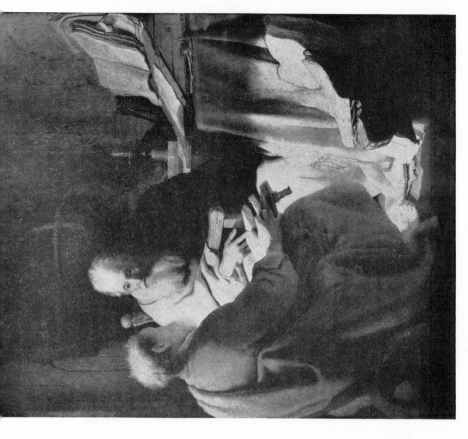

Two Scholars Disputing. 1628. Panel, 71×58·5 cm. Melbourne, National Gallery of Victoria. (Br. 423)

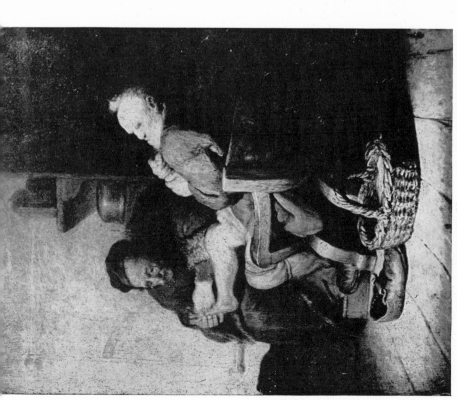

A Foot Operation. 1628. Panel, 31·5×24·5 cm. Zurich, Mrs. E. Haab-Escher. (Br. 422)

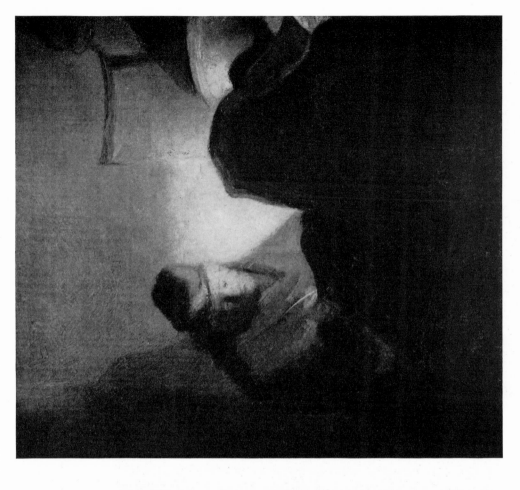

A SCHOLAR WRITING. Panel, 15·5×13·5 cm. Private Collection, U.S.A. (Br. 426)

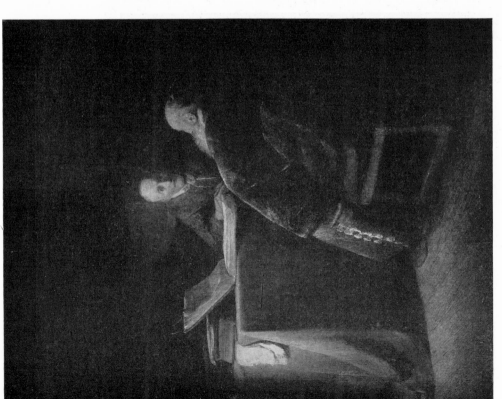

TWO SCHOLARS DISPUTING. Panel, 39×30·5 cm. Dortmund, Dr. F. Becker. (Br. 424)

An Old Man Asleep at the Hearth. 1629. Panel, 52×41 cm. Turin, Galeria Sabauda. (Br. 428)

A Scholar in a Lofty Room. Panel, 55·5×46·5 cm. London, National Gallery. (Br. 427)

A SCHOLAR IN A LOFTY ROOM ("St. Anastasius"). 1631. Panel, 60×48 cm. Stockholm, National-
museum. (Br. 430)

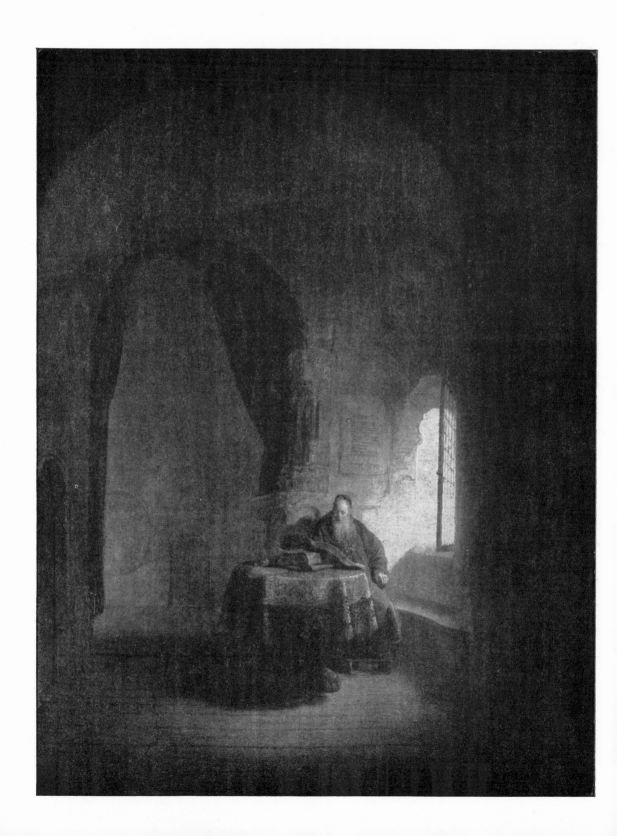

A Scholar in a Room with a Winding Stair. 1633. Panel, 29×33 cm. Paris, Louvre. (Br. 431)

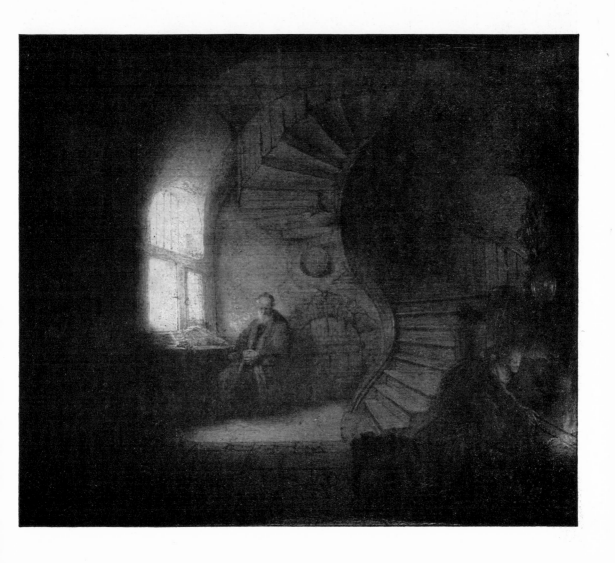

An Old Man at His Study Table. 164(3?) Panel, 70·5×53·5 cm. Budapest, Museum of Fine Arts, (Br. 435)

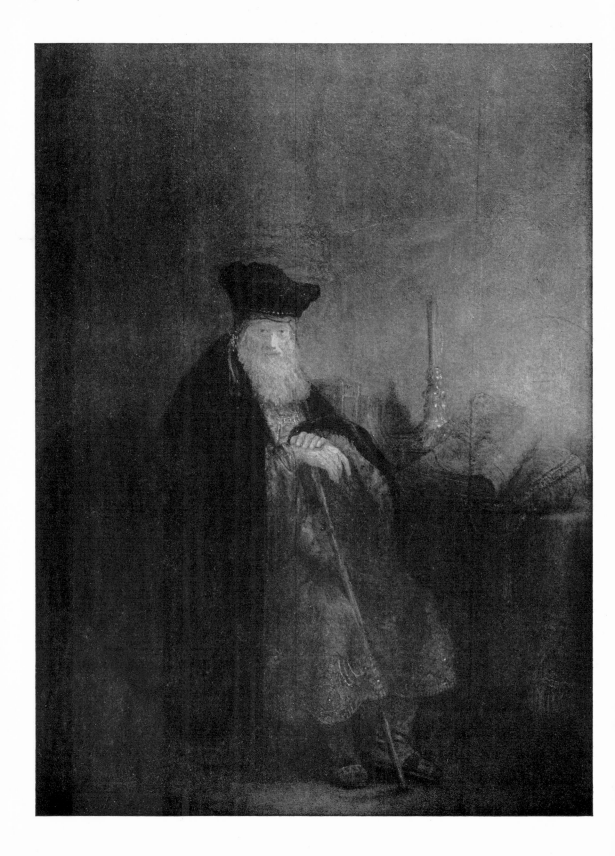

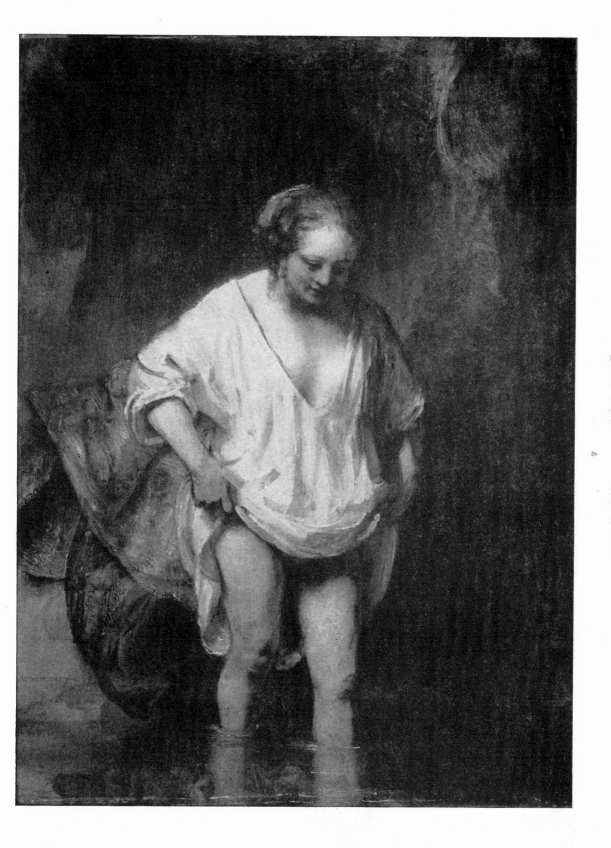

A Woman Bathing (Hendrickje Stoffels?). 165(4?). Panel, 61·5×47 cm. London, National Gallery. (Br. 437)

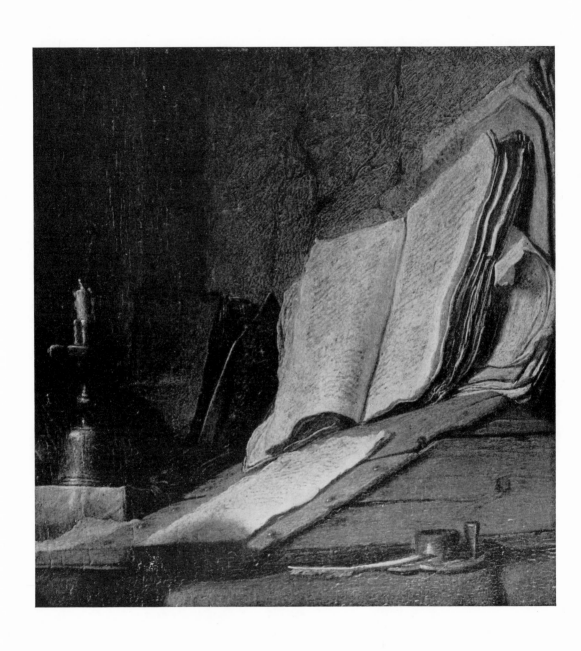

DETAIL FROM THE "TWO SCHOLARS DISPUTING" REPRODUCED ON PAGE 339

LANDSCAPES
AND
ANIMAL STUDIES

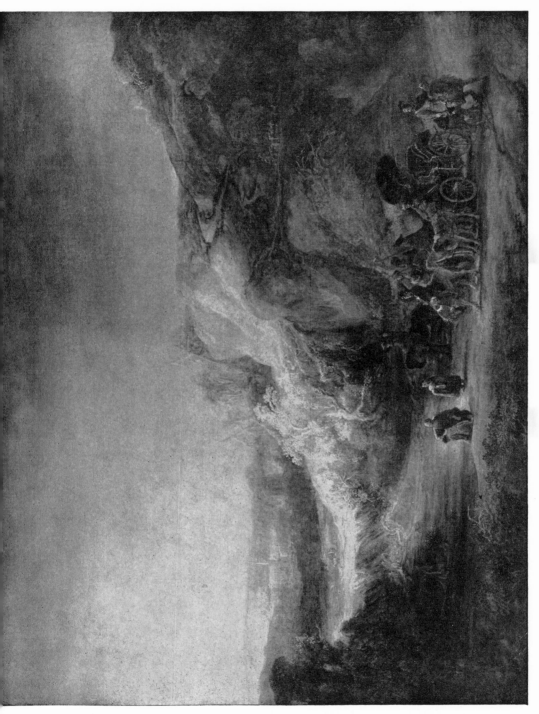

LANDSCAPE WITH THE BAPTISM OF THE EUNUCH. 1636. Canvas, 85.5×108 cm. Hanover, Landesmuseum (on loan). (Br. 439)

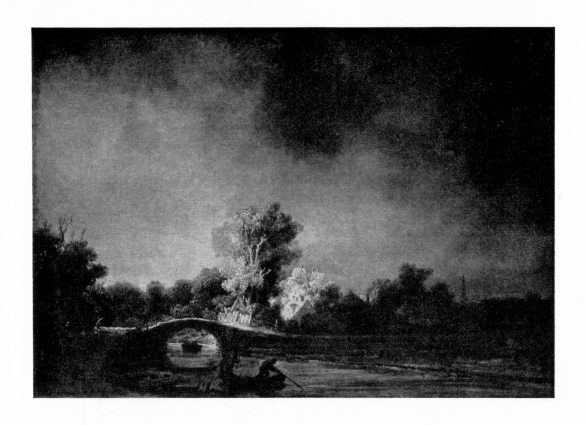

LANDSCAPE WITH A STONE BRIDGE. Panel, 29·5 × 42·5 cm. Amsterdam, Rijksmuseum. (Br. 440)

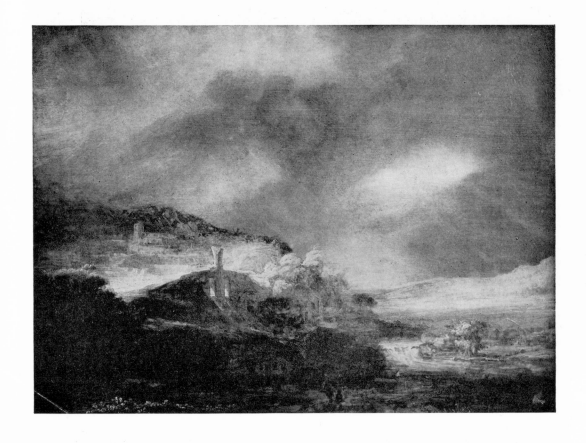

STORMY LANDSCAPE. Panel, 52 × 72 cm. Brunswick, Herzog Anton Ulrich Museum. (Br. 441)

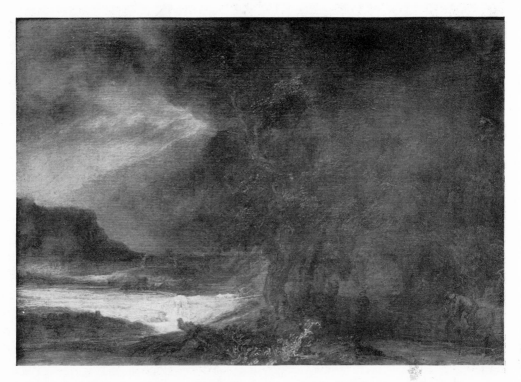

STORMY LANDSCAPE, WITH THE GOOD SAMARITAN. 1638. Panel, 46·5×66 cm. Cracow, Czartoryski Museum. (Br. 442)

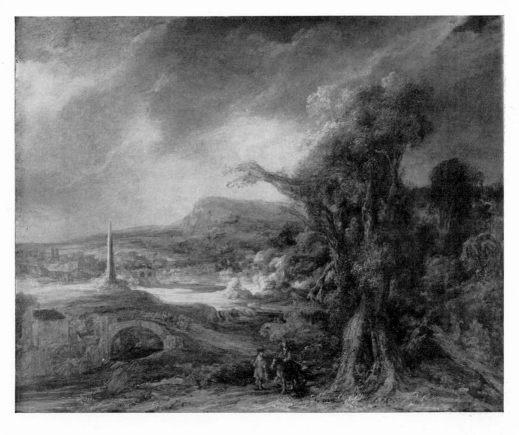

LANDSCAPE WITH AN OBELISK. 1638(?). Panel, 55×71·5 cm. Boston, Isabella Stewart Gardner Museum. (Br. 443)

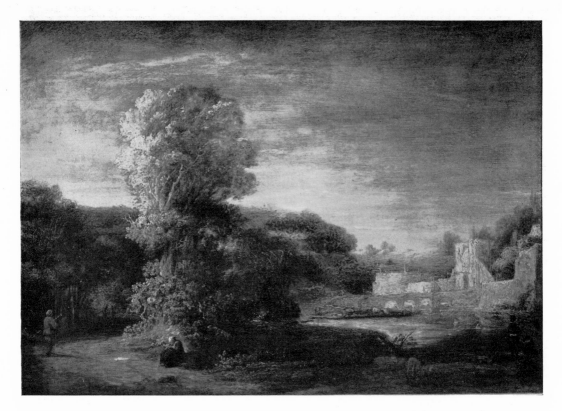

WOODY LANDSCAPE WITH RUINS. Panel, 30×46 cm. Wassenaar (The Hague), Private Collection. (Br. 444)

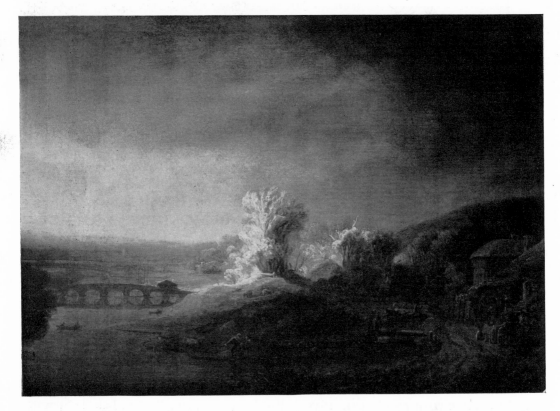

STORMY LANDSCAPE, WITH AN ARCHED BRIDGE. Panel, 28×40 cm. Berlin-Dahlem, Gemälde-galerie. (Br. 445)

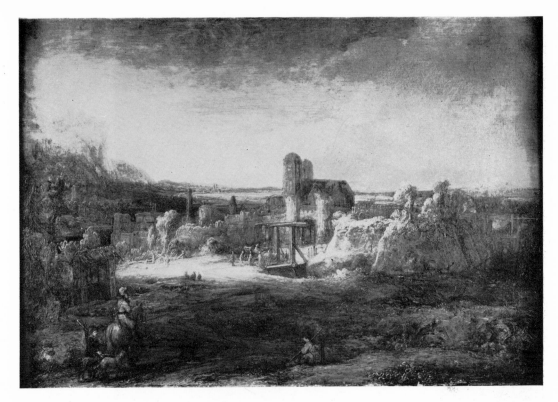

LANDSCAPE WITH A CHURCH. Panel, 42×60 cm. Madrid, Duke of Berwick and Alba. (Br. 446)

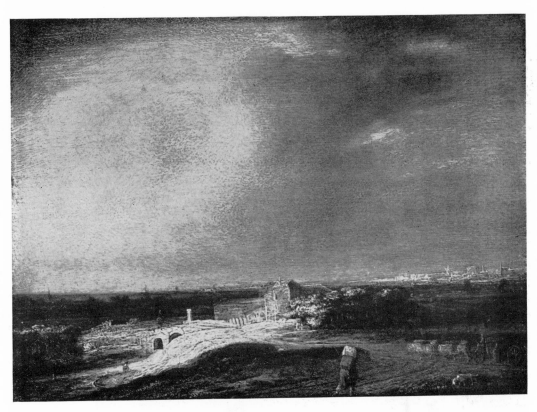

LANDSCAPE WITH A DISTANT TOWN. Panel, 22×29.5 cm. Lugano, Baron H. Thyssen-Bornemisza. (Br. 447)

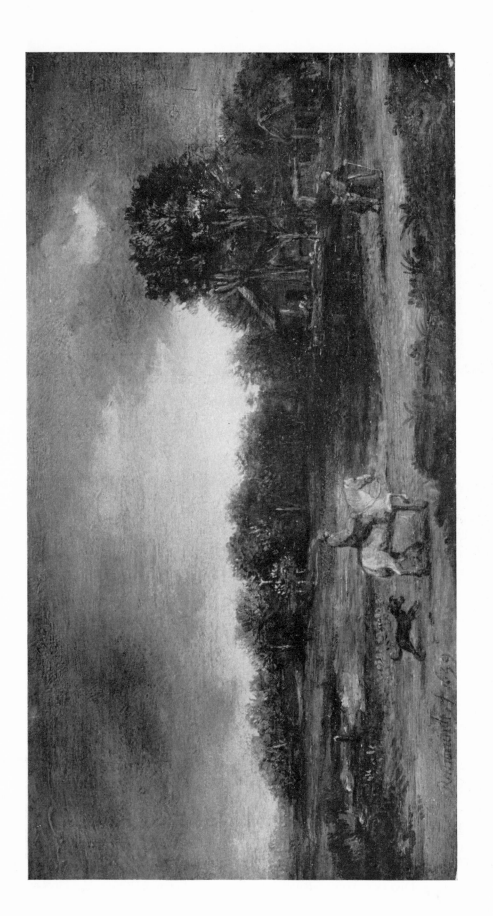

EVENING LANDSCAPE WITH A HORSEMAN. 1639. Panel, 19.5 × 36.5 cm. Oslo, National Gallery. (Br. 448)

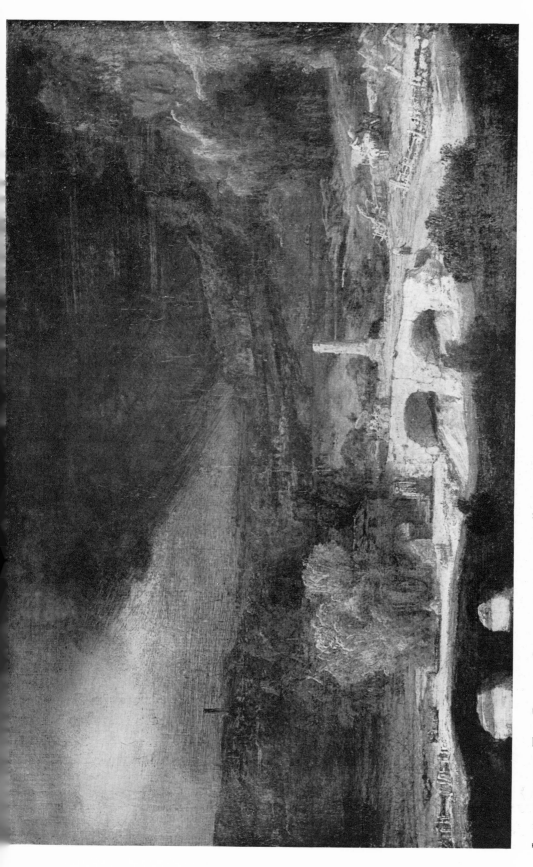

LANDSCAPE WITH TWO BRIDGES. Canvas, 38 × 62 cm. Eindhoven, Mrs. A. H. E. M. Philips-de Jongh. (Br. 449)

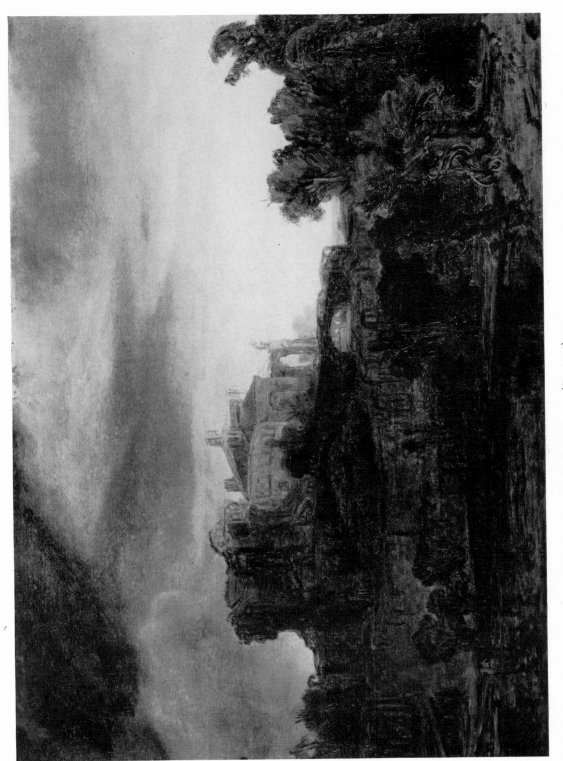

LANDSCAPE WITH A CASTLE. Panel, 44·5 × 70 cm. Paris, Louvre. (Br. 450)

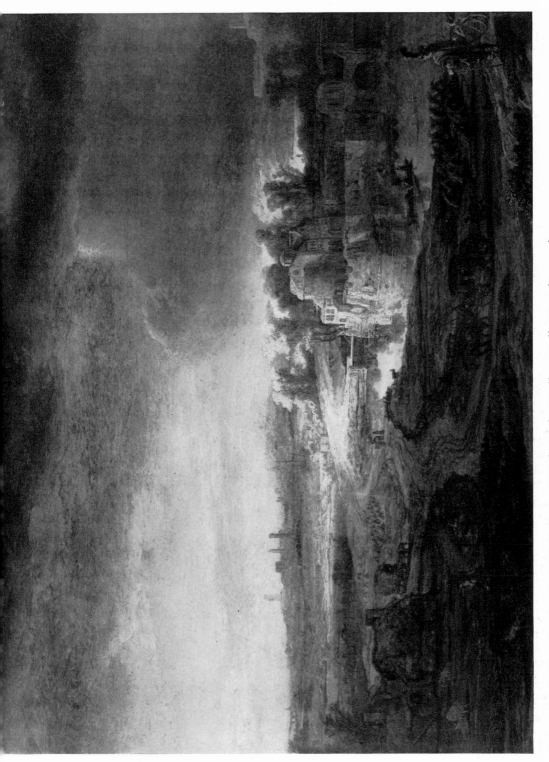

LANDSCAPE WITH A COACH. Panel, 46×64 cm. London, The Wallace Collection. (Br. 451)

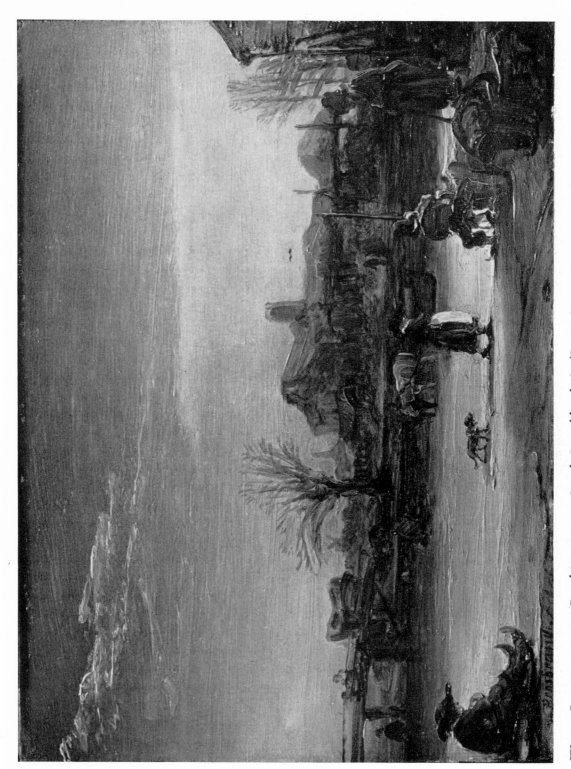

WINTER LANDSCAPE. 1646. Panel, 17×23 cm. Cassel, Gemäldegalerie. (Br. 452)

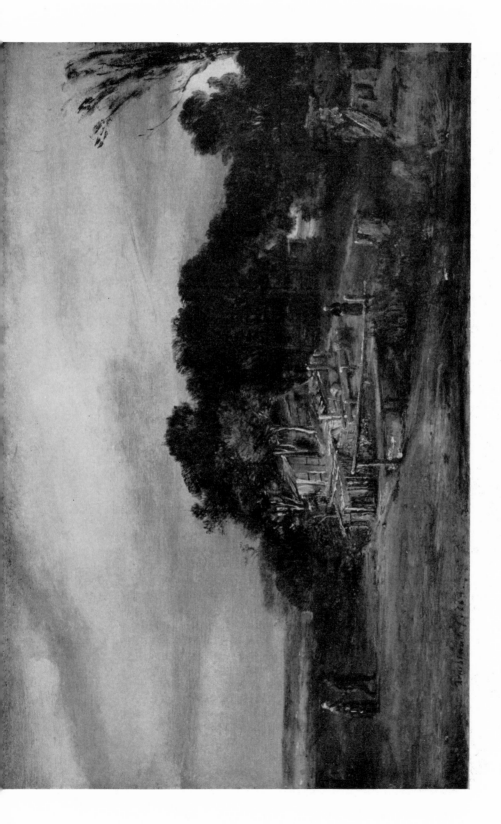

EVENING LANDSCAPE WITH COTTAGES. 1654. Panel, 25·5 × 39·5 cm. Montreal, Museum of Fine Arts. (Br. 453)

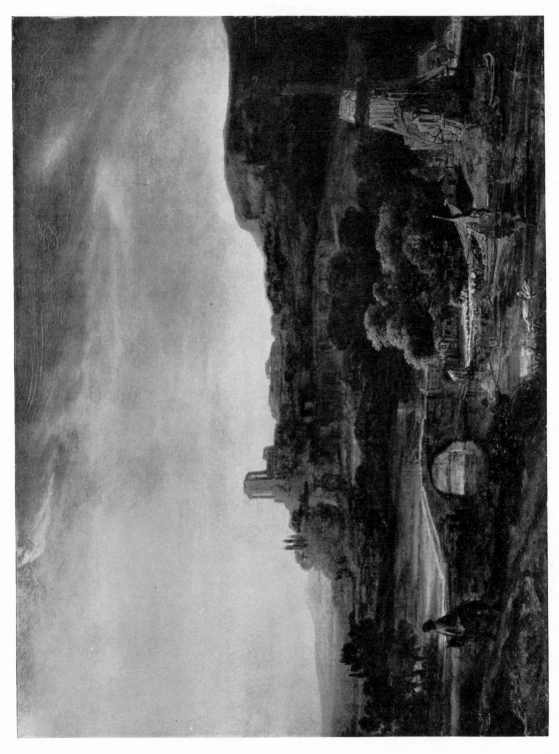

River Landscape with Ruins. Panel, 67×87·5 cm. Cassel, Gemäldegalerie. (Br. 454)

Detail of the River Landscape with Ruins

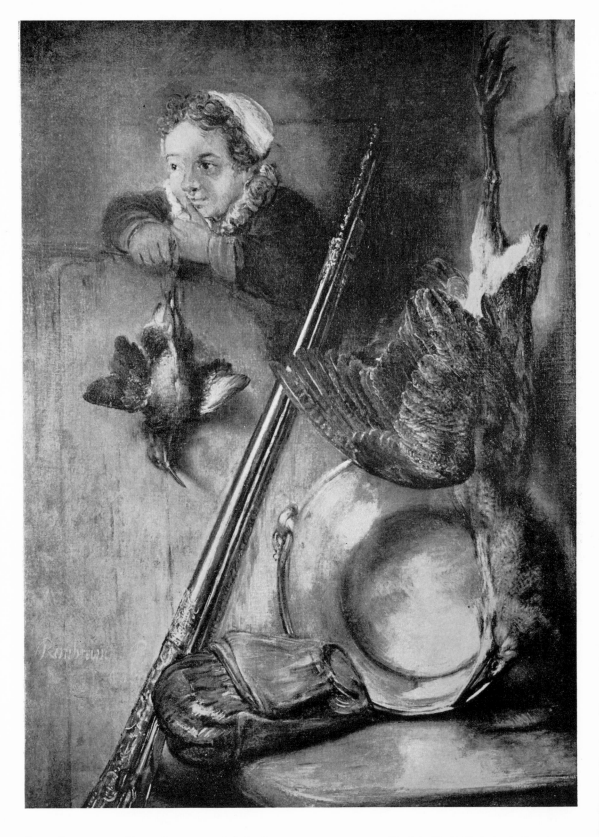

STILL-LIFE WITH A DEAD BITTERN. 163(7?). Canvas, 120·5×91 cm. Zurich, E. G. Bührle Collection. (Br. 455)

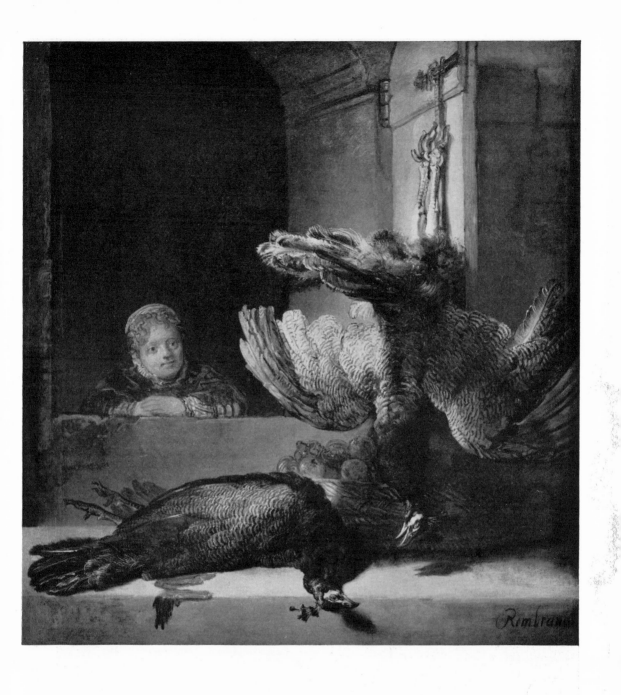

CHILD WITH DEAD PEACOCKS. Canvas, 145×135.5 cm. Amsterdam, Rijksmuseum. (Br. 456)

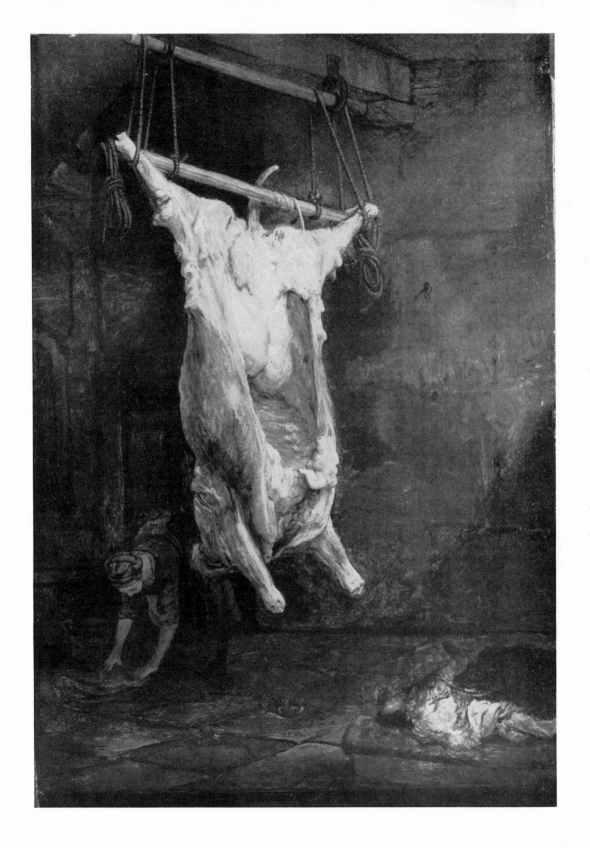

THE SLAUGHTERED OX. Panel, 73·5 × 51·5 cm. Glasgow, Art Gallery and Museum. (Br. 458)

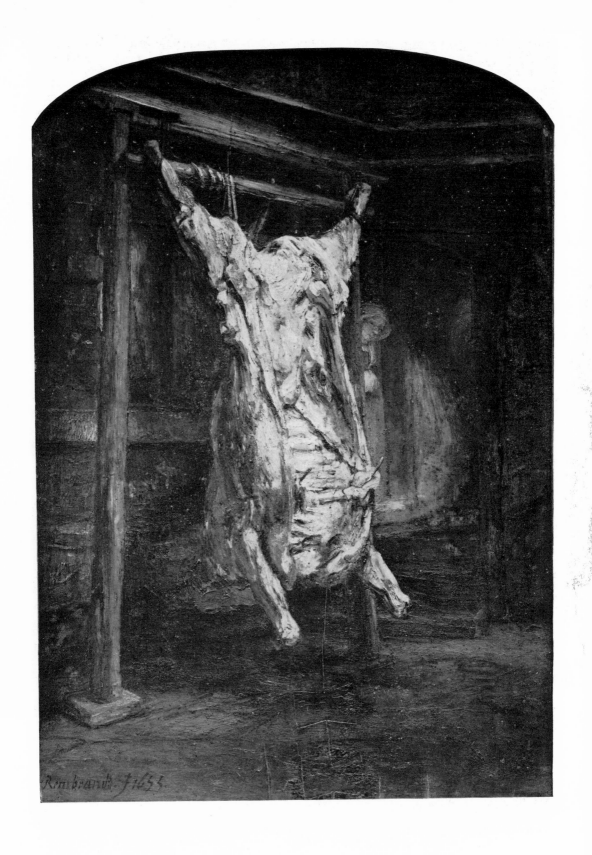

THE SLAUGHTERED OX. 1655. Panel, 94×67 cm. Paris, Louvre. (Br. 457)

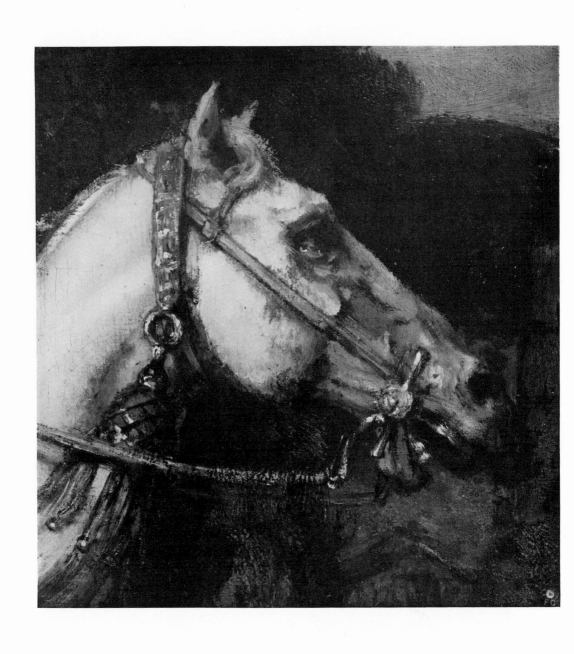

Detail of "The Polish Rider", Reproduced on Page 214

PROFANE HISTORY
MYTHOLOGY
ALLEGORY

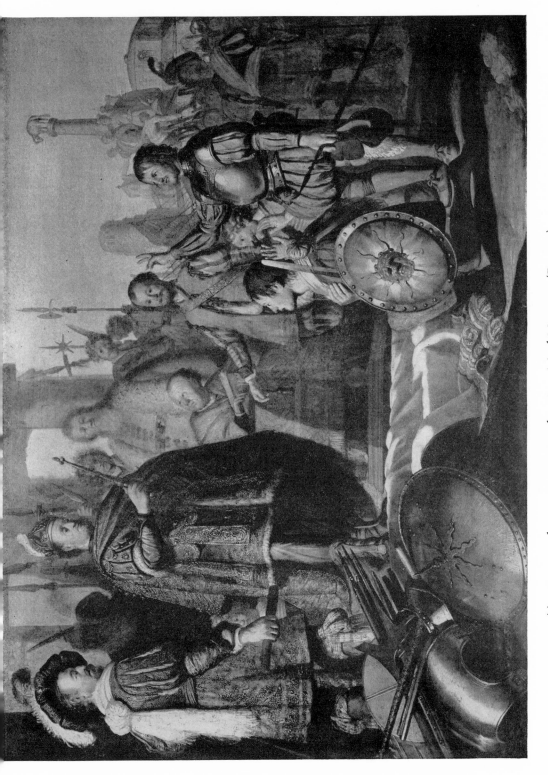

THE JUSTICE OF BRUTUS (?). 1626. Panel, 90×121 cm. Leyden, Municipal Museum. (Br. 460)

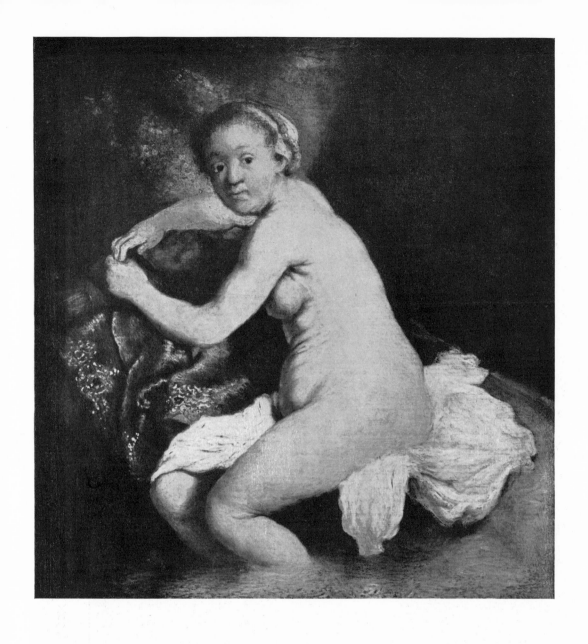

Diana Bathing. Panel, 18 × 17 cm. Amsterdam, A. H. Kleiweg de Zwaan. (Br. 461)

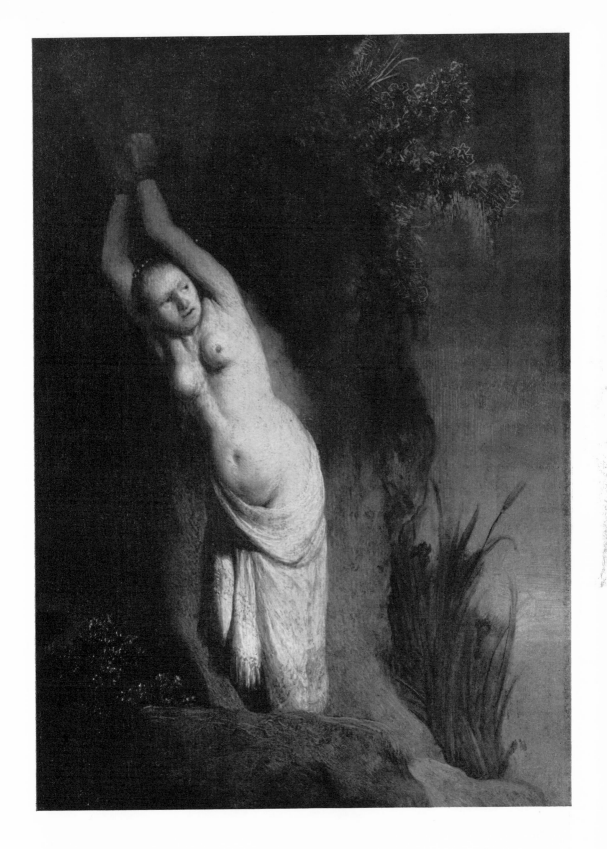

ANDROMEDA CHAINED TO THE ROCK. Panel, 34·5×25 cm. The Hague, Mauritshuis. (Br. 462)

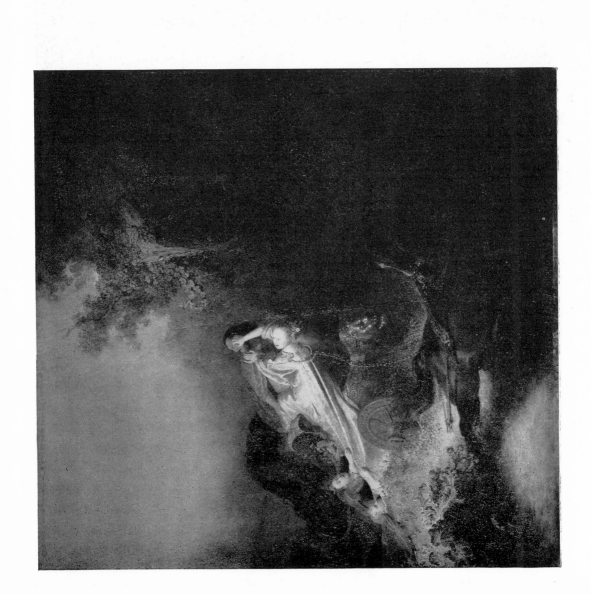

THE ABDUCTION OF PROSERPINE. Panel, 83×78 cm.
Berlin-Dahlem, Gemäldegalerie. (Br. 463)

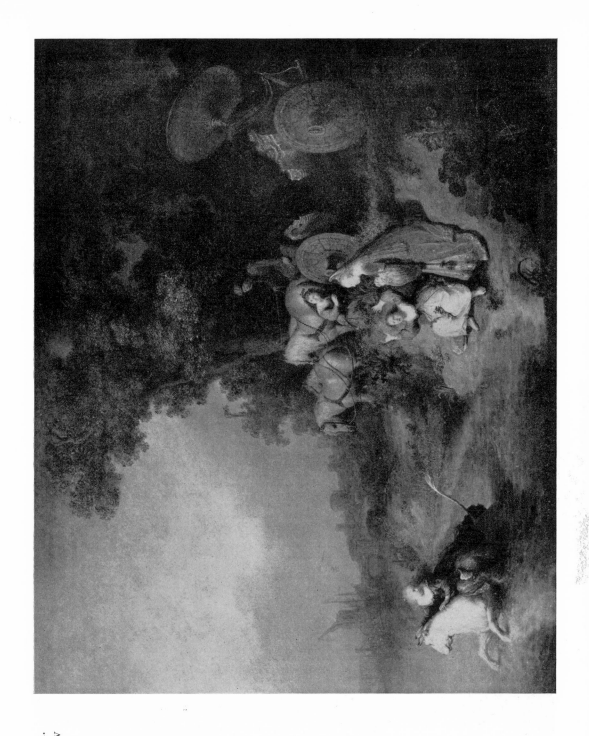

THE ABDUCTION OF EUROPA.
1632. Panel, 70×77·5 cm. New
York, Paul Klotz. (Br. 464)

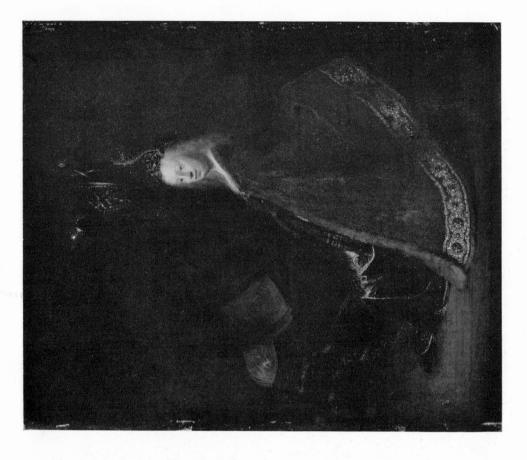

MINERVA. Panel. 59×48 cm. Berlin-Dahlem, Gemäldegalerie. (Br. 466)

MINERVA. Panel, 43·5×35 cm. Denver, Art Museum. (Br. 465)

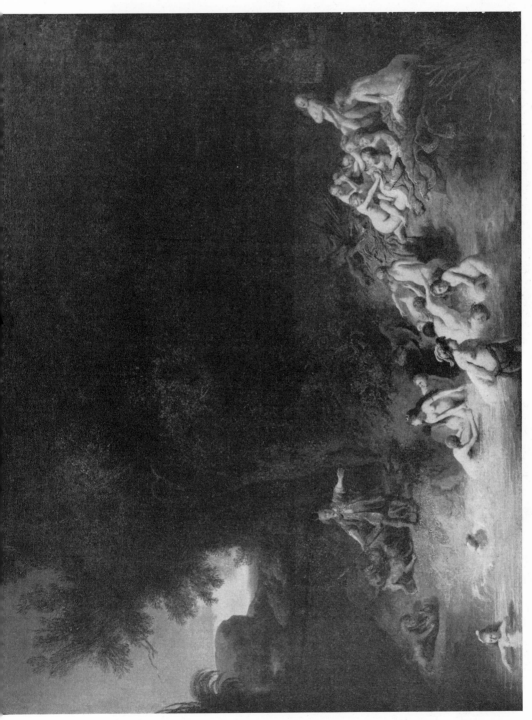

DIANA, WITH SCENES FROM THE STORIES OF ACTAEON AND CALLISTO. 1632 (?). Canvas, 73·5×93·5 cm. Anholt, Prince of Salm-Salm. (Br. 472)

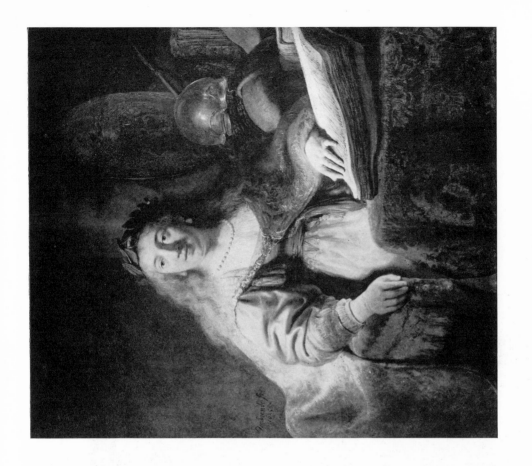

Minerva. 1635. Canvas, 137×116 cm. London, Julius Weitzner. (Br. 469)

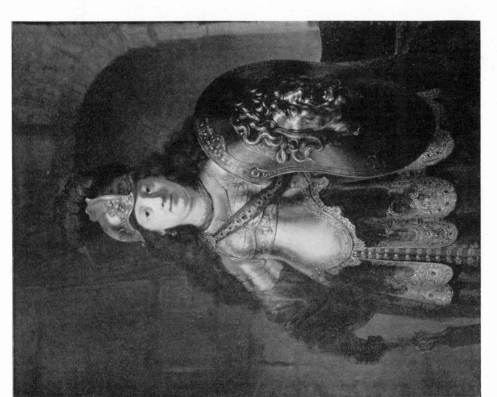

Bellona. 1633. Canvas, 125×96.5 cm. New York, Metropolitan Museum of Art. (Br. 467)

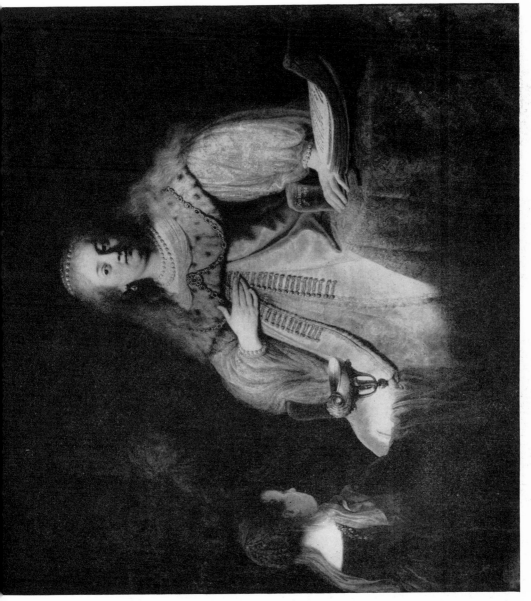

Sophonisba Receiving the Poisoned Cup (?). 1634. Canvas, 142×153 cm. Madrid, Prado. (Br. 468)

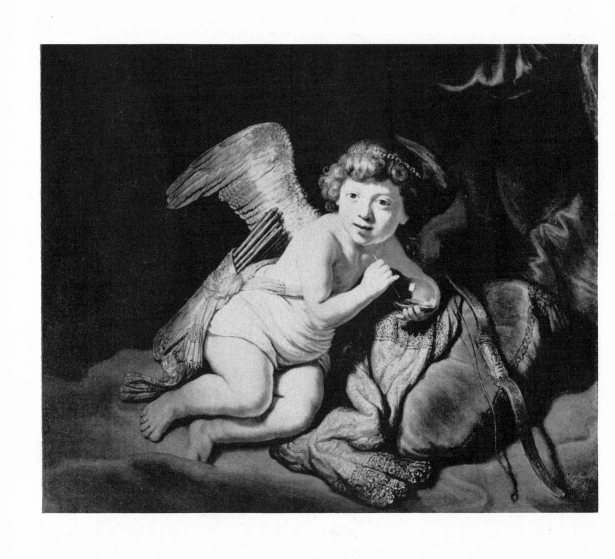

CUPID. 1634. Panel, 74.5×92 cm. Paris, Baron A. W. C. Bentinck. (Br. 470)

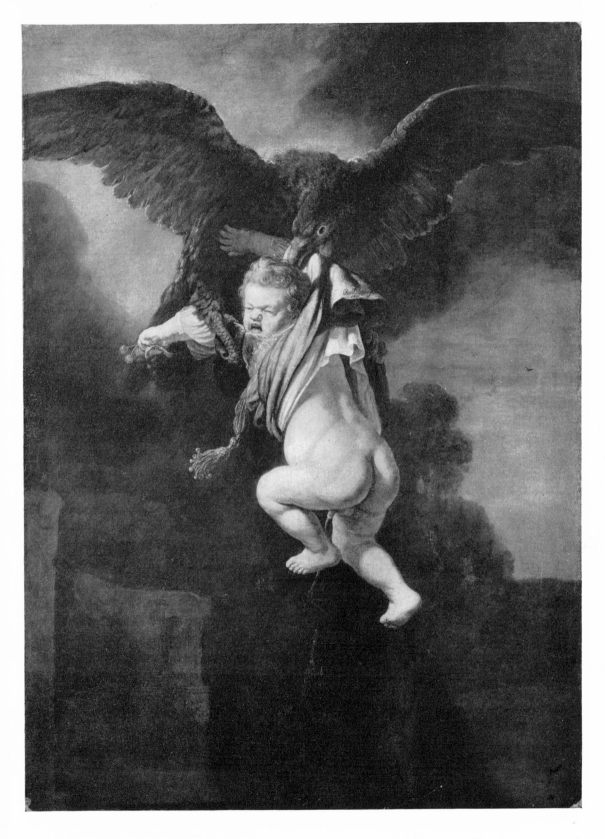

THE ABDUCTION OF GANYMEDE. 1635. Canvas, 171·5×130 cm. Dresden, Gemäldegalerie. (Br. 471)

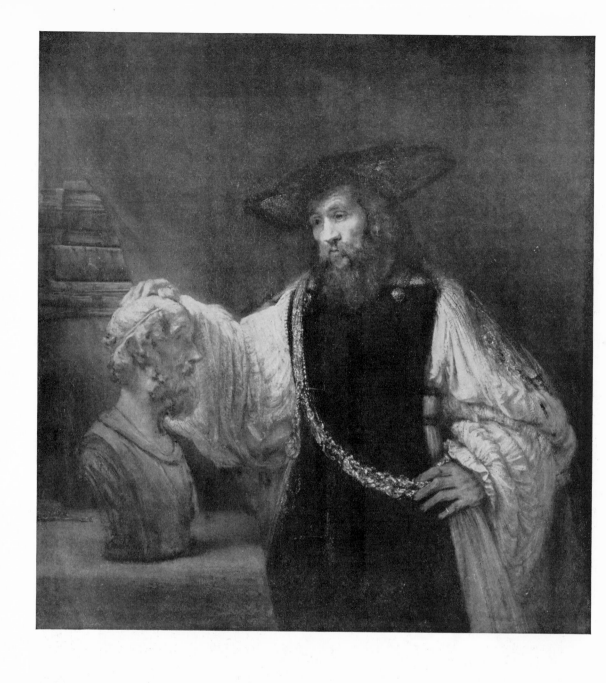

ARISTOTLE CONTEMPLATING A BUST OF HOMER. 1653. Canvas, 143·5×136·5 cm. New York, Metropolitan Museum of Art. (Br. 478)

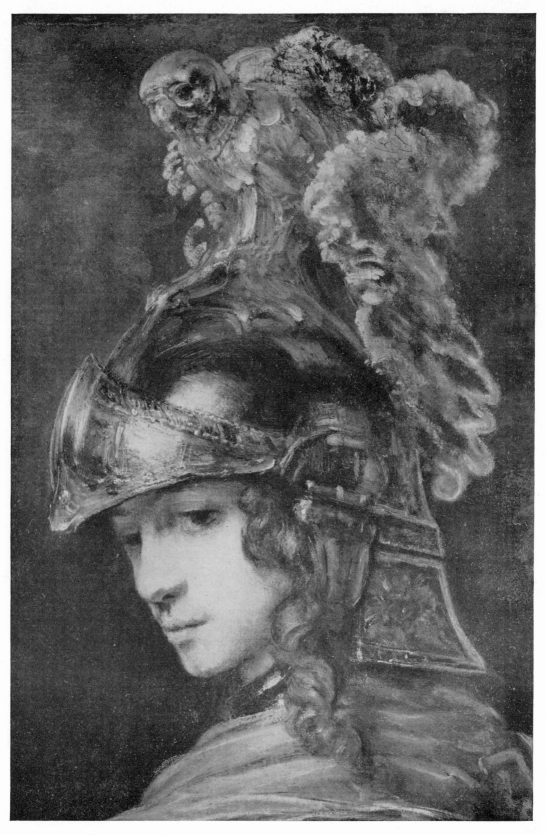

Detail of the "Alexander" Reproduced on Page 388

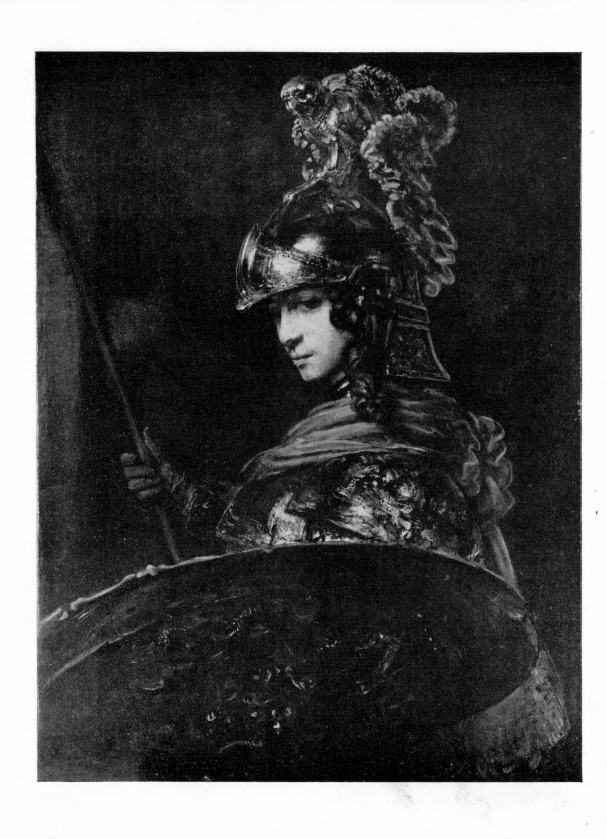

ALEXANDER. Canvas, 118×91 cm. Oeiras, Calouste Gulbenkian Foundation. (Br. 479)

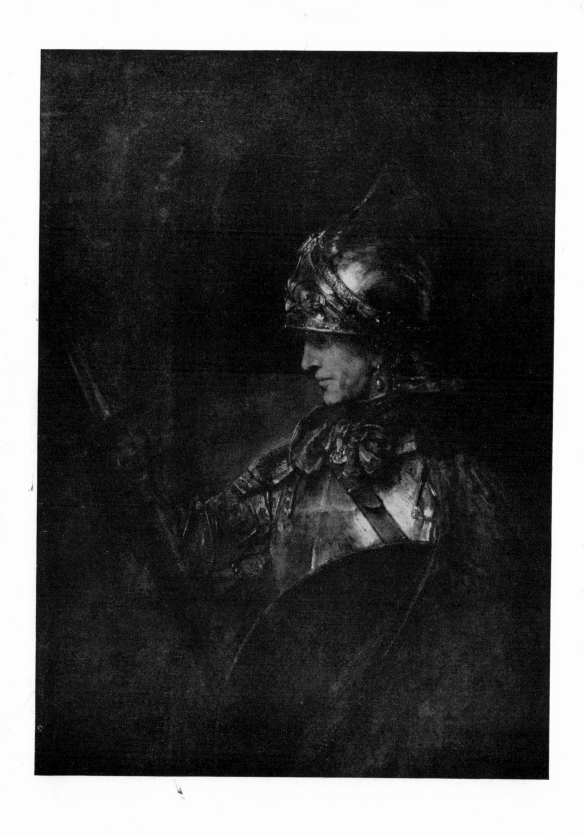

ALEXANDER. Canvas, 137.5×104.5 cm. (enlarged from approx. 115.5×87.5 cm., the area shown here). Glasgow, Art Gallery and Museum. (Br. 480)

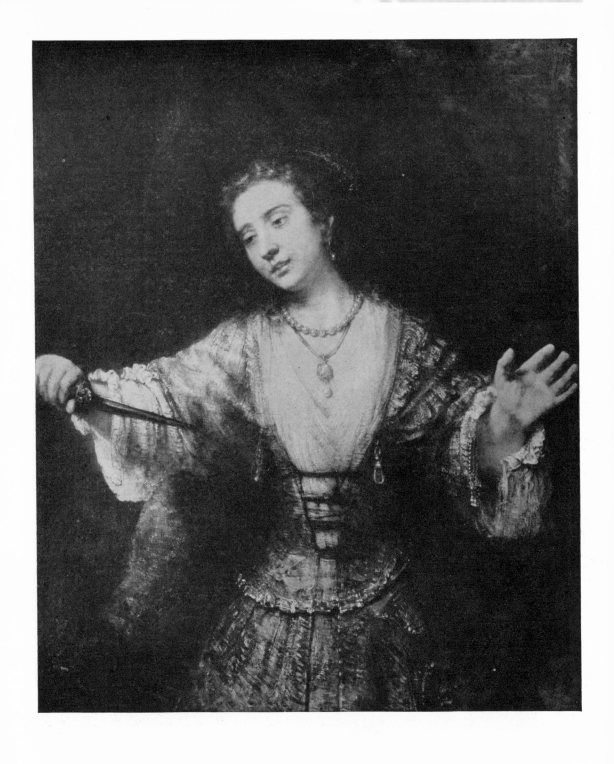

THE SUICIDE OF LUCRETIA. 1664. Canvas, 116×99 cm. Washington, D.C., National Gallery of Art (Mellon Collection). (Br. 484)

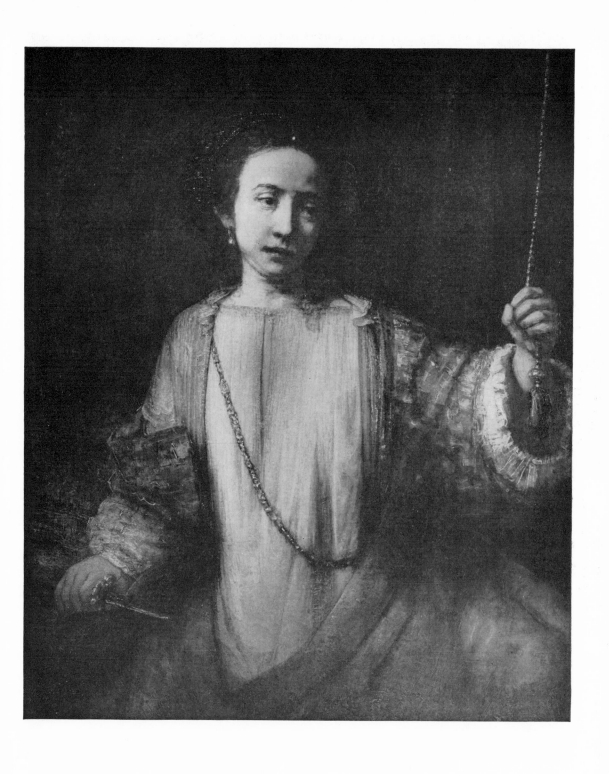

THE SUICIDE OF LUCRETIA. 1666. Canvas, 111×95 cm. Minneapolis, Institute of Arts. (Br. 485)

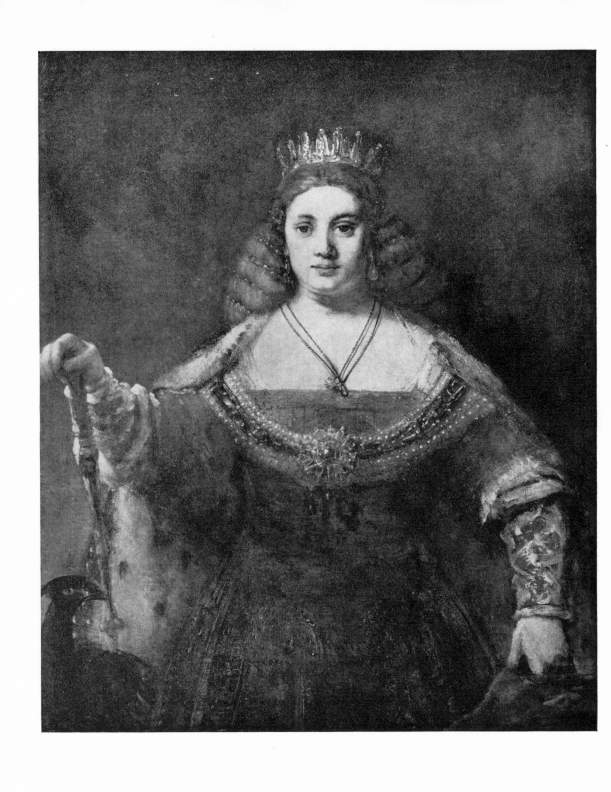

JUNO. Canvas, 127×106 cm. New York, Metropolitan Museum of Art (on loan). (Br. 639)

BIBLICAL SUBJECTS I
OLD TESTAMENT

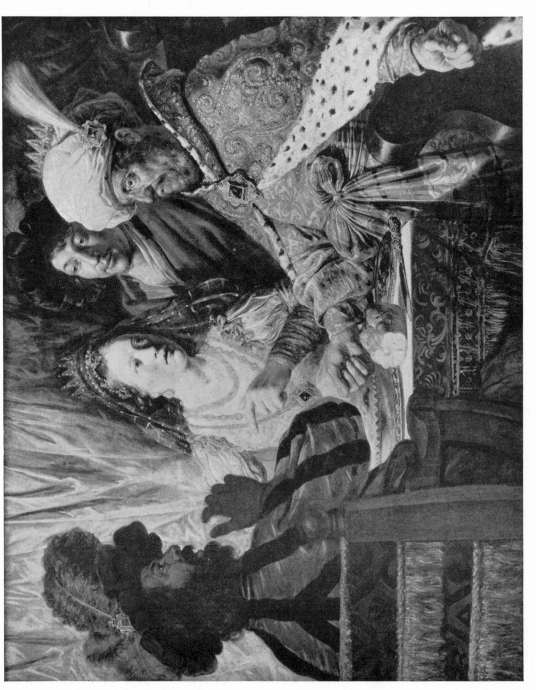

The Wrath of Ahasuerus. Canvas, 130×165 cm. Raleigh, N.C., Museum of North Carolina. (Br. 631)

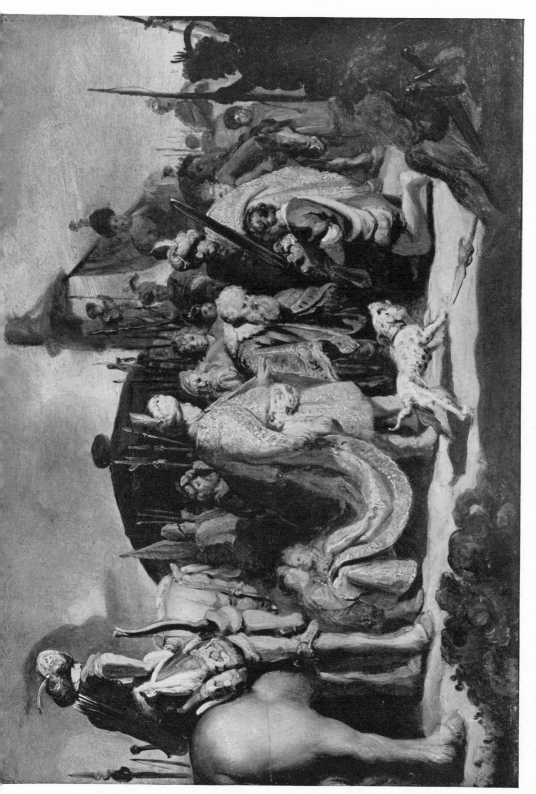

DAVID PRESENTING THE HEAD OF GOLIATH TO SAUL. Originally 1625 (?). Panel, 26.5×38 cm. Basle, Öffentliche Kunstsammlung. (Br. 488)

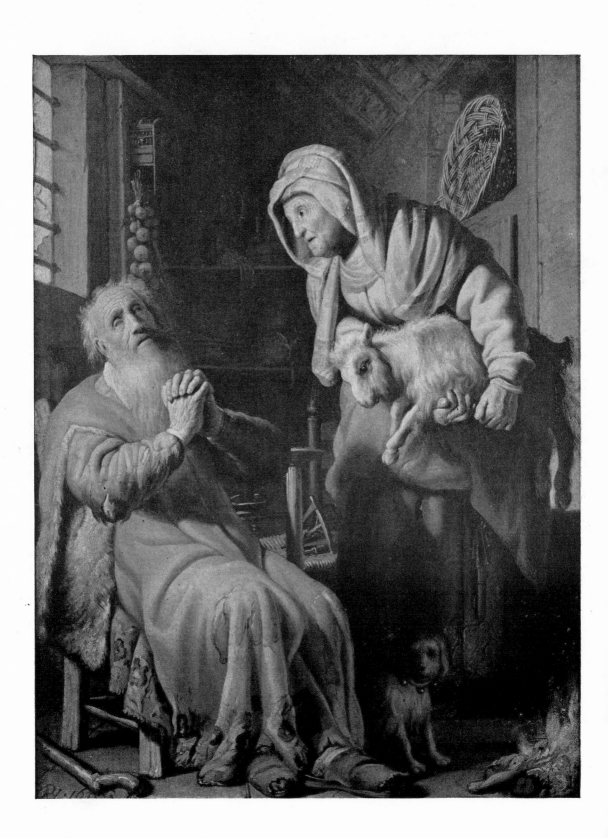

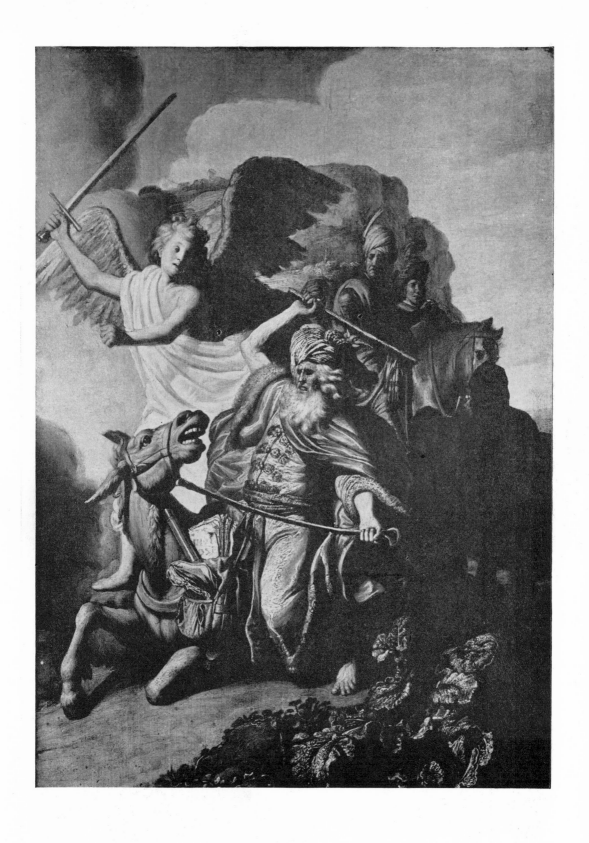

THE ASS OF BALAAM BALKING BEFORE THE ANGEL. 1626. Panel, 65×47 cm. Paris, Musée Cognacq-Jay. (Br. 487)

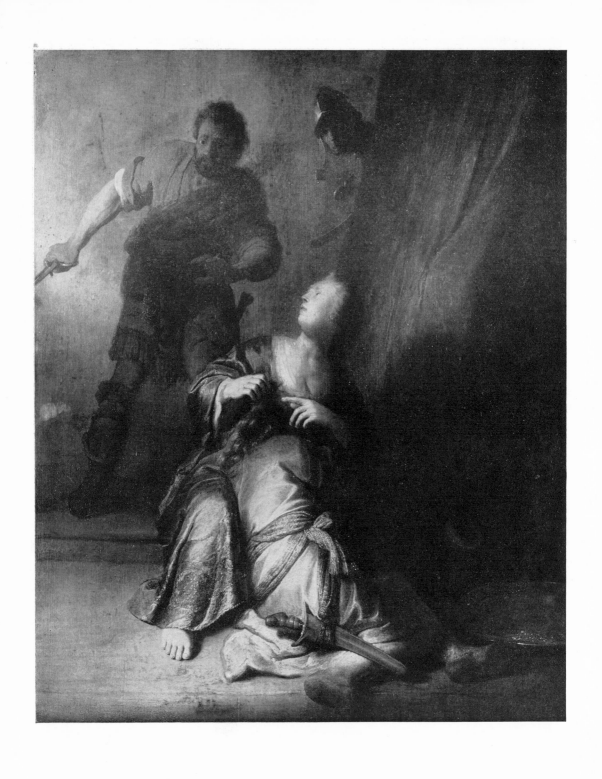

SAMSON BETRAYED BY DELILAH. 1628. Panel, 59·5×49·5 cm. Berlin-Dahlem, Gemäldegalerie. (Br. 489)

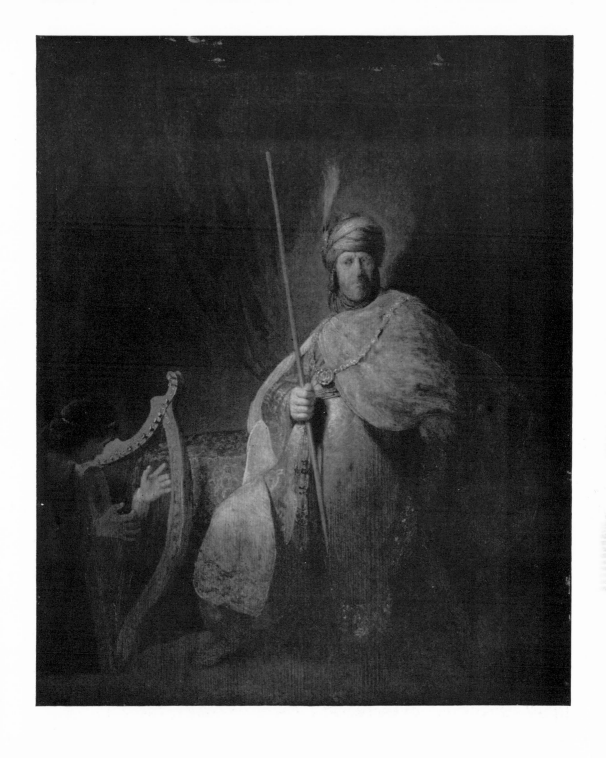

DAVID PLAYING THE HARP BEFORE SAUL. Panel, 62×50 cm. Frankfurt, Städelsches Kunstinstitut. (Br. 490)

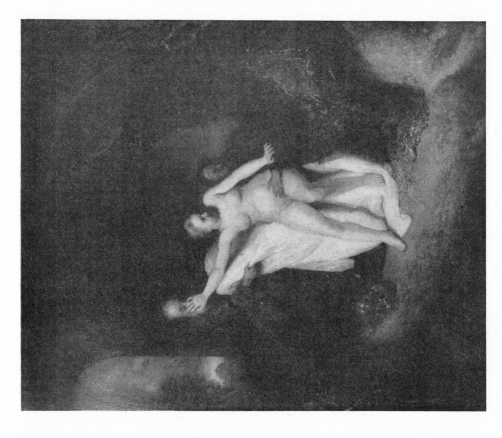

SUSANNA SURPRISED BY THE ELDERS. Panel, 51×41 cm. Private Collection. (Br. 493)

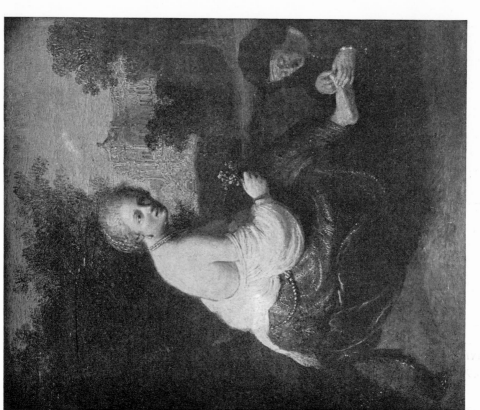

BATHSHEBA AT HER TOILET. 1632. Panel, 25×21 cm. Rennes, Musée des Beaux-Arts. (Br. 492)

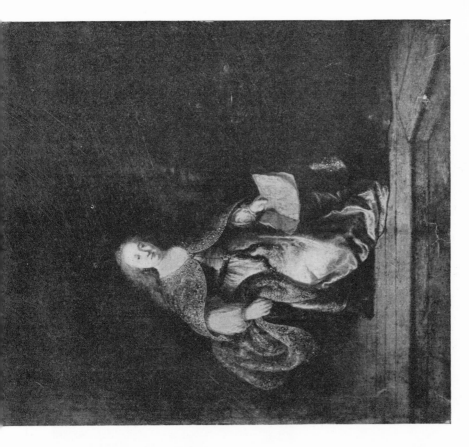

Esther Preparing to Intercede with Ahasuerus. Panel, 54.5 × 47.5 cm. Formerly Berlin, W. Heilgendorff. (Br. 495)

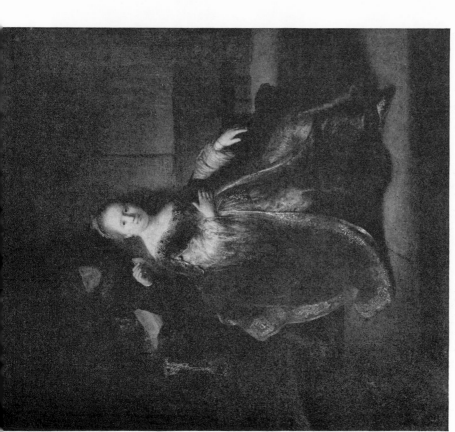

Esther Preparing to Intercede with Ahasuerus. 1633(?). Canvas, 109 × 93 cm. Ottawa, National Gallery of Canada. (Br. 494)

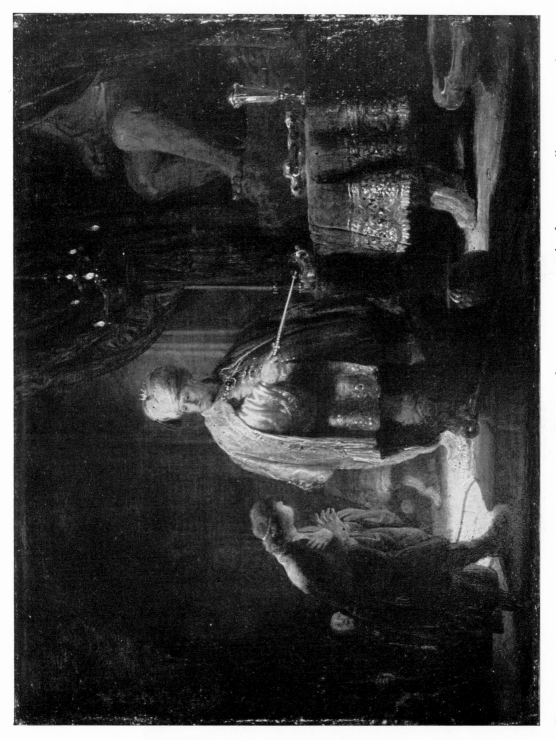

DANIEL AND KING CYRUS BEFORE THE IDOL OF BEL. 1633. Panel, 22·5 × 28·5 cm. England, Private Collection. (Br. 491)

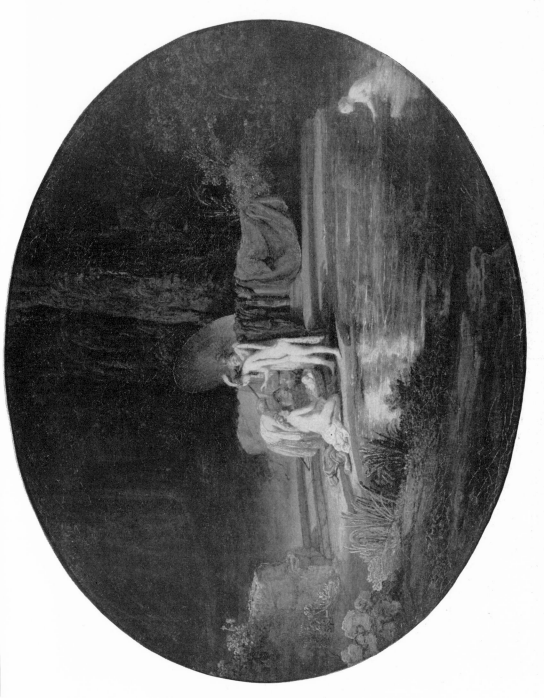

THE FINDING OF MOSES. Canvas, 47 × 59 cm. Philadelphia, John G. Johnson Collection. (Br. 496)

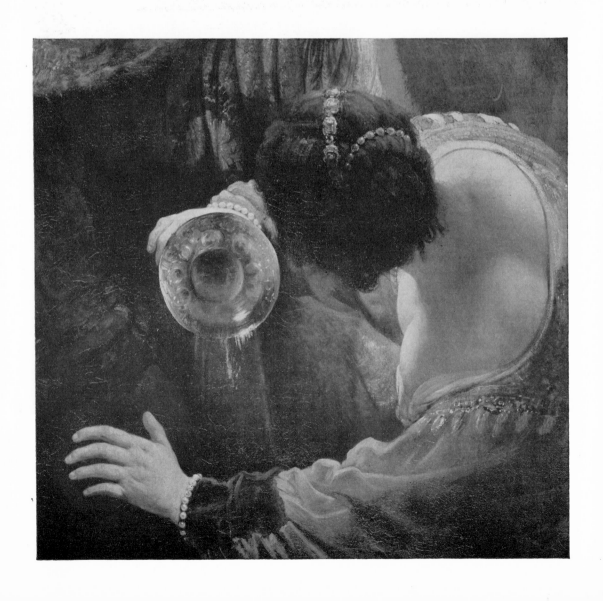

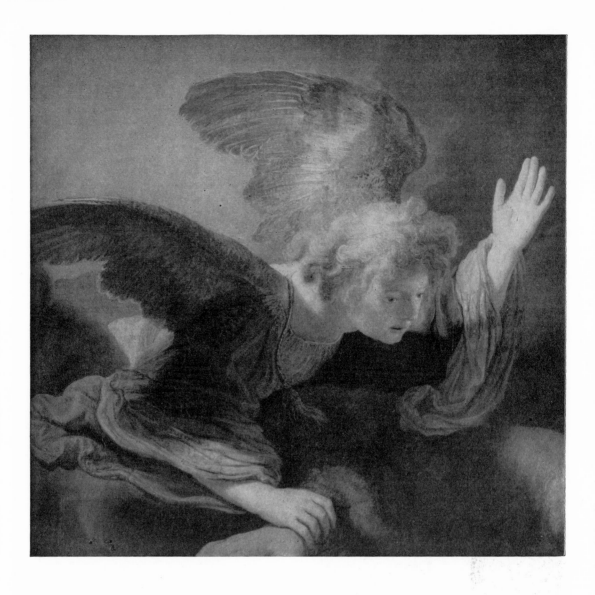

Old copy
mutilation.

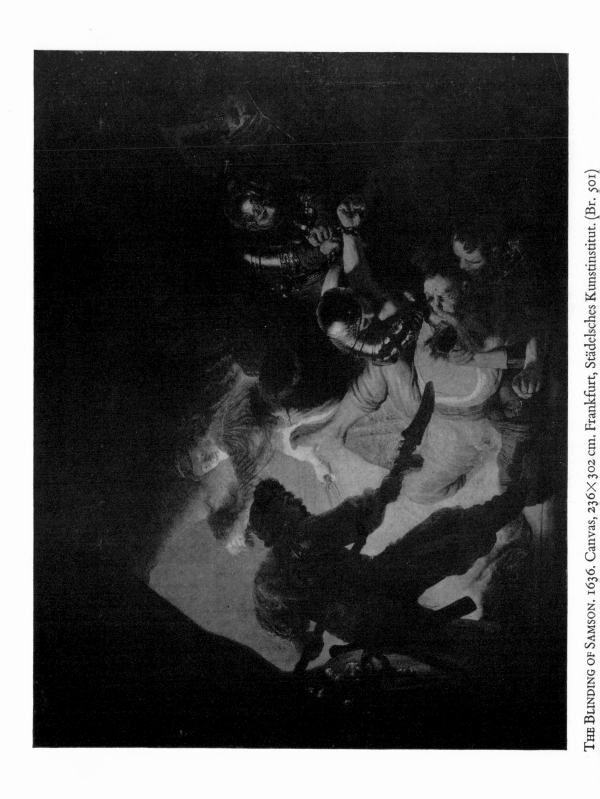

THE BLINDING OF SAMSON. 1636. Canvas, 236×302 cm. Frankfurt, Städelsches Kunstinstitut. (Br. 501)

SAMS
Gem

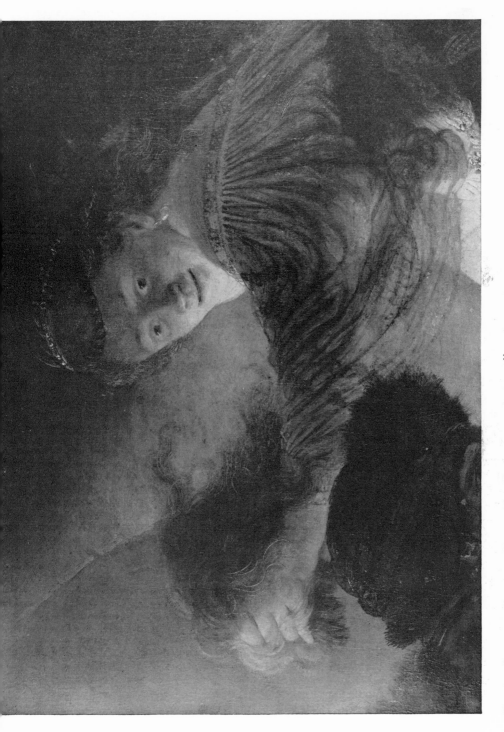

Detail, Showing Delilah, From "The Blinding of Samson".

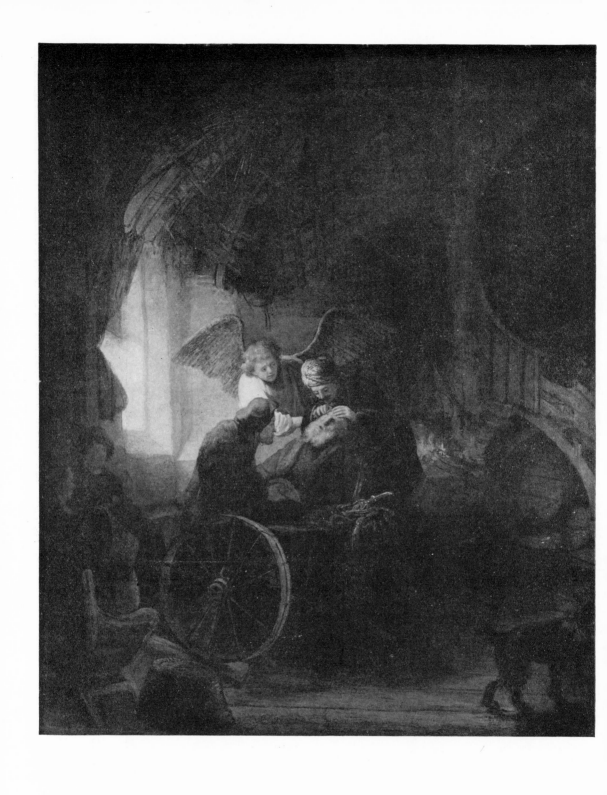

Tobias Healing his Father's Blindness. 1636. Panel, 48×39 cm. Stuttgart, Staatsgalerie. (Br. 502)

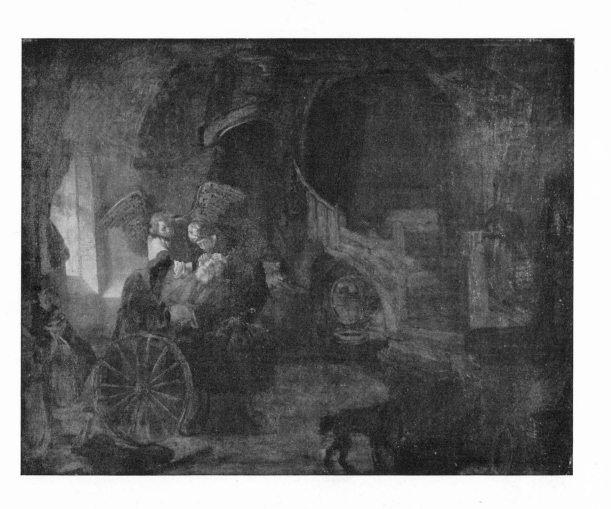

Old copy of Tobias Healing his Father's Blindness showing the original format, before mutilation. Canvas, 48×65 cm. Brunswick, Herzog Anton Ulrich Museum

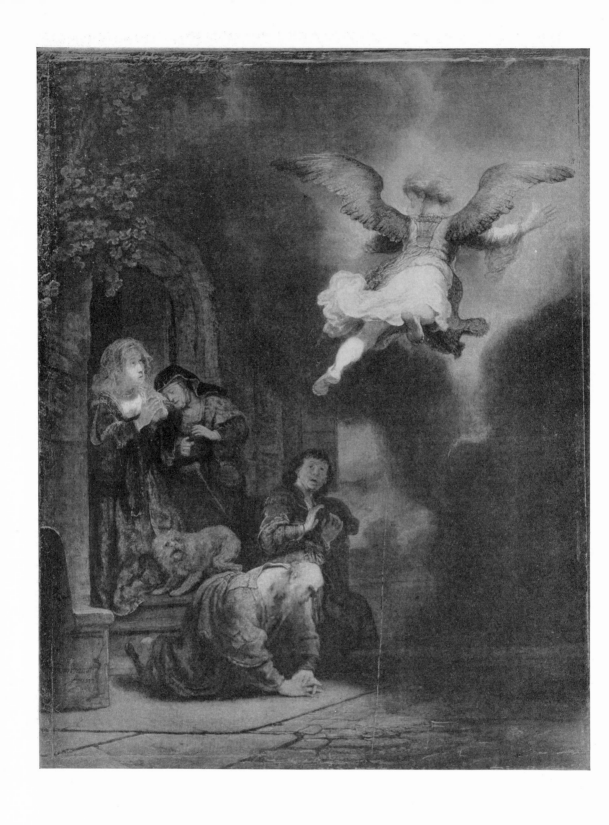

THE ANGEL LEAVING TOBIAS AND HIS FAMILY. 1637. Panel, 68×52 cm. Paris, Louvre. (Br. 503)

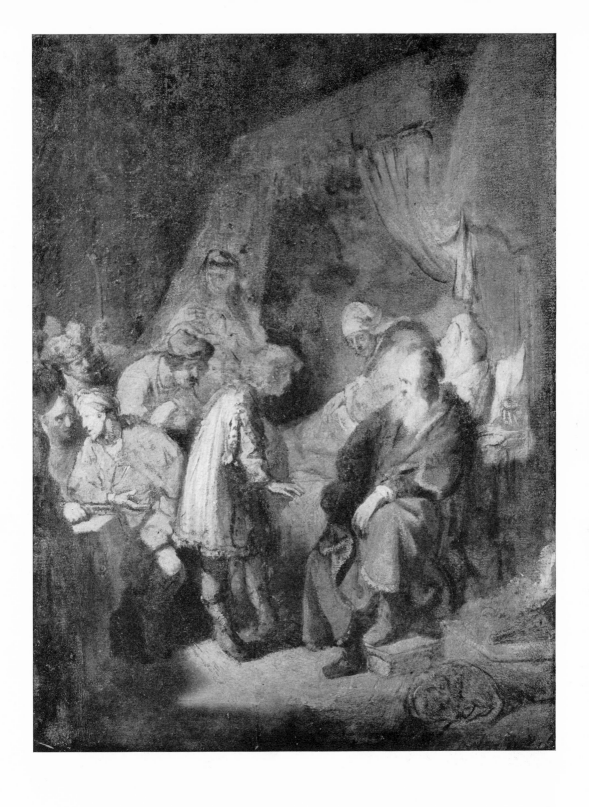

JOSEPH RELATING HIS DREAMS. Paper on panel, 51×39 cm. Amsterdam, Rijksmuseum. (Br. 504)

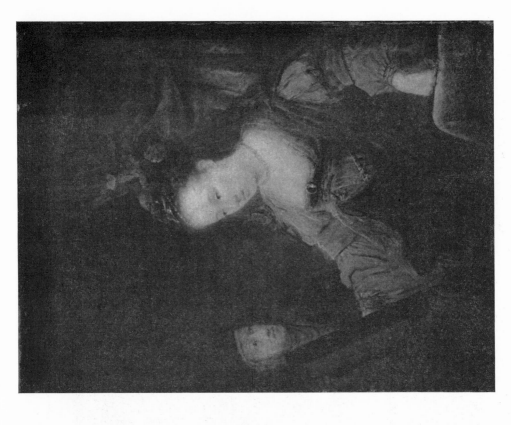

BATHSHEBA AT HER TOILET. Panel, 41×31 cm. Leningrad, Hermitage. (Br. 506)

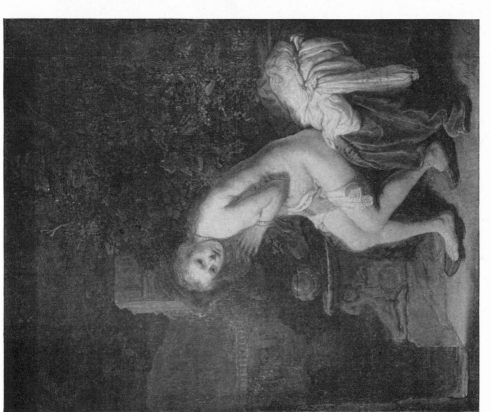

SUSANNA SURPRISED BY THE ELDERS. 1637(?). Panel, 47.5×39 cm. The Hague, Mauritshuis. (Br. 505)

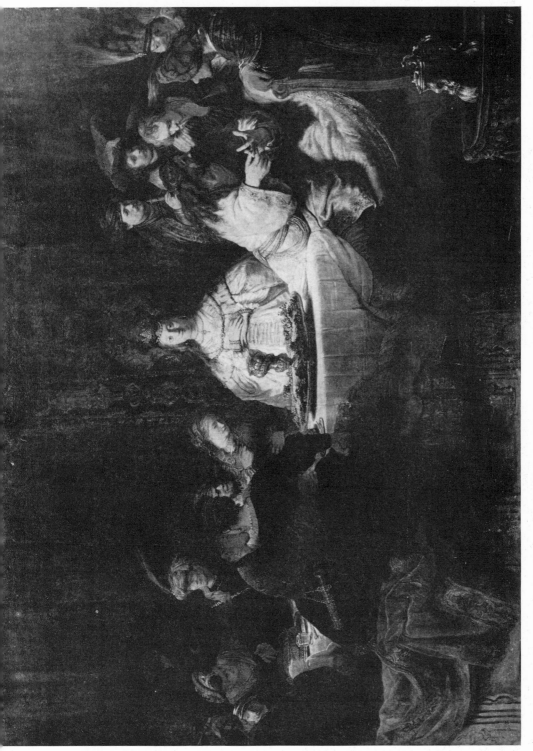

SAMSON POSING THE RIDDLE TO THE WEDDING GUESTS. 1638. Canvas, 126.5 × 175.5 cm. Dresden, Gemäldegalerie. (Br. 507)

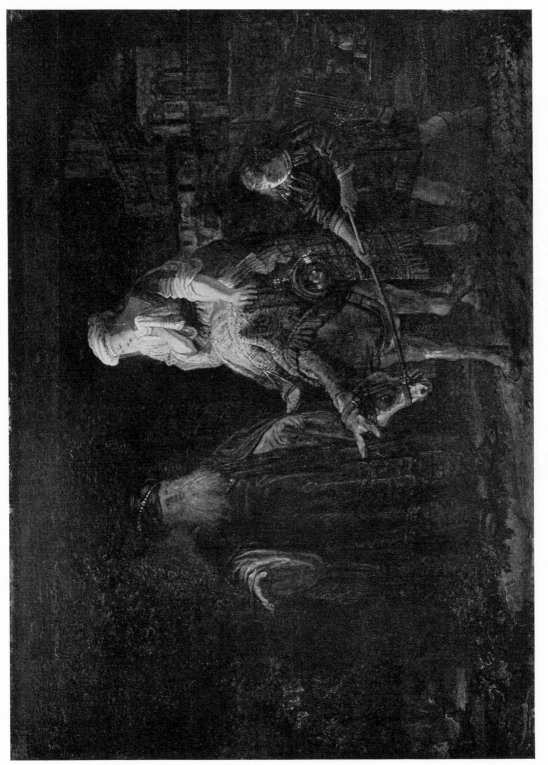

THE DEPARTURE OF THE SHUNAMITE WIFE. 1640. Panel, 39 × 53 cm. London, Victoria and Albert Museum. (Br. 508)

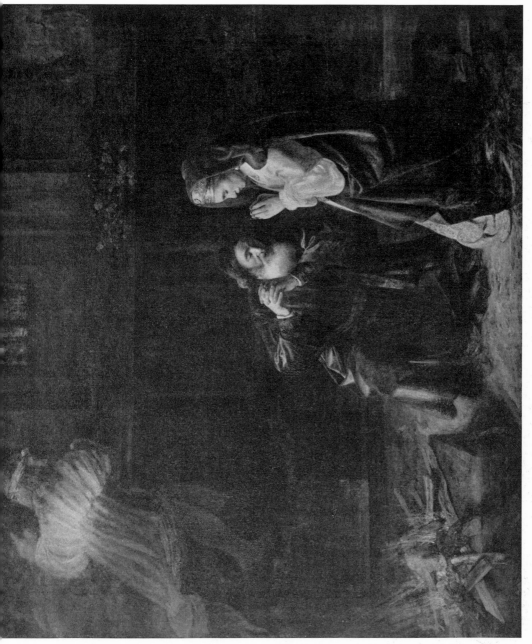

The Angel Ascending in the Flames of Manoah's Sacrifice. 1641. Canvas, 242×283 cm. Dresden, Gemäldegalerie. (Br. 509)

THE RECONCILIATION OF DAVID AND ABSALOM. 1642. Panel, 73×61·5 cm. Leningrad, Hermitage. (Br. 511)

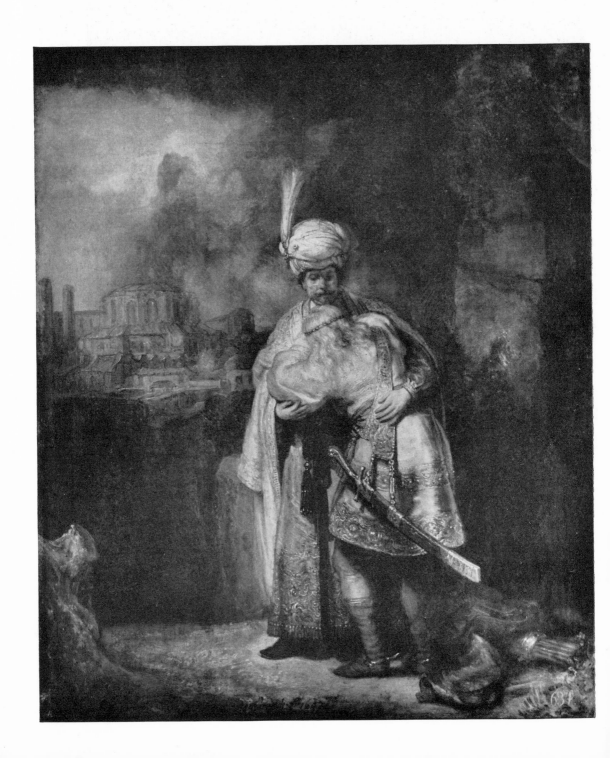

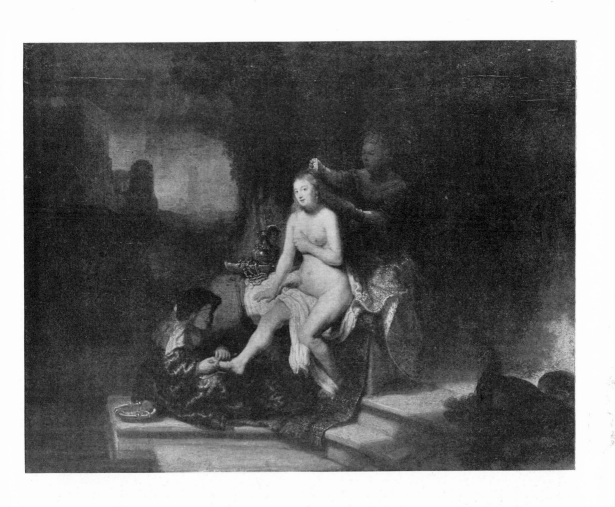

BATHSHEBA AT HER TOILET SEEN BY KING DAVID. 1643. Panel, 57×76 cm. New York, Metropolitan Museum of Art. (Br. 513)

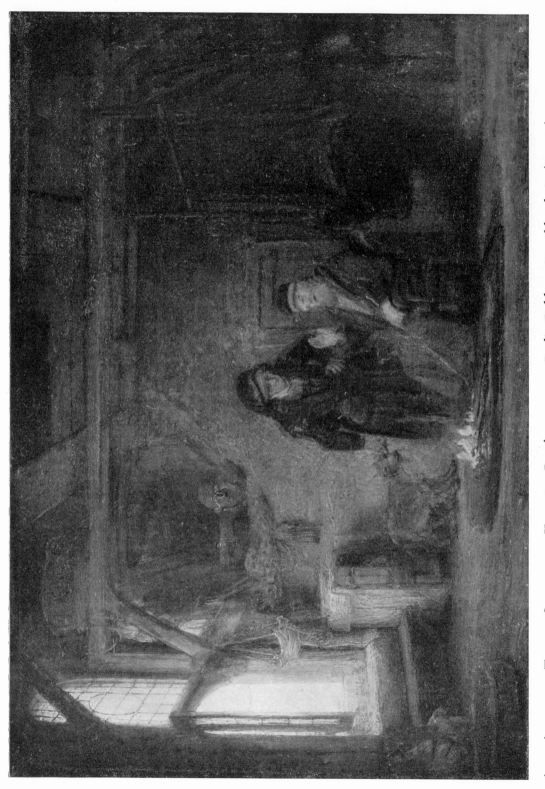

ANNA ACCUSED BY TOBIT OF STEALING THE KID. 1645. Panel, 20×27 cm. Berlin–Dahlem, Gemäldegalerie. (Br. 514)

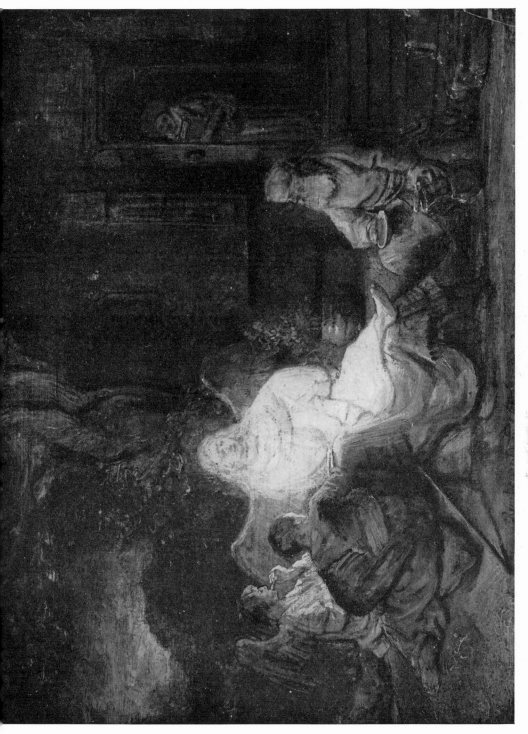

ABRAHAM SERVING THE ANGELS. 1646. Panel, 16×21 cm. New York, Mrs. C. von Pannwitz. (Br. 515)

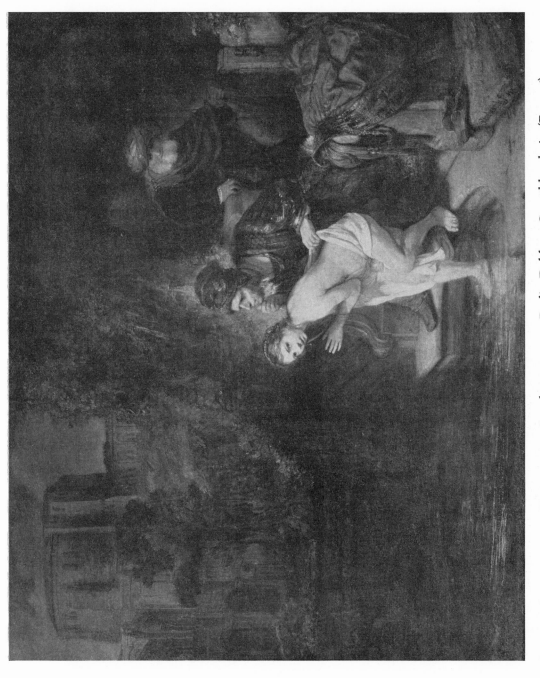

SUSANNA SUPRISED BY THE ELDERS. 1647. Panel, 76×91 cm. Berlin-Dahlem, Gemäldegalerie. (Br. 516)

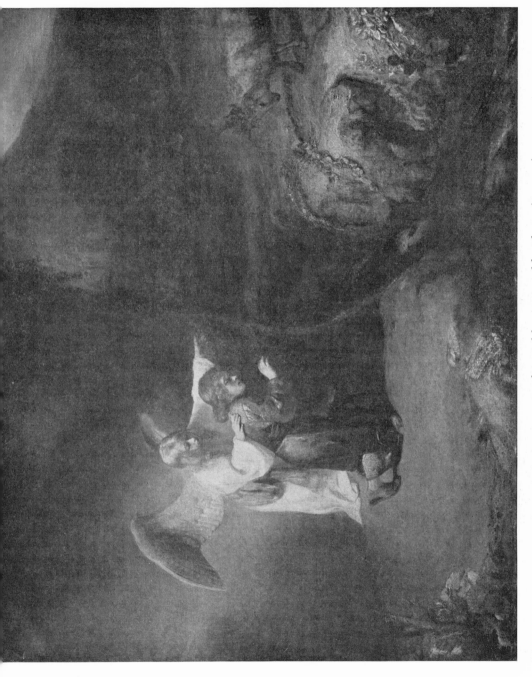

THE VISION OF DANIEL. Canvas, 96 × 116 cm. Berlin-Dahlem, Gemäldegalerie. (Br. 519)

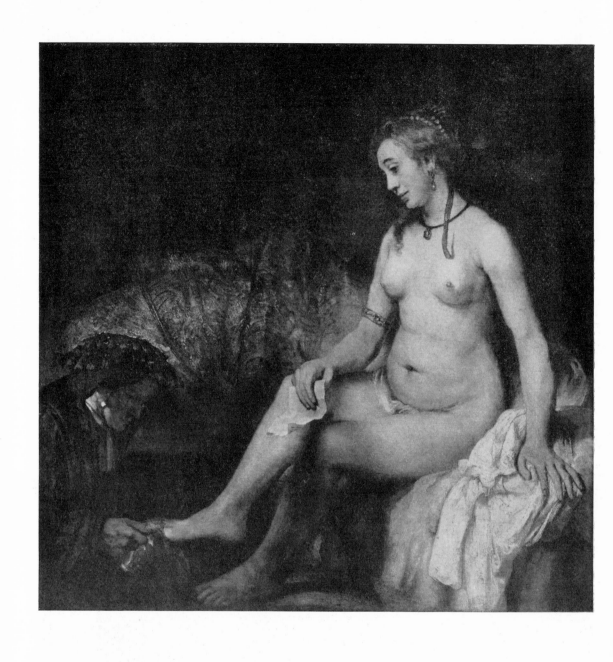

BATHSHEBA WITH KING DAVID'S LETTER. 1654. Canvas, 142×142 cm. Paris, Louvre. (Br. 521)

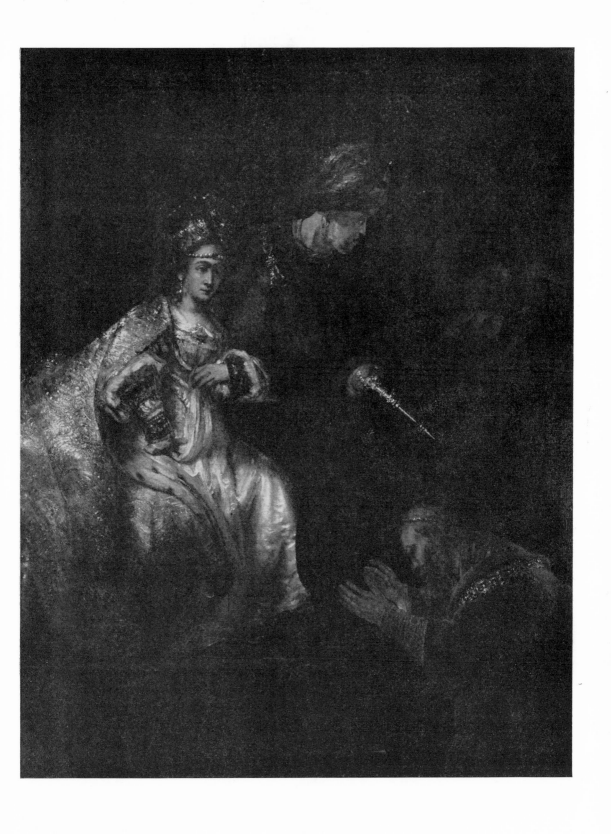

THE CONDEMNATION OF HAMAN. Canvas, 235×190 cm. Bucharest, Museum of Art. (Br. 522)

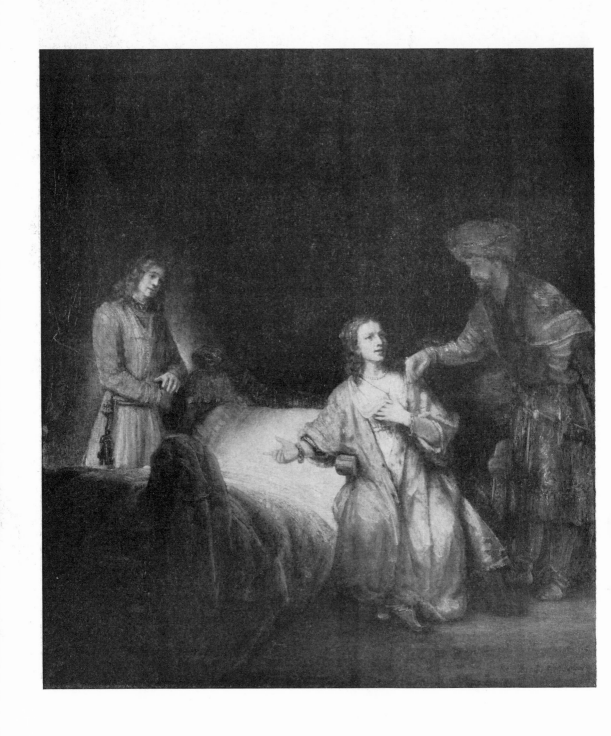

JOSEPH ACCUSED BY POTIPHAR'S WIFE. 1655. Canvas, 106×98 cm. Washington, D.C., National Gallery of Art (Mellon Collection). (Br. 523)

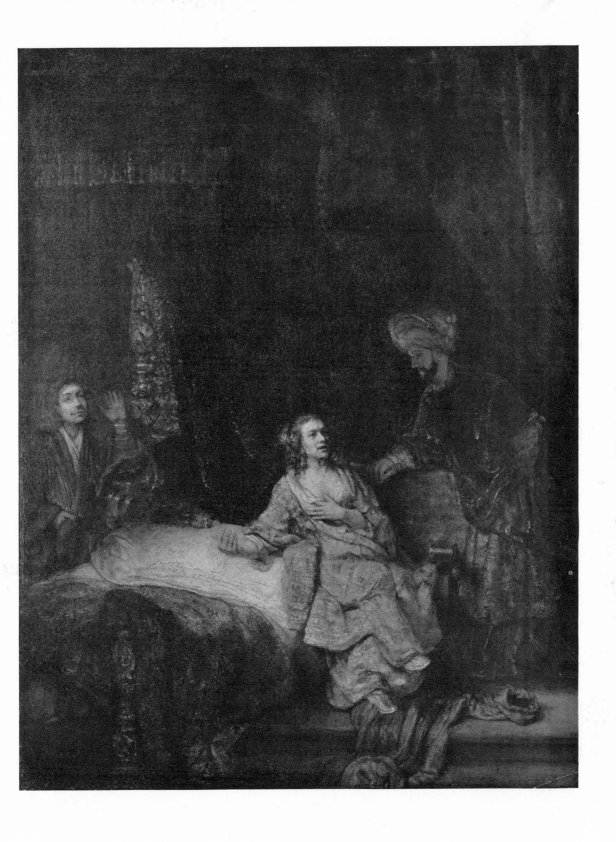

Joseph Accused by Potiphar's Wife. 1655. Canvas, 110×87 cm. Berlin-Dahlem, Gemäldegalerie. (Br. 524)

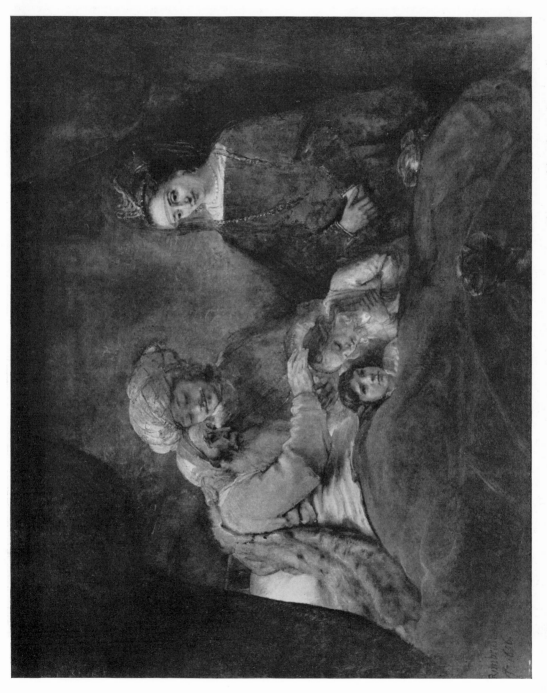

JACOB BLESSING THE CHILDREN OF JOSEPH. 1656. Canvas, 175·5 × 210·5 cm. Cassel, Gemäldegalerie. (Br. 525)

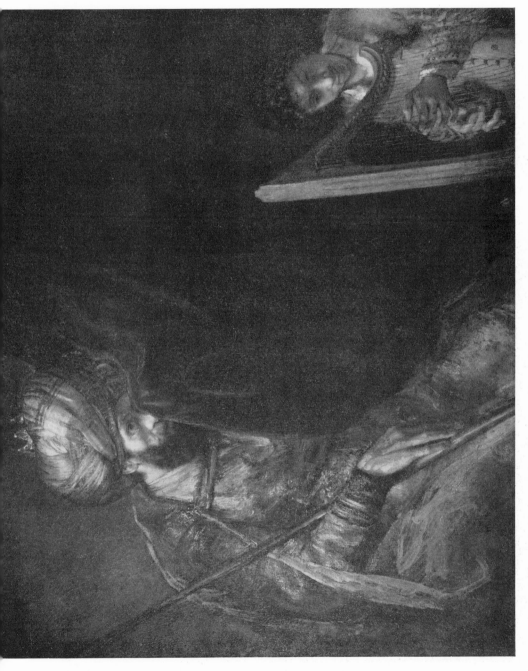

DAVID PLAYING THE HARP BEFORE SAUL. Canvas, 130·5 × 164 cm. The Hague, Mauritshuis. (Br. 526)

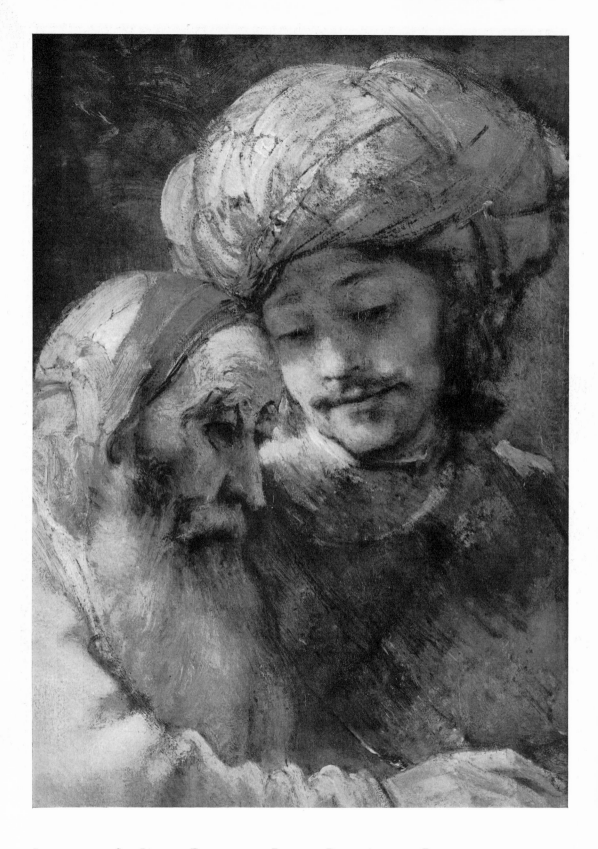

JACOB AND HIS SON JOSEPH—DETAIL OF THE PAINTING REPRODUCED ON PAGE 434

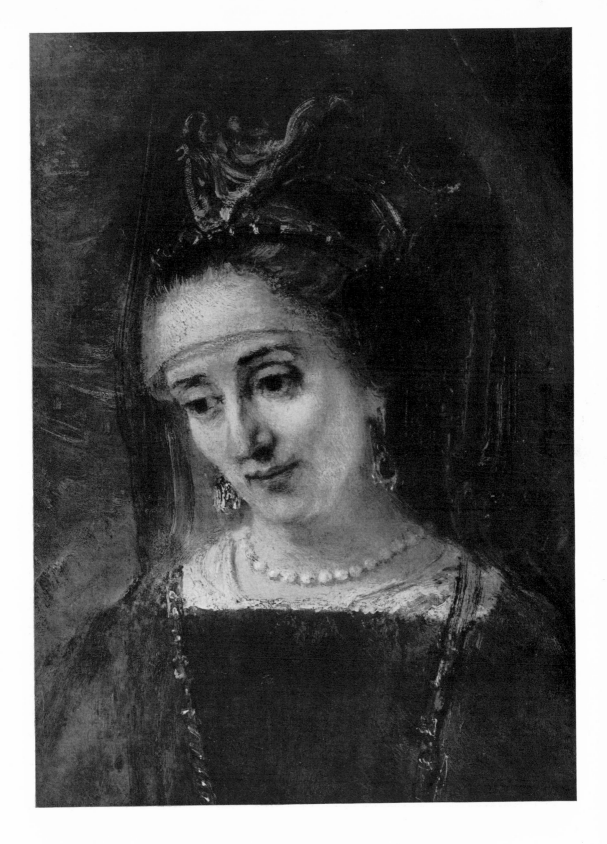

ASNATH, THE WIFE OF JOSEPH—DETAIL OF THE PAINTING REPRODUCED ON PAGE 434

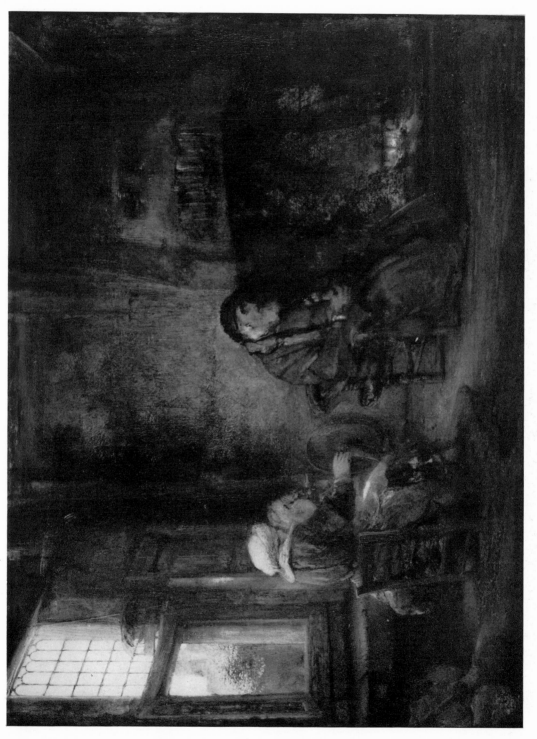

TOBIT AND HIS WIFE. 1659 (?). Panel, 40·5 × 54 cm. Rotterdam, Willem van der Vorm Foundation. (Br. 520)

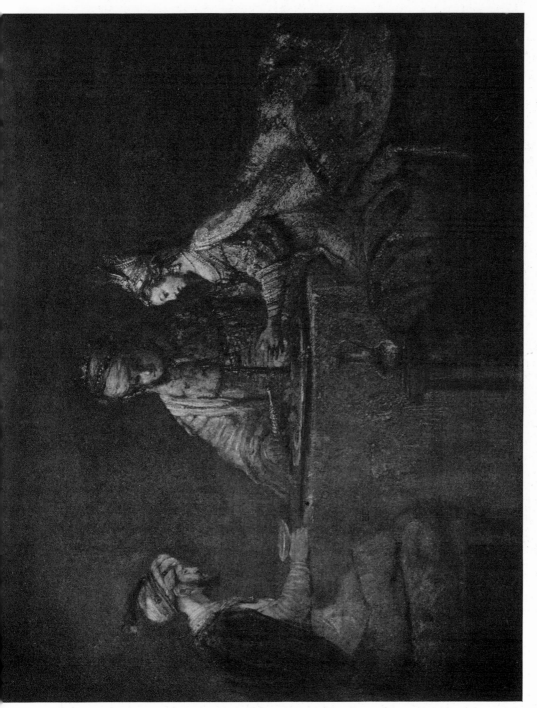

HAMAN AND AHASUERUS AT THE FEAST OF ESTHER. 1660. Canvas, 71·5×93 cm. Moscow, Pushkin Museum. (Br. 530)

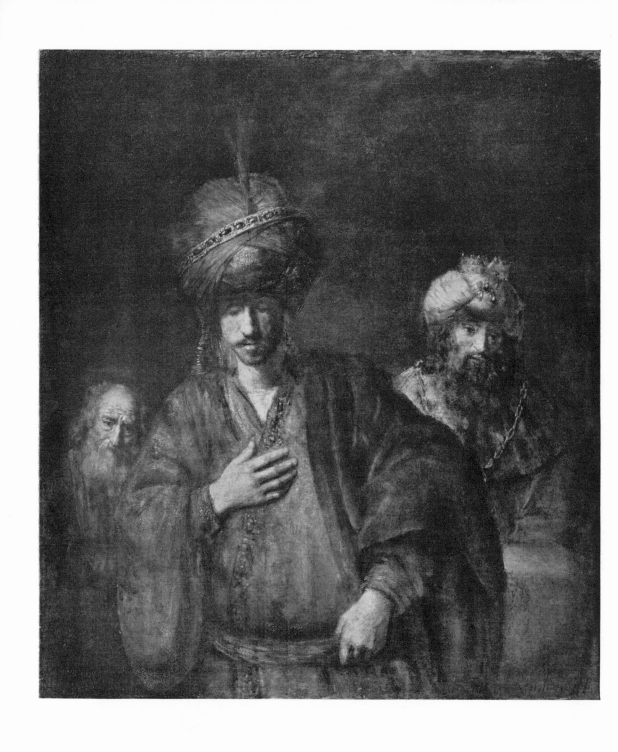

THE DISGRACE OF HAMAN. Canvas, 127×117 cm. Leningrad, Hermitage. (Br. 531)

BIBLICAL SUBJECTS 2
NEW TESTAMENT

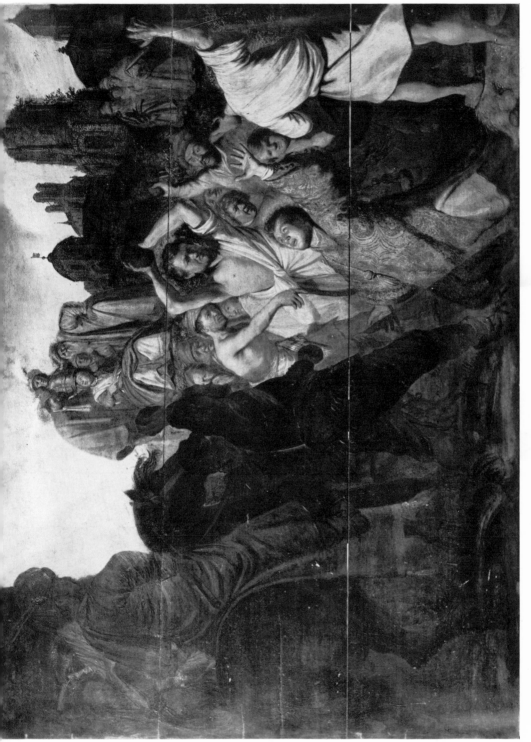

THE MARTYRDOM OF ST. STEPHEN. 1625. Panel, 89·5 × 123·5 cm. Lyons, Musée des Beaux-Arts. (Br. 531A)

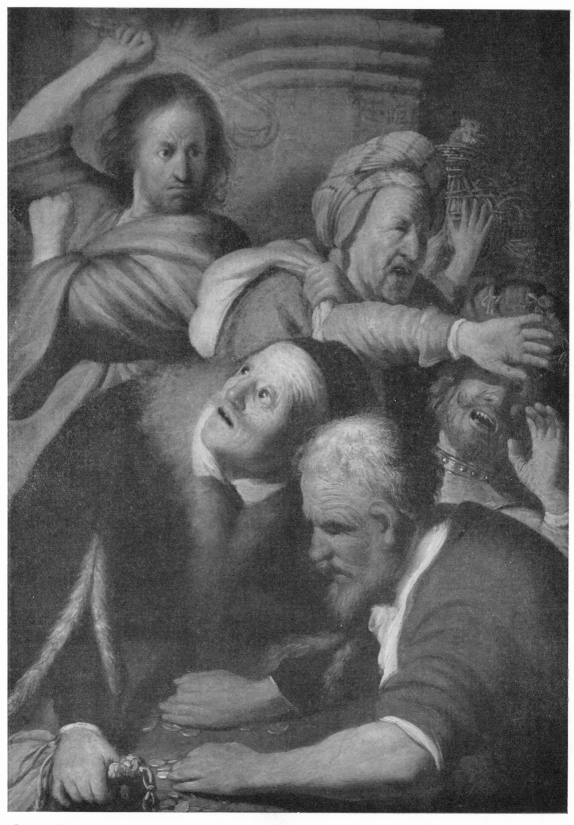

CHRIST DRIVING THE MONEY-CHANGERS FROM THE TEMPLE. 1626. Panel, 43×33 cm. Moscow, Pushkin Museum. (Br. 532)

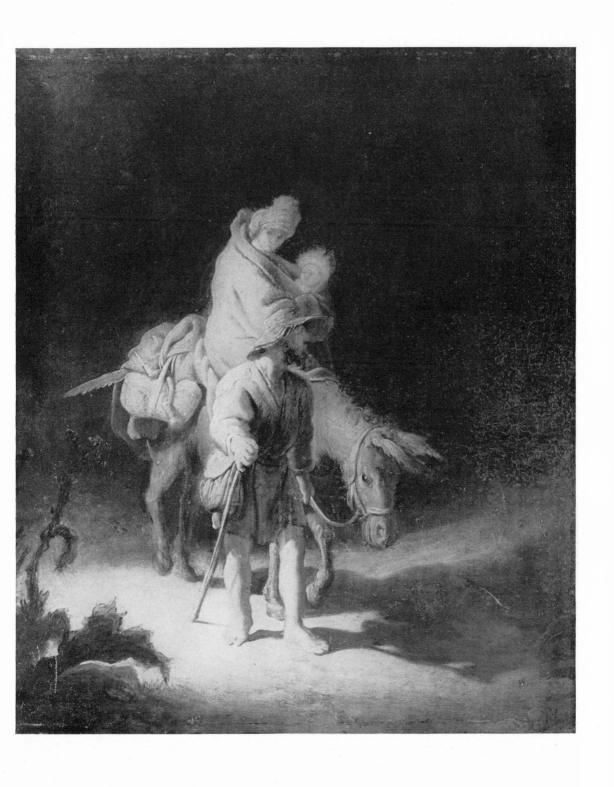

THE FLIGHT OF THE HOLY FAMILY INTO EGYPT. 1627. Panel, 26.5×24 cm. Tours, Musée des Beaux-Arts. (Br. 532A)

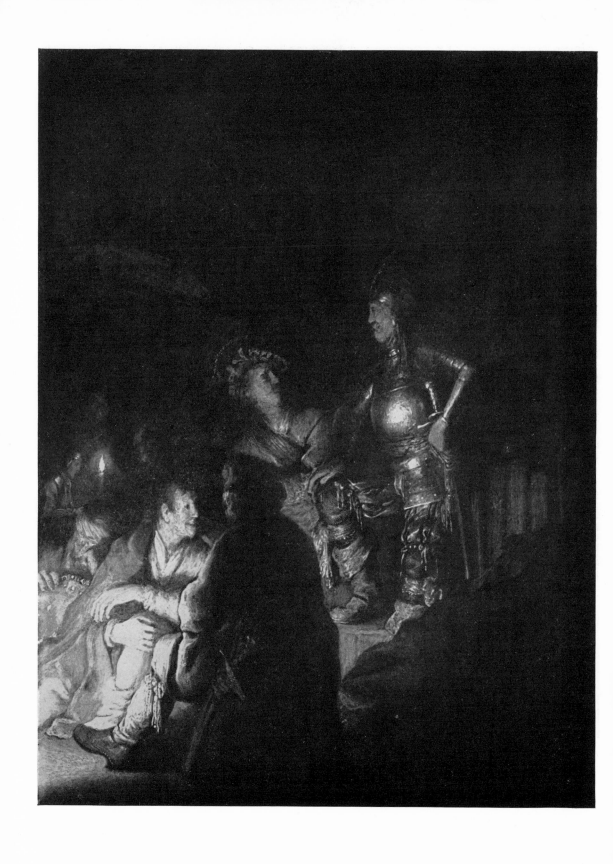

St. Peter Denying Christ(?). 1628. Copper, 21·5× 16·5 cm. Tokyo, Bridgestone Gallery. (Br. 533)

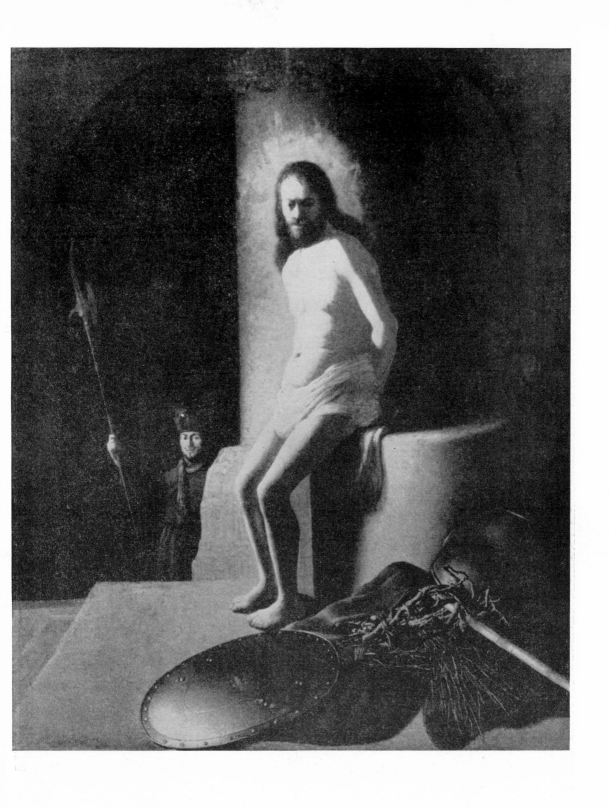

CHRIST AT THE COLUMN. Canvas, 74·5×63·5 cm. London, Sale, May 23, 1951 (lot 100). (Br. 534)

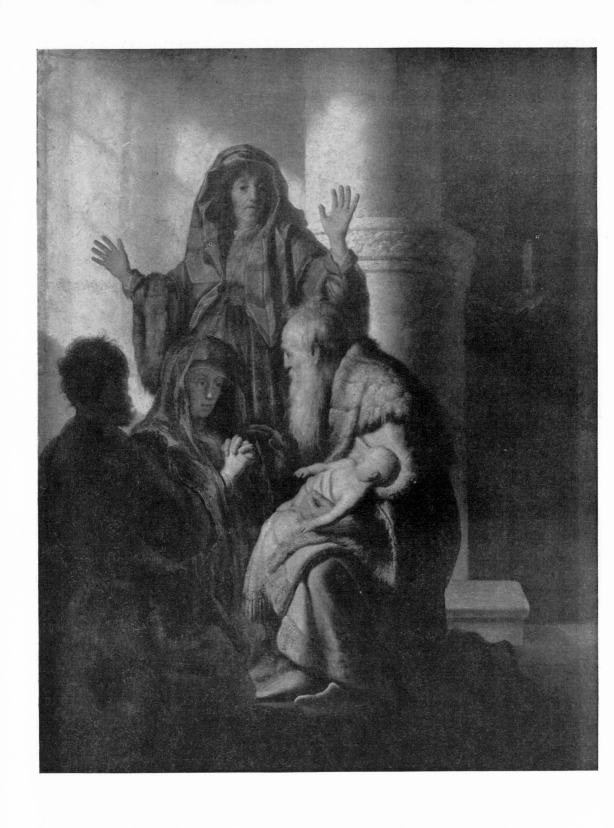

THE PRESENTATION OF JESUS IN THE TEMPLE. Panel, 55.5 × 44 cm. Hamburg, Kunsthalle. (Br. 535)

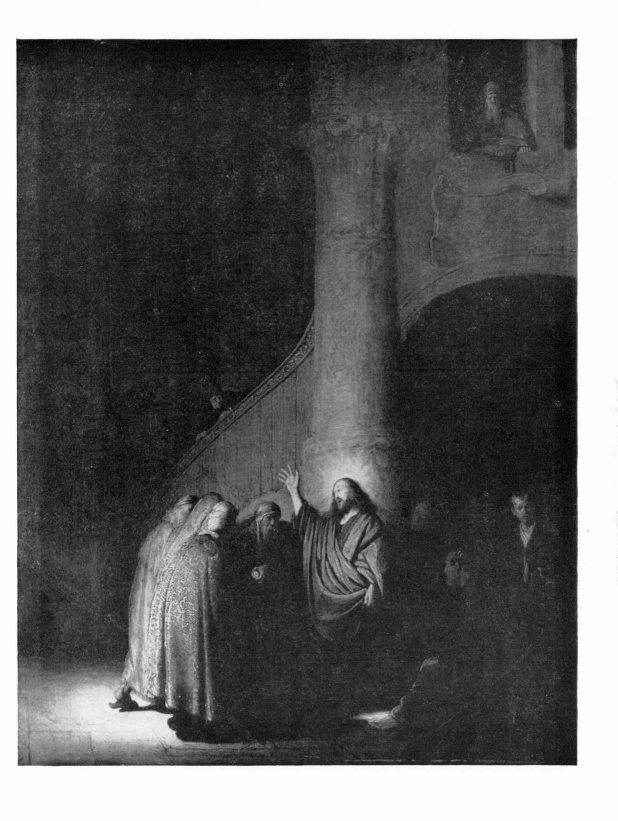

THE TRIBUTE-MONEY. 1629. Panel, 41 × 33 cm. Ottawa, National Gallery of Canada. (Br. 536)

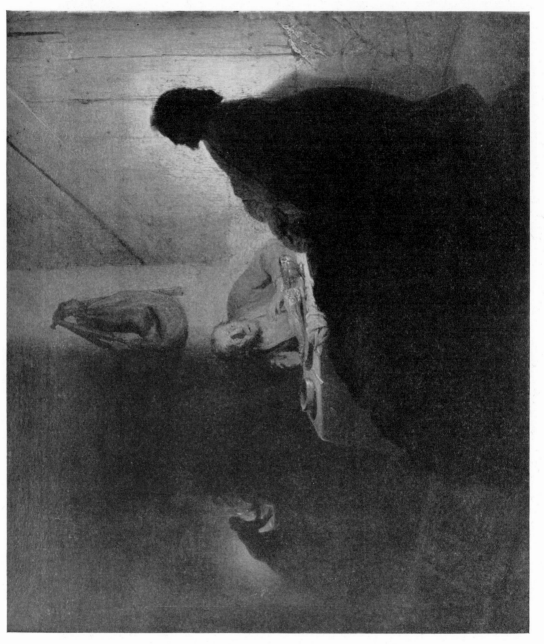

CHRIST AT EMMAUS. Paper on Panel, 39 × 42 cm. Paris, Musée Jacquemart-André. (Br. 539)

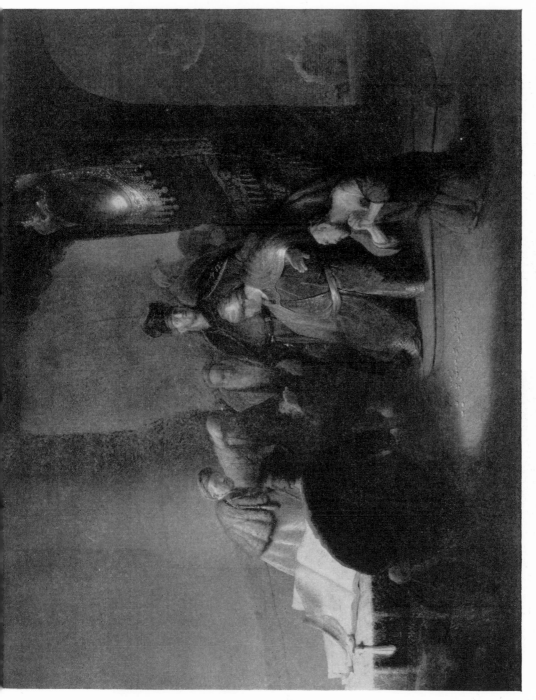

JUDAS RETURNING THE THIRTY PIECES OF SILVER. 1629. Panel, 76×101 cm. Mulgrave Castle, Yorkshire, Normanby Collection. (Br. 539A)

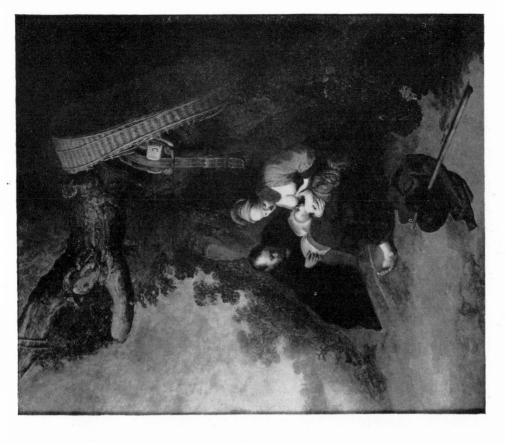

The Rest on the Flight into Egypt. Panel, 76.5 × 64 cm. Downton Castle, Major W. M. P. Kincaid-Lennox. (Br. 540)

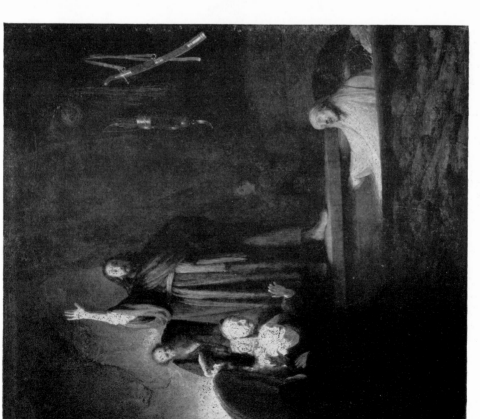

The Raising of Lazarus. Panel, 93.5 × 81 cm. Los Angeles, Calif., Private Collection. (Br. 538)

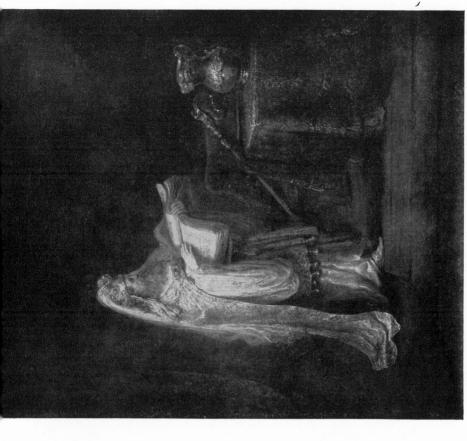

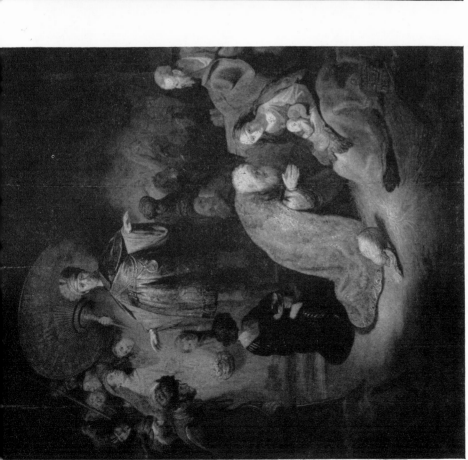

The Adoration of the Magi. Panel, 75×65 cm. Gothenburg, Museum. (Br. 541)

Zacharias in the Temple. Panel, 58×47·5 cm. Formerly Amsterdam, P. de Boer. (Br. 542)

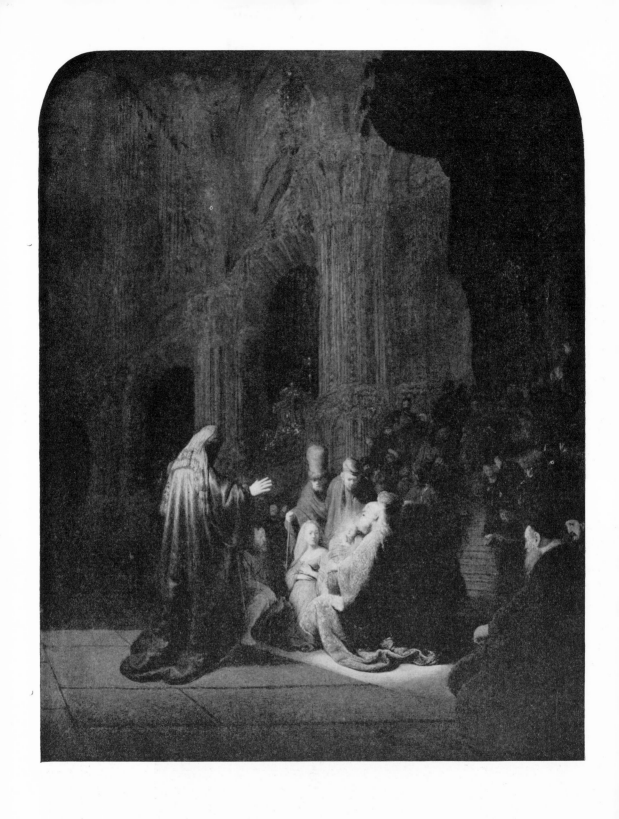

THE PRESENTATION OF JESUS IN THE TEMPLE. 1631. Panel, 61×48 cm. The Hague, Mauritshuis.
(Br. 543)

CHRIST ON THE CROSS. 1631. Canvas on panel, 100×73 cm. Le Mas d'Agenais (France), Parish Church. (Br. 543A)

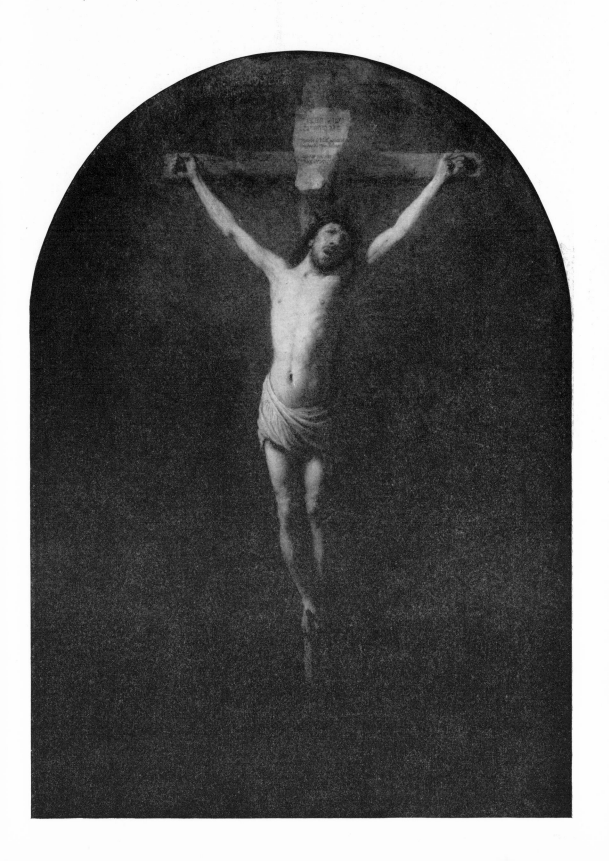

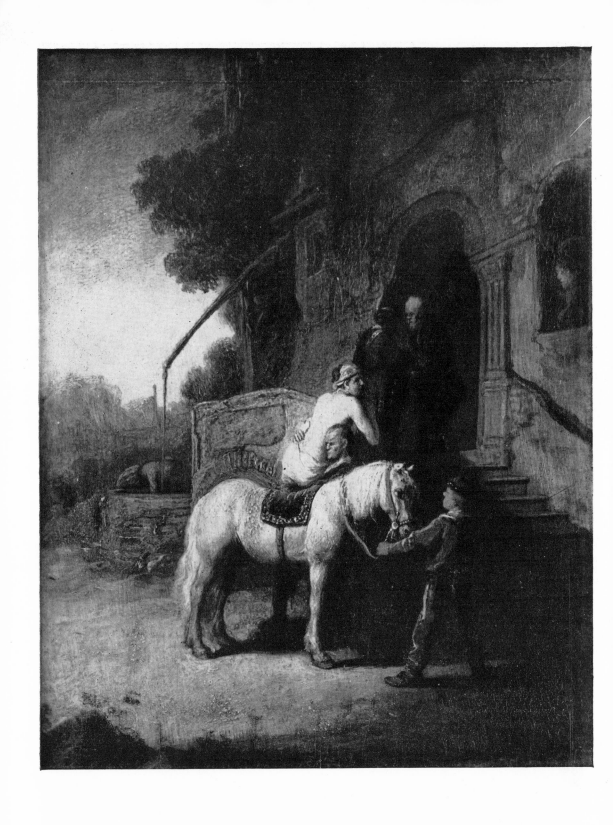

THE GOOD SAMARITAN. Panel, 25×21 cm. London, The Wallace Collection. (Br. 545)

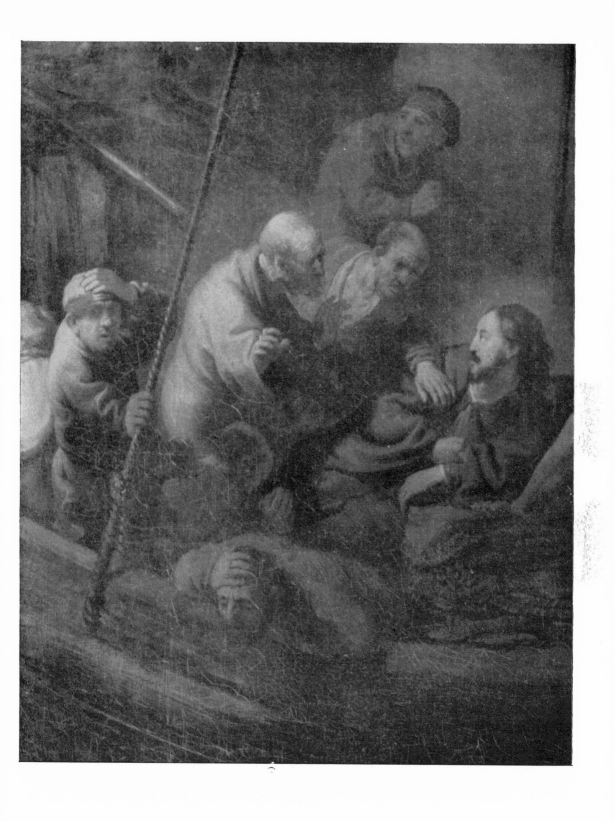

Detail from "Christ in the Storm on the Lake of Galilee" Reproduced on Page 460

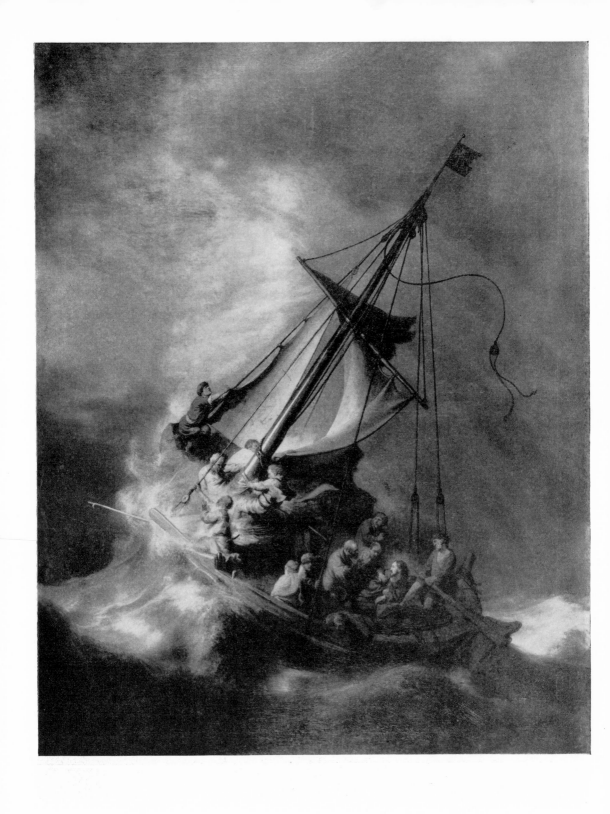

CHRIST IN THE STORM ON THE LAKE OF GALILEE. 1633. Canvas, 159·5×127·5 cm. Boston, Isabella Stewart Gardner Museum. (Br. 547)

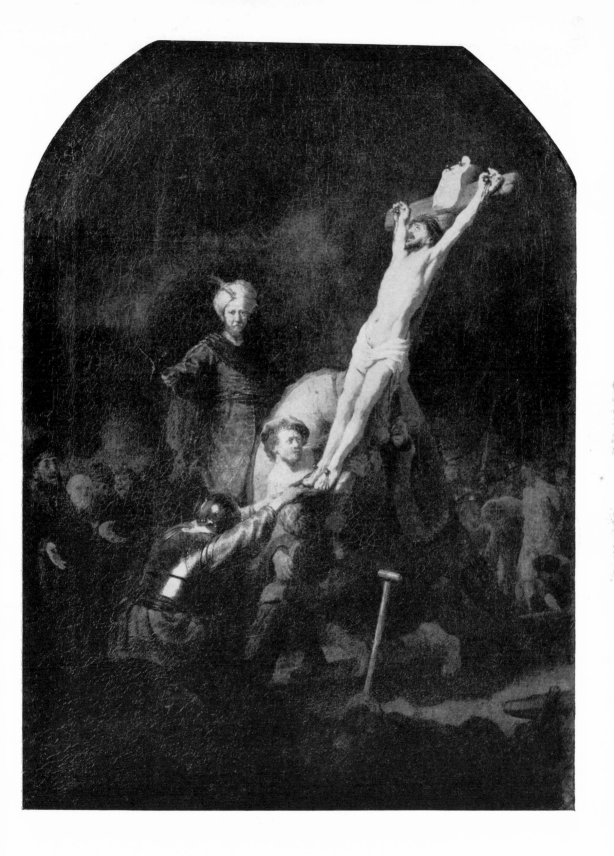

THE RAISING OF THE CROSS. Canvas, 96×72 cm. Munich, Alte Pinakothek. (Br. 548)

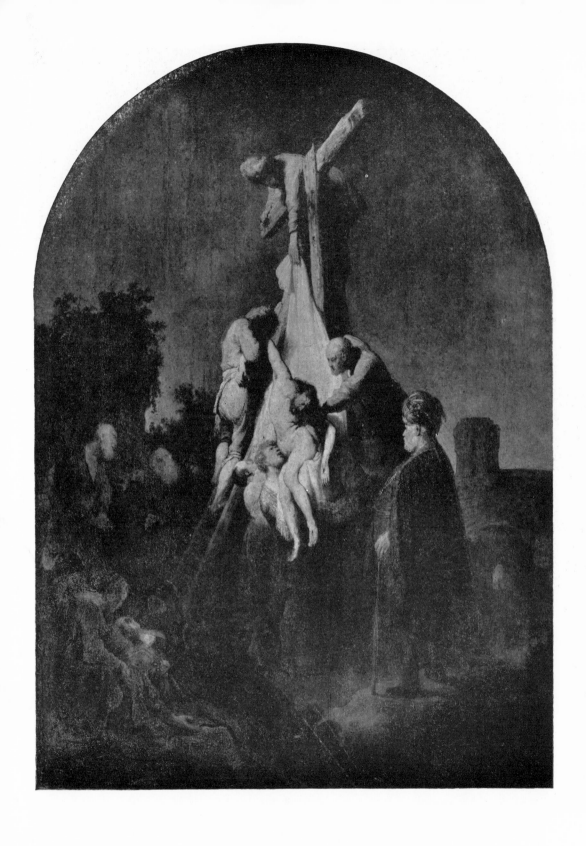

THE DESCENT FROM THE CROSS. Panel, 89.5 × 65 cm. Munich, Alte Pinakothek. (Br. 550)

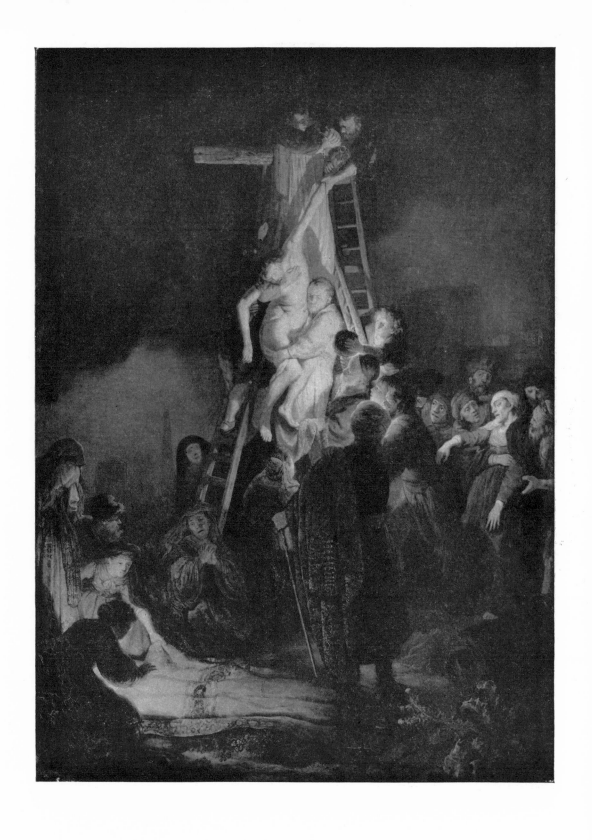

THE DESCENT FROM THE CROSS. 1634. Canvas, 158×117 cm. Leningrad, Hermitage. (Br. 551)

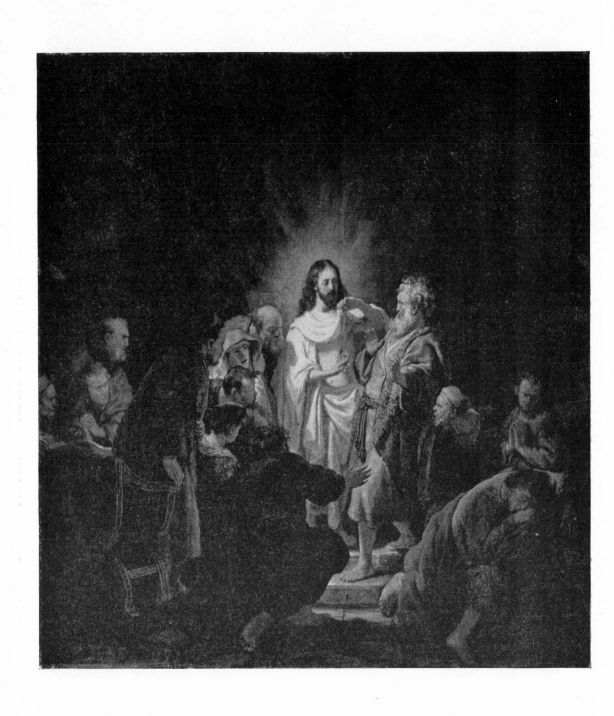

THE RISEN CHRIST SHOWING HIS WOUND TO THE APOSTLE THOMAS. 1634. Panel, 53×51 cm.
Moscow, Pushkin Museum. (Br. 552)

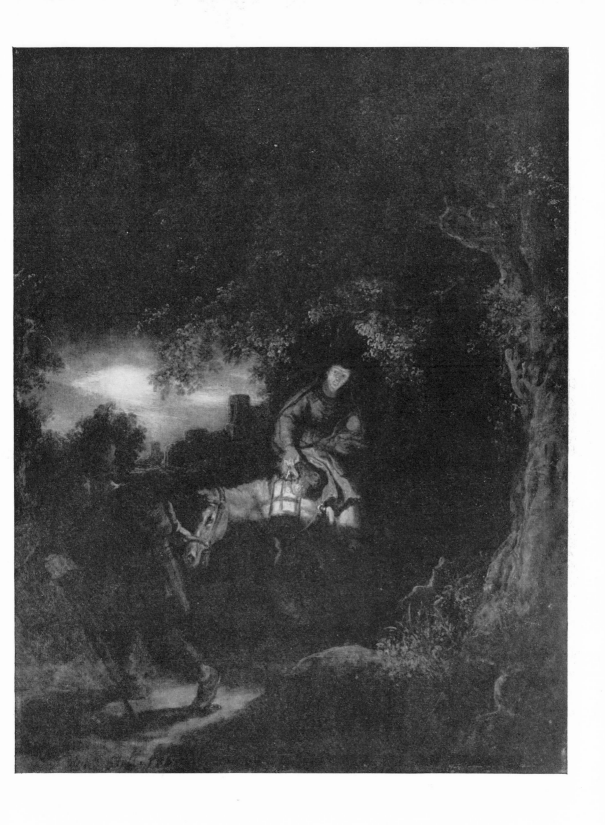

THE FLIGHT INTO EGYPT. 1634(?). Panel, 52×41 cm. London, Lord Wharton. (Br. 552A)

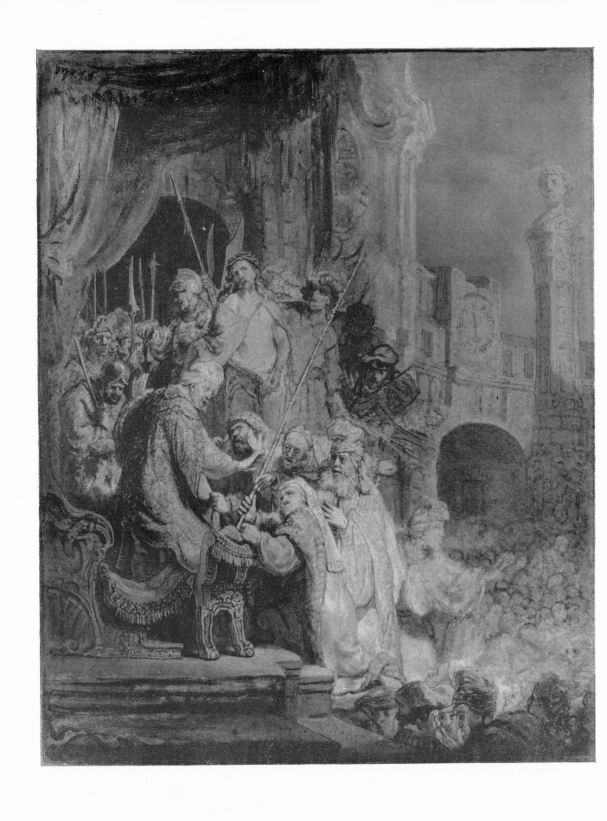

CHRIST BEFORE PILATE AND THE PEOPLE. 1634. Paper laid down on canvas, 54·5×44·5 cm. London, National Gallery. (Br. 546)

THE HOLY FAMILY. Canvas, 183·5 × 123 cm. Munich, Alte Pinakothek. (Br. 544)

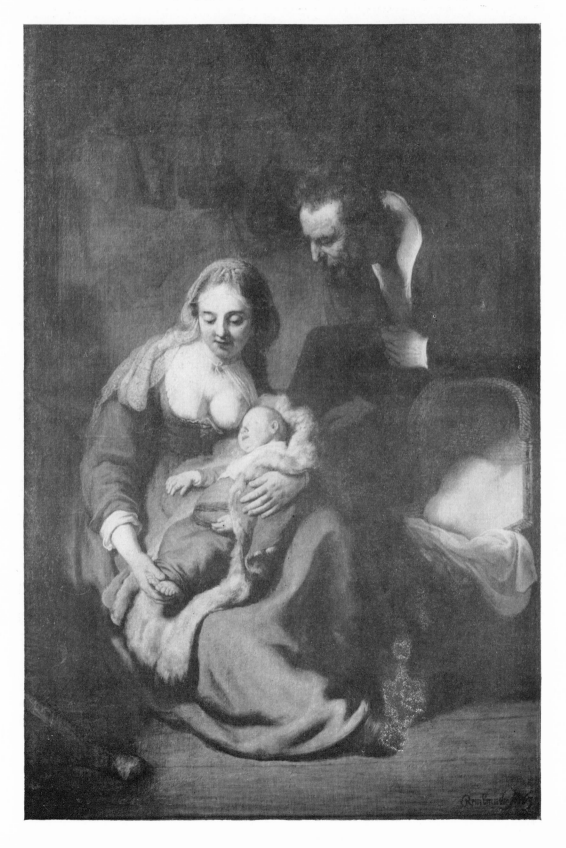

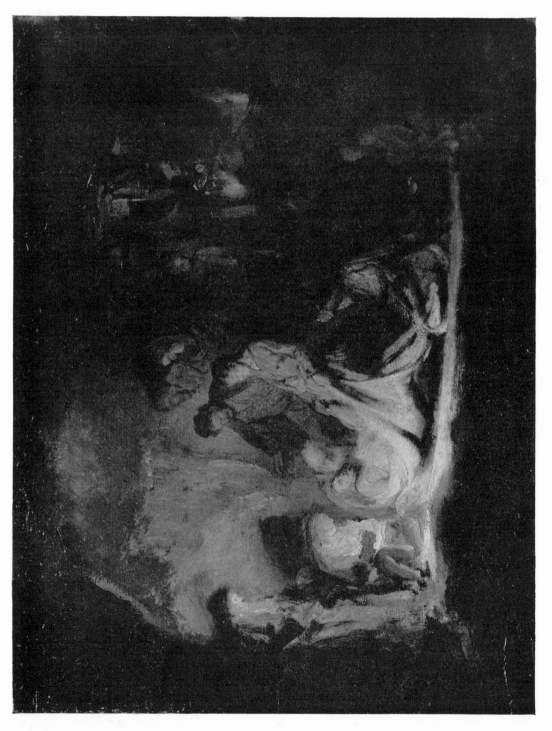

THE ENTOMBMENT OF CHRIST. Panel, 32 × 40·5 cm. Glasgow, University, Hunterian Museum. (Br. 554)

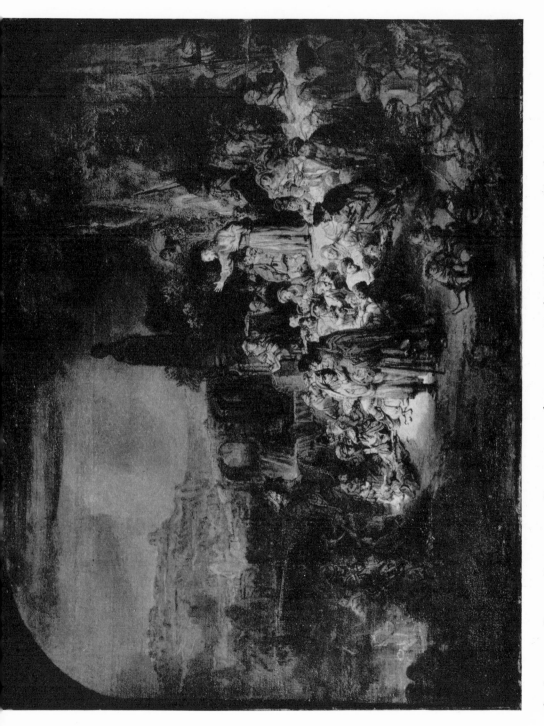

Sᴛ. Jᴏʜɴ ᴛʜᴇ Bᴀᴘᴛɪsᴛ Pʀᴇᴀᴄʜɪɴɢ. Canvas on panel, 62×80 cm. Berlin-Dahlem, Gemäldegalerie. (Br. 555)

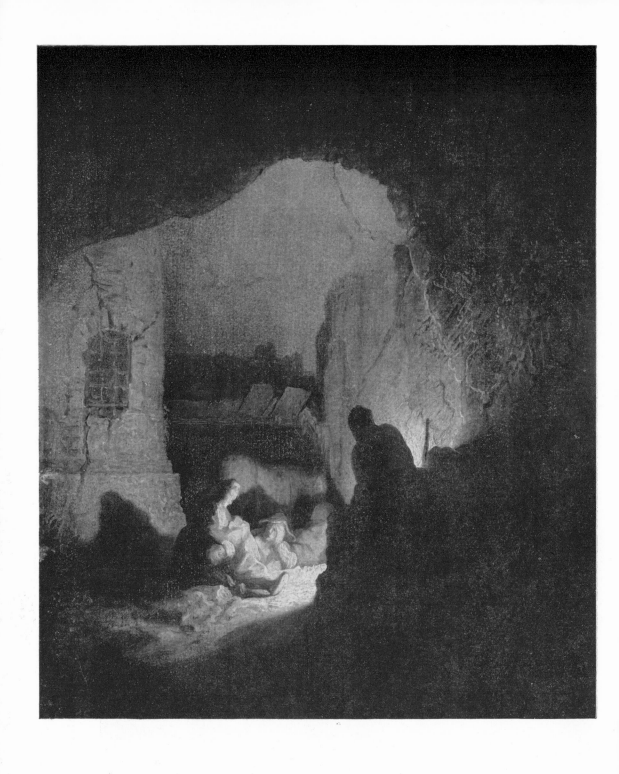

THE REST ON THE FLIGHT INTO EGYPT. Paper on panel, 38·5×34 cm. The Hague, Mauritshuis.
(Br. 556)

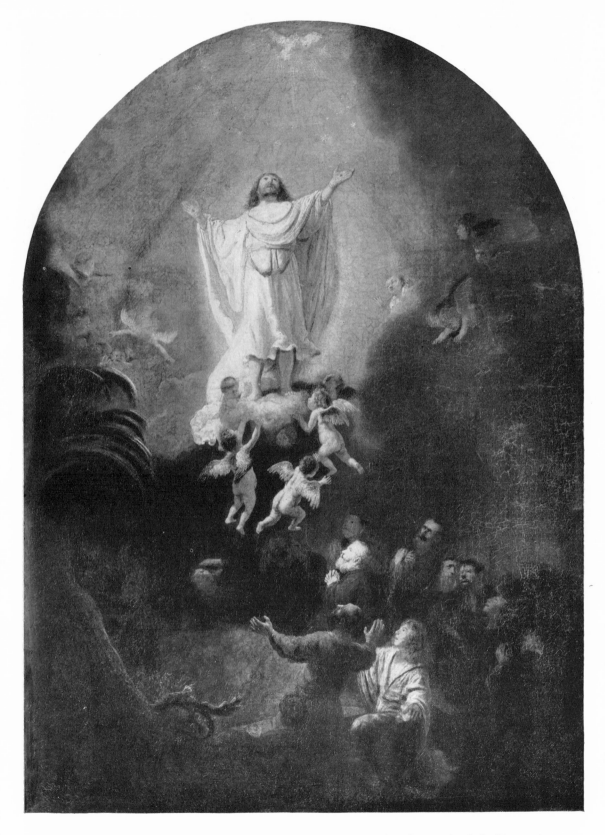

THE ASCENSION OF CHRIST. 1636. Canvas, 92·5×68·5 cm. Munich, Alte Pinakothek. (Br. 557)

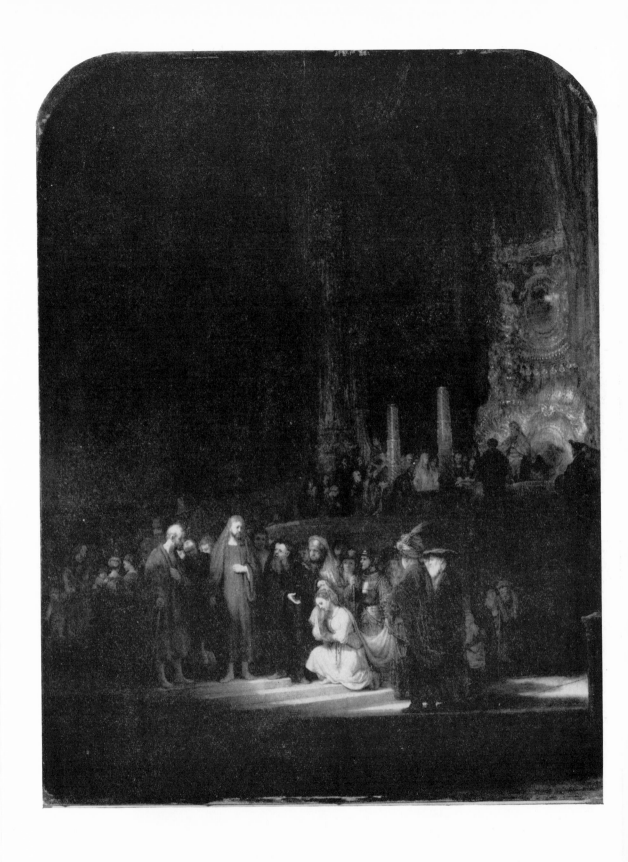

CHRIST AND THE WOMAN TAKEN IN ADULTERY. 1644. Panel, 83·5×64·5 cm. London, National Gallery. (Br. 566)

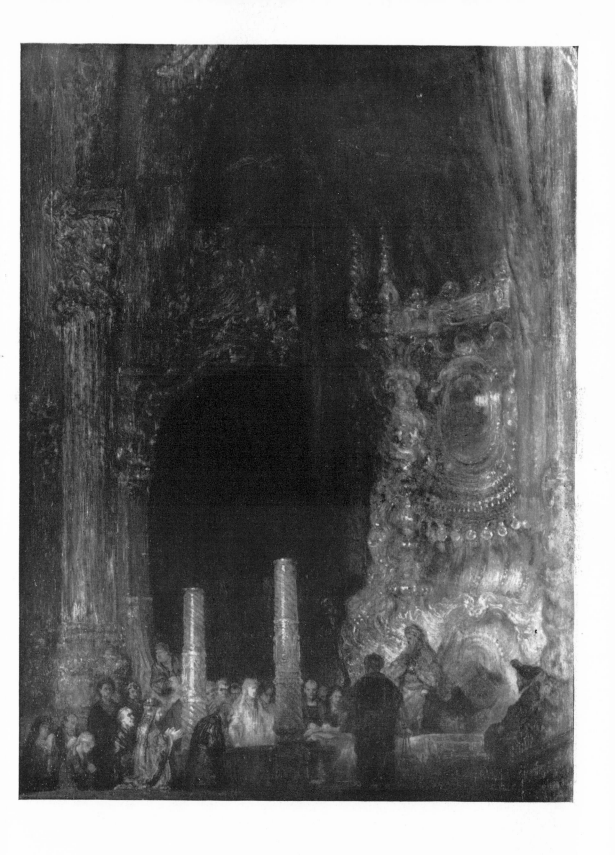

Detail from "Christ and the Woman Taken in Adultery"

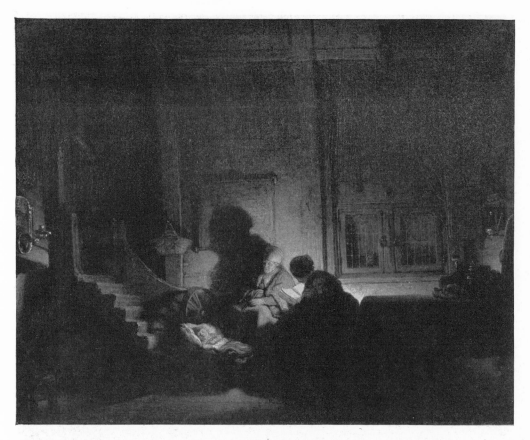

THE HOLY FAMILY. Panel, 60×77 cm. Amsterdam, Rijksmuseum. (Br. 568)

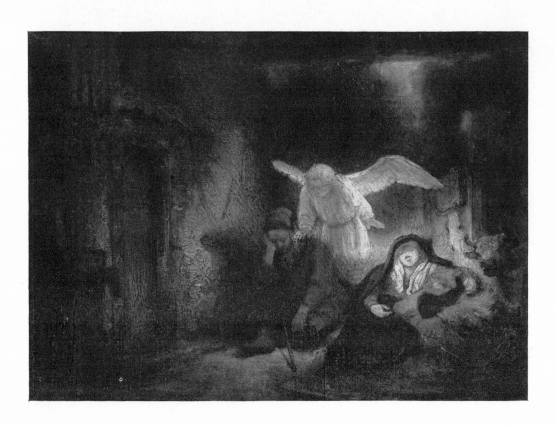

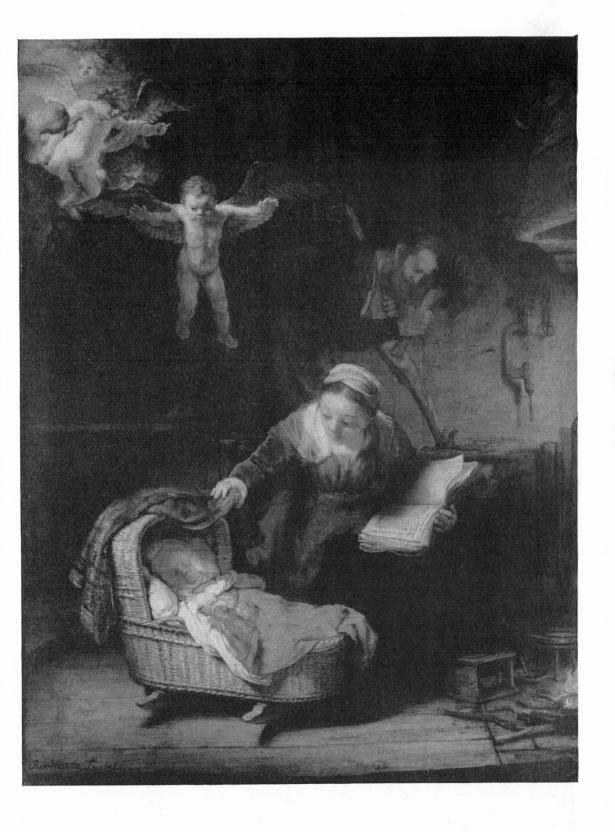

THE HOLY FAMILY WITH ANGELS. 1645. Canvas, 117×91 cm. Leningrad, Hermitage. (Br. 570)

JOSEPH'S DREAM IN THE STABLE AT BETHLEHEM. 1645. Panel, 20×27 cm. Berlin-Dahlem, Gemäldegalerie. (Br. 569)

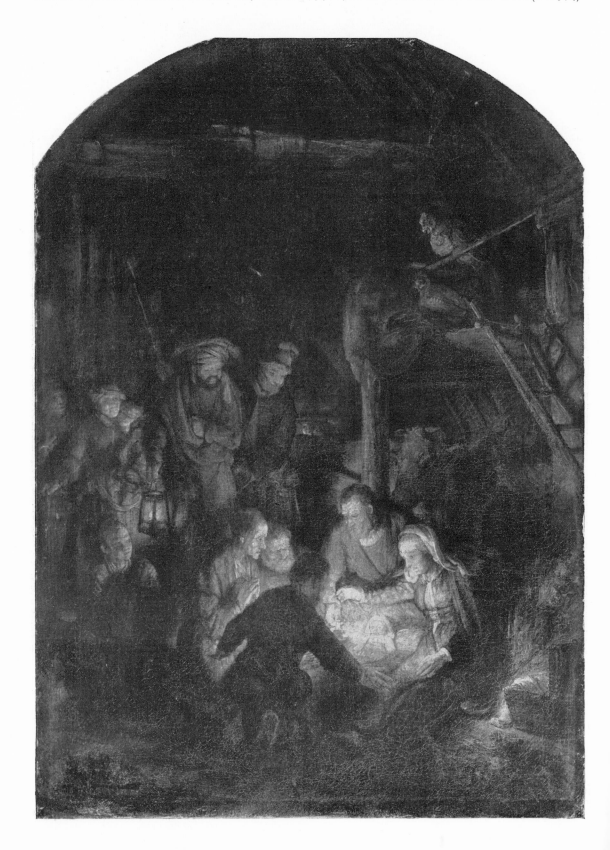

THE ADORATION OF THE SHEPHERDS. 1646. Canvas, 65.5×55 cm. London, National Gallery. (Br. 575)

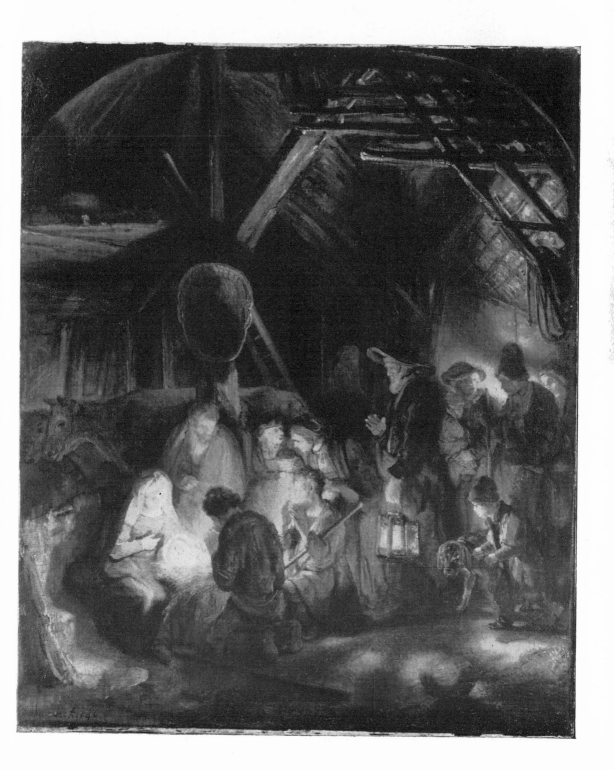

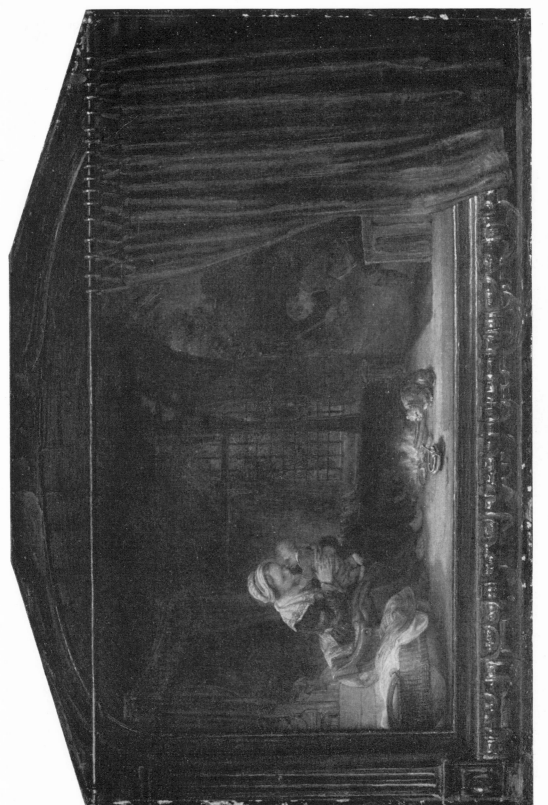

THE HOLY FAMILY (with painted frame and curtain). 1646. Panel, 46·5×68·5 cm. Cassel, Gemäldegalerie. (Br. 572)

THE REST ON THE FLIGHT INTO EGYPT. 1647. Panel, 34 × 47 cm. Dublin, National Gallery of Ireland. (Br. 576)

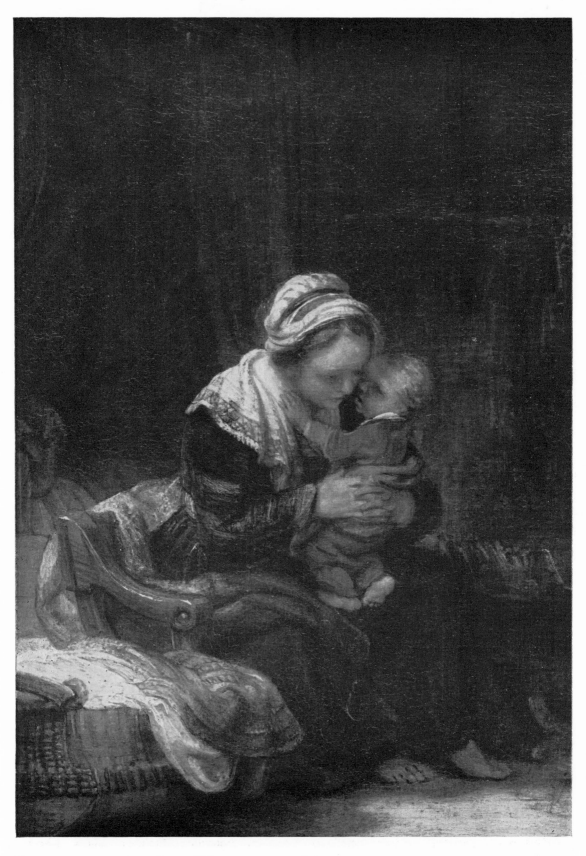

Detail from the "Holy Family" Reproduced on Page 486

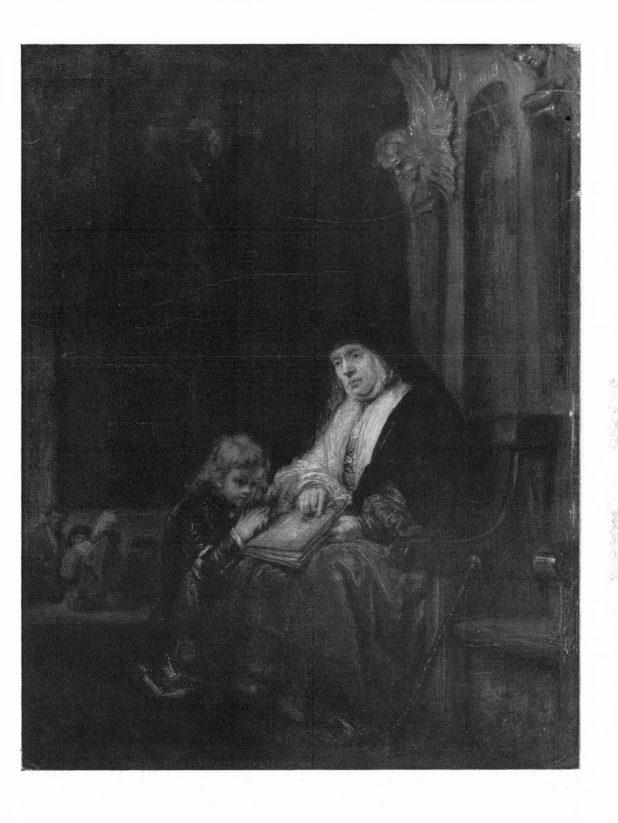

HANNAH IN THE TEMPLE(?). 1650(?). Panel, 40·5×31·5 cm. Edinburgh, National Gallery of Scotland (on loan from the Duke of Sutherland). (Br. 577)

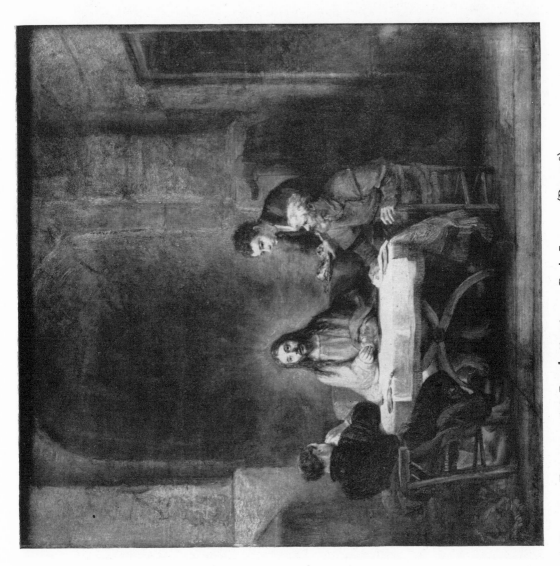

CHRIST AT EMMAUS. 1648. Panel, 68×65 cm. Paris, Louvre. (Br. 578)

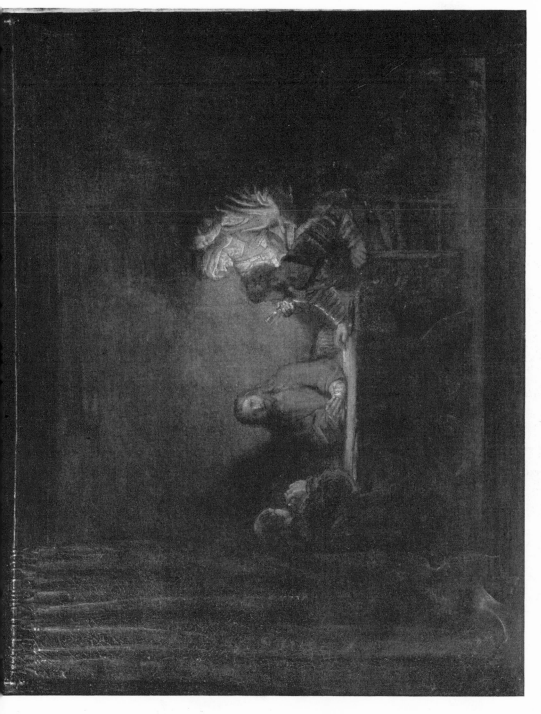

CHRIST AT EMMAUS. 1648. Canvas, 89.5 × 111.5 cm. Copenhagen, Statens Museum .(Br. 579)

THE LAMENTATION OVER THE DEAD CHRIST. 1650. Canvas, 177·5 × 196·5 cm. Sarasota, Florida, John and Mabel Ringling Museum. (Br. 582)

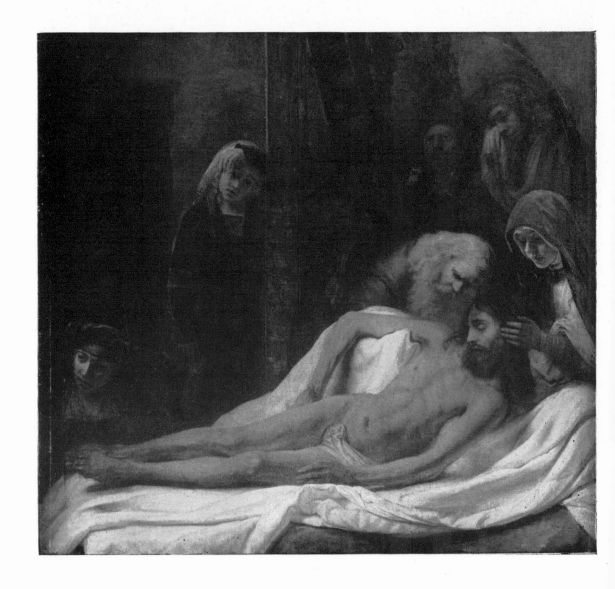

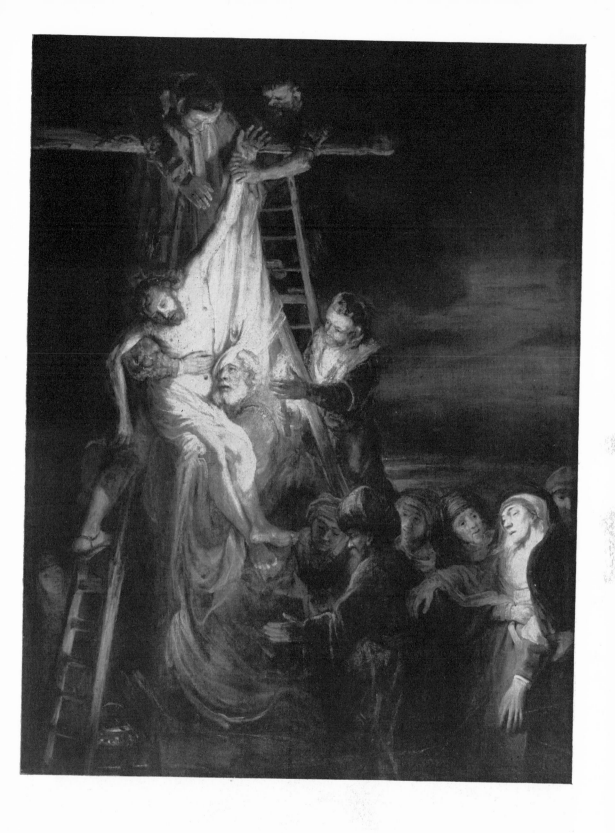

THE DESCENT FROM THE CROSS. 165(1). Canvas, 142×106 cm. Washington, D.C., National Gallery of Art (Widener Collection). (Br. 584)

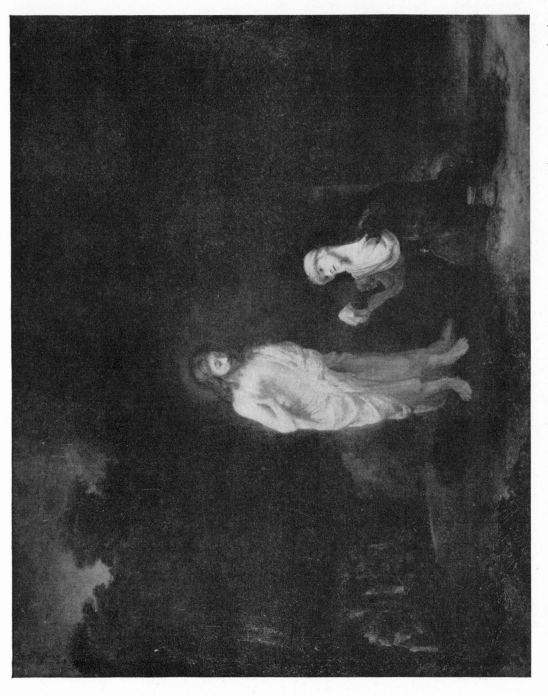

THE RISEN CHRIST APPEARING TO THE MAGDALEN. 1651. Canvas, 65×79 cm. Brunswick, Herzog Anton Ulrich Museum. (Br. 583)

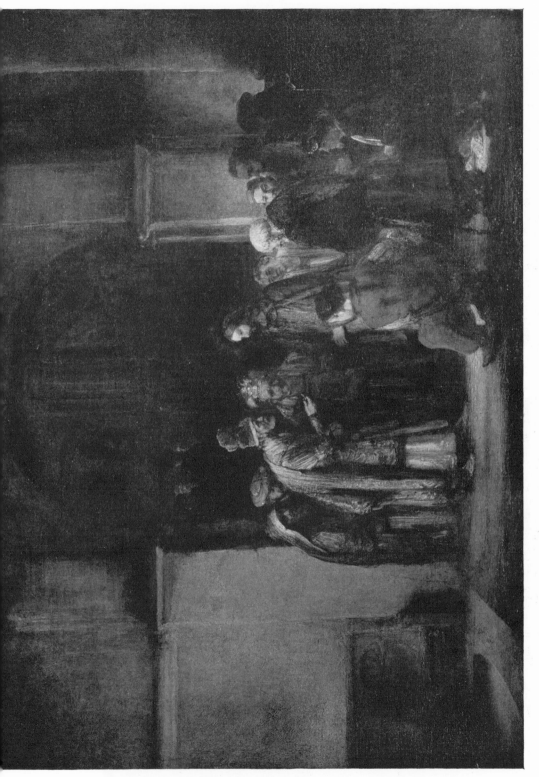

THE TRIBUTE-MONEY. 1655. Canvas, 63 × 84 cm. Bywell, Northumberland, Viscount Allendale. (Br. 586)

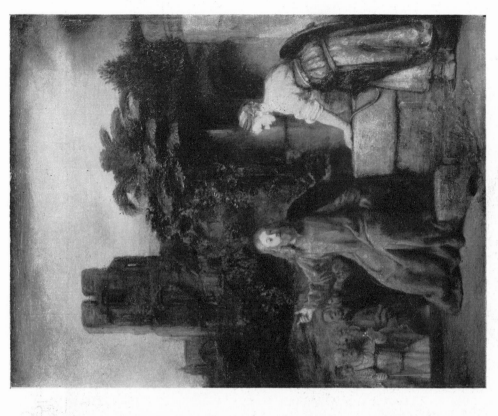

CHRIST AND THE WOMAN OF SAMARIA AT THE WELL. 1655.
Panel, 62×49.5 cm. New York, Metropolitan Museum of Art.
(Br. 589)

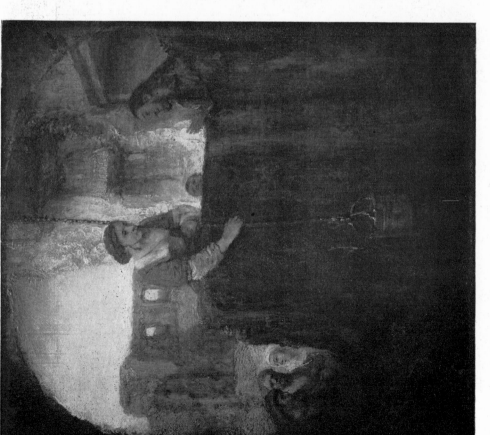

CHRIST AND THE WOMAN OF SAMARIA AT THE WELL. 1655. Panel.
46.5×39 cm. Berlin-Dahlem, Gemäldegalerie. (Br. 588)

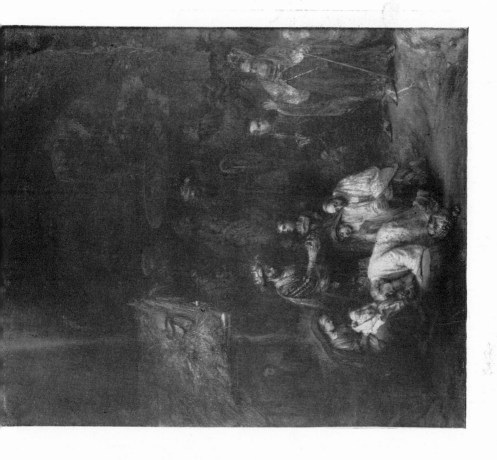

THE ADORATION OF THE MAGI. 1657. Panel, 123×103 cm. London, Buckingham Palace. (Br. 592)

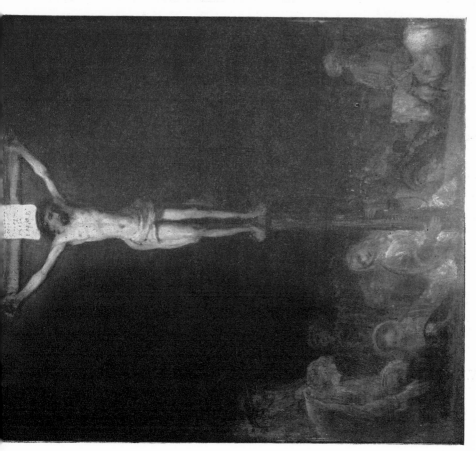

CHRIST ON THE CROSS. 1657. Panel, 32×29 cm. Williamstown, Mass., The Sterling and Francine Clark Art Institute. (Br. 590)

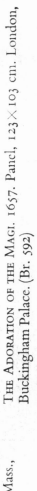

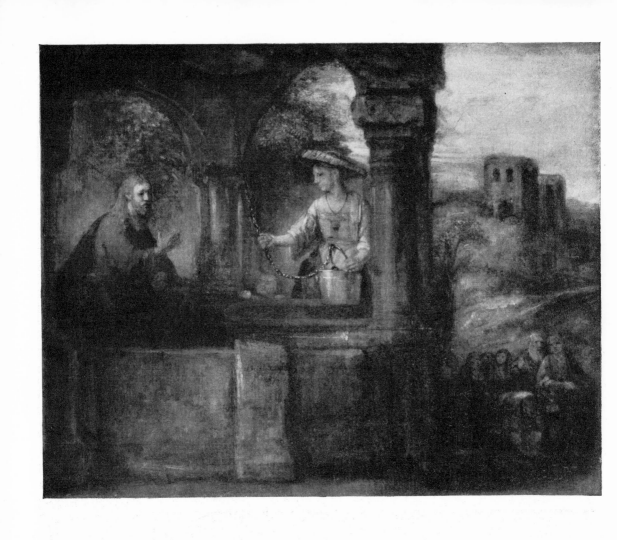

CHRIST AND THE WOMAN OF SAMARIA AT THE WELL. 1659. Canvas, 60×75 cm. Leningrad, Hermitage. (Br. 592A)

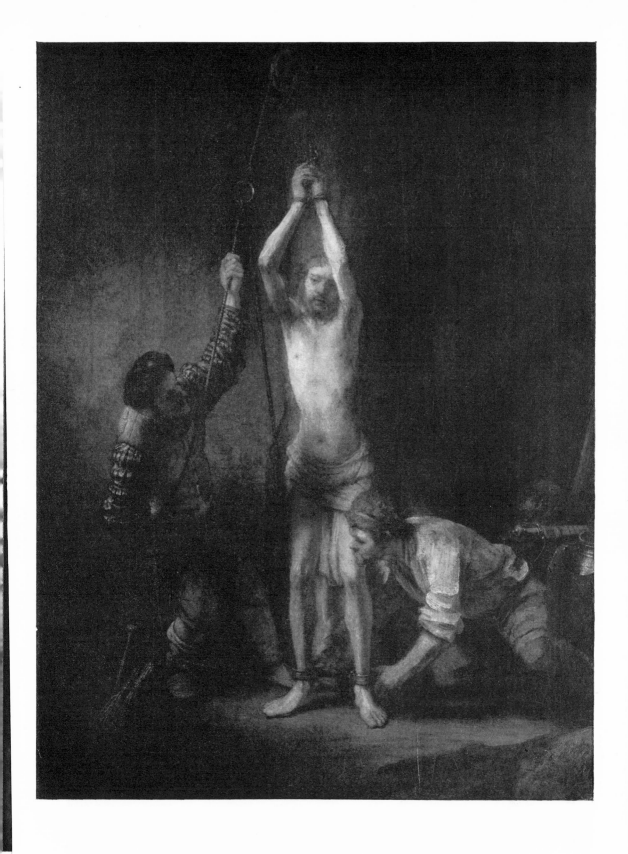

CHRIST AT THE COLUMN. 1658. Canvas, 93×72 cm. Darmstadt, Museum. (Br. 593)

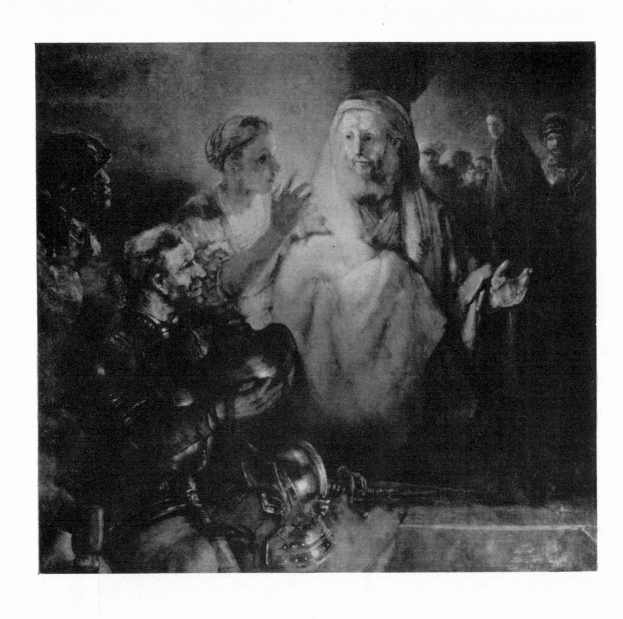

THE APOSTLE PETER DENYING CHRIST. 1660. Canvas, 154×169 cm. Amsterdam, Rijksmuseum.
(Br. 594)

THE RETURN OF THE PRODIGAL SON. Canvas, 262 × 206 cm. Leningrad, Hermitage. (Br. 598)

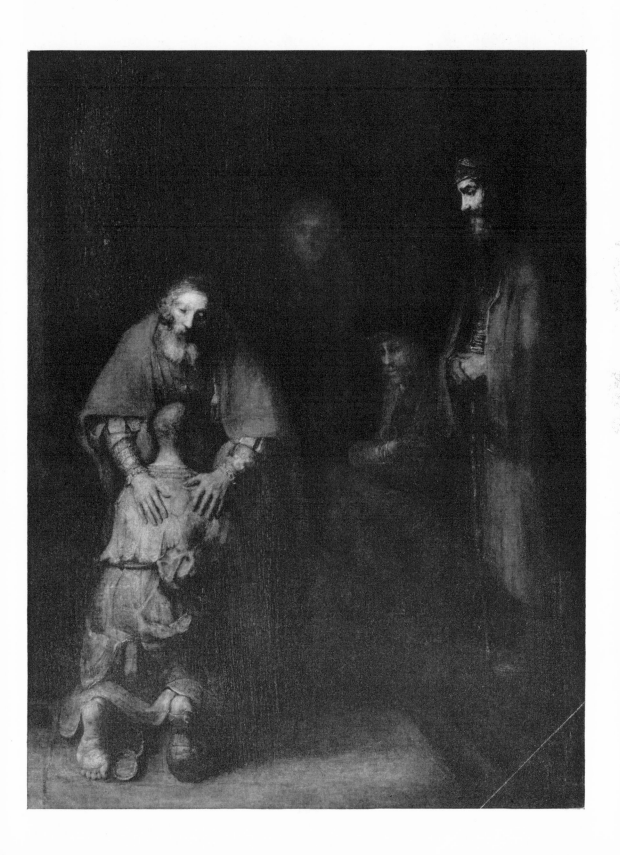

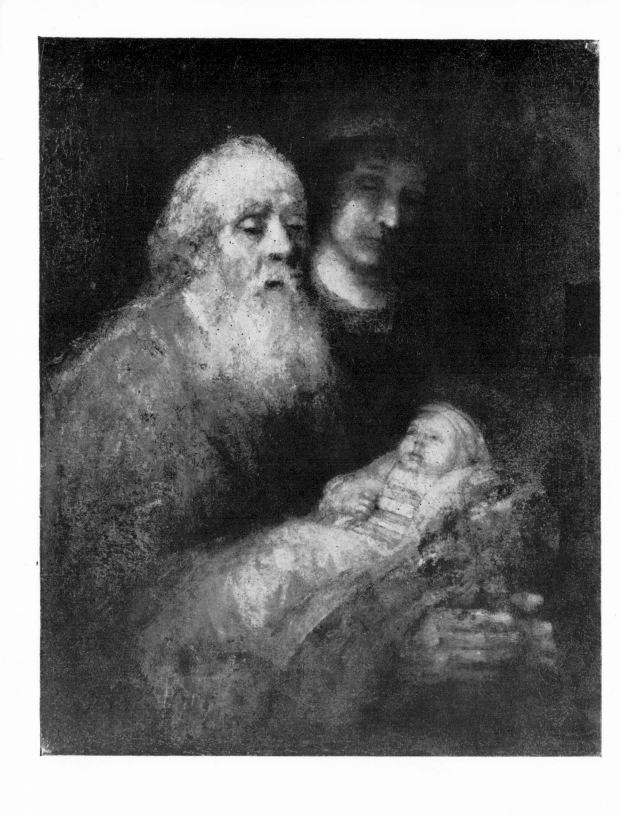

SIMEON WITH THE CHRIST CHILD IN THE TEMPLE. 1669. Canvas, 99×78.5 cm. Stockholm, National-
museum. (Br. 600)

BIBLICAL SUBJECTS 3
SINGLE FIGURES

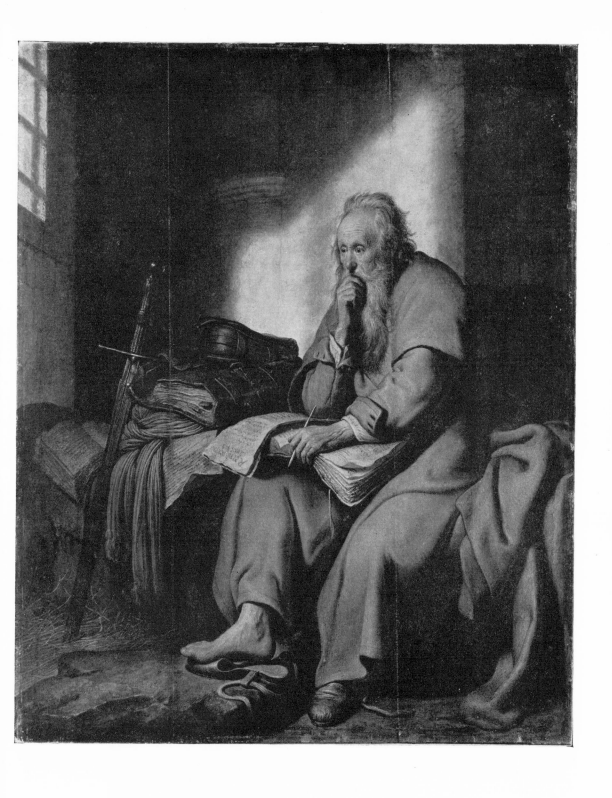

The Apostle Paul in Prison. 1627. Panel, 73 × 60 cm. Stuttgart, Staatsgalerie. (Br. 601)

THE APOSTLE PAUL. Canvas, 135×111 cm. Vienna, Kunsthistorisches Museum. (Br. 603)

THE APOSTLE PAUL AT HIS DESK. Panel, 47×39 cm. Nürnberg, Germanisches Nationalmuseum. (Br. 602)

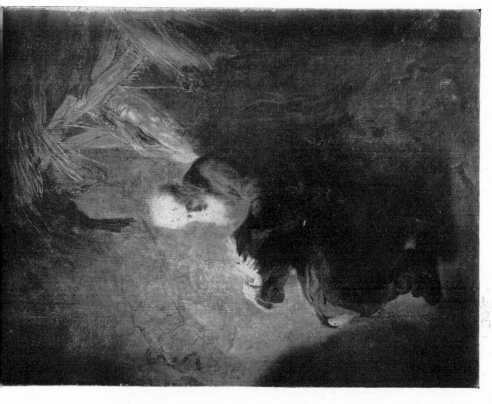

A Hermit Reading. 1630. Panel, 59×46 cm. Paris, Louvre.
(Br. 605)

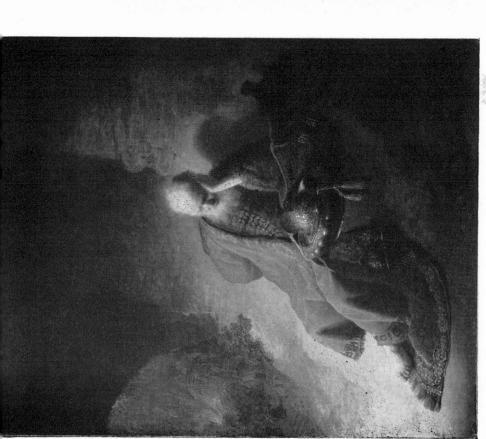

The Prophet Jeremiah Mourning over the Destruction of Jeru-
salem. 1630. Panel, 58×46 cm. Amsterdam, Rijksmuseum. (Br. 604)

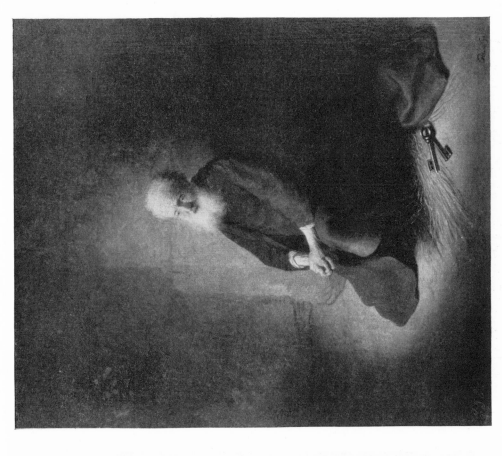

THE APOSTLE PETER IN PRISON. 1631. Panel, 58×48 cm. Brussels, Prince de Mérode-Westerloo. (Br. 607)

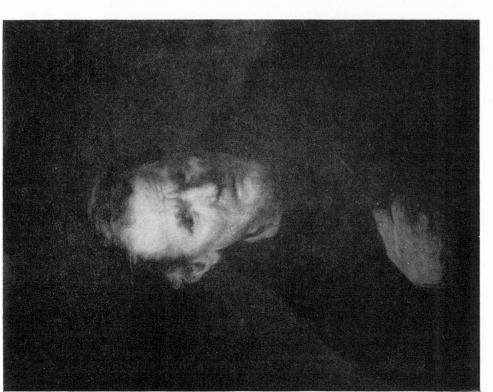

THE APOSTLE BARTHOLOMEW. Panel, 62×46 cm. Worcester, Mass., Worcester Art Museum. (Br. 606A)

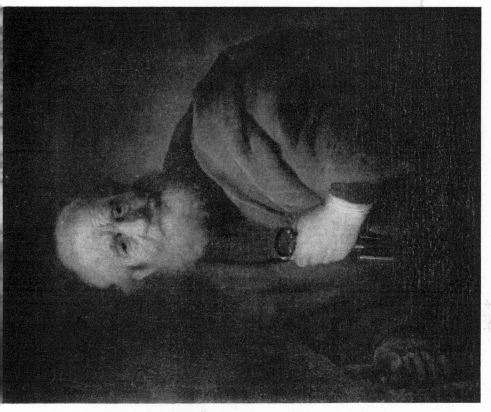

THE APOSTLE PETER. 1632. Canvas, 72×54 cm. Stockholm, Nationalmuseum. (Br. 609)

ST. JOHN THE BAPTIST. 1632. Panel, 64×48 cm. Los Angeles, County Museum of Art. (Br. 608)

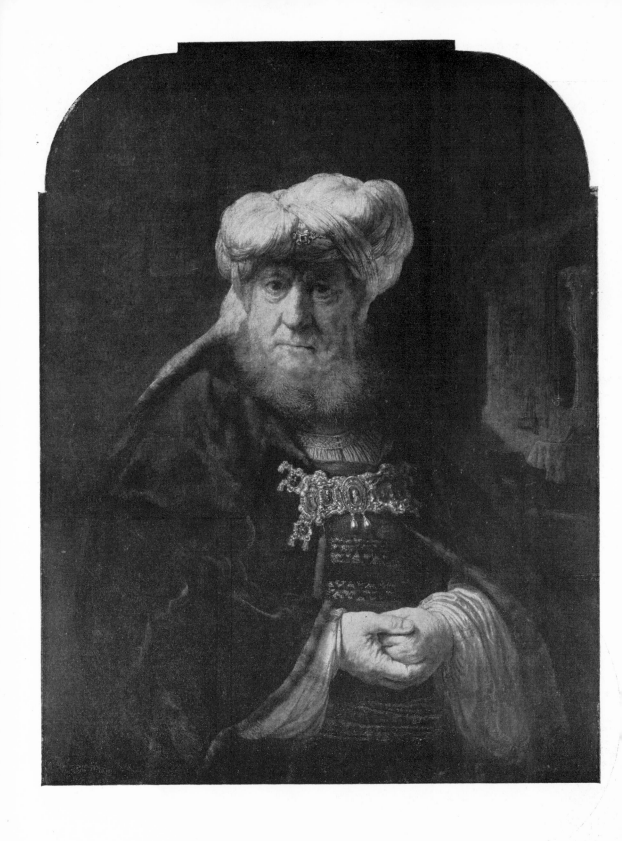

Uzziah Stricken with Leprosy. 1635. Panel, 101×79 cm. Chatsworth, The Trustees of the Chatsworth Settlement (Devonshire Collection). (Br. 179)

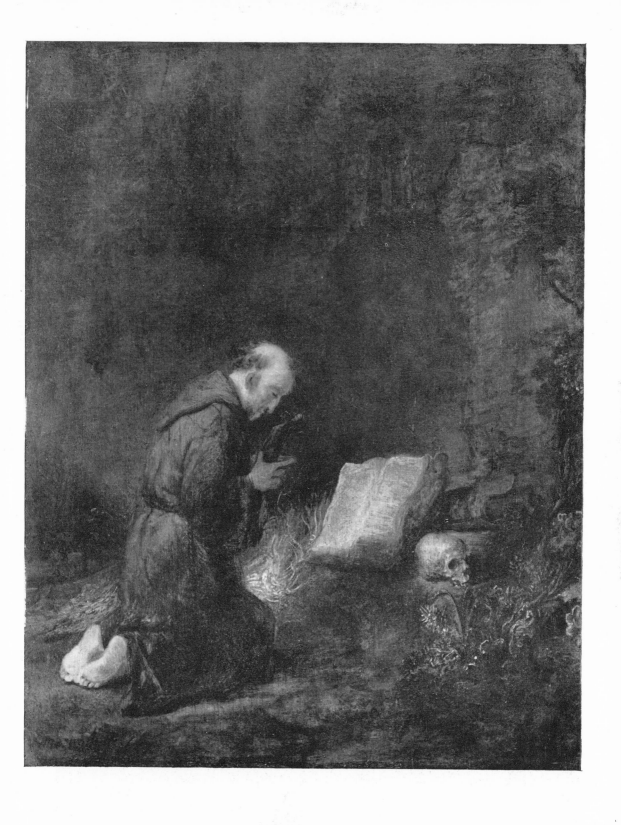

ST. FRANCIS AT PRAYER. 1637. Panel, 58×47 cm. Columbus, Ohio, Gallery of Fine Arts. (Br. 610)

KING DAVID. 1651. Panel, 30×26 cm. New York, Louis Kaplan. (Br. 611)

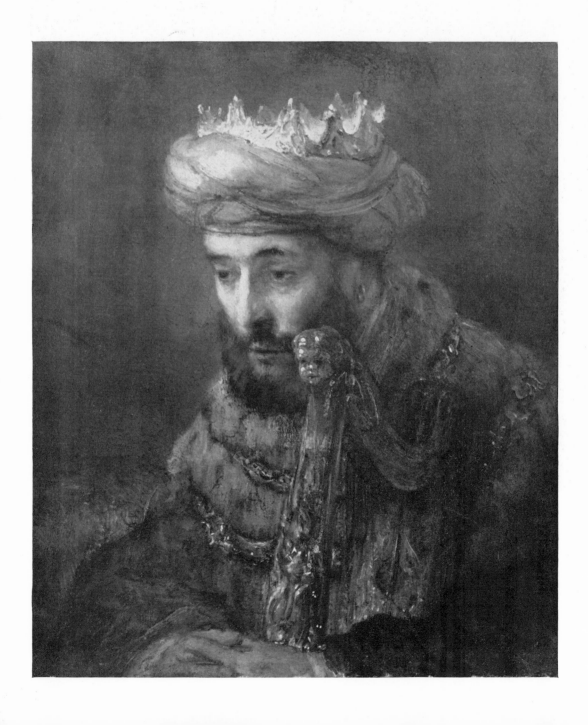

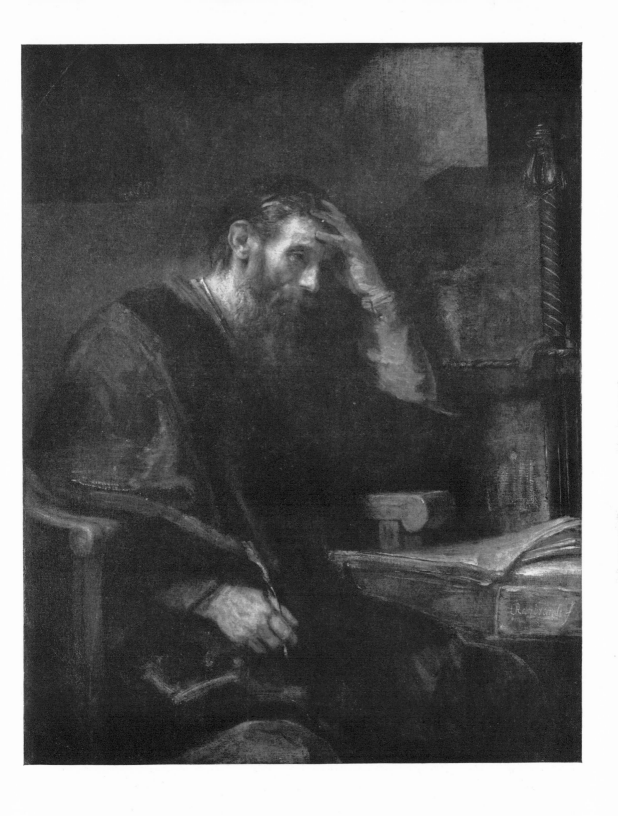

THE APOSTLE PAUL AT HIS DESK. Canvas, 129×102 cm. Washington, D.C., National Gallery of Art (Widener Collection). (Br. 612)

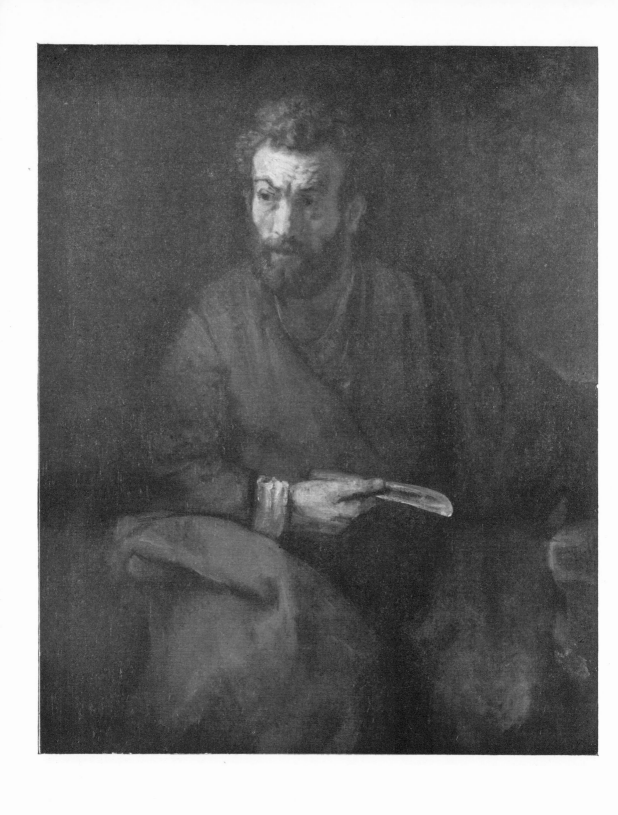

THE APOSTLE BARTHOLOMEW. 1657. Canvas, 126·5×100·5 cm. San Diego, Calif., Timken Art Gallery. (Br. 613)

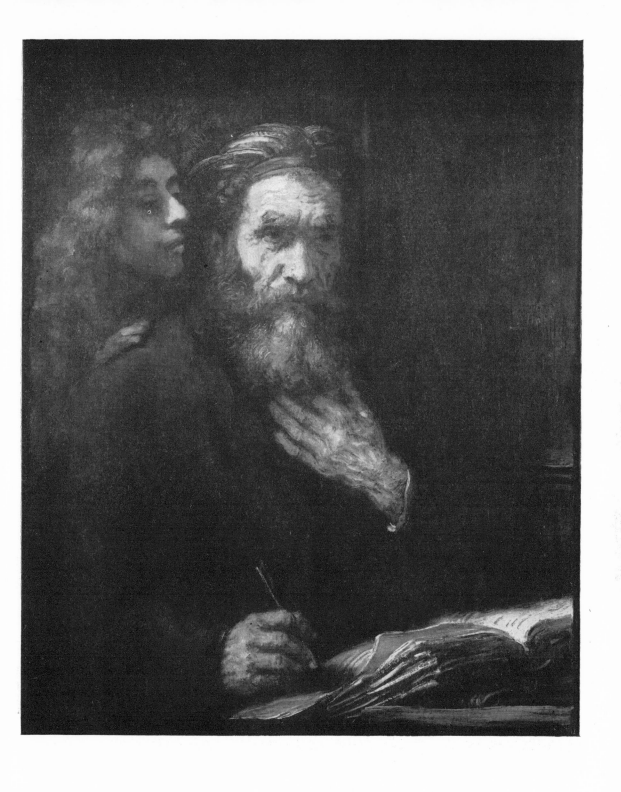

THE EVANGELIST MATTHEW INSPIRED BY THE ANGEL. 1661. Canvas, 96×81 cm. Paris, Louvre.
(Br. 614)

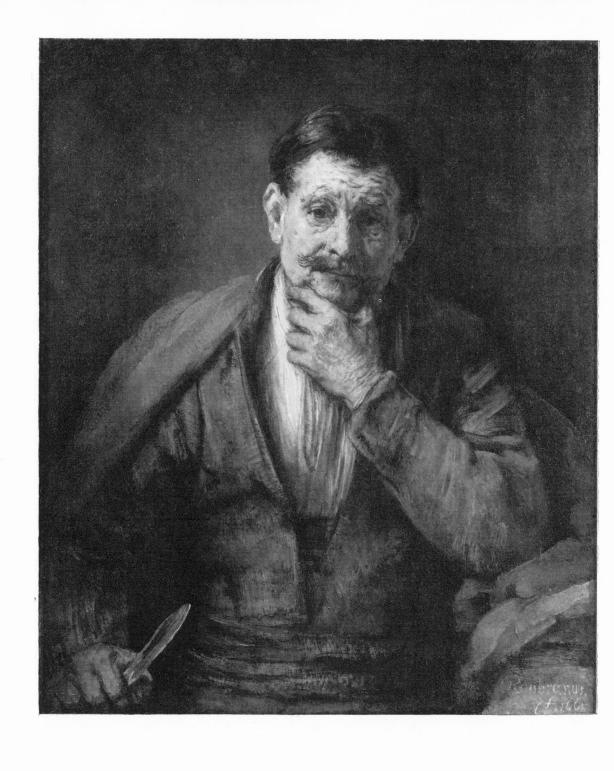

THE APOSTLE BARTHOLOMEW. 1661. Canvas, 87·5×75 cm. Sutton Place, Surrey, The J. Paul Getty Collection (Art Properties Inc.). (Br. 615)

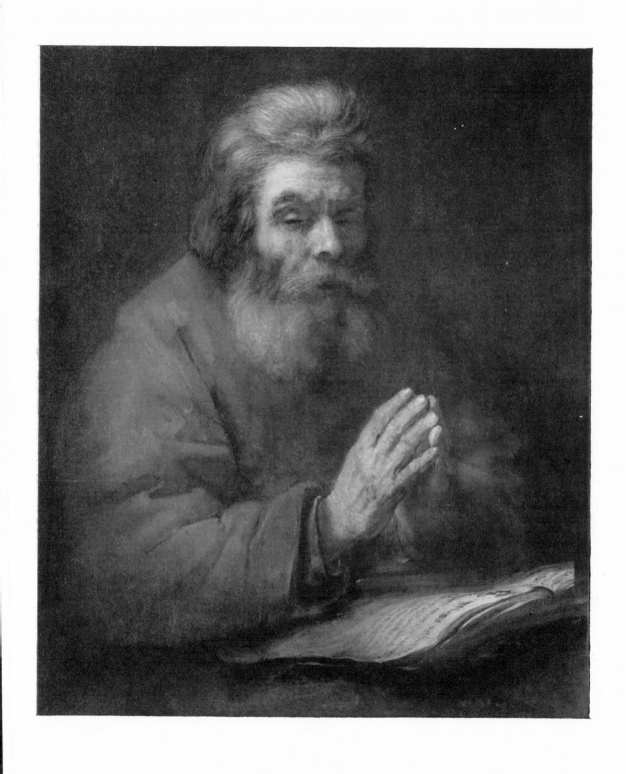

AN APOSTLE PRAYING. 1661. Canvas, 83×67 cm. Cleveland, Museum of Art. (Br. 616)

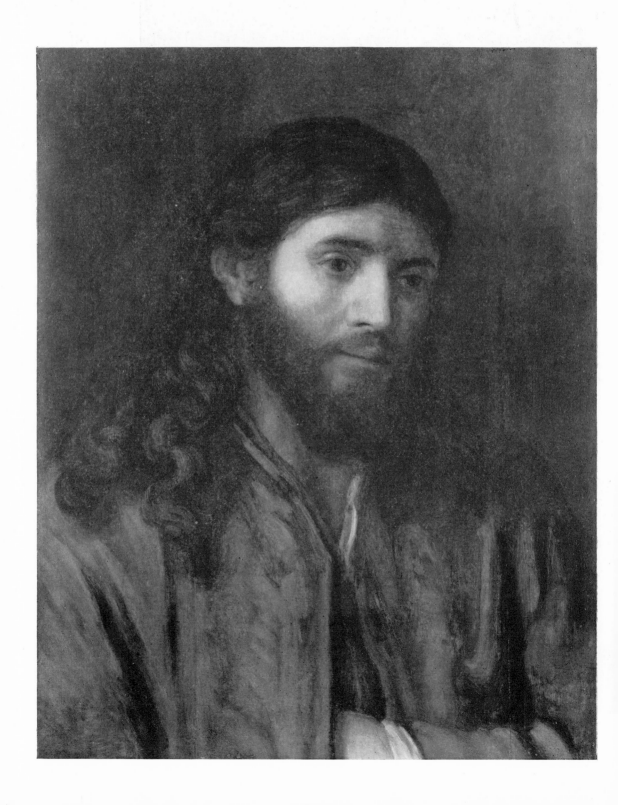

CHRIST. Panel, 62×49 cm. Milwaukee, Harry John. (Br. 627)

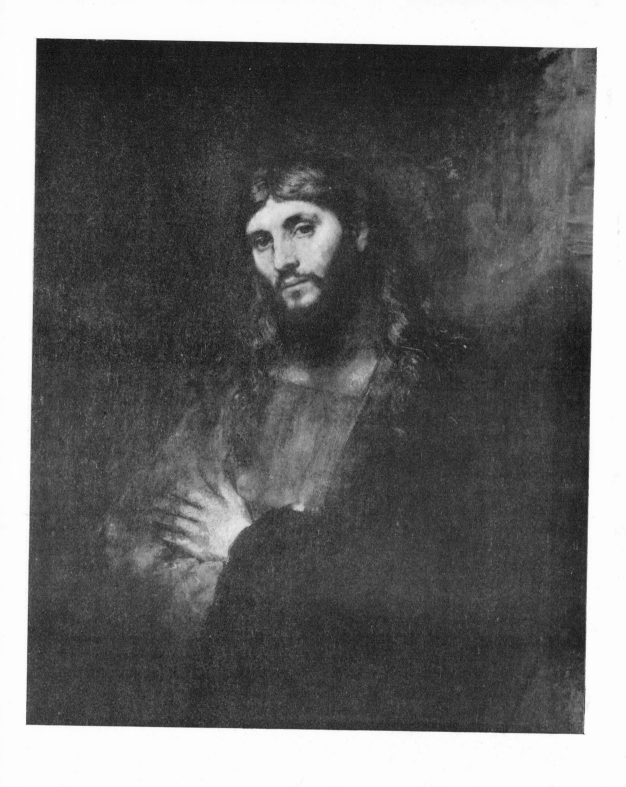

CHRIST. Canvas, 108×89 cm. Glens Falls, N.Y., Hyde Collection. (Br. 628)

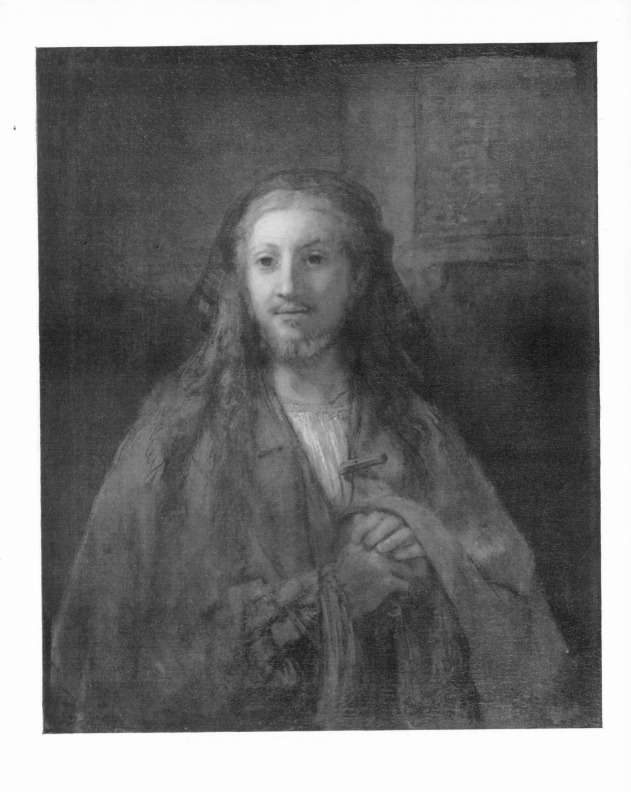

CHRIST. 1661. Canvas, 94·5×81·5 cm. New York, Metropolitan Museum of Art. (Br. 629)

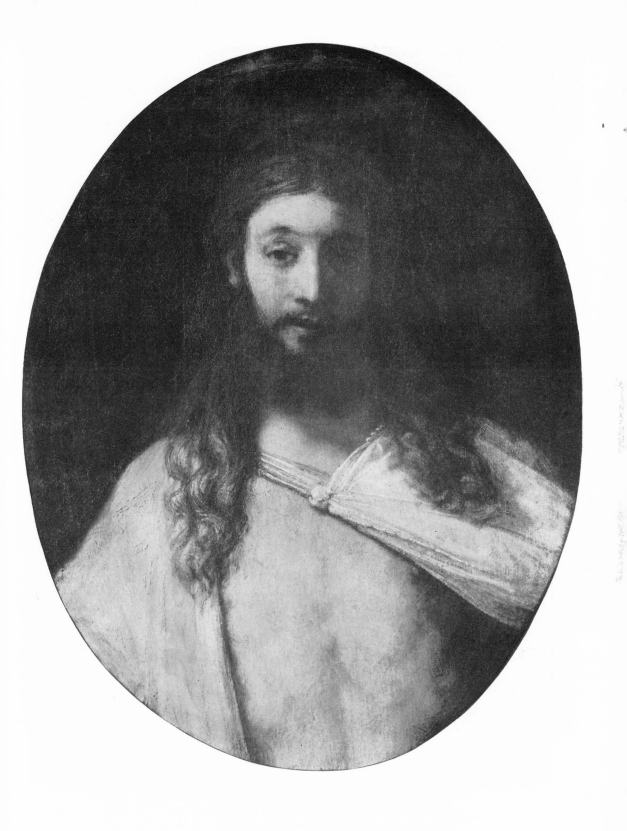

THE RISEN CHRIST. 1661. Canvas, 81 × 64 cm. Munich, Alte Pinakothek. (Br. 630)

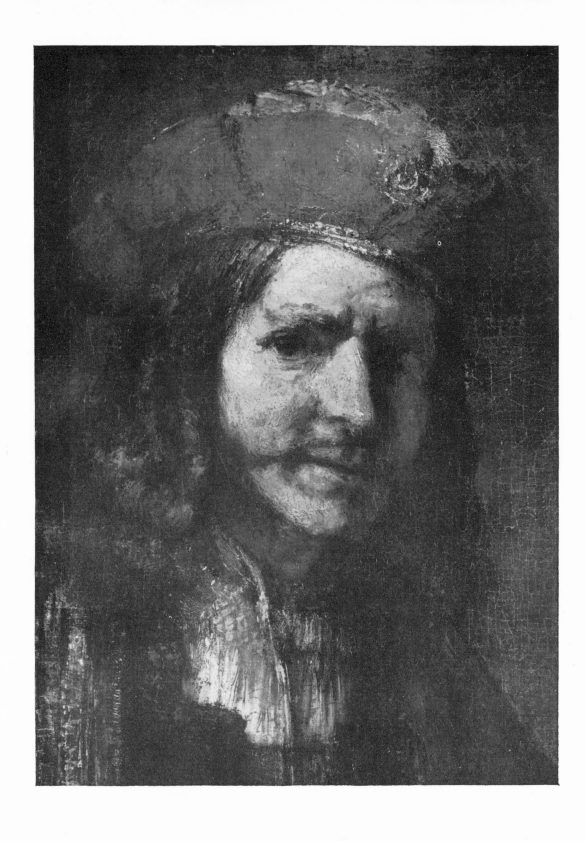

Detail from An Evangelist Writing Reproduced on Page 522

APPENDIX

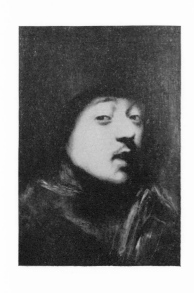
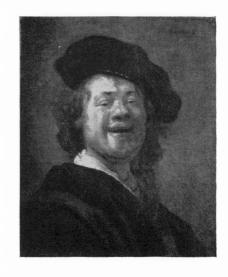

14 15

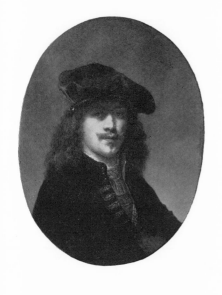
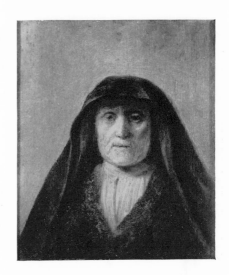

28 65

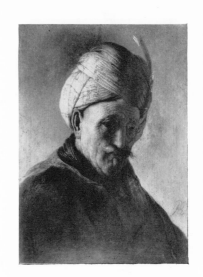

66 72

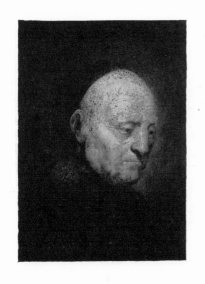

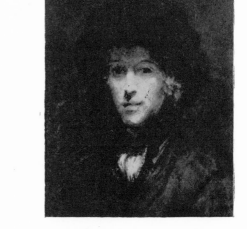

75 127

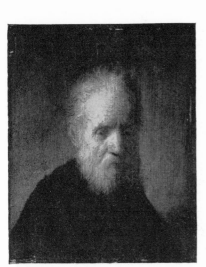

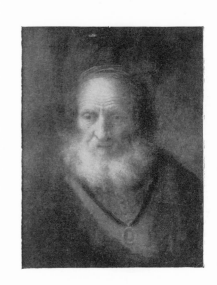

140 151

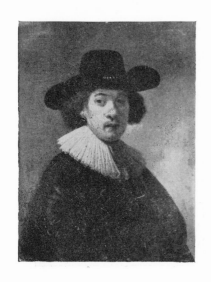

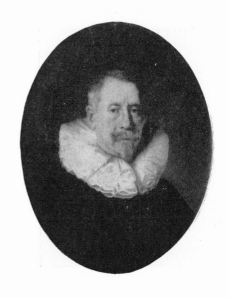

157 158

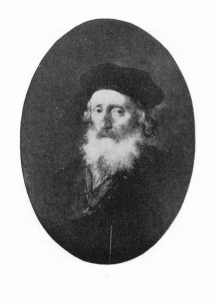 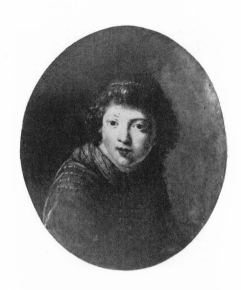

184 189

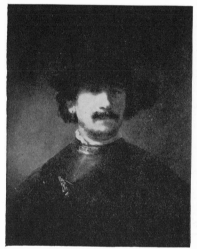 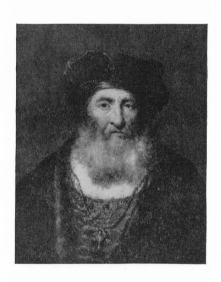

193 209

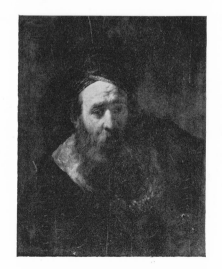 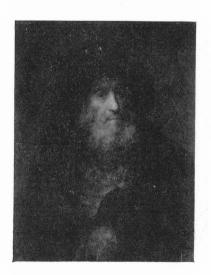

210 220

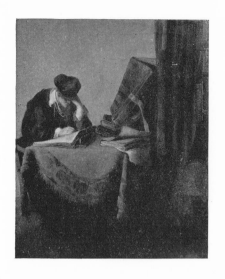

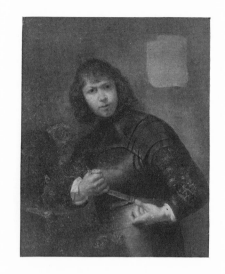

429 434

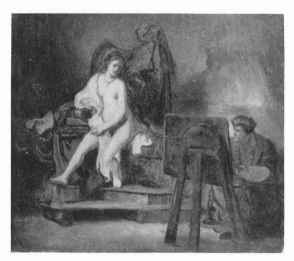

436 438

459

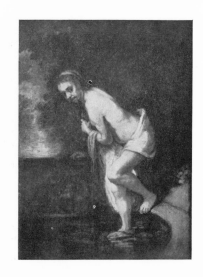

473　518

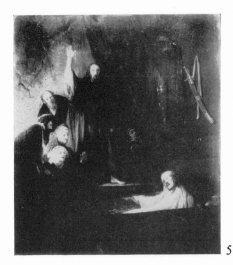
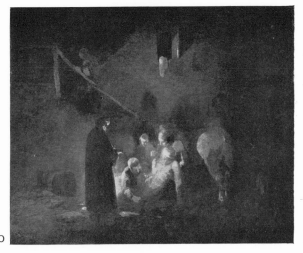

537　580

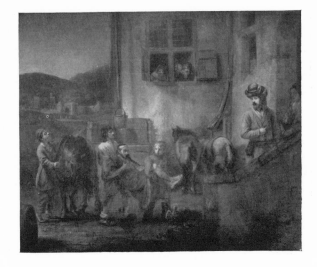

581

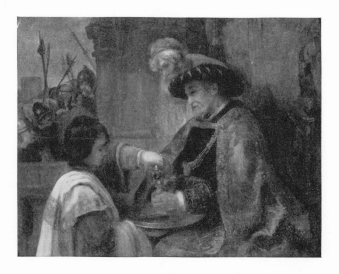

595

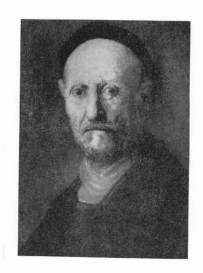

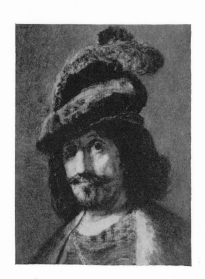

635 636

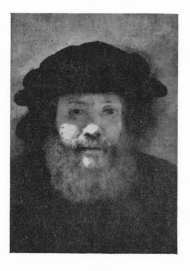

638

NOTES TO THE PLATES

ABBREVIATIONS

Bauch 1933: K. Bauch, *Die Kunst des jungen Rembrandt*, Heidelberg, 1933.

Bauch 1960: K. Bauch, *Der frühe Rembrandt und seine Zeit.* Berlin, 1960.

Bauch 1966: K. Bauch, *Rembrandt Gemälde*, Berlin, 1966.

Benesch: O. Benesch, *The Drawings of Rembrandt*, 6 vols., London, 1954-7.

Clark 1966: Sir Kenneth Clark, *Rembrandt and the Italian Renaissance*, London, 1966.

Emmens: J. A. Emmens, *Rembrandt en de regels van de kunst*, Diss. Utrecht, 1964.

Glück 1933: G. Glück, *Aus drei Jahrunderten europäischer Malerei*, Vienna, 1933.

HdG: C. Hofstede de Groot, *Catalogue raisonné of the works of the Dutch . . . Painters*, vol. VI, London, 1916; German edition, Esslingen, 1915.

G. Knuttel 1956: G. Knuttel Wzn., *Rembrandt*, Amsterdam, 1956.

MacLaren 1960: N. MacLaren, *The Dutch School*, National Gallery Catalogues, London, 1960.

Münz: L. Münz, *Rembrandt's Etchings*, London, 1952.

Rosenberg, 1964: J. Rosenberg, *Rembrandt: Life and Work*, revised edition, London, 1964.

Rosenberg and Slive, 1966: J. Rosenberg, S. Slive and E. H. ter Kuile, *Dutch Art and Architecture 1600-1800*, Harmondsworth, 1966, pp. 48-100.

Sumowski 1957/8: "Nachträge zum Rembrandt-jahr 1956", *Wissenchaftliche Zeitschrift der Humboldt Universität zu Berlin : Gesellschafts- und sprachwiss. Reihe 7*, 1957/8, p. 223-78.

Tümpel 1968: C. Tümpel, *Studien zur Ikonographie der Historien Rembrandts*, Diss. Hamburg, 1968.

Urkunden : C. Hofstede de Groot, *Die Urkunden über Rembrandt*, The Hague, 1906.

Valentiner 1921 : W. R. Valentiner, *Wiedergefundene Gemälde (Klassiker der Kunst)*, Stuttgart-Berlin, 1921; 2nd edition, 1922.

Von Moltke 1965: J. W. von Moltke, *Govaert Flinck*, Amsterdam, 1965.

NOTES

1. *Self-portrait*. HdG 533. Bauch 288. Bauch (*Wallraf-Richartz-Jahrbuch* 24, 1962, p. 321) has published another version, in the Cevat Collection (currently on loan to the Rijksmuseum, Amsterdam), as the original (see also Bauch 1960, p. 178, and 1966, no. 287). Van Vliet's etching after Rembrandt (Bartsch 19), according to Bauch, was done from the Cevat version; and the Cassel picture should be attributed to Jan Lievens. Having seen both versions side by side at the exhibition *De Schilder en zijn wereld* (Delft-Antwerp, 1964-5, nos. 92 & 93), I am convinced that the Cassel portrait is an autograph work by Rembrandt. Rosenberg and Slive (1966, p. 51 & p. 267) are also of this opinion. The authenticity of the Cevat version is strongly stressed in the catalogue *Rondom Rembrandt*, Leyden, 1968, no. 35. A copy was formerly in the Matsvansky Collection in Vienna (Frimmel, *Blätter für Gemäldekunde* 3, 1907, p. 165 with reproduction); another belongs to Sir John Heathcoat Amory, Bt. *Page 1*

2. *Self-portrait*. Signed with monogram RHL and dated 1629. HdG 542. Bauch 290. Additional strips have been added to the panel, at the left (0.8 cm.), and at the top (0.7 cm.). Formerly in the Gotha Museum; acquired from the Duke of Sachsen-Coburg-Gotha in 1953 (*Münchner Jahrbuch der bildenden Kunst* 3/5, 1954, p. 218). *Page 2*

3. *Self-portrait*. Signed with an unusual monogram: f. RHL [Bauch mentions a date of "1628 (?)"]. HdG 549. Bauch 289. The original is unknown to me, but existing copies suggest a prototype by Lievens rather than Rembrandt. Bauch, however, has withdrawn his former doubts about the attribution (Bauch, 1933, p. 209). *Page 3*

4. *Self-portrait*. Genuinely (?) signed with monogram and dated 1629 (?). Bauch 291. First published by W. R. Valentiner (*Art in America* 14, 1925/6, p. 117). I am not fully convinced of the attribution. *Page 4*

5. *Self-portrait*. Signed with an unusual monogram. HdG 531. Bauch 298. G. Glück, (1933, p. 298) saw this picture as a study in expression rather than a self-portrait. A copy, formerly in the Heugel Collection, was sold at auction in Brussels, Trussart, November 19th, 1956, lot 28. A certain amount of confusion over the respective versions was created by Bode and Hofstede de Groot, who, in the German edition of their *Rembrandt* (Paris, 1897), re-produced the Stoop version (i.e. Br. 5) as the original, while in the English edition of the same year they published the Heugel variant (the copy). *Page 5*

6. *Self-portrait*. HdG 544. Bauch 295. *Page 6*

7. *Self-portrait*. HdG 552. Bauch 294. The condition of the painting seems to be somewhat unsatisfactory. As it has not been available for inspection for the last twenty years, it would seem wiser not to offer any final comments on its autograph character. A copy, of smaller size, was in Sotheby's sale, London, June 21st, 1950, lot 76. *Page 7*

8. *Self-portrait*. Said to be signed with monogram and dated 1629. Today, the signature is difficult to read, and the date invisible. HdG 529. Bauch 292. The character of this self-portrait (as Slive rightly pointed out) is rather formal, and is closer to that of a commissioned portrait (S. Slive, *Allen Memorial Art Museum Bulletin* 20, 1963, p. 148). The picture is in rather a bad state. *Page 8*

9. *Self-portrait*. Signed with monogram RL and dated 1630. HdG 530. Bauch 300. The criticism of F. Winkler (*Kunstchronik* 10, 1957, p. 143), about the restoration of the painting, seems to me to be too severe. *Page 8*

10. *Self-portrait*. HdG 564. Bauch 293. I am not convinced that the attribution to the young Rembrandt is correct. *Page 9*

11. *Self-portrait*. Indistinctly signed and dated (1630?). HdG 570. Bauch 299. The delicacy of the handling is reminiscent of an etching on copper. *Page 9*

12. *Self-portrait*. Signed: Rembrandt f. (the genuineness of the signature is questioned in the Liverpool Catalogue). HdG 522A. Bauch 297. The portrait can be identified as one of the two (or three) Rembrandts which Lord Ancram had acquired in Holland, probably in 1629, The other is Br. 70. These were, in all probability, the first works by Rembrandt to reach England. The self-portrait had been given by Ancram to Charles I by 1633. See: Ursula Hoff, *Rembrandt und England*, 1935, p. 33; Oliver Millar, *Walpole Society*, vol. 37, 1958-60, p. 57; Chr. White, *Apollo* 76, 1962, p. 177. *Page 10*

13. *Self-portrait*. Bauch 296. Identical with HdG 591, 601 and 486. First published by Valentiner,

(1921, p. 7). Although engraved by T. Worlidge (who made, incidentally, many imitations of Rembrandt) to my mind this portrait is neither by Rembrandt nor from his period. *Page 11*

[14. *Self-portrait.* Panel, 47×31 cm. Sale, Stockholm, November 8th, 1961, lot 218. After having seen the picture, I cannot accept the attribution to Rembrandt. It is also rejected, sight unseen, by Bauch (1966, p. 47) and Rosenberg. *Appendix*]

[15. *Self-portrait.* Panel, 20.5 × 17.5 cm. Adda Sale, Paris, November 29th, 1965, lot 124. HdG 572. After studying both the picture and the signature ("Rembrandt 163."), I have come to the conclusion that the panel is not by Rembrandt. It is also rejected by Bauch (A 27). *Appendix*]

16. *Self-portrait.* Signed: Rembrant f. 1631. The signature was added later, probably over another signature. HdG 350. Bauch 301. A painting by one of Rembrandt's Leyden followers, c. 1630-3. Doubts have also been cast on both the picture and the signature by Knuttel (1956, p. 249). *Page 12*

17. *Self-portrait.* Signed: R.H.L. van Rijn 1632. HdG 573. Bauch 302. The first self-portrait in the more polished style that Rembrandt developed after he moved to Amsterdam. Many copies exist. For the so-called companion picture see Br. 86. *Page 13*

18. *Self-portrait.* Signed: Rembrandt f. 1633. HdG 566. Bauch 303. *Page 14*

19. *Self-portrait.* Signed: Rembrandt f. 1633 (4?). Recently cleaned. The signature is genuine. HdG 567. Bauch 305. *Page 15*

20. *Self-portrait.* HdG 538. Bauch 306. The picture is difficult to judge in its present condition. The cloak has been overpainted (perhaps in the 18th century) and there are some alterations in the cap. It is certainly inferior to Br. 18, 19 and 21 of the same period. The panel has been cut and a strip of 9 cm. added at the bottom. *Page 16*

21. *Self-portrait.* Signed: Rembrandt f. 1634. The last digit is not very clear. HdG 526. Bauch 308. *Page 17*

22. *Self-portrait.* Signed: Rembrandt f. 1634. The placing of the signature and the calligraphy are both unusual. HdG 534. Bauch 307. An attribution to Govaert Flinck should be considered. The picture is difficult to judge,

however, through the thick varnish. The X-ray reveals a rich facture. *Page 18*

23. *Self-portrait.* HdG 525. Bauch 304. As can be seen from the X-ray, Rembrandt originally painted himself without the cap. The X-ray is reproduced by W. Sumowski (1957-8, p. 235, repr. 92-3). Although not signed, a vigorously painted work of high quality. *Page 19*

24. *Self-portrait.* Signed: Rembrandt f. HdG 545. Bauch 311. The status of this painting, as a self-portrait, has been questioned by G. Glück (1933, p. 296) and by Bauch. *Page 20*

25. *Self-portrait.* Signed: Rembrandt f. 1635. HdG 584. Bauch 309. This portrait is close, in quality and character, to the *Young man with a sword* in the North Carolina Museum of Art, Raleigh, N.C. (once dated 1636; reproduced in the 1960 catalogue, p. 139). The latter is probably a work by Govaert Flinck—although J. W. von Moltke (1965, p. 248, no. 108) rejects the attribution. A copy of Br. 25 was in the Cook sale, Sotheby's, London, June 25th, 1958, lot 113 (as signed Rembrandt and dated 1638). *Page 21*

26. *Self-portrait.* Signed (original signature?): Rembrandt. HdG 582. Bauch 172. Bauch doubts the status of the picture as a self-portrait. The attribution to Rembrandt is not wholly convincing. C. Müller Hofstede (*Kunstchronik* 10, 1957, p. 124): "some elements that remind one of Flinck." According to Benesch, a work by Flinck (note in his archives, kindly communicated to me by Mrs. Eva Benesch). A copy of the head was recently on the Amsterdam art market. *Page 22*

27. *Self-portrait.* Signed (original signature?): Rembrandt. HdG 559. Bauch 315. Originally, the top was flat at the sides, with a semi-circular projection in the centre. This portrait, too, (like Br. 25, 26, 28, 29) is close to Flinck, but an attribution to Rembrandt—notwithstanding some uncommon features (rather dully executed with short hatching strokes)—is probably correct. *Page 23*

[28. *Self-portrait.* Panel (originally rectangular?), 66×51.5 cm. Glasgow, Art Gallery and Museum. HdG 541. Almost certainly a portrait of Rembrandt, painted by Flinck (cf. J. C. van Dycke, *Rembrandt and his School*, 1923, p. 85). A more or less positive attribution to Flinck is made in the 1961 Glasgow catalogue (no. 44); by Bauch, p. 47; and by J. W. von Moltke (1965, p. 112, no. 225). *Appendix*]

29. *Self-portrait.* Signed: Rembrandt f. 1637. The signature was added later. HdG 568. Bauch 310. The execution of the work as a whole is rather harsh; but until the picture is cleaned, it seems wiser to withhold final judgement as to its authenticity, though even in its present condition, an attribution to Flinck seems to me reasonable. The drawing which is always connected with this portrait (Benesch 437) is a genuine Rembrandt. *Page 24*

30. *Rembrandt and Saskia (The Prodigal Son in the tavern?)* Signed: Rembrandt f. HdG 334. Bauch 535. Modern scholars have tended to reject the identification of this picture as a self-portrait, in a boisterous mood, preferring to see in it a moralising subject. J. A. Emmens (*Rembrandt en de regels van de kunst*, Diss., Utrecht, 1964, p. 165) interprets it as an illustration of St. Paul's Epistle to Titus 2:12. J. Bergström (*Nederlands Kunsthistorisch Jaarboek* 7, 1966, p. 143) and Chr. Tümpel (1968, p. 90; cat. no. 24) as a representation of the Prodigal Son. Tümpel does not accept the identification of Rembrandt with the figure of the Prodigal Son; while Bergström stresses the moral implications of the theme for the spectator: "Rembrandt and Saskia confess that everyone is a prodigal son." Both rightly point to the influence, on the composition and character of the painting, of the Utrecht School of Caravaggists. Even if there are many links, in detail as well as in spirit, with the Prodigal Son theme, it is remarkable how Rembrandt has transformed the story of feasting in a tavern into a compact, portrait-like group. For further literature, see Bergström's article, and the catalogue of the exhibition, *De schilder en zijn wereld*, Delft-Antwerp, 1964-5, no. 95. *Pages 25, 26 & 90*

31. *Self-portrait with a dead bittern.* Signed: Rembrandt fc 1639. HdG 283. Bauch 312. In an excellent state of preservation, with a perfect signature. *Page 27*

32. *Self-portrait.* Signed: Rembrandt f. 163 . . HdG 576. Bauch 313. The picture should be dated around 1638. J. G. van Gelder (*Burlington Magazine* 92, 1950, p. 328) dates it around 1638-9, pointing at the same time to an engraving by J. B. le Sueur said to be done after a portrait by Flinck of 1636. *Page 28*

33. *Self-portrait.* Signed: Rembra . . . (the rest is cut off). HdG 585. Two versions of this portrait exist. The Bedford picture was bought at the Bragge sale in 1748 (lot 56) for less than £20. The other version, now in the National Gallery of Canada, Ottawa (1957 catalogue,

p. 88) comes from the Collection of the Earl of Listowel. J. Rosenberg (1964) accepts the Bedford version; J. G. van Gelder (*Burlington Magazine* 95, 1953, p. 33) the Ottawa one, which F. Winkler (*Kunstchronik* 10, 1957, p. 143) calls an "overpainted copy". Bauch (314) quotes the statement of A. Blunt and J. Wilde (from the Ottawa catalogue) that the Ottawa canvas is the better version and concludes with them that both versions were done in Rembrandt's studio after a lost original. I have only seen the Bedford version, which seems to me too weak to be an original Rembrandt. *Page 32*

34. *Self-portrait.* Signed: Rembrandt f. 1640. Inscribed : Conterfeycel (the last word, according to the Gallery catalogue, is by another hand). HdG 550. Bauch 316. The original shape—the top was flat at the sides, with a semi-circular projection in the centre—could not be reinstated during the last restoration of 1964-5 which eliminated, however, later retouchings that had not been cited in the N.G. catalogue of 1960. X-ray photographs have revealed that more of the shirt was visible at the bottom and that the left hand was originally on the parapet. The portrait is based on the so-called *Ariosto* by Titian and Raphael's *Castiglione;* both pictures were with the Amsterdam dealer Alfonso Lopez in 1639. Rembrandt made a drawing after the Castiglione portrait, when it was sold in Amsterdam in 1639 (Benesch 451); M. Imdahl (*Pantheon* 20, 1962, p. 38) claims that Rembrandt made the drawing from memory, an observation which is also made by K. E. Maison (*Themes and Variations*, London, 1960, p. 69). There is also an etched self-portrait of 1639 (Münz 24) which is based on the two Italian pictures : see Clark (1966, p. 124). *Page 29*

35. *Self-portrait.* Faked signature: Rembrandt f. 1642. HdG 578. Bauch 318. The picture, which was stolen in 1922, has only recently been re-discovered (and exhibited for some time in the National Gallery of Art, Washington); an inspection of the original suggests that it is a portrait by or after Bol. *Page 30*

36. *Self-portrait.* HdG 565. Bauch 317. Although probably a pendant to Br. 109 (according to S. Gudlaugsson), which appears to be autograph, there are many strange features about the self-portrait which make the attribution to artist and period doubtful. *Page 31*

37. *Self-portrait.* Signed: Rembrandt f. 164 . . HdG 555. Bauch 319. Probably painted around 1642. The picture has suffered somewhat from

Rembrandt's own alterations—the beret has been changed probably more than once—and later restorations, although Winkler's statement (*Kunstchronik* 10, 1957, p. 143: totally overpainted original) seems to be too strong. *Page 33*

38. *Self-portrait.* Some remains of a signature. HdG 547. Bauch 320. Already in the 18th century (or earlier), the picture was enlarged to a rectangular shape. Some later additions still remain on the left. The portrait is painted over another, of an elderly man with a beard, probably also by Rembrandt. This is revealed by X-ray; but it can also be discerned by the naked eye, in places like the doubly-painted ear. A work from the first half of the 1640s. *Page 34*

39. *Self-portrait.* Signed: Rembrandt f. 1650. HdG 574. Bauch 321. The signature is not genuine, and the portrait is an 18th- or 19th-century imitation, combining light effects typical of Rembrandt's early work with a composition and mood characteristic of the later period. *Page 35*

40. *Self-portrait.* Signed (?): Re. HdG 548. In the first edition of this book, Bredius noted the attribution to C. Fabritius, though he did not agree with it. It was put forward by Schmidt Degener (catalogue of the Boymans Museum, Rotterdam, 1921, p. 33), Valentiner (*Art Bulletin* 14, 1932, p. 213) and most vigorously by Bauch (1966, p. 47): "An important portrait of Rembrandt by Carel Fabritius." In any case, the attribution to Fabritius is nearer the mark than one to Rembrandt. J. Q. van Regteren Altena (*Oud Holland* 82, 1967, p. 70) maintains, however, the old attribution to Rembrandt; Rosenberg (1964, p. 40) rejects it. *Page 36*

41. *Self-portrait.* (?). Signed: Rembrandt f. 1650. First published by Hofstede de Groot (*Die holländische Kritik der jetzigen Rembrandtforschung*, 1922, p. 43). Bauch 399. Already Bredius doubted the identification as a self-portrait, and so did G. Glück (1933, p. 296), and Bauch, who called it "an artist's portrait." I can only judge from a photograph; even so, I am not convinced that the attribution to Rembrandt is correct. *Page 37*

42. *Self-portrait.* Signed: . . .dt f. 1652. HdG 580. Bauch 322. G. Glück (1933, p. 294) reported on the cleaning, noting that a strip of 7 to 8 cm. had been cut from the left side. Several copies exist, one of the bust only being exhibited at Bregenz in 1966 (no. 79) with the absurd claim that it was the "preliminary study

for the Vienna picture". Important in connection with the proud pose is the drawing in the Rembrandthuis, Amsterdam (Benesch 1171). *Page 38*

43. *Self-portrait.* Signed: Rembrandt f. 165(4). HdG 536. Bauch 324. Painted over a female portrait in the style of the 1630s. The X-ray, showing the underlying image, is reproduced by K. Wehlte (*Verhandlungen der Deutschen Röntgengesellschaft* 25, 1932, p. 13). The picture as it stands today is difficult to judge through the thick varnish. Although belonging to the De Roever collection in 1709, the attribution to Rembrandt is not wholly convincing. *Page 39*

44. *Self-portrait.* Signed: Rembrandt f. 1655. HdG 528. Bauch 325. The condition is not as bad as F. Winkler believes (*Kunstchronik* 10, 1957, p. 143: "beautiful ruin"). *Page 40*

45. *Self-portrait.* HdG 539. Bauch 328. According to S. Slive (*Rembrandt and his Critics*, The Hague, 1953, p. 65) a copy. It is difficult to judge through the dark varnish, but Slive is certainly right. The X-ray photograph (made by Dr. M. Meier-Siem) reveals a weak underlying structure. *Page 42*

46. *Self-portrait.* Signed: Rembrandt f. 1657. HdG 537. See note on Br. 47A. *Page 42*

47. *Self-portrait.* Signed: . . .brandt 1653. Published by R. R. Tatlock in *Burlington Magazine* 46, 1925, p. 259 and by A. L. Mayer in *Burlington Magazine* 47, 1925, p. 160. From the E. Lindley Wood Collection at Temple Newsam, where Waagen saw it in 1856 (quoted by Hofstede de Groot, 537 as a copy). See note on Br. 47a. *Page 43*

47A. *Self-portrait.* Bauch 323. From the Alexis Livernet sale, London, T. Coxe, May 27th 1808, lot 75 (said to have been purchased from Sir Joshua Reynolds). According to C. Müller Hofstede (*Pantheon* 21, 1963, p. 89) and Bauch, this version, which was discovered and cleaned by H. Hell, is the original of Br. 46 and 47, which are copies or versions of lesser quality. To my mind, the picture in the Cottrell Dormer Collection is not an original either. Br. 47 is also of unimpressive quality. The Dresden version (Br. 46) still seems to me the best. Rosenberg (1964, p. 371) expressly denies the authenticity of the Dresden version. A fourth version, in an English private collection, was shown to me in 1968; it was in a bad state and to my mind was not an original by Rembrandt. Bauch finally points to the mezzotint by

J. Gole (J. Charrington, *The Mezzotints after or said to be after Rembrandt*, 1923, no. 54) which, according to him, reproduces still another version—perhaps the lost original. *Page 43*

48. *Self-portrait.* Signed: Rembrandt f. 1657. HdG 553. Bauch 327. Later additions were removed during the restoration; but it seems to me that the painting was originally larger. *Page 41*

49. *Self-portrait.* Signed: Rembrandt f. HdG 581. Bauch 326. It must have been painted around the same time as Br. 48. Hofstede de Groot's dating of c. 1665 is much too late. *Page 44*

50. *Self-portrait.* Signed: Rembrandt f. 1658. The signature has been repainted and the date could also be read as 1655. HdG 563. Bauch 329. One of the most powerful and regal self-portraits in the Venetian vein. The drawing Benesch 1176 may be the study for it. See also Clark, 1966, p. 130. *Pages 45 & 46*

51. *Self-portrait.* (Genuinely?) signed: Rembrandt f. 1659. HdG 554. Bauch (330) believes that the portrait was originally painted without the cap. Examination of the X-rays does not sustain this claim. *Page 47*

52. *Self-portrait.* HdG 556. Bauch 331. Cleaning of the picture in the late 1940s emphasised the "rectangular, flat areas of paint" and its "solid frame work" (*Burlington Magazine* 92, 1950, p. 183), but at the same time revealed the damages caused by pressing during relining. The head is in good condition. The circles on the walls have troubled interpreters. They were formerly seen as cabalistic signs or circles which reflected God's perfection; they were called "rota aristotelis" (J. G. van Gelder in *De Gids* 119, 1, 1956, p. 408-9). J. A. Emmens (*Rembrandt en de regels van de kunst*, Diss. Utrecht, 1964, p. 174-5), bearing in mind Cesare Ripa's *Iconologia*, believes the circle to the left to be an emblem of theory and the one to the right (with a ruler) that of practice: Rembrandt sees himself as 'ingenium' with palette and maulstick, between these emblems of theory and exercise. To my mind the signs in the back are not clear enough to permit this interpretation, and I agree with the author of the *Burlington Magazine* editorial (q.v.) that the circles serve to stress the geometrical framework of the design. That they derive from world-maps which were hung on the walls of Dutch houses—as H. van de Waal (*Museum* 61, 1956, p. 199) and Bauch have suggested—is only right in so far as these circles, as they appear now, suggest, but do not reproduce, the prototypes. *Pages 48 & 56*

53. *Self-portrait.* Signed: Rem . . . f 1660. The original signature is restored and cut, and the date added later, but the date would have been 1660. HdG 569. Bauch 333. Again the face is the best preserved part; the hands are thin and the structure of the cloak lacks crispness. The X-rays have revealed a pentimento in the cap, which can also be discerned with the naked eye: originally there was a bonnet which was later replaced by the white turban (see repr. in M. Hours, *Bulletin du laboratoire du Louvre*, 1961, no. 6). A (probably 19th-century) replica of the head is reproduced by J. L. A. A. M. van Rijckevorsel, *Rembrandt en de traditie*, Rotterdam, 1932, opposite the title-page. *Page 49*

54. *Self-portrait.* Signed: Rembrandt f. 1660. HdG 562. Bauch 332. Probably a companion portrait to Br. 118. An impressive X-ray is reproduced by A. Burroughs (*Burlington Magazine* 59, 1931, p. 10). *Page 50*

55. *Self-portrait.* Signed: . . . f. 1669. HdG 551. Bauch 339. The portrait was cleaned in 1966 and the remains of the signature revealed (G. Martin in *Burlington Magazine* 109, 1967, p. 355). A strip of about 3 cm. has been cut from the left side. X-rays reveal that the turban, originally higher, was reduced by Rembrandt himself, and that at first the artist depicted himself with brush and maulstick in his hands. *Pages 55 & 57*

56. *Self-portrait.* Signed: Rembrandt f. 1660. HdG 579. Bauch 335. Hofstede de Groot had no opportunity of seeing the picture in a really good light and withheld judgement as to its authenticity. It was first published by Sir Charles Holmes in the *Burlington Magazine* 62, 1933, p. 103 and later by U. Hoff in *Apollo* 79, 1964, p. 456. I know the painting only from photographs, which do not give a favourable impression. A replica, probably of inferior quality, was reproduced in the second (English) edition of Bredius, as no. 637. The genuineness of that version, however, (HdG 561, from the Marquess of Lothian collection), was vigorously refuted (orally) by Bredius himself. It is also rejected by Rosenberg (1964, p. 371) and Bauch (p. 49). It was sold at the Baronesse Cassel van Doorn sale, Paris, May 30th, 1956, lot 44. *Page 50*

57. *Self-portrait.* Bauch 334. First published by R. Fry in *Burlington Magazine* 38, 1921, p. 262. The attribution to Rembrandt does not seem to me certain. *Page 51*

58. *Self-portrait.* HdG 524. Bauch 336 (not seen). Although lately accepted by Rosenberg (1964, repr. 43) and C. Müller Hofstede (*Pantheon* 21, 1962/3, p. 89), I can only see in this sketchy portrait an imitation after Rembrandt. *Page 51*

59. *Self-portrait as the Apostle Paul.* Signed: Rembrandt f. 1661. HdG 575. Bauch 338. It has been rightly argued that this portrait belongs—as a 'disguised' St. Paul—to the series of apostles (see Br. 615): F. Schmidt-Degener in *De Gids* 83, 1919, p. 222; W. R. Valentiner in *Kunstchronik* 32, 1920, p. 219; L. Münz in *Burlington Magazine* 90, 1948, p. 64; O. Benesch in *Art Quarterly* 19, 1956, p. 353. *Page 52*

60. *Self-portrait.* HdG 540. Bauch 340. Probably a picture of good quality, but covered by heavy varnish so that it is impossible to judge its real character. The X-ray (by Dr. M. Meier-Siem) shows very powerful under-painting. *Page 53*

61. *Self-portrait.* HdG 560. Bauch 341. The laughing (or better, smiling) expression has always puzzled commentators. W. Stechow (*Art Quarterly* 7, 1944, p. 233) interpreted the picture as a laughing Democritus opposite a weeping Heraclitus bust. J. Białostocki, however (*Wallraf-Richartz-Jahrbuch* 28, 1966, p. 49), has, to my mind convincingly, demonstrated (with the help of X-rays) that the "figure" to the left is the Roman herm of "Terminus" with the emblematic meaning of "Concedo nulli". Originally Rembrandt had his right hand with the brush on the bust, which made the connection with older representations of this subject still stronger. The upper corners have been cut (and are restored). The X-ray photographs were reproduced by C. Müller Hofstede (*Pantheon* 21, 1963, p. 83) and again by Białostocki. *Page 54*

62. *Self-portrait.* Signed: Rembrandt f. 1669. The signature may have been redrawn, but the date is correct. HdG 527. Bauch 342. An upper strip has been covered (by Rembrandt himself?) with black colour. It does not show in our reproduction. See also: H. E. van Gelder in *Openbaar Kunstbezit* 1, 1957, no. 28. *Page 58*

63. *"Rembrandt's mother"* HdG 687 (and 322): Bauch 250. Rembrandt's mother, Neeltgen Willems-dochter van Zuidbroeck, married the miller Harmen Gerritsz van Rijn at Leyden on October 8th 1589. She died in Leyden and was buried on September 14th, 1640. The art-dealer Clement de Jonge (d. February 11th 1679) had a large stock of etchings and engravings, of which an inventory was drawn up after his death. He had 73 different subjects by Rembrandt, among them "Rembrandt's Mother". We may therefore suppose that the old woman who occurs in different etchings (Münz 13, 83, 83, 85-87) is Rembrandt's mother, and that the old woman in the early pictures also represents her. According to Chr. Tümpel (1968, page 130 and cat. nos. 17-20) this and Br. 64, 69, 70, 71 and 361 are representations of the prophetess Hannah. On the other hand, there seem to be portraits and studies of another type of old woman in Rembrandt's early pictures and etchings. See Münz, 'Rembrandt's Bild von Mutter und Vater', *Jahrbuch der Kunsthistorischen Sammlungen in Wien*, N.F. 14, 1953, p. 141. Br. 63 has recently been cleaned and this cleaning "has removed any doubts about the originality of the painting" (*Katalog*, Residenz Galerie, Salzburg, 1962, no. 145). I agree and should like to point to its relationship to Br. 11, on copper. Br. 63 is also on copper: 15·5 × 12·2cms. *Page 61*

64. *"Rembrandt's mother."* HdG 685. Bauch 249. Generally connected with the etching Münz 83, of 1628, but to my mind the picture, in view of the powerful execution, can be dated earlier. Bauch doubts whether Rembrandt's mother was the model for this study. *Page 62*

[65. *"Rembrandt's mother"*. Panel, 19×11.5 cm. Basle, Private Collection. Signed (?): R. 162(7). According to Bauch (*Wallraf-Richartz-Jahrbuch* 2, 1939, p. 247; 1960, pp. 208, 261, 283 and 1966, no. A 3) a picture by Lievens repainted by Rembrandt. To my mind it is too dry for either of them. Accepted as a Rembrandt by Rosenberg but not listed as such by W. R. Valentiner (*Art Quarterly* 19, 1956, p. 404). *Appendix*]

[66. *"Rembrandt's mother"*. Panel, 22×17 cm. Formerly Zurich, Private Collection. Signed with monogram. HdG 685A. Bauch 448. Published by Bredius in *Burlington Magazine* 25, 1914, p. 325. Although Bauch has called the picture a copy (1960, p. 261, note 127), he reproduces it later as the best of several versions. Neither Bauch nor I have seen the picture itself. To judge from the photograph there is little reason to attribute it to Rembrandt. *Appendix*]

67. *"Rembrandt's mother"*. HdG 686. Many replicas are listed by Hofstede de Groot, who considers the authenticity of Br. 67 as "not certain". Like Valentiner (1921, p. 112),

Münz (1953, p. 146), Rosenberg [1964, p. 6., fig. 4 (copy?)] and Bauch (1960, p. 261, note 127), I consider the picture to be an old copy after a lost original. W. Martin (*Kunstwanderer* 3, 1921-2, p. 34), however, praises the quality of Br. 67, as Bredius himself had done (*Zeitschrift für bildende Kunst* N.F. 32, 1921, p. 153). *Page 63*

68. *Rembrandt's mother reading.* HdG 320. The attribution to Rembrandt has been rejected by Bauch (1960, p. 283 and note 127): "work of pupil copying Br. 69 in reverse"; (1966, p. 47): "Schulwerk", J. G. van Gelder (*Burlington Magazine* 92, 1950, p. 328) and Münz (1953, p. 146): "near to Lievens". There are certainly weak areas in the picture—the washed out pages of the book, for example, and the empty body of the woman—but on the other hand the figure itself is strongly constructed and the brushwork of the face is of superior quality; so a collaboration with Rembrandt must still be considered a possibility. *Page 64*

69. *"Rembrandt's mother" as a Biblical prophetess* (Hannah?). Signed RHL and dated 1631. HdG 316. Bauch 252. In the same delicately drawn style as the (smaller) figures in the *Presentation in the Temple* (Br. 543). *Page 65*

70. *"Rembrandt's mother".* HdG 688. Bauch 251. Belonged with Br. 12 to those pictures which were given before 1633 by Robert Kerr, Earl of Ancram, to King Charles I. The King's inventory of about 1640 lists it only as "an old woman". There is a label on the back: "Given to the King by Sir Robert Kerr". Robert Kerr bought these pictures probably during his stay in Holland in 1629. See also: *Burlington Magazine* 95, 1963, p. 37; Chr. White, *Apollo* 76, 1962, p. 177. X-rays have revealed a man's head upside down, which must have been overpainted by Rembrandt himself. *Page 66*

71. *"Rembrandt's mother".* Signed: Rembrandt f. 1639. HdG 511. Bauch 262. The only portrait of Rembrandt's mother which must have been done in the Amsterdam period—after an interval of about seven years. Bauch denies the portrait-status of the picture and interprets it as a representation of the prophetess Hannah. *Page 67*

[72. *"Rembrandt's father".* Panel, 26.5×20 cm. Signed with an unusual monogram. According to Bauch (1966, p. 47) "probably by J. Lievens". See also Bauch in *Wallraf-Richartz-Jahrbuch* 2, 1939, p. 257 and 1960, p. 283. The attribution to Rembrandt is also rejected by Rosenberg (1964, p. 371). I am not so sure

that the attribution to Lievens is right, but the one to Rembrandt is wholly unconvincing. However, neither Rosenberg nor I have seen the picture. It was last recorded at the F.D. Heastand sale, New York, December 12th, 1956, lot 42. *Appendix*]

73. *"Rembrandt's father".* HdG 672. Bauch 123. L. Münz (see literature under 63), who has carefully studied the problems concerning the so-called portraits of Rembrandt's parents, comes to the conclusion that "there is for the moment no picture that can be considered with some reason as an authentic portrait of Rembrandt's father". The basis for the identification of Rembrandt's parents has for long been a pair of portraits by G. Dou (Cassel, Gemäldegalerie, cat. nos. 257 & 258); but the argument is far from watertight. The type of old woman represented by Dou seems to be different from that which Rembrandt painted in his youth. There is, however, a drawing in Oxford (Ashmolean Museum) which bears an old inscription: Harmen Gerritsz. van de Rhijn (Benesch, 56; first published by A. M. Hind, *Burlington Magazine* 8, 1906, p. 426). If one accepts drawing and inscription as authentic (which Münz does not), we have another type for Rembrandt's father, which only recurs in two pictures, Bredius 633 (see page 122) and the Rembrandt-Dou picture of Tobias' parents in the National Gallery, London (no. 4189). See also: Rosenberg (1964, p. 345 note 1 A) and Bauch (1966, p. 8). See further note to Br. 83. As to Br. 73, the picture—whether it represents Rembrandt's father or not—could have served as a study for a penitent St. Peter. The execution is rather heavy, the design (of the ear, for instance) very poor. Could it be an early copy? By G. Dou? The following Bredius numbers are mostly related to the so-called Rembrandt's father. *Page 68*

74. *"Rembrandt's father".* Signed with a strange monogram and dated 1629. HdG 682. Bauch 114. In 1962 doubted by Bauch (*Wallraf-Richartz-Jahrbuch* 24, 1962, p. 325, note 4: "uncertain as to whether painted by Rembrandt himself"). Several copies exist. This version is certainly not of sufficiently good quality to be ascribed to Rembrandt himself. *Page 68*

[75. *"Rembrandt's father".* Panel, 16.5×12.5 cm. New York, Brooklyn Museum. HdG 683. Hofstede de Groot, Bauch (1960, p. 283; 1966, p. 47) and Rosenberg (1964, p. 371) rightly considered the picture to be a copy or imitation after Rembrandt. *Appendix*]

76. *"Rembrandt's father."* Signed with (an original?) monogram and dated 1630. HdG 677. Bauch 124. Bauch (1960, note 129): after cleaning to be considered as a Rembrandt, not as a copy. Although the picture is not of high quality, I agree with Bauch. Copied by the etcher J. G. van Vliet (B. 24, dated 1633). This copy in turn was re-copied by F. Langlois, called Ciartres, with the title "Philon le Juif". *Page 69*

77. *"Rembrandt's father."* HdG 676. Bauch 116. The cap seems to have been added by Rembrandt himself somewhat later, perhaps to make it conform to the etching of 1630 (Münz 39) which is related to it and which also has the model wearing a cap. The painting may be a little earlier. A. B. de Vries has drawn my attention to the fierce colours of the head, which may be—according to him—reflections of a fire at the figure's right shoulder. *Page 69*

78. *"Rembrandt's father."* HdG 674. Bauch 347. Probably neither Rembrandt's father nor the so-called Rembrandt's father. J. Veth (*Onze Kunst* 1905, II, p. 135) suggested Rembrandt's brother Gerrit, Bauch (1966) Rembrandt's brother Adriaen. The same model is represented in the etching Münz 46. *Page 70*

79. *"Rembrandt's father."* A modern signature covers the remains of an old one. HdG 673. Bauch 130. From X-rays it can be seen that there was originally another head to the right of the actual one, seen full-face. *Page 71*

80. *"Rembrandt's father."* Genuinely signed with monogram: RHL. HdG 681. Bauch 117. In excellent condition. *Page 72*

81. *"Rembrandt's father."* Signed with monogram. HdG 675. Bauch 129. A good X-ray photograph was published by A. Burroughs, *Burlington Magazine* 59, 1931, p. 4. A copy was exhibited in the exhibition of Dutch Art, R.A., 1952-3, no. 36 (see J. G. van Gelder, *Burlington Magazine* 95, 1953, p. 37 and E. Plietzsch, *Kunstchronik* 6, 1953, p. 123). *Page 73*

82. *"Rembrandt's father."* Signed with monogram and dated 1631. HdG 679. Bauch 131. The picture has lately been cleaned and is in good condition. The identification of this portrait and the related ones with Rembrandt's father becomes harder to accept in the light of the fact that Bredius 82 is dated 1631 (Rembrandt's father was buried April 27th, 1630). According to Bauch, perhaps the brother Adriaen. The same model recurs in a picture of 1632 (Br. 169). *Page 74*

83. *"Rembrandt's sister."* HdG 505. Bauch 450. The identification of this model with Rembrandt's sister Liesbeth is of a rather recent date and not proved. Moreover, it is hard to say whether the girl represented is Saskia, Rembrandt's wife, or another model—the so-called sister. Bauch considers all the portraits quoted here as Rembrandt's sister as more or less certain ones of Saskia. H. F. Wijnman (*Maandblad Amstelodamum* 43, 1956, p. 94) has put forward the charming theory that the model of Br. 83-91 and 100 is Maria van Eyck, wife of Hendrick Uylenburgh, in whose house Rembrandt lived during the early Amsterdam years. In any case, there must have been in existence a portrait of "H. Uylenburgh's wife painted as a small oriental head, by Rembrandt": a copy of such a picture was described as early as 1637 in the inventory of the Frisian painter and art-dealer Lambert Jacobsz., who had business and other relations with the Uylenburghs. According to Wijnman, the so-called father-portraits may represent Hendrick van Uylenburgh, and the boy in Br. 186-191 their son Gerrit Uylenburgh.
Br. 83 is not known to me in the original, nor to Bauch, who considers it a copy after a lost original, which could have been the pendant to Br. 16 (which I do not consider a Rembrandt). *Page 75*

84. *"Rembrandt's sister."* Signed: RHL van Rijn, 1632. HdG 697. Bauch 451: probably a portrait of Saskia. The picture is unknown to me in the original. *Page 78*

85. *"Rembrandt's sister."* Genuinely signed: RHL van Rijn 1632. HdG 698. Bauch 455. The face has suffered somewhat, but the delicate design still makes a considerable impact. *Page 77*

86. *"Rembrandt's sister."* Signed: RHL van Rijn 1632. HdG 696. Bauch 453. Perhaps a pendant to Br. 17. Not known to me in the original. *Page 76*

87. *"Rembrandt's sister."* Signed RHL van Rijn 1632. HdG 694. Bauch 454. Covered by thick varnish, but of excellent quality. *Page 78*

88. *"Rembrandt's sister."* HdG 695. Bauch 463. To my mind only a copy. *Page 79*

89. *"Rembrandt's sister."* Signed: RHL van Rijn 1632. HdG 699. Bauch 452. A picture of excellent quality that would reveal its great beauty if it were cleaned. *Page 79*

90. *"Rembrandt's sister."* Signed: RHL van Rijn 1633. HdG 693. Bauch 464. To my mind, only a copy, related in style to Br. 91. *Page 80*

91. *"Rembrandt's sister."* Chr. White in *Burlington Magazine* 98, 1956, p. 322: not by Rembrandt; Bauch (1966, p. 47): Jacob Backer. To my mind a work of the Haarlem school, probably by P. de Grebber or S. de Bray. Other versions exist—the one in Leipzig was formerly believed to be the orignal by Rembrandt (HdG 692). *Page 80*

92. *Saskia.* HdG 886. Bauch 487. The attribution to Rembrandt is certainly wrong. *Page 81*

93. *Saskia.* Published by Hofstede de Groot, *Die holländische Kritik der jetzigen Rembrandt-forschung*, 1922, p. 32. Bauch 484. The attribution to Rembrandt is not at all convincing. Neither Bauch nor I have seen the picture. *Page 81*

94. *Saskia.* Genuinely signed: Rembrandt ft. 1633. HdG 606. Bauch 473. After the recent cleaning, the delicate handling and the sensitive colouring—to which the effect of the warm ground shining through the pigment materially contributes—have become much more evident. Saskia van Uylenburgh was a niece of the art-dealer Hendrick van Uylen-burgh, in whose house Rembrandt lived and worked from the time when he arrived in Amsterdam up to 1635 or 1636. The couple married on June 22nd, 1634, in St. Anna Parochie, Frisia, the home of Saskia's parents. Her portrait is known to us from the charming silverpoint drawing by Rembrandt, which is inscribed by the artist's hand: "dit is naer mijn huijsvrou geconterfeijt, do sij 21 jaer oud was, den derden dach als wij getroudt waeren—den 8 Junijus 1633" (Berlin, Printroom; Benesch 427). It corresponds well with the etching of Rembrandt and Saskia of three years later (Münz 21) and the paintings Br. 30, 94, 96-8, 101-9. *Page 83*

95. *"Rembrandt's sister."* Signed: Rembrandt f. 1633. HdG 691. Bauch 468. Neither Bauch nor I have seen the picture, the quality of which, to judge from the photograph, is poor. *Page 84*

96. *Saskia.* HdG 615. Bauch 488. The X-ray confirms the powerful underpainting and solid construction of the figure; the picture's surface is covered by thick varnish. After cleaning, it would probably look as beautiful as Br. 94. *Page 85*

97. *Saskia.* Signed: Rembrandt ft. 1633. HdG 608. Bauch 474. In excellent condition. *Page 87*

98. *Saskia as Flora* (?). Signed (original ?): Rembrandt f. 1633. HdG 204. Bauch 256. The picture was transferred from panel to canvas in 1765 (Hofstede de Groot, *Die holländische Kritik der jetzigen Rembrandtforschung*, 1922, p. 16). It has suffered considerably, but even on the strength of what can be seen of the original paint, an attribution to Rembrandt is unjustified. Perhaps a work by G. Flinck. *Page 86*

99. *Amalia van Solms.* Signed: RHL van Rijn 1632. HdG 612. Bauch 456. When this portrait was cleaned in The Hague, in 1965, it was seen to have a painted decorative frame similar to the one in Honthorst's portrait of Stadholder Frederick Henry (Huis ten Bosch, The Hague). Both pictures are painted on canvas and are of the same size, so that an identification of the female portrait (which has hitherto been called "Saskia" or "Rembrandt's sister") with Amalia van Solms, wife of the Stadholder, became obvious. Moreover, in the 1632 inventory of the Prince's various homes there are listed two portraits *en profil*, one of Amalia van Solms by Rembrandt, the other of her husband by Honthorst (*Oud Holland* 47, 1930, p. 213 and p. 210). The Honthorst portrait of Frederick Henry is signed and dated 1631, and the one of his wife (Br. 99) may well be the first commission that Rembrandt received from the Stadholder. This portrait of Amalia must have been removed, probably in the 17th century, since the Frederick Henry portrait has now another Honthorst female portrait (on wood!) as companion, also supposed to represent Amalia van Solms, (reproduced in A. Staring, "Conterfeitte Rembrandt Frederik Hendrik en Amalia?", *Oud Holland* 58, 1953, p. 12, repr. 1 and 2). *Page 261*

100. *"Rembrandt's sister."* Signed: Rembrandt 1634 (original?). Bauch 483. Said to come from the Burin des Rosiers collection at The Hague, sold Amsterdam, June 4th, 1929, lot 95. Coll. J. M. Stettenheim, New York; Coll. Herbert Wilcox, London; sold in London, Sotheby, February 22nd, 1956, lot 76. The picture is reproduced in colour and discussed by D. G. Carter in *The Bulletin of the John Herron Art Institute* 43, 1956, p. 19, though the problem of the identification is left open. Known to me only from the photograph, from which the quality is difficult to judge. *Page 88*

101. *Saskia.* HdG 607. Bauch 489. Like the drawing (Benesch 431) which is connected with the picture, done around 1633/4. One of the most carefully executed portraits of Saskia, with regard both to the surface and the under-

painting. According to K. Wehlte (*Verhand-lungen der Deutschen Röntgengesellschaft 25*, 1932, p. 18) the fur was added only shortly before the completion of the painting. New X-rays (taken by Dr. M. Meier-Siem) reveal more alterations, which still need careful examination. The present appearance of the panel is distorted by dirty varnish. The history of the painting can be traced without a break from Rembrandt selling it in 1652 to Jan Six, through the Six sales (1702 and 1734), and the Valerius de Roever collection, from which it passed into the collection of Landgraf Wilhelm VIII von Hessen-Kassel, in 1750. *Page 89*

102. *Saskia as Flora*. Signed: Rembrandt f. 1634. HdG 206. Bauch 258. It is probably more correct to describe this portrait-type "Saskia as a Shepherdess" (E. Kieser, 'Über Rembrandt's Verhältnis zur Antike', *Zeitschrift für Kunst-geschichte* 10, 1941/2, p. 155). Julius Held (*De Artibus Opuscula XL : Essays in honor of Erwin Panofsky*, New York, 1961, p. 207), however, stresses the Flora connotation. *Page 92*

103. *Saskia as Flora*. Signed: Rem . .a 1635, a false signature probably copied from the lost original. HdG 205. Bauch 261. Several copies exist, some in the style of G. Flinck (see: J. W. von Moltke, 1965, p. 85). For the interpretation see previous entry. *Pages 91 & 93*

104. *Saskia*. Signed: Rembrandt f. 1638 (according to the report of a restorer). HdG 613. Bauch 490. De Groot and Bauch give the date as 1635, which would be understandable as in 1636 Flinck based his portraits of a shepherd and shepherdess on this type of Rembrandt (Amsterdam, Rijksmuseum, and Brunswick, Herzog Anton Ulrich Museum; exhib. Leyden 1956, nos. 47 & 48). The original is not known to Bauch or to me. *Page 94*

105. *Saskia*. Signed (genuinely?): Rembrandt f. 1636. HdG 611. Bauch 493. The execution is rather clumsy and an attribution to Rembrandt very doubtful. Another version was sold in the Schloss sale, Paris, May 28th, 1954, lot 93; while Hofstede de Groot saw a third one, in 1927 in the J. Max collection; according to him this should be the original work. This version cannot be traced. *Page 94*

106. *Saskia*. Signed: Remb(r)andt f. 1636 (difficult to read). HdG 614. Bauch 495. The picture is very probably by Flinck. It is not in the J. von Moltke catalogue of Flinck's works, but a drawing in Washington after the picture is there attributed to Flinck (J. W. von Moltke, 1965, p. 207). *Page 95*

107. *Saskia at her mirror*. Said to be signed: Rem . . . HdG 307. Bauch 263. The picture was last exhibited in 1929; and was stolen in 1938. To judge from the photograph, an attribution to Rembrandt seems very unlikely. *Page 95*

108. *Saskia with a flower*. Indistinctly signed and dated 1641. HdG 609. Bauch 264. The connection with Titian's *Flora*, which was in Amsterdam during Rembrandt's lifetime, has often been stressed. See: F. Lugt, *Oud Holland* 53, 1936, p. 97; W. Stechow, *Art Quarterly* 5, 1942, p. 135; E. M. Bloch, *Gazette des Beaux-Arts* 29, 1946, p. 175; J. Held, *De Artibus Opuscula XL: Essays in honor of Erwin Panofsky*, New York, 1961, p. 218. *Page 96*

109. *Saskia*. Signed: Rembrandt f. 1643 (the date is not very clear). HdG 605. Bauch 503. A posthumous portrait of Saskia, painted the year after her death. According to S. Gudlaugsson, a companion portrait to Br. 36. An X-ray photograph is reproduced by Chr. Wolters, *Die Bedeutung der Gemäldedurch-leuchtung*, Frankfurt, 1938, pl. 1). The X-ray and the surface of the painting reveal a technique that is not at all typical: it is a very carefully applied, rather dry and compact field of paint, without the usual accents that Rembrandt created with the brush-stroke. *Page 97*

110. *Hendrickje Stoffels in bed*. Signed: Rembra . . . f. 164 . . HdG 305. Bauch 266. In the 18th century the date was read as 1641 (N. Trivas, *Burlington Magazine* 70, 1937, p. 252), but the picture must date from the late 1640s; stylistically it is close to the Biblical scenes of the early 1650s. It is probably a fragment of a picture representing the wedding night of Sarah and Tobias. Christian Tümpel, however, stresses its importance as an "Herauslösungs-beispiel" of Rembrandt's art, which means that the figures fulfil their dramatic function in the scene without losing their individual, portrait-like emphasis (Chr. Tümpel, 1968, p. 117; cat. no. 21). For the identification of the model as Hendrickje, see the following entry. *Page 98*

111. *Hendrickje Stoffels*. HdG 721. Bauch 512. The picture is covered by thick varnish and its surface has suffered a great deal; in its present state it is impossible to decide whether it is an original or a copy. To M. Hours (*Bulletin du Laboratoire du Louvre*, 1961, no. 6) the picture 'parait avoir été signé en bas, à droite, mais on ne peut rien lire dans l'état actuel.' The name of Hendrickje Stoffels appears for the

first time on October 1st, 1649, in a document confirming a quarrel which Rembrandt had had in the previous summer with a certain Geertge Dircx. Without a doubt, Hendrickje replaced Geertge as nurse for the young Titus and as Rembrandt's mistress. She died in 1663. Their daughter, Cornelia, was baptized on October 30th, 1654. Although we have no documentary proof, the model who appears in portraits and historical paintings from the early 1650s onwards must be Hendrickje. Of the dozen or so supposed painings of her, MacLaren (N.G. cat., 1960, p. 313) claims only four after the same model, which he accepts as probably being Hendrickje. *Page 99*

112. *Hendrickje Stoffels.* HdG 717. Bauch 513. *Page 100*

113. *Hendrickje Stoffels.* Signed: Rembrandt f. 166.. HdG 715. Bauch 521. Neither Bauch nor I have seen this picture. There seems to be some doubt about the reading of the date. MacLaren (1960, p. 313-4) would prefer a reading of 1650. *Page 102*

114. *Hendrickje Stoffels as Flora.* HdG 202. Bauch 282. J. Held (*De Artibus Opuscula XL: Essays in honor of Erwin Panofsky*, New York, 1961, p. 218) has instructively demonstrated how the erotic appeal of the Flora theme has been reduced in this later picture. E. Kieser's interpretation (*Zeitschrift für Kunstgeschichte* 10, 1941/2, p. 155)—that the work must be seen as Rembrandt's answer to the church authorities' attack on Hendrickje's conduct—is not supported by the visual appearance of the painting. See also: W. Stechow, *Art Quarterly* 5, 1942, p. 135. *Page 103*

115. *Hendrickje Stoffels.* Signed: Rembandt (*sic*). HdG 718. Bauch 517. No doubts have ever been officially expressed about this painting, except by Winkler (*Kunstchronik* 10, 1957, p. 142: unfinished, puzzling), but Bredius wrote an informal note—which was eventually disregarded—to the editors of the first edition of this book: "perhaps genuine, but I have always felt uneasy about it." I am convinced that the picture, with its sketchy technique and heavy, almost overpowering composition, is an imitation of the 19th century, with whose conception of Rembrandt it is fully in accord. Weak in construction and insensitive in handling, the painting does not convey that sense of inner conviction and certainty that is to be found in authentic works. The partially covered hands, in particular, are empty and inexpressive. *Page 101*

116. *Hendrickje Stoffels.* HdG 716. Bauch 518. According to C. Müller-Hofstede, a companion to the original of Bredius 46-7. Kenneth Clark (1966, p. 132) rightly stresses the connection with Venetian art, in this case with a type created by Palma Vecchio. The X-ray makes it clear that the artist reworked the portrait heavily. Hendrickje was first seen full-face with both hands together. *Page 104*

117. *Hendrickje Stoffels as Venus.* HdG 215. Bauch 107. Bauch and Rosenberg (1964, p. 97) have rejected the formerly accepted date of 1662, placing the picture in the late fifties, but they stress the painting's breadth of style. Technical investigation (M. Hours, *Bulletin du Laboratoire du Louvre*, 1961 no. 6) has prompted the observation: "pas la même rapidité que dans les compositions précédentes". There is, to me, an incompatibility between invention and execution which points to a pupil like F. Bol. A copy after the painting was sold in Berlin, May 16th, 1933, lot 301, as F. Bol. E. Kieser (*Zeitschrift für Kunstgeschichte* 19, 1941/2, p. 140) proposes that a painting of the *Madonna and Child* by Q. Massys might have been the source for the composition. The Delft exhibition catalogue (*De schilder en zijn wereld* 1964-5, no. 97) reminds us that in the inventory of Harmen Becker in 1676 (*Oud Holland* 28, 1910, p. 195) there were three pictures (all by Rembrandt?) of Venus, Juno and Minerva, which formed a classical 'trio'. The tender relation between Venus and Cupid is untypical of the classical tradition, but expresses Rembrandt's personal interpretation—even if the execution is not autograph. *Page 105*

118. *Hendrickje Stoffels.* Signed: Rembrandt f. 1660. HdG 720. Bauch 522. Companion picture to Br. 54. The face is the best preserved part of this damaged painting. *Page 106*

119. *Titus (?).* HdG 489. Bauch 410. Titus, the only surviving child of Rembrandt and and Saskia, was born in 1641 (baptized on September 22nd) and died in 1668 (buried on September 7th), the year of his marriage to Magdalena van Loo. His daughter Titia was born posthumously the next year. About the identity of portraits of Titus, there is some uncertainty. Bauch and Slive are not sure whether this portrait is of the same boy as the following pictures. *Page 107*

120. *Titus.* Signed: Rembrandt f. 1655. HdG 702. Bauch 411. Probably the earliest identifiable portrait of Rembrandt's son. A sensitive interpretation is given by H. van de Waal (*Openbaar Kunstbezit* 9, 1965, no. 9). *Page 108*

121. *Titus.* Wrongly signed: Rembrandt f. 1655. HdG 706. Bauch 412. As far as I know never doubted in the literature on Rembrandt, but certainly an 18th or 19th century imitation. The plumed cap is borrowed from Rembrandt self-portraits of the 1650s. *Page 109*

122. *Titus reading.* HdG 238. Bauch 418. After restoration in 1938 a strip which was bent back over the stretcher was exposed with the result that the picture has become 2 cm. broader at the right. See L. Münz in the *Burlington Magazine* 89, 1947, p. 253. *Page 110*

123. *Titus.* Signed: R. HdG 704. Bauch 419. According to L. Münz (*Burlington Magazine* 89, 1947, p. 253) the initial R is the first letter of Rembrandt's name which was cut. Therefore it is to be concluded that the picture is rather heavily cut. It must have been painted in the late 1650s. At present the painting is disfigured by thick varnish. *Page 111*

124. *Titus.* Signed (?): Rembrandt f. 1660. HdG 707. Bauch 430. There is a pentimento near the thumb (also recorded by Bauch), but the picture is heavily restored, partly over-painted and partly very thin; a definitive judgement about its original quality and character is impossible. *Page 112*

125. *Titus.* Published by W. R. Valentiner (1921, p. 80). Bauch 230. Neither Bauch nor I have seen the picture. Sumowski supposes it to be a study for the angel who inspires Matthew (e.g. Br. 614), which would explain the emptiness to the right. *Page 113*

126. *Titus.* HdG 709. Bauch 427. The latest portrait of Titus that is identifiable with certainty; painted around 1662. *Page 114*

[127. *Titus* (?). Canvas, 52×40.5 cm. Formerly Detroit, Whitcomb Collection. HdG 708. Bredius had already expressed doubts, when he saw the picture in its uncleaned state. Both Rosenberg (1964, p. 371) and Bauch (1966, p. 47) reject the attribution to Rembrandt. The picture is unknown to me, but to judge from the photograph the negative opinions of Bredius, Bauch and Rosenberg seem wholly convincing. *Appendix*]

128. *"The man with the golden helmet"* (Rembrandt's brother?). HdG 261. Bauch 199. That the model for this and the following portraits can be identified as Rembrandt's brother, Adriaen, was a suggestion put forward by Bode (*Oud Holland* 19, 1891, p. 4); but the brother, a modest cobbler, remained in Leyden, where he died in 1652; the model, however, occurs

in a Rembrandt picture of 1654 too, and moreover in paintings produced in Rembrandt's circle in Amsterdam. The contrast between the thickly painted helmet (like the uniform of the lieutenant in "*The Nightwatch*") and the thinly painted face adds to the richness and variety of the conception. *Page 115*

129. *"Rembrandt's brother."* HdG 420. Bauch 401. Engraved by G. F. Schmidt in 1754 and 1768—which does not say too much in favour of an attribution to Rembrandt, as more often than not Schmidt engraved school pictures under the guise of original Rembrandts. To my mind a copy or imitation of the 18th century. *Page 116*

130. *"Rembrandt's brother."* Signed: Rembrandt f. 1650. HdG 384. Bauch 400. It was this painting that Bode originally introduced as the portrait of brother Adriaen (*Oud Holland* 19, 1891, p. 1). The brushwork is very close to that of Carel Fabritius. The picture must have been folded once; creases are clearly visible on the surface of the canvas. *Page 117*

131. *"Rembrandt's brother."* Signed: Rembrandt f. 1654 (old signature?). HdG 442. Bauch 406. The thick varnish partially conceals the powerful composition. The hand seems to have suffered. *Page 118*

132. *A warrior.* Bauch 109. The picture was introduced into the Rembrandt literature in the first edition of this book. The signature, RH van Rijn, is difficult to read. W. R. Valentiner (*Art Quarterly* 19, 1956, p. 404) does not include the painting among the accepted works. There remain some doubts about the attribution. Another version was sold in London, Christie's, May 25th, 1952, lot 148 (as de Poorter). Reproduced in colour in the *Connoisseur* 133, 1954, p. 120; it is later in the hands of the art-dealer Paul Brandt, New York. *Page 121*

133. *A man in a turban.* HdG 345. Bauch 133. A painting from the Leyden circle of Rembrandt, but not strong enough to be attributed to the master himself. *Page 122*

134. *A man laughing.* HdG 543. Bauch 113. Formerly—and wrongly—called a self-portrait. Bauch proposes to interpret it as a portrait of Rembrandt's brother Adriaen (like Br. 133 and 135). In comparison with the *Self-portrait* (Br. 11), which is also on copper and dates from the same period, Br. 134 emerges as a not particularly sensitive work, and not of sufficiently good quality to be attributed to Rembrandt himself. *Page 123*

135. *Head of a man*. HdG 266. Bauch 132. F. Winkler (*Kunstchronik* 10, 1957, p. 153) emphatically rejects an attribution to Rembrandt; I agree with Winkler. Other versions exist. *Page 123*

136. *Head of an old man*. Later signed with monogram. HdG 388. Bauch 345. Not accepted as a Rembrandt by Bauch (1960, p. 283: good old copy; 1966: best version, but still only a fluently painted copy), nor by Rosenberg (1964, p. 371). Another version is reproduced by W. R. Valentiner (1921, p. 110). The Copenhagen version (i.e. Br. 136) is very poor and does not even allow one to support that a (lost) original by Rembrandt ever existed. *Page 124*

137 & 138: see under 138A

138A *Head of a man*. Bauch 115. According to Bauch the best of several versions—of which Bredius reproduced two as nos. 137 and 138. The Oxford version was first published by Isarlo (*La Renaissance*, 1936, p. 14, then P. Cailleux Collection). Br. 138 is now in the Museum of Fine Arts in Houston, Texas (formerly Sholam Ash sale, New York, October 14th, 1948, lot 46). Rosenberg (1964, p. 371) does not accept Br. 137. Even if Br. 138A is accepted as the best existing version, it is still not a work of Rembrandt; again I think it is doubtful whether a Rembrandt original ever existed. *Page 124*

139. *Portrait of Constantijn Huygens* (?). HdG 571. Bauch 346. The portrait was once thought to be of Constantijn Huygens; it is not listed as such by H. E. van Gelder (*Ikonografie von Constantijn Huygens*, The Hague, 1957). The picture is unknown to me (and to Bauch), but an attribution to Rembrandt is far from convincing. *Page 125*

[140. *Portrait of an old man*. Panel, 20.5×17 cm. Leipzig, Museum. HdG 390. Bauch 344, reproduces another version (in an American collection) which he tentatively identifies as "Rembrandt's father." (See also Bauch, 1960, pp. 172-3, 283 and note 130). Again, both versions (and many others in existence) seem too poor for Rembrandt. *Appendix*]

141. *Old man with a jewelled cross*. Signed with monogram RHL and dated 1630. HdG 371. Bauch 128. One of the most powerful and at the same time most delicately painted studies of the Leyden period; in good condition. Already recorded in a Cassel inventory of 1731. *Page 125*

142. *Young man in a turban*. Signed with monogram RHL and dated 1631. HdG 354. Bauch 136. A portrait from Rembrandt's late Leyden period in a style influenced by Lievens' broader handling. Several copies exist; one, in the Museum in Bern, has been attributed by J. W. von Moltke (1965, p. 117, no. 247) to Govaert Flinck, though without substantial reasons. *Page 126*

143. *Young man in a plumed hat*. Signed with monogram RHL and dated 1631. HdG 577 (as a self-portrait). Bauch 138. *Page 127*

144. *A young officer*. Signed with monogram and dated 1631. HdG 375A. Bauch 137. Not known to me in the original. *Page 130*

145. *The Amsterdam merchant Nicolaes Ruts*. Signed with monogram and dated 1631 (but only the date is clearly visible). HdG 670. Bauch 348. Nicolaes Ruts (1573-1638) was a merchant in Amsterdam. His identity is rather well documented: the picture was copied by an 18th century artist, A. Delfos, with the sitter's name (and date 1633; it was then in the collection of descendants of Nicolaes Ruts). When Ruts' daughter, Suzanna, married Pieter van der Hagen in 1636 she possessed: 't Conterfeytsel van Nicolaes Ruts, by Rembrandt gedaen (*Urkunden*, no. 49). This portrait must have been among the first Amsterdam commissions that Rembrandt received; the portrait type shows the influence of Flemish models. *Page 128*

146. *Young man at a desk*. Signed with monogram RHL and dated 1631. HdG 775. Bauch 349. Certainly an important commissioned portrait, though the identity of the sitter has so far eluded scholars. The portrait type is again derived from a Flemish model. *Page 129*

147. *Portrait of an old man*. Signed RHL van Rijn 1632. HdG 417. Seymour Slive (*Allen Memorial Art Museum Bulletin* 20, 1963, p. 137) has rightly observed that the portrait "bearing an authentic Rembrandt signature shows unmistakable traces of the soft, silvery touch Lievens developed around 1630." Bauch (1966, A 8) agrees in so far as he thinks that the painting was done by a pupil (Jacob Backer?), but he feels that it was reworked by Rembrandt himself. I cannot see any evidence of Rembrandt's participation in the picture, which I would also attribute to Lievens. Not accepted by Rosenberg (1964, p. 371) and mentioned by Rosenberg-Slive (1966, p. 84) with an attribution to Lievens. *Page 131*

148. *Bald-headed man.* Signed with monogram RHL and dated 1632. HdG 372. Bauch 143. I agree with Bauch's comments on the (partly) thin paint and the poor condition of the picture. The signature is over a greyish coloured paint, which may well not be authentic. A careful cleaning, however, may reveal pictorial qualities that are at present concealed beneath the restoration. *Page 132*

149. *An old man with a gold chain.* HdG 443. Bauch 144 (not seen by him). The picture is much harder in execution than, for example, Br. 152; an attribution to Rembrandt seems doubtful. *Page 132*

150. *Portrait of an old man.* Signed: Rembrandt f. HdG 436. Bauch 145 (not seen by him). The portrait was on the London art market in 1951 (reproduced *Connoisseur* 127, 1951, no. 50, p. XLV); inspection then convinced me that the attribution to Rembrandt cannot be maintained. *Page 133*

[151. *Portrait of an old man.* Panel, 61.5×47.5 cm. Formerly Oldenburg, Museum. HdG 416. The doubts expressed by Bredius in the first edition have been strongly emphasized by Rosenberg (1964, p. 371) and Bauch (1966, p. 47: manner of Sal. Koninck). I have not seen the picture—the whereabouts are unknown to me—but an attribution to Rembrandt seems unjustified. *Appendix*]

152. *An old man with a gold chain.* Signed: RHL van Rijn 1632. HdG 373. Bauch 146. Powerfully painted and in a good state of preservation. The X-rays show underpainting as expressive and rich as the surface handling. The picture can be traced back to the collection of Valerius de Roever's father (1693). *Page 133*

153. *A young man with a broad-brimmed hat.* HdG 736a. Bredius had already noted the doubts of colleagues; these have been emphasized, more recently, by Rosenberg (1964, p. 371), Bauch (1966, p. 47: probably Flinck) and J. W. von Moltke (1965, p. 118, no. 253: "I am certain that it was painted by Flinck"). I am not so sure about this attribution, but the trouble is that none of us has ever seen the picture. An attribution to Rembrandt, however, seems out of the question. *Page 134*

154. *Portrait of a young man.* HdG 762. Bauch 350. Neither Bauch nor I have seen the picture. To judge from the photograph, it is a masterly portrait by Jan Lievens, of the Leyden period. Bauch seems to uphold an attribution to Rembrandt, but draws attention to the fact that the same model was painted by Lievens (Los Angeles). *Page 134*

155. *Portrait of a young man.* Signed: RHL van Rijn 1632. HdG 783. Bauch 355. Probably painted a year or so later than Br. 154; it reflects the Amsterdam portrait-tradition of Thomas de Keyser rather than the Leyden tradition. *Page 135*

156. *A young man with a gold chain.* Signed: RHL van Rijn 1632. HdG 557 (and 588). Bauch 142. In 18th century sale-catalogues considered to be the companion piece to Br. 96, with the supposition that Br. 156 was a self-portrait—which is, however, unlikely. It is probable that in the 18th century either a collector or a dealer made them into a pair by framing them as such. Bauch thinks that in this portrait Rembrandt might have painted his pupil Ferdinand Bol. The painting itself is of excellent quality and in good condition. *Page 135*

[157. *Portrait of a young man.* Panel, 21.5×16 cm. Formerly Paris, Flersheim Collection. HdG 773. The portrait had already disappeared when the first Bredius edition was published. The attribution to Rembrandt is probably an error. Bauch (1966, p. 47) considers it a work from the school of Rembrandt. *Appendix*]

[158. *Portrait of a grey-haired man.* Canvas, 65.5× 52.5 cm. New York, Historical Society. HdG 759. Bredius already had doubts about the attribution. It is a Dutch portrait of poor quality and in poor condition. The attribution to F. Bol (Bauch, 1966, p. 47) does not convince me. There is no signature on the picture. *Appendix*]

159. *Portrait of a man.* Under the wrong signature "Rembrandt f", there is the original one: RHL van Rijn (163)2. HdG 733. Bauch 354. In an excellent state; only the background (and the signature) are retouched. The X-ray confirms the lively underpainting which is smoothed down on the surface. For the so-called companion piece, see Br. 338. *Page 136*

160. *Portrait of a man.* Signed: RHL van Rijn 1632. AET 40. HdG 761. Bauch 357. An excellent portrait in good condition. Probably the companion picture to Br. 335. *Page 136*

161. *Maurits Huygens.* Signed: RHL van Rijn 1632. HdG 654. Bauch 352. Maurits Huygens (1595-1642) was the elder brother of Constantijn Huygens (see next number with literature). He assisted his father, Christiaen I. Huygens (1551-1624), who was Secretary to

the Council of State. Up to his early death in 1642, he was his successor in this office. The name of the sitter is written on the back: 'M. Huygens, secretaris van den Raad van Staten in den Hage.' *Page 137*

162. *The painter Jacob de Gheyn III.* Signed: RHL van Rijn 1632. HdG 745. Bauch 353. Jacob de Gheyn was Canon of St. Mary's church in Utrecht. He was a friend of Maurits Huygens. H. E. van Gelder (*Oud Holland* 60, 1943, p. 33) discovered that this—up to then unidentified—portrait must represent Jacob de Gheyn III. Some years later an inscription on the back of the picture was deciphered as follows: JACOBUS GEINIUS IUNʳ / H(uyge)NI IPSIUS/ EFFIGIE(m) / EXTREMUM MUNUS MORIENTIS . . . (H. E. van Gelder, *Oud Holland* 68, 1953, p. 107). The inscription proves that this portrait is indeed the one which Jacob de Gheyn left in his will to Maurits Huygens. (*Oud Holland* 33, 1915, p. 127). Rembrandt painted both portraits as companion pictures. They were still together in the A.R. van Waay sale, Utrecht, February 27th, 1764, lot 123: "two original portraits of the Huygens family, by Rembrandt"—Jacob de Gheyn's name was already forgotten. *Page 137*

163. *Portrait of a seated man.* HdG 785. Bauch 367. Companion picture to Br. 332. The underpainting (revealed in the X-rays taken by Dr. M. Meier-Siem) is as rich and articulated as the surface of the picture. *Page 138*

164. *A man sharpening a quill.* Signed on the letter: RHL van Rijn. HdG 635. Bauch 351. On the basis of an eighteenth-century sale catalogue, this picture has been identified as a portrait of Lieven Willemsz. van Coppenol, "a half-witted, conceited calligrapher", who ran a school on the Singel in Amsterdam (H. F. Wijnman, *Jaarboek Amstelodamum* 30, 1953, p. 150 and the same in Christopher White, *Rembrandt*, Amsterdam, 1964, p. 154). His appearance is known to us from two etchings by Rembrandt, one of 1658 (Münz 78), and the other undated (Münz 80). The similarity, however, between the etchings and Br. 164 is not sufficiently close to warrant identifying the painting as a portrait of Coppenol. Bauch has rejected the identification; Münz (p. 69) accepts it. The picture is covered with discoloured varnish. X-rays reveal powerful and varied underpainting. *Page 139*

165. *Aelbert Cuyper.* Signed: Rembrant ft 1632 AE 47. HdG 668. Bauch 356. The signature may replace an older one; its position in the picture is rather uncommon and the spelling not typical. It may have been retouched when the companion picture (Br. 336) was added to it the following year. Bauch remarks on the poor conservation of the work, an opinion with which I cannot agree. The X-ray, moreover (M. Hours, *Bulletin du Laboratoire du Louvre*, 1961, nr. 6), reveals a solid pictorial structure as well as pentimenti. The sitter, Aelbert Cuyper (1585-1637), was identified by I. H. van Eeghen (*Maandblad Amstelodamum* 43, 1956, p. 111). *Page 140*

166. *Maerten Looten.* On the letter a few lines of writing beginning: Maerten Looten Xɪ Januari 1632 and at the end of the paper the signature: RHL. HdG 659. Bauch 358. Maerten Looten (1586-1649) was a well-to-do merchant of Amsterdam. He spent his youth in Leyden and Rembrandt may have known him from his Leyden period. Attempts to decipher the letter have resulted in fantastic interpretations, which are described in J. Paul Getty's memoirs (*The Joys of Collecting*, London, 1966, p. 116). See the studies of J. G. van Gillen (*Tijdschrift voor Geschiedenis* 54, 1939, p. 181) and P. van Eeghen (*Maandblad Amstelodamum* 44, 1957, p. 150). *Page 141*

167. *Portrait of a man.* Signed: R H L van Rijn 1632. HdG 624. Bauch 360. Identification as a Beresteijn family portrait rests only on the fact that the picture (and its companion, Br. 331) were bought from the van Beresteijn-Vucht family. The genealogist of the van Beresteijn family denies a connection with any of the 17th century members of the family (Jhr. E. A. van Beresteijn, *Genealogie van het geslacht van Beresteijn*, The Hague, 1941, p. 135). Although still covered with thick varnish, a portrait that is rich both in design and nuances of colour. A. Burroughs (*Art criticism from a laboratory*, 1938, p. 168) attributes this pair to J. Backer! *Page 142*

168. *Portrait of a man with gloves.* Signed: RHL van Rijn 1632. HdG 764. This very weak portrait is heavily overpainted, and in its present state, an attribution to Rembrandt is unwarranted. Bauch (1966, p. 47) rejects it too, adding "probably in the manner of F. Bol". *Page 143*

169. *A man in fanciful costume.* Signed: RHL van Rijn 1632. HdG 349. Bauch 141. Rosenberg (1960, p. 345, note 1A) rightly observes that Rembrandt uses here as a model the type known to us as Rembrandt's father, although this painting was done two years after the father's death. Rosenberg does not exclude the possibility that an identification with Rembrandt's father is correct. *Page 144*

170. *Joris de Caullery.* Signed: RHL van Rijn 1632. HdG 633. Bauch 359. Joris de Caullery (c. 1600 - c. 1661) was a ship's captain in Amsterdam, later a wine merchant and inn keeper in the Hague. When he set off on a voyage in 1654, he gave family portraits to his children in order to protect them from seizure by his creditors. His daughter Josyna got: "the portrait of himself with 'het roer' in the hand, done by Mr. Rembrandt" (*Urkunden*, nr. 156). The 'roer' can mean either rifle or helm. A rifle in a captain's hand is unusual; a helm would make more sense, but no pictures of helm-holding captains are known to me! It is not certain what kind of object the man in Br. 170 holds in his hand, and therefore the identification with Joris de Caullery remains doubtful. The picture is in excellent condition. *Page 145*

171. *The poet Jan Hermansz. Krul.* Signed: Rembrandt f. 1633. HdG 657. Bauch 363. Jan Hermansz Krul (1602-1644/6) was a poet and blacksmith in Amsterdam. The recent cleaning has restored the picture's original beauty and strength. *Page 146*

172. *Portrait of a fashionably dressed man.* Signed: Rembrandt f. 1633. HdG 736. Bauch 366. J. Q. van Regteren Altena (in *Jan Veth, Rembrandt*, 2nd edition, 1941, p. 73) wishes to see Constantijn Huygens' portrait in the picture; H. E. van Gelder (*Ikonografie van Constantijn Huygens*, The Hague, 1957, p. 36) denies the identification. Companion piece to Br. 341. The portrait is not known to me in the original, but the attribution to Rembrandt seems to be fully justified. *Page 147*

173. *The preacher Johannes Uyttenbogaert.* Signed: Rembrandt f. 1633. AET 76. HdG 726. Bauch 361. Johannes Uyttenbogaert (1557-1646) was a well-known Remonstrant preacher in The Hague. He is known from several portraits, among them an etching by Rembrandt of 1635 (Münz 50) and a painting by Jacob Backer of the same year, still in the possession of the Wardens of the Remonstrant Reformed church in Amsterdam (on loan to the Rijksmuseum, Amsterdam). There can be no doubt that Br. 173 represents the same man. That Rembrandt painted the preacher's portrait in 1633 is confirmed by the memoirs of Uyttenbogaert himself: "13 April 1633 painted by Rembrandt for Abraham Anthonisz." (*Urkunden*, no. 29). The latter, who therefore commissioned the portrait, was a fervent admirer and friend of Uyttenbogaert. Several copies of the head alone exist. (See also B. Tideman, *Oud Holland* 21, 1903, p. 125). *Pages 148 & 149*

174. *Portrait of a musician.* (Genuinely?) signed: Rembrandt f. 1633. HdG 760. Bauch 362. Several identifications with musicians have been proposed: Nicolaes Lanier (A. de Hevesy, *Burlington Magazine* 69, 1936, p. 153; J. Held, ditto, p. 286); Heinrich Schütz (B. Maerker, *Deutsche Musikkultur* 6, 1937/8, p. 329; O. Benesch, *Festschrift Otto Erich Deutsch*, 1963, p. 12). E. Greindl (*Apollo*, 1942, nr. 10, p. 10), however, believes that Constantijn Huygens is represented, an observation which was denied by H. E. van Gelder (*Ikonografie van Constantijn Huygens*, The Hague, 1957, p. 37). The attribution to Rembrandt is not correct. The handling seems to me closer to the work of Jacob Backer. Some details—the hands for instance—are rather poor. *Page 150*

175. *Willem Burchgraeff.* Signed: Rembrandt f. 1633. HdG 629. Bauch 368. Willem Burchgraeff (1604-1647) was master baker and corn dealer; he married Margaretha van Bilderbeecq in 1625. As the companion piece (Br. 339) is said to have once been in the Burchgraeff family (a claim for which I can find no confirmation), the pair is considered to be the couple Burchgraeff-van Bilderbeecq. Br. 175 is mentioned for the first time in the Dresden inventory of 1722 without any sitters name. Its quality is superior to the so-called wife (Br. 339). *Page 150*

176. *Portrait of a man in a red coat.* Signed: Rembrandt fec 1633. Bauch 364. Published for the first time by W. R. Valentiner (*Burlington Magazine* 57, 1930, p. 260, and supposed to be a companion piece to Br. 337). Not seen by Bauch or me. *Page 151*

177. *A bearded man in a wide-brimmed hat.* Signed: Rembrandt f 1633. HdG 769. Bauch 365. Companion piece to Br. 344. The pair was still together at the W. H. Moore sale, London, Sotheby, March 23rd, 1960, lots 67 and 68. *Page 151*

178. *A man in oriental costume.* Signed: Rembrandt f. 1633. HdG 348. Bauch 155. Probably not a "portrait"; it is more likely to be a study for a biblical subject. *Page 152*

179. *Uzziah stricken with leprosy.* Signed: Rembrandt f. 1635. HdG 346. Bauch 164. I was unable to check the signature, or date (read as 1633 by O. Benesch, *Rembrandt*, 1935, p. 14). Robert Eisler has identified the story of King Uzziah, who was struck with leprosy beside the incense altar (II Chron. XXVI: 18-19). Gary Schwartz has found that the details, as told in Flavius Josephus, *Jewish Antiquities*, IX, par. 222 (of the Loeb edition) are even

have in accordance with Rembrandt's representation. Several copies of this powerful picture exist. *Page 512*

180. *A man in oriental costume.* Signed: Rembrandt ft. HdG 351. Bauch 170. As powerful, in design and handling, as Br. 169. *Page 153*

181. *Portrait of an old Jew.* Said to be signed: Rembrandt f. 1633. HdG 405. Bauch 147. At a recent inspection I came to the conclusion that the picture is too poor to be attributed to Rembrandt. I could not read any signature or date. *Page 154*

182. *An old man with a beard.* Signed: Rembrandt 163(4). HdG 419. Bauch 152. Several versions exist, but I am not convinced that Br. 182 is an original by Rembrandt. Bauch also considers it only "the best of several copies". The picture has lately been cleaned, with the result that the dry execution and the poor signature are now very clear. *Page 154*

183. *Study of an old man.* Signed: Rembrandt 1633. HdG 369. Bauch 153. The smallest known painting by Rembrandt. The date is in original 17th century script, but the writing of the name appears spurious. Perhaps a fragment of a grisaille sketch, and as such related to the powerful drawings of the 1630s (i.e. Benesch 89 of 1634). *Page 155*

[184. *Portrait of an old Jew.* Panel, 64×47 cm. Paris, Weill-Schloss Collection. Signed: Rembrandt f. 1634. HdG 427. Bauch 161. Neither Bauch nor I have seen the picture, which seems to have been lost in World War II. The attribution to Rembrandt is very unlikely. *Appendix*]

185. *Portrait of an old Jew.* Signed: Rembrandt f. 1643. HdG 457. Bauch 165. Neither Bauch nor I have seen the picture, which has been especially praised by J. G. van Gelder (*Burlington Magazine* 92, 1950, p. 328). *Page 181*

186. *A child in fanciful costume.* HdG 492. Bauch 151. This model, which appears around 1634 in several pictures, could be—according to H. F. Wijnman (*Maandblad Amstelodamum* 43, 1956, p.94)—the eight-year-old Gerrit Uylenburgh, the son of Hendrick, in whose house Rembrandt stayed during the early 1630s. I am not sure about the attribution to Rembrandt; most of these pictures are very much in the style of Govaert Flinck. W. Martin (*Kunstwanderer* 3, 1921/2, p. 30) also expressed strong doubts: he felt that of the whole group of "children with calf eyes" perhaps only one was wholly by Rembrandt. All the others are overpainted (by Jouderville?). *Page 155*

187. *A child in fanciful costume.* Signed: Rembrandt f. 1633. HdG 493. Bauch 148. See remarks to Br. 186. As far as I know, not seen by any living art-historian; the picture seems to have been lost, presumably during the Russian Revolution. *Page 156*

188. *A child in fanciful costume.* Signed: Rembrandt f. 1633. HdG 491. Bauch 149. See remarks to Br. 186. The date could be right, but the name is written in a different script. The attribution to Rembrandt cannot be sustained. For Martin (see Br. 186) this version is the poorest of all. *Page 156*

[189. *Portrait of a youth.* Panel, 46.5×41 cm. Dutch Private Collection. See remarks to Br. 186. Published for the first time in the first Bredius edition. It is a coarsely painted study, only vaguely related to Rembrandt's style. Several versions exist: Stockholm, Nationalmuseum, 590; Mrs. E. Andriesse sale, New York, February 24th, 1949, lot 17; and in the art-trade; all are very mediocre. Bauch's (1966, p 47) proposed attribution to Flinck for Br. 189 was not endorsed by J. W. von Moltke (1965). *Appendix*]

190. *A child in fanciful costume.* Signed: Rembrandt 1633. HdG 490. Bauch 150. See remarks to Br. 186. Neither Bauch nor I have seen the original. *Page 157*

191. *A boy with long hair.* Signed: Rembrandt f. 1634. HdG 494. Bauch 159. Not seen by Bauch or me. To judge from the photograph, the best version of this type (Br. 186-191). *Page 157*

192. *Portrait of an officer.* HdG 275e. Bauch 158. W. R. Valentiner (1921, p. 32 and *Rembrandt Paintings in America*, 1931, no. 45) classifies it as a self-portrait, a supposition that is rejected by G. Glück (1933, p. 296). Not known to Bauch or me in the original. *Page 158*

[193. *Portrait of an officer.* Panel, 66×51 cm. London, The Wallace Collection. Faked signature: Rembrandt f. HdG 558. Bauch 160. Formerly called a self-portrait. Although Bauch only felt that the picture was "somewhat unusual in execution", W. Martin (*Kunstwanderer* 4, 1922/3, p. 408) had already—and rightly—recognised it as the work of "a known forger". D. S. MacColl (*Burlington Magazine* 45, 1924, p. 15) also "gravely doubts" the picture. I suspect that the English painter Th. Worlidge fabricated this and other imitations after Rembrandt. *Appendix*]

194. *A member of the Raman family.* Signed: Rembrandt ft 1634. AET 47. HdG 739. Bauch 374. Although the signature is retouched, the attribution to Rembrandt should be sustained. It is said that the picture was once in the possession of the Raman family, hence the identification. Br. 354 is supposed to be the companion piece. Both pictures were originally ten-sided. *Page 158*

195. *Portrait of a young man.* Signed: Rembrandt f. 1634. The signature is a later addition. HdG 778. Bauch 370. The young man's hat is also a later addition. J. Michałkowa and A. Chudzikowski (*Catalogue of Rembrandt Exhibition*, Warsaw, 1956, nr. 12) believe that Br. 195 and Br. 199 represent the same man; but Benesch (*Kunstchronik* 9, 1956, p. 189) is not wholly convinced of the identity with Maerten Soolmans. I think that the painting is only a work from Rembrandt's studio; it is rather clumsy, especially if one compares it with Br. 196 of the same year. An attribution to Flinck should be considered. See also: *Burlington Magazine* 98, 1956, p. 280. *Page 159*

196. *A young man with a moustache.* Signed: Rembrandt f. 1634. HdG 777. Bauch 371. Said to be a companion piece to Br. 345. *Page 160*

197. *Portrait of a young man.* Signed: Rembrant f. 1634. HdG 732. Bauch 369. I am not wholly convinced of the authenticity of the signature (with its wrong spelling), but the portrait itself seems to be by Rembrandt, although it is near the border-line between the master and Flinck. Companion to Br. 346. *Page 161*

198. *Portrait of a young man.* HdG 737. Bauch (1966, p. 47) and J. W. von Moltke (1965, p. 254, nr. 198) attribute the painting to Flinck— and, I would add, it is not one of Flinck's most inspired works. *Page 159*

199. *Maerten Soolmans.* Signed: Rembrandt f. 1634. HdG 637. Bauch 373. The portraits of the couple Soolmans-Coppit (Br. 342) are among the most impressive official portraits that Rembrandt painted in the 1630s. It was in 1633 that Maerten Soolmans (1613-1641) married Oopjen Coppit, who was two years older. The widow remarried (after 1646) Maerten Daey (died 1659). In the inventory of Maerten Daey, made at the time of his death, the pictures were still described as "portraits of Maerten Soolemans and Oopie Coppit" (without the name of the artist!). They remained with the Daey family, where they were considered later as their family portraits. Dr. I. H. van Eeghen has reconstructed the real history of the pictures (*Maandblad Amsteloda-*

mum 43, 1956, p. 85). R. van Luttervelt (op. cit., p. 93) draws attention to the fact that the female portrait is not dated, and may have been done later when Oopje Coppit was a widow. The artistic coherence of the two portraits, however, is so strong that I cannot imagine they were painted at different periods. *Page 162*

200. *The preacher Johannes Elison.* Signed: Rembrandt ft. 1634. HdG 645. Bauch 372. Companion to Br. 347. Johannes Elison (c. 1581-c. 1639) was a Protestant preacher in Norwich, England. While he was staying with his wife in Amsterdam in 1634, his son had the portraits of his parents painted. In his will, made in 1635, Jan Elison the younger stipulated that both portraits (no painter's name is given) should go after his death to his brother-in-law at Norwich. They remained there, in the family of the descendants, until the middle of the last century. See H. F. Wijnman in *Jaarboek Amstelodamum* 31, 1934, p. 81 and the same in *Maandblad Amstelodamum* 44, 1957, p. 65. *Page 163*

201. *A man in a broad-brimmed hat.* Signed: Rembrandt fec. 1635. HdG 730. Bauch 375. Probably the companion picture to Br. 350. Neither Bauch nor I have seen this painting; but, judging from the photograph, there is no reason to doubt the attribution. *Page 164*

202. *Philips Lucasz., Councillor Extraordinary of the Dutch East Indies.* Signed: Rembrandt 1635. HdG 660. Bauch 376. I think the date should be read 1633. Philips Lucas (born towards the end of the 16th century, died in 1641) was a merchant in the Dutch East Indies, from 1628 to 1631 Governor and in 1633 commander of the merchantile fleet returning to Holland. The pictures of the couple Philips Lucas-Petronella Buys (see companion piece, Br. 349) were made for Petronella Buys' sister, who was married to Jacques Specx, a Governor-General of the Dutch East Indies. The National Gallery catalogue mentions the fact that the picture was reduced in size (by Rembrandt himself?). That could well have been the case in order to make it match the companion piece, which may have been commissioned a little later. The hand of the sitter has been overpainted; it can still be detected by the naked eye, and is clear in the X-ray. The identification is due to C. Hofstede de Groot (*Oud Holland* 31, 1913, p. 236) and I. H. van Eeghen (*Maandblad Amstelodamum* 43, 1956, p. 116). *Page 164*

203. *The diplomat Anthonis Coopal.* Signed: Rembrandt f. 1635. HdG 634. Bauch 377. Anthonis

more in accordance Coopal (1606-1672) was a secret agent of Stadholder Frederick Henry: his name and titles are inscribed on the back of the picture. His brother François was married to Saskia's sister Titia. The execution is less vigorous than in other portraits of this period. *Page 165*

204. *Portrait of an officer.* Imitated signature: Rembrandt f. 1636. HdG 786. Bauch 378. Rightly attributed by Benesch (*Kunstchronik* 9, 1956, p. 202) and J. W. von Moltke (1965, p. 254, nr. 142) to Govaert Flinck. The date may be about right. This and the companion (Br. 352) are certainly early works by Flinck. *Page 165*

205. *A man with dishevelled hair.* (Genuinely?) signed: Rembrandt 1635. HdG 415. Bauch 167. Neither Bauch not I have seen this painting. *Page 166*

206. *A man in oriental costume.* Signed: Rembrandt ft. 1635. HdG 353. Bauch 163. Probably a study for an Old Testament figure. *Page 167*

207. *A man in fanciful costume.* Genuinely (?) signed: Rembrandt f. 1635 (the last digit could also be a 6). HdG 387. Bauch 166. The dark parts of the surface are covered with strange cracks. The panel, which originally may have been used for another purpose (see key(?)–hole on the back) is of foreign wood. The paint is rather thick and unarticulated. The attribution to Rembrandt is doubtful. *Page 168*

208. *A man in fanciful costume.* Imitation of a signature: Rembrandt f. 164 . . HdG 398. Bauch 169 (not seen by him). A work of the school of Rembrandt. *Page 169*

[209. *Portrait of a Rabbi.* Panel, 62.5×52 cm. Formerly New York, Cintas Collection. HdG 409. Bredius already noted the doubts of other scholars as to the attribution. Not accepted as a Rembrandt by Rosenberg (1964, p. 371), or Bauch (1966, p. 47): manner of Salomon Koninck. J. W. von Moltke (1965, p. 165, no. 178) attributes it—rightly—to Govaert Flinck. *Appendix*]

[210. *An Oriental.* Panel, 72.5×59 cm. Dutch State property. Signed (?): Rembrandt f. 1637. HdG 344. Bauch 173. According to Bauch, the best of several versions, but to my mind an imitation after Rembrandt. *Appendix*]

211. *A man in Polish costume.* Signed: Rembrandt f. 1637. HdG 271. Bauch 174. According to Bauch, perhaps a portrait of Rembrandt's brother Adriaen. A powerfully built-up portrait of a type that served as a model for pupils such as Govaert Flinck. *Page 170*

212. *A man seated in an armchair.* Inscribed: Aet 69. HdG 738. Bauch 382. Perhaps the companion portrait to Br. 348. The recent cleaning has revealed a portrait painted in an altogether un-Rembrandt-like technique. An attribution to Rembrandt cannot be upheld. *Page 171*

213. *The Minister Eleazar Swalmius.* The "signature" Rembrandt f. 1637 is re-written on a thinly painted surface. HdG 722. Bauch 380. The execution is too tame for Rembrandt himself: probably a painting by Govaert Flinck. As early as 1938 A. Burroughs (*Art criticism from a laboratory*, p. 157) had attributed the picture to G. Flinck, claiming to have detected Flinck's monogram. *Page 172*

214. *A man seated in an armchair.* Genuinely (?) signed: Rembrandt f. 1637. HdG 744. Bauch 381. J. G. Van Gelder (*Burlington Magazine* 92, 1950, p. 328): flattened by relining; once, no doubt, a Rembrandt. As it is stylistically close to Br. 213, I have some doubts about the attribution to Rembrandt. *Page 173*

215. *A man seated in an armchair.* (Genuinely ?) signed: Rembrandt f. 1638. HdG 768. Bauch 383. The attribution to Rembrandt is not convincing. The portrait is related to the early works of Van der Helst, e.g. the portrait of a preacher, of the same year, in the Boymans–van Beuningen Museum, Rotterdam (cat. 1962, nr. 1293). *Page 174*

216. *A man standing in front of a doorway.* Signed: Rembrandt f. 1639. HdG 535 (as a self-portrait). Bauch 384. F. Schmidt-Degener (*Oud Holland* 32, 1914, p. 219) identified the man as Frans Banning Cocq. Although this identification is unjustified, stylistically the portrait is related to those in "*The Nightwatch*"; the analogy would be more obvious if the dirty varnish were removed. The pose is based on a Van Dyck formula; this may account for the inexpressive gesture of the hand, which is not as well modelled as one would expect of a work by Rembrandt of this period. *Page 175*

217. *The frame-maker Herman Doomer.* Signed: Rembrandt f. 1640. HdG 642. Bauch 385. Companion picture to Br. 357. Herman Doomer (before 1600-1654) was the father of Rembrandt's pupil, Lambert Doomer. Herman Doomer's widow bequeathed the portraits in 1662 to her son on condition that he had them copied for each of his five brothers and sisters. Several copies are known to exist. The pair in the Devonshire collection is signed (Doomer) and the female portrait is also said to be dated 1644. See: *Urkunden*, Supplement 251a; W. Martin, *Bulletin van den Ned.*

Oudheidk. Bond 2/11, 1909, p. 127. I. H. van Eeghen, *Maandblad Amstelodamum* 43, 1956, p. 133. *Page 176*

218. *Nicolaas van Bambeeck.* Signed: Rembrandt f. 1641. AE 44. HdG 734. Bauch 386. Companion portrait to Br. 360. The pair was identified by I. H. van Eeghen (*Een Amsterdamse burgermeestersdochter van Rembrandt in Buckingham Palace*, Amsterdam, 1958). Nicolaas van Bambeeck was a merchant with a house in the St. Anthoniebreestraat; in 1640 he provided the art-dealer Hendrick van Uylenburgh with some money (as Rembrandt had done too). The inventory of the younger van Bambeeck (died 1671), includes portraits of his parents done by G. Flinck, which can no longer be traced. *Page 177*

219. *A scholar at his desk.* Genuinely (?) signed: Rembrandt f. 1641. HdG 239. Bauch 176. Companion portrait to Br. 359—although the proportions of the figures are rather different. The whereabouts of the pictures, after World War II, could not be traced. To judge from the photographs, an attribution to Rembrandt is most unlikely. *Page 178*

[220. *A Rabbi.* Panel, 75×61 cm. Genuinely (?) signed: Rembrandt f. 1642. New York, Metropolitan Museum of Art. HdG 425. The attribution to Rembrandt is rightly contested by Rosenberg (1964, p. 371) and Bauch (1966, p. 47). *Appendix*]

221. *A man holding a glove.* Signed: Rembran. . . . f.164 . . HdG 757. Bauch 387. I would date the picture in the second half of the forties. There are some pentimenti in the hat and restorations in the area of the coat and collar. The execution is rather weak. *Page 179*

222. *Portrait of a man.* Signed: Rem f.164 . . HdG 747. Bauch 390. Through the dark varnish some pentimenti (ear, hat) can be discerned. *Page 180*

223. *Portrait of a man.* HdG 765. Bauch 389. Both this and the companion portrait (Br. 364, dated 1643) are certainly by F. Bol, an attribution already put forward by A. Burroughs (*Art criticism from a laboratory*, 1938, p. 157). Bauch tentatively proposed the same attribution. The Metropolitan Museum Catalogue classifies them as "Rembrandt?". *Page 182*

224. *Portrait of a man with a falcon.* Doubtful "signature": Rembrandt f. 1643. HdG 748. Bauch 388. Both this and the companion picture, Br. 363, are in my opinion by Bol. The date 1643 may rightly point to the year of origin. The

often observed Italian influence will have reached Bol through Rembrandt, on whose "paintings in the Venetian mood" his own were modelled. *Page 183*

[225. *Portrait of a man.* Panel, 21×17 cm. False signature: Rembrandt f. 1643. Sold London, Sotheby's, July 10th, 1968 (lot 13). Bauch 182. See following number. *Appendix*]

[226. *Portrait of a man.* Panel, 19×16 cm. Formerly New York, van Diemen Galleries. Br. 225 and 226 were first published by W. R. Valentiner (*Burlington Magazine* 57, 1930, p. 265). Other versions exist. Opinion as to the prime original is divided: Bauch considers Br. 225 to be the best of several versions. Valentiner (2nd edition, 1923, p. 40) reproduced the version in Dresden as such. Rosenberg (1964, p. 371) gives preference to the version in Philadelphia, Johnson collection (HdG 444; Valentiner, *Rembrandt, Klassiker der Kunst*, 1909, p. 356 left). There is no reason to assume that even the best version must be a work by Rembrandt himself. *Appendix*]

[227. *Portrait of an old Jew.* Panel, 18.5×15.5 cm. North America, private collection. (Genuinely ?) signed: Rembrandt f. 1643. Bauch 178. Published by W. R. Valentiner, (1921, p. 47). Neither Bauch nor I have seen this painting. The attribution to Rembrandt is most unlikely. *Appendix*]

[228. *Portrait of an old Jew.* Panel, 23×18 cm. HdG 433. Bauch 179. Formerly Amsterdam, P. de Boer. The signed study by G. van den Eeckhout (Haarlem, Teyler Museum) makes an attribution of the painting to this artist very probable. The loose handling is also in accordance with the style of van den Eeckhout. *Appendix*]

229. *An old man wearing a beret.* HdG 437. Bauch 183. The monogram is certainly not Rembrandt's, but the attribution to Rembrandt is convincing. A copy was in the collection of the Earl of Brownlow, wrongly signed and dated 1632. *Page 185*

230. *A bearded man.* HdG 374. Bauch 187. Several versions exist. None of them can be ascribed with any degree of certainty to Rembrandt. Bauch has observed that the model occurs in an earlier picture of the Rembrandt school in Budapest (Catalogue, 1954, no. 342, as Rembrandt and Dou) and later in an anonymous etching of 1646. *Page 184*

231. *Portrait of an old Jew.* Faked signature. HdG 378. Bauch 200 (not seen by him). The

attribution to Rembrandt is out of the question. It is not even a Dutch picture of the 17th century. *Page 185*

232. *An old man wearing a beret.* Faked signature and date 1643. HdG 385. Bauch 181. According to Bauch, the best of several versions. I have not seen the painting; to judge from the reproduction, not very convincing as a Rembrandt. *Page 184*

[233. *Man with a red cap.* Canvas, 111.5×105 cm. Henfield, Lady Salmond. HdG 232. The signature (Rembrandt f. 1644) vanished after cleaning. Now attributed by many scholars to S. van Hoogstraeten (H. Honour, *Leeds Art Calendar* 7, 1953, no. 22; J. G. van Gelder, *Burlington Magazine* 95, 1953, p. 38; W. Sumowski, 1957/8, p. 232; W. R. Valentiner, *Art Quarterly* 9, 1965, p. 393). Bauch (1966, p. 47) follows the attributions of J. G. van Gelder and Sumowski, who claims it, more-over, as a self-portrait by S. van Hoogstraeten. Benesch (*Rembrandt, Werk und Forschung*, Vienna, 1935, p. 34) had already stated that the portrait was close to the early works of S. van Hoogstraeten. The catalogue of the Edinburgh Rembrandt exhibition (1950, no. 18) proposed an attribution to A. de Gelder; while J. Q. van Regteren Altena (*Oud Holland* 82, 1967, p. 70) favoured Nicolaes Maes or Willem Drost "with retouchings by Rembrandt himself". I am convinced—in agreement with the Leyden exhibition catalogue of 1956 (nr. 72)—that there is only one plausible attribution: Nicolaes Maes. *Appendix*]

234. *A man wearing a gorget-plate.* Faked signature: Rembrandt f. 1644. HdG 758. Bauch 393. To my mind an 18th century imitation. *Page 186*

235. *A young man holding a sword.* Signed: Rembrandt ft. 1644. HdG 746. Bauch 184. I do not know the painting itself. To judge from the photograph, the attribution to Rembrandt is not very convincing. *Page 187*

236. *An old man in a fur-lined coat.* Signed: Rembrandt f. 1645. (A fake signature above another, probably genuine one). HdG 364. Bauch 190. Face and hands are good, but the rest has suffered from pressing by relining. *Page 189*

237. *A scholar at his desk.* (Genuinely?) signed: Rembrandt f. 164(5). HdG 752. Bauch 392. The portrait probably represents the preacher Jan C. Sylvius (1564-1638). The drawing, which may have served as a model, is the sketch in Dresden (Benesch 762). The sitter was also etched, twice, by Rembrandt (Münz 49 and 68); the latter etching is dated 1646.

This etching, therefore, as well as the painted portrait (and probably the drawing, Benesch 762) are posthumous portraits. The attribution of the painted version to Rembrandt is by no means certain. The execution points to a pupil, probably Gerbrandt van den Eeckhout, who may have been working from a design by Rembrandt. Bauch, however, believes that the design of the whole picture and the execution of the face are by Rembrandt, and the rest by somebody else. Probably a companion portrait to Br. 369. *Page 188*

238. *Portrait of a man reading.* The signature: Rembrandt f. 1645 was added later. Many replicas exist; they are described in Hofstede de Groot, VI, p. 468. This version was published by Bredius (*Burlington Magazine* 36, 1920, p. 208; *Gazette des Beaux-Arts*, 5/3, 1921, p. 213; *Zeitschrift für bildende Kunst*, N.F. 32, 1921, p. 150). W. Martin (*Kunstwanderer* 3, 1921/2, p. 30) and J. Q. van Regteren Altena (*Oud Holland* 82, 1967, p. 70) support the attribution of this version to Rembrandt. Others emphasize the stylistic connection with Carel Fabritius; according to W. Fraenger (*Hercules Seghers*, 1922, p. 88): a self-portrait by this artist which Rembrandt has reworked. According to Bauch (1966, p. 347) the best version of the four known copies after a lost original, which is perhaps by Carel Fabritius. I would prefer an attribution to the young Barent Fabritius. *Page 190*

239. *An old man in fanciful costume holding a stick.* Signed: . . . f. 1645. HdG 438. Bauch 185. A picture of excellent quality that can serve as a standard against which several doubtfully attributed paintings of this period can be measured. *Pages 191 & 192*

240. *An old man with a beard.* HdG 377. Bauch 191. Not only are the accessories, such as the hat, the cloak and the gloves, restorations and additions of the 18th century (as was stated already in the first edition of Bredius), but the face also cannot have been painted by Rembrandt. *Page 193*

[241. *Study of a head.* Panel, 19.5×15.5 cm. Oslo, National Gallery. First published by W. R. Valentiner (1921, p. 53). C. Müller Hofstede (*Kunstchronik* 9, 1956, p. 92) rightly criticizes the Oslo version, which—to my mind—is very clumsily painted. Bauch (1966, nr. 186) considers the panel in Philadelphia (Johnson collection) as "plainly the best of several versions". *Appendix*]

242. *An old man wearing a beret.* HdG 365A. Bauch 168. Although reproduced by Rosenberg

(1964, p.110), according to Bauch only "the best of several versions". The painting is not known to me, but the attribution to Rembrandt is not convincing. *Page 194*

[243. *Study of a head.* Panel, 24×19 cm. Washington, National Gallery of Art. HdG 448. Painted on a panel on which another head was already begun the other way up. The doubts already expressed by Bredius himself were strongly emphasized by W. Martin (*Kunstwanderer* 3, 1921/22, p. 34) and Bauch (1966, p. 47). The attribution to Rembrandt is certainly wrong. *Appendix*]

244. *Study of an old man.* Published by W. R. Valentiner (2nd edition, 1923, no. 60). Bauch 180. The picture was not known to Bredius in the original; nor to Bauch or me. The attribution to Rembrandt does not seem wholly convincing. Another version exists. *Page 194*

245. *An old man with a beard.* Signed (?): Rembrandt and indistinctly dated. HdG 403. The attribution to Rembrandt is probably not right; according to Bauch (1966, p. 47) in the manner of Salomon Koninck. Neither Bauch nor I, however, have seen the picture. *Page 195*

246. *A young man with a beard.* Signed (?): Rembrandt 16 . . . HdG 414. Bauch (1966, p. 47) attributes the work to Carel Fabritius (possibly); I am reminded of early pictures by Aert de Gelder or Barent Fabritius. An attribution to Rembrandt is probably not right. *Page 195*

247. *Head of a bearded man.* HdG 396. Bauch 189. The study is rather near to G. van den Eeckhout. *Page 196*

[248. *Portrait of a Jew.* Panel, 27×22.5 cm. Formerly Paris, Bischoffsheim collection. HdG 59. There is another version, formerly in the Von Nemes and Heibluth collections which, according to W. R. Valentiner (2nd edition, 1923, p. XXIV) "is better and perhaps the original". The general opinion, however, is that both versions are copies after one of the Elders in the Suzanna picture in Berlin (Br. 516). See for the negative judgement: Benesch (591); W. Sumowski (1957/8, p. 236); Rosenberg (1964, p. 371) who, however, accepts the other version (W. R. Valentiner, 2nd edition, 1923, no. 115; Bauch note with no. 28 and page 47). *Appendix*]

249. *An old man wearing a fur cap.* Signed: Rembrandt f. 1647. HdG 362. Bauch 395. The signature is re-drawn, but the attribution to Rembrandt seems correct. *Page 196*

250. *Portrait of a young Jew.* HdG 365. Bauch 396 (in his notes, by error, 397). Although not signed, one of the best studies from the second half of the 1640s. *Page 197*

251. *The painter Hendrick Martensz Sorgh.* Signed: Rembrandt f. 164(7). The date could also be read as 1644. HdG 749. Bauch 394. Companion picture to Br. 370. The pair was identified through comparison with Sorgh's self-portrait and that of his wife which were for a time on loan to the Boymans Museum, Rotterdam (F. Schmidt-Degener, *Oud Holland* 32, 1914, p. 223). The portrait of Sorgh is of much higher quality than the companion painting of his wife. P. G. Konody (*Apollo*, 9, 1929, p. 207) thought that "Rembrandt's hand had no part in the pictures"; he attributes the female portrait to G. van den Eeckhout, and draws attention to the foreign wood (Honduras mahogany?). *Page 198*

252. *The Jewish physician Ephraïm Buëno.* HdG 627. Bauch 397 (in his notes, by error, 396). An oil-sketch of excellent quality for the etching (Münz 69), which is dated 1647. Dr. Ephraïm Buëno (1594-1665) was a well-known physician and publisher of Jewish works in Amsterdam. *Page 199*

253. *A man with a gold chain.* Signed (?): Remb . . . 1648. HdG 288. Bauch 193. The picture, which was published by W. R. Valentiner (1921, p. 57), has been criticized lately by W. Sumowski (1957/8, p. 242) and by Benesch (*Kunstchronik* 9, 1956, p. 201), who connects it with the Rembrandt school picture in the Rijksmuseum (no. 921). Bauch regards it as a school picture in the manner of G. van den Eeckhout. I share the doubts about an attribution to Rembrandt. *Page 197*

[254. *A painter.* Canvas, 99.5×89 cm. New York, The Frick Collection. HdG 763. After cleaning it became evident that the portrait is by a pupil of Rembrandt, perhaps C. à Renesse or B. Fabritius. Neither Rosenberg (1964, p. 371) nor Bauch (1966, p. 48) has accepted the portrait as a work of Rembrandt. The added strip at the top has been removed. *Appendix*]

255. *Portrait of a man on horseback (Frederick Rihel?).* Signed: R. . . .brandt 1663 (?). HdG 772. Bauch 440. The faint signature and date were detected during the cleaning undertaken after the painting was acquired by the National Gallery in 1959 (see the report in: *National Gallery* [*London*] *Acquisitions 1953-1962*, p. 72). A dating 'around 1665' (as opposed to the formerly accepted date of 1649) had already been put forward by H. Honour (*Leeds Art*

Calendar, Summer 1953, p. 7) and endorsed by J. G. van Gelder (*Burlington Magazine* 95, 1959, p. 395). There is some reason to suppose that the officer represented belonged to the honorary escort which greeted Prince William III on his entry into Amsterdam. Two candidates have been put forward, though objections have been raised against both identifications. R. van Luttervelt's candidate is Jacob de Graeff (who was 18 years old in 1660), whilst I. H. van Eeghen takes up Bredius' suggestion (*Oud Holland* 28, 1910, p. 193) that this is the portrait described in Frederik Rihel's inventory of 1681 ("het counterfeytsel van de Overledene te paert door Rembrandt": "the portrait of the deceased on horseback by Rembrandt") (*Nederlands Kunsthistorisch Jaarboek* 8, 1952, p. 189; *Maandblad Amstelodamum* 45, 1958, p. 13 and p. 147). W. R. Valentiner (*Art Quarterly* 19, 1956, p. 395) and Bauch adhere to the Rihel theory. *Pages 239, 240 & 256*

256. *A man in fanciful costume holding a large sword.* Signed: Rembrandt f. 1650. HdG 532. Bauch 398. Companion picture to Br. 380. Although I listed this picture in the Fitzwilliam Museum Catalogue (1960, p. 102) as a Rembrandt, I am now doubtful about the attribution, especially since the companion piece does not destroy at all the "theatrical conception and composition, which are unusual for Rembrandt" (see Bauch, 1966, under no. 510). The many surface cracks (especially over the hat and the feather) make a judgment of the painterly qualities difficult. *Page 200*

[257. *Portrait of a Jewish merchant.* Canvas, 137.5× 105 cm. London, National Gallery. Signed(?): R . mbrandt . 6 . . . HdG 391. In the National Gallery Dutch Catalogue (1960, p. 341/2) this painting has rightly been eliminated from the list of Rembrandt's autograph pictures. Bauch (1966, p. 48) quotes W. Sumowski as having attributed this work to S. van Hoogstraeten. I am afraid the picture is not even good enough for this Rembrandt pupil. *Appendix*]

258. *A man wearing a beret.* Signed(?): (Re)mbrandt f. 1650. HdG 412. Bauch 201. Bredius calls it in a note a "queer picture" and Bauch admits a faint doubt. A careful inspection has convinced me that the attribution to Rembrandt is wrong: the signature has been put on later, the face is without structure and the cap, beard and jacket without any real painterly qualities. *Page 200*

259A. *An old man with a gold chain.* Signed: Rembrandt f. 1657. Bauch 219. Rosenberg (*Bulletin of the California Palace of the Legion of Honor* 6,

1949, p. 87) has published this version as the original of Br. 259. W. R. Valentiner (Catalogue of the Rembrandt Exhibition, Los Angeles, 1947, no. XXVII) and Bauch accept Rosenberg's statement. I have never seen Br. 259, but I am not convinced at all that Br. 259A is the real original Rembrandt. *Page 201*

[260A. *Portrait of a Jewish philosopher.* HdG 449. There are two versions of this study, one is Br. 260 (in 1962 in the H. John collection, Milwaukee, Wisconsin), the other (reproduced here) in the National Gallery, Washington (panel, 61.5×49.5 cm.). Bredius was unwilling to attribute either version to Rembrandt; so am I. Rosenberg (1964, repr. p. 98) and Bauch (214) accept the Washington version, Bauch calling it "the better of the two versions". One of the versions (or a third one?) was in the L. M. van Loo sale, 1771 (E. Dacier, *Les catalogues illustrés par Gabriel de Saint-Aubin* 5, 1911). *Appendix*]

261. *Study of the head of an old man.* HdG 366. Bauch 245. Neither Bauch, who has some doubts about the attribution, nor I have seen this small study. *Page 201*

[262. *Study of a man with a swollen nose.* Panel, 18.5× 16 cm. Published by C. Hofstede de Groot (*Die holländische Kritik der jetzigen Rembrandtforschung*, 1922, p. 41). Identical with HdG 461. Neither Bauch (1966, p. 48), who rightly denies the attribution to Rembrandt, nor I have seen the picture, which was lately in the Samuel Borchard Sale, New York, January 9th, 1947, lot 40. *Appendix*]

263. *An old man wearing a linen head-band.* Signed: Rembrandt f. 1651. HdG 453. Bauch 402. A picture of excellent quality, though this was hardly apparent from the poor reproduction in the first edition of this book. *Page 202*

[264. *Jew with a linen head-band.* Panel, 24×21 cm. Formerly Munich, Julius Böhler. HdG 370. Bauch 403. Although probably the same model as in Br. 263, not a painting by Rembrandt. Neither Bauch nor I have seen the original. Another version, which I have seen (formerly in the Paul Methuen coll.), is of better quality, but also not by Rembrandt. *Appendix*]

265. *The art-dealer Clement de Jonghe*(?). Signed: Rembrandt f. HdG 735. Bauch 391. The identification of the sitter with the art-dealer Clement de Jonghe (died 1679) was first put forward by F. Schmidt-Degener (in the catalogue of the Rembrandt Exhibition, Amsterdam, 1932, no. 25); it is based on the resem-

blance with his etched portrait by Rembrandt (Münz 72); but the comparison is not wholly convincing. Clement de Jonghe's inventory, compiled after his death, comprises 73 numbers with etchings by Rembrandt; it is the first "catalogue" of Rembrandt etchings (*Urkunden* 346). The picture was not originally a companion portrait to Br. 365. *Page 203*

266. *An old man in fanciful costume.* Signed: Rembrandt f. 1651. HdG 399. Bauch 204. *Page 204*

267. *An old man in an armchair.* (Genuinely ?) signed: Rembrandt f. 1652. HdG 292. Bauch 206. The Venetian tradition echoed in this portrait has often been stressed (most recently by K. Clark, 1966, p. 130). Imposing as the mood is, however, the overall structure of the picture—and in particular the "painterly" execution of the beard and the fur coat, as well as the right hand—is very weak, and even contradictory. The old man's left hand and the sleeve, for example, are conceived in a different style, one that is superficially powerful and impressionistic. These divergences are not to be found in Rembrandt's autograph portraits from this great period, as may be seen by comparing Br. 266, 268 and 276. *Page 205*

268. *Nicolaes Bruyningh.* Signed: Rembrandt f. 1652. HdG 628. Bauch 404. Nicolaes Bruyningh was a distant relative of the secretary Frans Jansz Bruyningh, who in 1657-8 was in charge of the settlement of Rembrandt's affairs (see W. F. H. Oldewelt, *Amsterdamse archiefvondsten*, 1942, p. 158). The picture was in the possession of Bruyningh's sister, Hildegonda Graeswinkel, whose daughter exchanged it in 1728 with the well-known collector and art-dealer Valerius de Roever of Delft, who sold it with many other items to the Landgraf Wilhelm VIII of Hessen in 1750. *Page 206*

269. *An old man in an armchair.* HdG 363. Bauch (203) interprets the picture as Jacob sitting in a chair. In any case, it is obvious that this work belongs to the series of studies for history paintings and has nothing to do with any portrait commission. A copy was recently sold to the United States (Cook sale, London, Sotheby's, June 25th, 1958, lot 112). *Page 208*

270. *An old man in an armchair.* Signed: Rembrandt f. 1654. HdG 439. Bauch 210. Companion portrait to Br. 381. Both pictures have been enlarged. The original size of this one was 89×76 cm. *Page 207*

271. *A bearded man.* Genuinely (?) signed: Rembrandt f. 1654. Published by W. R. Valentiner

(1921, p. 70). Bauch 209 as "the best of several versions". To my mind none of the known versions (Br. 271; Glasgow, Art Gallery and Museum, no. 599 [HdG 381]; Lady Stones Sale, London, July 2nd, 1937, lot 69 [later Cape Town, Art Gallery]) has a claim to be accepted as a work by Rembrandt. *Page 208*

272. *An old man in fanciful costume.* (Genuinely ?) signed: Rembrandt f. 1654. HdG 231. Bauch 208. Most certainly only a work of a pupil. *Page 209*

[273. *Portrait of a Jew.* Canvas, 66×57 cm. Zurich, Labia Collection. Said to be signed: Rembrandt f. 1656. Bredius' doubts, expressed in the first edition of this book, have been sustained by Rosenberg (1964, p. 371) and Bauch (1966, p. 48), who both refuse to accept the picture as a Rembrandt. Bauch attributes it "to a very good pupil, in the manner of W. Drost", which in my view is still praise of too high an order for this poor picture (which I know only from a photograph). See also A. Scharf, *Burlington Magazine* 100, 1958, p. 304. *Appendix*]

274. *An old man in an armchair.* Signed (?): Rembrandt f. HdG 440. Bauch 407. Definitely inferior in quality to the other pictures of old people dating from this period (for instance Br. 270). *Page 209*

275. *The standard-bearer.* Signed: Rembrandt f. 1654. HdG 269. Bauch 408. *Page 210*

276. *Jan Six.* HdG 712. Bauch 405. Painted in 1654, as appears from the "poem" composed by Six himself: AonIDas qVI sVM tenerIs VeneratVs ab annIs TaLIs ego IanVs SIXIVs ora tVLI (such a face had I, Jan Six, who since childhood have worshipped the Muses), (*Urkunden*, 151). The capital letters, read as Roman numerals, and added up, give the year 1654. Jan Six was an Amsterdam merchant, who must have been in rather close contact with Rembrandt from the middle of the 1640s. He had married Margareta Tulp, a daughter of Doctor Nicolaes Tulp (whom Rembrandt had painted in 1632) and in 1691 was for one year burgomaster of Amsterdam. If the anecdote concerning the speedy execution of the etched landscape (Münz 156; dated 1645) is right, then this etching too originated at Six's country seat. In 1647, Rembrandt made a portrait etching of Six and a year later an illustration for a tragedy which Six had composed (Münz 70 and 270). There are also several drawings connected with commissions from Six, among others two in the family book of Jan Six (Benesch

913/914). After 1654 the contact between Rembrandt and Six seems to have ceased. See Christopher White, *Rembrandt and his World*, London, 1964, p. 93, and M. G. de Boer, *Jaarboek Amstelodamum* 42, 1948, p. 10. See also Br. 358. *Page 211*

277. *Portrait of a man.* HdG 753. Bauch 425. The picture has gained in appearance through recent cleaning and restoration. I agree with Bauch's late dating, about 1660. *Page 212*

278. *A man in a fur-lined coat.* Signed: Rembrandt f. and indistinctly dated. HdG 750. Bauch 409. The date was formerly interpreted as 1655, and is accepted as such by Bauch. W. R. Valentiner (*Burlington Magazine* 57, 1930, p. 266) read it as 1665 and in a later publication (*Festschrift Kurt Bauch*, 1957, p. 233) as 1666, in accordance with W. Heil's observation (*Pantheon* 6, 1930, p. 383). Valentiner recognizes Titus' features in the portrait. I would date this great portrait in the late 1650s. *Page 213*

279. *"The Polish Rider".* Signed: Re . . . HdG 268. Bauch 211. The picture has been cut at the right edge so that only part of the signature can be seen. A strip added later (which must have replaced part of the original canvas) has been taken away and replaced by a new one. The basic interpretation of the subject is due to J. Held (*The Art Bulletin* 26, 1944, p. 259): it is not a real portrait but a poetic composition with an allegorical meaning, connected with the concept of the "Christian Soldier". To W. R. Valentiner (*Art Quarterly* 11, 1948, p. 116) the picture is an historical portrait, that of Gijsbert van Amsterdam, the mythical founder of Amsterdam. A Polish historian, however, has proved that the title "The Polish Rider" is justified in that the elements of dress and military equipment are truly Polish (Z. Zygulski, *Biuletyn Historii Sztuki* 26, 1964, p. 83). J. Białostocki (lecture held in 1967 in the Warburg Institute) has recently suggested that the idea of creating a symbol (and a kind of ideal portrait) of an "Eques Polonus" may have been suggested by the struggle for liberty of conscience led by the Polish Socinian, Jonasz Szlichtyng. His '*Apologia*' was published in Amsterdam in 1654; it attacked the States Generals' edict of the previous year which banned propagation of the Socinian doctrine. The Polish Socinians, in Holland called the Polish Brethren, had found a great deal of support for their beliefs among Dutch dissidents. Moreover, the Mennonites had close relationships with the Polish Socinians, and Rembrandt had Mennonite contacts through the Uylenburgh family.

The picture went from Holland to Poland in the late 18th century (A. Ciechanowiecki, *The Art Bulletin* 42, 1960, p. 294). The drawing of the Skeleton Rider (Darmstadt; Benesch 728) and Dürer's horses in the woodcut of *The Four Horsemen of the Apocalypse* have often been connected with the conception of Rembrandt's horse (see K. Clark, 1966, p. 36). *Pages 214 & 368*

280. *An old man with a stick.* False signature: Rembrandt f. 1655. HdG 452. Bauch 414. Companion portrait to Br. 388. F. Winkler (*Kunstchronik* 10, 1957, p. 142) has pointed out that the male portrait is poorly preserved. E. Buchner (*idem*) doubts whether Br. 388 is really a companion portrait at all. After having admired these paintings for years, I was struck on a renewed inspection by their poor construction and superficial execution. I even doubt whether the pictures are works of the 17th century. *Page 215*

281. *The Amsterdam physician Arnout Tholinx.* Signed: Rembrandt f. 1656. HdG 725. Bauch 415. Arnout Tholinx was an Inspector of the Amsterdam Medical Colleges from 1643 to 1653. He was succeeded by Dr. Joannes Deyman (see Br. 414). Tholinx was related to Dr. Nicolaes Tulp and Jan Six, both of whom were clients of Rembrandt. The sitter is identified by comparison with the rare portrait etching Münz 73, the identity of which is rather well established. The picture is covered by thick varnish, which makes it very hard to verify the signature and estimate the real quality of the painting. *Page 215*

282. *An old man in a cape.* HdG 454. Bauch 220. Not seen either by Bauch or by me. *Page 216*

283. *A bearded man in a cap.* Signed: Rembrandt f. 165 . . HdG 392. Bauch 218. The same model occurs in other late paintings by Rembrandt; see Br. 259, 309 and 478. See also O. Benesch in *Art Quarterly* 19, 1956, p. 335. *Page 217*

284. *A bearded man.* Published by W. Bode (*Jahrbuch der preussischen Kunstsammlungen* 38, 1917, p. 107). Bauch 216. Although the picture has suffered somewhat from relining, it is still one of the most expressive studies of this period. Bode's suggestion that the model's features are those of a Russian is rather unconvincing. *Page 218*

285. *An old man in an armchair.* Signed: Rembrandt f. 166. . HdG 380. Bauch 431. The real surface of the painting is almost invisible, so thick is the yellow varnish. The X-ray by Dr. M. Meier-Siem reveals the powerful structure

of the underpainting. The signature is doubtful, but the picture itself is certainly autograph. The catalogue of the Amsterdam Exhibition, 1956 (no. 76) dates the picture around 1657, but I would not be surprised if the portrait belonged originally to the series of apostles dating from the early 1660s (Br. 614 etc). The identification with the Jewish Rabbi Haham Saul Levy Morteyra (J. Zwarts, *Oud Holland* 48, 1926, p. 1) is probably not correct (see 1956 Catalogue, no. 76). The picture was probably already in the collection of the Medici in the late 17th century—the date 1670, however (Amsterdam Exhibition Catalogue) cannot be ascertained. It was among the possessions of "principe Fernando" (i.e., Ferdinando di Cosimo III) de' Medici, who died in 1713 (information kindly communicated by Dr. Karla Langedijk). *Page 219*

286. *A man with a stick.* False signature: Rembrandt f. 1657. HdG 421. Bauch 222. The technical report of the Louvre Laboratory referred to the signature as 'à peine lisible' (M. Hours, *Bulletin du Laboratoire du Louvre* no. 6, 1961). A picture of the period, but not by Rembrandt. *Page 220*

287. *A man with a pearl-trimmed cap.* Signed (?): Rembrandt (difficult to read). HdG 741. Bauch 416. Bauch suggests that the portrait is a companion to Br. 389. Both pictures were in the Spengler inventory of 1827, attributed to G. Flinck. They are certainly school pictures; Br. 287 is in the manner of Samuel van Hoogstraeten. *Page 220*

[288. *A youth.* Panel, 23 × 18 cm. Paris, Private Collection. HdG 434. Last exhibited in Paris, Musée Carnavalet 1955, no. 55. An attribution to Rembrandt is unjustified. Bauch's attribution (1966, p. 48) "an excellent Carel Fabritius" does not convince me. *Appendix*]

289. *Portrait of a young man (Titus?).* HdG 705. Bauch 434. The revindication of this beautiful portrait and, to a lesser degree, its identification as a portrait of Titus (by W. R. Valentiner) has generally been accepted. There are remains of a date which have been interpreted as 1663. The picture could be even later. W. Martin (*Der Kunstwanderer* 3, 1921/2, p. 34) calls the attribution to Rembrandt "incomprehensible". *Page 248*

290. *A man with arms akimbo.* Bauch 421. Signed: Rembrandt f. 1658. Published by T. Borenius (*Burlington Magazine* 57, 1930, p. 53) and by W. R. Valentiner (*idem*, p. 260). The picture came to light in the George Folliott of Chester sale, London, Sotheby's, May 14th, 1930, lot 31. *Page 222*

291. *The writing-master Lieven Willemsz. van Coppenol.* HdG 636. Bauch 424. This study on paper is claimed to be the oil-sketch for the etching Münz 78, which is dated 1658. The execution of the picture is, however, too weak to be attributed to Rembrandt. Lieven Willemsz. van Coppenol was a writing master, who went mad in 1650. Half recovered, he visited painters and poets, in the hope of being painted and his art glorified! (H. F. Wijnman, *Jaarboek Amstelodamum* 30, 1933, p. 150). *Page 221*

292. *Portrait of a young man.* (Genuinely?) signed: Rembrandt f. 1658. HdG 422. Bauch 420. There is a strange (17th-century?) painting under the actual one, which makes the attribution to Rembrandt still more doubtful. *Page 221*

293. *A young man with a beret.* Signed: Rembrandt f. HdG 703. Bauch 417. Bredius and Bauch have rightly rejected the often expressed opinion that Titus is represented here. In its picturesque interpretation, however, it is very similar to the portraits of Titus of the late 1650s. *Page 223*

294. *A man holding a manuscript.* Signed: Rembrandt f. 1658. HdG 756. Bauch 422. A particularly sensitive appreciation of this beautiful portrait has been written by O. Benesch (*Art Quarterly* 19, 1956, p. 340). *Page 224*

295. *A man holding a letter.* Signed: Rembrandt f. 1658. HdG 774. Bauch 423. Probably a most impressive late portrait, but the original is not known to Bauch or me. *Page 225*

295A. *An old man.* Signed: Rembrandt f. 1659. HdG 367. Bauch 225. Another version was in the collection of W. van Horne, Montreal (HdG 416; W. R. Valentiner, 1921, p. 89). Bredius (*Zeitschrift für bildende Kunst*, N.F. 32, 1921, p. 152) had only minor reservations about this and the other version; the inclusion of one version in this new edition seems therefore justified. Both versions are accepted by Rosenberg (1964, p. 371). Bauch, however, calls Br. 295A the best version of "a picture which exists in several copies". Neither Rosenberg, Bauch, nor I have seen the picture itself. *Page 226*

296. *Young man in a red cloak.* (Genuinely?) signed: Rembrandt f. 1659. HdG 411. Bauch 426. Although probably the same model as the male figure in *The Jewish Bride* (Br. 416), the attribution of this study to Rembrandt is not convincing. *Page 228*

297. *An old man as St. Paul.* Signed: Rembrandt 165(9?). HdG 291. Bauch 224. W. R. Valentiner, in particular, has stressed that this picture may belong, as a Biblical portrait, to the series of the apostles (Br. 614 etc.). There are, however, some obvious weak parts in the picture (the modelling of the hands, the unbalanced colour scheme), due either to heavy wear or to the fact that the picture is only an old copy. *Page 227*

298. *A man seated before a stove.* Bauch 432. Published by W. R. Valentiner (1921, p. 90). The picture is in a bad state of preservation; the attribution to Rembrandt is unconvincing. *Page 228*

299. *Portrait of a young man.* Signed: Rembrandt f. 1660. HdG 782. Bauch 433. The portrait has suffered, but the attribution to Rembrandt is correct. *Page 229*

300. *Portrait of a young Jew.* Signed: Rembrandt f. 1661. HdG 407. Bauch 435. This model served for Rembrandt's late portrayals of Christ. *Page 229*

[301. *Portrait of an Oriental.* Panel, 25×21.5 cm. Copenhagen, Statens Museum. HdG 347. Bauch, p. VIII, note 1 and p. 48. All critics have rightly noted the poor condition of the picture, which makes it impossible to judge its original quality. Except for a superficial resemblance to a figure in Br. 481, there is no reason to attribute this ruin to Rembrandt. *Appendix*]

302. *Head of an old man.* HdG 174. See notes to Br. 305. *Page 230*

303. *Head of an old man.* HdG 172. See notes to Br. 305. *Page 230*

304. *Head of an old man.* HdG 175. Bauch 233. See notes to Br. 305. Enlarged on all four sides. *Page 231*

305. *Head of an old man.* Published by W. R. Valentiner (1921, p. 91). These heads, studies (?) for the *St. Matthew* in the Louvre (Br. 614), have, in recent years, been the subject of divergent views: Rosenberg and Slive (1966, p. 78) accept all of them as genuine preparatory oil sketches for the Louvre *St. Matthew*; Bauch calls Br. 304 "the best version of several heads with different features". J. Q. van Regteren Altena (*Oud Holland* 82, 1967, p. 70-1) stresses that Br. 304 is the original, which, from the photograph, at least, also seems to me the best version. Br. 302, the only one which I have studied lately, is an imitation of a later period. *Page 231*

306. *A young Capuchin monk (Titus).* Signed: Rembrandt f. 166(0). HdG 193. Bauch 227. There has been some discussion as to whether the subject should be interpreted as a portrait of Titus as a monk, or as a representation of St. Francis. W. R. Valentiner (*Art Quarterly* 19, 1956, p. 400) suggested a "Franciscan monk", Bauch (*Burlington Magazine* 101, 1959, p. 105) a representation of St. Francis, for which Titus may have served as a model. It is certainly not a portrait of Titus in the usual sense; but it was quite within Rembrandt's thinking (and not only a 19th-century interpretation) to imbue an "historical portrait" with the likeness of an actual one. *Page 232*

307. *A Capuchin monk reading.* Signed: Rembrandt f. 1661. HdG 190. Bauch 232. This portrait may belong to the rather unspecific series of evangelists and holy men of the 1660s (see Br. 615). Its surface has suffered, but the original delicacy can still be appreciated. There are some pentimenti in the area of the left shoulder. *Page 233*

308. *A Franciscan monk.* Signed: (Re)mbrandt f. 165. . HdG 191. Bauch 205. If the date of the "badly worn and cracked" picture (*National Gallery Catalogue*) is rightly interpreted as 1655 (or 1656), it must be placed before Br. 306/7. Though less sensitively painted than these, the attribution to Rembrandt seems to be correct. Bauch's observation, that the model for the monk is the same as for the portraits Br. 266 and 280, I do not find convincing. *Page 234*

309. *A bearded man.* Indistinctly signed: Rembrandt f. 1661. HdG 441. Bauch 239. As Rosenberg has observed (1964, p. 360 and *Bulletin of the California Palace of the Legion of Honor* 6, 1949, p. 87) probably the same model as Br. 259, 283 and 478. *Page 235*

310. *Two negroes.* Signed: Rembrandt f. 1661. HdG 336. Bauch 539. Bredius supposed that "the picture was probably begun earlier, and the date added some years afterwards, when Rembrandt worked on it again". A. B. de Vries (*150 Jaar Koninklijk Kabinet van schilderijen*, 1967, p. 222 puts the origin of the picture about seven years earlier than the inscribed date, a hypothesis also adopted by Bauch. From a study of the painting I cannot detect anything which points to a date earlier than that implied by the signature. The idea of re-dating has probably been stimulated by the desire to identify it with an item described in Rembrandt's inventory of 1656, "no. 344 two Moors in one picture". Two

versions of inferior quality exist, one in the Museum of the Rumanian People's Republic in Bucharest, and the other in an English private collection (exhibited Nottingham, September 1945, no. 34). *Page 236*

311. *Portrait of a young man.* Signed: Rembrandt f. 1662 (the signature is spurious, the date could also be read as 1661). HdG 744A. Bauch 438. The picture looks like the portrait of a painter (with the beret that Rembrandt liked to wear himself), but so far the sitter has not been identified. The costume is probably not wholly finished; some pentimenti in the area to the right. *Page 237*

312. *Portrait of a young man.* Signed: Rembrandt f. 1663 (or 1662?). HdG 784. Bauch 439. One of the most beautiful of the late commissioned portraits; the hands alone have suffered. *Page 238*

313. *A man in a tall hat.* HdG 781. Bauch 437. Bauch rightly observes that the portrait has suffered considerably, and I should like to stress the poor condition of the hands and the costume. The face may—after cleaning—reveal its original quality. *Page 241*

314. *The Dordrecht merchant Jacob Trip.* Signed: Rembr . . . HdG 393. Bauch 429. Companion portrait to Br. 394. The identification of the sitter and his wife is due to C. Hofstede de Groot (*Oud Holland* 45, 1928, p. 255). The statement in the *National Gallery Catalogue* that the picture is "in very good condition except for the area beneath the seat of the chair" seems over-optimistic; the face certainly is, but the dress and, to a lesser degree, the hands have suffered from pressing and and relining (as so many late Rembrandts have). The X-ray reveals some pentimenti in the area of the left hand; the stick may have originally been held in an oblique position. *Page 242*

315. *Dirk van Os.* HdG 664. Bauch 428. Inscribed near the coat of arms: D. VAN OS (DIJCK-GRA)EF VAN D(E BEEMSTER). Not seen by either Bauch or me. To judge from the photograph, the attribution to Rembrandt is not at all convincing. *Page 243*

[316. *Portrait of a man.* Panel, 56×47 cm. Chicago, Art Institute. Published by W. R. Valentiner (*Rembrandt Paintings in America*, 1932, no. 167). Listed in the 1961 catalogue of the Chicago Art Institute as "attributed to Rembrandt". According to Bauch (1966, p. 48) perhaps by S. van Hoogstraten. Not seen by either Bauch or me. *Appendix*]

317. *Portrait of a man.* Faked signature: Rembrandt f. 1665. HdG 754. Rightly deleted from Rembrandt's works by Bauch (1966, p. 48), who supposes it to be an English imitation of the eighteenth century. The fact that the painting was engraved by W. Baillie (in 1764) only proves that the portrait must have been in existence before that date. *Page 244*

[318. *"The Falconer"*. Copenhagen, Statens Museum. HdG 265. Bauch 243. The picture is now reduced to its original size (canvas, 66.6×50.5 cm.). In the 1951 Copenhagen Catalogue the attribution to Rembrandt is rightly rejected. E. Plietzsch (*Repertorium für Kunstwissenschaft* 60, 1917, p. 187 and *Pantheon* 22, 1938, p. 302) and W. Martin (*Hollandsche Schilderkunst* 2, 1936, p. 504) have also expressed strong doubts. J. Q. van Regteren Altena (*Oud Holland* 82, 1967, p. 71), however, maintains that an attribution to Rembrandt has to be considered. I regard the picture as a later derivative from Br. 319. *Appendix*]

319. *"The Falconer"*. Bauch 242. Published by W. R. Valentiner (1921, p. 97a). See also: O. Benesch (*Jahrbuch für Kunstgeschichte* 3, 1924/5, p. 115), A. L. Romdahl (*Göteborg Museums Arstrijck* 1929, p. 93), W. R. Valentiner (*Art Quarterly* 11, 1948, p. 117) and J. Gantner (*Festschrift Karl M. Swoboda*, 1959, p. 97). Gantner follows Valentiner's interpretation that the Dutch Count Floris V (1254-1296) is represented here in a "historical portrait". Rembrandt could have known about the Count's life from plays and accounts by Vondel, Colevelt and Ph. van Zesen. Gantner elaborates further, presuming a connection between this historical portrait and the Passion of Christ, and expressing the view that "this picture also shares the timelessness of all sacred things". Gantner's idea is even more fantastic, as well as being both visually and theoretically less well founded, than Valentiner's basic proposition. The picture is not identical with the *Rembrandt, Young Man*, which was sold at the L. Lesser sale, London, Christie's, February 10th, 1912, lot 81, as was believed by Valentiner and Bredius. *Page 245*

320. *The poet Jeremias de Decker.* Signed: Rembrandt f. 1666. HdG 776. Bauch 442. The portrait was painted in the year of the poet's death. The identification is based on the resemblance with the engraved portrait in one of the editions of Decker's works. Jeremias de Decker wrote a poem of gratitude "to the excellent and world famous Rembrandt

van Rijn", which was published in 1667; and already, in or before 1660, Rembrandt must have painted the poet in another (lost or unidentified) portrait (*Urkunden*, 221-2 and 291). The poet also wrote a poem on Rembrandt's *Christ and St. Mary Magdalen at the tomb* (Br. 559). *Page 246*

321. *The painter Gerard de Lairesse*. Signed: Rembrandt f. 1665. HdG 658. Bauch 441. The left hand and some other parts have suffered from pressing, but the face is well preserved. F. Schmidt-Degener's identification of the portrait with the artist Gerard de Lairesse (1640-1711) is unanimously accepted (*Onze Kunst* 23, 1913, p. 117). *Page 247*

322. *Portrait of a youth*. (Genuinely?) signed: Rembrandt f. 1666. HdG 780. Bauch 443 (a portrait of the painter Samuel van Hoogstraten?). Even though the signature may be retouched, the portrait belongs to the series of genuine late official portraits of high quality. *Page 249*

323. *Portrait of a fair-haired man*. Signed: Rembrandt f. 1667. HdG 743. Bauch 445. Ursula Hoff (*Apollo* 79, 1964, p. 456) has stated that "this is Rembrandt's last commissioned portrait", and one of his most impressive, but Br. 323A, 326 and 327 are either as late or even later in date. *Page 250*

323A. *Portrait of an elderly man*. Signed: Rembrandt f. 1667. Bauch 444. Identical with HdG 829. Published by W. R. Valentiner (1921, p. 98). Bredius (*Zeitschrift für bildende Kunst*, N.F. 32, 1921, p. 152) vigorously denied the authenticity of this portrait; in his view it was a Belgian fake of the 19th century. This must, however, be an error. The portrait, which was shown at the Royal Academy in London (1938, no. 128; 1952/3, no. 175), in Edinburgh (1950, no. 35) and in Manchester (1957, no. 105) is genuinely signed and dated; it can be traced in English collections in 1758 and 1761. Moreover, it has such an overwhelming power, character and directness of expression, that it matches perfectly the other commissioned portrait of 1667, Br. 323. As far as I can see, it has received only praise from—among others—C. Hofstede de Groot (*Die holländische Kritik der jetzigen Rembrandtforschung*, 1922, p. 13), J. G. van Gelder (*Burlington Magazine* 95, 1953, p. 53), and Rosenberg (1964, p. 371). *Page 251*

324. *Portrait of an old man in a pearl-trimmed hat*. HdG 376. Bauch 247, as the best of several versions. W. Scheidig (*Rembrandt und seine Werke in der Dresdner Galerie*, 1958, p. 21) connects this picture with Br. 526 and 595.

The latter is certainly not by Rembrandt, and the colour scheme and the lame execution of Br. 324 preclude an attribution to the master himself, although I would certainly not claim that both works—Br. 595 and 324—are by the same hand. The underlying paint structure which the X-ray reveals is better than the quality of the surface painting. *Page 253*

325. *Portrait of an old man*. Signed: Rembrandt f. 1667. HdG 401. Bauch 246. Bauch puts a question mark after the signature. I have not seen the picture. The photograph does not inspire any confidence in the attribution. *Page 252*

326. *A man with a magnifying glass*. HdG 755. Bauch 447. Companion portrait to Br. 401. There has been much speculation about the pair represented in these beautiful late, "un-official" portraits: J. Goedkoop-de Jong (*Feestbundel Bredius*, 1915, p. 53) suggested that Spinoza was represented; J. Zwarts (*Onze Kunst* 49, 1929, p. 11) proposed Miguel de Barrios and Abigaël de Pina. F. Lugt (*Art in America* 30, 1942, p. 174) preferred an identification with J. Lutma the younger; while W. R. Valentiner (*Rembrandt, Klassiker der Kunst* 1909, p. 482-3 and, in G. Glück, 1933, p. 346) favoured Titus van Rijn and Magdalena van Loo. There is some—though not to my mind a very convincing—resemblance with the pair in the so-called "*Jewish Bride*" (Br. 416). *Page 254*

327. *A man holding gloves*. HdG 779. Bauch 446. Companion portrait to Br. 402, which is lighter in tonality. The lower right area of the canvas has suffered the most and the left hand is repainted. The X-ray, however, confirms that the structure of the underpainting is vigorous in all the lighter parts of face and costume. According to the National Gallery authorities, this portrait is neither signed nor dated—contrary to the statements of Bredius and Bauch. *Page 255*

[328. *Portrait of a young girl*. Panel, 68 × 55.5 cm. Helsinki, Ateneum. HdG 499. Bauch (1966, p. 48) has attributed the picture to a Leyden pupil of Rembrandt, proposing Isaac de Jouderville (1960, p. 267). This seems a very likely attribution, and is in any case better than the supposed relationship to Br. 154 (K. Bauch, *Die Kunst des jungen Rembrandt*, 1933, p. 225). *Appendix*]

329. *Portrait of a young girl*. Said to be signed: R. HdG 853. Bauch 457. Unknown to Bauch and to me. To judge from the photograph, a doubtful attribution. *Page 259*

330. *Portrait of a young woman.* Signed: RHL van Rijn 1632. HdG 884. Bauch 460. The surface of this picture, as well as the underpainting revealed by the X-ray, is rather more carefully and more cautiously painted than is generally the case with portraits from Rembrandt's early Amsterdam period. *Page 260*

331. *Portrait of a young woman.* Signed: RHL van Rijn 1632. HdG 625. Bauch 459. Companion portrait to Br. 167 (see note). Technique and expression, however, are absolutely dissimilar to those of the male portrait. The signature seems to be copied from the one on Br. 167. The obvious conclusion is that the female portrait was painted by another artist of less originality and power. *Page 262*

332. *Portrait of a woman.* HdG 883. Bauch 470. Companion portrait to Br. 163. Although not signed, both pictures not only form a perfect pair but also conform to Rembrandt's vigorous style of the early 1630s. The relationship is still more evident in the underpainting revealed in X-rays taken by Dr. Meier-Siem. *Page 263*

333. *An old woman in a white cap.* Signed : RHL van Rijn 1632. HdG 877. Bauch 461. Seen by neither Bauch nor me lately, but the attribution to Rembrandt seems correct. *Page 264*

334. *A young woman with a hymn-book.* Signed: RHL van Rijn 1632 and AET 39. HdG 875. Bauch 458 (not seen by him). The picture was in the process of being cleaned in 1966; some parts—for instance the hand with the book—seemed very weak in their newly revealed state. An attribution to Rembrandt is not convincing. *Page 264*

335. *Portrait of a woman.* Signed: Rembrandt f. 1633. HdG 867. Bauch 462. Perhaps a companion picture to Br. 160, according to Valentiner and Bauch. The execution, however, is far inferior to that of the male portrait. The attribution to Rembrandt is not wholly convincing. *Page 265*

336. *Cornelia Pronck, wife of Aelbert Cuyper.* Genuinely(?) signed: Rembrandt ft. 1633. AET 33. HdG 669. Bauch 471. Companion to Br. 165 (see there for literature). As Br. 336 is inferior in quality and, according to Mme. Hours, reveals a different technique in the underpainting, this picture is probably not by Rembrandt. *Page 265*

337. *Portrait of a young woman.* Signed: Rembrandt f. 1633. Published by W. R. Valentiner (1921, p. 28). Bauch 472. Probably a companion portrait to Br. 176. Not known to either Bauch or me, but the attribution to Rembrandt is convincing. *Page 266*

338. *Portrait of a young woman.* (Genuinely?) signed: Rembrandt ft. 1633. HdG 849. Bauch 465. Companion portrait to Br. 159 (see the observations under that number). There is a remarkable difference between the male and the female portrait. The latter has an enamel-like surface quality, in contrast to Rembrandt's usual modelling. The underpainting revealed by the X-ray also has a structure that differs from Rembrandt's normal method in these years. It may be a pupil's work. *Page 266*

339. *Margaretha van Bilderbeecq.* Signed: Rembrandt f. 1633. HdG 630. Bauch 466. Companion portrait to Br. 175. Although less powerful than the male portrait, it has, on a smaller scale, all the vivacity of brushwork that one expects from Rembrandt's work in the early 1630s. *Page 267*

340. *A woman with a lace collar.* Signed: Rembrandt f. 1633. HdG 873. Bauch 475. Not seen by either Bauch or me. *Page 267*

341. *A young woman with a fan.* Signed: Rembrandt (f) 1633. HdG 881. Bauch 469. Companion portrait to Br. 172. The picture is covered by a thick varnish, which conceals the delicate design of the face and the head. *Page 268*

342. *Oopjen Coppit, wife of Maerten Soolmans.* HdG 638. Bauch 478. Companion portrait to Br. 199. About the recent research connected with these portraits, see the note to Br. 199. The female portrait is neither signed nor dated, but it is in every respect an exact companion to Br. 199. R. van Luttervelt's suggestion, (*Maandblad Amstelodamum* 43, 1956, p. 93) that this female portrait was executed about seven years later, is unconvincing. *Page 269*

343. *Portrait of an 83-year-old woman.* Signed: Rembrandt f. 1634. AE SVE 83. HdG 856. Bauch 476. A drawing by J. Stolker after this portrait (or better: after a lost drawing by Hendrik van Limborch after this picture) gives the name of the sitter as Françoise van Wassenhoven. Stolker's identifications have proved to be unreliable; moreover, his own mezzotint after the drawing omits the identification. One of the most powerful and best preserved female portraits of the 1630s. *Page 270*

344. *Portrait of a young woman.* Signed: Rembrandt f. 1634. HdG 874. Bauch 480. Companion portrait to Br. 177. *Page 270*

345. *A young woman with flowers in her hair*. Signed: Rembrandt f. 1634. HdG 859. Bauch 479. Said to be a companion portrait to Br. 196, although a little weaker in execution. *Page 271*

346. *A young woman with a gold chain*. Signed: Rembrandt f. 1634. HdG 848. Bauch 482. Companion portrait to Br. 197. Although the signature on the female portrait is written in an odd way, the picture itself is as well constructed and powerful in execution as the companion piece. *Page 271*

347. *Maria Bockenolle, wife of Johannes Elison*. Signed: Rembrandt f. 1634. HdG 646. Bauch 477. Companion picture to Br. 200, and in every respect its equal. See note to Br. 200. *Page 272*

348. *A 70-year-old woman seated in an armchair*. Genuinely (?) signed: Rembrandt f. 1635. AET.SVE 70. HdG 868. Bauch 491. Perhaps the companion portrait to Br. 212. The attribution to Rembrandt is not convincing; it is a portrait from the Amsterdam circle of Rembrandt. *Page 273*

349. *Petronella Buys, wife of Philips Lucasz*. Signed: Rembrandt f. 1635. HdG 661. Bauch 486. From an inscription on the back we learn the name of the sitter, who married first Philips Lucasz and after his death (in 1641) Jean Cardon, in 1646. Companion portrait to Br. 202. Not seen either by Bauch or me. *Page 274*

350. *Portrait of a young woman*. Signed: Rembrandt f. 1635. HdG 846. Bauch 485. Probably a companion portrait to Br. 201. The collar has been overpainted. *Page 274*

351. *A young woman with a book*. Faked signature: Rembrandt f. 1635 (or 1636). HdG 317A. Bauch 260 ("the best of several existing versions"). There is another version without the book. The Los Angeles version, the only one I have seen, is very poor and certainly not a work by Rembrandt. I doubt whether it is even a 17th century painting. See also B. F. Fredericksen in *Burlington Magazine* 108, 1966, p. 378 (as a third-rate school picture). *Page 275*

352. *A young woman with a heron's plume in her hair*. Imitated signature: Rembrandt f. 1636. HdG 885. Bauch 496. Companion picture to Br. 204. Both are the work of G. Flinck (see note to Br. 204). *Page 275*

353. *A young woman holding a carnation*. HdG 851. Bauch 494. The thick varnish makes it difficult to judge the quality of the painting. I am afraid that Bauch's doubts ("perhaps a work by F.

Bol") are partly conditioned by the yellow surface of the portrait; the underpaint, revealed by X-ray (taken by Dr. M. Meier-Siem), is strong and vigorous. *Page 276*

354. *A lady of the Raman family*. Signed: Rembrandt f. 1636. HdG 882. Bauch 492. A companion portrait to Br. 194, and also originally ten-sided. J. G. van Gelder (*Burlington Magazine* 92, 1950, p. 328) had some doubts about the attribution. The picture is unknown to me in the original. *Page 276*

355. *Alotta Adriaensdr*. (Genuinely?) signed: Rembrandt 1639. HdG 619. Bauch 497. The identity of the sitter is based on the resemblance to a copy (not known to me) in the Trip family portrait collection, which now belongs to Jhr. S. Laman Trip, Den Helder. I agree with F. Winkler's remarks about this picture's poor state of preservation, (*Kunstchronik* 10, 1957, p. 143), which makes a final attribution difficult. After another cleaning in 1947 the hand and the table (?) were brought to light. Alotta Adriaensdr. (1589-1656) married in 1609 Elias Trip, whose brother Jacob and his wife were also painted by Rembrandt (Br. 314, 394 and 395). See also next number. *Page 277*

356. *Maria Trip, daughter of Alotta Adriaensdr*. Signed (very thin): Rembrandt f. 1639. HdG 845. Bauch 498. J. Q. van Regteren Altena's suggestion that perhaps Saskia is represented here (*Kunstmuseets Aarskrift* 1948/9, p. 24) has been replaced by Dr. I. H. van Eeghen's theory, that the picture is a portrait of Maria Trip, one of the ancestors of the Van Weede family (*Maandblad Amstelodamum* 43, 1956, p. 166). The portrait is painted—like Br. 358—on Indonesian djati panel, which may partly explain the unusual, careful and somewhat heavy—and even slightly impersonal—technique. Even the underpainting, visible in the X-ray, has this character. The preparatory drawing in London (Benesch 442) is very vigorous and straight-forward; it makes it clear, incidentally, that the picture has been cut on all four sides. *Page 278*

357. *Baartjen Martens, wife of Herman Doomer*. Signed: Rembrandt f. HdG 643. Bauch 499. Companion portrait to Br. 217, which represents her husband. See note to Br. 217. *Page 279*

358. *Anna Wijmer* (?). Signed: Rembrandt f. 1641. HdG 728. Bauch 500. Anna Wijmer (1584-1654) married Jan Six in 1606; their son Jan Six jr. (1618-1700), was painted by Rembrandt in 1654 (see Br. 276). The identity of the sitter

[376. *Study of the head of a young girl*. Panel, 26×21 cm. New York, S. J. Lamon. HdG 494c (probably identical with HdG 919). The same arguments apply to this as to Br. 375. This time the head is copied after one in the lost *Circumcision* by Rembrandt (see HdG 82a, copy in Herzog-Anton-Ulrich Museum in Brunswick, 241). Bauch (1966, p. 48) classifies it as "manner of Fabritius". *Appendix*]

377. *A young girl at a window*. Signed: Rembrandt f. 1651. HdG 330. Bauch 269. A small drawing in Dresden (Benesch 1170) is the preparatory study for this most powerful picture: the painting has wrongly been connected with the "servante" which Roger de Piles owned, and which he put into a window in order to deceive the passers by, who thought that there was a "real" girl in the window (*Abrégé de la vie des peintres*, 2nd ed. 1715, p. 423). Roger de Piles, however, owned the school-picture (HdG 326, now at Woburn Abbey). *Page 294*

378. *A young girl holding a broom*. (Genuinely?) signed: Rembrandt f. 1651. (The date is not very clear). HdG 299. Bauch 270. X-ray reveals that the position of the head was originally higher, a change in an artist's conception which is generally supposed to express an original thought and not a copyist's correction. On the other hand, neither the structure of the surface-paint, nor the under-painting, is as powerful and decisive as that of Br. 377. The surface is composed of small particles of paint curling slightly at the edges, such as one observes on pictures which have been exposed to extraordinary heat—or on pictures of the 18th century. The latter possibility, in the present state of Rembrandt research, should not be excluded. *Page 295*

379. *A young girl*. Signed: Rembrandt f. 1651. HdG 504. Bauch 511. Bauch has not seen the picture at all, and I only once, many years ago, which makes a final judgement difficult. A copy is in the Wachtmeister collection; another was in the art-trade in Amsterdam in 1967. *Page 293*

380. *A woman in fanciful costume*. Bauch 510. Shown for the first time at the Rembrandt exhibition at Detroit, 1930 (no. 34). Companion portrait to Br. 256. Although neither Bauch nor I have seen the picture, I share Bauch's carefully expressed doubts about both the Sarasota and Cambridge pictures ("Unusual on account of the theatrical idea and composition"). *Page 296*

381. *An old woman in an armchair*. (Genuinely?) signed: Rembrandt f. 1654. HdG 506. Bauch

274. Companion portrait to Br. 270. Both pictures have been enlarged from 89×76 cm. Again, the man's portrait is of higher quality, which leaves some doubts about the authenticity of this one. *Page 297*

382. *Portrait of an old woman*. Faked signature: Rembrandt f. 1642. HdG 496. Bauch 271. Contrary to the notes in Bredius' first edition and to Bauch, the date must be read as 1642 and not 1652 (see also P. C. Grigaut in *Art Quarterly* 19, 1956, p. 440). The late date would indeed fit better with the type of the model—which is imitated here in a painting of a later century. *Page 298*

383. *An old woman in a hood*. (Genuinely?) signed: Rembrandt f. 1654. HdG 507. Bauch 275. Companion portrait to Br. 131. One of the finest of Rembrandt's studies of old women. *Page 298*

384. *Portrait of an old woman*. HdG 502. Bauch 276. Already, in 1818, it was stated that this picture was damaged. It has recently been relined, and carefully cleaned, but what remains of the original painting points to a 17th-century picture of the school of Rembrandt. *Page 299*

385. *An old woman reading*. Signed: Rembrandt f. 1655. HdG 315. Bauch 279. Praised by J. G. van Gelder (*Burlington Magazine* 92, 1950, p. 329) when exhibited in Edinburgh in 1950 (no. 29). *Page 302*

386. *A woman in fanciful costume*. Faked signature: Rembrandt f. 16(48)? HdG 325. The picture has been withdrawn from exhibition, as there is "considerable doubt as to the authenticity of the painting". Some parts of the picture, for instance the right hand of the girl, are in a very poor condition. Rosenberg (1964, p. 371): not by Rembrandt. Bauch (1966, p. 48): school picture in the manner of N. Maes, quoting W. Sumowski, who attributes the work to S. v. Hoogstraten. It certainly is a work of the school of Rembrandt, and not a fake of later date, which has also been suggested. Bauch's attribution is quite plausible. The date, 1648, may be about right. *Page 299*

387. *A young woman at her mirror*. Signed (indistinctly): Rembrandt f. 165(4). HdG 309. Bauch 272. W. Martin had suggested that the picture is a fragment (*Der Kunstwanderer* 3, 1921, p. 33), but G. Glück (1933, p. 301) rightly denies this, presuming that the picture is identical with no. 39 of Rembrandt's inventory of 1656: 'one courtesan doing her hair'. (See also Clark, 1966, p. 195). Strips have

been added to the top and bottom of the original panel. *Page 303*

388. *Portrait of an old woman.* Faked signature: Rembrandt f. 1655. HdG 510. Bauch 514. Companion portrait to Br. 280 and like that an imitation after Rembrandt. See notes to Br. 280. *Page 300*

389. *A young woman with a carnation.* Faked signature: Rembrandt f. 1656. HdG 854. Bauch 516. According to Bauch, a companion portrait to Br. 287; in fact, it was probably only enlarged later in order to match the other one. The strips added to the bottom and to the left are by another hand. The attribution to Rembrandt is not wholly convincing, but the appearance of uneven quality may be due to restorations. *Page 300*

390. *A young woman with a carnation.* (Faked?) signature: Rembrandt f. 1656 (not to be seen in ultra-violet light). HdG 878. Bauch 515. This portrait is especially praised by Clark (1966, p. 127). Its solid structure combined with a smooth surface, however, are more characteristic of the school of Rembrandt than of the master himself. It could be a work of Bol or Maes. A copy after the picture is in the Zorn Museum at Mora (Sweden). Under a portrait by Maes in the Museum at Worcester there is another, the head of which resembles Br. 390 (A. Burroughs, *Art criticism from a laboratory*, 1938, p. 103, repr. 25). Burroughs attributes this "first" portrait also to Maes. S. Slive kindly drew my attention to this fact. *Page 304*

391. *Catharina Hooghsaet.* Inscribed and signed: Catrina Hoog/Saet. out 50/Jaer. Rembrandt f. 1657. HdG 652. Bauch 519. Catharina Hooghsaet (1607-after 1657) and her husband Hendrick Jacobsz. Rooleeuw belonged to the Mennonites. It is possible that Rembrandt also painted the husband's portrait, which is lost (H. F. Wijnman, *Jaarboek Amstelodamum* 31, 1934, p. 81). *Page 305*

392. *Head of an old woman.* Faked signature: Rembrandt f. 1657. HdG 508. Bauch 273. The X-ray shows exactly the same, very rough handling as the surface paint; neither resembles the style of Rembrandt's authentic oil sketches. *Page 301*

393. *A young girl seated.* Signed: Rembrandt f. 1660. HdG 497. Bauch 525. Not seen by Bauch or me; judging from the photograph, the attribution to Rembrandt is not convincing. *Page 301*

394. *Margaretha de Geer, wife of Jacob Trip.* HdG 857. Bauch 523. Companion portrait to Br. 314. Margaretha de Geer (1583-1672) was a sister of the merchant Louis de Geer and had married Jacob Trip around 1600. She wears, as old people often do, a costume no longer in fashion, at the time when her portrait was painted, about 1660. There are pentimenti in the area of her hands which can be seen in the X-ray. *Pages 306 and 314*

395. *Margaretha de Geer.* Retouched signature: Rembrandt f. 1661. HdG 863. Bauch 524. The head is in excellent condition. There is a carefully executed portrait drawing in the Museum Boymans-van Beuningen, Rotterdam (Benesch 757), which almost certainly represents the same lady. For stylistic reasons the drawing must be dated around 1635/40. Did the woman's expression change so little in the more than twenty years that lie between the two portraits? As to the sitter, see Br. 394 and 314. *Page 307*

396. *Portrait of an old woman.* Signed: Rembrandt f. 1661. HdG 498. Bauch 526. Not seen by me. *Page 308*

397. *A nun* (a representation of the Virgin Mary?). Signed: Rembrandt f. 1661. HdG 189. Bauch 283. Bauch has observed that the rosary was added later. Originally Br. 397 may have been a representation of Mary (as is also supposed by Chr. Tümpel [1968, cat. no 23]) and could, therefore, have belonged to a not strictly limited series of Christ, apostles and saints. *Page 309*

398. *A woman with a lapdog.* HdG 852. Bauch 527. W. R. Valentiner supposed that this portrait was a companion to Br. 311 (*Rembrandt Paintings in America*, pl. 158), but neither the size nor the style of the pictures match at all well. *Page 310*

[399. *Portrait of a young woman.* Canvas, 68.5×59 cm. London, National Gallery. Falsely signed: Rembrandt f. 1666. HdG 855. Bauch, pp. VIII and 48. With good reason, attributed to W. Drost by MacLaren (1960, p. 108). Bauch blames the bad state of the picture for making any judgement impossible. With the compiler of the National Gallery Catalogue, I see only minor restorations in this school picture, which—like many Rembrandts, and many school pictures—reveals pentimenti. *Appendix*]

400. *A young woman.* (Hendrickje Stoffels?). HdG 503. Bauch 520, who identifies the sitter with Hendrickje Stoffels. It seems to be the same

model as in Br. 401. As to the dating, I prefer a rather late one, c. 1665 (as the catalogue of *The Age of Rembrandt*, San Francisco etc., 1966-7, no. 75), than Bauch's proposal, around 1659. *Page 311*

401. *A woman holding a carnation.* HdG 869. Bauch 529. Companion portrait to Br. 326. For the possible identification of the couple see Br. 326. To the left of the woman there was originally a child's head, which was painted out by the artist himself (Rosenberg, 1964, p. 348). Although the portrait has suffered from relining (especially in the area of the hands) it is still—like the companion—one of the most impressive of Rembrandt's unofficial late portraits. *Page 312*

402. *A woman holding an ostrich-feather fan.* Signed: Rembrandt f. 166. (the signature is difficult to read). HdG 880. Bauch 528. Companion portrait to Br. 327 and, contrary to most other cases, of higher quality than the male portrait. In excellent condition. *Page 313*

403. *Doctor Nicolaes Tulp demonstrating the anatomy of the arm.* Signed: Rembrant f: 1632. HdG 932. Bauch 530. Dr. Nicolaes Pietersz Tulp (1593-1674) was an important Amsterdam anatomist and was hailed by contemporaries as "the Amsterdam Vesalius". He had been a pupil of Dr. P. Paaw in Leyden, who in turn had been a pupil of the famous Vesalius and who had re-published his teacher's works in 1616. From 1628 to 1653 Tulp held the office of Praelector Anatomiae of the Amsterdam Guild of Surgeons. He was a City Counsellor, City Treasurer eight times, and on four occasions one of the burgomasters of Amsterdam. This great group-portrait was Rembrandt's first really important commission after he had settled in Amsterdam.

The recent careful cleaning has, to a certain degree, freed the picture from yellow varnish; it has also confirmed that the head and the left hand of Tulp, and the dark costumes on the left side, have been slightly damaged, though the areas of damage are not so widespread as older reports would like us to believe (A. B. de Vries in *150 jaar Kon. Kabinet van schilderijen*, 1967, p. 76). The background has become more translucent. The original (?) signature was revealed (see above). There may be some unreadable traces under this signature (see facsimile in Mauritshuis *Catalogue*, 1935, p. 277) but W. S. Heckscher's reading cannot be confirmed by the naked eye (*Rembrandt's Anatomy of Dr. Nicolaes Tulp*, 1958, p. 11). The paper which Hartman Hartmansz. holds in his hands was originally an anatomical drawing on which (later) the names of the guild mem-

bers (not one of them held a medical degree!) were written with numbers corresponding to those above their heads. Whether the figure to the left and the one whose head is uppermost at the back were added by a pupil (J. Backer?), as W. S. Heckscher supposed (see below), could not be proved by the cleaning. My own view is that the man on the extreme left could have been added as an afterthought (by Rembrandt? by Backer?).

After a long article by H. Schrade (*Das Werk des Künstlers* 1, 1939/40, p. 60), W. S. Heckscher's book—*Rembrandt's Anatomy of Dr. Nicolaes Tulp* (1958)—has stimulated fresh discussion about this picture. Heckscher, in fact, has written a splendid history of the Anatomy through the ages, and of anatomical theatres as a source of public entertainment; the Anatomy was a simultaneous demonstration of the doctor's magical power and scientific knowledge. Heckscher analyses the complete balance maintained in the painting between lifelike realism and the idealization of the models, individually and corporately (p. 65). The corpse is depicted realistically and the anatomical details of the hand are probably copied from a reproduction in an anatomical book. But Heckscher is not satisfied with tracing Rembrandt's sources, the older Anatomies that he must have known, pictures of entombments, martyrs, vivisections, etc.; the whole "history of anatomies must be seen in the light of man's attitude to death". According to this interpretation, the vital energies of the guild members triumph over the lifeless criminal, Tulp triumphs through science over the ignorance of sin (p. 120) and—if we are willing to follow Heckscher's view of the associative power of magic—over the superstitious undertones associated with the public anatomies (p. 115).

Critics of Heckscher, however, have rightly, I think, stated that Tulp's anatomy was not a public one—these always started with the abdominal cavity. Here Tulp compares his findings in a private anatomy with the anatomical book of Adriaen van der Spiegel (1627). The difficult dissection of arm and hand was performed by the anatomist himself (C. E. Kellet, *Burlington Magazine* 101, 1959, p. 150). J. R. Judson (*Art Bulletin* 42, 1960, p. 305) follows this interpretation and stresses the fact that the picture does not represent a real anatomy demonstration at night in the Amsterdam theatre, as Heckscher would make us believe: the use of light and imaginary architecture supports the view that Rembrandt did not paint an actual moment in 1632, but conceived a "highly imaginative and original commemoration". Therefore, Heckscher's interpretation—that we must "try to visualize

the presence of a large numerous audience in Rembrandt's painting" and that Tulp "clearly addresses himself to persons outside his inner circle" (p. 5) is a "misreading" of Rembrandt's composition and a misinterpretation of the inner logic of the group portrait structure. Rembrandt's Baroque art can easily deceive the modern critic: a strictly comparable misunderstanding has been demonstrated by H. van de Waal vis-à-vis the group portrait of the Syndics (see Br. 415). Notwithstanding all criticism (see also Rosenberg and Slive, 1966, p. 267), Heckscher's book represents a major attempt to unearth the different layers of meaning that a great work of art may contain. Among medical men, there is still disagreement as to whether the dissected left arm was painted from an actual limb or after a drawing in an anatomy book (G. Wolf-Heidegger and A. M. Cetto, *Die anatomische Sektion* in *Bildlicher Darstellung*, 1967, p. 308, no. 257; A. Querido, *Oud Holland* 82, 1967, p. 128). *Pages 317 & 318*

405. *Portrait of a fashionably-dressed couple.* Signed (signature somewhat redrawn): Rembrandt f. 1633. HdG 930. Bauch 531. Although painted only one year later than *The Anatomy Lesson*, this double portrait is less expressively designed. The design and the execution are reminiscent of Thomas de Keyser. The face of the man is modelled in a richer colour scheme than the somewhat flat one of his wife. Most of the early Amsterdam companion portraits show this same characteristic differentiation. *Page 319*

406. *Jan Pellicorne, with his son Caspar.* Signed: Rembran . . ft (there may be traces of a date under the signature). HdG 666. Bauch 533. Companion portrait to Br. 407. The identity of the sitters probably goes back to a family tradition, which cannot be checked; the sitters were not yet identified at the J. van de Poll Sale, November 14th, 1842, nor at the King William II of Holland Sale, August 12th, 1850 (lots 84 and 85). The marriage of the Amsterdam merchant Jan Pellicorne (born 1567) with Susanna van Collen took place on June 11th, 1626. The daughter was born in 1627, the son was baptized on June 11th, 1628. Contrary to what was said in the first Bredius edition (and not wholly in accordance with the apparent age of the children), I would date the pictures in the early 1630s. These large paintings are covered with a heavy varnish and protected by glass, a combination which makes it difficult to appreciate their real character. *Page 320*

407. *Susanna van Collen, wife of Jan Pellicorne, with*

her daughter Eva Susanna. Signed: Rembrant ft 16. . HdG 667. Bauch 534. Companion portrait to the number above. See notes there. *Page 321*

408. *"The shipbuilder and his wife".* Signed: Rembrandt f. 1633 (on the paper in the woman's hand). HdG 933. Bauch 532. The picture, which has been cleaned, is in excellent condition. L. Münz (*Burlington Magazine* 89, 1948, p. 253) has shown that it has been cut down somewhat, especially at the top; in 1800 it was engraved by J. de Frey, who reproduced the picture in a format different from its present shape. *Page 322*

409. *The Mennonite minister Cornelis Claesz. Anslo in conversation with a woman.* Signed: Rembrandt f. 1641. HdG 620. Bauch 536. Cornelis Claesz. Anslo lived from 1592 to 1646. There is an etched portrait of the preacher also dated 1641, and drawings exist for both etching and picture in London and Paris (Benesch 758 and 759), both dated 1640. The poet Joost van den Vondel wrote a poem on Rembrandt's portrait, which runs as follows: "On Kornelis Anslo. Rembrandt should paint the voice of Kornelis, his outward appearance is the least of him; the invisible can only be known through the ears. He who wants to see Anslo must hear him." J. A. Emmens (*Nederlands Kunsthistorish Jaarboek* 7, 1956, p. 133) went carefully into the literary tradition of the epigram covering the contrasts between body and spirit, picture and word, sight and hearing. The remark that the voice ought to be depicted is a commonplace already known in antiquity and used in European literature from Petrarch onwards. In our case, however, the poem had a special bearing on Rembrandt's art, if we accept the assumption that the etching was done first and that Vondel's poem praised (or criticized) the etched portrait afterwards. Rembrandt answered the challenge by really painting a minister's portrait, with the minister seemingly in mid conversation—open mouthed and gesticulating—with a woman who listens attentively to him. The picture was perhaps intended to hang in the "Anslohofje", a home for elderly servants. R. Hamann (*Rembrandt*, 1948, p. 167) thought that the figure of the servant was added by a pupil. As a matter of fact, the female head is painted rather thinly (see reproduction in: A. Burroughs, *Burlington Magazine* 59, 1931, p. 9). But its construction is well differentiated and the underpainting is in accordance with the underlying structure of Anslo's head, which is also less vigorous in handling than is the case with smaller works of this period. Hamann's observation, therefore, should only

be accepted in part: the listening woman may well have been added as an afterthought, but by Rembrandt himself, in order to emphasize, more strikingly, the impact of a man talking. The woman's position in the picture is rather awkward. W. Sumowski (1957/8, p. 236) also stresses the similarity of the X-rays of both heads. *Page 323*

410. *The Militia Company of Captain Frans Banning Cocq ('The Night Watch').* Signed: Rembrandt f. 1642. HdG 926. Bauch 537. Since the cleaning and relining, undertaken after the Second World War, many new studies have been published about Rembrandt's largest surviving picture. A history of the painting, with accounts of its many restorations, has been published by A. van Schendel and H. H. Mertens (*Oud Holland* 62, 1947, p. 1; see also A. van Schendel in *Museum* 3, 1950, p. 220; T. Koot, *Rembrandt's Nachtwacht in nieuwe luister*, 1947; W. Martin, *Van Nachtwacht tot Feeststoet*, 1947; D. Wijnbeek, *De Nachtwacht*, 1944).
The picture has been cut on the left and at the bottom, probably after it was transported from the Civic Guard Building to the small war council room in the Town Hall, where it had to fit into a smaller space. Fifty years ago, there was much discussion about whether "*The Night Watch*" had been cut down or not. It was generally agreed that it had been mutilated; quite recently, however, Mrs. A. J. Moes-Veth (*Oud Holland* 75, 1960, p. 143) has tried to demonstrate (unconvincingly, in my view) that the painting is intact. The original state of "*The Night Watch*" has been preserved in the old copy (by G. Lundens?) in the National Gallery, London (reproduced on page 325). The shield on the wall was painted in later; it contains the names of the eighteen foremost people portrayed. Many of them can be identified. The chief figure is the Captain, Frans Banning Cocq; on his left, in yellow, the Lieutenant, Willem van Ruytenburgh; in the background the cornet Jan Cornelisz. Visscher with the Amsterdam colours, two sergeants to the left and right (Reinier Engelen and Rombout Kemp) (J. G. van Dillen, *Jaarboek Amstelodamum* 31, 1934, p. 97), and three musketeers in red, who demonstrate three phases of an exercise in firing the musket (W. Martin, *Miscellanea L. van Puyvelde*, 1949, p. 225; *Oud Holland* 66, 1951, p. 1).
The commission for the painting probably came from the Captain himself. The "family album" of Banning Cocq (now exhibited with '*The Night Watch*' in the Rijksmuseum) contains a coloured drawing after the picture, with the following text on the opposite page:

"sketch (sic!) of the picture in the Great room of the Civic Guard House, wherein the young Seigneur of Purmerlandt [Banning Cocq's title] as captain gives orders to the Lieutenant, the Seigneur of Vlaerdingen [Willem van Ruytenburgh's title] to have his company march out." From other documents, however, we know that sixteen of the Civic Guard Officers and other rank each had to pay about 100 Guilders "the one more, the other less, according to their placing in the picture". The concept of "marching out" makes Rembrandt's composition something of a novelty; traditionally, group portraits of the militia had shown the members either around a table or standing, full length, before or in their meeting place. The name "nightpatrol" or "nightwatch" has only been in use since the early 19th century, by which time the picture had darkened considerably. All the old documents speak plainly of Banning Cocq's company. Other group portraits of the Civic Guard were painted between 1638 and 1645 to decorate the new room of the "Kloeveniersdoelen" (by G. Flinck, J. Backer, N. Elias, J. v. Sandrart and B. v. d. Helst). That Rembrandt's was made to commemorate the entry of Marie de' Medici into Amsterdam in 1638 is probably incorrect (M. Kok, *Bulletin van het Rijksmuseum* 15, 1967, p. 116).
The originality of Rembrandt's interpretation of a portrait group marching has always stimulated critics' curiosity. After F. Schmidt-Degener's careful investigations (*Onze Kunst* 21, 1912, I, p. 1; 26, 1914, II, pp. 1 and 37; 29, 1916, I, p. 61; 30, 1916, II, p. 29; 31, 1917, I, pp. 1 and 27; 33, 1918, p. 91; and *Verzamelde Studiën en Essays van Dr. F. Schmidt-Degener* II, 1950, p. 135), J.Q. van Regteren Altena put forward the theory that Rembrandt's first idea for this picture must have been a pageant of Civic Guards on horseback (*Actes du 17ième congrès international de l'histoire de l'art*, 1952, The Hague, 1955, p. 405). H. van de Waal (see below) stresses the contrast between movement in the foreground and repose in the background as a basic compositional devise of Rembrandt's art. The importance of the architectural motif, the arched portico, its place in the design and links with the Renaissance tradition, has been made clear by K. Clark (1966, p. 85).
The most controversial new thesis was put forward by W. Gs. Hellinga (*Rembrandt fecit 1642*, 1956). He takes the view that much of the meaning in the 17th-century literature and art, which at that time was commonplace knowledge, has become unintelligible to us, especially the symbolic significance of colours. For him all the colours, as well as the genre-like figures of the two girls, have an important

meaning; seen and combined together, they give the picture a deeper meaning, a second "layer of thought". The picture does not just represent an actual marching out; Banning Cocq assumes here the role of a second Gysbrecht van Amstel, personifying Amsterdam's triumph over its adversaries. Rembrandt's fantasy was inspired by Vondel's play "Gysbrecht van Amstel".

M. Imdahl has, in a more general way, elaborated the "moral content" of the picture (*Festschrift Werner Hager*, 1966, p. 103), although others have refused to accept Hellinga's interpretation, with its literary emphasis. There is, to begin with, no basis for this interpretation in the 17th-century sources, and it is certainly not in keeping with Rembrandt's cast of mind (Rosenberg and Slive, 1966, p. 208). There is an unscientific compilation of iconographic details, each one of which is ambiguous (H. van de Waal, *Museum* 61, 1956, p. 203). I share these reservations, and share too van de Waal's belief that Rembrandt's fantasy and the compositional scheme in this picture were partially inspired by a study of contemporary theatrical performances, of the design, technique and the movement of the stage. Moreover, van de Waal has pointed to direct copies after actors in Vondel's play (see Benesch 122-3, 178, 312, 316-22, 354). See also : *Kunstchronik* 10, 1957, p. 135. V. Volskaja, *Iskusstwo* 4, 1961, p. 54 (in Russian) and lecture by H. van de Waal, at the Maatschappij voor Letterkunde, Leyden, November 17th, 1967. For a general discussion of 'The Nighwatch', see also: Bauch, *Die Nachwache* (Reclam) 2nd ed. 1963; Gerson, *Openbaar Kunstbezit* 10, 1966, no. 1. *Page 324 & 326*

414. *The anatomy lesson of Doctor Joan Deyman.* Signed: Rembrandt f. 1656. HdG 927. Bauch 538. Dr. Joan Deyman (1620-1666) was the successor to Nicolaes Tulp as Praelector Anatomiae, from 1653. To his left the college master Gysbrecht Matthijsz. Calcoen, with the scalp in his hand. Representations of dissections of the brain are very rare in Dutch art (A. M. Cetto, *Ciba Symposium* 6, no. 3, 1958, p. 122). The records of the Anatomy Theatre book say that "on January 28th, 1656, there was punished with the rope Joris Fonteijn of Diest, who by the worshipful lords of the lawcourt was granted to us as an anatomical speciman. On the 29th Dr. Joan Deyman made his first demonstration on him in the Anatomy Theatre, three lessons altogether" (I. H. van Eeghen, *Maandblad Amstelodamum* 35, 1948, p. 34; C. White, *Rembrandt*, 1964, p. 105). The picture, which—like Br. 403—hung originally in the Anatomy Theatre ("Snijcamer") of Amsterdam, was partially destroyed by

fire; the remaining parts, now restored, have also suffered heavily. The drawing in the Rijksmuseum is not a preparatory study, but was made after the picture was finished to show how it should be framed and how it was to hang in the narrow confines of the "Snijcamer" (J. Q. van Regteren Altena, *Oud Holland* 65, 1950, p. 171). Benesch (*Rembrandt Drawings*, no. 1175) rejects this thesis, which was already voiced by J. Held (*Art Bulletin* 26, 1944, p. 262). It is generally believed that the eloquent foreshortening of the corpse stems from Italy, especially from Mantegna's composition of the dead Christ (Clark, 1966, p. 93), but E. Haverkamp-Begemann (*The Yale Review* 56, 1966/7, p. 306) and others have indicated Orazio Borghianni (painting in Rome, Galeria Spada) as the more probable source, and other works of art and anatomical illustrations as possible intermediate visual stimulae (see G. Wolf-Heidegger and A. M Cetto, *Die anatomische Sektion*, 1967, p. 313, no. 261). *Page 328*

415. *The Board of the cloth-maker's guild at Amsterdam* (*De Staalmeesters*). Signed, on the table-cloth: Rembrandt f. 1662. HdG 928. Bauch 540. The signature on top of the panelling to the right (Rembrandt f. 1661) is apocryphal and probably copied from an etching (A. van Schendel, *Kunsthistorisk Tidskrift* 25, 1956, p. 39). The picture was formerly in the "Staalhof" (cloth-maker's office) where four different groups or "committees", were accustomed to meet. The people represented here were probably the "Waerdijns van de Laekenen" (controllers of the cloth samples), annually chosen on Good Friday. If the people painted here are those of the session 1661-1662, their names and denominations are known (I. H. van Eeghen, *Jaarboek Amstelodamum* 49, 1957, p. 65; *Oud Holland* 73, 1958, p. 80). "Five staalmeesters, of four different religious beliefs, in brotherly unity around a table, are a typical symbol of the power of commerce and the tolerance of Amsterdam during the age of prosperity of the Dutch republic" (J. G. van Gelder, *Openbaar Kunstbezit* 8, 1964, no. 11). The X-ray examination, conducted by the Rijksmuseum after the war, revealed many important changes made during execution. The position of the servant was tried out in different places (A. van Schendel, *Oud Holland* 71, 1956, p. 1); there are three carefully-executed drawings, studies for the two men to the left and for the group in the centre (Benesch 1178-1180).

H. van de Waal (*Oud Holland* 71, 1956, p. 61) has, in a magisterial study, analysed the history of the interpretations of this picture and stresses the picture's character as a group

[425. *A scholar writing.* Copper, 14×14 cm. Milwaukee, Dr. A Bader. HdG 240. Bauch 118. The monogram of G. Dou vanished during a restoration in 1951. Bredius and J. G. van Gelder (*Burlington Magazine* 95, 1953, p. 37) ascribe the picture to G. Dou. Bauch (who has not seen the picture) calls it the best of several versions (see also Bauch, 1960, p. 283, note 98). I am only acquainted with this version, the execution of which seems to be too weak for Rembrandt. *Appendix*]

426. *A scholar writing.* Bredius considered this version—formerly in the C. Fairfax Murray sale, Paris, June 15th, 1914, lot 24 and anon. sale, Amsterdam, October 27th, 1927 lot XLVIII—to be the original. Not known to either Bauch or me. See also Br. 425. Bauch considers the version which was engraved in the Le Brun catalogue of 1790 to be a third copy, different from Br. 425 and 426. *Page 340*

427. *A scholar in a lofty room.* Signed: Rem.randt. Published by C. J. Holmes in the *Burlington Magazine* 31, 1917, p. 171. Bauch 119. An oil sketch in greyish colours of excellent quality, painted around 1628. *Page 341*

428. *An old man asleep at the hearth.* Said to be signed and dated 1629. HdG 293. Bauch 121, as "The old Tobias (?) alseep". J. G. van Gelder (*Mededelingen der Kon. Nederl. Akademie voor wetenschappen, afd. letterkunde,* N.R. 16/5, 1953, p. 293, note 54 and *Burlington Magazine* 95, 1935, p. 37) attributes the picture to Dou, stating that Rembrandt's signature had vanished and that Dou's had appeared. I was unable to see any signature, but I share the doubts about the attribution to Rembrandt, even though the picture may be identical with the "Rembrandt" described in Jacob de Gheyn's inventory of 1641: "an old sleeping man, sitting near a fire, having his hand in his bosom" (*Oud Holland* 33, 1915, p. 127). *Page 341*

[429. *A scholar reading at a table.* Panel, 51×44 cm. Brunswick, Herzog Anton Ulrich Museum. HdG 228. Rightly rejected by most Rembrandt experts: Bauch, 1966, p. 48; J. G. van Gelder (*Mededelingen der Kon. Nederl. Akademie voor wetenschappen, afd. letterkunde,* N.R. 16/5, 1953, p. 293); Rosenberg (1964, p. 371 and *Kunstchronik* 9, 1956, p. 354); W. R Valentiner (*Art Quarterly* 19, 1956, p. 404). The picture has recently been cleaned; it could be an early work by G. Dou. *Appendix*]

430. *A scholar in a lofty room* ("*St. Anastasius*"). Signed on a paper on the wall : Rembrant f. 1631. HdG 186. Bauch 135. This type of

signature is unusual for the period around 1631 and I suspect that the real one can still be detected under it. The picture itself is of excellent quality. *Page 342*

431. *A scholar in a room with a winding stair.* Signed: RHL van Rijn 163. HdG 233. Bauch 156. The date has always been recorded as 1633, but after a careful examination I can decipher the last digit only as a one or two, which would be quite in accordance with the style of the picture, which has all the tenderness of the late Leyden-early Amsterdam period (compare Br. 430 and 543). The early drawing at Copenhagen (Benesch 392) is related in style and composition. Slive (*Allen Memorial Art Museum Bulletin* 20, 1963, p. 125) refers to this connection and also to an engraved study in perspective by Jan Vredeman de Vries. This painting has a "companion picture" (also in the Louvre) which was formerly attributed to Rembrandt (HdG 234; W. R. Valentiner, *Rembrandt, Klassiker der Kunst*, 1909, p. 111 top). It can without doubt be given to Salomon Koninck, however, and is a useful example of the situation in which school pictures have been made to match an original Rembrandt, or have been misused for this purpose by later collectors. This picture is now catalogued in the Louvre (inv. 1741) as "école de Rembrandt". Mme. Hours (*Bulletin du laboratoire du Louvre,* 1961, no. 6) points to the "notable differences" in the X-ray photographs of these two works. Curiously enough, Rosenberg (1964, p. 371) upholds the attribution of this "companion picture" to Rembrandt. *Page 343*

432. *A scholar in his study.* Signed: Rembrandt f. 1634. HdG 236. Bauch (162), very rightly suggests that Rembrandt is depicting here a character from the Old Testament. *Page 344*

433. *The standard-bearer.* Signed: Rembrandt f. 1636. HdG 270. Bauch 171. Since the recent cleaning, the date has been read as 1636. W. R. Valentiner (*Rembrandt,* 1909, p. 147), W. Pinder (*Rembrandts Selbstbildnisse,* 1943, p. 61) and C. Müller Hofstede (*Pantheon* 21, 1963, p. 89)—some of them with certain reservations—consider this to be a self-portrait, a suggestion that seems to me (and others) most unlikely. *Page 345*

[434. *Young warrior buckling a cuirass.* Canvas, 100×82.5 cm. Formerly, Washington, Lamont Belin. HdG 272. Bredius was not quite convinced of the attribution, and Bauch (1966, p. 48) has called it a school picture of the late 1640s, which is certainly what it is (although I have not seen the orignal). *Appendix*]

435. *An old man at his study table.* Signed: Rembrandt f. 1643. HdG 230. Bauch (177), records the date as 1642. *Page 346*

[436. *Rembrandt painting Hendrickje Stoffels.* Panel, 51×61 cm. Glasgow, Art Gallery and Museum. HdG 335. H. Miles, in the Glasgow catalogue of 1961, rightly concludes that the authenticity of this picture can no longer be considered seriously. Some scholars still believe it to be a work by Rembrandt, others consider it an imitation (see Glasgow catalogue). Bauch (1966, p. 49): perhaps S. van Hoogstraten. G. Knuttel (*Actes du XVIIIième congrès international d'histoire de l'art*, 1952, The Hague, 1955, p. 421) supposes the picture to be a "study" for Br. 513. *Appendix*]

437. *A woman bathing* (Hendrickje Stoffels?). Signed: Rembrandt f. 1654 (1655). HdG 306. Bauch 278. The National Gallery catalogue (1962) reads the date as 1655, but the last digit may well be a 4. The picture was cleaned in 1946. The cleaning started a long controversy between those who favoured radical cleaning and those who preferred a more cautious treatment. See also: *Catalogue of the National Gallery Exhibition of Cleaned Pictures*, 1947, no. 68. I think that the cleaning was well done, and that the ground shining through some thinly painted parts is an important element in the artistic expression. The condition is good except for a vertical crack. The underpainting, too, is powerful. One X-ray photo is reproduced by A. Burroughs in *Burlington Magazine* 59, 1931, p. 9. *Page 347*

[438. *A Sibyl.* Canvas, 96×76 cm. New York, Metropolitan Museum of Art. HdG 214. In the first edition, Bredius had already noted that the picture was given to Drost, an attribution first suggested by G. Falck and later taken up by W. R. Valentiner (*Art Quarterly* 2, 1939, p. 308), with a question mark by Rosenberg (1964, p. 326) and without reservation by Bauch (1966, p. 49). The Metropolitan Catalogue of 1954 lists the *Sibyl* as "Rembrandt?" I am not so sure about the attribution to Drost, but I cannot see any trace of Rembrandt's own brushwork in the picture, contrary to the observations made by J. Q. van Regteren Altena (*Oud Holland* 82, 1967, p. 70). *Appendix*]

439. *Landscape with the baptism of the Eunuch.* (Genuinely?) signed: Rembrandt ft. 1636. Bauch 542. The picture came to light at the Ravensworth Castle sale, London, Christie's, June 15th, 1920, lot 13, and was published for the first time by W. R. Valentiner (1921, p.

379). It has suffered somewhat from relining and pressing; there are many restorations in the sky. *Page 351*

440. *Landscape with a stone bridge.* HdG 939. Bauch 543. Cleaning would probably result in stronger, 'Baroque' contrasts between the light and dark areas. A sensitive appreciation has been written by H. van de Waal (*Openbaar Kunstbezit* 2, 1958, no. 26). *Page 352*

441. *Stormy landscape.* Signed: Rembrandt f. HdG 942. Bauch 547. A beautiful landscape study from the same period as the picture in Cracow (Br. 442). The brushwork in the group of trees is reminiscent of parts of the landscape by Hercules Seghers (in the Uffizi) which are supposed to have been added by Rembrandt (see: E. Haverkamp Begemann, *Catalogue of the Hercules Seghers Exhibition*, Rotterdam, 1954, no. 4). *Page 352*

442. *Stormy landscape with the Good Samaritan.* Signed: Rembrandt f. 1638. HdG 109. Bauch 545. "The best work by Rembrandt in Poland" (J. Białostocki and M. Walicki, *Europäische Malerei in polnischen Sammlungen* 1957, no. 236) was acquired at the beginning of the 19th century by the Czartoryskis (A. Zatuski, *Biuletyn Historii Sztuki kultury* 18, 1956, p. 370); also rightly praised by Benesch (*Kunstchronik* 9, 1956, p. 190). The sketch, moreover, is in excellent condition, except for some repainting in the left part of the sky. *Page 353*

443. *Landscape with an obelisk.* There are remains of a signature (?), which is no longer legible. In older publications the date was given as 1638. Hofstede de Groot already had doubts about the signature. HdG 941. Bauch 546. Stylistically, and in quality, close to Br. 442, and also in good condition, except for the fact that the bluish-green colour has altered somewhat. *Page 353*

444. *Woody landscape with ruins.* Remains of a signature. HdG 946. Bauch 548. *Page 354*

445. *Stormy landscape with an arched bridge.* HdG 951. Bauch 544. The underpainting revealed by the X-ray is as beautiful and differentiated as the surface handling. Stylistically, the picture is nearest to Br. 440, and therefore probably earlier than the group of 1638. *Page 354*

446. *Landscape with a church.* HdG 949. Bauch 549. I share the view that the picture is nearer to Seghers than to Rembrandt. See the reports of a discussion in *Kunstchronik* 10, 1957, pp. 142 and 145. *Page 355*

447. *Landscape with a distant town.* HdG 947. Attributed by me to Philips Koninck, as an early work (*Burlington Magazine* 95, 1953, p. 48 and *Festschrift Dr. h.c. Eduard Traurtscholdt*, 1965, p. 109). Bauch (1966, p. 49) accepts the attribution. *Page 355*

448. *Evening landscape with a horseman.* (Genuinely?) signed: Rembrandt f. 1639. HdG 945. Bauch 556. The picture is in such a poor state that no attribution can be put forward with any real confidence. See also: C. Müller Hofstede in *Kunstchronik* 9, 1956, p. 92. Bauch, who has not seen the picture, believes that it must have been painted in the 1650s. *Page 356*

449. *Landscape with two bridges.* Published by H. Schneider in *Kunstchronik* N.F. 31, 1919, p. 191. Bauch 551 (not seen by him). The picture has not been on view at any exhibition for a long time. In my opinion, it is so insecurely and superficially painted, without any inner structure, that it can only be an imitation after Rembrandt. This observation is contrary to the view of J. Q. van Regteren Altena, who concludes that the landscape is basically by H. Seghers, but overpainted by Rembrandt (*Oud Holland* 82, 1967, p. 71). *Page 357*

450. *Landscape with a castle.* Bauch 553. This important addition to the corpus of Rembrandt landscapes was first published by M. Conway (*Burlington Magazine* 46, 1925, pp. 241 and 322). It was formerly in the Stroganoff collection in Leningrad. I would date the picture in the very early part of the 1640s. *Page 358*

451. *Landscape with a coach.* HdG 948. Bauch 550. The picture must have been painted around 1640/1, and should be compared with the landscape details in Br. 476. *Page 359*

452. *Winter landscape.* Signed: Rembrandt f. 1646. HdG 943. Bauch 552. Painted fluently and quickly, as a sketch; the signature is so pressed into the wet paint that it can even be read in the X-rays—a very rare instance! *Page 360*

453. *Evening landscape with cottages.* Signed: Rembrandt f. 1654. HdG 950. Bauch 555. The same spot appears repeatedly in drawings and etchings both by Rembrandt and by his pupils. See: F. Lugt (*Mit Rembrandt in Amsterdam*, 1920, p. 120 and *Jahrbuch der Preussischen Kunstsammlungen* 52, 1931, p. 60). Bredius wrote (in a MS note to the compiler of the first edition of this book): "probably right, but it has something which alarms me"; I have the same feeling of uneasiness about the attribution. *Page 361*

454. *River landscape with ruins.* Signed: Rembrandt f. HdG 944. Bauch 554. There are many pentimenti, which show either that Rembrandt changed the composition while working on it, or that he remodelled a somewhat older project, which was probably more sketch-like. The powerful picture that we see today must date from the early 1650s. This dating is in accordance with the opinions of Bauch and A. B. de Vries (1956, p. 62) but Benesch (*Rembrandt*, 1957) dates it about 1642/3. There is some damage in the foreground and in the sky; the barge and the mill are the best preserved parts, an observation which is supported by the X-ray. *Pages 362 & 363*

455. *Still-life with a dead bittern.* (Genuinely?) signed: Rembrandt f. 163(7). Bauch 559. Published for the first time by C. Hofstede de Groot (*Die holländische Kritik der jetzigen Rembrandtforschung*, 1922, p. 35). The painting is less powerful than Br. 456; the design of the bird and the modelling of the pan are uncertain. I suspect that it is a picture of the Rembrandt school. *Page 364*

456. *Child with dead peacocks.* (Genuinely?) signed: Rembrandt. HdG 968. Bauch 558. In accordance with Benesch, Bauch and Rosenberg (1964, p. 204), I date the picture in the second part of the 1630s. A drawing for the bird is in Berlin (Benesch 353). *Page 365*

457. *The slaughtered ox.* Signed: Rembrandt f. 1655. HdG 972. Bauch 562. The picture has enjoyed a rather special reputation ever since it was acquired by the Louvre in 1857. Copies have been made by Delacroix, Bonvin and Soutine; and the motif was used by Daumier (B. Lemann, *Bulletin of the Fogg Art Museum* 6, 1936, p. 13). *Page 367*

458. *The slaughtered ox.* Signed: Rembrandt f. 16.. (scratched into a band of dark paint [added?] along the bottom of the picture). HdG 971. Bauch 561. I share the opinion of the cataloguer of the Glasgow collection (H. Miles): acceptable as an autograph work, despite some evident weaknesses of execution. And if Rembrandt, painted in the late 1630s; it was formerly dated around 1650. Bredius, in a MS note, expressed doubts too, which were shared by H. Schneider. *Page 366*

[459. *An ox standing.* Panel, 48×69.5 cm. Copenhagen, Statens Museum. HdG 970. Published for the first time by K. Madsen (*Kunstmuseets Aarsskrift* 1, 1914, p. 128) who praised the picture's good state of preservation. Hofstede de Groot already had doubts and

noticed some overpainting in the background. W. R. Valentiner (1921, p. 46) accepted, and G. Falck (*Kunstbladet* 2, 1923/4, p. 102) denied the attribution to Rembrandt. So does Bauch (1966, p. 49), quoting Rosenberg as having expressed the opinion that the picture deviates from Rembrandt's style. It is a coarsely-painted work of the Rembrandt school (L. Doomer?), and actually in a rather bad state. The Copenhagen catalogue of 1951 puts a question mark with the attribution. J. Q. van Regteren Altena (*Oud Holland* 82, 1967, p. 71), however, takes up the attribution to Rembrandt, calls it a genuine sketch, identical with the picture in Rembrandt's inventory of 1656: "108. One small picture of an ox, painted from life, by Rembrandt". As to the latter, Bauch had already remarked that the inventory reference could also refer to a *dead* ox (like Br. 457 or 458). *Appendix*]

460. *The Justice of Brutus* (?). Signed: R f 16(2)6. Bauch 96. First published by C. Hofstede de Groot (*Burlington Magazine* 50, 1924, p. 126). The identification of the subject is still a problem. To the former interpretations— 'Justice of the Consul L. Junius Brutus' (W. C. Schuylenburg; W. Stechow, *Oud Holland* 46, 1929, p. 134 ; C. Müller, *Jahrbuch der Preussischen Kunstsammlungen* 50, 1929, p. 77; O. Benesch, *Art Quarterly* 22, 1959, p. 310); 'Judgment on the son of Manlius Torquatus' (W. R. Valentiner, *Rembrandt Handzeichnungen* 2, [1934], p. 401, no. 577 and *Art Quarterly* 19, 1956, p. 404); 'Clemency of the Emperor Titus' (F. Schmidt-Degener, *Oud Holland* 58, 1941, p. 106; G. Knuttel, *Burlington Magazine* 97, 1955, p. 46; J. Rosenberg, 1964, p. 13, fig. 9)—a new one has been added by Bauch (1960, p. 99): 'Consul Cerealis pardons the legions which have taken sides with the rebels.' This scene was also illustrated by Otto van Veen (engraved by Antonio Tempesta); the story is told by Tacitus (*Historiae* IV, 72). W. Sumowski (1957/8, p. 23) interprets it as an Old Testament subject: 'Saul sentencing Jonathan' (1 Samuel 14:41). The newly found picture in Lyons (Br. 531A) —which is exactly the same size—could, thematically, be a companion picture to this one; the relationship should help to identify the subject of Br. 460. So far, however, I have not been able to do so. Compared with the "bravura" design and powerful brushwork of Br. 531A, Br. 460 seems to lack overall unity; and even after the recent cleaning, the execution seems somehow tame. Collaboration with Lievens has been suggested; also repeated reworking by Rembrandt himself. G. Knuttel (*loc. cit.*) elaborates on the latter point unconvincingly. As the background, especially

to the right, is in the fluent manner of Lastman, I wonder whether Rembrandt has in fact reworked an (unfinished?) history painting by Lastman. Rembrandt's self-portrait is to the right of the main figure. *Page 371*

461. *Diana bathing*. HdG 199. In accordance with the opinion of Bauch (p. 49) and W. Sumowski (1957/8, p. 229), I think the picture is only a copy after the etching Münz 134. *Page 372*

462. *Andromeda chained to the rock*. HdG 195. Bauch 254. I would date the study rather early, about 1627/8. W. Sumowski (*Oud Holland* 71, 1956, p. 111) refers to a drawing by A. Bloklandt as one source for the composition. A representation of Andromeda without the monster is iconographically rare. *Page 373*

463. *The abduction of Proserpine*. HdG 213. Bauch 99. Iconographically, there is certainly a connection with the antique, directly or indirectly through the Soutman print after Rubens. Kenneth Clark (1966, p. 8) has wittily analysed the different attitudes to the antique shown by Rembrandt and Rubens. The relation to a composition by L. Sustris, which P. Frankl pointed out (*Oud Holland* 55, 1938, p. 156) is less obvious. The picture was described in the 1632 inventory of the Stadholder's collection as "a great piece, where Pluto rapes Proserpine, done by Jan Lievensz of Leyden" (*Oud Holland* 47, 1930, p. 203), but there can be no doubt that it is a picture by Rembrandt (and not a big one). See also Br. 466. There is, however, some disagreement about its dating: J. Q. van Regteren Altena (*Kunstchronik* 10, 1957, p. 135) puts it as late as 1634, but—with Winkler (*Kunstchronik* 10, 1957, p. 137)—I think it belongs to Rembrandt's Leyden period, perhaps as early as 1628/9. *Page 374*

464. *The abduction of Europa*. Signed : RHL van Rijn 1632. HdG 201. Bauch 100. The subject is taken from Ovid (*Metamorphoses* II, 870); the composition is derived from Elsheimer rather than from Lastman (Rosenberg, 1964, p. 15, fig. 12). Neither Bauch nor I have seen the original; but even on the evidence of photographs, clearly an early painting by Rembrandt. *Page 375*

465. *Minerva*. HdG 211. Not seen by either Bauch (1966, p. 49) or me, but to judge from the photograph, I share Bauch's doubts: he attributes the picture to a Leyden pupil (W. de Poorter?). *Page 376*

466. *Minerva*. Said to be monogrammed, but I have been unable to see the remains of it. HdG 209.

Bauch 253. Probably identical with the "Melancholy, being a woman sitting on a chair near a table whereupon books, a lute, and other instruments, by Jan Lievens", described in the 1632 inventory of the Stadholder's collection (*Oud Holland* 47, 1930, p. 204). See J. G. van Gelder in *Mededelingen der Kon. Ned. Academie van Wetenschappen, afd. letterkunde*, N.R. 16, 1953, p. 295 about the iconography of this subject. See also Br. 463. *Page 376*

467. *Bellona*. (Genuinely?) signed: Rembrandt f. 1633. HdG 196. Bauch 257. The cleaning is discussed in the *Bulletin of the Metropolitan Museum* 6, 1947, p. 49. Although accepted as far as I can see by all Rembrandt scholars, the picture seems to me too dull in expression and design and too awkwardly composed to be by Rembrandt himself. *Page 378*

468. *Sophonisba receiving the poisoned cup* (?). Signed: Rembrant f. 1634. HdG 223. Bauch 101. The story of Sophoni(s)ba is told by Livy (XXX, 12 and 15). She was the wife of Syphax and later of Massinissa, who sent her a cup of poison when Scipio—whose prisoner she was—made his dishonourable intentions clear. The subject could as well be the story of Artemisia, who added to her cup of wine the ashes of her dead husband, King Mausolos (Aulus Gellius, *Noctes Atticae* X, 18, 3). Purely in terms of iconographic tradition, it is difficult to judge which story fits the composition better. The Madrid catalogue (1963, no. 2132) adheres to the latter identification; so does J. I. Kusnetzow (*Works of the State Hermitage, West European Art*, 3 1964, p. 197—in Russian) arguing that Rembrandt may have been inspired by the Sophonisba painting of Rubens, which in 1632 was in possession of Amalia van Solms as "de historij van Artemise" (*Oud Holland* 47, 1930, p. 227). J. G. van Gelder (*Nederlands Kunsthistorisch Jaarboek* 3, 1950/1, p. 113) had already pointed to the identity of the Artemisia of the inventory with the subject of Artemisia or Sophonisba. The Rubens painting is now in Potsdam, Sanssouci Gallery (Cat. 1930, no. 94). Chr. Tümpel (1968, p. 94) is in favour of the Sophonisba interpretation. I have not seen Br. 468 for a long time; its authenticity has been much questioned (E. Kieser, *Zeitschrift für Kunstgeschichte* 10, 1941/2, p. 157). *Page 379*

469. *Minerva*. Signed: Rembrandt f. 1635. Bauch 259. The picture was published for the first time—after it had appeared at the Harriet Somerville sale, London, Christie's, November 21st, 1924, lot 123—by W. R. Valentiner in *Zeitschrift für bildende Kunst* N.F. 59, 1925/6, p. 267. There is a drawing of the same composition, signed F. Bol (formerly in the Amsterdam art trade), which according to Bauch was done after the picture. Comments on the painting vary: J. G. van Gelder (*Mededelingen der Kon. Ned. Akademie van Wetenschappen, afd. letterkunde*, N.R. 16, 1953, p. 297) and W. Sumowski (1957/8, p. 224): Rembrandt and Bol. C. Müller Hofstede (*Kunstchronik* 9, 1956, p. 91), on the other hand, praises the present condition of the painting, which he accepts as autograph. Personally, I doubt the attribution. J. G. van Gelder (*loc. cit.*) sees in the subject another variant on the theme of "Melancholy". *Page 378*

470. *Cupid*. Faked signature (on another one?): Rembrandt f. 1634. Bauch 157 (perhaps with the help of a pupil: Flinck?). The picture is painted on canvas not on panel (as erroneously stated in the caption to the plate). Published for the first time by W. R. Valentiner (1923, p. 35). Bauch expressed his doubts earlier (1960, p. 262); I share them completely, and have no hesitation in attributing the painting to Flinck. W. Sumowski (1957/8, p. 231) prefers an attribution to Bol. The etching Münz 324 ("perhaps by Bol") was done after the painting, which might well have been this pupil's own picture. In the etching too I see the style of Flinck's hand. *Page 380*

471. *The abduction of Ganymede*. Signed: Rembrandt ft. 1635. HdG 207. Bauch 102. The signature (on the boy's shirt) is genuine; the picture itself has suffered somewhat. There is a preliminary sketch in Dresden (Benesch 92), but the so-called "*Naughty Boy*" (Benesch 401) is also connected with it. About Rembrandt's attitude to antique and Renaissance subjects, see: E. Kieser (*Zeitschrift für Kunstgeschichte* 10, 1941/2, p. 132) and K. Clark (1966, p. 13); V. Bloch (*Burlington Magazine* 109, 1967, p. 715: "The rape of Ganymede looks like a grotesque parody of the Michelangelo idea known to us through the engraving by Barbizet"). *Page 381*

472. *Diana, with scenes from the stories of Actaeon and Callisto*. Signed: Rembrandt fc 1635 (but the last digit is retouched, and is over another one). The date is probably 1633 (or 1632). HdG 200. Bauch 103. Stylistically, the picture is strongly related to Br. 464. Rembrandt has combined here two stories, the one of Callisto with that of Diana and Actaeon (Ovid, *Metamorphoses* II, 409 and III, 138). *Page 377*

[473. *Diana bathing*. Panel, 46×35.5 cm. London, National Gallery. Faked signature: Rembran. HdG 198. In accordance with Bauch (1966, p. 49) and MacLaren (1960), I attribute the pain-

ting only to the school of Rembrandt. It could perhaps be an early work by G. van den Eeckhout. *Appendix*]

474. *Danaë*. Signed: Rembrandt f. 16(3)6. HdG 197. Bauch 104. After E. Panofsky (*Oud Holland* 50, 1933, p. 193) had re-established the subject of the painting as Danaë, the interpretations of W. Weisbach ("Venus awaiting Mars"), Sh. Rosenthal ("Rachel awaiting Jacob"), and Niemeijer ("Sarah awaiting Abraham") were abandoned. Only Cl. Brière-Misme (*Gazette des Beaux-Arts* 6/39, 1952, p. 305) has put forward another Biblical subject, namely "Lea expecting Laban", an interpretation that was followed by A. B. de Vries (1956, p. 28). Observations by Agafonova (*Hermitage Museum, Works of the Department of European Art*, 1940, p. 23) and Chr. Tümpel (1968, p. 191; cat. no. 12) support, however, Panofsky's thesis, which is also accepted here. J. I. Kusnetzow (*Bulletin of the Hermitage* 27, 1966, p. 26; *Oud Holland* 82, 1967, p. 225) has demonstrated (what others, like J. Held, had observed too) that the painting, which was first conceived by Rembrandt in the 1630s—the date, which is difficult to read, may be 1636—was re-worked by the artist at a later period; Kusnetzow suggests around 1645. I would go so far as to "around 1650". To the later remodelling belongs, in the first place, the figure of Danaë herself who—to my mind—can be compared in the softness of the surface-painting and in the "classical" structure, to the Bathsheba of 1654 (Br. 521). X-rays, showing the change of position of the out-stretched arm for instance, corroborate this observation fully. Once one has appreciated the later, monumental style of the figure (in contrast with the Baroque design of the curtains and bed), one understands better Clark's hymn on the Venetian mood of Danaë's representation (1966, p. 118). In this light, too, Hofstede de Groot's assumption that the drawing in Munich (Benesch 1124) is a study for the figure of Danaë becomes once more fully intelligible. *Pages 382 & 383*

476. *The concord of the state* (De Eendragt van 't Lant). Signed: Rembrandt f. 1641. HdG 227. Bauch 105. Painted in brown monochrome, except for the dark blue sky; this sketch-like technique makes it probable that the picture was preparatory either to an etching (J. Q. van Regteren Altena, *Oud Holland* 67, 1952, p. 59: the original composition of the 'Hundred-guilders' print) or to a bigger, painted composition (F. Schmidt-Degener, *Onze Kunst* 21, 1912, I, p. 1; *Oud Holland* 31, 1913, p. 76) namely an allegorical scene to go over a mantlepiece in the civic guard building in Amsterdam. This picture, however, was never executed, or at any rate is not known now. The sketch was still in Rembrandt's possession in 1656, and is described in his inventory, "No. 106, De Eendragt van 't lant". The subject is well described in the Rotterdam catalogue: "Rembrandt has probably wished to symbolize the unification of all the Netherlandish forces to fight the common Spanish enemy. Concord must be based on co-operation of the political Union (the column to the left with the charter), Religion (the inscription: 'Deo soli gloria'), military power and Justice (blindfolded figure to the left). The Netherlandish towns have joined hands under the leadership of Amsterdam, the arms of which are the biggest." Much research and discussion has, however, taken place as to whether Rembrandt took the side of Amsterdam, or of the State General, or the Prince, in the political question; whether the allegory arose from a special political fact or not; and what should be the real meaning of details like the double-chained lion, the arrangement of the arrows, the empty throne, the broken tree, and whether the troops are marching out or returning (from victory, etc.) See further: J. D. M. Cornelissen, *De Eendracht van het land*, 1941; F. Schmidt-Degener, "Rembrandt's een-dracht van het land opnieuw beschouwd", *Maandblad voor beeldende Kunst* 18, 1941, p. 161; J. A. van Hamel, *De Eendracht van het land*, 1946; J. Q. van Regteren Altena, "Het genetische probleem van de Eendracht van het land", *Oud Holland* 67, 1952, pp. 30 and 59; Clara Bille, "Rembrandt's Eendracht van het land en Staten wt-tredinge van de Borgerij van Amsterdam", *Oud Holland* 71, 1956, p. 25; W. G. Hellinga, *Rembrandt fecit 1642*, 1956, p. 29; and S. Kraft, *En Rembrandt-Tavlas politiska backgrund*, 1959. *Page 384*

477. *Quintus Fabius Maximus visiting his sons at the camp of Suessa*. Signed: Rembrandt f. 1653 (or 1655). HdG 224. The young Quintus Fabius Maximus commands his father, who is visiting him at the camp of Suessa, to dismount, this homage being due to him as Consul Romanus (Livy, XXIV 44, 9; Valerius Maximus, *Facta et Dicta mirabilia* II, 24). A first study for this composition is the Rembrandt drawing in Berlin (Benesch 956). F. Schmidt-Degener (*Rembrandt en Vondel*, reprinted in F. Schmidt-Degener, *Rembrandt*, 1950, p. 57) has suggested that Rembrandt intended this picture for the Town Hall in Amsterdam, where it was replaced in 1656 by a picture of the same subject, the work of Lievens (H. Schneider, *Jan Lievens*, 1932, no. 102). More recently, however, some doubts have been

raised as to whether the picture actually is by Rembrandt. Bauch (1966, p. 49) thinks that the execution may be by G. van den Eeckhout. G. Falck (*Tidskrift för Konstvetenskap*, 9, 1924/5 p. 78) had proposed earlier an attribution to Barend Fabritius. W. R. Valentiner (*Art Bulletin* 14, 1932, p. 200), Rosenberg-Slive (1966, p. 210), O. Benesch (*Art Quarterly* 22, 1959, p. 319) and others uphold the attribution to Rembrandt. I have never seen the picture and I can only judge from excellent photographs, which do not convey the impact of a powerful work by the mature Rembrandt. *Page 385*

478. *Aristotle contemplating a bust of Homer.* Signed: Rembrandt f. 1653. HdG 413. Bauch 207. Count Antonio Ruffo, a collector in Messina, commissioned the picture from Rembrandt, who sent it to Sicily in 1654. Ruffo had only ordered a "philosoph, half figure", so it must have been Rembrandt's own idea to depict this special subject. The Italian noble-man later asked (in 1660 and 1661) Guercino and Mattia Preti for companion-pieces, but although they were willing (and honoured) to deliver them, Ruffo returned once more to Rembrandt, in order to complete the scheme. Rembrandt sent an "Alexander" in 1661 and a "Homer" in 1662 (see Br. 479/80 and 483). The documents relating to this important commission were published in 1916 by a descendant of the collector: V. Ruffo, "Galleria Ruffo nel secolo XVII in Messina," *Bolletino d'Arte* 10, 1916, p. 21 (extracts and interpretation by G. J. Hoogewerff, *Oud Holland* 35, 1917, p. 129; C. Ricci, *Rembrandt in Italia*, 1918; H. Schneider, *Kunstchronik N.F.* 30, 1918, p. 69).
It is known that Rembrandt owned busts of Socrates, Homer and Aristotle (nos. 162-4 of his inventory of 1656), though we do not know what kind of busts they were, antique, original or copies. In the Ruffo picture, Rembrandt followed a Hellenistic type, "with respect and fidelity" (E. Kieser, *Zeit-schrift für Kunstgeschichte* 10, 1941/2, p. 135). J. A. Emmens (1964, p. 173/4) has demonstra-ted that Aristotle was the 'official' philospher of Dutch Calvinism. The trio, Aristotle, Homer and Alexander, accords well with 17th-century art theory; Aristotle, moreover, was the interpreter of Homer and the teacher of Alexander. It is therefore quite understandable that it was on Rembrandt's advice that the figures of Homer and Alexander were added to *Aristotle contemplating a bust of Homer*. The gold medal, hanging on the gold chain, is an Athena with helmet, not an Alexander (K. Kraft in *Jahrbuch für Numismatik und Geldge-schichte* 15, 1965, p. 7).

From the Ruffo documents we know that all the pictures ordered by Ruffo must originally have been larger; some have suffered from heat, but still they are most impressive examples of Rembrandt's power in creating historical portraits. See also: H. v. Einem, "Rembrandt and Homer", *Wallraf-Richartz-Jahrbuch* 14, 1952, p. 187 and Th. Rousseau, "Aristotle contemplating the bust of Homer", *Bulletin of the Metropolitan Museum* 20, 1961/2, p. 149. *Page 386*

479. *Alexander the Great.* HdG 210. Bauch 281. See note to the following Bredius number. *Page 387 & 388*

480. *Alexander the Great.* HdG 208. Bauch 280. From the Ruffo documents (referred to under no. 478), it becomes evident that Rembrandt painted an Alexander twice. The first was sent with the bill of Ruffo's representative in Amsterdam in July 1661: "un. . . quadro nominato Gran Alexander fatto della mano del Pittore Rembrant van Rijn", according to the agreement with the painter, done for 500 guilders. On the same bill the costs for the canvas of the pictures and of a Homer are already added. The Alexander should hang—so Rembrandt proposed—between Aristotle and Homer. After more than a year there were complaints about the Alexander: Ruffo wrote that originally the picture consisted of only of a head, to which Rembrandt had sewn four pieces of canvas. From the answer which Rembrandt gave Ruffo's agent in Amsterdam, it becomes clear that the artist was prepared to paint a second Alexander.
The question remains whether the Glasgow (Br. 480) and the Oeiras (Br. 479) figures are really those mentioned in the Ruffo papers. Until now, art historians have been rather reluctant to accept the identification, as the additions to the canvas of the Glasgow figure seemed to be of a later date. The Glasgow picture also had an early date of 1655, while the other version seemed to represent a female person who could be identified by the owl as Athena or Bellona.
New numismatic and art-historical research— which can be summarized as follows—makes it easier, however, to accept the identity of the two versions of the Alexander with Br. 480 and 479. First of all it seemed probable that two pictures, so related in composition, were also related in subject. Through a confusion in the interpretation of the face and back of Greek coins representing Alexander and Athena, one may suspect that not only on Renaissance coins, but generally in art, the Alexander and Athena types became mixed. It can be shown that all the attributes of

Athena are to be found on portraits of Alexander too: the shield of Medusa, the locks, the owl. The breasts are rightly missing on both portraits. The date of the Glasgow picture can no longer be deciphered with the naked eye (H. Miles, *Catalogue of Dutch and Flemish Painting*, Glasgow Art Gallery, 1961, p. 109). Moreover, there is to my mind a stylistic difference which would make Br. 479 later than Br. 480. R. van Luttervelt (*Gazette des Beaux-Arts* 37, 1950, p. 99) also puts Br. 479 about five years later than Br. 480. I do not share, however, the rest of his interpretation and arguments. Rembrandt was quite capable of reworking an older study (in this case a portrait of Titus?) and of enlarging it in connection with a new idea or commission. That is what has happened with the first version of the Alexander, the Glasgow picture. The additions to be seen today are recent, but they may replace the original ones, which must have been larger, to match the original size of the Homer.

The tournament stick which both figures hold is a male attribute, not Athena's, and finally the helmet decoration of Br. 480 is again an owl (not a dolphin) which belongs to the Alexander type. In the second version, the Oeiras picture, Br. 479, this feature has grown into a marvellous "child of Rembrandt's imagination, completely recreated in paint" (K. Clark, 1966, p. 138). For the reinstated identification, see: K. Kraft in *Jahrbuch für Numismatik und Geldgeschichte* 15, 1965, p. 7. For a drawing connected with Br. 480 see Mrs. K. A. Agafonova, *Burlington Magazine* 107, 1965, p. 404. *Page 389*

481. *Jupiter and Mercury visiting Philemon and Baucis.* Signed: Rembrandt f. 1658. HdG 212. Bauch 106. The signature is difficult to read through the varnish, but the picture is sensitively drawn and extremely beautiful in its colour scheme. The drawings formerly connected with the picture (Benesch A 76 and 940), belong to another period and to another composition. E. Kieser (*Zeitschrift für Kunstgeschichte* 10, 1941/2, p. 147) has rightly observed the fundamental connection with the early Emmaus picture (Br. 539). *Page 390*

482. *The conspiracy of Julius Civilis: The Oath.* HdG 225. Bauch 108. This picture, which originally was much larger (ca. 550×550 cm.) was intended to decorate an arched space in the Great Gallery of the new Town Hall (now the Royal Palace) at Amsterdam. Originally the commission to paint stories from the Batavian war of liberation against the Romans was given to Govaert Flinck, who made—in two days!—watercolours on canvas in August 1659, so as to have the gallery quickly decorated for a state visit of Amalia van Solms, the Prince of Anhalt, and others. H. van de Waal (see below) believes that these were only sketches to be shown at floor level to the princely visitors. On November 28th, 1659, Flinck received an official contract for eight to twelve decorative paintings to be delivered two per year. Flinck, however, died on February 22nd, 1660, and several months later Jürgen Ovens had to rearrange and repaint Flinck's sketches again for another state visit, "within four days". After that the official commission seems to have gone to Jan Lievens, Jacob Jordaens and Jürgen Ovens.

How Rembrandt came to be involved in this commission it is not known. The 1662 edition of the Amsterdam guide book of Melchior Fokkens, however, says that the first picture in the gallery was done by Rembrandt; "Claudius Civilis at the meal at night appeals to the Batavians to go into war" is how the subject is described. At that time four of the eight decorative paintings were ready. This town guide-book was "rediscovered" by the Amsterdam archivist in 1891, and when he and a commission climbed up to check, they found that the Rembrandt was gone; in its place was another painting by J. Ovens—which, moreover, was already described in later guide-books. Rembrandt must therefore have taken down his work in order to retouch it. Only one more surviving document refers to this case: On August 28th, 1662, Rembrandt offered to a creditor "a quarter of all the money that he should get for the picture delivered for the Town Hall, and as well as the money still to come for it, and also what he may get by overpainting it". In the event, however, the picture was never put back. Rembrandt must have cut it, and repainted the fragment. It was sold by auction on August 10th, 1734, and bought by a certain Nicolaes Cohl, whose Swedish heirs gave it to the Swedish Academy. In the meantime, the identification of the subject had been forgotten.

H. van de Waal (*Drie eeuwen Vaderlandsche Geschiedenis-uitbeeldingen*, 1952, I, p. 233) has thoroughly analysed the reasons why Rembrandt's work was refused for the Town Hall, in the process analysing the tradition for this type of Dutch history painting. Claudius Civilis' conspiracy and war against the Romans was plainly understood by Rembrandt's Dutch contemporaries as an analogy of William of Orange's revolt and war against Spain. The past should be shown in an heroic light, as people had a strong

sense of stylistic "decorum", of what was ex-
pected—and suitable—for official places like the
Town Hall. Rembrandt, however, was fascin-
ated by the story; he returned to the exact
rendering of the sources—the one-eyed Civilis
—which excited his imagination to such an
extent that he broke the conventions accept-
able for an official scheme of decoration.

To obtain an idea of the original design, one
should turn to the prepatory drawing or
drawings. According to Benesch (nos. 1058-61
and *Art Quarterly* 22, 1959, p. 322) there are
four in Munich, though according to others—
including me—only Benesch 1061 is genuine.
This one was drawn on the back of an in-
vitation card to attend the funeral of Rebecca
de Vos, on October 25th, 1661; this sketch must
therefore be dated around that day. It shows
how important the architectural setting for
the composition was to Rembrandt. The
(repainted) fragment, which has only slightly
suffered from pressing, is still "the supreme
example of Rembrandt's work [in the] Vene-
tian mood . . . Light becomes the means of
revealing [the] expressive possibilities [of the
forms]" (K. Clark, 1966, p. 98-9).

Modern research on the picture has been
published in the first (Rembrandt) double
number of *Konsthistorisk Tidskrift* 25, 1956,
with contributions by K. G. Ankarswärd, C.
Bille, I. H. van Eeghen, R. van Luttervelt, C.
Müller Hofstede, L. Münz, C. Nordenfalk,
A. van Schendel and H. van de Waal. There is
a critical resumé by J. Bruyn Hzn in *Oud
Holland* 71, 1956, p. 49. See also: the con-
troversy between A. Noach and H. van de
Waal in *Oud Holland* 56, 1939, pp. 49 and
145; W. Sumowski (1957/8, p. 233); C. Bille
in *Oud Holland* 71, 1956, p. 54; C. Müller
Hofstede in *Kunstchronik* 10, 1957, p. 129;
A. J. Moes-Veth in *Oud Holland* 75, 1960,
p. 143. *Pages 391 & 392*

483. *Homer dictating to a scribe.* Signed: . . .andt f.
1663. HdG 217. Bauch 244. This picture was
the third commissioned by Antonio Ruffo
(see Br. 478-80): in July 1661 the canvas was
paid for, although the picture had not yet
been started; in November, 1662, there were
complaints that the picture had been sent to
Italy "mezzofinito". It was returned to the
artist, to be completed. That Rembrandt
complied is proved by the fact that the
painting is dated 1663. It has been damaged by
fire and only a fragment of the original
composition remains; in the 1737 inventory of
Ruffo's collection the canvas is described as a
"half-figure, giving instruction to two
disciples, life-size". The original composition
can to some extent be reconstructed from a
Rembrandt drawing in Stockholm (Benesch

1066) and a picture by Rembrandt's pupil,
Aert de Gelder, in Boston (inv. 39.45) which
may derive from Rembrandt's original
composition. About the motive of Homer's
blindness and Rembrandt's interpretation of
it, see: E. Panofsky, *Studies in Iconology*, 1939,
p. 109; J. Held, "Paintings by Rembrandt",
Metropolitan Museum of Art, New York, 1956;
H. v. Einem, "Rembrandt and Homer", in
Wallraf-Richartz-Jahrbuch 14, 1952, p. 182.
The painting was one of the Rembrandts
owned by Bredius. *Page 393*

484. *The suicide of Lucretia.* Signed: Rembrandt f.
1664. HdG 218. Bauch 284. The story is told
by Livy (*Historiae* I, 57/8). The glorious
colour harmony, golden and greenish in tone,
would sparkle still more after a cleaning, even
though the damage— especially below —
might then be revealed too clearly. See next
number. *Page 394*

485. *The suicide of Lucretia.* Signed: Rembrandt f.
1666. HdG 220. Bauch 286. The Washing-
ton picture depicts the moment before the
suicide, with the dagger pointed at the breast;
here Lucretia is represented the moment after.
She has already inflicted the fatal wound, and
her face has the pallor of approaching death.
The cord of a curtain may be an allusion to
the theatre; Rembrandt's representation could
have been inspired by a theatrical perform-
ance. Compare also: W. Stechow "Lucretia
statua" in *Beiträge für Georg Swarzenski*, 1951,
p. 124. It has recently been suggested (Michael
Hirst in a letter published in the *Burlington
Magazine* 110, 1968, p. 221) that the com-
position is based on Caravaggio's *David* in
the Borghese Gallery, Rome. *Page 395*

486. *Anna accused by Tobit of stealing the kid.* Signed:
RH. 1626. HdG 64a. Bauch 2. Published for
the first time by W. Bode (*Art in America* 1,
1913, p. 13). W. Martin (*Oud Holland* 42,
1925, p. 48) and W. Sumowski (*Oud Holland*
71, 1956, p. 109) have shown that the com-
position is based on models by W. Buytewech
and M. v. Heemskerck. J. Bruyn (*Rembrandt's
keuze van bijbelse onderwerpen*, 1959, p. 24)
disputes Sumowski's theory. *Page 400*

487. *The ass of Balaam balking before the Angel.*
Signed: R f. 1626. HdG 26. Bauch 1. The
picture is in all probability the one which
Claude Vignon refers to in a letter of Novem-
ber 1641 from Paris, telling his correspondent
that he has appraised the painting of the pro-
phet 'Bilam', which the art and diamond
dealer Lopez had bought from Rembrandt
(*Urkunden*, no. 90). The composition derives
from a drawing by D. Vellert ; Lastman

used the same composition. I. Graber (*A newly discovered picture by Rembrandt*, 1956, p. 3 [in Russian]) thinks that the picture is a modern fake. As far as I can see, nobody else has taken this line. *Page 401*

488. *David presenting the head of Goliath to Saul.* Signed: RH. 1627(?). HdG 34. Bauch 3. W. Martin (*Jaarboek van de Maatschappij der Nederlandsche Letterkunde* 1936/7, p. 62, note 2) writes: before cleaning, clearly dated 1625. This date would fit much better stylistically than the actual (restored?) date of 1627. However, on other occasions (*Kunstwanderer* 3, 1921, p. 34; *Rembrandt en zijne tijd*, 1936, p. 500) the same authority quotes the date as 1626. When the picture came up for the first time at the Eyre Hussey and others sale, London, Robinson and Fisher, February 18th, 1909, lot 82, there was no mention of any signature and the picture was attributed to G. v. d. Eeckhout. *Page 399*

489. *Samson betrayed by Delilah.* Signed: RHL van Rijn 1628. HdG 32. Bauch 4. The signature is painted very thinly in a bluish-grey colour, but seems to be perfectly correct. With its dramatic composition and rich shades of colour, the picture is rightly regarded as one of Rembrandt's most expressive Leyden works, especially when the subtle draughtsmanship and sensitive colouring are compared with the paintings of the previous year. Kenneth Clark (1966, p. 24) rightly praises it as Rembrandt's first Baroque work; and Constantijn Huygens may have had it in mind when comparing Rembrandt with Lievens (who had made during these years another *Samson and Delilah*, Amsterdam, Rijksmuseum, 1458): "he (Rembrandt) likes to pack into the limited scope of small paintings effects one can look for in vain in even the hugest works of others; Lievens, in the spirit of youth, aims only for vastness and splendor, painting his subjects in life-size or even larger" (A. H. Kan, *De Jeugd van Constantijn Huygens*, 1946, p. 79). W. Sumowski (*Oud Holland* 71, 1956, p. 111) thinks that the poses of Rembrandt's figures may derive from Honthorst's "*Granida and Daifilo*" (painted in 1625). *Page 402*

490. *David playing the harp before Saul.* HdG 35. Bauch 7. The picture has suffered a little from the disintegration of the blue colour, but the attribution to Rembrandt's Leyden period seems to be correct. It was formerly attributed to S. Koninck, an attribution which is upheld by J. C. Van Dyke (*Rembrandt and his School*, 1923, p. 112). A copy after the picture was reproduced in the 38th catalogue of J.

Goudstikker, Amsterdam (no. 59; bought at the Brussels sale of May 8th, 1929, lot 98). Another (?) copy (1967, with the art dealer P. de Boer, Amsterdam) was attributed to J. Lievens by Bauch (*Pantheon 25*, 1967, p. 166). *Page 403*

491. *Daniel and King Cyrus before the idol of Bel.* Signed: Rembrandt 1633. HdG 50. Bauch 11. The date 1633 (instead of the wrong one of 1631) came to light after a cleaning in 1959. G. Knuttel (1956, p. 249) had already doubted the signature and date of 1631 in 1956. Formerly known as *Nebuchadnezzar before the Golden Image*. The true subject of the story was recovered by H. van de Waal. It is taken from the apocryphal book of Daniel, chapter 14 (J. G. van Gelder, *Oud Holland* 75, 1960, p. 73). Bauch (*Studien zur Kunstgeschichte*, 1967, p. 125) discusses the iconographic interpretation. *Page 406*

492. *Bathsheba at her toilet.* Signed with monogram and dated 1632. HdG 42. Bauch 8. Bauch calls it the best of several versions. The etching, Münz 323, is done after this picture, or—if interpreted in another way—the picture Br. 492 is the "sketch" for the etching Münz 323 (it does not have, however, a sketch-like quality). The etching is no longer attributed to Rembrandt; according to Münz it could be a work of P. Verbeecq. Neither Münz, nor Bauch, nor I have seen the picture in Rennes; a plausible attribution from the photograph alone is impossible. *Page 404*

493. *Susanna surprised by the elders.* Bauch 10. Published by W. R. Valentiner (1921, p. 26). Bredius (*Zeitschrift für bildende Kunst*, N.F. 32, 1921, p. 3) had already lamented the over-cleaned, ruined and over-painted state of the picture. Unknown to me, but probably difficult to attribute to any artist in view of its deplorable condition. *Page 404*

494. *Esther preparing to intercede with Ahasuerus.* Signed: Rembrant f. 163. . ' HdG 311. Bauch Formerly called *Bathsheba at her toilet.* The subject, related in the book of Esther (chapter 5:1), has been newly interpreted by M. Kahr (*Oud Holland* 81, 1966, p. 228), taking up a suggestion of W. S. Heckscher (*Rembrandt's Anatomy of Dr. Nicolaes Tulp*, 1958, p. 118 and p. 176). Mrs. Kahr also discussed the signature and date: "It is possible that Rembrandt signed the painting in 1633 and painted a "7" over the final "3" in 1637". I am not so convinced of the originality of the signature and still think the picture belongs to the period of about 1632/3. This difference in dating does not interfere with Mrs. Kahr's convincing re-

interpretation of the picture and of the etching, Münz 90. *Page 405*

495. *Esther with the decree.* Said to be signed with a monogram. HdG 40a. Bauch 255. The picture seems to have been lost in World War II. I agree with Mrs. Kahr's supposition that the picture is a pastiche after the painting Br. 494 and the etching Münz 90. Formerly called *Bathsheba with David's letter.* Mrs. Kahr has again identified the subject from the Book of Esther 4:8. Neither Bauch, Mrs. Kahr nor I have seen the picture. A copy, somewhat larger, is in the Leyden Museum (cat. 1949, no. 177). *Page 405*

496. *The Finding of Moses.* (Genuinely ?) signed: Rembrandt. HdG 23. Bauch 12. Bauch claims that the picture was originally rectangular. To my mind it is so inferior in quality to the other small figure histories (such as Br. 464 and 472), that I cannot support the attribution to Rembrandt. *Page 407*

497. *The Feast of Belshezzar.* HdG 52. Bauch 21. Signed: Rembrandt fecit 163... The excellent state, the signature, date and inscription of the picture are discussed in the 61st annual report of the National Art Collections Fund 1964, no. 2149 and in the National Gallery's Report for 1962-4 (1965), p. 41-2. R. Haussherr (*Oud Holland* 78, 1963, p. 142) has pointed out that the formula of the Hebrew inscription derives from Mennaseh ben Israel's book *De termino vitae* which appeared in 1639. He dates the painting accordingly as late as 1639, as W. Sumowski (*Oud Holland* 71, 1956, p. 233) had done before. I think, however, in agreement with the National Gallery report, and with J. G. van Gelder (*Burlington Magazine* 95, 1953, p. 38), that a date around the middle of the 1630s would be nearer the mark. Incomprehensible to me is the early dating ("considerably earlier than Dr. Tulp's Anatomy Lesson of 1632") proposed by Kenneth Clark (1966, p. 107); this has also been rejected by others (E. Haverkamp-Begemann in *Yale Review* 56, 1966/7, p. 305). An X-ray report is printed in *Speculum Artis* 16, 1964, p. 5, but I do not think that the pentimenti revealed by the X-ray allow one to conclude that Rembrandt really painted the picture twice on the same canvas. A. Burroughs (*Art criticism from a laboratory*, Boston, 1938, p. 164) did not discuss any X-rays, but attributed the picture to Lievens! *Pages 408 & 410*

498. *The Angel stopping Abraham from sacrificing Isaac to God.* Signed: Rembrandt f. 1635. HdG 9. Bauch 13. Signature and picture seem to be in good condition. Another version is in the Alte Pinakothek, Munich (no. 438). It has the unusual signature: Rembrandt verandert En overgeschildert. 1636 (Rembrandt changed and overpainted); in other words, Rembrandt has corrected a pupil's work. This pupil could be Govaert Flinck (H. Gerson, *Kunstchronik* 10, 1957, p. 122; W. Sumoswki, 1957/8, p. 237; J. W. v. Moltke, 1965, p. 66, no. 6, and others). J. N. v. Wessem (*Catalogue, Rembrandt als leermeester*, Leyden, 1956, p. 6) sees Lievens and W. R. Valentiner (*Art Quarterly* 19, 1956, p. 404), F. Bol as the pupil who started this version. The connection with Lastman and Rembrandt drawings is discussed by C. Müller in *Jahrbuch der preussischen Kunstsammlungen* 50, 1929, p. 66. E. Brochhagen ("Holländische Malerei des 17. Jahrhunderts", *Alte Pinakothek Katalog* 3, 1967, p. 73) very rightly observes that Rembrandt has reworked the painting so extensively that the pupil's own manner is difficult to discern. Other copies exist. *Pages 409 & 411*

499. *Samson threatening his father-in-law.* Signed: Rembrandt ft. 163(5). HdG 31. Bauch 14. The picture is cut, but the original composition is known from an old copy (repr. page 413), which may have been done by G. Flinck (H. Gerson, *Kunstchronik* 10, 1957, p. 122; J. W. v. Moltke, 1965, p. 69, no. 22). A. Burroughs (*Art criticism from a laboratory*, Boston, 1938, p. 160-4) critizes the picture heavily—but incorrectly; he attributes it wrongly to Lievens. *Page 412*

501. *The Blinding of Samson.* Signed: Rembrandt f. 1636. HdG 33. Bauch 15. From (rather poor) copies it can be deduced that the Rembrandt picture was originally still larger. The copy in Cassel was lost in World War II. The drawings of this subject (Benesch 93 and 127) should be connected with another (not executed) version. Br. 501 is most certainly the picture which Rembrandt sent to Constantijn Huygens, the secretary of Frederick Henry of Orange, as a present, with a letter of January 27th, 1639. In a postscript to the letter, the artist adds: "the picture should be hung in a strong light and so that one can stand at a distance from it, then it will show its brilliance best" (*Urkunden*, 67; H. Gerson, *Seven letters by Rembrandt*, 1961, p. 50 and the important correction by I. H. van Eeghen in *Maandblad Amstelodamum* 49, 1962, p. 71). Constantijn Huygens was a patron of the artist and an intermediary in commissions for the House of Orange. H. E. van Gelder (*Oud Holland* 74, 1959, p. 177) has traced the later vicissitudes of the picture. *Pages 414 & 415*

502. *Tobias healing his father's blindness.* Signed: Rembrandt f. 1636. HdG 69. Bauch 16. The composition has been cut off to the right. See the original shape, handed down to us by a copy in Brunswick (repr. page 417). Projects for the composition are the drawings Benesch 131 and C.21. For the Tobias representations see: R. Greeff, *Rembrandts Darstellungen der Tobiasheilung*, 1907, and J. Held, *Rembrandt and the Book of Tobit*, 1964. *Page 416*

503. *The Angel leaving Tobias and his family.* Signed (redrawn): Rembrandt f. 1637. HdG 70. Bauch 17. Executed in brownish and white colours with the priming partly shining through, the picture is a kind of oil-sketch. The condition is excellent, although this would be more apparent after cleaning. Powerful X-rays are published by M. Hours (*Bulletin du laboratoire du Louvre*, 1961, no. 6). Many copies exist. Rembrandt took the basic compositional idea from a woodcut by M. van Heemskerck. The connection with different drawings of this subject and the etching Münz 179 of 1641 has been discussed by O. Benesch (*Bulletin du Musée hongrois des Beaux Arts*, no. 22, 1963, p. 71. *Page 418*

504. *Joseph relating his dreams.* Signed: Rembrandt 163.. HdG 14. Bauch 19. This is a preparatory study for the etching Münz 175 of 1638. This sketchy picture too was prepared with the aid of figure and compositional studies, one dated as early as 1631 (Benesch 20 for the figure of old Jacob). For the relation of drawings, print and picture, see: O. Benesch, Drawings nos. 127, 455; L. Münz, 1952, no. 175. *Page 419*

505. *Susanna surprised by the Elders.* Signed: Rembrandt f. 1637 (the letters "andt f" and the figure "7" are on a strip of wood which was added later, perhaps to replace an original one, which was damaged). HdG 57. Bauch 18. The date of the picture is certainly right, as the picture corresponds well with other works of this period (Br. 503, 559). It was used as a "modello" for the first version of Br. 516 (see there). *Page 420*

506. *Bathsheba at her toilet.* HdG 310. The attribution to Rembrandt and the interpretation of the subject are doubtful. The design and the execution is rather restless and unsecure. E. Fechner, *Rembrandt*, Moscow, 1964, calls it *Judith before the mirror*. The attribution to Rembrandt is denied by J. Rosenberg (1964, p. 371) and Bauch (1966, p. 518: perhaps F. Bol). *Page 420*

507. *Samson posing the riddle to the wedding guests.* Signed: Rembrandt f. 1638. HdG 30. Bauch 20. Although this picture has a sketchy quality, it is certainly a work of art in its own right and not a design for another, more complete composition. Only three years after it was finished, Philips Angel praised Rembrandt in a speech, held in Leyden on St. Luke's day, October 18th, 1641. He described it in detail and concludes: "this blossom of personal invention derived from carefully reading the story in question and by thinking it over thoroughly" (*Urkunden*, 91). C. Nordenfalk (*Konsthistorisk Tidskrift* 25, 1956, p. 79) points to O. van Veen as a model for the composition; J. Bruyn (*Rembrandt's keuze van bijbelse onderwerpen*, 1959, p. 17) to a print of Ph. Galle after Marten van Heemskerck, and A. B. de Vries (*Rembrandt*, 1956, p. 34) and K. Clark (1966, p. 57) to Leonardo da Vinci. The two men in the right background seem like actual portraits. C. Hofstede de Groot called the man with the feathered beret a self-portrait; while H. Erpel (*Die Selbstbildnisse Rembrandts*, 1967, p. 169, no. 69) and W. Scheidegg (*Rembrandt und seine Werken*, 1958, p. 23) recognized Rembrandt's features in the man with the flute. The X-ray (by Dr. M. Meier-Siem) is indistinct, which may be due to the fact that Rembrandt corrected and re-painted the canvas a good deal before the final solution was reached. *Page 421*

508. *The departure of the Shunamite wife.* Signed: Rembrandt f. 1640. HdG 5. Bauch 22. A strip of 4 cms has been added at the top. Formerly called *The Dismissal of Hagar*. The new interpretation of the subject is due to Chr. Tümpel (*Kunstchronik* 19, 1966, p. 302; 1968, cat. no. 3). The design and execution are of the utmost delicacy. *Page 422*

509. *The Angel ascending in the flames of Manoah's sacrifice.* Signed: Rembrandt f. 1641. HdG 27. Bauch 23. The first to study carefully the drawings connected with this picture was F. Saxl (*Rembrandt's sacrifice of Manoah*, 1939). It has become clear, however, that some of the drawings are by pupils and reworked by Rembrandt; others are of a later date than the painting itself (O. Benesch in *Bulletin du Musée hongrois des Beaux Arts*, no. 22, 1963, p. 81). As to the picture, I agree with W. Sumowski (1957/8, p. 227) that it was executed by J. Victors, but partly retouched by Rembrandt. I think the cooperation took place around 1640 and the signature and date (although executed in a spurious way) mark the completion of the picture. It is quite probable, however, that work on another version (never executed, or lost) went on in the Rembrandt studio, as is suggested by drawings of a later period. K. Bauch, O. Benesch,

K. Clark (1966, p. 156-7), Chr. Tümpel and A. B. de Vries (1956, p. 51) consider the Dresden picture as a work of Rembrandt's pupil(s), perhaps executed in the 1650s. J. Bruyn (*Rembrandt's keuze van bijbelse onderwerpen*, 1959, p. 18), J. Rosenberg (1964, p. 194) and Slive/Rosenberg (1966, p. 63) very emphatically praise its originality. *Page 423*

511. *The reconciliation of David and Absalom.* Signed: Rembrandt f. 1642. HdG 38. Bauch 24. Since Loevinson-Lessing (*Bulletin of the Hermitage* 11, 1957, p. 97; resumé in *Burlington Magazine* 99, 1957, p. 422) made a strong case for interpreting the subject as the story of the parting of David and Jonathan (1 Samuel 20), and to be identified with HdG 36b, most art-historians have followed his suggestion: the catalogue of the Rembrandt exhibition, Amsterdam, 1956, no. 46; K. Bauch, J. G. van Gelder (*Kunstchronik* 10, 1957, p. 146), Chr. Tümpel (1968, p. 138; cat. no. 4**)**, W. R. Valentiner (*Art Quarterly* 19, 1956, p. 395), A. B. de Vries (1956, p. 47). J. Q. van Regteren Altena (*Kunstchronik* 10, 1957, p. 146) and J. Rosenberg (*Kunstchronik* 9, 1956, p. 347 and *Art Quarterly* 19, 1956, p. 383), however, keep to the formerly accepted theme in accordance with Bredius, stressing the sense of fatherly dignity towards the lovely youth. To my mind, the iconographic details of the picture are in accordance with the parting of two friends. *Page 424*

513. *Bathsheba at her toilet seen by King David.* Signed: Rembrandt ft 1643. HdG 40. Bauch 25. The style of the work is not consistent; the old servant, for instance, is still done in the "Leyden manner". I therefore presume that Rembrandt has here reworked an earlier painting by one of his pupils. G. Knuttel's interpretation (*Actes du XVIIe congrès international d'histoire de l'art*, 1952, 1955, p. 421), that Br. 436 is an earlier version of this composition is unjustified. *Page 425*

514. *Anna accused by Tobit of stealing the kid.* Signed: Rembrandt f. 1645. HdG 64. Bauch 26. As far as size, date and the foreign mahogany wood are concerned, a companion picture to Br. 569, though thematically there is no real connection. The drawing Benesch 572 has the same kind of strongly-built forms as this sensitively executed picture. *Page 426*

515. *Abraham serving the Angels.* Signed: Rembrandt f. 1646. HdG 1a. Bauch 27. Not seen by me. The drawings, Benesch 576 and 577, which are connected with the picture, are only by pupils of Rembrandt. According to J. Rosenberg, and W. R. Valentiner (*Rembrandt*

Handzeichnungen 1, 1925, nos. 12 and 13), they are done after the picture, according to Benesch they are done by Rembrandt himself, and are preparatory drawings for the painting. *Page 427*

516. *Susanna and the Elders.* Signed (redrawn): Rembrandt f. 1647. HdG 55. Bauch 28. H. Kauffmann (*Jahrbuch der preussischen Kunstsammlungen* 45, 1924, p. 72) was the first to demonstrate that the picture consists of two different layers: the earlier one must have been done around 1635, and the existing surface above it, as the signature states, in 1647. For both versions preparatory drawings exist (Benesch 155/9, 536, 592). Kauffmann's theory has been disputed by K. v. Baudissin (*Repertorium für Kunstwissenschaft* 46, 1925, pp. 190 and 204), but A. Burrough's X-ray report (*Burlington Magazine* 59, 1931, p. 9) confirms the important changes made in the design of *Susanna and the Elders*. In the final version of the picture, all the excitement of the first, more lively design, has been reduced. There is a beautiful preparatory study (Benesch 590) and the painted study in The Hague (Br. 505), but the most important factor in the creation of the new harmonious style of the 1640s evident here is a renewed study of Lastman's art: there is, for example, Rembrandt's copy (Benesch 448) of a picture of this subject by Lastman at Berlin. *Page 428*

[518. *Study for Susanna at the bath.* Panel, 62 × 48 cm. Paris, Louvre. HdG 58. This is not a study for, but a copy after, Br. 516, probably by a pupil who worked with Rembrandt during the 'fifties (C. A. van Renesse?). A. Burroughs (*Burlington Magazine* 59, 1931, p. 9, note 3), Bauch 1966 (under no. 28 and p. 49) and W. Sumowski (1957/8, p. 238) call it a copy or work of a pupil. Mme. Hours (*Bulletin du Laboratoire du Louvre*, no. 6, 1961) notes that the X-ray picture "does not present the same qualities as the other documents". J. Rosenberg (1964, p. 371), however, does not list it under the copies. A thick, dark varnish covers the surface of the picture. *Appendix*]

519. *The Vision of Daniel.* HdG 53. Bauch 29. As far as I can see, only W. Sumowski (1957/8, p. 236/8) shares my criticism of this picture. I do not agree with all of his arguments, especially in relating this picture to the art of Carel Fabritius or pictures connected (partly wrongly) with him, but I do believe with him that both the drawing Benesch 901 and the picture are by a pupil. The composition may go back to a (now lost) invention by Rembrandt. The feeble tenderness of the angel and the dry execution of Daniel are shortcomings

typical of a pupil. I am not so sure (as Sumowski is) about retouchings by Rembrandt himself. To my mind, also, the X-ray picture misses the accents of light and shadow that are characteristic of Rembrandt's underpainting. *Page 429*

520. *Tobit and his wife.* Signed: Rembrandt f. 1659. HdG 65. Bauch 30. The drawing, Benesch 597, is the first compositional idea for this picture. The cleaning in 1947 revealed the date 1659 (instead of 1650), which matches much better with the violet-red colour scheme of about 1660 and the loosened structure—both of which, incidentally, had their importance for Aert de Gelder, who became Rembrandt's pupil in these years. Bauch, however, defends the date of 1650. In the right of the picture, there was originally a still life, the colours and design of which to a certain degree destroy the perfection of the actual painting in this area. J. S. Held (*Rembrandt and the book of Tobit*, 1964, p. 30) points to the similarity with the emblem XLIV in Johan de Brunes *Emblemata of zinne-werck*, Amsterdam, 1624, accompanying a text in praise of humble industry. *Page 440*

521. *Bathsheba with King David's letter.* (Genuinely?) signed: Rembrandt ft. 1654. HdG 41. Bauch 31. Although covered by heavy varnish and probably damaged, especially in the dark parts, this picture is one of Rembrandt's greatest Biblical works. Hendrik Bramsen (*Burlington Magazine* 92, 1950, p. 128) has demonstrated that an engraving by François Perrier, after an antique relief, inspired Rembrandt's composition. In the first project the head of Bathsheba was raised and her gaze directed upwards (as revealed by X-rays, published by M. Hours, *Bulletin du Laboratoire du Louvre*, no. 6, 1961). The model for Bathsheba is certainly Hendrickje, the exotic hat of the servant is the same as in the drawing, Benesch 1345 (London, Victoria and Albert Museum). The drawing Benesch 1113, however, is not directly connected with the picture. *Page 430*

522. *The Condemnation of Haman.* HdG 47. Bauch 40. Previously called *Mordecai before Esther and Ahasuerus.* M. Kahr, *Oud Holland* 81, 1966, p. 229) has found the exact interpretation of the story, which is told in the book of Esther V:7-9. Chr. Tümpel (1968, p. 146; cat. no. 7) comes to the same conclusion. The execution of this painting by Rembrandt has been questioned repeatedly and even the name of the pupil J. Victors has been mentioned in this connection before. I think that the picture is really by Victors, with a Rembrandt design before him. The drawings Benesch 1005 and A.63 verso

are also school-drawings. The back of the drawing Benesch 747 could be a first idea for the picture (V. M. Nevejina in *Bulletin du Musée National Pouchkine* 2, 1964, p. 93). *Page 431*

523. *Joseph accused by Potiphar's wife.* Signed (retouched): Rembrandt f. 165(5). HdG 18. Bauch 33. The quality of the picture is difficult to establish, as heavy varnish and a curious "craquelure" cover the surface. The X-ray of Potiphar's wife is, however, convincing. Bauch (*Wallraf-Richartz-Jahrbuch* 24, 1962, p. 321 and 1966, no. 33) has analysed very well the differences between Br. 523 and 524. His conclusion, which I could share, is: a comparison side by side might still prove the Berlin picture to be the real original and the Washington one the work of a pupil retouched by Rembrandt. The connection with the drawing, Benesch 623, is not convincing. *Page 432*

524. *Joseph accused by Potiphar's wife.* (Genuinely?) signed: Rembran . . f. 1655. HdG 17. Bauch 32. The recent cleaning has disclosed earlier damage to the uppermost surface colours, so that the colour scheme is out of balance now. Nevertheless I share the opinion of Rosenberg (1964, p. 222) and others (see no. 523) that this version is superior to the Washington one: the dramatic treatment, and delineation of the characters, is more concentrated, and the pentimenti in the area of the figure of Potiphar's wife reveal the process of artistic invention in actual development. Especially beautiful is the powerfully constructed underpainting with its "impressionistic" execution. In a first stage Joseph covered his face with his hand. For a poor reproduction of the excellent Berlin X-ray, see W. Sumowski (1957/8, p. 237). From Benesch's interpretation of the drawing Benesch 958 one may conclude that, according to him, the Washington picture was the earlier of the two. A rather poor copy was in Christie's sale of December 8th, 1961 (lot 84). *Page 433*

525. *Jacob blessing the children of Joseph.* Faked signature: Rimbran. . . f. 1656. Copied from a lost one? HdG 22. Bauch 34. Although it has suffered from relining and pressing and was perhaps never completely finished, the picture is immensely impressive: powerful alike in its suggestion of inner emotion and painterly richness. Notwithstanding the date (genuine?), I could imagine that Rembrandt reworked parts of the picture in the 1660s. The X-rays (taken by Dr. M. Meier-Siem and others; more difficult to read than usual on account of paint on the back of the picture) reveal

small compositional changes—the elder boy was originally seen more in profile. W. Stechow (*Gazette des Beaux-Arts* 85, 1943, p. 193) and H. v. Einem (*Rembrandt, der Segen Jacobs*, 1950 and 1965) have carefully traced (in different ways) the iconographic tradition of the subject, its connection with the Biblical text and secondary sources, sometimes conforming with, sometimes opposing, Rembrandt's interpretation. Special Rembrandt-esque features in this context are the place reserved for Asnath, Joseph's wife, and the neglect of the motive of the crossed hands. Important observations have been added by Ilse Manke (*Zeitschrift für Kunstgeschichte* 23, 1960, p. 252), J. Held (*Rembrandt and the book of Tobit*, 1964, p. 32, note 23), J. Rosenberg (1964, p. 223) and Rosenberg-Slive (1966, p. 79). Contrary to older interpretations, it becomes clear that the younger boy, Ephraim, who is actually being blessed by Jacob is the bigger, fair-haired one; the older child, Manasseh whom Joseph would have preferred to receive his grandfather's blessings, is represented as the darker and smaller of the two. *Pages 434, 436 & 437*

526. *David playing the harp before Saul.* HdG 36. Bauch 35. Ever since this famous picture—which does not have an old history—was acquired by A. Bredius in 1898 for exhibition in the Mauritshuis, it has been hailed as one of Rembrandt's greatest and most personal interpretations of Biblical history (see, for instance: H. E. van Gelder, *Saul en David; Petrus verloochent Christus*, 1948 ; G. Knuttel Wzn, *Openbaar Kunstbezit* 3, 1959, p. 9). I fear that the enthusiasm has a lot to do with a taste for Biblical painting of a type that appealed specially to the Dutch public of the Jozef Israëls generation, rather than with the instrinsic quality of the picture itself. The painterly execution is superficial and inconsistent: Saul's turban is shining and variegated, and rather pedantic in treatment, in contrast with the clothing and the hand, which are painted loosely, in one monotonous tone of brownish red. All this points to an execution in Rembrandt's studio, after a design of the master in the manner of Benesch C.76 (which is itself a copy). This atelier-work could have been executed about the same time —and by the same pupil(s)?—as Br. 584. It is revealing that art-historians have never been able to agree as to the date of this picture. Bredius (*Zeitschrift für bildende Kunst*, N.F. 32, 1921, p. 147) puts it in the 1650s, referring to some pictures now considered doubtful, followed by J. Rosenberg (1964, p. 228); A. B. de Vries (1956, p. 63; *150 Jaar Kon. Kabinet van schilderijen*, 1967, p. 221), K. Bauch

and others; they are contradicted by C. Hofstede de Groot, W. R. Valentiner (*Genius*, 1920, I, p. 44; 1921, p. 128), G. Knuttel (*loc. cit.*) etc., who think it was painted in the 1660s. As far as I can see there is only one voice whose admiration for the picture is restrained (G. Martin in *Burlington Magazine* 109, 1967, p. 543: "it does not reveal Rembrandt at his best"). One should take into account that the canvas has been cut into two parts and that the upper right quarter with a female figure has been lost and replaced in modern times. (H. E. van Gelder, *loc. cit.*). This may partly help to excuse t e emptiness of the curtain-motive, but not the superficial handling and the somewhat "larmoyant" interpretation. David's figure is the best and most consistent part of the picture, but not to the degree that I would recognise Rembrandt's touch in it. Benesch, on the other hand, thinks that the figure of David is weaker than that of Saul, in the drawing (C.76) as well as in the picture. *Page 435*

527. *Moses with the tables of the law.* Signed (on a damaged part): Rembrandt f. 1659. HdG 25. Bauch 226. A. Heppner (*Oud Holland* 52, 1935, p. 241) has shown that this is a fragment of a larger composition probably intended for the Amsterdam Town Hall. Heppner interprets the subject as Moses solemnly showing to the people the renewed covenant (Exodus XXXIV, 29), but Chr. Tümpel (1968, p. 107; cat. no. 13) sees it as Moses breaking them. The X-ray photographs of Br. 527 and 528, which are highly praised by W. Sumowski (1957/8, p. 237) are not known to me. *Page 438*

528. *Jacob wrestling with the Angel.* Signed on a separate piece of canvas, which was inserted at the lower right corner of the actual painting: Rembrandt f. HdG 13. Bauch 36. The picture was originally larger. Whether it belonged to the same cycle, or commission, as Br. 527 is not clear, (see the information there). M. M. van Dantzig (*Het Vrije Volk*, June 27th, 1956) has declared it to be a fake, but I do not think that this claim can be sustained. J. Rosenberg (*Kunstchronik* 9, 1956, p. 348) calls it a work not easy to explain. As to the X-ray photograph, see no. 527. *Page 439*

530. *Haman and Ahasuerus at the feast of Esther.* Signed: Rembrandt f. 1660. HdG 46. Bauch 37. Although the picture has become rather dark because of the superimposed discoloured varnish, the beauty of the original colours, the yellow- golds and red, can still be sensed. *Page 441*

531. *The disgrace of Haman.* (Genuinely?) signed: Rembrandt f. HdG 48. Bauch 39. Mrs. M.

Kahr (*Journal of the Warburg and Courtauld Institute* 28, 1965, p. 258) and Chr. Tümpel (*Kunstchronik* 19, 1966, p. 302; 1968, p. 74 ; cat. no. 6), independently and with different arguments, have interpreted this subject as a rendering of the book of Esther VI: 1-10: Haman departing to lead Mordecai on his triumphal tour of the capital. Although this explanation has been rejected by J. Nieuwstraaten (*Oud Holland* 82, 1967, p. 61), it seems basically right. (See M. Kahr's reply, *Oud Holland* 83, 1968, p. 63). It replaces I. Linnik's attempt (*Iskusstwo* 19, 1956, no. 7, p. 46; see also *Jahrbuch der Münchner Kunstsammlungen* 3/8, 1957, p. 210; *Burlington Magazine* 99, 1957, p. 422) to read the picture as the story of the fate of Uriah, sent into battle by King David, taking up a suggestion by W. R. Valentiner (1921, p. 128 and *Festschrift für Kurt Bauch* 1957, p. 229).

As far as the execution is concerned, A. B. de Vries (1956, p. 80) posed the question as to whether only the chief person in deep red was painted by Rembrandt. G. Knuttel (1956, p. 266) reported doubts by Jhr. D. C. Roëll and F. Schmidt-Degener. I do not share any of these doubts and reservations. *Page 442*

531A. *The Martyrdom of St. Stephen.* Signed: R f 1625. Bauch 41. The picture was published by me in the *Bulletin des Musées et monuments Lyonnais* 3, 1962/6, p. 57, reprinted in translation in *Apollo* 77, 1963, p. 371. The attribution is accepted by S. Slive (*Bulletin Allen Memorial Art Museum* 20, 1963, p. 127) and by K. Bauch. I have re-checked the signature during another inspection of the picture: it is as given above, contrary to the description in the Lyons *Bulletin*, p. 127, note 4. The picture is the earliest dated picture we know of; it is in size a companion to Br. 460; but in content too? F. Erpel (*Die Selbstbildnisse Rembrandts*, 1967, p. 138) has observed that the portrait-head to the right of Stephen's outstretched arm may be that of Jan Lievens (the one, to the right of the man holding the stone with both hands, is Rembrandt's). An important link in the iconographic tradition of representations of St. Stephen, not known to me in 1962, is the small picture on copper by A. Elsheimer in the Edinburgh National Gallery, published by I. Jost (*Burlington Magazine* 108, 1966, p. 3; see also Catalogue of the Adam Elsheimer exhibition, Frankfurt, 1967, no. 21). *Page 445*

532. *Christ driving the money-changers from the temple.* Signed: R. f. 1626. Bauch 42. Published by W. Stschawinsky in *Starij Gody*, 1916, p. 108, as school of Rembrandt. This attribution was amended to "Rembrandt" by K. Bauch in *Jahrbuch der preussischen Kunstsammlungen* 45, 1924, p. 277; republished (with signature) by V. Bloch in *Oud Holland* 50, 1933, p. 97. The signature came to light during a cleaning outside the museum, around 1930, when the picture was in the Dutch art-trade. I. Graber (*A newly discovered Rembrandt*, Moscow, 1956, p. 4—in Russian; see also *Burlington Magazine* 99, 1957, p. 422) vigorously attacks K. Bauch and V. Bloch and declares both the signature and the picture to be a fake. However, the signature conforms well with the earliest known examples of Rembrandt (compare Br. 531A, 486) and in colour scheme and general handling, the picture is in complete accordance with the other small works of 1626. The painting had been enlarged later on all sides (that occurs more than once with early Rembrandts). G. Knuttel (1956, p. 240; *Burlington Magazine* 97, 1955, pp. 46 and 260) takes the side of sceptics, V. Bloch (*Burlington Magazine* 97, 1955, p. 260 and *Apollo* 80, 1964, p. 292) defends the attribution to Rembrandt as does K. Clark (1966, p. 105). *Page 446*

532A. *The flight of the Holy Family into Egypt.* Signed: RH 1627. Bauch 43. The picture was recognised as a Rembrandt by B. Lossky and published by O. Benesch in *Burlington Magazine* 96, 1954, p. 134. The date has sometimes been incorrectly read as 1625 (A. B. de Vries, 1956, p. 14). *Page 447*

533. *St. Peter denying Christ* (?). Signed with monogram and dated 1628. HdG 333. Bauch 44. Previously known as *St. Paul in the Roman camp*. The new interpretation is due to K. Bauch, who has discussed the iconographic problems once more in *Studien zur Kunstgeschichte*, 1967, p. 143. Chr. Tümpel (1968, cat. no. 8) reverts to the older interpretations ; the theme of the picture, which is a fragment, is probably "St. Paul at Malta". R. J. Judson (*Oud Holland* 79, 1964, p. 142) doubts the authenticity of the picture, which I have never seen. *Page 448*

534. *Christ at the column.* HdG 126. Bauch 45. Bauch has not seen it, I only years ago. I share the doubts expressed by Bauch, who also comments on the bad state (Bauch, 1960, p. 283, note 100). *Page 449*

535. *The Presentation of Jesus in the temple.* Signed: Rembrandt f. HdG 81. Bauch 46. The yellow varnish now tones down the originally powerful contrasts between the yellow and bluish colours, and the whitish-grey of the background. Except for Mary's face in the shadow, the picture is in good condition. The painting is perhaps identical with the one described in the inventory of Prince Frederick

Henry of 1632: "Simeon in the temple, holding Christ in his arms, done by Rembrant or Jan Lievensz" (*Oud Holland* 47, 1930, p. 205). Painted around 1627/8. *Page 450*

536. *The tribute-money*. Signed with monogram and dated 1629. HdG 117. Bauch 48. The drawing Benesch 10 is a study for one of the figures. I have not seen the picture in the original, but there is no reason to cast any doubt on its autograph quality. *Page 451*

[537. *The raising of Lazarus*. Panel, 41×36 cm. Formerly Chicago, Angell-Norris Collection. Signed (?): Remb. . . HdG 107. See note to 538. *Appendix*]

538. *The raising of Lazarus*. HdG 107A. Bauch 51. I think that A. Bredius (*Zeitschrift für bildende Kunst* N.F. 32, 1921, p. 147) was the only one who considered the small version (Br. 537) as the original, and this one as the copy. J. Rosenberg (1964, p. 371) apparently accepts both versions as originals by Rembrandt. The relationship between Lievens' painting of 1631 in Brighton, his etching B.3, Rembrandt's drawing of 1630 (Benesch 17) and this undated composition, seems to me more complex than Bauch pretends (*Pantheon* 25, 1967, p. 166). *Page 454*

539. *Christ at Emmaus*. Signed : RHL. HdG 147. Bauch 49. Painted about 1628. Bauch (1960, p. 201) dates it 1629, and later (1966) around 1630. (See also the catalogue of the Rembrandt exhibition Amsterdam, 1956, no. 10). I prefer the earlier dating. The drawing, Benesch 11 (with the composition in reverse), is of the same period. It is generally believed that Rembrandt's composition was based on Elsheimer's picture of *Philemon and Baucis*, which was known to Rembrandt through the engraving of H. Goudt. (J.L.A.A.M. van Ryckevorsel, *Rembrandt en de traditie*, 1932, p. 77). The traditional nimbus of Christ is replaced by exaggerated natural light. *Page 452*

539A. *Judas returning the thirty pieces of silver*. Signed with monogram and dated 1629. Bauch 47. This dramatic picture was enthusiastically praised by Constantijn Huygens, the secretary to the stadholder Frederick Henry, in an autobiography, written about 1629/30 (A. H. Kan, *De jeugd van Constantijn Huygens*, 1936, p. 79; S. Slive, *Rembrandt and his critics*, 1953, p. 15). Huygens even exaggerates the narrative action, and the expressions of the figures. The composition was already known through different copies (see HdG 123); this version was first published by C. H. Collins Baker (*Burlington Magazine* 75, 1939, pp. 179 and

235). Bauch's book (*Der frühe Rembrandt und seine Zeit*, 1960) starts with these words: "Rembrandt's 'Judas' has come to light again. The significance of the art that produced this work will be related in this book." L. Münz (*Jahrbuch der Kunsthistorischen Sammlungen in Wien* 50, 1953, p. 182) is more reserved: "Notwithstanding bad conservation in parts, this version has the best claim to be considered as the original one." The remarks about the condition are true. The drawing Benesch 8 is a sketch for the picture, those of Benesch 6 verso and 9 are studies for details. *Page 453*

540. *The Rest on the Flight into Egypt*. HdG 87. J. G. van Gelder (*Mededelingen der Kon. Nederl. Akademie van Wetenschappen, afd. letterkunde*, N.R. 16, 1953, p. 293, note 50; *Burlington Magazine* 95, 1953, p. 37, note 9) has rightly attributed the picture to G. Dou, perhaps with the collaboration of Rembrandt. K. Bauch (1960, p. 283; 1966, p. 49) seems to accept this suggestion. Not accepted as a Rembrandt by J. Rosenberg (1964, p. 371). *Page 454*

541. *The Adoration of the Magi*. The picture was formerly attributed to Salomon Koninck, but published by O. Granberg (*Burlington Magazine* 27, 1915, p. 49; *Tidskrift för Konstvetenskap* 1, 1916, p. 99) as a Rembrandt. The attribution to Rembrandt was accepted by W. R. Valentiner (1921, p. 21). Modern critics, however, like K. Bauch (1960, pp. 231, 283; 1966, p. 49) and W. Sumowski (1957/8, p. 233) revert to the attribution to Salomon Koninck. J. G. van Gelder (*Mededelingen der Kon. Nederl. Akademie van Wetenschappen, afd. letterkunde*, N.R. 16, 1953, p. 293, note 57) attributes it to (Rembrandt and) Dou; others like C. Müller Hofstede (*Kunstchronik* 9, 1956, p. 91) express doubts, or reject the attribution to Rembrandt (J. Rosenberg, 1964, p. 371). I wonder whether an attribution to a Haarlem painter like the (early) W. de Poorter or P. de Grebber would be nearer the mark. A certain fluency combined with Rembrandt-esque chiaroscuro would seem to me a typical Haarlem interpretation of Rembrandt's art. In the meantime, a small sketchy painting of the same composition (signed Rembrandt and dated 1632) has been found in the Hermitage in Leningrad, and is believed by the Russian art historians and K. Bauch to be the original sketch by Rembrandt (I. Linnik, *Bulletin du Musée de l'Ermitage* 29, 1968, p. 26—in Russian). Judging from the photograph only, I cannot yet share this optimistic view. *Page 455*

542. *Zacharias in the temple*. (Genuinely?) signed: Rembrandt f. HdG 72. There is a better ver-

sion in the Mecklenburgisches Landes-museum in Schwerin (Cat. 1951, no. 143; Rembrandt exhibition Warsaw 1956, no. 47) which is generally attributed to Salomon Koninck. O. Benesch (*Rembrandt drawings*, 1954, no. 103 ; *Kunstchronik* 9, 1956, p. 202) prefers an attribution to Jan Lievens. I am not sure about either attribution, but I reject any attribution to Rembrandt of the Schwerin picture and the version, Br. 542. The latter is not accepted by Bauch either (1960, p. 283; 1966, p. 49). *Page 455*

543. *The Presentation of Jesus in the temple*. Signed (redrawn): RHL 1631. HdG 80. Bauch 52. A semi-circular arch was added to the top in order to make the picture a companion to G. Dou's *Young Mother*, also in the collection of the Stadholder. A recent cleaning has revealed the extreme delicacy of the colouring and the design which makes this moving work a highpoint of Rembrandt's Leyden style. There has been some difference of opinion as to whether the imposing figure seen from behind is Hannah or a high priest: W. Stechow (*Print Collectors Quarterly* 1940, p. 371, note 7) first put forward the Hannah-interpretation, but H. Schulte Nordholt (*Openbaar Kunstbezit* 4, 1960, no. 40) sees Hannah as the figure descending the stairs. It is Chr. Tümpel (1968, p. 207) who points to the exact Biblical story (Luke II:21-39): the encounter with Simeon and Hannah in the midst of the temple, not before the altar. There are several copies known, one in Dresden, by W. de Poorter; another in the London collection of A. Soós, who claims his property to be the original and Br. 543 to be a work of C. v. d. Pluym! (A. Soós, *Rembrandt, Simeon in the Temple*, London, 1965). *Page 456*

543A. *Christ on the Cross*. Signed (redrawn?): RHL 1631. Bauch 54. The picture was recognised as a Rembrandt at the Louvre, after it had been cleaned. It was published by K. Bauch (*Pantheon* 20, 1962, p. 137). It is obvious that this Cruxifixion has some connection with the Passion series, which Rembrandt made later for Prince Frederick Henry (see Br. 548, 550, 557, 560, 561). It may have been a kind of trial-picture, which in the event did not come into the Stadholder's collection. I think it is more likely, however, that Rembrandt—in imitation of Rubens—made first this *Christ on the Cross*, added shortly afterwards the *Raising of the Cross*, and *Descent from the Cross*, also after a Flemish pattern, by which he tried to outdo Rubens. Huygens may have seen these pictures in the making, which resulted in a purchase and finally in a commission for a

"series". The *Christ on the Cross* is very close in design and expression to Lievens' work in Nancy (H. Schneider, *Jan Lievens*, 1932, no. 35), which makes the common origin as a Leyden undertaking side by side with Lievens still more probable. *Page 457*

544. *The Holy Family*. Signed: Rembrandt f. 163 .. HdG 92. Bauch 53. The picture was formerly thought to be dated 1631, which to my mind did not match with its Baroque style of about 1635. On my request, Dr. E. Brochhagen has gone into the case and ascertained that the last digit was painted on a later, added strip. The top of the picture was originally flat, with a semi-circular projection in the centre. G. Knuttel (1956, p. 249) had already doubted the date and J. Rosenberg (1964, p. 196) stressed the fact that "in character it is closer to the Amsterdam period". The X-ray reveals strong underpainting, to be compared with the structure of a Rubens. *Page 467*

545. *The Good Samaritan*. HdG 111. Bauch 55. Although this small picture is the reverse of the etching Münz 196 and could therefore very well be the original sketch for it, I think the execution is so timid and the (architectural) details so insecure, that the picture must be considered an old copy after a (lost) original. Doubts on the authenticity have been expressed earlier by W. Martin (*The Times*, March 3rd, 1922; *Kunstwanderer* 3, 1921/2, p. 33 and ditto 4, 1922/3, p. 410); they were contradicted by D. S. MacColl in *The Burlington Magazine* 45, 1924, p. 16, and by L. Münz (1952, II, p. 94). *Page 458*

546. *Christ before Pilate and the people*. Signed: Rembrandt f. 1634. HdG 128. Bauch 62. Painted in brownish, monochrome colours as a preparatory study for the etching Münz 204, dated 1635. *Page 466*

547. *Christ in the storm on the Lake of Galilee*. Signed: Rembrandt. f. 1633. HdG 103. Bauch 58. The composition is partly derived from an engraving by Maerten de Vos (reproduced in: K. E. Maison, *Themes and Variations*, 1960, p. 99). The surface of the picture has suffered from abrasion, with the result that the bluish and pink colours look rather modern and are no longer perfectly harmonious; but the strong light blue is Rembrandt's, of a kind that can be seen for instance on Br. 501. *Pages 459 & 460*

548. *The raising of the Cross*. HdG 130. Bauch 57. This and Br. 550 are the first pictures in the set bought through Constantijn Huygens for Prince Frederick Henry (see also no. 543A).

We are rather well informed about this affair through seven letters by Rembrandt (the only ones in existence; see H. Gerson, *Seven Letters by Rembrandt*, 1961) to Constantijn Huygens, the Stadholder's secretary. In the first letter, which has a date of 1636 (added later; by Huygens?) Rembrandt writes that he is "very diligently engaged in completing as quickly as possible the three Passion pictures, which His Excellency himself commissioned him to do: an Entombment, a Resurrection and an Ascension of Christ. These are companion pictures to Christ's Elevation and Descent from the Cross". From this wording, it can be deduced that both the Erection and Descent were not actually ordered by, but bought through Huygens from Rembrandt, who had started painting them on his own account. E. Brochhagen (*Katalog III, Holländische Malerei des 17. Jahrhunderts*, Alte Pinakothek, Munich, 1967 and *Kunsthistorische Studien, Hans Kauffmann, zum 70. Geburtstag*, 1967) has carefully treated the drawings connected with it and the pentimenti revealed through X-ray examination. The most interesting observation is that the position of Christ's head was in the first version nearer to that of the *Christ on the Cross* of 1631 (Br. 543A). I. Bergström (*Nederlands Kunsthistorisch Jaarboek* 7, 1966, p. 165) has discussed the significance of Rembrandt's self-portrait under the cross. *Page 461*

550. *The descent from the Cross.* Faked signature: C Rhmbrant. HdG 134. Bauch 56. The composition is etched (in reverse) by Rembrandt himself (Münz 197). The etching is signed and dated 1633 and in a second versino (Münz 198) as: Rembrandt f cum pryvlo: 1633. Rembrandt used in this wording a Flemish pattern to protect his etchings from being copied and sold by others. For interpretations and literature see Br. 548. E. Brochhagen (*loc. cit.*, at Br. 548) has reported on the pentimenti, which show that there was a first version (under the actual one) exactly in accordance with the details of the etching. The face of the man on the ladder is again that of Rembrandt, but this time of a very early type (see also G. Lenge in *Das Münster* 20, 1967, p. 52). *Page 462*

551. *The descent from the Cross.* Signed: Rembrandt f. 1634. HdG 135. Bauch 59. An excellent reworking of the 1633 version, wholly by Rembrandt himself, with still greater emphasis on the physical action and the response of the mourners. *Page 463*

552. *The risen Christ showing His wound to the apostle Thomas.* Signed: Rembrandt f. 1634. HdG 148. Bauch 60. Excellently preserved, and with a genuine signature. *Page 464*

552A. *The Flight into Egypt.* Signed: Rembrandt f. 1634 (?). The date is difficult to read. Bauch 61. The picture appeared for the first time at the Clinton sale, London, Sotheby, July 19th, 1950 (lot 114). Except for G. Knuttel (1956, p. 240) it seems to have been—rightly—accepted by those who saw it at the Royal Academy exhibition, London 1952-3 (no. 35). For a favourable comment see: J. G. van Gelder in *Burlington Magazine* 95, 1953, p. 37; E. Plietzsch in *Kunstchronik* 6, 1953, p. 122. *Page 465*

554. *The Entombment of Christ.* HdG 139. Bauch 74. I agree with Bauch that this wonderful sketch must have been intended for a (never executed) etching. I disagree with him, however, and with J. G. van Gelder (*Burlington Magazine* 92, 1950, p. 328) and W. R. Valentiner (*Art Quarterly* 19, 1956, p. 404) that the picture should be dated later (Valentiner even 10 years later) than Br. 560. I think the powerful brushwork is completely in accordance with the energetic drawings of the 1630s. *Page 468*

555. *St. John the Baptist preaching.* HdG 97. Bauch 63. The painting, a grisaille (intended for an etching?), was originally smaller but it was enlarged all around with a strip of about 10 cms. in width by Rembrandt himself, perhaps in the 1650s (W. Sumowski, 1957/8, p. 228), although the sketch itself dates from around 1635/6. According to Benesch, his Add. no. 10 is a project for the composition (see Benesch's exhaustive comments and J. Rosenberg's criticism in *Art Bulletin* 41, 1959, p. 118). There are several detail-studies for some of the figures (Benesch 140-2, 336) and one for St. John himself ([A. Seilern], *Paintings and drawings III*, London, 1961, no. 182) and there is finally a later drawing (Benesch 969) of the whole composition with the frame, done around 1650. C. Neumann (*Aus der Werkstat Rembrandt's*, 1918, p. 83) was the first to observe that this drawing was expressly done for the frame and F. Lugt (*Inventaire général des dessins*, Musée du Louvre, 1933, no. 1131) believed that the drawing was done when Jan Six acquired the painting. At the Baptist's feet, Rembrandt has painted himself and his mother. *Page 469*

556. *The Rest on the Flight into Egypt.* Signed (?): Rembrandt f. HdG 89. Bauch 50. The recent Mauritshuis catalogue and Bauch (1960, p. 133; 1966, p. 4) doubt the attribution or call it a copy after an early Rembrandt. J. Rosenberg (1964, p. 371) has also—rightly—struck it off the list of Rembrandt's works. *Page 470*

557. *The Ascension of Christ.* Signed: Rembrandt f. 1636. HdG 149. Bauch 64. For literature and

notes see the remarks under Br. 548. The letter of Rembrandt, quoted there, continues: "of these three aforementioned pictures, one has been completed, namely Christ ascending to Heaven and the other two are more than half done . . ." The signature and date of the picture agree well with the presumed date of the letter, 1636. E. Brochhagen (*loc. cit.*, at Br. 548) has published the X-rays, from which it can be seen that Rembrandt originally painted above the head of Christ a figure of God the Father. This scheme and the angels supporting the clouds belong to the iconography of an *Assumption of the Virgin* which, as a compositional idea, Rembrandt may have had in mind when composing (and later changing) this *Ascension*. The model was probably Titian's *Assumption* (1516-18. Venice, Santa Maria dei Frari) or one of Rubens' own derivatives from it. *Page 471*

558. *The parable of the labourers in the vineyard.* (Good) signature: Rembrandt f. 1637. HdG 116. Bauch 65. The powerful design corresponds exactly with the character of many drawings of this period. The drawings Benesch 329-335, in particular, are close in style. *Page 472*

559. *The risen Christ appearing to the Magdalen.* Signed: Rembrandt f. 1638. HdG 142. Bauch 66. This excellent picture was originally bought from Valerius de Reuver for the Cassel collection; de Reuver owned it already in 1721. On the back of the picture is pasted the written copy of a poem by Jeremias de Decker ("On the painting of the risen Christ and Mary Magdalen, painted by the excellent master Rembrandt van Rijn for H.F. Waerloos"), published in 1660. Notwithstanding C. Hofstede de Groot's objections (*Urkunden*, 221) this poem is really written in praise of this picture (K. H. de Raaf, *Oud Holland* 30, 1912, p. 6). Benesch (no. 537 and no. 538) denies that these drawings are studies for this picture, but I think Benesch's dating of the drawings is too late. *Page 473*

560. *The entombment of Christ.* HdG 140. Bauch 68. Together with Br. 561, the two last pictures of the set, which were—in 1636—more than half done. See notes to Br. 548 and 557. In another letter, dated 12th January, 1639, Rembrandt announces to Huygens that the two pictures "the one being where Christ's dead body is being laid in the tomb and the other where Christ arises from the dead to the great consternation of the guards, these same two pictures have now been finished through studious application." His excuses for the tardy delivery were that the pictures have

been executed with "die meeste ende naetuereelste beweechgelickheyt", words which are difficult to interpret; they mean either "the most natural movement" or "most innate emotion" (see H. Gerson, *loc. cit.* p. 38-9 and the literature quoted there). The picture has suffered considerably. Several copies exist, two are in Dresden, of which no. 1566 seems to be one from Rembrandt's studio with a repainted signature of Rembrandt and dated 1653 (Bauch, 1966, A 11). *Page 474*

561. *The resurrection of Christ.* Signed: Rembr. . .t 163. . HdG 141. Bauch 67. See notes to Br. 560. There is an unusual inscription of the restorer on the back of the picture: Rimbrand Creavit me P.H. Brinkman resuscitavit Te, 1755. The court-painter Ph. H. Brinckmann therefore restored the picture in 1755, and also probably transferred it from canvas to panel. Consequently, L. van Puyvelde (*Dutch drawings at Windsor*, 1944, no. 117), W. Sumowski (1957/8, p. 225) and Bauch have assumed that the figure of Christ in the sarcophagus was added by this restorer too. There is a drawing by L. Doomer in Windsor and an old painting in Munich (inv. 4894), which copy Rembrandt's composition without the figure of Christ. E. Brochhagen (*loc. cit.*, at Br. 548) contradicts this thesis. From X-rays, it can be deduced that Rembrandt himself made changes in the composition during the four or five years he worked on it. The idea of combining the Resurrection of Christ with the appearance of the angel, moving the stone, is very unusual and is commented upon by H. Kauffmann (*Jahrbuch der preussischen Kunstsammlungen* 41, 1920, p. 74), Chr. Tümpel (1968, p. 196) and K. Bauch (*Kunsthistorische Studien*, 1967, p. 129). *Page 475*

562. *The meeting of Mary and Elizabeth (The Visitation).* Good signature: Rembrandt. 1640. HdG 74. Bauch 70. J. Bruyn (*Rembrandt's keuze van bijbelse onderwerpen*, 1959, p. 9) has pointed out that this subject is almost unique in Rembrandt's work. The source of inspiration was probably Dürer. The character of the setting owes a good deal to Lastman. *Page 476*

563. *The Holy Family.* Signed: Rembrandt f. 1640. HdG 93. Bauch 71. The X-ray, published by M. Hours (*Bulletin du laboratoire du Louvre*, 1961, no. 6) shows an unusual light near the window. *Page 477*

564. *The raising of the Cross.* Bauch 75. Published by A. Bredius in *Gazette des Beaux-Arts* 63, 1931,

p. 231. I cannot agree with Bredius' comments that this is a replica of Br. 548, "altered and improved by Rembrandt himself". It is a crude imitation, vaguely based on Rembrandt. Bauch has expressed cautious doubts ("nicht ganz sicher".) *Page 478*

565. *The lamentation over the dead Christ.* HdG 136. Bauch 69. Sketch, in brown and grey, probably intended as a "modello" for an etching. W. Stechow (*Jahrbuch der preussischen Kunstsammlungen* 50, 1929, p. 226) has written a monograph on this composition. O. Benesch (no. 63) and N. MacLaren (1960, p. 304) have studied in detail the condition of the painting and its date, and were able to correct some of Stechow's observations. The composition, which "has been altered drastically several times", was being worked on from 1637/8 onwards, for a considerable length of time. The drawing of the lower part of Br. 565 in the British Museum (Benesch 154) was also cut by Rembrandt and reworked again. *Page 478*

566. *Christ and the woman taken in adultery.* Signed: Rembrandt f. 1644. HdG 104. Bauch 72. N. MacLaren (1960, p. 308) rightly observes that "to a limited extent the picture harks back to a much earlier phase of Rembrandt's evolution, namely in the finish and elaboration of detail, and in the construction of the background". MacLaren has also corrected the history of the picture which can be traced back well into the 17th century. There are preparatory drawings (Benesch 531-535, Addenda C 5, 535, A 42; some are copies). See also the notes to Br. 366. *Pages 479, 480 & 481*

568. *The Holy Family.* HdG 91. The picture has lately been cleaned and is extensively discussed by P. J. J. van Tiel in *Bulletin van het Rijksmuseum* 13, 1965, p. 145 and J. G. van Gelder in *Openbaar Kunstbezit* 10, 1965, p. 36. The latter stresses the problem of dating, but with Van Tiel arrives at a date around 1638/40. A. B. de Vries, (1956, p. 49): 1645/6, in agreement with W. Bode and C. Hofstede de Groot. The question of dating is related to that of authenticity: the painterly execution resembles Rembrandt's manner of the 1640s, though it is much dryer than, say, Br. 570 and 572; the composition, however, with its effects of light and shadow is rooted in Rembrandt's style of the 1630s and is nowhere to be found in a real Rembrandt of the 1640s. This combination is—to my mind—typical of a studio work. I came to this conclusion without knowing R. Hamann's opinion (*Rembrandt*, 1948, p. 288) or that of K. Bauch (1966, p. 49); their tentative attribution to Nicolaes Maes is not un-

reasonable. J. Q. van Regteren Altena (*Oud Holland* 82, 1967, p. 70) emphatically rejects Bauch's suggestion and so does J. G. van Gelder (*loc. cit.*): "the only thing that we are certain about, is that we are standing before a work of Rembrandt, and of nobody else"(!). *Page 482*

569. *Joseph's dream in the stable at Bethlehem.* Signed thinly and redrawn: Rembrandt f. 1645. HdG 85. Bauch 76. Companion piece to Br. 514. Chr. Wolters (*Die Bedeutung der Gemäldedurchleuchtung mit Röntgenstrahlen*, 1938, p. 60, repr. 96/7) published X-ray photos, which among other things show that important changes were made in the area of the angel. *Page 482*

570. *The Holy Family with angels.* Signed: Rembrandt f. 1645. HdG 94. Bauch 73. The drawing Benesch 567 is a preparatory study, and Benesch drawings 569 and 570 are probably connected with it. Benesch rightly stresses that the sketch 567 is "one of Rembrandt's most brilliant projects for the layout of a painting". The painting Br. 375 is not a study for, but a copy after this picture (by a pupil of Rembrandt). *Page 483*

572. *The Holy Family (with painted frame and curtain).* Signed: Rembrandt fc 1646. HdG 90. Bauch 77. Miss R. J. Manke has referred to a drawing by N. Maes (private collection Oxford) as being a copy after this picture, but giving it a rounded upper portion. The X-ray picture is as delicate as the surface of the work, only the little pot being well marked by a stronger use of white. *Page 486 & 488*

574. *The Adoration of the Shepherds.* Signed indistinctly and dated 1645. HdG 78. Bauch 79. In November 1646, Rembrandt received 2,400 guilders from the treasury of Prince Frederick Henry for a Nativity and a Circumcision (*Urkunden* 107). In the inventory of 1667 these two paintings were united with the so-called Passion series (Br. 548, 550, 557, 560, 561) all "done by Rembrandt, all in black frames, with oval top and encircled by gilt carved foliage". The *Circumcision* has been lost, but the *Nativity* is identical with this *Adoration of the Shepherds*. A copy of the lost *Circumcision* is in the Museum of Brunswick (repr. in W. R. Valentiner, 1921, p. 104). *Page 484*

575. *The Adoration of the Shepherds.* Signed: Rembrandt f. 1646. HdG 77. Bauch 78. The composition of this freely-painted picture is more or less in reverse to Br. 574. Its underpainting is as vigorous and differentiated as its surface. There are several pentimenti. *Page 485*

576. *The rest on the flight into Egypt.* Good signature: Rembrandt f. 1647. HdG 88. Bauch 80. One of the most sensitively painted landscapes with figures in the Elsheimer tradition. Some of the background details recall the vigorously painted trees of the landscape in the Louvre (Br. 450). *Page 487*

577. *Hannah in the Temple*(?). Signed: Rembrandt f. 16(50). HdG 154. Bauch 81. The date is difficult to read, but on the evidence of infrared photography, it "can hardly be anything except 1650" (Colin Thompson, Keeper of the National Gallery of Scotland, Edinburgh). The subject was earlier interpreted as Timothy and his Grandmother. The problems of interpretation are discussed extensively by Chr. Tümpel (1968, p. 162; cat. no. 9): The background illustrates the song of praise by Simeon at the Presentation in the Temple (see Br. 543), without the figure of Hannah. This prophetess has become the chief feature of the foreground. That she and the boy are grouped together is a compositional device of school-pictures. From iconographic reflections, Tümpel comes to the conclusion that the picture is the work of a pupil, corrected by Rembrandt. His conclusion meets the doubts about the authenticity voiced by Bredius and Bauch. The pupil—to my mind—should be somebody in the manner of S. van Hoogstraeten, perhaps Abraham van Dijck. *Page 489*

578. *Christ at Emmaus.* Signed (signature reinforced but genuine): Rembrandt f. 1648. HdG 145. Bauch 82. K. Bauch (1960, p. 187) has given a sensitive interpretation of the use of light in the painting. W. S echow (*Zeitschrift für Kunstgechichte* 3, 1934, p. 337) has discussed the iconographic tradition of this and Br. 579. Kenneth Clark (1966, p. 60) and others have observed the Leonardesque type of Christ with which Rembrandt would have become familiar through the woodcut of the *Small Passion* by Dürer (1511). On the other hand, one should not overlook the Venetian character of the background, with its monumental niche. The X-rays published by M. Hours (*Bulletin du laboratoire du Louvre* 6, 1961, no. 6) confirm the thorough construction of the picture. The yellow varnish has softened both the richness of colour, the restorations and nuances in the design. *Page 490*

579. *Christ at Emmaus.* Signed: Rembrandt f. 1648. The signature is good, the date very thin. HdG 144. One of the three cases where I disagree with Bauch (1966, p. 49: free good repetition of Br. 578) about the group of pictures which he eliminates from the first

Bredius edition. The other examples are Br. 68 and Br. 597. I fully accept J. Q. van Regteren Altena's view (*Oud Holland* 82, 1967, p. 70) that the picture is a genuine Rembrandt; Altena had earlier given an iconographic and stylistic history of the development of the subject and its relation to the Last Supper representation. He also draws attention to the unorthodox lighting from the right which Rembrandt had employed before in the "Hundred Guilders" print (*Kunstmuseets Aarsskrift* 35/6, 1948/9, p. 1). The beautiful detail of the curtain to the left would probably regain its place in the overall colour scheme if the picture were cleaned. *Page 491*

[580. *The Good Samaritan.* Canvas, 29.5 cm × 36 cm. Berlin-Dahlem, Gemäldegalerie. HdG 110. The picture is no longer exhibited with the other Berlin Rembrandts. The doubts which Bredius expressed have been taken up by J. Rosenberg (1964, p. 371), K. Bauch (1966, p. 49), and others, who deny the attribution to Rembrandt. I agree with Bauch that this sketch is an 18th-century painting. *Appendix*]

[581. *The Good Samaritan.* Canvas, 114 × 135 cm. Paris, Louvre. Faked signature: Rembrandt f. 1648. HdG 112. After an attempt by G. Falck to attribute the picture to B. Fabritius, (*Tidskrift för Konstvetenskap* 9, 1924/5, p. 82) Mme. C. Brière Misme (*Musée de France* 5, 1949, p. 122) has convincingly demonstrated that the picture is in any case a work of the Rembrandt studio, related to drawings by Rembrandt and his pupils. The drawing nearest to the picture is Benesch 1018 (Chicago), but this drawing is probably by the same hand as the picture and not by Rembrandt. There seems to be full agreement about the school-character of the picture in question, less about the drawings, and no solution as to which pupil in particular. I do not share the admiration for the supposed quality of the picture, which culminates in a tentative attribution to Carel Fabritius (W. Sumowski, 1957/8, p. 232; W. R. Valentiner in *Art Quarterly* 19, 1956, p. 394). My guess is G. van den Eeckhout, but the preparatory drawing in Chicago does not bear out my idea, at least if the drawing is supposed to be done for and not after the picture. *Appendix*]

582. *The lamentation over the dead Christ.* Signed (?): Rembrandt f. 1650. HdG 137. Bredius (see notes in first edition) always defended the attribution to Rembrandt, for the last time when publishing a so-called oil sketch for the picture (*Oud Holland* 54, 1937, p. 219). This sketch, however, is a late and superficial work, probably by Jan Lievens. W. R. Valen-

tiner (catalogue of the exhibition, *Rembrandt and his school*, Raleigh, N.C., 1956, no. 19) also defends Br. 582 ("the composition is far superior to anything even the best pupils could create"). Paul C. Grigaut (*Art Quarterly* 19, 1956, p. 410) has pointed to the disturbing state of the picture. K. Bauch (1966, p. 49), and J. Rosenberg (1964, p. 371) have rightly denied the attribution to Rembrandt; W. Sumowski (1957/8, p. 231/5) has carefully collated the school drawings and sketches connected with this picture, in order to make a tentative attribution to Barend Fabritius or N. Maes, though neither he—nor I—have seen the picture itself. *Page 492*

583. *The Risen Christ appearing to the Magdalen.* Signed: Rembrandt 165(1). There seem to be traces of letters before the signature. HdG 143. Bauch 83. The picture is now so dark and thin that it is difficult to judge properly the painterly qualities of the surface, which may have suffered from abrasion. Some connection with the work of Samuel van Hoogstraten seems likely. *Page 494*

584. *The Descent from the Cross.* Signed: Rembrandt f. 165(1). HdG 133. Bauch 84. Contrary to the general opinion, perhaps best expressed in J. Rosenberg's moving description of this "highly important" work (1964, p. 220), I regard the execution of this painting as very definitely by a pupil, basing his repetition on the early Rembrandt of 1634 (Br. 551). The pupil partly retained the style of the turban-headed figures from the earlier picture (Bauch presumes that the figure with the turban is overpainted!), but mostly he adopts the Rembrandt technique of the 1650s. I think the gestures are lame, the expression sentimental and the composition as a whole lacks concentration. These shortcomings, together with quite a good painterly technique, point to a pupil like B. Fabritius or S. van Hoogstraten. There is some stylistic relationship with the replica of Br. 560 in Dresden (no. 1566). *Page 493*

586. *The Tribute-money.* Signed: Rembrandt f. 1655. HdG 118. Bauch 85. F. Schmidt-Degener (*De Gids* 1919, I, p. 253) suggested that this may be a sketch for an overmantle picture for the treasury room of the Amsterdam Town Hall, a picture which no longer exists, but which had been praised in a poem by Vondel, who, however, does not give any painter's name. C. Nordenfalk (*Konsthistorisk Tidskrift* 25, 1956, p. 81) supports Schmidt-Degener's idea as well as the attribution to Rembrandt, which must have been questioned by R. Hamann (*Rembrandt*, 1948, p. 231) and H. Schnei-

der (reported by H. van de Waal, *Drie eeuwen vaderlandse geschiedenis*, 1952, p. 217). The attribution which has been proposed is G. van den Eeckhout. I have not seen the picture. *Page 495*

588. *Christ and the woman of Samaria at the well.* Signed: Rembrandt f. 1655. HdG 100. Bauch 86. See no. 589. *Page 496*

589. *Christ and the woman of Samaria at the well.* Signed: Rembrandt f. 1655. HdG 101. Bauch 87. The subject appears repeatedly in Rembrandt's works of the 1650s, also in drawings and etchings, with a strong Venetian flavour. I see in both these versions (and also in Br. 592A) powerful interpretations of Rembrandt, which are moreover quite distinct from each other in emotional content and compositional structure. I can not therefore share W. Sumowski's (1957/8, p. 231) negative opinion of Br. 589 ("compilation by a pupil"). *Page 496*

590. *Christ on the Cross.* Genuinely (?) signed: Rembrandt 16(51). First published by W. R. Valentiner (1921, p. 79). Bauch 89. The last digit of the date is uncertain. W. R. Valentiner read it as 1656. Bauch as 1657. Bauch (*Pantheon* 20, 1962, p. 144, note 5) sees the picture as an example of Rembrandt's last manner, though this would obviously contradict the date on it. I agree to the latish Rembrandt-style, but I wonder whether the modelling is not too loose and the expression too sentimental to attribute the execution to Rembrandt himself. *Page 497*

591. *Christ at the column.* HdG 125. Bauch 192. Bredius had already suggested that the dating "about 1646" would be the most satisfactory, since the small picture is related in style (as well as in the choice of model) to the etchings and drawings of that period. A. B. de Vries (1956, p. 52) dates it accordingly, and stresses the emotional content as a "Christ at the column", whilst for Bauch it is in the first place a life study after a nude. I share Bauch's interpretation, but I believe it is the work of a pupil (many of the nude drawings of this type are also school-works; see H. Gerson in *Kunstchronik* 10, 1957, p. 148): nicely but timidly executed, without Rembrandt's sense of grandeur or his feeling for outline and masses. It could be a work of G. van den Eeckhout. *Page 479*

592. *The Adoration of the Magi.* (Genuinely ?) signed: Rembrandt f. 1657. HdG 84. Bauch 88. Since the picture has become better known through recent exhibitions, doubts about its autograph quality have been expressed by several

scholars: J. G. van Gelder (*Burlington Magazine* 92, 1950, p. 328/9): not a Rembrandt, pupil in the manner of C. Renesse; W. Sumowski (1957/8, p. 231): "compilation by a pupil"; K. Bauch: "to a great extent executed by a pupil". The connection with Br. 526 and the drawings, Benesch 1029/31 which has been suggested, does not support an attribution to Rembrandt. I feel again, that the execution points to the 1660s; perhaps a work by A. de Gelder? A copy was in the Cook sale, London, Sotheby, June 25th, 1958 (no.114). *Page 497*

592A. *Christ and the woman of Samaria at the well.* Signed: Rembrandt f. 1659, the signature is genuine but redrawn. HdG 102. Bauch 91. From Bredius Ms. notes I report the comment: "rather questionable". I would however stress that the picture, although it is very thin and the surface has suffered, fits perfectly with the monumentally designed compositions of this subject in a Venetian mood of the 1650s. It has to be valued as the last, beautiful example of this series. *Page 498*

593. *Christ at the column.* Faked signature: Rembrandt f. 1658. HdG 124. Bauch 90. The date has been read also as 1668, but G. Knuttel (1956, pp. 196 and 266) and J. Rosenberg (*Art Quarterly* 19, 1956, p. 381) claim 1658 as the year of execution. W. R. Valentiner (1921, p. 128) was of the same opinion, though he believed that the picture was repainted for a second time by Rembrandt himself, about 1668. Several other versions exist, one under a wrongly attributed, so-called self-portrait by Rembrandt (repr. cat. *Rembrandt Ausstellung*, Zürich, Katz Galerie, 1948, no. 29; M. Porkay, *Das gegeisselte Rembrandt-Bild*, 1951). Bauch expresses some doubts about the execution but states that the underpainting, as revealed by X-rays, is in accordance with authentic Rembrandts. I wonder whether one can be so certain about an X-ray photograph (which I regret not having seen in this case). The surface-painting, anyhow, is a pupil's work in every detail. Benesch's suggestion "pupil in the manner of Barend Fabritius" is very much to the point (*Actes du 17e congrès international d'histoire de l'art* 1952, 1955, p. 402). See also W. Sumowski (1957/8, p. 231). Benesch came to the same conclusion, when discussing the Rembrandt drawing in Amsterdam (Benesch 311), but I think (with others) that he dates the drawing much too early. *Page 499*

594. *The Apostle Peter denying Christ.* Signed: Rembrandt 1660. HdG 121. Bauch 92. M. D. Henkel (*Pantheon* 6, 1933, p. 292 and *Burlington Magazine* 64, 1934, p. 153; 65, 1934, p. 187)

stresses that G. Segher's composition was the model for Rembrandt's picture, while J. R. Judson (*Oud Holland* 79, 1964, p. 141) points to a drawing by J. Pynas (P. de Boer collection, Amsterdam). M. D. Henkel also discussed the drawings connected with this picture (Benesch 1050 and Valentiner, *Rembrandt Zeichnungen*, no. 465), about which opinion is divided. H. v. Einem (*Wallraf-Richartz-Jahrbuch* 14, 1952, p. 202/5) referred in this context to the Homer theme of blindness and weakness. An affectionate appreciation of this powerful picture is to be found in H. E. van Gelder's *Rembrandt, Saul en David, Petrus verloochent Christus*, 1948. *Page 502*

[595. *Pilate washing his hands.* Canvas, 129×165 cm. New York, Metropolitan Museum of Art. HdG 129. Today, it seems almost incomprehensible that this empty picture should ever have been hailed as a great achievement of Rembrandt's art. I am not even sure, in my own mind, whether the picture was really executed in the Rembrandt circle. The soldiers to the left should probably provide a clue to the identity of the (Haarlem?) painter. Copies after parts of the picture exist (one reproduced in *Weltkunst* 29, 1959, no. 13, another mentioned in Hofstede de Groot). The attribution to Rembrandt is denied by J. Held (*Art Bulletin* 26, 1944, p. 265: "while largely a work of one of Rembrandt's pupils, [it] is clearly based upon a characteristic idea by the master himself"), O. Benesch (Drawings VI, p. 195, no. A 119), J. Rosenberg (1964, p. 371) and K. Bauch (1966, p. 49). *Appendix*]

596. *The Circumcision of Christ.* Signed: Rembrandt f. 1661. HdG 82. Bauch 93. Contrary to iconographic tradition, Rembrandt has visualized the scene not in the temple, but in the stable. Chr. Tümpel (1968, p. 201) assumes that a correct interpretation of the Biblical text (Luke II:21) would place the Circumcision indeed not in the temple but in the home. Rembrandt's picture is a superb example of his late style, when he was turning away from a too emphatic and powerful construction of form to a looser, more sensuous, even picturesque rendering of the subject. *Page 500*

597. *Christ at Emmaus.* HdG 146. The attribution to Rembrandt has always been questioned (see notes to the provenance in Hofstede de Groot) and modern scholars like Benesch (A66), W. Martin (*Der Kunstwanderer* 3, 1921/2, p. 33), Bauch (1966, p. 49), W. Sumowski (1957/8, p. 226) and Rosenberg (1964, p. 371) have more or less emphatically denied its authenticity. J. Q. van Regteren Altena had included it in his

essay "Rembrandts *Way to Emmaus*" (*Kunst-museets Aarsskrift* 35/6, 1948/9, p. 24, notes 43 and 44); and so had W. Stechow before him (*Zeitschrift für bildende Kunst* N.F. 3, 1934, p. 329), discussing also the drawings connected with it. The picture is in a very poor state, but the remains of the original paint point to Rembrandt and not to Aert de Gelder for instance, as has been reluctantly proposed by K. Lilienfeld (*Aert de Gelder*, 1914, p. 166, no. 98). The X-ray, published by M. Hours (*Bulletin du Laboratoire du Louvre*, 1961, no. 6) does not give any clue to a solution, although M. Hours interprets it in a negative sense. *Page 501*

598. *The Return of the Prodigal Son.* Signed: R v. Rijn f. HdG 113. Bauch 94. To the right, and below, a strip of 10 cms has been added. The signature is quite unusual and may not be genuine; the painting, however, is one of the great miracles of Rembrandt's art. Kenneth Clark (1966, p. 187) has praised anew the power of the composition. See also: E. Fechner (*Rembrandt, The Prodigal Son*, 1963—in Russian). *Page 503*

600. *Simeon with the Christ child in the temple.* Bauch 95. Published by W. R. Valentiner (1921, p. 99). The painting is unfinished and in a very bad condition, but what remains of the original paint surface is still impressive. The woman is by another hand. It is quite possible that this picture is identical with the *Simeon* in the collection of Dirck van Catten-burgh in Amsterdam, in 1671. He had com-missioned a *Simeon* from Rembrandt but the picture was still unfinished some months before Rembrandt's death (A. Bredius, *Oud Holland* 27, 1909, p. 239). *Page 504*

601. *The apostle Paul in prison.* Signed: R f. 1627 and on a page: Rembrandt fecit. HdG 179. Bauch 111. This and some of the following saints belong to a category which Bauch calls "one-figure-history-paintings". Rembrandt depicts St. Paul in a realistic prison. *Page 507*

602. *The apostle Paul at his desk.* HdG 177. Bauch 120. Painted around 1630. *Page 508*

603. *The apostle Paul.* Genuinely (?) signed: Rem . . . 163 . . HdG 180. The canvas had been turned over the stretcher, but the picture was restored to its original dimensions during a recent restoration. The attribution to Rem-brandt can no longer be seriously upheld. K. Bauch (1966, p. 29, A9): perhaps by J. Backer; J. W. von Moltke (1965, p. 80, no. 71) as G. Flinck; W. Oberhammer (*Die Gemäldegalerie des Kunsthistorischen Museums in Wien* 1, 1966,

plate 41), however, adheres to the tradition of Rembrandt's authorship. The attribution to G. Flinck seems to be well founded, but one should also consider the possibility of J. Lievens being the painter, especially in view of the (unsigned) *St. Paul* in Bremen (W. R. Valentiner, *Rembrandt, Klassiker der Kunst*, 1909, p. 16, right; H. Schneider, *Jan Lievens*, 1932, p. 26). *Page 508*

604. *The prophet Jeremiah mourning over the de-struction of Jerusalem.* Signed: RHL 1630. HdG 49. Bauch 127. It is not certain whether the Biblical story, which was first connected with this figure by F. Landsberger (*Rembrandt, the Jews and the Bible*, 1946, p. 109), really refers to the scene behind the melancholy old man (see also: J. G. van Gelder, *Openbaar Kunstbezit* 7, 1963, no. 15). *Page 509*

605. *A hermit reading.* Faked signature: RH 1630. HdG 192. Bauch 126. In its attempt to "beau-tify" Rembrandt's style, and to turn the Biblical story into genre, this picture is a typical example of a school picture, to be attributed without reserve to A. van Ostade (middle of the 1630s). The bluish colour scheme, the tame conception of the figure and the wild brushwork in the background are, moreover, in accordance with this artist's early style. *Page 509*

606A. *The apostle Bartholomew.* Signed on the knife: Rembrandt. Bauch 154. In the first edition of Bredius, the version in the Metropolitan Museum, New York (Friedsam coll.) was reproduced. It was described as in the "manner of Jan Lievens" by K. Bauch (1960, p. 283). W. Suhr discovered the version which is reproduced here, in the Bliss collection. J. Rosenberg (1964, p. 324/5) published it with details to show its superiority to Br. 606. K. Bauch follows Rosenberg's interpretation. Bredius (*Zeitschrift für bildende Kunst* 32, 1921, p. 147) pointed to a (third?) version in the Comte Leusse collection, which impressed him as "an original by Rembrandt". I have not seen the Worcester version for a long time, so I cannot put forward a considered opinion. *Page 510*

607. *The apostle Peter in prison.* Signed: RHL 1631. HdG 122. Bauch 134. Several replicas exist. Br. 607, which I have studied, is certainly genuine. *Page 510*

608. *St. John the Baptist.* Signed: Rembrandt ft. 1632. HdG 171. Bauch 140. This kind of signature is unusual for the year 1632 and it may have replaced an original one (on an originally somewhat bigger panel?), but the

picture is one of the best examples of Rembrandt's early Amsterdam style in the Rubens manner. *Page 511*

609. *The apostle Peter.* Signed: RHL van Rijn 1632. HdG 181. Bauch 139. Although the picture, according to tradition, was bought in Amsterdam as early as 1646, it looks like a contemporary copy and not an original. It should perhaps be cleaned in order to check the unfavourable impression it makes at present, although I cannot imagine that the transfer from panel to canvas has damaged the quality of the work to such a degree. Several copies exist. *Page 511*

610. *St. Francis at prayer.* Signed: Rembrandt f. 1637. HdG 187. Bauch 175. There exist other versions of this picture, none of which— including Br. 610—are known to me. *Page 513*

611. *King David.* Signed: Rembrandt f. 1651. HdG 39. Bauch 202. If Bauch is right—"according to the style done at the end of the 1650s"— the signature would not be correct. Neither Bauch nor I have seen the picture. *Page 514*

612. *The apostle Paul at his desk.* Signed (redrawn): Rembrandt f. HdG 178. Bauch 221 (in the notes, by error, as 223). Probably of the same date (1657) as Br. 613. Br. 612 has suffered from pressing, but it still remains a splendid work. *Page 515*

613. *The apostle Bartholomew.* Signed: Rembrandt f. 1657. HdG 169. Bauch 217. The picture was cleaned in 1951 and is in an especially good condition; the hand and the face, for instance, preserve intact the broad, powerful brushwork of Rembrandt's late figure style. Both these apostles (Br. 612 and 613) must have been painted in about the same period, though they may not have been companion pictures or parts of a set. See also Br. 614. *Page 516*

614. *The evangelist Matthew inspired by the angel.* Signed: Rembrandt f. 1661. HdG 173. Bauch 231. W. R. Valentiner (*Kunstchronik* N.F. 32, 1920, p. 219) supposes that in 1661 Rembrandt started work on a series of apostles and evangelists (see Br. 614-19), and to which also may belong the *Nun* (Br. 397), the monks (Br. 307-9), the *Self-Portrait as St. Paul* (Br. 59) and one of the Christ portraits (Br. 628-30). The series, however, is not a "closed" set, and is rather uneven in quality and execution, so that Valentiner's original idea—that they all belonged to one commission—is rather unlikely. Moreover, some saints are painted twice. It seems more probable that they were painted at different times, and some may have never been intended for immediate sale. Nevertheless, Valentiner's appreciative analysis (also: *Art Quarterly* 19, 1956, p. 400), supplemented by that of O. Benesch (*Art Quarterly* 19, 1956, p. 338), is very inspiring. Br. 614 is one of the best-preserved and most carefully executed of the group. The underpainting of the face, revealed by the X-ray, is as thoroughly modelled as the surface. *Page 517*

615. *The apostle Bartholomew.* (Genuinely ?) signed: Rembrandt f. 1661. HdG 168. Bauch 235. In contrast with the carefully, in part softly, modelled figure of Br. 614, this picture is handled with extraordinary vigour, and if it had not been engraved in the 18th century, one might have been induced to believe that a picture like this could only have been conceived and executed in the 19th century. *Page 518*

616. *An apostle praying.* (Genuinely ?) signed: Rembrand. f.166. . The remains of another signature on the upper edge of the book? HdG 194. Bauch 234. The picture has recently been cleaned (see report and appreciation of the work by Sherman F. Lee, *Bulletin of the Cleveland Museum of Art* 54, 1967, p. 295). My reservations about the inclusion of this work in the series of apostles, and its attribution to Rembrandt, have not completely vanished since the cleaning. It has a kind of looseness of surface texture that I have not observed in other works by Rembrandt. *Page 519*

616A. *The apostle Simon.* Signed (on the blade of the saw): Rembrandt f. 1661. Published by L. Münz in *Burlington Magazine* 90, 1948, p. 64. Bauch 237. This picture, discovered only in recent years, fits well into the series of apostles. *Page 520*

617. *The apostle James.* Signed: Rembrandt f. 1661. HdG 170. Bauch 236. *Page 521*

618. *An evangelist writing.* HdG 185. Bauch 248. This "man with the red cap" does not fit, without difficulties, into the series of apostles; although here the trouble arises partly from its condition. The top layer of paint has been abraded, so that the blocks of colour now appear to "jump out", in a rather inarticulate way. All modelling in the hands has been lost. According to Chr. Tümpel (1968; cat. no. 15), the evangelist Luke. *Pages 522 & 532*

619. *An evangelist writing.* Signed: Rembrandt f. 166. HdG 183. Bauch 238. The cleaning revealed the scarf around the neck, but showed that the beard was a later addition (compare

the reproduction before cleaning in the first Bredius edition; C. C. Cunningham, *Bulletin of the Museum of Fine Arts, Boston* 37, 1939, p. 56). Although the state of the picture has always been deplored (see: J. Rosenberg, *Kunstchronik* 9, 1956, p. 350; F. Winkler, *Kunstchronik* 10, 1957, p. 143), in many parts the original delicacy of the modelling can still be appreciated. According to Chr. Tümpel (1968; cat. no. 14), the evangelist John. *Page 523*

620. *Christ.* HdG 159. Bauch 194. The portraits of Christ and the studies of Jews have lately been studied by several art historians: H. M. Rotermund, "Wandlungen des Christus-typus bei Rembrandt", *Wallraf-Richartz-Jahrbuch* 18, 1956, p. 157; L. Münz, "Rembrandt's Vorstellung vom Antlitz Christi", *Festschrift für Kurt Bauch*, 1957, p. 205; S. Slive, "An unpublished head of Christ by Rembrandt", *Art Bulletin* 47, 1965, p. 407. Most of these studies belong to the second half of the 1640s, when Rembrandt painted the Emmaus pictures and etched the "Hundred Guilders" print. See also: Br. 300 and 578. The condition of this bust is not good, but the light parts of the face are well preserved. *Page 524*

621. *Christ.* HdG 161. Bauch 195. Genuinely (?) signed: Rembrandt f. Published by W. R. Valentiner (*Bulletin of the Detroit Institute of Art* 12, 1930/1, p. 2). This study is especially close to the Christ of the Louvre *Supper at Emmaus* (Br. 578) and should therefore be dated around 1648. *Page 524*

622. *Christ.* HdG 158. Bauch 215. This picture retains the character of a study after nature; and Slive's suggestion (see Br. 624A) that it is the first 'sketch' of the group is quite convincing. Bauch's dating—around 1656— seems too late. *Page 525*

623. *Christ.* Bauch 198. The picture appeared at the Moray sale, London, Sotheby's, June 9th, 1932, lot 83; it was for some time in a Dutch private collection, but has since disappeared. It could have been the version after which the mezzotint of B. Picart was made. I share Slive's doubts about the authenticity (see Br. 624A), but neither Bauch, Slive nor I have seen it in the original as we have been unable to trace the present owner of the painting. *Page 525*

624. *Christ.* HdG 163. Bauch 212. The signature is on the later, enlarged part of the picture and is therefore faked. S. Slive (*Art Bulletin* 47, 1965, p. 414) has traced the history of the picture

and corrected the errors of different writers (including the wrong statement about a cleaning, in the first edition of Bredius). It is not absolutely certain that it can be identified with the picture in the Van Loo sale, Paris, 1772, and sketched by Saint-Aubin in his copy of the sale catalogue, as R. Langton Douglas (*Art in America* 36, 1948, p. 69) believed. *Page 526*

624A. *Christ.* Bauch 213. Published by S. Slive (*Art Bulletin* 47, 1965, p. 407). The picture was acquired in the United States by the firm of A. E. Silberman in 1939 and was said to have come from a Polish collection. Slive rightly places the picture in the series which was executed in the late 1640s; he stresses the connection with the "Hundred Guilders" print. Bauch's dating (around 1655) is much too late. *Page 526*

625. *Christ.* Bauch 197. Contrary to the statement in Bredius' first edition, this version was published for the first time by W. R. Valentiner in *Bulletin of the Detroit Institute of Art* 12, 1930/1, p. 37. It is probably one of the latest of the series done in the 1640s. J. Rosenberg (1964, p. 117) has very sensitively described the character of the painting: it "moves a step further from reality toward a more idealized expression of mildness and humility. But Rembrandt's transition from the realistic to the imaginary is so subtle, that it is almost impossible to draw a borderline between the two". The picture is not known to me. *Page 527*

626. *Christ.* HdG 160. Bauch 196. See about the condition: Josephine L. Allen in *Bulletin of the Metropolitan Museum of Art* 4, 1945, p. 73. Notwithstanding some weak parts (the ear) and its blackish colour, this is a genuine picture which has suffered. It is not listed by S. Slive. I would date it later than Bauch does ("around 1648"). *Page 527*

627. *Christ.* Bauch 228. Published for the first time by C. Hofstede de Groot (*Die holländische Kritik der jetzigen Rembrandtforschung*, 1922, p. 41). It is not known to Bauch or me, and is not listed by Slive. *Page 528*

628. *Christ.* HdG 162. Bauch 229. The figure was once cut irregularly out of the original canvas; it has suffered by this operation and by rubbing all over, but it is still a fine interpretation of an ideal image of Christ. The posture is related to the study Br. 625 but, as Slive (*loc. cit.*, p. 415) rightly observes, Rembrandt's "incredible

power of invention led him to depict quite another aspect of Christ's character". It is painted around 1661 and W. R. Valentiner (*Art Quarterly* 19, 1956, p. 404) would combine it with his "series" of the four evangelists. *Page 529*

629. *Christ.* Signed: Rembrandt f. 1661. HdG 164. Bauch 241. H. M. Rotermund (*Wallraf-Richartz-Jahrbuch* 18, 1956, p. 230) interprets the subject as a Jewish pilgrim. W. R. Valentiner (*Art Quarterly* 19, 1956, p. 390) repeats his view that this *Christ* belonged to the series of the apostles. If Rembrandt had in mind a complete series (of the kind Rubens had painted in his youth) the inclusion of the Saviour would have been highly suitable. *Page 530*

630. *The Risen Christ.* Signed: Rembrandt f. 1661. HdG 157. Bauch 240. The "function" of this representation is not clear. W. R. Valentiner (*Kunstchronik und Kunstmarkt* N.F. 32, 1920/1, p. 22) combines it with one of his two apostle- or evangelist-series. G. Knuttel (1956, p. 195) combines it with an Ecce Homo representation and G. Lengl (*Das Münster* 20, 1967, p. 55) with an Emmaus representation. Important changes seem to have been made during the course of painting; one X-ray I have seen shows Christ with a book (?) in his hands. These X-rays are not discussed in the 1967 Munich catalogue of the Dutch paintings (by E. Brochhagen). The picture, whatever its original meaning and shape may have been, is one of the most sincerely and carefully executed of the series. *Page 531*

631. *The wrath of Ahasuerus.* Bauch, p. 29, no. A.1. The picture appeared at a Brussels sale, December 12th, 1936, lot 80 (ascribed to A. de Gelder), and was bought by P. de Boer, Amsterdam. Since its appearance, it has figured in all studies of the early Rembrandt, attributed either to Rembrandt or Lievens (or as a collaboration of both), or—more rarely—to a third artist. I am in favour of an attribution to the early Jan Lievens (around 1625), who, in my view, is an artist of great power and imagination. The X-rays (partly published by Bauch and kindly put at my disposal by the Raleigh Museum authorities), are not especially characteristic of the early manner of Rembrandt, as Bauch seems to find them. See: K. Bauch, *Wallraf-Richartz-Jahrbuch* 11, 1939, p. 240; 1960, p. 112; 1966, A 1; *Pantheon* 25, 1967, p. 162: Rembrandt and Lievens; W. Martin, *Jaarboek van de Maatschappij der Nederlandsche letterkunde te Leiden*, 1936/7, p. 557; J. G. van Gelder, *Elsevier's geïll Maandschrift* 93, 1937, p. 353; *Mededelingen Kon. Ned. Akademie van Wetenschappen, afd. letterkunde*, N.R. 16, 1953, p. 281; *Kunstchronik* 10, 1957, p. 121: Rembrandt; J. Held/M. Kahr, *Oud Holland* 81, 1966, p. 229: neither Lievens, nor Rembrandt; G. Knuttel, *Burlington Magazine* 97, 1955, p. 45; 1956, p. 240/2: Lastman?; J. Rosenberg, *Kunstchronik* 9, 1956, p. 354 and 1964, p. 14 and p. 345: Rembrandt, possibly with some collaboration with Lievens; S. Slive, *Allen Memorial Art Museum Bulletin* 20, 1963, p. 139: Rembrandt; W. Sumowski, 1957/8, p. 225: J. Lievens; W. R. Valentiner, *Catalogue of Paintings, North Carolina Museum of Art 1956*, no. 65; *Catalogue of Rembrandt Exhibition, Raleigh North Carolina*, 1956, no. 1 and *Art Quarterly* 19, 1956, p. 398: Rembrandt. *Page 398*

632. *The music-makers.* Signed: RHL 1626. Bauch 97. The picture was recorded for the first time at the F. Cripps sale, London Christie's, November 16th, 1936, lot 155 (2100 gns to Speelman). The signature came to light after cleaning. First published by V. Bloch (*Oud Holland* 54, 1937, p. 49) it has been accepted as a genuine early Rembrandt by O. Benesch (*Art Quarterly* 3, 1940, p. 13), K. Bauch (1960, p. 138), J. G. van Gelder (*Mededelingen der Kon. Nederl. Akademie van wetenschappen, afd. letterkunde*, N. R. 16/5, 1953, p. 284) and others, except for G. Knuttel (*Burlington Magazine* 97, 1955, p. 46 and 1956, p. 240; see also Bloch's answer in *Burlington Magazine* 97, 1955, p. 260). Bauch insists on an interpretation of the painting as an allegory of Music or Hearing (not a genre picture or portrait

group) with portraits of Rembrandt and his family. According to Chr. Tümpel (1968, cat. no. 10) a representation of the Prodigal Son. *Page 335*

633. *Head of an old man* (Rembrandt's father?). Signed: RHL. Bauch 343. Engraved by J. G. van Vliet in 1634 (B 23). Two other versions of poor quality are recorded: a) in the Oulmont Collection, Paris (W. R. Valentiner, 1921, p. 103), and b) Private Collection, Rome (J. Kronig, *Bolletino d'Arte* 1, 1921, p. 145). Bauch (1960, p. 261, note 130) calls Br. 633 "a much better, but probably still not authentic version" and later (1966, no. 343) "the best of many versions." He rightly stresses the iconographic resemblance to the Oxford drawing of Rembrandt's father (Benesch 56). The picture was formerly in the Prince Gonzaga Collection, Vicenza (1931) and afterwards in the D. Bingham Collection in New York. *Page 122*

634. *Saskia.* Signed: Rembrandt f. 1633. Identical with HdG 618 and 700. Bauch 467. First published by W. R Valentiner, *Burlington Magazine* 57, 1930, p. 260; discussed by W. Sumowski (1957/8, p. 233). Although highly praised by both Valentiner and Sumowski, I doubt the genuineness of the signature and the attribution to Rembrandt; it is most probably a work by G. Flinck. *Page 82*

[635. *"Rembrandt's father."* Panel 18×16 cms. Los Angeles, Private Collection. Published for the first time by W. R. Valentiner (2nd ed., 1923, p. 13). Not accepted by Bauch (1966, p. 49) or J. Rosenberg (1964, p. 371). I have not seen the picture myself (it was exhibited in Los Angeles, 1942, no. 2), but to judge from the photograph it is not an original by Rembrandt. Another version (panel, 21.5×18.5 cm.; formerly in the castle of Schleissheim; inv. of 1822, no. 3328; there attributed to F. Bol) was, in 1966, in a private Dutch collection. This is also too crudely painted to be attributed to Rembrandt. Both seem to be imitations after a Rembrandt type like Br. 78. *Appendix*]

[636. *Study of a man's head.* Said to be signed with monogram. Panel 22.5×15.6 cm. American private collection. The painting was formerly in the Swiss art trade, but its actual whereabouts are unknown. Neither J. Rosenberg (1964, p. 371), Bauch (1966, p. 49), nor I have seen the picture, but none of us sees any

reason to attribute it to Rembrandt. Bauch thinks it may be the work of an artist like J. de Rousseaux. *Appendix*]

637. See under Br. 56.

[638. *Portrait of a Rabbi.* Genuinely (?) signed: Rembrandt f. (according to Hofstede de Groot also dated: 166.). Panel 48×36 cm. Formerly Dutch art trade. HdG 408a. The picture became known only after it was shown in the Dutch and American art trade. I have not seen the original, but judging from a good photograph, the attribution to Rembrandt is very doubtful. Bauch (1966, p. 49) rates the quality rather high and looks for the author in the circle of Barend Fabritius. *Appendix*]

639. *Juno.* Bauch 285. First published by A. Bredius in *Pantheon* 18, 1936, p. 277; J. L. A. A. M. van Rijckevorsel in *Oud Holland* 53, 1936, p. 270. See also: E. Kieser in *Zeitschrift für Kunstge-*

schichte 10, 1941/2, p. 141. Rembrandt painted this *Juno* for the art-collector Harmen Becker, who complained in the spring of 1664 that the picture was still unfinished; but he finally accepted it, finished or unfinished, as it is listed in his inventory of 1678 (A. Bredius, *Oud Holland* 28, 1915, p. 195). In fact, there were two Junos in Becker's collection: one "a Juno life-size", without the painter's name, and a "Juno by Rembrandt van Rijn". Thereafter it was lost, until it reappeared at the Wesendonk sale, Cologne, November 27th, 1935, lot 87 ("in the manner of Rembrandt"), after having been on loan (but never exhibited) to the Museum of Bonn. After recent cleaning it appears to be of equal beauty to the late Lucretia pictures (Br. 484-5). J. S. Held (in an unpublished Manuscript: *The story of Rembrandt's Juno*, 1967) supposed that the picture was begun before 1660 and was finished around 1665. It seems that Rembrandt's first idea had been to represent the figure with two hands resting on a red table at the lower side of the picture. *Page 396*

CONCORDANCE AND INDEX

CONCORDANCE

To find the Bredius number for any picture listed by Bauch or Hofstede de Groot, look for the Bauch or HdG number in the central column. The corresponding Bredius number will be found under the left-hand column (for Bauch numbers) or under the right-hand column (for HdG numbers).

Bauch		HdG	Bauch		HdG	Bauch		HdG
487	I		532A	43		588	86	
	Ia	515	533	44		589	87	540
486	2		534	45		592	88	576
488	3		535	46	530	590	89	556
489	4		539A	47	522	593	90	572
423	5	508	536	48	531	592A	91	568
424	6		539	49	604	594	92	544
490	7		556	50	491	596	93	563
492	8		538	51		598	94	570
494	9	498	543	52	497	600	95	
493	10		544	53	519	460	96	
491	11		543A	54		632	97	555
496	12		545	55	516	422	98	
498	13	528	550	56		463	99	
499	14	504	548	57	505	464	100	588
501	15		547	58	518	468	101	589
502	16		551	59	248	471	102	592A
503	17	524	552	60	372	472	103	547
505	18	523	552A	61		474	104	566
504	19		546	62		476	105	
507	20		555	63		481	106	
497	21		557	64	514	117	107	537
508	22	525		64a	486		107a	538
509	23	496	558	65	520	482	108	
511	24		559	66		132	109	442
513	25	527	561	67		420	110	580
514	26	487	560	68		601	111	545
515	27	509	565	69	502	419	112	581
516	28		562	70	503	134	113	598
519	29		563	71		74	114	
520	30	507	566	72	542	138A	115	
521	31	499	570	73		77	116	558
524	32	489	554	74	562	80	117	536
523	33	501	564	75		425	118	586
525	34	488	569	76		427	119	
526	35	490	572	77	575	602	120	
528	36	526	575	78	574	428	121	594
530	37		574	79			122	607
416	38	511	576	80	543	73	123	
531	39	611	577	81	535	76	124	593
522	40	513	578	82	596		125	591
	40a	495	583	83		605	126	534
531A	41	521	584	84	592	604	127	
532	42	492	586	85	569	141	128	546

Bauch		HdG	Bauch		HdG	Bauch		HdG
81	**129**	595	228	**179**	601	125	**230**	435
79	**130**	548	244	**180**	603	614	**231**	272
82	**131**		232	**181**	609	307	**232**	233
135	**132**		225	**182**		304	**233**	431
133	**133**	584	229	**183**	619	616	**234**	
607	**134**	550	235	**184**		615	**235**	
430	**135**	551	239	**185**	618	617	**236**	432
142	**136**	565	241	**186**	430	616A	**237**	
144	**137**	582	230	**187**	610	619	**238**	122
143	**138**		247	**189**	397	309	**239**	219
609	**139**	554	236	**190**	307	630	**240**	425
608	**140**	560	240	**191**	308	629	**241**	
169	**141**	561	591	**192**	605	319	**242**	
156	**142**	559	253	**193**	306	318	**243**	
148	**143**	583	620	**194**	616	483	**244**	
149	**144**	579	621	**195**	462	261	**245**	
150	**145**	578	626	**196**	467	325	**246**	
152	**146**	597	625	**197**	474	324	**247**	
181	**147**	539	623	**198**	473	618	**248**	
187	**148**	552	128	**199**	461	64	**249**	
188	**149**	557	231	**200**	472	63	**250**	
190	**150**		258	**201**	464	70	**251**	
186	**151**		611	**202**	114	69	**252**	
182	**152**		269	**203**		466	**253**	
183	**153**		266	**204**	98	462	**254**	
606A	**154**	577	308	**205**	103	495	**255**	
178	**155**		267	**206**	102	98	**256**	
431	**156**		478	**207**	471	467	**257**	
470	**157**	630	272	**208**	480	102	**258**	
192	**158**	622	271	**209**	466	469	**259**	
191	**159**	620	270	**210**	479	351	**260**	
193	**160**	626	279	**211**	465	103	**261**	128
184	**161**	621	624	**212**	481	71	**262**	
432	**162**	628	624A	**213**	463	107	**263**	
206	**163**	624	260A	**214**	438	108	**264**	
179	**164**	629	622	**215**	117	359	**265**	318
185	**165**		284	**216**		110	**266**	135
207	**166**		613	**217**	483	361	**267**	
205	**167**		283	**218**	484	368	**268**	279
242	**168**	615	259A	**219**		377	**269**	275
208	**169**	613	282	**220**	485	378	**270**	433
180	**170**	617	612	**221**		382	**271**	211
433	**171**	608	286	**222**		387	**272**	434
26	**172**	303		**223**	468	392	**273**	
210	**173**	614	297	**224**	477	381	**274**	
211	**174**	302	295A	**225**	482	383	**275**	
610	**175**	304	527	**226**			**275e**	192
219	**176**		306	**227**	476	384	**276**	
435	**177**	602	627	**228**	429	371	**277**	
227	**178**	612	628	**229**		437	**278**	

Bauch		HdG	Bauch		HdG	Bauch		HdG
385	**279**		50	**329**		204	**378**	231
480	**280**		51	**330**	377	213	**380**	285
429	**281**		52	**331**	359	214	**381**	
114	**282**	420	54	**332**		212	**382**	
397	**283**	31	53	**333**	533	215	**383**	
484	**284**		57	**334**	30	216	**384**	130
639	**285**		56	**335**	436	217	**385**	232
485	**286**		58	**336**	310	218	**386**	
1	**288**	253	59	**338**		221	**387**	207
3	**289**		55	**339**		224	**388**	136
2	**290**		60	**340**		223	**389**	
4	**291**	297	61	**341**		222	**390**	140
8	**292**	267	62	**342**		265	**391**	257
10	**293**	428	633	**343**		237	**392**	283
7	**294**			**344**	210	234	**393**	314
6	**295**		136	**345**	133	251	**394**	
13	**296**		139	**346**	179	249	**395**	
12	**297**		78	**347**	301	250	**396**	247
5	**298**		145	**348**	178	252	**397**	
11	**299**	378	146	**349**	169	256	**398**	208
9	**300**		154	**350**	16	41	**399**	266
16	**301**		164	**351**	180	130	**400**	
17	**302**		161	**352**		129	**401**	325
18	**303**		162	**353**	206	263	**402**	273
23	**304**		159	**354**	142	264	**403**	245
19	**305**	110	155	**355**		268	**404**	
20	**306**	437	165	**356**		276	**405**	181
22	**307**	107	160	**357**		131	**406**	
21	**308**		166	**358**		274	**407**	300
25	**309**	387	170	**359**		275	**408**	
29	**310**	506	167	**360**			**408a**	638
24	**311**	494	173	**361**		278	**409**	209
31	**312**		174	**362**	249	119	**410**	
32	**313**		171	**363**	269	120	**411**	296
33	**314**		176	**364**	236	121	**412**	258
27	**315**	385	177	**365**	250		**413**	478
34	**316**	69		**365a**	242	280	**414**	246
36	**317**		172	**366**	261	281	**415**	205
	317a	351	163	**367**	295A	287	**416**	151
35	**318**		175	**368**		293	**417**	147
37	**319**	361	197	**369**	183	122	**418**	
38	**320**	68	195	**370**	264	123	**419**	182
39	**321**		196	**371**	141	292	**420**	129
42	**322**	63	200	**372**	148	290	**421**	286
47A	**323**		199	**373**	152	294	**422**	292
43	**324**	367	194	**374**	230	295	**423**	
44	**325**	386	201	**375**		291	**424**	
49	**326**			**375a**	144	277	**425**	220
48	**327**	368	202	**376**	324	296	**426**	
45	**328**		203	**377**	240	126	**427**	184

Bauch		HdG	Bauch		HdG	Bauch		HdG
315	**428**		342	**478**		398	**527**	62
314	**429**		345	**479**		402	**528**	44
124	**430**		344	**480**		401	**529**	8
285	**431**		346	**482**		403	**530**	9
298	**432**		100	**483**		405	**531**	5
299	**433**	228	93	**484**		408	**532**	256
289	**434**	288	350	**485**		406	**533**	1
300	**435**		349	**486**	13	407	**534**	22
	436	150	92	**487**		30	**535**	216
313	**437**	229	96	**488**		409	**536**	43
311	**438**	239	101	**489**	119	410	**537**	46
312	**439**	270	104	**490**	190	414	**538**	20
255	**440**	274	348	**491**	188	310	**539**	45
321	**441**	309	354	**492**	186	415	**540**	60
320	**442**	131	105	**493**	187	417	**541**	28
322	**443**	149	353	**494**	191	439	**542**	2
323A	**444**			**494c**	376	440	**543**	134
323	**445**		106	**495**	375	445	**544**	6
327	**446**		352	**496**	382	442	**545**	24
326	**447**		355	**497**	393	443	**546**	
66	**448**	243	356	**498**	396	441	**547**	38
	449	260A	357	**499**	328	444	**548**	40
83	**450**		358	**500**		446	**549**	3
84	**451**		360	**501**	373	451	**550**	34
89	**452**	280	363	**502**	384	449	**551**	55
86	**453**	263	109	**503**	400	452	**552**	7
87	**454**	282	364	**504**	379		**552a**	12
85	**455**		365	**505**	83	450	**553**	48
99	**456**		369	**506**	381	454	**554**	51
329	**457**	185	367	**507**	383	453	**555**	37
334	**458**		362	**508**	392	448	**556**	52
331	**459**		370	**509**	374		**557**	156
330	**460**		380	**510**	388	456	**558**	193
333	**461**	262	379	**511**	71	455	**559**	27
335	**462**		111	**512**			**560**	61
88	**463**		112	**513**		458	**561**	
90	**464**		388	**514**		457	**562**	54
338	**465**		390	**515**			**563**	50
339	**466**		389	**516**			**564**	10
634	**467**		115	**517**			**565**	36
95	**468**		116	**518**			**566**	18
341	**469**		391	**519**			**567**	19
332	**470**		400	**520**			**568**	29
336	**471**		113	**521**			**569**	53
337	**472**		118	**522**			**570**	11
94	**473**			**522a**	12		**571**	139
97	**474**		394	**523**			**572**	15
340	**475**		395	**524**	58		**573**	17
343	**476**		393	**525**	23		**574**	39
347	**477**		396	**526**	21		**575**	59

Bauch		HdG	Bauch		HdG	Bauch		HdG
	576	32		666	406		732	197
	577	143		667	407		733	159
	578	35		668	165		734	218
	579	56		669	336		735	265
	580	42		670	145		736	172
	581	49		672	73		736a	153
	582	26		673	79		737	198
	584	25		674	78		738	212
	585	33		675	81		739	194
	588	156		676	77		741	287
	591	13		677	76		743	323
	601	13		679	82		744	214
	605	109		681	80		744a	311
	606	94		682	74		745	162
	607	101		683	75		746	235
	608	97		685	64		747	222
	609	108		685a	66		748	224
	611	105		686	67		749	251
	612	99		687	63		750	278
	613	104		688	70		752	237
	614	106		691	95		753	277
	615	96		693	90		754	317
	618	634		694	87		755	326
	619	355		695	88		756	294
	620	409		696	86		757	221
	624	167		697	84		758	234
	625	331		698	85		759	158
	626			699	89		760	174
	627	252		700	634		761	160
	628	268		702	120		762	154
	629	175		703	293		763	254
	630	339		704	123		764	168
	633	170		705	289		765	223
	634	203		706	121		768	215
	635	164		707	124		769	177
	636	291		708	127		772	255
	637	199		709	126		773	157
	638	342		712	276		774	295
	642	217		715	113		775	146
	643	357		716	116		776	320
	645	200		717	112		777	196
	646	347		717a	366		778	195
	652	391		718	115		779	327
	654	161		720	118		780	322
	657	171		721	111		781	313
	658	321		722	213		782	299
	659	166		725	281		783	155
	660	202		726	173		784	312
	661	349		728	358		785	163
	664	315		730	201		786	204

Bauch	HdG	Bauch	HdG	Bauch	HdG
829	323A	873	340	933	408
845	356	874	344	939	440
846	350	875	334	941	443
848	346	876	362	942	441
849	338	877	333	943	452
850	365	878	390	944	454
851	353	879	371	945	448
852	398	880	402	946	444
853	329	881	341	947	447
854	389	882	354	948	451
855	399	883	332	949	446
856	343	884	330	950	453
857	394	885	352	951	445
859	345	886	92	968	456
860	360	919	376	970	459
861	369	920	337	971	458
863	395	926	410	972	457
864	363	927	414	631	A1
865	370	928	415	65	A3
867	335	929	416	147	A8
868	348	930	405	603	A9
869	401	931	417	15	A27
871	364	932	403		

Pictures accepted by Bredius but not by Bauch

Br. 14, 28, 40, 68, 72, 75, 91, 127, 189, 198, 209, 220, 233, 238, 243, 245, 246, 248, 254, 257, 262, 273, 288, 301, 302, 303, 305, 316, 317, 328, 366, 372, 373, 374, 375, 376, 386, 399, 421, 429, 434, 436, 438, 447, 459, 461, 465, 473, 477, 506, 518, 540, 541, 542, 568, 579, 580, 581, 582, 595, 597, 635, 636, 637, 638.

Pictures accepted by Bredius but not by HdG

Br. 4, 14, 47, 57, 65, 72, 91, 93, 100, 132, 138, 176, 189, 225, 226, 227, 228, 241, 244, 259, 260, 271, 284, 290, 298, 305, 316, 319, 380, 419, 421, 422, 423, 424, 426, 427, 439, 449, 455, 460, 469, 470, 493, 532, 541, 600, 623, 625, 627.

INDEX

Items marked 'A' will be found in the Appendix

629